The Photographer's Bible

An Encyclopedic Reference Manual

Bruce Pinkard

ARCO PUBLISHING, INC.
New York

To Khadidja for her love and
understanding

Published 1983 by Arco Publishing, Inc.
215 Park Avenue South, New York, N.Y. 10003

Library of Congress Cataloging in Publication Data

Pinkard, Bruce, 1932–
 The photographer's bible.

 1. Photography—Dictionaries. I. Title.
TR9.P58 1983 770′.3′21 82-20658
ISBN 0-668-05781-5

Printed in Great Britain

Acknowledgment

Without the help of these and many other people, this book could not have been attempted or completed.

Bill Brandt, Ansel Adams, Christian Vogt, Jerry Uelsmann, Ben Helprin and André Kertész for there kind arrangements for reproducing examples of their work.

George Crisp of Ilford Ltd, Rollei Technik and Agfa Gevaert of West Germany, Kodak Ltd, 3M Company Ltd, May & Baker Ltd, Bowens Ltd, Berkey Colortran (UK), Minolta (UK) Ltd, Patterson Ltd, Hasselblad (GB) Ltd, and the Polaroid Corporation for their invaluable technical help. Particularly in this respect, special thanks are due to Keith Johnson of Keith Johnson Photographic Ltd, who willingly supplied much of the hardware to be seen in the book, and Roger Bell of Broncolor, Switzerland, and Laptech Photographic Distributors Ltd, who arranged usage of the immaculate Broncolor professional studio lighting used in the technical illustrations, and Mr Alan Wood of Jet Propulsion Laboratory, California, for the very recent images of Saturn from Voyager 1 probe. My thanks also to Kurt Weiss of Ciba-Geigy Photochemie AG for technical advice on Cibachrome and supplying the Lumière photograph used in the colour pages. Other photographers who supplied valuable visual material for this book include Carl Furuta and John Cahoon of Los Angeles and Mayotte Magnus, Calvin Walker and Theo Brown of London.

Special thanks to Roger Davis and Annette Main who were the patient models involved in producing the technical illustrations and Judy Smith for her constant and excellent work in typing the text, also Bill Waller of Batsford Ltd, for ceaseless encouragement and unhesitating faith in the outcome of the project.

All photographs are by the author except where a credit denotes otherwise.

USING THIS BOOK EFFECTIVELY

If you have never used a camera before, read first *Photography for the First Time*, *Basic Photography*, *Camera Types*, *Focusing the Camera*, *History of Photography*, *Black and White Photography*, *Enlarging*, in that order, then follow up the cross references from these sections.

If you are a student of photography with ability to use a camera, read *Black and White Photography*, *Enlarging*, *Mounting*, *Archival Processing*, *Storage and Presentation*, *Vision*, *Large Format Cameras*, *Lighting*, *Optics*, *History of Photography*, *Colour Enlarging*, *Colour Harmony*, *Image Management*, in that order, before reading anything relating to special interests. Follow the italicized cross references and pay particular attention to those text areas emphasized by box lines. Turn to the *Appendix* and read the list of personalities mentioned in this book and follow up each entry.

If you are seriously interested in conceptual photographic matters but less content with technical information, read *Vision*, *Light*, *Lighting*, *History of Photography*, *Colour Harmony*, *Abstract Photography*, *Fine Art Photography*, *Image Management*, *Equivalence*, *Bauhaus*, *New Bauhaus*, *Surrealism* in that order before taking up any cross references. Turn also to the *Appendix* and read the entries listed under *Photographic Personalities*.

Introduction

'We take a handful of sand from the endless landscape
of awareness around us and call that handful the
world. . . . Each grain of sand is different.'

ROBERT M. PIRSIG
*Zen and the Art of
Motor Cycle Maintenance*

In the impenetrable darkness and bitter winds of the cosmic pre-dawn, there were nameless mysteries, shifting like sand in the slowly spinning consciousness of early man. The imagery which caught the hints and feelings of the darker, undeclared hemispheres of his mind was simple and direct. But the image makers were anything but that. They worked by meagre lamp light, in clinging caves or shrouded in the stones of early temples, to register and witness the tribal hopes and fears of common men and women. The artists were men of mystery who made picture signs and lived apart, as artists do, yet within the group and deeper still . . . within themselves, consumed by their own magic.

So art began and the slow search for those images that would more perfectly record real life spread out over the centuries and the picture makers remained separate, a strange sub-species, with their eyes always on distant events, some of which took place entirely in their own souls. Evangelizing, prophesying, holding the dazzling mirror of self-esteem before kings, popes and generals, the artists quested and hunted for tangible images that would faithfully reflect the world about them in something approximating reality. This was the core, the rationale, on which all of art fed; it was both fulcrum and axis in the searching pilgrimage of those who were the image makers.

A thousand years ago an Arab scholar, Abu Ali Al-Hasan Ibn Al-Haytham (called Alhazen in the West), devised a theory to turn this mirage into substance, but the waves of history swept this discovery aside for nearly 500 years, until European technology found the secret once again in the sixteenth century, and invented the camera obscura, a means to pass light through a machine and see reality, albeit upside down. Another three centuries drifted by until in 1839 in France and England, a dark Pandora's box was opened and photography began, reproducing life in awe-inspiring fidelity, a sliver of occult magic creating in an instant a timeless monument to time itself.

So ended 10,000 years of fervent inquisitions by the artists, some of whom now fled to the deeper realms of abstraction, others, with frail faith, took refuge behind walls of jargon and in the thickets of a cynical art market, but art of course did not die. Its main stream turned a little in 1839, but now sweeps on with the newcomer, photography, bobbing along safe within it, often though, it must be said, within the white water. The year of 1839 saw photography launched, its name, craft and skills defined for the first time and future growth perceptively outlined. It destroyed many cherished artistic aspirations and posed some unanswerable questions but, without doubt, it was soon to bring joy to millions. Hidden longings for immortality seemed to be served, envied skills of easel artists were easily and instantly within the grasp of ordinary folk and the nobility of a genuine and democratic people's art seemed to be assured by the amazing little black box which could detach a fragment of life before it and hold it within its chemistry, for years if necessary, there to be reconstituted at will at the hands of the photographer or his delegated suppliers. Photography from the beginning has always appeared simple – but deceptively so, as those who read this book will find.

The camera is basically a box, simple and light-proof. The front carries a lens which optically collects an image, not as the eye does with flickering, subjective, 3D vision, but from a cool two-dimensional point of view, a glassy, monocular, fixed focus wedge of the visible world. The camera stares, the eye scans and this must certainly be understood by anyone wishing to come to a proper understanding of the medium. The lens is equipped with two methods of mechanically controlling the amount of light which passes through it to the film and these are called the aperture and shutter. They interact with each other and radically alter the optical appearance of the image as they move through various configurations. This is also a difficult concept to grasp.

While the front of the box collects the image, the back of the box preserves it, in a flat package of chemicals lying precisely in the plane of focus and when light strikes this sensitive film, an irreversible change takes place and a 'latent' image is produced. The image remains completely invisible until further chemical treatment reveals it. This development functions to build up silver density in the exposed latent image so that it is visibly separated from the unexposed sections.

So our simple box, our rudimentary machine, already offers evidence of sophistication which requires more than passing attention if the manual skills and mysterious capabilities are to be mastered. Simple, very basic steps, of course, can be devised to produce good results and these may be no more complex than cooking a good meal in a modern kitchen. The ingredients are mixed correctly, strict attention is paid to time and temperature and the whole operation performed in a special room which has a particular need to be absolutely clean and free of dust. In the section *Basic Photography*, in this book, this approach is detailed, hopefully with simplicity and could form the basis of a completely satisfying technique,

one in fact which closely parallels the routines of the professional who usually is too busy to experiment.

For those who aspire to greater skills, photography must become a craft and its intricacies and potentials explored in depth. This book attempts this, essentially in a brief form, because the task of effectively and fully discussing all the subjects listed would take many volumes. Technically complex material is encapsulated so that it may form a useful introduction from a practical viewpoint and a background to further study. There are many cross references, emphasized by italics, which may help explain difficult text, and there are other listings at the end of each entry, which should also be read as further background to any particular subject.

Photography is very much concerned with people, not only those in front of the cameras and those who operate them but those who are concerned with its mechanical evolution, the most important of whom are mentioned so that the reader may trace their influence and fix their position in the history of the medium.

We are fortunate that many of the acknowledged masters of modern photography are still living and working and there are many opportunities to view their original work and images. Because of copyright problems it has not been possible to include more than a handful of examples and those photographers chosen for biographical mention in the text are not by any means a complete list, but are generally regarded worldwide as providing special areas of interest for those needing to know more of image style. Their work should be studied closely whenever possible.

Photography seems inextricably bound up with the souls of great men. Aristotle gained much from his contemplation of light and foresaw the possibility of a lens. Alhazen, in the eleventh century, devised practical mathematical solutions which formed the basis of optical perspective, the lens and the camera obscura. Roger Bacon transmitted this information to scientific sources in Europe in the thirteenth century, Leonardo da Vinci wrote about the camera obscura in the fifteenth century and in the seventeenth century the great Dutch philosopher, Spinoza, was also Europe's leading lens maker. Canaletto and Vermeer studied optics and probably both used the camera obscura to breathe a startling reality into their paintings, while in the mid-nineteenth century, great astronomers used photographic plates, tracing the light of distant stars whose energy began its journey earthwards long before photography was a practical invention. Even man's first experience of a negative image may have been the mysterious *Shroud of Turin* which bears an imprint considered by some to be that of Christ. New research puts this image beyond the fourth century. And now our cameras reach among the stars themselves, 1,000,000,000 kilometres from Earth, probing the eerie beauty of a universe which we ourselves could reach only in half a decade of space travel.

Perhaps the magic attraction of the photograph is the hint of alchemy that is found in its ability to transmute light into explicit imagery, allowing instant access to the elusive non-optical reality which is concealed in the structure beneath the surfaces and planes of each subject. New experiences must be photographed by us all, it seems, as if to hold reality, gently and forever in the fingers. Pictures of loved ones, holidays, accidents, social events, even war, are further concrete acquisitions of transient reality made permanent and standing out of time – ageless.

But what makes a good photograph? Each year, more than 20,000,000,000 photographs are made throughout the world, very few of them memorable and even fewer sufficiently of interest to qualify as art. Our modern society consumes images as a hungry nation takes bread to ward off famine: less concerned with quality, more with logistics.

Photographs are disfigured, debased and intrinsically devalued as they span communication gaps between cultures or link commerce to consumers. Nevertheless this part of our century sees the promise that the people's art, the machine-made image, is capable of deeper and more relevant meaning. The painter must spend time, the photographer always 'takes' it: slice by slice, with more than a hint of aggression and, lately, with considerable introspection. The purist rendering of accidental reality with strict geometrical perspective, once thought to be the pinnacle of the photographer's aspirations, today is receiving less emphasis. Expressionistic photographic images are now becoming more and more important, with their tangential, glinting half-glance at the world which connects to feelings and moods very much in the manner of peripheral vision. This metaphysical imagery from the modern photographer is making beach heads in the mind of the viewing public, connecting each to each and to the creator, wordlessly interposing a mutual bridge of memories and unconscious experiences, which deeply amplify the meaning. Pictures are now being made first in the head and not in the camera and for those who desire a serious love-affair with photography, it should be understood that this then is where good photography begins.

Of course, photography may be practised at very different levels – with unaffected mechanical simplicity or with more intensity and complexity perhaps than with any other art or craft activity and it is my hope that this book suggests this duality. For those who are as fascinated as I am in making images with this miraculous machine, I trust that in both a technical and conceptual sense, the book will also provide the beginnings of answers to their questions, at least enough to stimulate a need for deeper study and to offer some signposts along the way.

Colour pages

Between Pages 136 and 137

Page 1
1 Action photography may be stylized by the use of very planned and constructed images which do not, however, remain as frozen moments in the unfolding movement. Here the use of a slotted filter has permitted a partial blurring of action which has enhanced the high speed effect. (*Courtesy John Cahoon*)

2 Modern fashion photography is much more documentary than ever before and as it frequently now appears in magazines as much smaller pictures, the photographer must simplify composition and structure quite considerably. Here there is a clarity about the nature of the garment with a sense of informality in the visual which makes it communicate very strongly. (*Courtesy Calvin Walker*)

3 Kirlian photography (see entry), is an unusual branch of photography now receiving attention from graphic artists as well as medical researchers. Theo Brown, a London photographer, used 3M colour paper as the receiving emulsion for this photograph. (*Courtesy T. Brown*)

Pages 2 & 3
This is a selection of colour photographs taken by the author on various professional assignments throughout the world. Cameras used range from large format down to 35mm and they were executed between 1970 and 1981.

Page 4
14 This is a formal colour wheel used in planning colour harmony (see entry). After making film overlays as described on pages 80–82, they may be imposed on this wheel to see the actual harmony. The wheel may also be photographed as a technical test for colour lighting and colour filter balance.

15 Steps in making a Cibachrome print from a transparency. (*Courtesy Cibachrome*)
(1) Image is projected in an enlarger on to print paper.
(2) Latent images are formed in yellow, magenta and cyan layers.
(3) B/W development creates silver images, representing blue, green and red of original.
(4) Silver images and excess dye are removed by bleaching.
(5) Superimposed triple layer of images in yellow, magenta and cyan remain.

16 A colour negative looks like this, colours appearing as complementary to the real scene.

17 When such a negative is printed on colour paper, a positive, reversed colour print is the result, in natural colours. In reversal or transparency photography, the image appears as this example, with natural colour and a positive image which is achieved in one step without the negative.

18 Colour mixing. If three primary colours (red, blue and green) are mixed, white light is formed. If any two primaries are mixed equally, a secondary colour results: yellow, cyan or magenta.

Page 5
19 An early Lumière colour photograph taken in 1919. The Lumière Bros invented the only practical colour process for photographers during the first three decades of this century. (*Courtesy Ciba-Geigy AG*)

Page 6
20 Modern photographers can use the brilliant colour from today's colour technology, yet as in this still life, seek inspiration from the master printers of the 18th and 19th centuries.

Page 7
21 This is a metagraph (see entry) by the author, entitled 'City Man'. It measures 75 × 100cm (30 × 40 inches) is printed on Cibachrome and specially treated to give it archival properties in respect of light and dark fading. This kind of image uses constructed photography to synthesize various image elements to suit the photographers arbitrary choice, but does not depart from pure mechanical photographic techniques.

Page 8
22 Only two generations after the invention of photography the camera explores the stars, millions of kilometres from Earth. Using new technology to translate light into digital numbers, the image is returned to a radio telescope and is reconstructed as a normal colour print. It may take several years for the camera to reach the point at which the picture is taken. (*Courtesy Jet Propulsion Laboratory, California*)

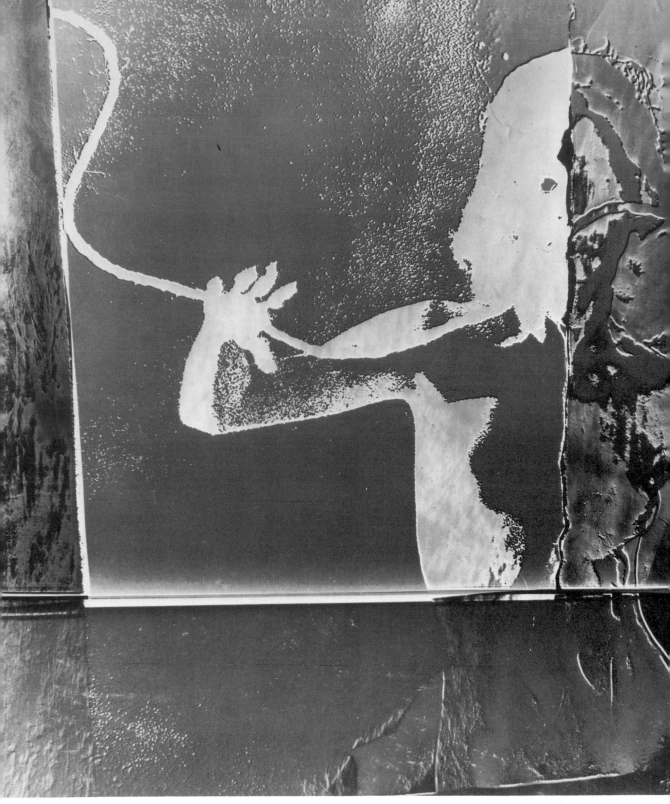

The abstract photograph can retain as much or as little of
the original image as is needed to convey the artist's
meaning.

ABBÉ, ERNST (1840–1905)

A brilliant German lens designer with a long association with Carl Zeiss, beginning at Jena when he was 26 years old. He led a team of optical scientists, responsible for new designs, such as apochromatic lenses (focusing three primary colours in precise registration) and the invention of improved flint glasses which made new lenses possible. Much of modern optical theory is based on his early work.

ABERRATION (OF A LENS)

No lens can be made optically perfect and cannot form an absolutely faithful image of the object in front of it. Each design from each manufacturer will display different short-comings and these errors in performance normally fall into three broad classifications: chromatic aberration, spherical aberration and aberrations due to diffraction. These deficiencies can degrade sharpness, alter shape, change contrast and create colour abnormalities. (See *Lenses*.)

ABSTRACT PHOTOGRAPHY

When photography began, its fascinating ability to produce life-like records of whatever the lens beheld and the ease with which geometrical reality could be recreated as an image pre-empted further experiment by many painters in that direction. It thus brought to a close five centuries of agonizing search for better techniques by painters who wished to produce on their easels images which were 'true-to-life'. The sudden achievement by mechanical means of aesthetic and optical disciplines which had eluded artists for centuries produced in them total bewilderment and shock. Well might Paul Delaroche's famous remark 'from today, painting is dead' have been taken as an accurate assessment of the artist's position in the mid-nineteenth century.

However, as we know, painting remained as lively as ever, even though highly representational art did suffer considerably in competition with the camera. Artists used the discovery of new optical and photographic principles to assist their efforts in evolving *Impressionism* and, at the turn of the century, non-representational or abstract art began to arrive in the salons and avant-garde exhibitions.

Startling images that did not represent actual objects were created just before the 1914–18 World War by Georges Braque, Pablo Picasso and Juan Gris. They themselves were influenced by earlier developments in later works of Signac, Cézanne, Seurat and Gauguin. The shocking catalyst of World War I assisted the artists of that time to explore non-representational, unsentimental abstractions and notably Kandinsky, Mondrian, Matisse, Picasso and Delaunay produced disturbing images resembling nothing the world had ever seen, using colour, line and pure design to produce expressive statements about their subjective experiences. It was an area in which photographers found difficulty in following and few had the desire or the skill to try.

However, just as abstraction in painting was rooted in the rising influence of the machine, the machine, which was the camera, began to suggest to various artists and photographers a new and limitless road toward the purity of modern abstraction; different from painting, but aligned with it in exploring the subjective depths of their experience that had nothing to do with factual representation. So, in Europe and later in the United States, photographers began to discover the chasm which would eventually divide those who worked toward an increasing optical perfection and those who saw their future in masking the solitary glass eye that was the omniscient, but dispassionate, observer of the twentieth century. They wanted their 'light machines' to help them see less clearly and feel more deeply. They wanted to subdue the deafening visual noise from the now perfect optics which had been handed to them and meditatively, precisely, totally to control their images in order to increase conceptual communication.

Paul Strand was a towering figure in the movement for a time, using realistic objects dynamically suppressed by light and image isolation, producing rhythmic abstractions totally free of manipulation. In the period 1915–17 he gave leadership to the rising world interest in 'representational abstraction'. Christian Schad, a vigorous Dadaist and one of the founders of this movement, experimented with photograms in 1918, Alvin Langdon Coburn, a year earlier, produced his kaleidoscopic *vortographs*, fragmented non-representational images inspired no doubt by the multi-faceted paintings from the Cubists. Francis Bruguière made total abstracts by photographing cut paper, often using a harsh specular light and, within the growing influence of the *Bauhaus*, Laszlo Moholy-Nagy led photographers into modern photo-abstraction. With other artists in the group, he produced collages, photograms, montages, 'bird's-eye viewpoints', optical distortion, solarization and line and contrast control. His depth of interest in the non-realistic image created many of the now commonplace techniques used in modern advertising and in fact all visual communication today. In photographic art his influence during his lifetime was seminal and in the eighties is likely to extend profoundly the concepts and performance of those photographers interested in abstraction. *André Kertész*, in the late 1920s and early 1930s, produced notable abstractions of nudes by using a distorting mirror and *Man Ray* explored the *Sabattier effect* to amplify edges and subdue form. Artists and photographers often worked directly on the sensitive paper without a camera, producing photograms and chemical reactions to, hopefully, edge them toward 'absolute photography' – creating solely and directly with light.

In the late twenties and thirties Steichen, Weston and

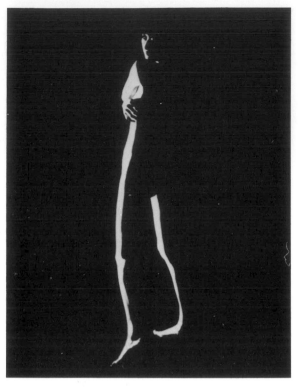

An abstract photograph can begin with a high contrast photograph like this. (*Courtesy Ben Helprin*)

others were exploring abstraction by the use of isolation of form and close-up techniques. Man Ray continued his effervescent experiments, drifting increasingly towards surrealism, whilst in 1937, four years after Hitler closed the Bauhaus in Germany, Moholy-Nagy had begun a *New Bauhaus* in Chicago, where his dedicated defence of the machine-made image and his continued interest in abstraction created the well springs of much modern photography. His active presence in photography for several decades thereafter inspired such photographers as Aaron Siskind and Harry Callahan who totally revitalized American photography.

The easier access to colour photography in the mid-thirties did not produce any overwhelming interest in abstract photography using this medium and it was not until the fifties that serious abstract photographers enlarged their horizons to take advantage of the new colour technology.

Soon after the European war ended, *Bill Brandt* began working on his extraordinary abstractions of the nude which was to end, 15 years later, in the publication of his startling book *Perspective of Nudes*. British photography, lost in its fading pictorial reverie for the past several decades, regained world status once more, but even though Brandt with his solitary, Herculean endeavours, brought Britain to the brink of modernity in photography, it has remained largely apart from successful world movements in abstract photography. A few notable exceptions being Sir George Pollock, *Raymond*

Moore and various technical specialists, some of whom explored the submicroscopic world in search of non-representational imagery.

Continental European photographers were less uneasy than British ones about meeting abstract art on its own ground and in the 1950s *Otto Steinert* produced an inspirational exhibition entitled 'Subjective Photography'. His work and that of Swedish photographers Hans and Caroline Hammarskold stand out as a major European influence on both modern photography and on graphic design generally.

Meanwhile, whatever Europe was doing to re-activate the techniques of the Bauhaus photographers, the Americans were naturally and gracefully assuming leadership in all forms of photographic abstraction. Brett Weston, Minor White, Harry Callahan, Aaron Siskind, Gyorgy Kepes, Elliot Porter, Robert Heinecken, Walter Chappell, Paul Caponigro, Naomi Savage, Todd Walker, Ernst Haas, Scott Hyde, John Wood, Pete Turner and *Jerry Uelsmann* are just some of the American photographers who became involved with the haunting mystery of photographic abstractions and derivation. Some acted tentatively, some with total conviction, but all were willing to accept that the camera machine and the monocular, lambent docility of its lens was not essentially limited to reportage or socially concerned images. Modern artists like Richard Hamilton, Robert Rauschenberg, David Hockney and Andy Warhol gladly nourished their easel paintings by the selective use of photography and if European photographers argued interminably about aesthetics and withdrew to their word-orientated enclaves, the men and women from the New World, using abstract photography, boldly shared their dreams and deepest subjective experiences with us. As Orson Welles said, 'the camera is much more than a recording apparatus, it is a medium via which messages reach us from another world'.

Alvin Langdon Coburn, in this century's second decade, argued that black and white photography was nothing but abstraction and so, in an elementary way, it is. Look at the majesty of an original Ansel Adams print, glowing with monochromatic technique and masterful realism; it already passes several tests of abstraction: purity, compression, simplicity, isolation and universality. Add a filter to the lens, use shallow depth of field to isolate selected parts of the image, use a slow shutter speed to soften the crisp action of movement and abstraction has begun. Even the *F64 Group*, beloved of realists, sought to abstract by using the ambiguity of close-up or the distortion of 'bird's-eye' views. The Oxford dictionary defines abstraction as 'a distillation, a derivation, or a separation in mental conception', and photographers are fortunate that so many legitimate means exist to destroy selectively the mirror image from their camera-machines and so isolate and distil the unseen essence of their experiences. Mechanical representation gives way to creative presentation, as Moholy-Nagy says.

Representational images suggest historic and past times,

Right A high contrast photograph can be taken to an absolute limit by purely photographic means, to produce a totally abstract picture. (*Courtesy Ben Helprin*)

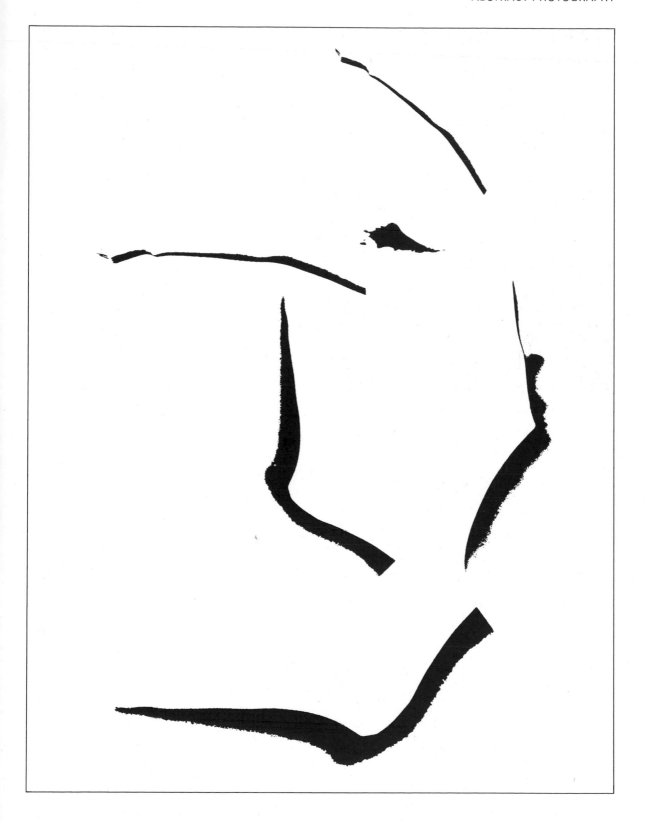

whilst the confusion and mobility of the abstract creates immediacy and communication, defying the icy intellectualism of logic and analysis. E.H. Gombrich suggests, in his fascinating book, *Art and Illusion*, that to think of modern art as a transcription of the images of our unconscious is a grave oversimplification. Rather we should think of it as a means of restoring to the artist a hitherto restricted choice of means of expression. As Professor Gombrich was something less than enthusiastic in that book about photography, he did not include it in his discussions of abstraction, but in the eighth decade of this century, photography is sufficiently well proven as one of many modern media available to artists and it should be emphasized that in abstract techniques of essential symbolism or structural synthesis it sometimes has no equal.

The photograph, of course, is never a literal transcription of the reality which lies in front of the camera. Even at its sharpest and most optically pure, the camera can produce only an image of that reality. As an image, it is a *translation* by the camera operator and is modified by his skills and techniques, his concepts and control and, finally, by the degree of enlightenment in the viewer. As the image deviates in any way from the real world it illustrates, so abstractive elements present themselves. To change a brightly coloured scene into tonally grey equivalences is an abstraction, even though a simple one. To alter perspective and spatial illusion by the use of optics which change the image geometry is also a first step on the road to abstraction.

To suppress form by lighting only perimeters of contour, or destroying form by the use of lens-axis lighting – these are the first faint stirrings of photographic abstraction. Step by step, reality may be changed, yet absolutely controlled by the photographer. One need only include those elements in the scene that assist in enhancing the image concept.

It has been established (and commonsense supports the view) that beyond any other image-making technique, photography is the easiest to understand or to 'read', without prior learning or experience and this skill is common to all races and cultures. Polaroids shown to tribal people who know nothing of civilization or sophisticated cultures were perfectly understood from the first moment. Children of less than six years old have easily decoded even very oblique visual references in photographs. The symbolism and structure of these mechanical images seems to cross all boundaries and enter effortlessly into communication with all cultures, somehow being absorbed intuitively, no matter what degree of education or experience exists in the beholder. What better base to build on for the exploration of abstraction, than a system of universal and instant comprehension?

The electronic image of television continues to deepen the skills of us all in understanding ciphers and symbols in photographic images. The flickering, broken images, fleeting moments in fragmentary news shots, lost definition by poor reception, all diffused by the familiar line scan, seem not in any way to distract us from decoding and comprehending any image. The extraordinary lithographs of Richard Hamilton's 'Kent State' are relevant in this context. They are both familiar yet abstract. They terrorize us with minimal photographic information.

Peripheral vision probably accounts for nearly 80% of our perceptual information but it is not an image of crystal purity. It is highly subjective, without colour, blurred, scattered by involuntary eye movements. The messages we receive through peripheral vision are sufficient to prompt all the most basic and intuitive psychic behaviour that exists in modern man. Abstract photography is very like peripheral vision, except that at the artist's whim, colour may be added, but also may be wilfully manipulated away from reality.

It is thematic in many learned discussions relating to photography as art, to denigrate abstraction in photography and to sanctify the undoubted capability of the camera to record 'unorganized reality' as the only praiseworthy attribute calling for an artist's attention. But the camera does not record reality, it creates, in whatever mechanical terminology the photographer's skill permits, *an image of that reality*. When Cartier-Bresson selects 'the decisive moment', or when Ansel Adams immortalizes the sweeping contour of western America, even when a classic photographer like Irving Penn slowly constructs a still life, the image becomes a conceptual statement, identified forever with the image maker. The abstract photographer merely extends that desirable control which must exist in all memorable images, and organizes the image to an extreme degree. Any photographic means may be used legitimately to achieve this purpose. Part of the reason why abstract photography has not found ready acceptance in certain establishment circles is that critics do not know enough about the many craft skills that exist, without departing from 'pure' photographic controls, which permit a photographer to modify the limited, geometric, mirror-image which is the usually anticipated result of using a camera. Contrary to much popular belief, abstraction in photography is not reached by a series of lucky accidents, but a culmination of precise photographic skills controlled by the photographer to achieve the first step in any image concept: the organizing of *selected* visual information.

An excellent example of an abstraction may be a straight line ruled on a page. It is symbolic of the deeper meanings of measurement, it is flat pattern with no other dimension, it is irreducible, it is totally understood by all beholders; it has direction, movement and tension and, with minimal visual means, achieves maximum expression of its total character. It is also totally organized information. However, although some noted photographers did seek abstraction in the rarity of straight lines to be found in nature, most photographers will be drawn to more comprehensive images.

The photographic abstractionist will be looking for images that contain ambiguity; those that offer only partial disclosure of the subject's character, images where pattern is as important as surface contour, edges will be explored rather than form, tones may be compressed or colours expressively changed. One apparently constant factor in abstract photographs is worth noting – whatever is done to alter representational information in the final image, *mood*, which seems to be intrinsically present in all photographs, will be *intuitively* communicated to almost all viewers, no matter what their visual literacy may be.

The photographic abstractionist will be searching for

techniques of fragmentation and then synthesis, destruction and then re-construction. The photographer will explore experimental accident, but remain in control of the final image. Eventually the abstract will seem to obtain a life of its own, the work will begin to have a direction and self-determined urgency and the photographer need only understand this, amplify it and guide it to a proper conclusion. For experienced workers there will appear to be an unconscious control exercised between themselves and their image.

Simple abstractions begin by changing expected characteristics in a subject; for example, by the use of modifiers on the lens, such as polarizers, filters, diffusers and de-saturation screens. Elementary effects can be achieved by the use of film types which distort the 'real' image, such as using tungsten balanced film in daylight situations or the use of infra-red or ultra-violet sensitive films. Texture screens may be added at the film plane, tones may be compressed by certain processing techniques or they may be artifically extended by other processing methods. Pattern may be explored by macro and microscopic techniques. Unseen colour abstractions may be found by using polarizers on crystal cultures (see *Polarizers*), or by the use of spark photography, *Kirlian* photography or the *Schlieren* method to explore natural phenomena. These photographs will appeal to the senses rather than disclose objective information.

Soft edges readily evoke mood and produce intuitive responses in viewers and these may be obtained by using shallow depth of field and differential focus, or by the use of camera movement or subject movement or both. The early work of Ernst Haas is important in this respect. The discreet use of a zoom lens can also achieve fascinating effects. The silhouette is, notably, an abstraction and the dynamic image 'Eleanor' by *Harry Callahan* in 1948 offers us a superb example, but here pattern has become hard-edged.

Those who wish to produce hard-edged abstraction usually begin 'in-camera', often by isolating chosen elements of the subject by the use of close-up techniques, while at the same time suppressing form by the manipulation of light. A good example to study is *Edward Steichen*'s 1921 print 'Harmonica Riddle' and his sunflower series begun in France a year earlier. Form may be destroyed by using rim lighting (see *Lighting*) or by lighting along the lens axis using either a ring flash or a beam splitter. In colour, form may be suppressed by using these lighting techniques along with a control of colour contrast. For example, a green apple in close-up, lit by either rim light or axis light, placed on a matching green background, will become an abstract pattern. If a lemon is lit with form-suppressing light but placed on a receding and featureless contrasting colour such as blue, spatial distortion will occur as well.

Exciting as it is to perform these elementary abstractions within the framework of respectability, which is derived from working with the camera alone, far more interesting abstractions are possible when the photographer acquires darkroom skills that provide increased control over the image.

When the camera is bypassed totally, it is possible to achieve beautiful effects in monochrome just by exposing a sheet of enlarging paper to white light, returning to a safe-lit

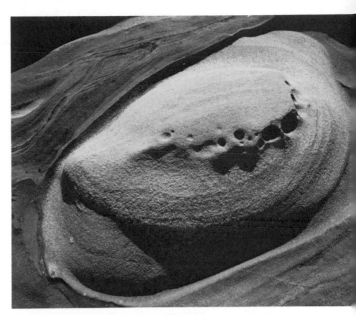

Satisfying abstract shapes may always be found in nature and if scale is not identified, the visual aspect becomes that much stronger.

darkroom and applying developer by sponge and brush to darken the print in selective areas, stopping the action at will by the use of water bath or acid rinse, until finally stabilizing the completed image in a normal fixing bath. The method obviously produces somewhat esoteric images, but in the search for abstraction it has a distinct photographic history, beginning with Erwin Quedenfeldt in 1919. Modern photographers and artists continue to explore its possibilites, even though it receives considerable criticism from pictorialists and realists. It is, after all, working with light and with the latency of photo-chemistry and the fact that no mechanical image is 'drawn' by the automatic camera machine may take it further toward absolute photography, as its adherents have always thought.

Working still with very simple means, yet without a camera, a mainstream in photo-abstraction can be found in the *photogram*. Using a focused light from an enlarger, the beam is interrupted by placing objects directly on the photographic paper or suspended on glass sheets some distance above the surface. Abstraction is immediate and satisfying and the famous Dadaist, *Christian Schad*, made the technique a life-time occupation. From this work and his inspiration came the fascinating photograms of *Man Ray* and *Moholy-Nagy*.

The camera lens imposes certain rigid disciplines upon the photographer which those who dispense with it can easily evade, but *especially* when working without a camera in this way, creative control, concept and structure must not be diluted. Nothing but superlative craftsmanship and confidently directed manipulation can be acceptable in any technique that seeks abstraction, with or without the camera.

Using an original camera image, thoughtfully composed to

> Abstraction relies on the use of unconscious vision (imagination) by the viewer. It requires ego-control on the part of the artist: first to protect a barely conceived idea, then consciously to fragment it into a symbolic concept of that idea.
>
> Abstraction requires ego-destruction in the Zen sense to allow the fusion of tentative and intuitive images with the creator's experiences of reality. Image completion requires an equally unconscious act on the part of the viewer which synthesizes the fragmented messages from the creator.
>
> The mutual effort by artist and observer of interdependent communication is the final and absolutely necessary part of the abstraction. Without it the image is meaningless and merely ornamental.

provide a basic structure, abstraction can be sought by the compression of tone. This is usually done by producing successive derivations on contrast film until form is suppressed to the desired degree (see *Lith Films*). A further enhancement of edge effect may be made by *pseudo-solarization*. True solarization was first noted by John Draper on Daguerreotypes only one year after the introduction of photography but this phenomenon is rarely seen now and is often confused with a very similar one, called the *Sabattier effect* after the French scientist who first described it in 1862. By arresting development and fogging the film in a short secondary exposure, then continuing development, an image is obtained which contains both negative and positive elements. By pre-planning, very surprising and totally controlled abstractions can be made.

Bas relief, sometimes used with tone-compression techniques, can suggest shallow third dimension and, used in conjunction with the Sabattier effect, can be a suitable tool in photo-abstraction.

Deliberately introduced *reticulation*, while difficult with modern films, can enhance abstractions in black and white emulsions.

Working in colour, with a combination of any or all of the above techniques, a photographer can produce separation negatives and positives, each designed to produce local colour or edge-to-edge additive colour matrices and which seem to provide an ultimate control for the abstract photographer (see *Metagraph*).

It cannot be stated too clearly once again, that those who pursue abstraction in photography do not let themselves loose among a lot of happy accidents. Such work is the result of pre-visualization, planning and craft skills of the highest order and those who merely play with and explore techniques do not usually produce meaningful abstractions. Abstractions must have invisible structure, certainty of concept and finally, must open a channel of communication between artist and viewer.

In general, abstractions are often more telling when they hint strongly at their photographic source material. Derivations should retain, if possible, ample evidence of photographic properties such as action, texture, pattern, mood,

spatial distortion, etc. Absolute abstraction, where these characteristics are eliminated, seems less satisfying and lacking in communication.

Abstract photographers will want to use ambiguity in their images and explore edges rather than contours. They may also find some of the following attributes useful ingredients in their images: symmetry, simplicity, innocence, timelessness, freedom, sexuality, humour, dimension, separation, inertia, equilibrium and mysticism. Above all, abstraction in modern photography is a hard-won synthesis, a search for the elusive essence of the subject, distilled by the unconscious experiences of the photographer, a phenomenon achieved despite the cold optical purity of twentieth-century machine-made images. It is not necessary to explain or rationalize this phenomenon to those who do not understand, for these expressive images will be read intuitively only by those who comprehend without question. The poet, Goethe, said in the nineteenth century, 'do not, I beg you, look *behind* phenomena'.

ACETIC ACID

This is a mild acid, very like strong vinegar, used as a stop bath between developer and fixer during both negative and positive processing, to arrest development quickly. In its concentrated 99% state it is dangerous to eyes and sensitive skin, and fumes can be flammable and also affect some people's respiration. The concentrate is referred to as 'glacial' because it solidifies at comparatively high temperatures, 15.5°C (60°F) and it is usual to dilute it to 28% strength for practical working solutions. This is done by taking three parts of concentrate and adding it slowly to eight parts of water. A 2% working stop bath can be made by diluting this 28% solution further in the proportion of 75ml acid to one litre of water for normal processing. Line materials processed in high alkaninity developers need a stronger bath, namely 125ml to one litre of water. Always add acid to water and stir gently during mixing (see *Acid*). When working with glacial (concentrated) acetic acid, always work in a ventilated room with no naked lights, avoid contact with the skin, and, if splashed in the eyes, immediately flood the face with large volumes of water. Call a doctor at once (see *Dangerous Chemicals*).

ACID

Acids used in photography are usually weak hydrogen compounds that generally react with other compounds to create metallic salts. Even though normally used at very dilute strengths, acids must be regarded as toxic and corrosive substances. When using them, good ventilation of the room is vital and they should not be placed in household articles that later find their way back into family usage. All photographic chemicals should be kept out of reach of children and solutions must be stored and used in containers which are specifically for photographic purposes only. Wash any utensil thoroughly in water after use.

Acids, which are measured in terms of strength on a 'pH' scale beginning at pH 7.0 (neutral) and ascending in acidity

as the scale decreases to pH 1.0, are used in photographic processing to neutralize alkaline developing actions, either as stop baths or acid fixing baths.

Always pour acid into water solutions – not water into acid, as this could cause minor explosions, sometimes making the surface boil. If photographic acids splash the skin or eyes, flood the effected part *immediately* with water and seek medical advice at once if any discomfort remains.

ACTINIC LIGHT

This is radiant energy in the form of light waves which acts upon certain photographic emulsions, increasing their sensitivity in selective areas. The nature of the sensitometry for each film determines which source has actinic properties. Ultra violet, infra red and x-rays have actinic qualities. For panchromatic emulsions, most visible light waves have actinic properties while for slower orthochromatic films the cooler, bluer wavelengths provide increased actinic activity (see *Light*).

ACTION PHOTOGRAPHY

Until the invention of the camera, action could not be analyzed and the well-known experiments of *J.E. Muybridge* in the 1870s and 1880s, using the camera to record locomotion in humans and animals, disclosed startling departures from the accepted theories for depicting action. This affected artists, scientists, engineers and physicians to a considerable degree.

The modern camera, operating quite easily at shutter speeds of $\frac{1}{2000}$ of a second is capable of 'stopping' most conventional action, while the use of high-speed flash and spark photography can freeze the bullet in flight or trace the path of exploding gases or air flows. (See *Schlieren Photography*.)

The photographer who is interested in portraying action effectively, will, after learning basic techniques, have to adopt a degree of subjectivity in the way that interest is extended. Totally stopped movement is easily obtained with just a little anticipation and becomes an analysis of a selected part of the action. Partially stopped action often creates a more dramatic sense of movement and immediacy and the degree of blur that is found acceptable will vary with each photographer. Really exaggerated blurring can often create a synthesis of the action and produce in the viewer a very strong and searching response to the image.

The print itself may be expanded physically to create symbolized blur from sharp images and is another fascinating way to explore motion and the forces creating it.

The use of *stroboscopic flash* can create startling impressions of movement or even the use of an ordinary electronic flash which has a rapid recycling time, can, when repeatedly fired at a moving subject in a darkened room, give dynamic impressions of action. The use of the blurred zooming technique in daylight with a slow shutter speed or using a zoom lens in a darkened room while the flash is fired, as the lens moves through its range, can bring apparent motion even to still subjects.

Graphic techniques in the darkroom, such as multiple printing of stopped action on to a single sheet of paper can produce interesting creative results, as can the use of line images of similar subjects allowing edges to overlap.

Photographers who photograph sports for purely creative purposes need only to study the effect of *partially* stopped action, but photo-journalists whose work will be reproduced in magazines or newsprint will probably need to use high shutter speeds and maximum anticipation so that participants are very sharp and easily recognized. Photographers who record high-speed nature subjects, especially birds and insects, usually will need to seek total action-stopping techniques, often employing intricate remote firing equipment (see fig. on the left).

Because of its special problems, action photography usually requires longer lenses than normal and for 35mm users, at least a 200mm lens is advisable. This will require higher shutter speeds than suggested in the table on page 11 for action stopping. Ability to follow action in the viewfinder right to the split second before exposure may mean that a non-optical frame viewfinder is best. For very long lenses, say 400mm or more on the 35mm format, a 'follow focus' facility such as is featured on the Novoflex lenses may be useful. This takes considerable skill to use and much anticipation, as the focus is changed by squeezing a tensioned trigger until sharpness is obtained. The shutter is tripped by a release built into the same trigger.

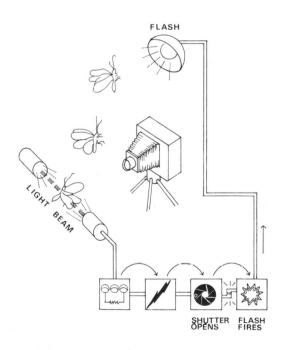

FLASH

LIGHT BEAM

SHUTTER OPENS FLASH FIRES

This is a diagram of a typical electronic trigger for photographing insects in flight. The subject flies through the light beam and breaks the circuit, causing the shutter to open and the flash to be fired in perfect synchronization.

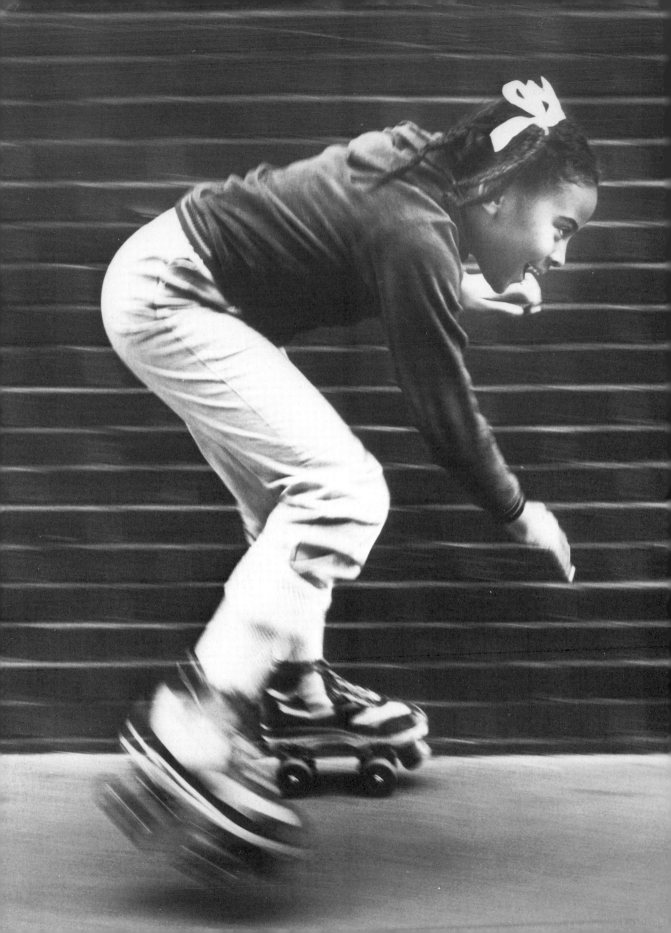

Very dramatic wide angle pictures of head-on action can be shot from a moving platform which keeps just ahead of, and at precisely the same speed as , the subject but this entails some degree of danger for the photographer, with considerable planning, and only a professional assignment would justify this approach.

With the agreement of those in charge of sports events, a wide angle view of oncoming action, for example steeple chasing or even motor sports, may be obtained by placing a motor-driven camera in a prepared position so that it can be fired by remote control, usually radio pulse. This dedicated, and perhaps expensive, approach can mostly only be undertaken by professionals. Fixing motor-driven cameras to hang gliders, acrobatic aircraft or free-fall parachutists, with the camera either fired remotely by radio pulse or by the performer using long cable releases, will produce eye-catching moments of peak action.

For the artist, who wishes to create a synthesis of motion and effort by the use of blurred images, no such sophisticated logistics are needed. Choosing a slow film, perhaps even modifying speed still further by the use of *neutral density filters* and stopping down to obtain maximum depth of field, this photographer explores motion within motion, the timelessness of time and the very essence of action. By using a mobile camera platform, exactly matched in speed and direction with the subject, slow shutter speeds of as much as four seconds will produce startling images, especially in colour. Here the wide angle lens can be used effectively as long as the photographer's movement is parallel to that of the subject.

Left This photograph was taken at $\frac{1}{30}$ of a second, from a moving platform which was exactly parallel to the action and travelling at the same speed as the subject. Identity of the person is clear and action is well demonstrated but not analyzed in detail.

Below Movement may be simulated carefully in the studio. Here the model has been carefully posed on the floor and arranged as if jumping. This obviously overcomes limitations in respect of fast shutter speeds.

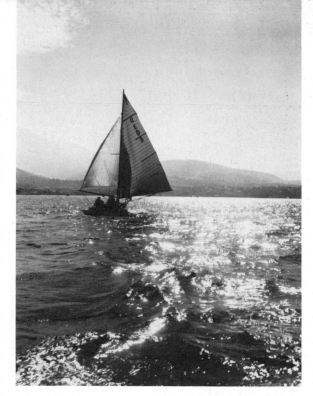

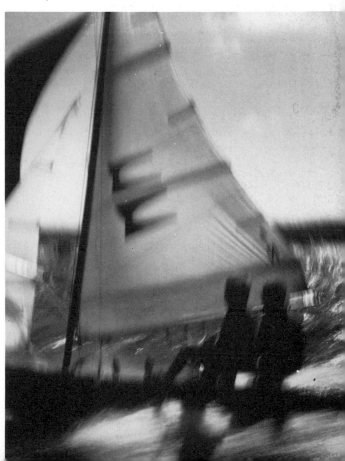

Sports photography can be taken in varying styles. Here yachting action is illustrated (*above*) by the romantic and peaceful interlude at sunset at the end of a hard race, and (*below*) with a moment of high speed action, further exaggerated by deliberate camera movement and slow shutter speed.

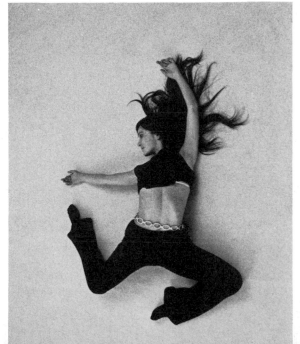

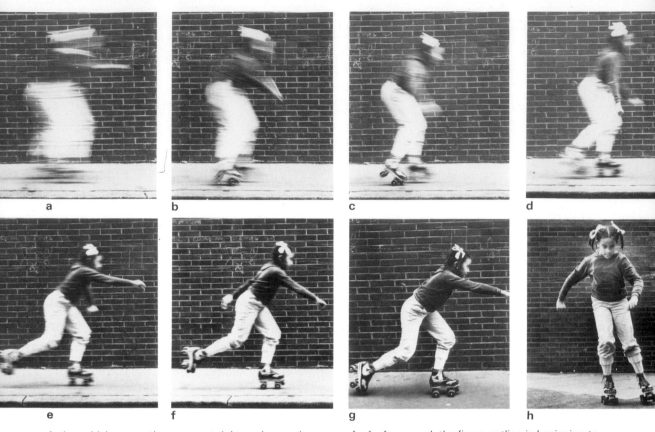

a b c d

e f g h

Action which passes the camera at right angles requires high shutter speeds to stop movement. Action which is toward or away from the camera requires only slow shutter speeds to give a sharp image. The most impressive pictures of action are made by panning or following the action while on a moving platform.

a $\frac{1}{8}$ of a second, the figure is blurred.

b $\frac{1}{15}$ of a second, the figure is more definite, the skates are identifiable.

c $\frac{1}{30}$ of a second, the figure outline is more defined, some action is stopped.

d $\frac{1}{60}$ of a second, the figure outline is beginning to become solid.

e $\frac{1}{125}$ of a second, although blurred, the figure could be identified.

f $\frac{1}{250}$ of a second, even at this speed, the figure is unsharp.

g $\frac{1}{500}$ of a second, action is just stopped, but feeling of movement is lost.

h $\frac{1}{30}$ of a second, compare this example with (c) at the same speed. Action towards camera can be frozen at slow speeds and action is easily analyzed.

Summary of precepts for good action photography

Research the subject completely.

For sharpness use $\frac{1}{1000}$ second shutter speed.

Use fixed focal length lenses.

Use a power winder of at least 3/fps capability.

Anticipate peak action.

Pre-focus on key run-through points.

Use tripod and cine-pan for long lenses.

Wait and watch.

Locate camera position with imagination.

Good equipment is essential.

Readiness of equipment is vital.

Action must move into focus, not away.

Crop on camera as far as possible.

Use long lenses to isolate the essence of action.

Move around.

Do not endanger yourself or others.

Blurred action must be sharply focused.

Maintain concentration.

ACTION-STOPPING SHUTTER SPEEDS FOR NORMAL LENSES

	mph	kph	3m or 10ft			7.5m or 25ft			25m or 83ft		
			↓	✕	→	↓	✕	→	↓	✕	→
Hand and body movements, slow walking, slow swimming	3	5	$\frac{1}{30}$	$\frac{1}{60}$	$\frac{1}{250}$	$\frac{1}{15}$	$\frac{1}{30}$	$\frac{1}{60}$	$\frac{1}{8}$	$\frac{1}{15}$	$\frac{1}{30}$
Normal walking, hand waving	5	8	$\frac{1}{60}$	$\frac{1}{125}$	$\frac{1}{250}$	$\frac{1}{30}$	$\frac{1}{60}$	$\frac{1}{125}$	$\frac{1}{15}$	$\frac{1}{30}$	$\frac{1}{60}$
Fast walking, jogging, horse walking, children playing, slow cycling	10	16	$\frac{1}{125}$	$\frac{1}{250}$	$\frac{1}{500}$	$\frac{1}{60}$	$\frac{1}{125}$	$\frac{1}{250}$	$\frac{1}{30}$	$\frac{1}{60}$	$\frac{1}{125}$
Football, baseball, running horses, fast cycling, skating, water skiing	25	40	$\frac{1}{500}$	$\frac{1}{1000}$	$\frac{1}{2000}$	$\frac{1}{250}$	$\frac{1}{500}$	$\frac{1}{1000}$	$\frac{1}{125}$	$\frac{1}{250}$	$\frac{1}{500}$
Fast vehicles on open road, birds flying, golf swing, race horses, storm waves, cycle racing, ski sports	50	80	$\frac{1}{500}$	$\frac{1}{1000}$	$\frac{1}{2000}$	$\frac{1}{500}$	$\frac{1}{1000}$	$\frac{1}{2000}$	$\frac{1}{250}$	$\frac{1}{500}$	$\frac{1}{1000}$
Motor sports, express trains, jet at take-off or landing	100+	160	$\frac{1}{500}$	$\frac{1}{2000}$	$\frac{1}{2000}$	$\frac{1}{500}$	$\frac{1}{1000}$	$\frac{1}{2000}$	$\frac{1}{500}$	$\frac{1}{1000}$	$\frac{1}{2000}$

Notes

If longer lenses are used, higher shutter speeds are needed.

If action approaches or recedes from camera ↓ lower speeds are needed.

If action crosses camera obliquely ✕ higher speeds are needed.

If action passes at right angles to camera → maximum speeds are needed.

Complete action stopping needs minimum of $\frac{1}{500}$ per second for normal lenses; $\frac{1}{2000}$ for very long lenses.

Shutter adjustment for long lenses on 35mm cameras
While subject is at 25 metres (or 80 feet)
135mm read as for 7.5 metres (25 feet)
250mm read as for 3 metres (10 feet)
Note Close-ups with longer lenses need minimum of $\frac{1}{500}$ of a second for stopped action.

Activities such as ballet give great opportunity for blurred action sequences, where a combination of slow shutter speeds, in strong ambient light, plus the firing of electronic flash at the moment of peak action, can result in deeply subjective images depicting action.

Certain areas of action photography, notably war photography and to some extent wildlife photography, will place both photographer and equipment at great risk. Here the photographic technique will be applied to produce sharp, informative images that need no creative structuring of the image. The moment of truth is all. The compelling images of war photographers Robert Capa, Larry Burrows and Donald McCullin are examples of this type of photography.

The action photographer will usually have a very idiosyncratic list of equipment and probably it will be heavily biased to 35mm SLR cameras with long and very long focal lengths which work at extremely large apertures. He/she will usually prefer fast films and uprate those considerably by increasing development. Motor drives will certainly be needed and sometimes remote triggering devices for both camera and lighting. The artist-photographer seeking action subjects will need the same type of equipment but less of it and usually with a substitution of slow film for fast, plus the addition of neutral density filters and a hand-held *spot meter*.

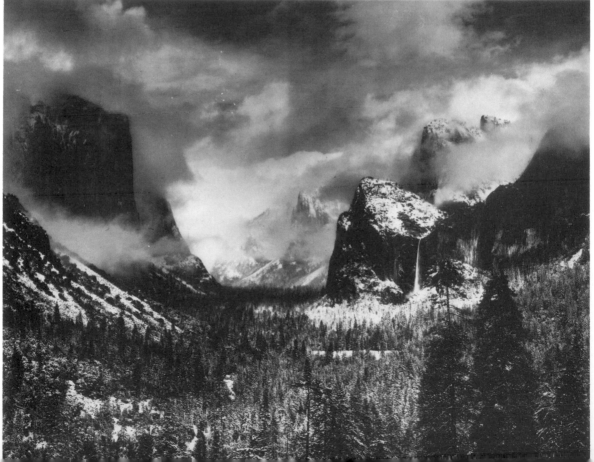

ACUTANCE

A condition indicating the sharpness between boundaries of light and dark areas in a negative. Usually improved by using thin emulsion films and special developers. Increased density from over-exposures or excess development reduces acutance, as does lens flare and halation from bright light sources or poorly corrected optics on camera or enlarger (see *Sharpness, Developers*).

ADAMS, ANSEL (1902–)

Born in the USA in 1902 and, in 1930, after beginning to establish a career as a musician, turned to what was to become a lifetime involvement with photography. Two years later, as the Depression swept over the world, he and others founded the F64 Group of photography – known for its superlative technique and sparkling definition, particularly of organic forms. It was located in its early days in California, and the movement confronted the hazy, pictorial and largely banal images of current salon photography with dynamic, mono-tone photographs, strongly structured, exquisitely printed and full of realism. This has been characteristic of Adams's monumental views of North American landscapes ever since and, as a teacher and writer of considerable authority in modern photography, Adams has had great influence on the worldwide acceptance of clarity and irreproachable technique as a basic ingredient of fine art photography.

Adams was a founding member of the group which created the photography department at the Museum of Modern Art, New York. A master technician, Adams led the group which devised the Zone System of exposure estimation and has published many books. He has exhibited widely throughout the world and is still a benign but powerful influence on photography as an international activity. Sale of his prints regularly creates record prices, sometimes in excess of 30,000 dollars per print.

Left Ansel Adams has become known for his masterly rendering of dramatic landscapes, particularly those of the western regions of the United States. (*Courtesy Ansel Adams*)

ADDITIVE COLOUR

If the eye is presented with three colours in the primary hues of pure red, green and blue in various proportions, a full colour effect is seen. This was the guiding principle behind the work of the Impressionist painters whose brilliant but tiny areas of pure colour produced an emotional colour image close to normal vision. The early colour photography processes used similar theories, particularly Lumière, whose colour plates contained starch grains dyed in the primary colours. An opposite system – the Subtractive System uses filters and dyes, in subtractive primaries of cyan (blue-green), magenta (pink) and yellow to filter out selected colours. These are usually to be found in modern colour printing and photography. (See *Colour Synthesis* and the colour plates for *Colour Photography*.)

ADVERTISING PHOTOGRAPHY

Those photographers who wish to accept the difficult problems and seek the considerable rewards of working for the advertising industry must achieve standards of excellence and understanding higher perhaps than in most branches of photography. It must be said at once that modern advertising photography is not generally art, although it can be art. It is part and often the major part in a visual communication for a commercial purpose. This commercial viewpoint will always be present in the best advertising and it will transcend style, technique and the photographer's ego. This does not mean that the photographer will fail to contribute or become a helpless tool in the hands of big business, but unless it is understood that the entire expensive exercise of buying and producing an advertising page is part of a much larger marketing operation for the commercial client, it is better that the photographer should seek other areas to practise his/her skills.

Although most large clients have internal advertising departments, these will rarely commission advertising photography without first seeking the advice of their advertising agencies. It is the job of the agencies to create ideas, study valid areas of communication for the client, buy space in media, plan campaigns (sometimes lasting several years), often on an international scale and generally create a communication between clients and their customers.

To the photographer seeking work in this field, the most important person in the advertising agencies will be the art director. When showing his/her portfolio to a new agency, however, the photographer will normally be asked to see the art-buying department first. Sometimes these are very skilled people who can easily assess the value of work shown and pass on good reports to the art director, but in many agencies, art buying is largely a clerical department, which for the dedicated photographer can be a somewhat difficult experience. It should be remembered that the art buyers in an agency have usually the power of life or death over the photographer's relationship with that agency.

If they like the *portfolio* or the photographer, very large amounts of work can follow, but if they do not find the meeting congenial or the work interesting, it may well be years before that agency will ask the photographer for a new presentation. The photographer must put a major effort, therefore, into this first agency meeting with an art buyer. The portfolio should be well prepared and presented, with transparencies mounted in black cut-out mounts, prints mounted or preferably laminated with a glossy film overlay and each piece identified with the photographer's name and telephone number. The photographer needs to be confident of his own work, have sound ideas as to why these images were useful in past jobs or why this agency may find this style of work acceptable. It is best to keep the most personal and creative images to the end of the interview and to present these as evidence of enthusiasm and the ability to contribute ideas to a project. It is essential that the photographer should be suitably dressed, clean and businesslike in appearance and does not allow his/her personality to override that of the interviewer. At this first meeting, prices and conditions of work

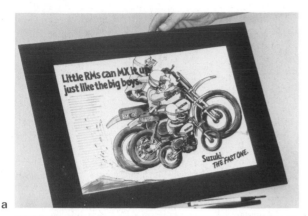

a

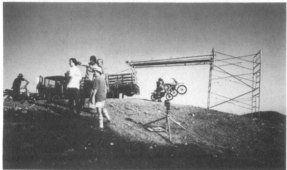

b

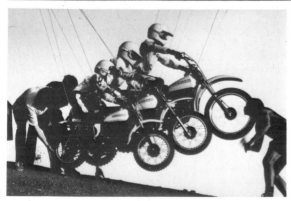

c

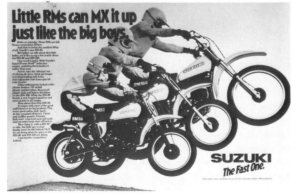

d

should be discussed and clearly understood by both parties.

Once the art buyer is convinced that a certain photographer is useful to the agency, a second and possibly other interviews will be arranged with those art directors thought to be most likely to express interest in the work. During interviews with art directors, the photographer will usually be judged solely on the portfolio, firstly on craftsmanship and secondly on image content. All good art directors will be highly critical of image quality at these early meetings. Evidence of ideas in image content will gain respect later and could lead to initial work being offered because of this, usually on a low fee, experimental basis.

After a surprisingly long series of meetings with various art directors, the photographer will get a call, usually at short notice, to come and talk about a job. Do not fail to meet the art director at the precise time chosen and do not fail to take notebook and pencil. The photographer will be shown a *layout*, being sometimes only a pencilled, rough and very vague sketch, or more often, a detailed colour drawing with type pasted down, all approved by the client. The photographer will be expected to achieve precisely the layout which has been offered to the client. This is known as a *tight brief* and of course can be produced only if the artist drawing such a sketch has a deep understanding of the technique of photography, with lens lengths and viewpoints being drawn accurately. After discussing the project and setting fees and budgets, a delivery date or deadline will be given. Failure to meet delivery deadlines is the quickest way to lose work in the advertising industry.

The beginning advertising photographer is placed in a difficult position. The industry pays high fees and therefore attracts the talented and established photographers who have already gathered together suitable studio space, equipment and staff in order to provide the art director with every possible facility. On these standards, both technical and physical, new photographers will be judged and few beginners will have a command of techniques and competitive facilities. Enthusiasm, dedication, energy and ideas are the young photographer's best attributes in seeking success in this market, therefore.

The majority of advertising work will call for two types of camera: the medium-format roll film type such as Rollei SLX, Hasselblad or Pentax 6×7 and the large sheet-film type accepting 9×12cm (4×5 inch), 13×18cm (7×5 inch), or 18×24cm (8×10 inch) (see *Medium Format Cameras* and

A team of people worked for many days in preparing this advertisement.

a The layout.
b The location.
c The final set-up.
d The finished advertisement.

As shown in (c) the motor cycles were hung from a frame by wires, in order to get the effect drawn in the layout and these were retouched out later. (Photography by John Cahoon, art direction by Larry Owen, copy writing by Kelly Smotherman, client US Suzuki, advertising agency Eisaman, John & Laws Inc.)

Large Format Cameras). High-quality flash equipment will be needed, delivering at least 2000–3000 watt/seconds of light from several lamp heads. Accessories and back-up equipment will add to the expense. In the United States it would not be possible to obtain the above for less than 8000–10,000 dollars and in Europe perhaps a 40–70% higher cost. This is before finding studio space and furnishing that for effective use. The present scale of fees and organization of the industry does not make this kind of investment profitable unless the photographer is a superb craftsman and has a good business head or has access to commercial information from a professional adviser.

Faced with such obstacles, the young photographer must probably find work as an assistant to an established advertising photographer, slowly putting together a small basic equipment list such as 9 × 12cm (4 × 5 inch) camera, a 210mm lens, good tripod and ten double dark slides. In free time the photographer must make portfolio shots to the maximum skill, using clearly thought-out advertising concepts. When feeling ready for the hazardous step of taking on his/her own clients, the range of equipment can be extended by going to professional hire shops and also studio space can be hired on a contract or casual basis. Some studios will provide good facilities for a percentage of the photographer's fee and this may be useful in the early stages, but no contracts on this basis should be signed for longer than a year.

Even very simple objects must be photographed with a sense of style if the visual is to communicate effectively.

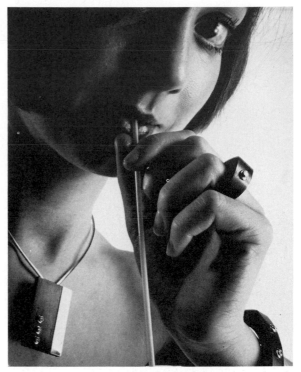

There are many ways to advertise an expensive modern ring. The unusual juxtaposition of glamorous elements against homely objects, plus the natural and human action, all help to create favourable interest.

Provided the newcomer in advertising works to exceptional standards and has the ability to contribute personal ideas to a job, however mundane the product, he/she can slowly progress. It may be assumed that to reach a point where his/her work has an established impact on the industry could take between five to ten years, with absolute dedication needed for all of this time.

There have been a number of skilful photographers who have made a considerable reputation in the advertising industry by using solely 35mm format. Very often they began their career as photo-journalists where this camera is the norm, but clients of agencies still have difficulty in accepting the tiny images as being worthy of high fees. In these situations, presentation becomes paramount and it is often necessary to duplicate 35mm on to 9 × 12cm (4 × 5 inch) to show a finished job, or go to the expense of 18 × 24cm colour prints. Lithographic printers are sometimes also quite reluctant to work with these small sizes as it requires of them much higher technical standards. If the photographer wishes to specialize and accepts the considerable problem of presentation of work to clients and can work to superlative standards of craftsmanship, this format only can be used. Where texture and detail or corrected perspectives are not important, there is no better camera for evoking mood and creating subjective communication (see *Small Format Cameras*).

Whatever else the advertisement does, it must do at least

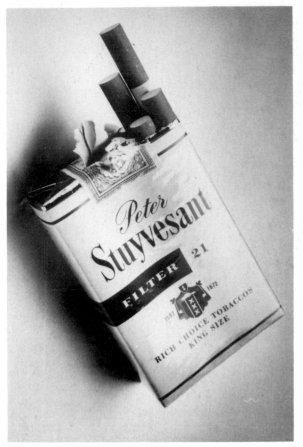

A typical product photograph, in this case, used as the entire visual message for a bill board.

three things if the client is not to waste company money: Attract the viewer, gain the viewer's attention and take command of him/her. The photograph contributes enormously to the first and second precepts and at its best will substantially assist the third.

Advertising photography will attempt to give to each product its natural character: if it is soft it must appear so, if it is hard and shiny it must look this way, if it is of a certain texture the photograph must disclose it. Transparency or translucency must clearly be seen and the colour of the product must be exact and harmonize with colours used in the rest of the image.

If a concept is the message, such as when institutions advertise or when certain skills must be clearly associated with the advertiser, then the photograph must suggest this. Banks and other financial services will tend to use heavy textures, low key moods, awe-inspiring viewpoints and sharp edges. Cosmetics tend to use softness in lighting and styling, shallow focus, melodic colour harmonies and delicate textures. Social messages such as appeals for aid, health warnings or public service communications will often use black and white images, documentary photography, contrasting tones and a

mood of immediacy. The list could go on indefinitely, but whatever technique is finally employed it will be carefully planned and agreed with the client. It will become part of the campaign strategy. The photographer, therefore, in helping to devise a technique, must be certain the picture will reproduce in the media chosen.

Food advertisements, depending as they do on colour and texture for appetite appeal, will usually be disastrous in B/W newsprint (see *Food Photography*).

Delicate cosmetic textures may not reproduce except on high-quality art paper and therefore lose impact when run in a mass circulation magazine on cheap paper.

If the technique is poor, the photograph will fail to communicate and the advertisement will be less effective. It has been found that most people, whatever their social or educational standards, are able to assess quality in a photographic image *as an intuitive process*, so the photographer must handle the technical problems at a very high level indeed.

Separation is going to be the primary concern, particularly as all printing processes will degrade the original image. Screen size, print process, paper surface, length of run, etc., will contribute in various degrees to this loss. The important parts of the image must separate one from the other so that the viewer can understand the message and concept. This separation must be exaggerated in the original take, if it is to be held in reproduction. Whites must all have tone and incident highlights, greys must separate from greys, and overlapping forms from each other. This will be largely a matter of careful lighting and exposure but can also be a question of choosing the most suitable objects to place before the camera. For example a girl in a white dress against a white wall to be photographed in B/W would be better in a light cream or beige garment, as this would create a visual separation at once. If the image does not separate into parts it will not communicate.

Keep the compositions simple and in line with known perceptual needs for the medium used. A poster in a public transit area needs very quick evaluation from a viewer – a matter of seconds. A roadside bill board, a matter of split seconds. These photographs cannot attempt subtlety, tone or mood and need bold colours and easily read forms. Packaging illustration is also in this category since supermarket shoppers are faced with a bewildering array of colours and type styles. Half a second is considered a maximum for the entire message of product content and appeal to be assessed. Magazine and record covers can, however, aspire to much more subtlety, the content can be more elusive and can require more effort on the part of the viewer. These images must have great impact, often from 3 metre (10 foot) distance, so bold use of colour is one area for the photographer to show skill, and the ability to dramatize simple forms is always necessary with this type of picture.

Within the limits of reproduction, more can be achieved on the inside pages as these are scanned from distances of about 25–35cm (10–14 inches) and more time is available. A visual 'hook' is usually needed to stop the viewer long enough for the more intricate parts of the image to begin working. Book illustrations in hard cover are far more long lived and

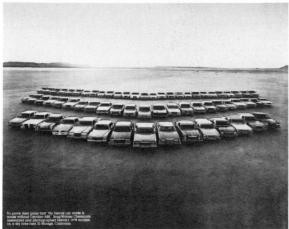

To prove their point that "No Detroit car made is made without Cycolac ABS," Borg-Warner Chemicals assembled and photographed Detroit's 1976 models on a dry lake bed, El Mirage, California.

One photographer, working on different occasions for the same client, may be asked to produce widely varied work. Note that in these pictures, control of the logistics of the job has been a primary factor in all cases. (*Courtesy Carl Furuta*)

therefore must exercise their fascination and deliver their content over a very extended time. This means that a full range of visual complexities can be built into such images.

The photographer should not work outside his/her experience of the product or concept which forms the basis of the message. Lack of knowledge can lead to weak viewpoints or re-shoots. For example, where one side of the object should be seen a certain way or fitted to an accessory in a special manner, the photographer must have researched the subject and have positive knowledge of everything that goes before the lens. Not only should these matters be discussed with the art director, but if time and protocol permit, the client should be visited and first-hand information obtained.

Advertising photographs are illustrations, that is to say,

they tell a story. Apart from the above technical needs, the advertising image has to support the story line or text. Photographs rarely appear without a headline, accompanied by body text which amplifies that first loud headline statement. In this area of creating image concepts, the photographer can contribute considerably. First he/she must be enthusiastic about the subject, even if it is only a homely can of potatoes. The desires and aspirations of viewers should be appealed to, not their reason. An advertising response rarely comes from reason, but arises in a complex and subjective blend of emotion. *Mood* is very effective in activating this state of mind and photography has the ability to create mood more effectively than other visual techniques. Lighting, contrast, tonal scales, *colour harmony* and tonal separation or compression, will all become precise tools in the hands of the experienced advertising photographer and should be placed at the disposal of the art director. Complete mastery of technique is assumed to be the starting point for all successful advertising photographers.

SUMMARY

Assemble a small but comprehensive portfolio.

Visit your clients often.

Use medium and large format cameras.

Acquire faultless technique with such cameras.

Provide back-up for all major equipment

Have an abundance of light available in the studio.

Learn to control completely that light.

Establish fees and budgets before work begins.

Honour deadlines absolutely.

Research every job and understand the concepts.

Plan the working day.

Pre-visualize images, especially if they have abstract concepts.

Review and finalize the mental viewpoint.

Gain attention for the image with dynamic composition.

Discard all irrelevancies.

Establish clear separation within the image, of every form.

Avoid psychological ambiguity in conceptual images.

Establish a diminishing hierarchy of emphasis in the image.

Find excitement and challenge in every assignment.

Review the image totally and in detail before shooting.

Control the studio environment carefully.

Extend normal courtesies to clients and colleagues.

Begin the day early, do not work late.

Symbols, backgrounds and the character of live models all contribute to the final impact of the message and must be carefully planned. Although a certain amount of logic must prevail in the illustrations or the viewer will take flight, a whimsical or surprise turn in the visual story can charm and gain attention. Surrealistic juxtaposition is a frequently used method of evoking abstract ideas for a product, for example, a refreshing draft of clean air from an air-conditioner could be symbolized by placing the product in a setting of a tree-lined mountain stream, or a pair of shoes could be photographed in a gilt frame at a select art gallery to demonstrate exclusivity and taste.

In a photograph which is to carry a headline or text on the photograph itself, tonal values and spaces must be controlled so that it is possible to read the message easily. This usually means the use of a mask on the back of the camera, scaled down from the final page size and precisely showing text position and sizes. Here the photograph must be even more supportive than usual, and selective sharp focus in main areas of the image, with deliberate softness near text positions, will often increase readability (see *Image Management*).

Many advertising photographers will be asked to work on catalogues and this is a somewhat different problem but never to be despised. The object is usually to produce a clear, informational photograph, yet with considerable ambience, showing large selections of the client's product on one page. Such work is usually on large format cameras, 18×24cm (10×8 inch), and it is part of the requirement to make the photography as economic as possible. This needs immense planning and meticulous costing. A generalized lighting plan is devised and there is little place for the idiosyncrasies of creative photography. Productivity is the keynote and the physical problems often far outweigh the photographic. Catalogue producers are, however, now becoming keenly aware of the need to entertain their prospective customers and are seeking creative compromises that will display quantities of product with challenging images to support their buying message, and more photographers are finding satisfaction in this work.

In general it will be found that those photographers who work successfully in advertising will need to be dedicated, intelligent and highly disciplined, physically fit enough to spend 10 to 16 hour days in the studio and creatively capable of extending the impact of the client's brief. Advertising photography is a matter of teamwork and each campaign will bring together such people as stylists, make-up people, models, set builders, copy writers and the art director. The photographer must control his own ego and contribute his special experience to the successful operation of that team, always remembering that most advertising pages are the result of creative work by a committee and the photographer is very seldom elected as chairman.

AERIAL FOG

An overall increase in negative density, produced by permitting an emulsion wet with developer to come into contact with air for an excessive period during development. Keep emulsion submerged in developing solutions as much as possible or add anti-foggants to the solution if the film manufacturer recommends them.

AERIAL PERSPECTIVE

This is an illusion of receding distance, created in a landscape by decreases in colour saturation or definition, which obscures sharp detail and persuades the eye that objects that are more diffuse lie further behind the plane of those objects which appear sharp. Scattered invisible UV light is usually the cause and this can be largely eliminated by the use of haze filters (UV) or by using infra red film with an appropriate filter. To

Geometric perspective is very different from aerial perspective. This picture demonstrates aerial perspective, with its typical receding planes enhanced by mist and soft edges.

enhance the effect for subjective reasons, a blue filter may be added for B/W photography and low-contrast or de-saturation filters may be used where colour film is in the camera.

It is interesting to note that Leonardo da Vinci was probably the first exponent of this misty element of picture composition, calling it *sfumato* and it is evident in the background of the 'Mona Lisa'. It can also be created to some degree by photographers using very long telephoto lenses in suitable atmospheric conditions. In small, controlled areas it is possible to use smoke bombs to create the same effect (see *Perspective*).

AERIAL PHOTOGRAPHY

Photography from the air has been practised since the 1860s when the famous French photographer *Nadar* made aerial photographs of Paris from an untethered balloon. With modern equipment and easy access to light-aircraft charter activities, it has now become a simple matter to extend any photographer's experience to this field.

Obviously the camera can be used from any commercial airliner, always remembering that they reach haze-producing altitudes very quickly, that pictures must be taken through double acrylic window glazing, with consequent degradation of the image and that because of random seat allocation on many routes, it may not be possible to occupy the best position for good picture taking. The best placement will be a window seat, well in front of, or well behind, the wing area, on the shady side of the aircraft. If any part of the plane is included in the viewfinder, set the camera on 15 metres (50 feet) and the shutter speed at least on $\frac{1}{250}$ of a second, preferably higher. Watch that the lens is clear of obstruction, especially if using a separate rangefinder/viewfinder camera, as *parallax* will cause viewfinding errors. Keep camera and body away from the aircraft structure, particularly the windows, otherwise structural vibration from the aircraft will

give unsharp pictures. Try and take pictures as soon as the aircraft is airborne; use a UV or skylight filter to reduce haze and use normal ground exposure with fast shutter speeds, $\frac{1}{250}$ or $\frac{1}{500}$ at least. At altitudes over 1000 metres (4000 feet) use a 2B skylight filter and reduce exposure by one stop from normal ground setting for that film/shutter/f stop combination. Do not use polarizers as the acrylic window may add unpredictable factors to the picture. Early mornings, evenings, take-offs or landings are going to offer better possibilities. Photographic charter flights in small planes will give the best results for aerial photography. Except for mapping and other reconnaissance, vertical pictures with the film plane parallel to the ground are unlikely to concern the average photographer. Oblique angles of view, downward, will be usual, unless air-to-air pictures of other aircraft are the objective. When these air-to-air photographs are needed, it is normal to work from special, small, very fast planes, totally equipped for photographic purposes and in constant radio contact with the target plane.

In general, look for a relatively slow, high-wing aircraft with sliding windows or a removable door. Helicopter rental is vastly more expensive, but its low-flying capability and authorization to fly at much lower altitudes than fixed-wing aircraft make it a good choice, particularly if it is a quieter turbine-driven machine. In the hover attitude heavy vibration is likely and this mode is not normally used for photography. It is usually permitted to fly with the door removed, for least possible interference with image clarity.

Always use commercially licensed pilots on these mis-sions; research all backgrounds to each main picture; study maps; identify any flying hazards; check legal height limits with the pilot and establish at least two possible angles of approach to each objective. Because noise is often a big factor in small aircraft, establish a system of hand signalling between yourself and the pilot who will have a very different viewpoint than that of the camera and needs to be directed, by the photographer, so that the aircraft is placed for the best results.

Check the weather, as visibility should be at least 20km (13 miles); wind should be light and not gusting, and clouds should be scattered or non-existent. Poor conditions and haze mean lower flying and looking down more vertically to the ground. Cold weather, early morning and evening can often be the best time for maximum clarity of ground contours.

It is best to work under 1500 metres (5000 feet) and as low as authorized flying permits. A conventional camera, pre-ferably a medium format or 35mm SLR, fitted with a pentaprism rangefinder or a direct, glassless viewing frame, is the best choice. 4 × 5 Speed Graphics with a windshield on the bellows are also ideal but only small amounts of material can be fed to this type of camera unless they are fitted with magazines or roll film adapters. A Rollei SLX with a 90° pentaprism would be ideal, as large quantities of 220 roll film could be pre-loaded into magazines and those changed during shooting in four or five seconds. This camera has a built-in frame sportsfinder, which, if a pentaprism is not fitted, makes an ideal choice for professional results.

It is an offence to drop objects from aircraft and, if the object happens to be your camera, considerable extra financial

A high altitude picture of San Francisco and its surrounding area. (*Courtesy NASA*)

saturate results. In all aerial photography, use a skylight filter to reduce UV light, and in hazy conditions increase this UV filtration by using a Wratten 2B filter, under-expose the film $\frac{2}{3}$ stop and increase first developer processing to compensate. This will help to increase contrast greatly and generally clean up the image.

Up to 500 metres (1500 feet) normal ground level exposures will be fine, but above that altitude, it is wise to decrease exposure half a stop from the normal ground level meter reading, but at 1500 metres or more decrease the exposure by one full stop. Automated cameras that have an overriding exposure adjustment are fine for exposure estimation, also hand-held spot meters with a 10° field of acceptance or less. Wide field meters and some SLRs can give very false readings at these higher altitudes for which compensation must be made when airborne exposures are calculated. Most meters indicate a higher reading than is actually needed for correct exposure.

Wide angle lenses help in aerial photography although they can decrease contour and lower image impact accordingly, but they do reduce effects of subject movement and as they require lower altitudes this also reduces haze effect and increases contrast and clarity. They can be used with somewhat lower shutter speeds. Long lenses magnify subject movement greatly and need shutter speeds of $\frac{1}{1000}$ of a second or faster, but dramatize contour and buildings.

Good aerial photography needs excellent co-ordination between photographer and pilot. Set the camera focus on infinity, choose a wide aperture f4.5 or greater and the highest shutter speed possible with the chosen aperture. Depth of field is a negligible factor so if your lens performs well at f2 or faster, use this setting. Keep the camera away from the aircraft structure and do not rest arms on windows or door edges, brace on neck strap or chest pod, and aim through the open window or door. If using other than an SLR, remove your eye from the viewfinder and visually check that the lens is clear of obstructions and that the view is not obscured by the

A freeway system from the air.

loss is added to the punishment. Make certain the camera is equipped with a strong strap which is kept around the neck at all times and, if possible, add a chest pod or hand grip to give greater safety and stability. High quality 35mm cameras give very acceptable results, especially at low altitudes.

The best B/W films are the 400 ASA group, such as Tri-X-, HP5, Agfa 400 etc., overrated to 800 ASA and this reduced exposure is compensated for by increased development, in a fairly active developer such as I.D.11, D76, DK50 or May and Baker Suprol. In B/W work a yellow filter will assist haze cutting at low altitudes (one giving a 2.5 filter factor) while at higher altitudes an orange filter with a factor of 4 or a red with a factor of 8 should be fitted (see *Filters*). For an *increased* haze effect, use blue filters with high factor numbers. Infra red film can bring benefits on special occasions particularly in heavy haze conditions. B/W infra red, used with a Wratten 25 or 88 filter, can render surprising detail in these circumstances, turning water and blue sky almost black, and green foliage nearly white. Colour infra red will give false rendering of natural colours, green trees turning red, autumn leaves going yellow, etc., but for special reasons these effects may be desirable. Use Kodak Ektachrome Infra red at 100 ASA with a Wratten 12 filter and normal (not infra red scale) focus. *The camera* should be loaded in total darkness with these films, so this makes it necessary to use bulk loading magazines for easy working.

Normal colour film will produce the best results in aerial photography and although negative/positive material gives increased latitude in exposure, with added printing control, beautiful results can be obtained from high-speed reversal films working at 200 ASA or faster. Haze is again a critical factor with colour as it can affect colour balance and also de-

SHUTTER SPEEDS FOR SHARP IMAGES

Ground speed		(150mph)
Altitude	1400 metres (4000 feet)	$\frac{1}{125}$
	1000 metres (3000 feet)	$\frac{1}{250}$
	700 metres (2000 feet)	$\frac{1}{500}$
	300 metres (1000 feet)	$\frac{1}{1000}$

Step 3
Step 4
Step 2
Step 1

aircraft's structure. If you are using a lens hood, have it solidly attached by screw thread or other mechanical means so that slip stream does not blow it away.

Ask the pilot to reduce airspeed and if necessary roll the wing out of picture. If you are using long lenses, an experienced pilot will slip the aircraft toward the subject, to reduce the lateral movement past the camera to a minimum, but this manoeuvre does require more airspace and altitude than normal. Wide-angle, low-altitude work is best done at the slowest safe airspeed possible. Do not ask your pilot to violate any authorized or safety regulations or to act in any hazardous manner to improve the viewpoint or the photographic results.

AGFA GEVAERT AG

Formed by a 1964 merger of the historic German photographic group Agfa and the outstanding Belgian company Gevaert, whose technical products such as x-ray, reprographic, graphic arts film and microfilm were considered by many to be the best in the world, Agfa Gevaert is an effective counterforce in photography to the giant Eastman Kodak Company. Agfa employs more than 30,000 people, has 24 factories throughout the world and a 1980 turnover in the vicinity of 5000 million Deutschmarks.

Discerning photographers everywhere use Agfa black and white material and, for exhibition printing, many regard the combination of a slow emulsion Agfa film, a soft working developer and an Agfa fibre-based paper to be unequalled for quality. Agfa has been one of the principal motivating forces in the development and marketing of new colour materials and in 1936 pioneered the subtractive colour process. Four years later the first feature films shot on Agfa negative/positive material were being shown in Germany and Agfa colour film has been in demand by both professional and amateur photographers ever since. The newest generation transparency films, compatible with the Kodak E6 chemistry, are outstanding.

AGITATION (INTERMITTENT)

In all processing of photographic material, agitation is needed at every stage in the process and in each solution. Too much agitation in sensitive moments such as film development can

Correct agitation will ensure even development. For tank development, for the first 30 seconds, three inversions per 5 seconds, thereafter every 30 seconds invert tank three times within 5 seconds. For sheet film, film holders are dipped and withdrawn in a cycle. The first 30 seconds should include 15 seconds of a *mild* pumping action. Thereafter, every 60 second, holders are dipped, withdrawn twice to alternate sides over a 10 second period (*see fig.*). For dish development, agitation for prints or large films is a rocking motion and the lifting of alternative corners. Do not set up a continuous swirling pattern.

On very fast acting developers, agitation can be increased, on slow or compensating developers it can safely be timed on 60 second intervals. Do not use excessive or fast agitation, or uneven development may result. Occasionally tap the holders or reel against the tank to dislodge air bubbles, particularly at the beginning of development.

cause stress and turbulence marks on the film, particularly around sprocket holes in 35mm or in sheet film hangers. These marks appear as distinct patterns of different density and can ruin negatives totally. Too little agitation prevents fresh developer from reaching film surfaces and exhaustion at such a point occurs, lowering developer activity, especially in heavily exposed areas. Uneven densities can result and general underdevelopment can give thin, low-contrast negatives that have no brilliance.

In developing negatives, especially in a highly active developer, it is important not to create a pattern of agitation, even though constant time intervals are desirable. Small roll-film tanks are usually inverted rapidly for the first 15 seconds of development, then four times during ten seconds at the end of each 60 seconds, during developing times. Large tanks, containing more than six reels, usually carry the reels on wire racks and these may be 'pumped' vigorously in the solution for the first 15 seconds, to remove air bubbles, then raised and lowered four times each during further 30 seconds of development. Nitrogen gas bursts are used by professional processors to achieve the same effect. The ideal objective is to achieve a random pattern of movement in the tank, but at regularly timed intervals. A waterbath used before developing

can also assist in preventing streaking from faulty agitation.

Print agitation is also vital so that solutions activate all parts of the emulsion evenly, but naturally this part of processing is less sensitive than film developing. In the print developer, the tray of solution may be rocked by the printer, prints may be carefully flopped over end for end. Prints should be kept under the surface of the solution. Stop bath and fixer agitation is the same and it is absolutely essential for effective washing that prints must be thoroughly agitated in the final wash. This can be achieved in part by the equipment itself, especially if it has a strong water jet action to move the prints around. Siphon action is not enough and hand agitation is always needed in print-washing tanks for some of the time. Poor agitation in fixing and washing will often cause immediate stains and certainly will set up the ideal preconditions for fading and short life in prints, with a near certainty of permanent damage. (See *Developers, Enlarging*.)

AGITATION (CONTINUOUS)
Used in many mechanical processes to achieve the effect of moving solutions around and in contact with photographic emulsions. More predictable but not necessarily better than hand agitation.

ALBUMEN
A protein found in white of egg which can be clarified and used to coat paper or glass in order to carry a light-sensitive emulsion which is then exposed to ultra violet or sunlight. It was first introduced as a photo negative process in France in 1848 and as a paper in 1850. The negative was soon superseded by other, faster methods but the paper print remained a standard material for 40 years, at one time consuming the entire output of almost all the hens of Austria in order to keep up with the demand for photographic paper in Victorian times.

ALHAZEN (965–1038)
Known to western science by this Latin derivative of his name, the brilliant and eccentric Arab mathematician, Abu Ali Al-Hasen Ibn Al-Haytham, was the true father of photography. He was born in Basrah and died in Cairo 73 years later, in 1038. His treatise on optics, *Kitab al Manazir*, discussed the optical laws for the foundation of images, how the eye sees, the causes of spherical aberration, magnification, refraction of light, incidence of light on parabollic mirrors and above all, geometric perspective as the eye and the lens would see it, with distant objects apparently diminished in size while near objects were larger. He recognized that the Greeks, who believed the eye gave out rays of light which identified objects, were wrong and that in fact the object reflected light from each point in the form of a cone of rays into the eye. This is precisely the theory of lens optics and became the foundation of the law of optical *perspective*. He made and wrote about the use of a simple *camera obscura* to view the eclipse and his theories, when they became known to the thirteenth-century

Al Hazen's theory of perspective. A is a more distant point on the subject, reflecting a cone of light rays at a sharper angle than point B, a nearer point source of the same size but appearing larger because of the wider angle of the cone.

English scientist and alchemist, Roger Bacon, began to filter through European science.

The Vatican library in Rome had a translation of his thesis on optics and it is thought that this probably informed the researches of the Florentine pioneers of perspective, Ghiberti and Brunelleschi. It was ironic that the Arab theorist who devised the principles of the camera image, which today preserves billions of human likenesses each year, would, because of his orthodox Islamic religion, have been forbidden to create the image himself, had he had the means to do so.

ALKALI
A chemical that neutralizes acids and has a pH value above 7.0. Most developers are alkaline in nature and consequently require an acid stop and fixing bath to prevent further developer activity. Examples used in photographic processing include sodium carbonate, sodium sulphite, potassium metabisulphite, and ammonium hydroxide. The presence of a strong alkali in a developer creates increased activity and contrast. Most normal developers use an alkaline accelerator such as sodium or potassium carbonate, although high proportions of sodium carbonate or sodium hydroxide in a developing solution can cause pin holes if films are placed in an acid rinse. A water bath is to be preferred for this type of developer, before fixing takes place.

ALUM
In the form of chrome alum or potassium alum, it is an excellent hardener for gelatin emulsions when they may be subject to high temperatures. Freely soluble chrome alum crystals are dissolved in water, 30g per litre to make a pre-bath for films, after development but before fixing. Such baths have a short life when mixed and the dark purple solution should be discarded when it turns greenish-yellow. Immerse films or prints for three minutes with vigorous agitation in the

first 30 seconds. A very effective short stop and hardening bath for 35mm film can be made as follows:

Water	1000cc
Chrome alum	20g
Sodium bisulphite	20g

Dissolve the chrome alum completely before adding the sodium bisulphite with slow stirring. Keep the bath at equal temperature with developer, immerse film, agitate briskly for 30 seconds and leave for five minutes before transferring film to the fixing bath in the normal way. This makes films almost impervious to scratches and abrasions.

Potassium alum, a white powder, is the most common hardening agent used in modern hardening-fixing solutions and is much to be preferred for hardening paper prints, as chrome alum has a great tendency to stain papers and is considered to be very toxic (see *Fixers* and *Dangerous Chemicals*).

AMIDOL

Amidol, introduced as a very active developing agent in 1891, oxidizes rapidly and should be prepared only immediately before use. It is also a good substitute developer for those affected by metol poisoning and can help to soften contrast in negatives which are over-exposed or harshly lit and is a suitable developer for obtaining the Sabattier effect. Amidol can stain finger nails if used regularly.

FORMULA

Negative developer*

Sodium sulphite (desiccated)	60g
Amidol	14g
Potassium bromide	3g
Water to make	2 litres

Process 20–40 minutes at 20°C (68°F)

Paper developer

Amidol	15g
Sodium sulphite (desiccated)	100g
Potassium bromide	2g
Water to make	2 litres

Process 2 minutes at 20°C (68°F)

* It may sometimes be necessary to add a preservative to this formula, including in it some potassium metabisulphite. The full formula then becomes: sodium sulphite 24g, pot. metabisulphite 10g, potassium bromide 2g, Amidol 5g, water to make 2 litres.

A paper developer can be mixed without the use of scales because of the unique properties and activities of Amidol which are very tolerant of sodium sulphite or potassium bromide in excess. Take one litre of warm water, add 4 level teaspoons of Amidol; 14 teaspoons of sodium sulphite (desiccated); half a teaspoon of potassium bromide. When mixed, add cold water to bring this solution to 2 litres.

AMMONIUM THIOSULPHATE

A fixing salt, similar in activity to 'hypo' or sodium thiosulphate, but more rapid in its action. Often found in fast fixers and fixing baths for mechanical processing. If a solution of this chemical is allowed to dry on equipment or tanks it is almost impossible to clean. It should be noted that fast fixers containing this fixing salt have a decided bleaching action and prints should not be immersed longer than the recommended fixing times. (See *Hypo, Archival Processing.*)

ANAGLYPH

A matching pair of images, superimposed slightly out of register, usually in red and green complementary colours. When viewed through spectacles which have one lens red and the other green, each eye sees only one monochromatic image, but the brain mixes them to provide a 3D effect. Artist-photographers will find this an interesting area for experiment. (See *Vision, Three-Dimensional Photography.*)

ANAMORPHIC LENS SYSTEMS

Such systems produce a compressed image, where the magnification is different for both horizontal and vertical planes. Laterally compressed images produce the familiar 'wide screen' effect and these are re-generated to acceptably normal effect by projection through a compatible projection system. Pseudo-anamorphic images can be contrived by projecting negatives via a concave mirror on the enlarger base board to produce dramatic and highly subjective images.

ANASTIGMAT

A lens type of several elements in which most errors are corrected, including astigmatism, to a high degree. Introduced in the late 1880s by Zeiss, these lenses had a flat field when photographing distant objects but their performance at close distances was less satisfactory. Modern, good-quality lenses are usually corrected for astigmatism but certain macro lenses are not, since their performance in close-up must be at the optimum level and curvature of field is sometimes noticeable when they are focused on distant objects (see *Lenses*).

ANGLE OF INCIDENCE

When a light ray strikes a shiny surface the light will be reflected at precisely the same angle. For photographers, knowing this fact helps them more easily to place lights around metallic or liquid objects, in positioning reflectors to obtain translucency in bottled products or to make images of the sky or sun on water. The principle must also be understood when using polarizers to minimize unwanted reflections (see *Lighting, Polarizers*).

ANGLE OF VIEW

This is the extent of the subject seen by the camera lens at a

given focus point and also varies considerably with change of focal length and format. A normal angle of view of say 50° at infinity will be reduced to perhaps half that if the same lens is focused at macro distances. This means that for close-up photography viewfinders must relate to the actual image and therefore SLR cameras and view cameras are the only practical equipment for such work. Angle of view changes rapidly with changing focal lengths, telephoto giving very narrow fields of view and ultra short lenses giving extreme wide angle coverage. Studio photographers often use narrow angle lenses to allow back lights and hair lights to be placed very close to the subject without producing lens flare or an image of the diaphragm (see *Lenses*).

ANIMAL PHOTOGRAPHY

Photographing domestic or well-trained animals will usually require a fast operating camera, such as a 35mm SLR automatic camera fitted with a moderately long lens of say 100mm. Good anticipation is still necessary for most domestic pets, especially when they are young and very active. Show animals must be photographed to exhibit full body profiles and often supporting pictures which show individual features. If possible this is best done by placing the animal on a long roll of white paper, or in the case of large animals, particularly horses, against very light natural backgrounds, such as sand, concrete, white buildings. In such high contrast conditions, expose for the deepest shadow so that the background will bleach out and become even less obtrusive. Animals in action will call for special preparation by the photographer (see *Action Photography*) and despite great temptations to do so, flash should be avoided. Circus animals are best photographed in the available ambient light, with fast film and somewhat longer lenses. For all moving animals, a zoom lens is most useful, possibly in the 70–210mm focal length if the camera is of 35mm format and the slightly decreased image quality is more than compensated for by its versatility. Zoo

Even domestic pets can offer opportunities for the enthusiastic nature photographer to test his/her skills.

animals are also delightful subjects and, by the use of telephoto lenses, striking pictures can be made. To eliminate cages and bars, or even mesh screens, bring the camera almost to touching point of the obstruction; use a moderately wide lens setting, say f4 or wider, and the animal will be seen without any apparent constraint. In these circumstances try and select a viewpoint that gives a natural background of foliage or rocks.

Field photography of animals is much more complicated and with wild animals the exercise is sometimes hazardous and always requires research, preparation and patience. In general, field photography calls for longer lenses than is the case for confined animals while, again, a high quality zoom can be extremely useful. Use fast film and lenses, with shutter speeds never less than $\frac{1}{125}$ unless for special effect. Do not use flash unless it is for a nocturnal subject or it is part of a high-speed technique for nature subjects. Follow the usual advice under *Action Photography* but add caution and silence to your ground rules. Work, if possible, only in colour, preferably in colour negative so that B/W prints can be made easily. This eliminates the need for carrying extra equipment just for B/W.

If the image that is being made is not necessarily a realistic likeness of the animal, movement can be blurred and subjective impressions can be sought. Often this can produce an essence and distillation of that animal's mood and behaviour or a generalization about that entire species, one of whom stands in front of the photographer for a given moment.

Animals that are to be photographed in a controlled setting, for example a studio, should be confined by close environmental boundaries, but not leashed. Exotic animals must always have a handler present and time must be given for all animals to come to terms with the new situation. Usually these kind of studio pictures will require flash, often very powerful professional equipment and several test firings must be made to assess the animal's response to the flash. Small animals can be placed on tables, and cats, for example, can be kept precisely on a focused point by using a tungsten spotlight (the light from this does not record with the flash exposure) which is aimed at the desired point. The animal will usually be happy to stay within this comforting but invisible 'cage'. Large, white boxes, with one glass end and perhaps mesh screening on top, can restrict movement during photographing. The camera must be placed at an angle to the glass to avoid reflections. Coloured backgrounds can be fixed into the back of the box and lighting can come largely from above with soft, slightly frontal lighting. Fish can be confined by using a sheet of glass to reduce their swimming area and again, top lighting is best, with perhaps a coloured background behind the aquarium which is separately lit. Using secondary flash off-camera, added back light may also be useful to define form, but it must not become the key light.

ANTI-HALATION BACKING

Light passing through a film emulsion could normally strike the base material and be reflected back within the emulsion,

appearing as a halo effect around bright highlights. To prevent this, films are backed with a light-absorbing dye which dissipates during processing. It may sometimes be seen as a slight magenta cast in B/W negatives but this does no harm to consequent printing. (See *Halation*.)

APERTURE

A camera has two separate controls to modify the amount of light which passes through the lens before striking the film: shutter speed and the iris diaphragm which can be set mechanically or electronically at various diameters. A progression of indicated points on the lens are called f stops which are calculated by dividing the focal length of the lens by the diameter of the iris aperture. These numbers are larger when the aperture is smaller, thus f32, using only the very centre of the lens, admits the minimum of light (in most SLR cameras) while f1.4 is commonly one of the largest, using most of the lens surface to allow maximum light to enter the camera. Each step to a higher number indicates that only half as much light is transmitted than for the previous smaller f number. For example, to double the amount of light entering a camera which has been set at f16, the aperture must be opened to f11. To halve the amount of light, the aperture is closed down to f22. The normal f numbers, in decreasing quantities of light passed are: f1, f1.4, f2, f2.8, f4, f5.6, f8, f11, f16, f22, f32, f64 and f90.

Although most lenses have totally variable aperture controls, click stops are often fitted to identify full stop positions more easily. It should be noted that f stop numbers are calculated for infinity focus and are not correct for focus points closer than eight times the lens focal length. For example: using a 20cm lens, if the subject is less than 1.6 metres from the camera the *effective* aperture is not that at which the lens is set. On some automatic cameras, this is normally corrected by electronics or by mechanical means in the lens barrel, but manual cameras require allowance to be made. To find this effective aperture, the lens-to-film distance is multiplied by the actual indicated f stop and this figure is then divided by the focal length of the lens in use (see *Bellows Extension Compensation*). All macro photography will need this matter to be understood. It should also be noted that altering the f stop number changes radically the visual effect and mood of the photograph by changing depth of field. (See *Bellows Extension Compensation, Differential Focus, Exposure, Hyperfocal Distance, Image Management, Lens, Vision*.)

APERTURE INC.

This is the name of a famous magazine and publishing house in the United States which has an established reputation for fine quality, sensitively produced material on photography. It was founded in 1952 by a group including *Ansel Adams*, Dorothea Lange and *Minor White*. The magazine was intent on reviving the kind of influence once exerted by *Camera Work*, the legendary publication about serious photography which was launched in 1903 by Alfred Stieglitz. Minor White, who held a commanding position in practical matters in the company until his death, saw its first principle to be 'to communicate with serious photographers and creative people everywhere'. This it undoubtedly still does, with considerable style. (Its address may be found in the *Appendix*.)

APOCHROMATIC

A lens is said to be apochromatic when it is corrected to permit all wavelengths of light to focus in the film plane at precisely the same point. This prevents colour fringeing and produces better colour and apparently sharper images. Normally found only in expensive lenses, particularly those designed for view cameras or for process copy cameras used in the graphic arts.

ARBUS, DIANNE (1923–71)

A New York photographer, originally working with fashion which she abandoned to create her own style of searchingly realistic photography that became one of the most compelling influences on the photo-art of the 1960s. She won her first Guggenheim Fellowship in 1963 for a project called 'The American Experience' and her second, three years later. In 1967 she achieved her first show at the New York Museum of Modern Art. Four years later she committed suicide. Only one year after her death an exhibition of her work was mounted at the Venice Biennale, the first occasion any American photographer's work had been so honoured.

Her images of humanity's freaks, waifs and strays have a scorching documentary honesty about them, devoid of pity or pictorialism but somehow celebrating a strange, mutually found heroism of both photographer and subject. Her work is still deeply influential in the main stream of modern photography.

ARCHITECTURAL PHOTOGRAPHY

The photography of buildings will be either to record them in terms of progressive construction, environmental position, isolated details of special interest to technical viewers, or, in a much more subjective way, illustrate their appearance or function.

Technical pictures will usually be commissioned by the contractors who build the structure, or government agencies who control its positioning and social function in the community. Many of these pictures will require site visits every several weeks, with the camera placed on the same viewpoint each time. Equipment for this work is almost the same as that used for illustrative architectural photography but fees should reflect the numerous site visits needed on these assignments. Much of this work is in black and white.

Architects will generally need a more illustrative picture, suggesting mood and usage and disclosing spatial volumes, textures, decoration and scale. This must be achieved from a sound base of research, site visits at least at morning, noon and evening on a sunlit day, long discussions with the architect, interviews with the occupants if possible and an understanding of the technical and social function of the building. From this information a *written* brief is established and fees and

photography budget agreed. It may be necessary to submit test pictures of any different techniques in order to satisfy the architect before the commission proceeds.

Architectural photographers will need a *large format camera*, at least 9 × 12cm (4 × 5 inch) which is capable of all movements and shifts, a tripod, very sturdy and able to rise 2.5 metres (8 feet) or more – the larger Gilux models are suitable. Also needed are a tall aluminium ladder, a lightweight hand truck to carry equipment on site and adequate flash and tungsten lighting on high-rise stands and ideally, of considerable power. Extra lamps for these are essential, plus an assortment of household type lamps ranging from 15 watts to compact 150 watts and a few high wattage photofloods. Note that these photofloods, although they fit normal lamps, burn at very high temperatures and can scorch shades and furnishings that are too close. They usually will burn at 3400 Kelvin, somewhat colder than the ideal colour balance for tungsten colour film (see *Colour Temperature*).

Exteriors will be best lit by the sun, or at morning or evening extremes of the day, when high skylight is present but no direct sun strikes the building. To achieve good results, a number of site visits may be necessary and several hours each time may be needed for thorough observations. Test Polaroids should be taken on these visits for discussion with the architects and fees must reflect these very important preparations for the job.

The final viewpoint for the major illustrative picture must demonstrate the interaction of the building with its environment and the time of day must enhance the mood of the design, while subduing any undesirable visual influences from nearby surroundings. Good tonal values must be seen in the sky and clouds, fine textures must read well, dominant extrusions must show their forms, glass must appear translucent as well as reflective. All verticals and horizontals must be parallel unless low viewpoints with wide angles have been chosen for theatrical effect. Three-dimensional volume should be present, with no flat planes taking over the image design. Shadows should be open, highlights must also have incident highlights and colours should be exact. Great patience, skill and preparation are needed to produce these ideal results.

Lens choice will rather depend on the initial briefing, but it should be remembered that wide-angle will distort perspective and enlarge spatial separations, normal angle lenses will give a sober rendition of the structure close to real life, while long lenses will compact the perspective, draw the landscape in closer to the building and permit otherwise inaccessible camera positions to be chosen to best effect.

It is usual with this work to use slow B/W film coupled with a yellow, orange or red filter to dramatize the sky. A green filter will lighten foliage so that the building is more easily seen. For very dramatic effect, a B/W infra red film with deep yellow, or red filtration (see *Filters*) may bring an added advantage. With this film, sky and water will be black and foliage nearly white. It is not available in sheet film, so little control of perspective will be possible with most roll film cameras.

Working with colour, a skylight filter is normal and a good polarizer is almost indispensable. Blue skies may be darkened and undesirable reflections on the building can be reduced. Colour compensating filters are usually needed to produce accurate rendition of subtle tones.

Extreme cantilevers in buildings can cause problems if the underside must be seen and this generally means photography has to take place early in the morning at sunrise, or late in the day when low sun angles can beam light into the dark shadows under the overhang.

North walls receive no direct sunlight and these are best photographed in colour, after the sun has dropped quite low and a polarizer is fitted to give maximum sky effect. For B/W, choose an overcast day, under-expose the film one stop, then develop to compensate, with a vigorous developer such as DK50 at full strength or Suprol (diluted 1 + 15).

With glass curtain walls that have gleaming textures, dramatic effect can be found in photographing from some distance away with a long lens, from a position where the sun is very low and is angled parallel to the lens axis. A star filter may be added for further effect, but exposure must be kept very rich so that no highlights burn out.

Foregrounds may be included to help indicate scale, and controlled human activity close to the building is also useful for the same reason. Nearby foreground objects, with the use of wide-angle lenses, give distorted scale, diminishing the building in proportion and producing too much space in the final image between the building and other objects. The same problem can arise when the building is not large enough in the final print.

In well-travelled streets, it may be necessary to use neutral density filters to give very long exposures, say one minute or more, then interrupting this carefully timed period by closing the shutter when traffic is passing. Stationary cars or people at bus stops can cause problems with this technique and with colour film increased exposure and colour compensation filtration may be needed to counter *reciprocity effect*. At night the method works well, and some tail light streams on otherwise empty street levels may add further dimension.

Night photography of buildings is most dramatic and best effects are found if two exposures are given. The first at dusk, when some skylight is present but the building receives only moderate light, just enough to render the basic structure. With the camera solidly mounted on a heavy tripod, all is left in place, the shutter closed until darkness falls. By pre-arrangement, lights are turned on inside the building, a suitable filter is added if altered colour balance is necessary and a short exposure given to record the details of the interior. Tungsten balanced colour film is best for this type of picture as the dusk is rendered a romantic blue, with good separation of building and sky. If the building itself needs more accurate illustration, a powerful tungsten halogen flood, at least 1000

Left A beautifully controlled architectural photograph by one of the acknowledged world masters, Richard Einzig (see the entry under *Einzig*). Notice the rich lighting which renders texture and form so well, the unobtrusive but essential figure to give a sense of scale and the perfect geometry of the image. (*Courtesy Brecht-Einzig Agency*)

It is important in interior photography to render atmosphere and pattern, but daylight should not burn out the window areas.

impact of the B/W image. Working in colour, daylight, fluorescent and tungsten lights often must all be balanced. If windows are an important part of the image a separate exposure must first be made to show these correctly and with the landscape outside. Without moving the camera in any way, a second exposure is made for the interior, either when daylight has faded or with heavy black-out curtains over the outside to mask the daylight. If tungsten light and film is being used in these circumstances, a Wratten 85B (orange) filter will be needed on the camera to alter the colour temperature of the daylight to 3200K and bring it into balance with the film. This is then removed for the second, interior exposure. It is easier (also the method adopted by most professionals) to use electronic flash to light the interior, adjusting the f stop for correct flash exposure and then the shutter speed for correct daylight exposure. A hand-held meter, especially a 1° spot meter, is useful for calculating this daylight exposure. For best results, flash must be off-camera, although bounce flash from camera may be used. Generally, however, light loss from this method is such that this results in very wide apertures being used and daylight burns out in the window areas. If no windows or daylight are included in the picture, tungsten light is usually to be preferred. Lighting should be natural, following the normal pattern falling from existing light sources. Shaded lamps can have their usual bulbs replaced temporarily by 250 watt photofloods but, as these burn with considerable heat, care must be exercised to prevent scorch marks. Conversely, to control over-exposure in sundry room lights in the picture during long exposures, when using either daylight or tungsten floodlight, normal lamps may have to be replaced by 15 watt pygmy lamps. If this is still not effective, these sundry lights may be turned out for part of the exposure. Even with daylight film, these fixtures should carry tungsten balanced lamps as this gives a cosy effect in the picture.

Although wide angle lenses unduly distort perspective and separate distances between objects to an unreal degree, small areas may require their use. This can result in excessive dominance of ceilings and floors unless the picture is cropped to a very long horizontal format. Using special wide angle bellows, view camera movements may still be used to obtain perfect verticals. Again, 3D volume should be rendered, with no flatly lit single planes facing camera and at least two walls should always be included. Back lighting can achieve useful separations and often can be naturally produced by throwing flood light beams through open doorways which appear in camera. No photographic lighting or equipment should be seen in camera or be reflected in mirrors, tables or windows. Flaring highlights in these surfaces should be avoided generally.

In large dimly lit interiors, painting with light may be used (see *Lighting*). This calls for careful calculation and usually Polaroid tests beforehand. Decorative or stained glass windows or walls are best photographed by diffused or overcast daylight to prevent over-exposure of delicate colours. Very dark, moody interiors are rarely of use to architects or designers and the tendency is to show adequate shadow detail and a general openness to the mood.

watts, can be 'washed' slowly over those walls facing the camera, this being a third separate exposure, after darkness has fallen and with the interior lights off. Polaroid trials are needed, but try a one minute exposure time at f16, with the flood moving *slowly* on the building during that time.

Large walls of principal interest should be photographed almost straight on to camera but with at least one other wall in dramatized perspective conjoining it. Very strong shadows on these subsidiary walls may be opened up if using B/W, by over-exposing 30–40% and under-developing at least 25%. If colour is used, large studio flash lights in diffuse reflectors may be needed or the careful use of a *matte box* and partial ND filters could assist control of contrast. Using the back movements of the view camera, increased or diminished perspective distortion can be achieved to heighten visual interest.

Photographing interiors is an even more complex operation if ideal results are needed. The picture again must show spatial design, fall of light, window views, function of space and decor. In B/W this is reasonably simple, technically speaking, because light sources need not be balanced. Textures and form will be the major contribution to the

ARCHIVAL PROCESSING, STORAGE AND PRESENTATION

A typical exterior of an interesting building (Los Angeles airport), using a light yellow filter to add tone to the sky.

If fluorescents are included in the lighting plan, these must be carefully filtered (see *Filters*) as most emit discontinuous spectrums which cause green or magenta shifts in the final transparency. Full exposure tests must be made and film developed. Such light will flatten textures and give a bland, uninteresting effect, so usually, a very directional key light must be added for interest. In B/W photography, where fluorescents are the major source of light, *under-expose* by 30–50% and over-develop by 100% to give added brilliance.

If the assignment calls for the photography of architectural scale models, photograph these outside if they are reasonably portable. With a very long lens, the out-of-focus natural foliage and the natural light gives a very acceptable result. If they must be photographed inside by artificial light, again the long lens will be needed and the key light must be orientated to the normal sunlight angle for the site. This can be determined by visiting the site with a compass, observing the fall of light and noting it on the ground or elevation plans.

Architectural photography requires exceptional technical ability and elaborate equipment, but above all it will be necessary for those who wish to excel at this subject to be in harmony with nature, have the ability to observe patiently the fall of natural light and, finally, to understand the fundamentals of good design and discreet taste.

Except when properly processed and stored, photography has to be considered as a fugitive process, highly likely to fade, stain or distintegrate over varying and, sometimes, very short periods of time. If the photograph is to be preserved, great care must be taken to achieve proper stability in the material with which the image has been made. Truly archival lifetimes for photographic images are defined as 500 years without a density loss of more than 10% in that time, in the entire emulsion or any one layer.

If the transparency or print comes from a commercial processing house, a good chance exists that archival techniques have not been used, as these are expensive in terms of labour and not often deemed necessary. The exception, as far as colour is concerned, is probably Kodachrome which is processed to exemplary standards by its manufacturers, Kodak, and modified processing by others is rarely possible. Kodachrome is extremely stable in dark storage, less so in light, while Ektachrome is less long-lived in dark but better than Kodachrome in light and when projected. Archival files should therefore be made on Kodachrome and duplicate projection slides should be on Ektachrome. Sometimes, however, circumstances do require the photographer to make arrangements without using his/her own processing, and archival control therefore can only begin at the storage stage, after processing is completed by others. It is far better to arrange processing matters yourself, under strict control and this will begin with the process of development. Good processing requires clean, fresh solutions, uncontaminated equipment and precision with regard to time and temperatures. Film gives up its unwanted chemical residues rather more easily than paper but, in the case of conventional B/W material, care is still needed. Such film will usually contain unexposed silver salts and black silver where light and developer have created them from the original silver halides. Only black silver is wanted and the excess silver halides must be removed by immersion in a fixer, usually sodium thiosulphate (hypo) or ammonium thiosulphate (fast fixer). To remove this fixing agent, films must be thoroughly washed. Archival processing is a matter of taking extra precautions to see that this simple process is effectively carried out.

Processing

For negative processing of B/W material, first see that the darkroom is lightproof and that no damaging or corrosive chemistry or vapour can reach the film or the solutions. Make sure that *safe-lights* are safe, that dishes and sinks are scrupulously clean and that towels are free of contamination. Provide proper space between processing baths, because splashes of fixer in developer tanks can easily degrade the results. Wash hands frequently in clear running water. It is important that temperatures of all solutions should be within a few degrees of each other, but in the case of wash-water, some latitude is permissible, provided that it is understood that cold wash temperatures need considerably longer washing times. It is essential to use a *stop bath* between developer and fixer and this should be a 2% acetic acid solution. Twenty

seconds will be sufficient time in this bath with continuous agitation.

Two baths of fixer should be provided. With fresh, normal fixer, four minutes in each bath is required, whilst with fast fixer, one to two minutes is needed. Fast fixer has a rapid, bleaching action so it is important to mix it accurately to the correct dilution and time the process exactly, according to the manufacturer's instructions. During processing do not turn on white light until the film material has been in the first fixing bath for 30 seconds to two minutes depending on the fixer used. After fixing the negative should then be immersed in a water bath for 15 seconds and a hypo clearing agent (or a 1% sodium sulphite solution) for two minutes, rinsed again in water for 20 seconds then washed for 15 minutes in a tank which changes its total volume every minute. A dump wash tank is ideal, where the operator can clear totally the tank at will, by opening a large gate in the side. It is necessary to use the hypo clearing agent in order to assist removal of the complex residual salts which are likely to remain in the material, even after fixing. Washing times are also shorter. After washing a two minute still-bath in a wetting agent (usually at half the strength recommended by the manufacturer) is needed and the film is then hung up in a dust-free cupboard for air drying without heat. Careful use of a spotlessly clean sponge, chemically inert, to clean off excess water droplets is sometimes advisable.

When dry, film should be numbered and coded and put into Du Pont Mylar plastic sleeves (not PVC), clear on both sides, so that contact proofing of negatives may be carried out while still sleeved. Alternatively it can be placed in a special paper envelope, acid free, such as those supplied by Hollinger Corporation, USA (see *Appendix*). Do not use normal envelopes or PVC sleeves containing plasticizer.

Print processing

This follows basically the same procedure as negative development but requires extended fixing and washing due to the ability of the paper base to retain chemical residues to a far greater degree than film. Archival printing must not use RC (*resin-coated*) papers even though they are designed to give up residual salts almost as fast as film. Fibre-based Baryta paper is the only proper material for longevity and the extra trouble in processing is worth it. Kodak, Agfa and, particularly, Ilford who have introduced a special paper 'Gallerie' and an archival processing kit to complement it, all make suitable papers. Hand-coated papers, made by the photographer in the darkroom, should employ mould-made or 100% rag paper (free of brightening agents) or other acid-free materials and these are obtainable from artists' supply stores, or the Hollinger Corporation.

After going through the normal routine of cleaning equipment and properly mixing solutions, safe-lights are turned on and printing and development of the image is completed (see *Enlarging*). The print is then immersed in a 2% acetic acid stop bath for 20 seconds and then in the first tray of fixer for five minutes, with constant agitation, if it is a normal fixer (hypo) or one to two minutes if it is a fast fixer. Do not add a hardener to the fixer unless tropical processing is

being carried out. After this time, transfer the print to fixer bath number two for a further timed period equal to the first. Wash then for 30 minutes in clear, fast changing water with constant agitation. A five-minute bath in a hypo eliminator follows. A two-minute bath in a 1% sodium sulphite clearing agent solution could be used before the first wash. A final wash for 30 minutes completes the process. Temperatures of solutions should be 20–22°C (68–72°F), not varying above or below that figure. Agitation in all solutions should be constant and simple siphon washers will not be sufficient by themselves. Exhausted solutions must be discarded. Washing times in sea water can be reduced by 50% from the above times because of its efficiency in neutralizing and removing the chemical residues.

Prints should be air dried on special muslin racks or muslin-surfaced photographic blotters (Kodak USA catalogue number 1499672 or plain blotters, catalogue number 1521996). Ordinary office blotters are not suitable (see *Appendix*). For glossy surfaces, do not use a hot glazing drum but have 6mm (¼ inch) thick sheets of plate glass cut to a convenient size and the edges polished. These plates should then be cleaned with metal polish or silicone cleaner and the prints rolled or squeegeed face down into contact with the glass, using maximum pressure to remove water and air. As the prints slowly dry they will fall free of the glass sheets, giving a perfect glaze. This may take one to three days.

Before drying, prints may be given a further treatment as part of extending print life. They may be sepia toned or, preferably, selenium or gold toned. Toning converts the silver image into silver compounds which are even more stable, particularly to airborne pollutants. Finger prints on archival prints should be removed immediately with ethyl alcohol, otherwise they will damage the emulsion. Storage of unmounted prints should be in acid-free and epoxy-coated metal boxes in controlled temperature and humidity, usually not exceeding 40% humidity and 25°C (77°F).

Chemical residues are removed by washing thoroughly and a photograph is archivally safe from chemical contamination only when it reaches .16 on this scale.

WASHING TIMES

Colour materials

Negative and transparency processing should be carried out with due regard to the above general practices for B/W materials and should follow manufacturers' exact instructions. Be particularly careful to note throughput in solutions that are being held over and do not use exhausted solutions. Colour processing requires exceptional cleanliness in the darkroom and from the operator, as contamination is more easily introduced in these processes than in B/W work. If it is impossible to process your own colour materials and you still require archival qualities, make sure that the commercial operators of your choice guarantee this, even perhaps allowing an inspection of their laboratory. Reasonably stable print quality is easily achieved in colour, within the inherent limits of the product, provided that special attention is given to washing and a final stabilization if this is required. With today's simplified chemistry, home processing is relatively easy but it must be remembered that, whereas it is possible to achieve real permanency in B/W materials with suitable processing, this is not yet true of colour, with a few notable exceptions. The doubts about stability in colour materials have often prevented collectors from encouraging those photographers whose chosen medium is colour, but if a comparison is drawn between, say, water colours and the best colour print technique, it will be seen that they have much in common and can have similar life spans if well cared for.

Storage and exhibition

Three main areas of hazard exist for photographs, in both print and transparencies. These are firstly, physical damage such as air pollution, particularly tobacco smoke and attacks from insect larvae which feed on gelatin. Secondly, chemical fading, either due to faulty processing or prolonged exposure to intense light and, finally, the break-up of the base material

Colour transparencies should be stored on hanging files and be protected by an acetate or clear PVC cover. Some PVC material is not suited to long term storage and special care should be taken when choosing slide files to obtain an archival PVC sleeve.

which supports the imaging chemistry. Physical damage can be minimized by exercising good environmental control for the photograph: storage at low temperatures with humidity not above 50% in acid-free containers, such as foil-lined envelopes (available from Kodak USA, catalogue number 1486398 for 4 × 5 inch or 1492028 for 8 × 10 inch) or metal epoxy-painted boxes. PVC sleeves containing high percentages of plasticizer to increase their flexibility are not suitable as they easily release this additive, especially in high temperatures, leaving a sticky, black deposit on the film surface. PVC also releases vinyl chloride gas over the years which is destructive to colour emulsions. Uncoated polyester is usually quite stiff and does not smell of plasticizer and is less harmful, but clear polypropylene or cellulose triacetate is much safer. Avoid glassine or tissue envelopes as their adhesives also allow acids to migrate over the years and cause damage; an alkaline-buffered paper envelope is an excellent choice. Hollinger Corporation in the USA are specialists in supplying archival materials of this kind as well as advice on archival storage (see *Appendix*). For transparencies, projection should be kept to a minimum. Originals that are required for archival purposes should not be left longer than one minute in the gate of a properly ventilated projector and should be protected by thin glass and be in plastic mounts such as those made by Gepe which have foil inserts. Ten minutes in a 250 watt projector can seriously damage an important transparency. Do not over project very valuable transparencies.

All colour materials should be stored in a manner that minimizes surface pressure on the emulsion as this can cause ferrotyping in localized areas. Store prints or films on edge in a hanging file and if prints must be mounted at all, acid-free adhesives should be used such as Gudy O, which is a cold pressure-sensitive neutral adhesive and, if desired, a surface protection should be applied (see *Appendix*, 'Special Products'). Certain colour materials lose density and suffer colour shifts in the dark as well as when exposed to light, and the only way to arrest this dark fading is to keep the materials in moisture-proof storage at deep freeze temperatures of − 18°C (0°F).

Most colour material is quickly affected by the sun and other strong light, especially ultra violet and, with the exception of the micro-jet electronic imaging process, none should be displayed in sunlight. Diffused daylight of 300 lux, say 2 metres (78 inches) away can cause noticeable shift in some materials in well under five years and fluorescent light of normal, bright office conditions, 300–500 lux, can create fading, staining and loss of density in certain materials in an even shorter time. UV filters can be built into print surface finishings but do not generally extend print life significantly and will produce a warm shift in colour and, if not compensated for when making the print, this could be unacceptable. Prints which are required for archival purposes should be displayed under reasonably low levels of tungsten light, not more than 250–420 lux (20–40 foot candles) and even then, infrequently. They should be stored in metal epoxy-painted boxes or in Hollinger acid-free archival files, free of surface pressure and in temperatures not exceeding 20°C (68°F) and between 30–40% humidity.

The base support for the emulsion of modern colour prints is often a polyethylene, pigmented, resin-coated paper, and manufacturers are very concerned to correct its very poor archival qualities. Most makers of colour paper will not guarantee their RC print base longer than two to five years, although the Ciba film-based print material, *Cibachrome* II-PSB, is a notable exception. Introduced in 1963, Cibachrome is a dye destruction, positive-to-positive process, is carried on an opaque polyester film base and is extremely stable in both light and dark conditions. Density loss during accelerated ageing tests for Cibachrome film-based print material has been shown to be less than 0.1 for a simulated 50-year period. Normal RC-based Cibachrome Pearl is equally suspect in archival terms along with the RC papers of Kodak, Agfa, Fuji and 3M and all should be avoided at present if long-term archival properties are required.

RC papers tightly held in glass frames can sometimes release harmful residues and the vapour from the base which will attack the emulsion. If the print must be mounted at all, this can be done on acid-free card, aluminium or linen, but should only be attached with suitable acid-free adhesive. A very good acid-free adhesive sheet material is that marketed under the Gudy trade name in Germany by Neschen which has been tested for archival properties and chemical inertia when in contact with photographs (see *Appendix*). This material requires no heat and relatively little pressure to bond well and has a pH of 7.0. The same manufacturer makes an excellent print surfacing material, Filmolux 75s, which also

TEMPERATURE EFFECT ON DYE STABILITY OF COLOUR MATERIALS AT 40% RH

Temp. $^\circ$C	Temp. $^\circ$F	Expected life
30°	86°	$\frac{1}{2}$ life
25°	77°	Normal life
10°	50°	5 × normal
5°	41°	15 × normal
-18°	0°	350 × normal

Note Based on a 0.1 density loss, dye fading increases rapidly with rises in temperature and is substantially reduced at lower temperature. Thus if the measurable density loss is nil for a normal five-year period at 25°C, at 5°C, life span of the material is increased 15 times to 75 years.

has a neutral pH factor, is ultra thin, very glossy and 98.8% clear. It is non-yellowing and, again, is a cold seal which gives the print a washable surface, proof also against oil or petroleum-based solvents, and obviates the need for glass protection. A matt-finished film, with similar characteristics, is also available. An alternative to mounting is to hold the print on to an acid-free card mount by foil corners (left fig.) and then frame with the glass holding the print in place. A foil-lined window mount (matt) will also be needed to separate the glass and print surfaces. This method is time-consuming, but does eliminate the use of any adhesives or mounting material and is very suitable for collections which must occasionally be exhibited, before returning them to dark storage.

Image changes in colour print materials vary greatly with different products and significant fading or staining will eventually take place in most, with perhaps the possible exception of the Fresson Quadrichromie process, the micro-jet electronic imaging techniques, which print on natural or synthetic textiles, or Ciba film-based prints. Even very unstable processes stored under sub-zero refrigeration and at low RH (relative humidity) will last many hundreds of years, but many collectors of colour photography are satisfied if the print is stable during dark storage and behaves well for several months of exhibition, under reasonable levels of tungsten or fluorescent light before being returned to safety in dark storage.

In general, it may be said that in order to obtain the longest life possible from any colour print it should be protected from air and chemical pollution, finger prints and abrasions, it should not be displayed near strong light, strong daylight or bright fluorescent sources, it should be, if possible, a saturated and rich, somewhat dark print and should contain the least amount of yellow in the image that is compatible with the photographer's artistic concepts and the subject. Prints with resin-coated support materials should be avoided.

Transparency material is more stable than negative or inter-negative material, so it is better to use reversal film,

Mounting for archival purposes or permanent exhibition.

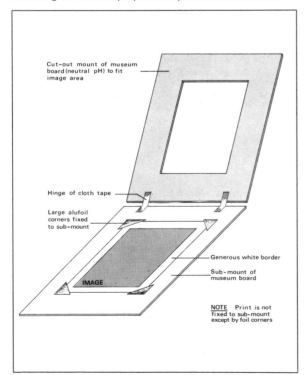

Cut-out mount of museum board (neutral pH) to fit image area

Hinge of cloth tape

Large alufoil corners fixed to sub-mount

Generous white border

Sub-mount of museum board

IMAGE

NOTE Print is not fixed to sub-mount except by foil corners

SUMMARY OF ARCHIVAL PRACTICE

Pre-process

1 Store unexposed film at $-18°C$ ($0°F$) and RH, (relative humidity) of 50% or less.
2 Take adequate time to warm up frozen film to room temperature.
3 Process exposed colour film within 48 hours.

Processing

1 Follow manufacturers' instructions accurately.
2 Do not use exhausted chemistry, test for chemical residues.
3 Do not use white light inspection too early in B/W processes.
4 Fix with minimum times, wash with maximum times.
5 Air dry slowly below $27°C$ ($80°F$).
6 Clean off all finger prints and dust from dried material.

Storage

1 Dead storage should be in foil-lined, polyethylene envelopes, sealed in 30% RH conditions.
2 Store materials on edge in hanging files, eliminate pressure on flat surfaces.
3 Do not use silica gel in containers for long term storage.
4 Use epoxy painted steel, rather than wood or plastic file drawers.
5 Store originals in individual Mylar* or polypropylene clear film.

*Mylar is a DuPont registered name.

6 Do not use PVC or plasticizer impregnated materials.
7 Use outer envelopes with pH of 7.0–8.5.
8 Protect from light and chemical pollution.
9 Store at RH of $25-35\%$, temperature $-18°C$ ($0°F$) to $20°C$ ($68°F$).
10 Sub-zero temperatures give maximum dye stability.
11 Kodachrome is substantially more stable in dark storage than other colour films.
12 Use acid-free tissue to interleave all prints or films.
13 Use frost-free refrigeration.

Exhibition

1 Dark storage is superior to display.
2 Display for short periods at a maximum of 320–400 lux (20–30 foot candles).
3 Do not use UV screen laminates on prints.
4 Never project any valuable transparency.
5 Mount only when absolutely necessary and then on acid-free materials.
6 Protect exhibited work from air pollution and tobacco smoke.
7 Do not expose exhibited work to daylight or sunlight.
8 Exhibit in controlled temperature, $20°C$ ($68°F$) and RH $30-50\%$.

especially Kodachrome, for original camera images and a direct positive print such as Cibachrome II-PSB for either archival master prints or a second set of matching exhibition masters. This approach would assure extremely long life under temperate room conditions of $20°C$ ($68°F$) and $30-40\%$ RH, and with a drop of storage temperature of $-18°C$ ($0°F$) they would certainly last hundreds of years.

New developments in converting images to digital codes means that it is now possible to hold full separations of colour images on electronic master tapes and these could be stored indefinitely, to be reconstituted as colour prints whenever needed. This bypassing of the silver image, with the ever increasing use of electronic imaging systems, would soon seem to offer the most practical archival system of storage, retrieval and transmission.

Currently, the best dark stable prints are Kodak Dye Transfer, Fuji dye colour, Hansfstaengl Tricolour Carbro, Fresson Quadrichromie and Cibachrome II-PSB, with the polyester film support. These should last indefinitely in the dark if the correct processing and storage is carried out.

The best light-keeping qualities are undoubtedly Fresson Quadrichromie, Cibachrome II-PSB and, for very large prints, the electronic scannergraph ink jet processes, printing on natural or synthetic fabrics with micro-jet imaging systems.

The expected life in the light, under controlled volumes and sources of light for all of these print types would suggest a life ranging from 20 to 200 years minimum, provided that they are properly processed and protected. Of the long-life materials easily printed only Cibachrome II-PSB comes close to exact reproduction of the original transparency, always provided that this material is not asked to handle excessive contrast. Photomechanical colour processes, such as off-set lithography and letter press, can be poor performers on display unless printed with special light-fast inks, but they have fairly stable behaviour in controlled dark storage and this is true also of Polaroid SX70 and Polacolour 2 film, which is being improved constantly. In the long term it may be that Polacolour does produce some yellow staining of the image in the dark, except when refrigerated to sub-zero temperatures. (see *Storage of Sensitized Materials, Enlarging, Developers, Hypo Test, Hypo Clearing Baths, Hypo Eliminators, Resin-Coated Paper, Cibachrome.*)

COLOUR PRINT PROCESSES AND ARCHIVAL QUALITY

Process name	Type	Base support	Date of introduction	Processing	Dark keeping at 24°C (75°F)	Dark storage needs
Kodak dye transfer	Dye imbibition from separations	Fibre paper	1946	Home or lab	Excellent	RH 30%; 15°C (60°F)
Fuji dyecolour	Dye imbibition from separations	Fibre paper	Late 1970s	Fuji only	Excellent	RH 30%; 15°C (60°F)
Polaroid sx70	Metallized dyes – one step print	Polyester	1972	Self contained	Good to excellent	Low temp., low humidity, best refrigerated; yellow stains may form in blacks
Polacolor	Metallized dyes – one step print	Polyester	1975	Self contained	Good to excellent	Keep refrigerated
Kodak Ektacolor RC	Neg/pos chromogenic	Resin-coated paper		Home or lab	Average to poor	Keep at − 18°C (0°F)
Collotype lithography	Dichromated gelatin transfer	Paper as selected	1899	Printing factory	Good to excellent	Low humidity & temp., interleaved with acid-free tissue
Kodak Ektachrome RC	Positive to positive	Resin-coated paper		Home or lab	Average to poor unless refrigerated	Keep at − 18°C (0°F)
Hansfstaengl carbro	Tricolor carbro tissue	Fibre paper or own choice	Early 1900s to 1950s; re-introduced 1970s	Home	Good to excellent	15–20°C (60–68°F); 30–50% humidity
Fresson Quadrichrome	Colour separation pigmented gelatine		1951	Fresson Laboratory, France	Excellent	15–22°C (60–73°F); 30–50% humidity

Dark life	Light keeping	Exhibition needs	Light life	General comments
100 years	Average to poor	Glassed frame, or total encapsulation in acid-free materials	5–25 years	Excellent reproduction, good choice for collectors; beware of excessive display in bright light; controlled exhibition needed
70 years +	Average to poor	Glassed frame or total encapsulation as above	5–25 years	Excellent reproduction suitable for careful collectors; low cost for multiples of same image; controlled exhibition needed
10–20 years	Average to poor	Surface protection of print; acid-free mounting; restrict exhibition times	2–20 years	Cannot handle excessive contrast, yet if modified by filters can be most attractive; provides a unique print with dry processing
10–20 years +	Average to poor	Surface protection; acid-free mounts: restricted exhibition times	2–20 years	Can handle subtle colours well; processing can be modified and filters add unique charm; fading produces excessive blue/green shift; yellow is least stable
5–10 years, unless refrigerated	Average to good	Total protection, no daylight, low light levels, exposure to high-level fluorescent light increases fading; restricted exhibition	5–20 years without more than .05cc filter shift	RC support can break up quickly, colour shift noticeable after a few years in light; colour reproduction excellent; good interim print but not suited to collections
20–50 years +	Average to good	Glassed frame and acid-free mount	10–30 years if paper base is stable	Beautiful colour reproduction, no screen or grain, suitable for maximum of 1000 copies before new plates; collections should be rarely exhibited in bright light
5–10 years unless at zero temp.	Average to good	Total surface protection, no daylight, low light levels, exposure to high-level fluorescent light increases fading; restrict exhibition	5–30 years before noticeable shift	Not suitable for collectors, cannot handle contrast well, RC support can break up quickly
20–70 years +	Good	Total surface protection, keep away from high-level daylight or intense tungsten spots	20–70 years +	Excellent colour reproduction, very good for collectors; latest processes may increase light stability significantly; safe for extended exhibition
Permanent	Excellent	Surface protection, do not expose to excessive sun or high levels of fluorescent light	50–100 years	Excellent stability; colours are soft and mellow rather than exact reproduction; grain may be increased from small formats; good choice for collectors if they accept modified colours from original

continued overleaf

Process name	Type	Base support	Date of introduction	Processing	Dark keeping at 24°C (75°F)	Dark storage needs
Cibachrome PS	Silver dye bleach, positive to positive, self masking	Cellulose triacetate film	Late 1970s from original 1963	Home or lab	Excellent	15–22°C (60–73°F); 30–50% humidity
Neco print or 3M architectural painting	Micro-jet imaging, non silver process	Any flexible materials	Early 1970s	Franchized agents	Excellent	15–80% humidity, safe in tropical temperatures

Note The life of colour print exhibited continuously in normal room light is almost impossible to quantify. These figures arise from research and contact with manufacturers and academic sources. They are based on a light level of 500 lux (50 ft candles) or less and are for display wholly in artificial light. Damage to a colour print by density loss is most subjective and varies considerably for each primary colour. Relative humidity and temperature vitally affect dye fading in addition to light levels. Consider these figures as a conservative guide only.

ART CENTER COLLEGE OF DESIGN

More than 50 years ago in Los Angeles, 12 teachers and eight students came together to begin what was to become one of the most interesting, notable commercial design schools in the world. Founded on the principle of the inter-

Students at the Art Center College of Design are instructed on photography of cars. The striking campus building is in the background. (*Courtesy Art Center College of Design*)

relationship of various design disciplines, students now may choose to major in any of six areas of instruction: film, fine arts, illustration, industrial design, advertising and photography. The requirement that all students must at some time work closely with those from other departments, and that many of the faculty are still actively engaged in professional design matters for their own business, considerably broadens the experience of those who attend.

The photography department is famous for its intensity of work and professional results and its faculty has, at various times, included world-renowned photographers such as Ansel Adams, Wynne Bullock and Man Ray. The photographic alumni of this college now spreads around the world and most occupy prominent places in the advertising industry, educational or other communication fields, wherever photography is the chosen means of expression. (See *Appendix*.)

ART OBJECTS, PHOTOGRAPHY OF

Both amateurs and professionals may often be called upon to record art objects and for a variety of reasons. A common need from collectors and small museums who do not possess a photographic department would be for insurance purposes, to create a research file or for audio visual presentation. The end use will control the degree of sophistication needed in technique and equipment, but a common factor will prevail in all assignments to copy artworks: the final result must look very like its original and there is little need for subjective image making from the photographer.

To control the B/W or colour process in such a way as to produce facsimile results is extremely difficult and requires considerable technique from the photographer, but for the less demanding areas of identification or record, rather normal methods can, with care, produce acceptable results.

Usually, the objects can be divided into two categories:

Dark life	Light keeping	Exhibition needs	Light life	General comments
Permanent	Good to excellent	Seal against air pollution with acid-free materials, mount on acid-free board or metal; exhibit with general tungsten or low power spots $1\frac{1}{2}$ metres from print or in low level fluorescents	25–100 years +	Excellent stability; may not be totally permanent in high light levels, should not be in sun or nearer than 2 metres from window; good for collectors, brilliant colour saturation; revised process PS handles contrast well, fascimile colour is possible
Permanent	Excellent	Protect from abrasion by spray seal; can be exposed to direct sunlight for long periods without damage	20 years +	Electronic photo print, good colour reproduction, usually on canvas or fabric base; not suitable for prints smaller than 2 square metres; thought to be permanent, can be exhibited in sunlight and outdoors; good for murals and wall hangings

two-dimensional flat art and three-dimensional subjects such as sculptures, ceramics, jewellery and performing arts.

Flat art that needs copying must be placed in an arrangement that allows the film plane to be exactly parallel to the subject plane, and usually with two equally balanced light sources at an angle greater than $45°$ to the lens axis (see *Copying*). Sometimes, if it is desirable to highlight texture, such as on bas reliefs, coins or heavy impasto paintings, a strong accent light may be angled very low across the surface to produce a distinct, if shallow, contour.

For the amateur faced with a recording problem, and if no special equipment is available, daylight photography in the hours between 10 a.m. and 3 p.m. can give quite good results. Direct sun should not fall on the copy subject and best results are on bright, but fully overcast, days. The sun should be above and behind the photographer and if a shadow of the camera is cast on the copy a longer lens must be used to increase the camera-to-subject distance. A diffusing scrim can be built (see *Lighting*) if the work must be done in bright sun. A tripod is essential, as is something to hold the copy in position. The copy should be placed on a black cloth background (black paper will not be very successful under daylight conditions) in order to eliminate flare and a lens hood should be used for the same purpose. An SLR is ideal because of its precise control in viewfinding but if using a 35mm rangefinder camera the following method can be used to line up the camera.

Before loading film, open the camera and attach a carefully cut piece of fine greaseproof kitchen paper to the film gate. Set the shutter on time or bulb. Mount the camera securely on a tripod in front of the copy and approximately in position. Place a dark piece of cloth over the head, open the lens and with the other hand slacken off the pressure on the tilt-head of the tripod and align the camera as exactly as possible. Lock the camera and tripod securely in position, open the camera

and take out the paper, then load the camera without in any way altering its orientation to the copy.

For daylight work, choose a slow film and *bracket* exposures, as some colours do not respond accurately to through-the-lens metering. If you are not using an SLR camera, measure lens-to-subject distance by using a flexible carpenter's rule. If working in overcast conditions a *skylight filter* may help, but a Kodak 81A, slightly brownish filter, may reduce unwanted blue casts in the final result. Use transparency film if working in colour and then select only the ideal result for later printing. Keep a note in your logbook of exposures and filtration on a frame-by-frame basis to guide you on future occasions.

The above approach can also be used for small three-dimensional images although some of these can benefit by direct sunlight to increase texture and contour. Glass and metallic objects can be best photographed late in the day when no direct sun strikes them, but this could induce excessive yellow and orange colour casts that will require Kodak *colour compensating filters* of the blue or cyan variety to produce more natural results.

Note that when working with precious objects out of doors, wind is a major hazard and great care must be taken at all times to see that they are secure from damage.

To produce first-class photographs of the smaller dimensional objects and flat copies, it will be necessary to work inside and to use a rigidly controlled technique. Again, flat copies must be placed exactly parallel to the film plane, be carefully secured against a dead black background and lighting must be evenly placed to avoid reflection into camera, and all hotspots or shadowed areas must be eliminated. The use of a *polarizer* on the copy lights can be helpful, plus a polarizing filter on the lens. Reflections, glare and highlights may thus be easily controlled (see *Filters*).

Tungsten lights may be used with tungsten film, but these

must be placed at sufficient distance from valuable objects not to create damage or hazard. Where colour balance is crucial it is best to use a combination of electronic flash and daylight film, provided these flash units are equipped with modelling lights that throw an exactly similar light pattern to that of the electronic tube. Very suitable units are to be found in the Multiblitz Vario range of flash equipment (see *Electronic Flash*).

For B/W copies of coloured artwork it may be necessary to use filtration and panchromatic film to separate colours satisfactorily (see *Copying*).

Three-dimensional objects will also need at least two or more light sources, plus some preparation of the background. As in any lighting plan designed to produce form and texture, there must be a key light and adequate fill light to give good shadow detail. A viewpoint must be chosen to disclose the most information about scale and spatial qualities while, to avoid any perspective distortion, a longer than normal lens is needed. It is usual to place any art piece which has a complicated contour against a plain, seamless paper background of a colour which assists separation and which does not produce unwanted colour casts in any colour photography. To eliminate shadows around the base of the object, which may greatly detract from the picture, objects can be arranged on a glass shelf which is suspended above and well in front of the background or, if it does not affect separation, they can be placed on a background paper which has been sprayed a dark tone at the front, graduating to a lighter tone at the top. Diffuse lighting can also assist.

Most lighting of figures or small three-dimensional objects will begin with a fairly large, diffused top light. A further diffused accent light may be needed to enhance contour and possibly a spot light may be called for, to produce important textures, although cast shadows from such specular sources of

Clear definition and good rendering of texture are essential for pictures of art objects, particularly for insurance purposes. These very rare duelling pistols were photographed in colour and this is a B/W copy.

light can be difficult to control.

Such dimensional objects can be photographed by *tungsten light* quite easily and with relatively inexpensive equipment, but remember, if colour film is being used, that, except for tungsten halogen lamps, these lights become progressively warmer as they age and exact film balance is difficult. Also, due to *reciprocity effect*, shutter speeds which are not precisely those recommended by the film maker as ideal can cause large colour shifts which are quite difficult to control. In a professional studio engaged in considerable amount of this type of photography, it is better to achieve exact colour results by using electronic flash equipped with modelling lights which are synchronized to the flash lamp for exactly pre-viewing all lighting plans. The totally variable units are ideal (*see Electronic Flash*) as they have modelling lamps of 3200K, therefore are often an excellent alternative if tungsten light is needed, while their output and light pattern is exactly proportional to that of the flash lamp.

A good *boom stand* is invaluable and an assortment of lighting accessories such as *barn doors*, flags and snoots, will be found necessary. For this type of work, a hand-held meter which reads incident light or a spot meter reading a 10° or smaller angle, and a flash meter are almost essential. One meter which incorporates all three systems is made by Minolta and the considerable investment needed is worthwhile in view of the pursuit of absolute clarity and accuracy in rendering tones and colours (see *Exposure*).

Fixed works of art, such as large paintings or sculptures, do not offer any different problems except logistical ones of getting equipment into position in very security-conscious areas. Flat objects such as tapestries, because of their size, may call for a number of lights to be used and sculptures may benefit by the inclusion of their own environmental lighting in the photograph. As this lighting will invariably be tungsten and of undetermined colour balance, tests are always necessary right through to processed film stage, if exact colours are demanded by the client.

Working out of doors, for example in a sculpture court, several visits to the subject will be needed to assess the fall of light during the day. Shadows may be modified in this case by flash on camera, suitably diffused (*see Available Light*). In B/W photography, selective filtration can be used to help the object stand away from the surroundings, for example, red or orange filters can darken skies, when a low viewpoint is taken, or a green filter can lighten foliage around a sculpture to increase tonal separation.

Dramatization of works of art is rarely advisable, except perhaps in poster or catalogue assignments, but the use of black backgrounds or unusual camera angles may be acceptable if they are not too extreme. For special cases, portable objects may be taken into a very different environment than the normal and the subsequent juxtaposition of images can produce unusual impact. Thus, a painting photographed on a park railing or on a busy urban street could be a good lead shot to a catalogue, while sculpture transplanted to the beach and photographed at sunset could be most exciting for an editorial coverage of the artist's work. The logistics are formidable and all details of insurance,

For major public exhibits, dramatic lighting and dark backgrounds will often be the best solution.

transport, etc., must be worked out in advance and confirmed *in writing* to the client.

As has been stated, the primary result demanded when photographing objects of art is a clear, accurate picture which will perform in the way the client expects. There is little room for innovative images from the photographer, except for occasional editorial assignments. Absolute care must be taken to see that the piece of art is not damaged in any way and that all security aspects are considered. No attempt should be made to alter or clean any work of art accepted for photography, as this is something only experts can do satisfactorily and, indeed, damage can be done all too easily by the layman.

The equipment needed for any continued professional interest in photographing art objects *must* include the following: A *large-format view camera*, at least 12 × 9cm (4 × 5

inch) with normal, long and super long lenses, fully corrected for colour. If this camera is also equipped with a roll film back to take 120 film, so much the better. This facility gives the economy of roll film plus the full movement capabilities of the view camera. Polaroid facilities for this camera are desirable. A heavy, high-rise tripod is needed, a spirit level, which works on both horizontal and vertical surfaces and a full range of colour compensating, polarizing and B/W filters. Lighting should include two or three tungsten halogen 800 watt floods, with dichroic filters and high-rise stands, tungsten spot light and three to five electronic flash units with integral modelling lights and perhaps an electronic flash ring light of at least 160–200 watt/seconds.

It must be stressed that logistics and very precise technique are the ingredients of good photography of art objects rather than any subjective, artistic interpretation from the photographer.

ASA

This is a number system for rating film speeds, as approved by the American Standards Association, now the American National Standards Institute. Manufacturers will normally show the ASA speed and the equivalent DIN rating (Deutsche Industrie Norm) which is often used outside English-speaking countries. JSA ratings (Japanese Standards Association) and the Russian GOST speeds will often suggest that a photographer using a particular film and developer combination does not achieve the equivalent listed ASA speeds. Practical tests will be more accurate for the photographer's own work, so the film may be designated with a re-rating, that is to say an exposure index or EI. Published film speeds can only be taken as a guide as variables such as lenses, shutters, temperature, storage conditions, age of film and processing will effect film speed. (See *Exposure Index, Exposure.*)

FILM SPEED EQUIVALENTS

ASA	DIN	ASA	DIN
1	1/10	40	17/10
1.2	2/10	50	18/10
1.5	3/10	64	19/10
2	4/10	80	20/10
2.5	5/10	100	21/10
3	6/10	125	22/10
4	7/10	160	23/10
5	8/10	200	24/10
6	9/10	250	25/10
8	10/10	320	26/10
10	11/10	400	27/10
12	12/10	500	28/10
16	13/10	640	29/10
20	14/10	800	30/10
24	15/10	1000	31/10
32	16/10		

ASTIGMATISM

This is an aberration in lenses which affects the outer edges of lens fields where lines in these marginal areas may be rendered as unsharp. It can be reduced by stopping down and in most medium-to-high priced lenses will have already been eliminated by the manufacturer by designing a compound lens, designated *anastigmat*.

ATGET, EUGÈNE (1857–1927)

Born near Bordeaux, France, he became a sailor in his youth and then, until just before the nineteenth century ended, was an actor but of only minor importance. At the age of 40 he left the theatre and became a photographer. He worked in unspectacular fashion and with old-fashioned techniques, to document the fast-vanishing environment of urban Paris. The streets, buildings and parks were immortalized by his poetic vision and pure technique. Today his images have an authority not lost on contemporary photographers or fine art collectors, especially in North America and his simple, mysterious originality has contributed a vital factor to the rise of documentary photography. After 30 patient years as a photographer he died in poverty, leaving a vast collection which faithfully depicts the structure and life of a great and vital city, painfully growing to modernity in the early years of this century.

AUTOCHROME PROCESS

The first available colour process devised in 1903 by Louis and Auguste Lumière and their associate Seyewetz and commercially available in 1907, first in France and later worldwide. A single-plate additive colour process using a panchromatic emulsion and potato starch grains, dyed magenta, cyan and yellow. It was 50 to 60 times slower than contemporary B/W emulsions but became widely used and most successful. The company was later taken over by Ilford Limited and materials continued to be used until the 1930s. The introduction of the subtractive colour system 'Kodachrome' in 1935 rendered the autochrome method obsolete.

AUTOMATIC CAMERAS

These have been with us for many decades, some of the earliest being produced by Zeiss. In recent years, however, electronic developments particularly by the Japanese camera industry have led to total automation, including exposure assessment, film transport, flash measurement and focusing. Polaroid, Honeywell and Canon all have effective autofocus methods and Kodak, Agfa and Minolta have produced highly reliable subminiature cameras which just require a film to be dropped into the camera to activate a complex automatic process of setting film speed, exposure meter, etc. In simpler cameras there seems to be no question of the need for this aid to more reliable picture taking, but in the expensive advanced amateur and professional markets, automation is not yet fully accepted by many. In the near future, many of the most advanced cameras will not even have indicated shutter speeds, while in the case of Polaroid and some other camera manufacturers, images will be recorded simply as digital numbers on magnetic tape, bypassing the silver process completely until a final print is required.

In using an automatic camera it must be understood that in certain lighting conditions the electronics will produce errors which, in the case of professional work, could be disastrous unless manual compensation has been made. For example, in most SLR system cameras a sophisticated centre-weighting meter measurement of ambient light takes place. When the subject is backlit, increased exposure is normally needed and where a subject is standing against a bright sky, serious under-exposure is possible, because the automatic camera will measure an average of the scene whereas the photograph will need a compromise exposure to record shadow detail of the subject, plus the bright skylight and cloud forms. A new routine is needed in this case. The photographer stands close to his subject, say 2 feet (0.60 metres), obtains this reading, retraces his footsteps to the final camera position, takes a reading, then manually overrides the automation to create a suitable compromise. As a general rule all backlit subjects will require an increase of $+1$ or $+2$ stops if good detail is to be read in the shadow area. The very sophisticated 6×6 cm camera, the Rollei SLX, seems to have an exceptional metering ability to cope with backlit and sidelit subjects, giving excellent compromise exposures in difficult conditions. Even so, in situations of extreme contrast where high concentrations of light appear in small areas of the image, great care must be taken, otherwise shadow detail will be lost. All automatic cameras encourage the use of extra film, especially where automatic film transport is a feature. It therefore becomes even more vital to pre-consider the picture before pressing the button.

Automation in cameras will usually choose between two systems and sometimes be a combination of both. In the semi-automatic systems the photographer will set one control and the camera will automatically select the other. Where the operator selects a shutter speed and automation provides the proper aperture setting, the system is considered to be 'shutter preferred', while if the correct aperture is selected by the user with automation deciding the right shutter speed, the system is said to be 'aperture preferred'. Total automation is often provided in the cheaper automatic cameras where a film notch programmes the camera system correctly as each film is inserted in the camera.

There are advantages, perhaps to a professional, where a shutterspeed to avoid camera shake can be set, or fast action can be stopped and the camera decides on aperture, but in practice both systems work well. All good automatic systems incorporate a manual 'override' and should permit limited mechanical operation in case of battery failure. Because these systems depend on battery power, serious photographers need to carry spare batteries for the camera on every assignment and make frequent changes, especially before important sessions. It should be stated once again that even expensive automation for judging exposures can give false readings and great care must be taken in high contrast conditions. (See *Exposure*, *Small Format Cameras*, *Basic Photography*.)

AVAILABLE LIGHT PHOTOGRAPHY

Working with daylight is usually a matter of limiting the over-abundance of available light rather than building an additive lighting plan such as is normally done in the studio. This is often a question of the ingenuity of the photographer rather than the use of any specialized equipment.

First, go into nature and study the fall of light in different environments at different times of day and consider how to use the superb quality of natural light as a key light.

Because of the tendency to over-expose even slow colour film in these conditions, a *neutral density filter* or a high shutter speed (or both) may be necessary. On brilliant days of full sunshine, if the subject is contained in a relatively small area, a muslin screen or Colortran silk can be attached to a light wooden frame and hung as a diffuser between sun and subject. This will give brilliant, directional light, but soft with open shadows, especially good for portraits. A set of large reflectors at least one metre (40 inches) square, covered with matt white, matt silver, matt gold and mirror foil are useful accessories. A large 20cm (8 inch) diameter concave mirror is also extremely helpful in bouncing directional light back from the key source, but must be used with discretion. Small cosmetic mirrors to beam light into selected areas may be needed if the subject is an intricate still life.

On large objects such as vehicles, it is better to wait until only diffuse light is present, for example at dawn or dusk, when the light still has considerable contrast, but direct light does not fall on shiny surfaces. If cars must be photographed in bright sun it is possible to use artificial smoke or huge scrims made from parachutes to diffuse the direct rays of the sun and prevent specular highlights from becoming too disturbing. Black canvas is also useful to act as a minus reflector to increase the depth of shadow areas and thus raise contrast.

Overcast light is excellent for photographing shiny objects especially cutlery, ceramics and glass and, as with cars, the short period at sunset when the sky has a high degree of reflected light, but the sun is not present, gives a very special lighting to these simple subjects. At this time of day condensation on metal surfaces can be a problem and it is sometimes necessary to wipe the entire visible areas between each exposure with a soft dry cloth. Mixing daylight and artificial light, usually from a flash unit synchronized to camera, is much to be recommended where harsh shadows need open lighting (for colour film), or wherever excessive contrast seems to be present.

In overcast daylight, however, it is much better to use the flash off camera where it becomes the key light and daylight becomes the fill light. A strong, sunny, but open picture will result, undetectable from a fine mid-morning effect. Of course, in these circumstances, it will be necessary to have a flash powerful enough to be two to three times stronger than the natural light present and this can be achieved by bringing the flash very close to the subject and using a longer focal length lens to avoid its intrusion into the picture. On 35mm cameras, it would be wise to use 135mm or even 200mm lenses in this event.

In volatile situations where people, and especially children

Existing daylight creates a distinctive mood for portraiture, with much more volatility and character.

or animals, are being photographed, the flash is best left on camera, but diffused either with a bounce reflector carried on the flash or by using face tissue, attached directly to the reflector of the flash. Ideally, this fill light would be one to two stops under the exposure needed for the sunlight in the rest of the picture. For a 1:3 ratio, use one stop under; a 1:5 ratio two full stops under. (See *Syncro-Sunlight*.)

With some of the new automatic cameras such as Contax, Olympus and Minolta, the flash and daylight exposures are monitored separately from inside the camera and the flash is cut off when sufficient light is reaching the subject. Manual operation is, however, usually the rule and therefore the dual exposure must be calculated. In large format and medium format cameras with Polaroid facilities it is best to use a meter to assess the daylight present, then choose a flash-to-subject distance which offers the proper flash exposure at an aperture which is suited also to the daylight present. It may be that on large format cameras, fairly large apertures are needed and this will involve the use of camera movements to achieve sufficient depth of focus.

On many focal plane cameras, particularly the SLR,

electronic flash *synchronization* is not possible at high shutter speeds, say above 1/125 second, which means it may be better to load with a slow film (64 ASA or 25 ASA). Exposure is decided by choosing the highest shutter speed which permits correct synchronization and setting the required daylight exposure and aperture for that speed. The flash unit is brought to a distance which co-ordinates the *guide number* for the film used with the aperture decided by the needs of the daylight exposure. For best results, do not eliminate the shadows altogether, or a bland, overlit picture is the result. Naturally, for correct colour balance, blue expendable bulbs or electronic flash should be used for 5500 Kelvin daylight colour film, but very striking effects may be achieved by using tungsten colour film (3200 Kelvin) and a flash off-camera, which has been filtered with the correct orange coloured filter (for example a Kodak 85B) attached to the flash. A further interesting experiment in this area is with filters such as the Cokin system. By using a filter of a chosen colour over the lens and a filter of the *precise* complementary colour over the flash, the foreground will have natural colour balance wherever it is lit by flash, while the background will have the colour of the camera filter. It is useful for special effects in outdoor situations where the light is not ideal, or in naturally lit interiors, for selective colour experiments to produce unusual effects of mixed colours.

Beautiful lighting can be produced on overcast days by using powerful flood lights fitted with *dichroic filters* which convert the light to approximately daylight colour film balance, but unless the lights are very powerful, say 2000 watts each, or the daylight is at a very low level, they must be very close to the subject, with a consequent danger of burning anything near the light source. In addition, cold winds or rain on hot lamps can cause them to shatter. Do not use open lamps in outdoor situations close to live subjects, unless the reflectors are protected with wire safety screens. Working at dusk with tungsten lights, one can produce very interesting pictures which are not possible in any other way.

Where daylight is only part of the scene, for example, in an interior, the mood of the room will be maintained in the photograph only if the daylight is used as the key light. Daylight, falling from windows and doors, leaves large areas of shadow, to which our eyes easily adjust but the film does not. It will be necessary to augment this light by artificial means, usually electronic flash, but it is easy to lose the mood by using excessive amounts of fill light. To capture this atmosphere correctly, measure the daylight accurately and if you are not using a separate meter, this means that the camera must be brought quite close to the lighted area. It is important that the apparent source of light is not allowed to burn out too much unless *halation* is wanted as an effect. The secondary flash exposure must be at least half a stop under-exposed, usually more. Be very careful not to get a reflection of the flash light in windows or shiny doors and this means placing these lights off camera and at reasonable angles to any highly reflective planes in the subject. In this kind of interior shot, turn on interior lamps if they are in picture, even replacing normal lights with photofloods, because shaded lamps will become quite gold on daylight film and give a warm look to the picture without affecting overall colour balance. If the interior has multiple small sources of light, for example from fan lights or tiny attic windows, it is possible to get a deliberate halation effect by *over-exposing* these by several stops, whilst using a fog filter or de-saturation filter on the lens. Only small amounts of extra fill light are needed, but this kind of picture is more likely to be successful if you are using a figure as the main subject and the interior is merely an environment. If an interior is being photographed per se, it is best to avoid heavy areas of shadow and attempt to achieve a long scale of light values, yet one in which all forms and textures are evident. This will produce a somewhat bland look to the photograph, but this is usually to be preferred when all interior features are to be illustrated clearly.

The photographer who wishes to work solely by available light, avoiding all artificial augmentation of the existing light, will be following a purist tradition which has been pursued by many of the greatest photographers. He/she will also face many of the same difficult problems, particularly if working in colour. One of the most basic problems will be found to be that of excessive contrast. The photographic film cannot provide a very successful rendering of extreme lighting contrast and the lighting purist may have to accept certain compromises, particularly if the light source is included in the picture. Landscape photography is perhaps an exception, for here it is possible to wait until the direction and contrast of the light exactly suits the photographer's purpose who in many cases will seek high-contrast light in order to dramatize the forms in the scene to be photographed.

The delicacy of tone which is usually evident in available light pictures is not spoilt by the blurring of some of the detail of this picture. The interaction between the two men is conveyed with more subtlety than if flash had been used.

Right This example, taken from a 35mm colour slide, indicates the richness of mood which existing light provides.

Outdoor pictures of fast-moving subjects such as people or animals leave no time to await ideal light conditions. The photographer will generally have to expose on the basis of recording sufficient shadow detail and allowing highlights to burn out. With live subjects it is usually far better to lose highlight details and see well into the shadows and therefore it is helpful to choose a viewpoint which *increases* shadow on the subject and minimizes highlight areas. Back-lit subjects with properly exposed shadows are a good example, often producing pictures of great beauty.

When using black and white film, the photographer can easily control lighting contrast with exposure and development. Over-exposing by 30% and under-developing by 20% can produce amazing gradation, even in harshly lit subjects, and a little experimental work in choosing film and developer combinations can achieve much. In the beginning choose a medium-speed, medium-contrast film and process as above, in D76, diluted 1:1. With this dilution, the solution must be discarded after each batch of films is developed, as it cannot be replenished. For even better control of contrast, or when accidental over-exposure is known to have occurred, it may be preferable to use a metol sulphite *compensating developer*, such as *Windisch* or the Kodak D23 formula. These soft working developers permit shadow areas in the negative to develop faster than highlight areas and also give grain effects about equal to D76. Metol can sometime irritate the skin and produce dermatitis, so gloves should be worn if it is likely that much contact will be made with the solution. These developers are, of course, unsuited to film which has been exposed in flat, overcast light.

Where lighting conditions permit, or even dictate, the use of high speed film, it will be found that these materials are inherently lower in contrast and most photographers working only with natural light will prefer to standardize on them. One other inherent factor in fast films (400 ASA and above) is increased grain, but as this can give a great sense of immediacy to the mood of available light pictures, it should be exploited rather than minimized. Grain is often at its most pleasing when it is to be found in quite large, evenly lit areas around the main subject and a carefully selected point of view can achieve this. When grain is to be used aesthetically it often helps if the highlights are allowed to over-expose and burn out, so that in the subsequent print, these become pure paper base and therefore free of grain.

When working in colour with fluorescent light as the main light source, it will be necessary to use a special filter and this can increase exposure times considerably (see *Filters*).

Photographers whose subjects are found in very low light will often wish to increase the apparent speed of their films by altering processing times. For black and white films, developers such as Promicrol from May and Baker, SD19A from Kodak, Microphen from Ilford, Ethol UFG or Edwal Super 12 are all worth testing (see *Developers*). Where ultimate speed is needed in black and white, Kodak 2475 recording film can be used in 35mm cameras, uprated to as much as 10,000 ASA with suitable developers, or Royal x Pan 4166 for 120 cameras, uprated to 3000–4000 ASA. Used at these EI settings, it must be understood that considerable increases are made in both grain

and contrast with shadows dropping out very quickly. Using Kodak DK50 for either of these films, at 4000 ASA, a development of six to nine minutes at 21°C (70°F) will produce good negatives. Suggested camera exposures will be in, for example, a supermarket or well-lit office, $\frac{1}{125}$ at f8, or in small domestic interiors, $\frac{1}{30}$ at f8. Using Ethol UFG developer on 2475 recording film exposed at 8000 ASA, a good start to experimentation would be a development time of 20 minutes at 24°C (75°F). 120 Royal x Pan film, exposed at 4000 ASA, processed in this developer at the same temperature, would need approximately 15 minutes. It should be stressed that in all of these non-standard situations, it is necessary carefully to test exposure indices with developers and processing times, in order to get the best results. Notes should be taken and recorded in a permanent darkroom logbook for future reference. *Push processing* will not give good results if high-contrast scenes are being photographed and if good detail is needed in both highlight and shadow areas. In these circumstances, it may be possible to achieve good results using Promicrol, diluted 1+2 at 24°C (75°F) with, however, quite long processing times. High fog level often results from extended development using this developer and 2475 recording film.

Push processing of colour film is best done on reversal (transparency) film as, unlike B/W film, there is a true gain of film speed, resulting in no significant loss of shadow detail. In practice, for example, using the E6 process for Kodak and other compatible films, if the first development is increased by two minutes, ASA film speed is increased by a factor of two, while if the film is left in this solution for an extra five and a half minutes ASA film speed is increased by a factor of four. Most professional and custom processing laboratories will carry out this service, where Kodak E6 chemistry is used.

Degradation of the image will result from departures from standard processing, but it is usually within acceptable limits or sometimes, for special effect, deliberately sought. Contrast is increased, grain is exaggerated, blacks are degraded and colour shifts occur, usually towards a yellow bias. It is not thought desirable to increase the first development longer than the above times as a rapid deterioration of the blacks occurs but some well-known photographers will extend development to extreme degrees to get a grainy, dreamlike photographic impression of the subject and this is quite a rewarding experimental project to undertake.

Using existing light only, the use of a tripod can mean that much lower film speeds are needed and many professionals always work on a tripod. Even if the scene is very active, it may be possible to choose a moment when most of the subject is still and an observant photographer can capture an enhanced sense of immediacy by choosing that moment to take the picture. Certain low-light areas of photography, notably theatre photography and wildlife photography, will need very quiet cameras and no motor drives should be used if the photographer is to work over a reasonable period of time.

In recording subjects in low levels of light, Polaroid Type 107 or 667 should not be forgotten even though no negative is made. With an ASA rating of 3000 and instant processing, it has considerable advantages and the print is a beautiful long scale

recording of the subject, perfect for re-copying by conventional means. A faster but very high contrast recording film, type 410 roll film, rated at ASA 10,000, may have experimental interest, especially for the non-scientific photographer.

Once a photographer has become dedicated to the purism of using only existing light and he/she has standardized on the most suitable equipment, materials and processing, it is often difficult to see photography in any other way. The sense of immediacy and action in the images, the subtlety of concept which is possible, the catering for what, for Henri Cartier-Bresson, became 'the decisive moment' and for Ernest Hemingway 'the moment of truth', these are life-time challenges which can produce enduring photographs that can, in the hands of a master photographer, easily rise to the status of art. (See *Lighting, Exposure, Black and White Photography, Push Processing*.)

AVEDON, RICHARD (1923–)

Born to well-off parents in New York whose circumstances changed radically in the Depression, Avedon had a poor scholastic record in high school but was deeply interested in literature and arts. At 19 he obtained a Rolleiflex, joining the merchant marine soon after, with whom he spent most of World War II, mainly using his camera to make thousands of identity pictures. After the war he became a successful fashion photographer with *Harper's Bazaar*, New York. Here he met and studied with that magazine's famous art director Alexi Brodovitch who revolutionized the thinking of many young photographers of the day. Drawing inspiration from wide sources in those exciting post-war years, keeping a keen interest in the arts, Avedon soon produced his own style, to some extent democratizing the model world of high fashion by using non-professionals in early pictures. He has become possibly the highest paid advertising and fashion photographer in the world.

In recent years his work has become even more starkly informational, particularly as he has largely forsaken the 6×6cm Rolleiflex for a heavy 18×24cm (8×10 inch) camera. He had comprehensive exhibitions of his work at the Museum of Modern Art, New York, in 1974 (at which he shocked viewers with a disturbing documentary of his dying father in large blow-ups), and at the Marlborough Gallery, New York, in 1975, with intensely realistic images, where his sitters had been posed against pure white backgrounds. He had a retrospective exhibition at the Metropolitan Museum in New York in 1978, was the subject of a *Newsweek* cover story that year and has published several books.

His work at first appears elementary, pitiless and chic, devoid of content, but within the frosty elegance of his best work, a duel between beauty and stress takes place, producing a dynamic tension in the image that becomes an almost unbearable glimpse of reality, while the extravagant and expert use of the full optical capability of the camera produces startling art images that both terrorize the viewer and immortalize the subject.

BACKGROUNDS

In studio photography, or professional portraiture, a wide seamless piece of heavy paper is sometimes used to give an indeterminate environment. Many colours are available and all good photo-stores will know a source of this useful material. Amateurs can also benefit by using this technique and the roll of the usual 3-metre wide paper can easily be cut in two or more pieces by a fine hand saw, before the roll of paper is opened. Some means of suspending the roll behind the subject of the photograph will be needed and lightweight stands are commercially available. One by Multiblitz is particularly good. Careful lighting of these monochromatic backgrounds will add enormous dimensions to otherwise ordinary lighting plans but this will require that the paper is absolutely smooth and free of cracks and blemishes.

Other backgrounds such as outdoor scenes, interiors or objects must be chosen with considerable forethought since they will be seen always as important symbols and will interact closely with the main subject. No background should dominate the main subject completely, except perhaps in social documentary photography. This is particularly true of the editorial portrait. *Irving Penn* is credited by many as being the first major user of the featureless background and certainly his stylish use of monochromatic backgrounds has changed the course of photographic style since the 1950s.

To eliminate unwanted or disturbing backgrounds it is

Mutually exclusive mask; print no.1 with colour filter, print no.2 with complementary filter.

usually necessary to make a copy negative (see *Copying*). This negative is then retouched by using a dense viscous solution called Photo-opaque, usually dark red in colour. This is painted on with a small brush, surrounding the subject with a dense screen through which no light penetrates. Shadows may also be eliminated this way, and a white background is the result. Photo-masking solution, obtained from graphic art suppliers, is also useful, as when dry, it can be peeled away after use, leaving the original image unaffected. Edges may be easier to handle with this method. A more complex, but extremely useful technique, using a film mask made from Lith is explained in the fig. on page 45. (See *Seamless Paper*.)

BACKLIGHTING

Light which is falling directly towards the camera lens is considered a backlight and it often reveals and exaggerates form more than any other light. Such light can outline a subject in dark surroundings and is useful for concealing unwanted parts of the subject which would be seen by the camera. Modern SLR exposure systems are often defeated by this lighting situation and lenses need to be opened often at least two stops if detail is to be seen in the shadows. Otherwise a supplementary light must be provided by the photographer to open up the shadow area (see *Lighting*.)

BARN DOORS

These are thin, flat rectangular pieces of metal attached by hinges to a frame and fitted to the front of spot lights and tungsten flood lights. They permit greater control of the flow of light from these lamps and are always needed in any complex lighting plan (see *Lighting*).

BARREL DISTORTION

This is an optical factor inherent in some lenses, particularly ultra wide angle and fish-eye lenses, which cause straight lines in the subject to appear as curved lines in the photographic image. In cheap lenses of normal focal length it is considered a defect but sometimes can be used for special creative effects, particularly with the ultra wide lenses.

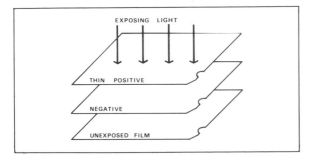

To make a bas relief photograph, with pseudo-sculptural effect, make a sandwich of a thin positive with a normal negative and print this in contact or enlarge it. If it is slightly out of register, the effect is exaggerated.

BAS RELIEF

By making a thin positive mask from a negative through contact printing and then taping them together, slightly out of register, a print is made which gives an illusion of a shallow relief image (see fig. at bottom left).

BASIC PHOTOGRAPHY

Photography began in 1839 in France and although cameras have been much modified and miniaturized since then, they still operate on the same general principle. A lightproof box is made with a lens at one end and a sensitized material at the other. There is some similarity with the eye which has its lens (retina) and sensitive material (cones) arranged within a lightproof space (see *Vision*). The image in our eye, however, can be seen at once while that of the camera cannot be seen until further work is performed on the sensitized material. It remains as a latent image until processed and can be stored in this way for many years, if necessary, or can be processed in as little as 30 seconds, as with *Polaroid* film.

The eye moves around the scene constantly altering its focus, taking rapid flickering glimpses many times per second, whereas the camera is a machine and sees only what it is pointed at with a fixed, focused stare. It glimpses nothing until the shutter release is pressed and one lone image flashes into the box and is recorded. The eye sees in stereo and makes objects appear round and space appear deep. The camera sees with a single lens and only in one flat dimension. Natural events as the eye sees them are recorded by the camera as *images* of the real world and only *symbolize* reality; they are not reality itself.

The camera *lens* collects rays of light reflected from the subject and brings them together as a sharp image inside the lightproof box, at the plane of focus where the sensitive material has been placed. The image is upside down (see fig. opposite).

The lens has a variable control built into it called an *aperture* with marked and numbered positions called f stops. These reduce or increase the amount of light passing through the lens in an arithmetical proportion, with largest numbers admitting least light and smallest numbers allowing more light to reach the film. The f stop also controls *depth of field*, or the zone of sharp focus, and this increases with the larger numbers and decreases with the smaller. Moving the f stop to the next largest number reduces the incoming light by half, and moving it to the next smallest number doubles the light available to the film. The camera has another device to control light which is called the shutter. It also alters the amount of light striking the film but does this by varying the amount of time the beam of light has to affect the film. The shutter works in the same proportional steps as the f stop; each new position halving or doubling the light as the numbers grow larger or smaller (see fig. on page 48) for proportional inter-relation of shutter and lens apertures.

The *shutter* will be located near the lens if it is a blade or leaf shutter or near the film if it is a focal plane shutter. Leaf shutters have slower top speeds than focal plane shutters but expose the film instantly over the entire format, while focal

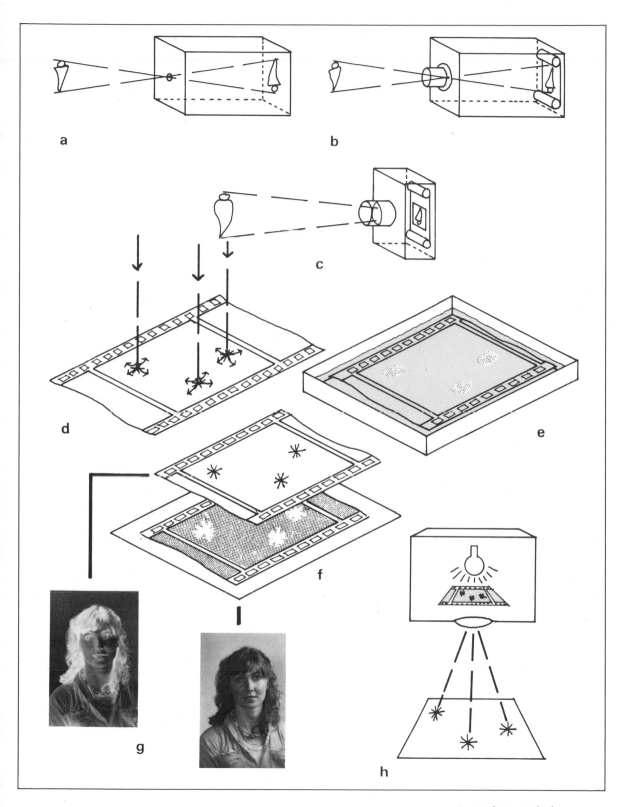

a

b

c

d

e

f

g

h

see captions overleaf

captions to previous page

a The camera is a light-proof box. The front of the box admits light, the back of the box collects it.

b If we add a lens and shutter we can control the light to form an image and deliver a measured amount of light to a light-sensitive film in the back of the camera. The image is invisible but later can be chemically processed for a permanent record.

c The modern camera is still basically just a light-proof box. It has undergone miniaturization and sophistication but is the same in principle and optical concept as the very first camera ever invented.

d Any light reaching the sensitive film emulsion creates a chemical change in the metallic salts, carried within the emulsion. Where no light reaches the film no change takes place. The reaction to light is invisible until a further chemical process takes place and the image is therefore called 'latent'.

e A liquid chemical 'develops' only those areas affected by light, causing grains of metallic silver to blacken and become visible. White or bright objects which reflect more light appear black, while black or shadowed objects which reflect little light do not create changes in

the emulsion and after development are seen as clear film. A second chemical solution is used to make the developed image permanent. This is called a 'fixer'. The final result is a 'negative' in which light tones are seen as dark or black areas and dark areas are seen as clear or almost clear film, giving an image which is tonally reversed from the original scene.

f When dry, the negative is placed in tight contact with light-sensitive paper or film and the two are exposed to light. Where the negative is clear, more light affects the print emulsion, producing blackened silver. Areas of negative which are black prevent light from reaching the emulsion and therefore no change takes place. The exposed paper or film is then developed and fixed to produce a positive which is tonally the same as the original scene and is called a print.

g A negative and a positive which has been made from it.

h A negative may be put in a light-proof box which is equipped with a lamp and a focusing lens and then projected to a bigger size on to light-sensitive paper. This is an enlarged print. The steps outlined in (f) are followed and a positive print is the result.

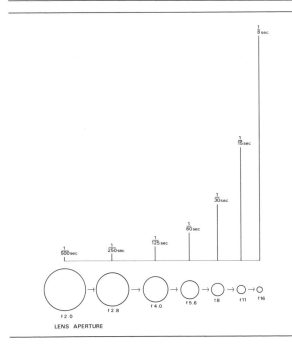

The use of aperture and shutter is proportional. As the lens aperture becomes smaller, the shutter must be left open longer to compensate. The amount of light reaching the film in these seven examples is equal in all cases.

plane shutters working either vertically or horizontally expose a strip of film progressively across the format. Short exposures stop movement, but also reduce the volume of light and therefore compensation must be made by widening the aperture in direct proportion, in order to let more light into the camera. The same quantity of light can reach the film from the shutter/f stop pairs, but while exposure remains constant the appearance of the image is different in each case (see fig. top opposite).

The sensitivity to a given quantity of light can be altered by loading different films in the camera and the less sensitive, slower film tend to have finer *grain*, higher contrast and sharper detail than the extremely fast, sensitive ones which are grainier and softer in contrast.

Making the latent and invisible film image visible usually requires wet processing in five steps: developing, stop bath, fixing, washing and drying.

These five steps are common to all photographic processes except the instant processes such as Polaroid or stabilized photography. The film emulsion is sensitized in manufacture by the use of silver salts and the image becomes visible when the *developer* changes any light-affected salt into black metallic silver in direct proportion to the quantity of light they receive. The *stop bath* neutralizes development action, the *fixer* dissolves unexposed silver salts away, leaving clear film and *washing* removes all excess chemistry and stabilizes the image completely. The result of this wet processing is called a negative which shows similar proportional tonal values to those in the original scene but in reverse order. Bright, light or

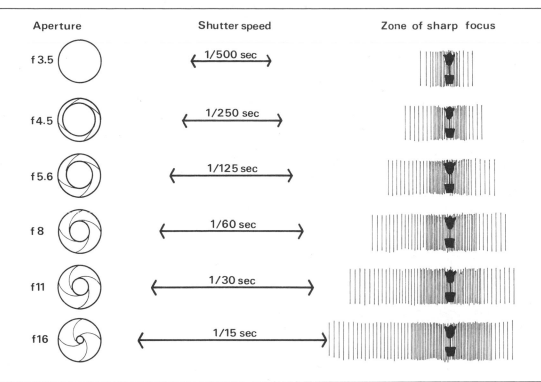

Aperture	Shutter speed	Zone of sharp focus
f 3.5	1/500 sec	
f4.5	1/250 sec	
f5.6	1/125 sec	
f 8	1/60 sec	
f11	1/30 sec	
f16	1/15 sec	

white areas create dense metallic silver on film and appear black, while dark, black or shadow areas in the original scene reflect very little light to the film, leaving the silver salts almost unaffected and these areas of the film appear practically clear.

In order to see records of the tone in the subject in a natural scale, the negative is reversed into a positive image by printing on opaque white paper which also has been coated with similar silver salts or halides. By contact or enlarging methods light is passed through the negative, creating a latent image on the paper which then becomes metallic silver in light-affected areas by the use of the same five wet processing steps but using slightly different developing chemistry. The print is now a record of the subject when photographed, rendered in *geometric perspective*.

Many modern cameras can estimate their *exposure* automatically provided controls are set on them to indicate the film's sensitivity. On cheaper fixed format cameras in 110, even this is done automatically by a notch in the film cassette which, when loaded, programmes the camera. In other automatic cameras the speed ring must be set to correspond with the film speed number which is to be found on the outer package of the film box.

However the exposure is determined, the camera must be held firmly and safely at the moment of shutter release (see right fig.). This prevents undue vibration and thus unsharpness. Very slow shutter speeds will need to be made on a *tripod*. The camera is focused, the subject is properly framed (get close!) and the release *gently* pressed and that exposure wound on so

The film when exposed at any of these aperture and shutter combinations will receive approximately the same amount of light, but the image will often look very different. As the aperture is made smaller, the zone of sharp focus extends in front and behind the subject, emphasizing other objects. At slower shutter speeds blurred movement is also apparent.

How to hold a small camera steady.

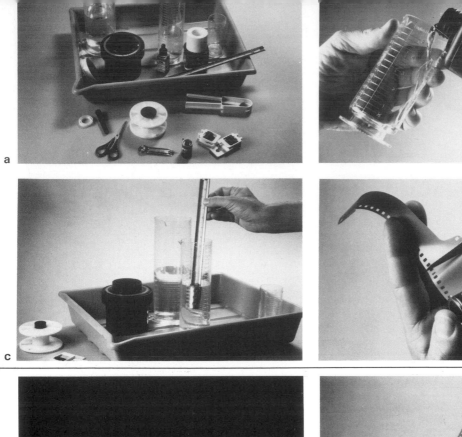

a

b

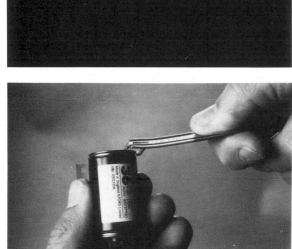

c

d

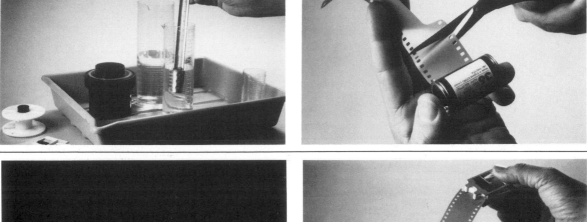

TURN OFF THE LIGHTS

e

f

g

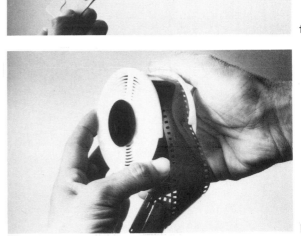

h

i

j

Left To develop a 35mm negative:
a Assemble all the equipment together, with liquids placed within a large developing dish. Check off every item needed. Read the manufacturer's instructions for film and chemicals.
b Measure solutions precisely.
c Bring all solutions up to exact temperature.
d Trim film leader off.
e Turn off light and work in complete darkness.
f Cut first few frames from test film and test for correct negative processing. Check results.
g Open cassette with can opener, *in total darkness*.
h Load spiral carefully, avoid kinks or buckles in film. Place loaded spiral in empty tank.
i Pour developer into tank, start timer and agitation. Precisely at the end of developing cycle, discard developer, pour in prepared acid or water rinse, then discard. Add fixing solution and leave for at least 60 seconds before white light inspection.
j After washing is complete add a measured amount of wetting agent to the tank, then hang film to dry, in a dust-free place.

Below Correct exposure and careful processing give good negatives.
a This negative is under-exposed with no detail in the shadows. Contrast is lowered also.
b This is a normal printing negative with good detail in shadow areas and blacks, with discernible separation of the incident highlight within the highlight area.
c This is a negative which has been over-exposed. Notice that shadows are 'blocked up' and highlight areas are impossible to print. Contrast is lowered also. All these negatives are from the same roll, processed for normal density.

that a new unexposed frame is ready.

Developing the first film is not more complicated than attempting a short, but unfamiliar, cooking recipe. First assemble the processing materials and equipment, be sure to be working in a clean area and have the means to time each step accurately and find precise temperatures. Read the manufacturer's instructions on film and processing solutions. The method of developing is shown on page 50, but do not forget to make a first rehearsal in the light with an old undeveloped film. Then, once again with the reject film, work in complete darkness. Finally, with the actual film to be developed, the photographer should be more confident of the mechanics of getting film into spiral, developer into tank and film into tank.

Making a contact print of the dried negatives is an easy task, once again needing accurate measurement of time and temperature – and absolute cleanliness. Carefully check the contact print with a magnifier and select one frame to enlarge. Place this negative in the enlarger after cleaning it free of dust and water marks. Follow the steps in fig. B10 and a good, clear print will be seen. Do not be tempted to alter time or temperature from that suggested until fully confident in processing methods. When dry, spot this print (see *Spotting*), to remove all traces of abrasion and dust. If it is for exhibition, mount it as illustrated under *Mounting*.

These basic routines are all that will ever be needed to make a crisp, clean, professional print and provided that strict attention to time, temperature and cleanliness is always the rule, processing problems or poor prints will never be experienced.

The only other major factor influencing good printing quality is outside the darkroom, in the moments before the

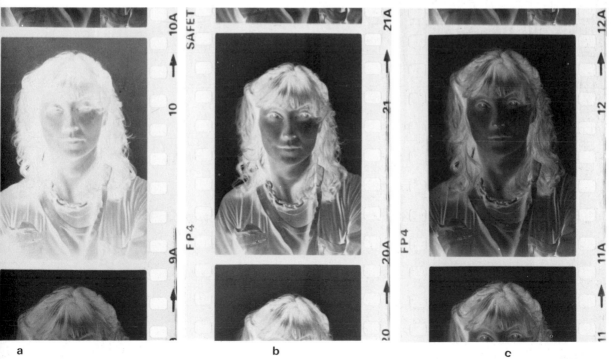

a b c

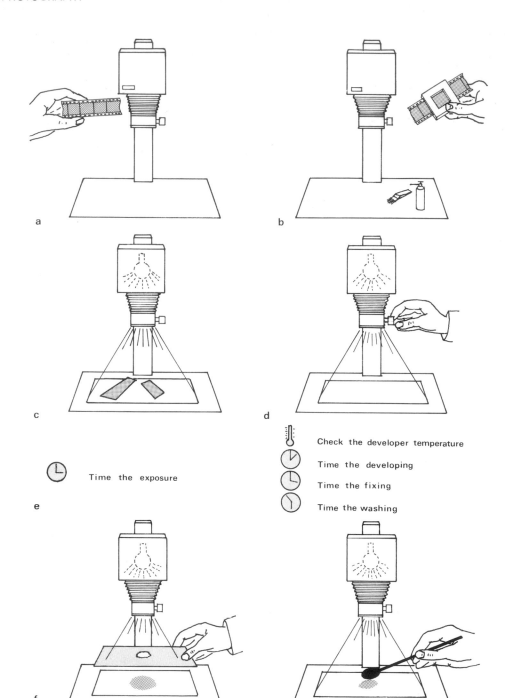

Check the developer temperature

Time the developing

Time the fixing

Time the washing

Time the exposure

a Handle negatives by the edges.
b Clean carefully with brush or canned air.
c Make small test strips to obtain correct exposure.
d For final print, re-focus carefully.
e Time exposure exactly and be accurate with
processing.

f Give extra exposure to local areas by burning in
through a large black card with a 2cm hole in the middle.
g Hold back or 'dodge' local areas with thin wire and
3cm circle of black card.
(See also the section *Enlarging*.)

52

Automatic exposure on modern cameras requires compensation in certain conditions.

a Bright light or heavy shadow in this area will cause under- or over-exposure elsewhere.

b A centre-weighted metering system will give a false reading if a bright area is surrounded by dark tones or vice versa. Use the manual override to compensate.

c Highlights in the sky will cause under-exposure in the foreground.

d Highlights such as water in the foreground will make other areas too dark. Use a graduated neutral density filter.

e Random, small highlights or heavy shadows may not record correctly. Use manual override to compensate, and if possible lower contrast in processing.

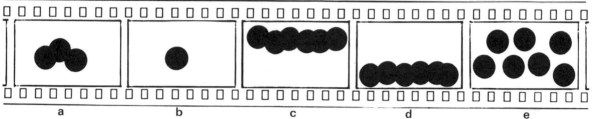

Processing a photograph.

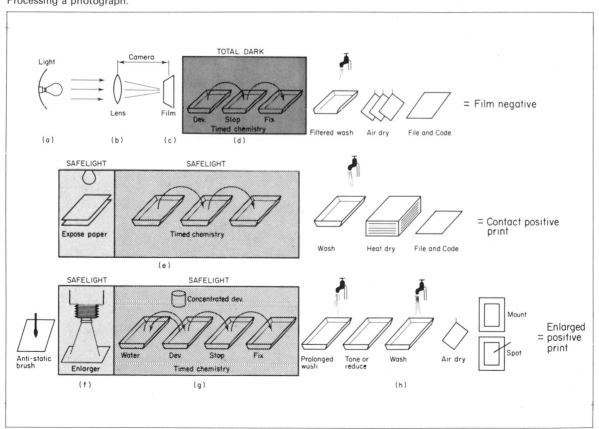

<div style="border:1px solid">

TO OBTAIN OPTIMUM QUALITY ON SLR CAMERAS

1 *Focus carefully.*
2 Use glasses or diopter lenses on the camera viewfinder if needed.
3 *Hold camera steady.*
4 Brace camera to body, body to solid object, hold breath while exposing.
5 Use a tripod and lock mirror up for slow exposures.
6 Do not handhold shutter speeds slower than $\frac{1}{125}$ second.
7 *Do not over-expose or over-develop.*
8 Rate film 30% faster than manufacturer's speed, reduce development.
9 Use dilute developers of a high energy type and discard each time.
10 Use condenser enlargers, with colour corrected enlarging lenses.

</div>

negative is made. This is when exposure is estimated and the camera set. A good negative, and therefore a good print, will be possible only if the scene brightness ratio is matched to the range of tones which can be reproduced on the enlarging paper.

Automatic cameras will under some circumstances give false readings and even hand-held exposure meters may not give correct information if they are not correctly aimed. (See also *Colour as Seen, Photography for the First Time, Focusing the Camera.*)

BAUHAUS, THE

The Bauhaus existed for 14 years, coincident to the rise and fall of the first German Republic. Started by the architect Walter Gropius in 1919, it was closed by police action on 10 April 1933 and 32 students were arrested. The National Socialist Party which was to install Hitler as Germany's overlord, saw it as a degenerate influence on art and a hot-bed of revolutionary politics. Since then much of its philosophy has conquered the world and in architecture, painting, sculpture, photography, weaving, communications and litcrature, its presence pervades much of our modern life. It stood for creative freedom, a free flow of art and life, and a concern that both should be intimately related with time and its problems. But however challenging the new creativity, however restless and probing of new techniques it was and however defiant of dogma, the Bauhaus asked above all that its goals be attainable.

To achieve this, although deeply concerned with the subject of architecture, Gropius appointed painters to provide the teaching, and lead the students towards a cultural unity. He chose unfashionable abstractionists or Cubists, including Kandinsky, Klee, Feininger, Schlemmer, Itten, Moholy-Nagy, Marcks, Muche and Albers. Later, as the faculty

became influential with students of photography, their leadership was to activate some remarkable new work. With photographer-artist Laszlo Moholy-Nagy as a primary force and Herbert Bayer and Walter Peterhans as dedicated faculty members, students began the leap into modernism which was to influence the entire world of photography and visual communication and still does. Important photographers who understood this decisive movement and quickly embraced its vitality, included Man Ray, Renger Patzsch, Edward Weston, John Heartfield, Hans Finsler, Burchatz, Max Ernst, Franz Roh, Paul Strand, and Gyorgy Kepes.

With the transfer of the Bauhaus to Chicago in 1937 and the fertility of the new environment which accepted the transplant, American photography and, eventually, modern photography worldwide, received a dynamic impetus which became irreversible and autonomous, the echoes of which are still transforming the best work at the present time (see *New Bauhaus*).

BAYARD HIPPOLYTE (1801–87)

A founder member of the French Photographic Society and a co-inventor with Daguerre and Fox Talbot of photography. His early paper process took ten to 30 minutes' camera exposure and was based on a silver chloride emulsion which was dipped in potassium iodide and exposed in the camera while wet. Final fix was in hypo-sulphite of soda. Bayard generated many beautiful images even by today's standards and often exhibited them in the early days of photography. He has never received the recognition or reward such as were offered to Daguerre, but it is worth seeking out his work for further investigation.

BELLOWS

In all view cameras and some smaller cameras an intricately folded leather attachment to the camera swing back allows the lens to be extended or contracted over an infinitely variable focusing range, whilst still maintaining the essential black box condition inside the camera. Its earliest use was in the *camera obscura* of the late eighteenth century and is still a feature of most modern and expensive professional large format cameras, such as those built by Sinar and Arca (see *Large Format Cameras*).

BELLOWS EXTENSION COMPENSATION

The extending of a lens by a bellows attachment, if it exceeds the infinity focus position, will reduce the effective aperture of the lens and therefore the amount of light reaching the film. Infinity focus, for example in a 210mm or $8\frac{1}{4}$ inch lens, will require that the lens is racked forward until it is precisely this distance from the film plane, that is 210mm. No exposure compensation is required in this situation. If the lens is racked further forward, anything in excess of 1.25 times the focal length of the selected lens, a compensation must be made for reduced exposure. This can be calculated by the following

formula: *Total extension × actual f stop selected: divided by the focal length of the lens.*

For example, to obtain a lifesize image of an object (that is an image proportion of one to one) it is required that the lens be extended for twice the total length of the lens used. The real working aperture of a lens stopped down to f32 at this magnification could be calculated for a 210mm lens as follows: 210mm + 210mm × 32, divided by 210 which equals 64. Thus the real f stop value is f64, two stops slower and therefore requiring that either the light falling on the subject is increased, or the f32 setting on the lens is changed to f16. This naturally alters depth of field and could shift focus points.

On a view camera, tilting the lens panel forward to more nearly parallel to the planes which are required to be in sharp focus will help (see *Large Format Cameras*). In studios equipped with variable intensity flash, such as made by Norman, Multiblitz or Broncolor, it is easier and more desirable to maintain the original f stop and increase the light value. When tungsten lighting from spotlights or floodlights is used this allows extended exposures to compensate, but *reciprocity* factors must be considered for some colour films when the extra exposure is particularly long.

To increase exposure with electronic flash it can be used in an additive manner by multiple flashing with an open shutter but the accumulated light on the subject falls off rapidly as reciprocity effects become apparent (see *Reciprocity Effect*).

A short cut for cameras equipped with Polaroid film backs, is to make several test exposures on B/W Polaroid film in order to determine correct exposures. Colour Polaroid is not as effective for this and if possible the film used for test should be the same ASA speed rating as that which will finally make the camera exposure. Certain exposure meters have a thin, flat probe which can be placed in the film plane and this too, effectively measures the actual light reaching the film from an extended lens without any formula of compensation.

Macro photography in rigid body cameras, such as 35mm SLRs also usually requires a bellows attachment, and the above formula can be used. The focal length of the lens plus the measured extension of the bellows will again be the basis of calculation.

BLACK AND WHITE PHOTOGRAPHY
(See table on following pages.)

BLACK AND WHITE PRINTS FROM COLOUR FILMS

If B/W prints are needed from colour *negative* material, a single step is required, as in conventional black and white photography, to produce a positive print, but it is advisable to use a panchromatic paper such as Kodak Panalure which will reproduce all colours in their correct tones of grey. Normal bromide paper, which is colour blind to a great degree, with an enhanced sensitivity to blue light, will tend to render the reddish colours far too light and bluish colours too dark. It is best to handle Panalure paper in total darkness, developing by *time and temperature* as would be usual for panchromatic

negatives. With extreme care a dark amber (Kodak number 10) safe-light fitted with a 15 watt lamp, 2 metres (7 feet) from the paper could be used. Normal enlarging safe-lights for B/W bromide papers will fog panchromatic papers. Exposure is by tungsten light without filters or with filters if other lamp types are used. Use the usual test strip techniques as explained under *Enlarging*. Because the paper is panchromatic, filters may be used to modify and dramatize the grey tones. For slight changes use CC filters. For greater theatrical effect use ordinary B/W camera filters but note that any filtration will change *all* colours. Choose a filter of the same general colour to alter any colour that is desired lighter and a filter of complementary colour to those which are to be darkened. Deep cyan filtration, at least more than CC 60, will tend to give orthochromatic effects, suitable for portraiture or to minimize blemishes in the skin, but remember it will change the colour of lips, hair and eyes. For printing B/W from *transparency* material, the easiest and often the best is to use a positive/negative polaroid film (see fig. below) and an enlarger,

To make black and white copies from colour slides, use a Polaroid 4×5 back, loaded with B/W positive/negative film if negatives are wanted, or B/W print film if proofs are needed. A Saunders borderless easel is ideal to grip the Polaroid back and hold it in position. Before inserting film, remove sheath and focus on white paper, which is held at the film plane of the upturned holder.

BLACK AND WHITE FILMS AND SOME BASIC DEVELOPERS

Film	ASA	Speed change	Developer	Dilution	Temperature C	Temperature F	Time in minutes 35mm	Time in minutes 120/roll	Time in minutes sheet	Remarks
Ilford Pan F	50	nil	Kodak D76 or Ilford ID	1+1	21°	(70°)	10	—	—	Ilford ID11 or Kodak D76 are ideal basic, general purpose developers; moderate fine grain, soft working, good acutance, active; can be replenished if used at full strength; 1+1 solution is discarded each batch; keeps well in concentration; economical
FP4	125	nil		1+1	21°	(70°)	11	10	9	
HP5	400	nil		1+1	21°	(70°)	12	11	10	
Ilford Pan F	50	nil	Agfa Rodinal	1+100	21°	(70°)	12	—	—	Fine grain at high dilution with *slow* film, contrast varies according to dilution; clean, sharp tight grain, good acutance; concentrate keeps well; compensating action; economical, one shot (discard) type
FP4	125	nil		1+75	21°	(70°)	12	12	11	
HP5	400	nil		1+50	21°	(70°)	14	16	18	
Ilford Pan F	50	100	Acufine	Full strength	20°	(68°)	3	—	—	Fine grain, good acutance, increased film speed, moderate contrast with good shadow detail, good general purpose, except for some fast films; contaminates easily
FP4	125	250			20°	(68°)	4	4	4	
HP5	400	800			20°	(68°)	NR	NR	6	
Agfa 25	25	50	May & Baker Promicrol	1+2	24°	(75°)	8	8	10	Very active at full strength but acutance poor; diluted 1:1, 1:2 or 1:3, speed loss minimal and acutance and grain pattern excellent; soft working compensating action, excellent shadow detail and highlight separation; full bodied negative; one shot when diluted
100	100	200		1+2	24°	(75°)	9	9	12	
400	400	800		1+2	24°	(75°)	12	10	14	
Ilford Pan F	50	75	Edwal Super 20	1+1	20°	(68°)	12	—	—	Ultra-fine grain, acutance good, film speed good, soft working with extremely long scale, good highlight separation; not recommended for high speed films as dichroic fog is produced; can stain negatives; needs continuous agitation
FP4	125	200		1+1	20°	(68°)	14	14	NR	
HP5	400	600		1+1	20°	(68°)	NR	NR	NR	
Kodak Panatomic X	32	40	Kodak HC-110	1+31	21°	(70°)	4	4	—	Very crisp medium grain, medium contrast, good for medium formats, excellent for large formats in commercial quantities; extremely concentrated stock solution needs care in dilution; keeps well
Plus-X	125	160		1+31	21°	(70°)	5	5	5	
Tri-X	400	600		1+15	21°	(70°)	6	8	4	

Film stock	ASA	ASA	Developer	Dilution	Temp				Notes
Kodak Panatomic									fine grain, soft working, good acutance; for best results expose with +½ stop (*reduce* film speed ASA number) as there is film speed loss with development
X	32	20	Kodak Microdol-x	1+3	20° (68°)	7	7	—	
Plus-x	125	100		1+3	20° (68°)	7	7	10	
Tri-x	400	320		1+3	20° (68°)	10	10	11	
Kodak Panatomic									Unusual developer, highly concentrated one shot developer; is panthermic (effective temperature range 14–27°C or 65–80°F); high film speed gain, high acutance, medium-fine grain, great latitude in processing extremes of under or over exposure; keeps well
X	32	64	Ethol Blue	1+60	20° (68°)	4	5	—	
Plus-x	125	400		1+30	20° (68°)	3	3	7	
Tri-x	400	1600		1+30	20° (68°)	6	5	12	
Agfa									Extremely active developer, fine grain when diluted, very high acutance; used as one shot developer; shadows drop out rapidly and need extra light for 3:1 ratio; also an excellent print developer, diluted 1+12; excellent shelf life in concentrated solution
25	25	25	May & Baker Suprol	1+49	20° (68°)	3	5	3	
100	100	100		1+49	20° (68°)	5	6	5	
400	400	400		1+24	20° (68°)	5	3	7	

Note Times given are guides only, to suggest starting point for tests. Many different film stocks will respond to these guide times provided their ASA speeds are similar. Density and contrast for negatives has been considered as average for dichroic head diffusion enlarger.

clearing the film negative in a bicarbonate of soda solution. With care, a slow panchromatic sheet film negative can be used to replace the Polaroid negative, but take care that the finished image is not excessively high in contrast.

Because transparency material gives a positive image, the results of the first step will be in *negative* and great care is needed to produce long-scale, low-contrast images. When these are obtained, either by the far easier and often more desirable Polaroid method, or the technically difficult panchromatic negative film method, they are then printed in the conventional method of B/W printing. For the amateur, the direct colour negative to Panalure enlarging paper technique is the simplest, but the internegative method, from positive transparencies, using for example, a 25 or 50 ASA Agfa sheet film and a soft working developer such as D76 diluted one to one, or D23 metol developer, has more control and can produce the better work. If using Polaroid type 55 or 665 positive/negative film, the best negatives are obtained by a certain amount of over-exposure, so that the paper print from that exercise which is peeled away will be useless and should be discarded. Negatives made by this method of over-exposure are almost grainless and of excellent gradation. They print very well on a contrast number 3 paper.

BLACK LIGHT PHOTOGRAPHY

The eye can see only white light made up of the *spectrum* colours but film is sensitive to other invisible wavelengths of radiant energy, notably infra red, ultra violet and x-rays. Black light is the photographer's term for *ultra violet* when it is emitted from a black, or dark blue, photographic lamp. UV light is composed of long, medium and short wavelengths, and only the *long wavelengths* can be considered safe for eyes and skin. On no account use medium or short wave UV radiation sources without the correct safety glasses. Fortunately, long wave UV light is the best for most experiments with black light photography and is the simplest to use.

A suitable source would be black or blue-black fluorescent tubes obtainable from specialist electrical suppliers or hardware stores (make sure they do not emit any white light at all as some black lights do) or use a professional quality electronic flash masked by a black snoot, and fitted with a Wratten UV filter 18A, supplied by Kodak. Do not look directly into any UV light source.

Many thousands of man-made materials and some natural substances contain certain items which will produce visible, fluorescent light when energized by the application of UV light. These may be found in plastics, papers, fabrics, paints, etc., and in a completely darkened room the effect is dramatic. It should be remembered that fluorescent subjects are visible only while the energizing UV beam strikes them, while phosphorescent material emits a glowing light long after any light energy source is turned off. Phosphorescence is extremely weak and generally not suitable for photography under normal conditions.

High speed colour or black and white film is best for first experiments and it may be wise to experiment with *push processing* to give at least one stop extra speed. At least 400 ASA

Flash on-camera should be turned upward to bounce light from the ceiling. When this is done, open up at least two stops from normal.

film is advisable. The lamps will need to be in very efficient reflectors and if black light tubes are used, fixtures may be fitted with mirror foil curved behind the tube to increase the available light. Household foil, uncreased, will also make a reasonable reflector.

Both daylight or tungsten film may be used for experiments, daylight giving emphasis to the red end of the spectrum, tungsten film giving it to the blue end of the spectrum. Also experiment with different makes of film and note all data and results.

With the room lights on, focus carefully on the subject and then turn off all lights. The room should be completely dark, otherwise white light will record and ruin the effect. Fluorescence tends to give a bluish cast to certain colours and a 2B haze filter could help to correct this if it is added to the lens. Anything which is matt black will not record.

Exposure will only be accurately determined by test processing but as a guide, begin with two 15 watt tubes in bright reflectors, positioned 60cm (2 feet) from the subject in a copy type lighting set-up. Expose $\frac{1}{8}$ second at f5.6 on 400 ASA film pushed in processing by half a stop. Bracket each normal exposure with one under and one over-exposed frame in one stop ratios.

To help decide test exposure, it is possible to use a reflected light meter, preferably with a narrow acceptance field. The reading must be taken from very near the subject and through the same filter pack which is to be fitted to the camera lens. The most promising experiments will usually come from the use of a powerful electronic flash fitted with a Kodak UV filter 18A, as this effectively freezes most action and provides intense illumination. Reliable exposures can be determined only with this equipment by test or by using a sophisticated flash meter such as Minolta make.

BLEACHING

In certain colour processing chemistry, a bleacher or a combination called a bleach-fix solution is required so that excess silver salts may be removed after the colour image has been developed. This is a complex liquid, pre-mixed by the manufacturer and usually re-usable for some considerable time.

In B/W photography a bleacher is used to reduce the image before a toning development begins (see *Toning*), or before intensification or reduction chemistry is applied as a corrective. In chemical reversal processes which are used to obtain a direct positive image, bleaching is a major step in converting the negative image silver to silver halides which can then accept further exposure and development and so lead to the positive image.

The most common bleacher used in B/W photography is *Farmer's Reducer*, for clearing highlights from negatives or prints or for local retouching.

The following bleaching formula for restoring chemically stained negatives is somewhat tedious, but effective. Pre-soak film for two minutes in Kodak SH1 hardener which consists of a 37% Formalin solution (5cc), 3g sodium carbonate and half a litre of water. After soaking, wash for seven minutes.

Make a two solution bleach by dissolving 3g potassium permanganate in half a litre of tepid water. If the crystals are not completely dissolved, they will deposit stains on the negative. Call this solution part A and hold apart. For part B, which must always be kept separate from A until mixing: dissolve 35g table salt (sodium chloride) and 10cc of concentrated sulphuric acid in half a litre of cold water. The acid *must* be added to the water, not vice versa.

When ready to use, combine equal amounts of A and B solutions and bleach the negative in it for three minutes. The film will be stained brown and this is removed by rinsing in flowing water then soaking in a 1% solution of sodium sulphite. Wash a further five minutes then expose the film to a 150 watt lamp held at one metre (3 feet) from the surface. The image will take on a purple tone and at this point, place in an Amidol developer for redevelopment (see *Amidol*). Use gloves throughout this process and take great care in handling the sulphuric acid. Test one negative before commencing on any images of special value.

BLEED

A print or page is said to bleed off when no border is left

between the edge of the image and the outside edge of the page. A full bleed is when the image is completely borderless.

BOOM STAND

In professional lighting assignments this equipment is almost essential, and for serious amateur photography can be the only light stand needed for a wide range of work. The reflector and light head are mounted on a long boom, usually counterweighted, and a movable joint connects the horizontal boom to a vertical stand, allowing a lamp to be easily swung over the subject, brought close to give maximum light and control, and yet be out of camera range (see *Lighting*).

BOUNCE LIGHT

This is a technique for softening harsh, artificial light when it comes from a controllable source and is much used by photographers using electronic flash on camera. By aiming the lamp at a light coloured wall, ceiling or large cardboard reflector, direct light is bounced back as soft, diffused illumination giving more open shadows and lower contrast. This is useful if subjects are moving unpredictably in a large area, for example if children are being photographed or a busy indoor reception is the subject. Much used by photojournalists to obtain a soft, natural top light for portraits, bouncing light in this way will require that the lens is opened up at least two f stops to compensate for the loss of direct light and that the light is reflected only from neutral or white surfaces, if colour film is used.

Automatic cameras and flash equipment will calculate the difference of exposure but the shorter depth of field should be noted and focusing should be extremely precise. For bounce lighting of portraits and small groups, focus always on the eyes. The fig. below illustrates various bounce light techniques (see also *Lighting*).

BRACKETING

Many experienced photographers will bracket exposures during any photography in adverse light or under any difficult conditions which may seem hazardous to the final high-quality image, and this is especially true of a professional who works on location. Bracketing is expensive as it trebles the film used and gives more work in processing and filing. After a normal exposure is made a second is made, one stop under-exposed and a third is made one stop over-exposed. If colour is used, and the camera is fitted with click stops in half stop increments, half stop changes are made in the bracket.

In B/W photography, *push processing* of bracketed exposures can get the optimum from any situation and give a useful printing choice to the photographer. In colour, the greater saturation which results from under-exposure is useful, especially if the image is to be reproduced by an engraving process, while over-exposure can preserve the shadow detail of difficult subjects in high-contrast lighting conditions. (See *Exposure*, *Nine Negative Test*, *Developers*.)

Bounce light off ceiling (a), off card fixed to camera (b), and off large white card to the side of the subject (c).

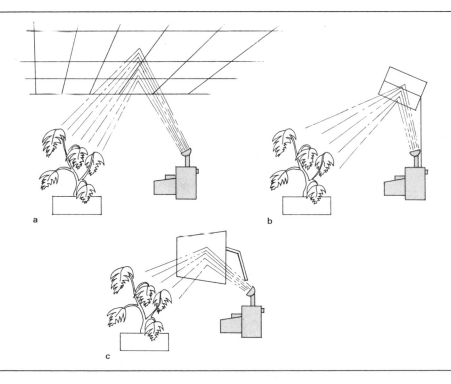

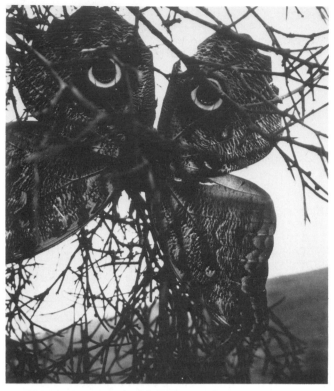

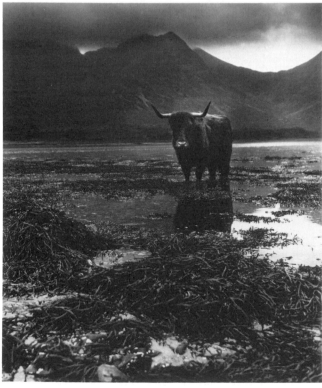

BRANDT, BILL (1905–)

Born in London. Early life in Germany and later, for health reasons, Switzerland. 1929, Paris as assistant to Man Ray. 1931, returned to England to work for *Lilliput Magazine*, *Harper's Bazaar* and *Picture Post*, concentrating on documentary photographs. During World War II made photographic essays of life in the community bomb shelters for the British Home Office and also worked on architectural subjects, recording buildings of national interest for government agencies. Major exhibitions include Paris (1938), Museum of Modern Art, New York (1969), Hayward Gallery, London (1970). Books include *The English at Home* (1936), *A Night in London* (1938), *Camera in London* (1948), *Literary Britain* (1951), *Perspective of Nudes* (1961), *Shadow of Light* (1966/1977), *Nudes 1945–1980* (1980).

Working in isolation outside the main stream of his contemporaries, with a deep humility for his craft, and an introspective reverence for his subjects, Brandt, single handedly, has restored the international status of British photography which seemed to evaporate in the years immediately before the 1914–18 war. He was a student of Man Ray's in Paris and deeply interested in Surrealism. His patience is legendary as, for example, his project of photographing the nude. Fifteen years after he made his beginning with an old wooden camera equipped with an extreme wide angle lens of very small aperture, he published in 1961 *Perspectives of nudes*, an intensely personal, moody and romantic series of distortions of the female body which astounded the art world.

He had been known, since his return to England in the Depression years of the 1930s, as a shadowy observer of English society and the intensity of these images, detached and cool yet glowing with empathy, are some of the most moving photographs ever made in the social documentary field. Working in black and white, his photographs are characterized by a rich, chiaroscuro of contrasting greys and blacks; the images he offers us are of people, his universal subject. His photographs are darkly romantic, introspective yet conservatively simple and direct in the best manner of classic art throughout history.

Left Pictures by Bill Brandt, Britain's only living photographer with an unshakeable international reputation. (*Courtesy Bill Brandt*)

BRASSAI (1899–)

Born in Transylvania, Hungary, near the birthplace of Count Dracula, Brassaï identifies himself as French and has been concerned with the avant-garde and intelligentsia of Paris all his life. Writer, painter and sculptor and most scornful of photography in the beginning, Brassaï was persuaded by André Kertész to become seriously interested in using a camera in the early 1930s. Since that time he has documented, often in the merciless light of flash, the colourful and tawdry night life of Paris, winning world renown for his simple, direct but highly structured images of the pleasure seekers and pleasure givers of that city. His book, *Paris de Nuit*, published in 1933, was a remarkable start to his career and his work is exhibited widely. Some of his later work, much more abstract, is also a hybrid of sculpture, photography and direct work on the engraving plate in the manner of a lithographer, and is a fascinating example of manipulative photographic images by a master of image organization.

BRIEFING

This is a term given to a written or verbal outline of the client's requirements for a professional photographic assignment. At such a meeting, the photographer, art director, agency account supervisor, stylists and the client will meet to decide the visual and logistic details that must be understood before any photography commences. It is essential for the photographer to be totally aware of the final decisions at these meetings before considering any actual photography. A *layout* is usually agreed on at this point.

BRIGHTNESS RANGE

The range of brightness is a measure of the reflectance or luminance range found in the lightest part of the subject, grading in steps down to the darkest shadow area. This is generally expressed in an f stop brightness range and in order to achieve a reasonable facsimile of the original subject, the range must be acceptable by both negative and print. The eye of course can read an incomparable range of luminance values, but panchromatic film generally accommodates a ten stop range – more than enough to render most subjects satisfactorily, while colour emulsions average seven stops which sometimes is not sufficient. When a film cannot accommodate the full range of luminance values, either the highlight area loses detail through over-exposure or the shadows lose detail because of under-exposure.

To measure the range of f stop values, take a reflected light reading from the brightest highlight and a second one from the deepest shadow, using the same shutter speed for both. This will establish the number of stops in the range. Except with special processing, there is generally some compression of tonal values when making bromide prints even from long scale negatives. (See *Nine Negative Test*, *Developers*, *Exposure*, *Contrast Control*.)

SUBJECT LUMINANCE EXPRESSED IN RATIO AND F STOPS

f stop range		Luminance ratio
4	Low-contrast outdoor scenes	16:1
5	Lowest average subject	32:1
6	Best for maximum film latitude	64:1
7	Limit for colour transparencies	125:1
8	Limit for colour negative	250:1
9	Highest average subject	500:1
10	Limit for panchromatic film	1000:1

BROAD LIGHTING

This is a term in portraiture where the key light illuminates that side of the face nearest the camera (see *Portraiture*). Short lighting, where the main light is placed to illuminate the side of the face turned away from the camera, is used to emphasize facial texture and skin tone.

BROMIDE PAPER

Bromide paper is photographic print material, with a coating of silver bromide (made from mixing a silver nitrate solution with a solution of potassium bromide, plus gelatin). A fast enlarging speed emulsion results and this emulsion is usually carried on a substrate of fibrous baryta (barium sulphate coated paper), the purpose of which is to give a pure white reflector for the transparent emulsion. When properly processed (see *Archival Processing*) these papers have a very long, stable life as finished prints and differ considerably in that respect from *resin-coated papers*, which have a guaranteed life of only a few years at present. Bromide paper is developed at normal temperatures in two to five minutes and must be processed under a safe-light of brownish-amber or greenish-yellow or red, of low power. Such paper can lose its brilliance if stored much longer than six months except when refrigerated, and can be chemically fogged even in storage, particularly if accidentally exposed to sulphide toner fumes. Prints may be toned by many chemicals to various colours, but when developed normally, the image ranges from brown-black to blue-black depending on developers used or the paper brand selected (see *Toning*).

Available in a series of contrast grades from 1 to 6 and also in variable contrast for use with filters, the paper is unable to reproduce the full scale of gradation which a negative can, and a considerable condensing of tonal range from that of the original scene is usual. The quality and intensity and, therefore, emotional impact, of a monochrome bromide print, changes considerably under differing illuminations. It is good policy to judge the finished wet print after fixing, by a daylight quality light, making allowance for the slight darkening that will be apparent after drying. If the final dry print will be displayed or viewed under a strong spotlight, a darker, richer print can be made which is considerably more powerful for some images.

By reducing exposure in the enlarger and extending the development past five minutes, longer scale prints may be made but safe-lights should be thoroughly tested and the print placed face down in the developer for as much time as possible. Any slight veiling of the highlights which may arise from this treatment can be removed by the use of a weak ferricyanide reducer (see *Farmer's Reducer*).

BROMOIL

A popular process in the early part of this century, bromoil was based on the fact that a silver image becomes insoluble when placed in bichromatic solution before the application of light to the image. A bromide print is developed to finality in an Amidol developer, dried then bleached, washed and rinsed in a 1–5% sulphuric acid solution. After washing and fixing in a weak hypo solution, the print is dried. This dried print is then soaked in warm water, 24–40°C (75–104°F), and the gelatin swells in proportion to those areas affected by exposure and bleaching.

An ink comparable to printers' ink is stippled onto the softened print after it has been blotted surface-dry, resulting in a pigmented image built up proportionally as a replica of the original bromide print. Experienced workers can exercise great local control and the final image can then be transferred by pressure to other support materials. (Further information, in detail, is to be found in *Photographic Facts and Formulas* by Wall and Jordan, published by Amphoto. Inc., USA.)

BRUGUIÈRE, FRANCIS (1880–1945)

An American painter who turned to photography, probably under the influence of the dynamic group clustered around Alfred Stieglitz, he was one of the first photographers seriously interested in photo-abstraction. By 1912 his experiments in this field had set him apart from the stultifying influence of salon photography at that time.

B SETTING

This is a *shutter* setting common to most cameras which allows the shutter to remain open as long as the shutter release button is pressed. It is useful for time exposures of up to 20 or 30 seconds' duration, but for longer exposures the T or time setting should be selected or a locking cable release used.

B or T settings will normally require that the camera is mounted on a tripod or stand, unless special effects are sought. Any useful techniques related to night illuminations or fireworks depend on the camera having a B or T setting.

BURNING IN

This is an enlarging technique where additional exposure is given to highlight areas by the use of a partial mask held between the lens and the paper (see *Enlarging*).

BURROWS, LARRY (1926–71)

Killed in Vietnam while on assignment, Burrows was an English war photographer perhaps without peer or even parallel, who brought home the ugly beauty of men in the stress of violent action. He composed his pictures with an unerring graphic eye, hinting, within the grim desolation, of the nobler attributes of war. One of *Life Magazine*'s most outstanding photographers, he was driven with the true artist's vision and dedication to simplify the visual concepts of image making and make his dark message understood by millions. His gentler images, during rare relaxation from war, were of oriental architecture.

CALLAHAN, HARRY (1912–)

The serenity of this American's black and white images hides a vitality of structure and modern classicism that perhaps only photography could produce. His camera and his life both turn on the important things to be found in his near environment and in the photographs of his wife, Eleanor, there are many masterpieces. He is only now becoming well known to a mass audience around the world but his influence on modern photography in the United States has been considerable, ever since the early forties, when he had an important role with Aaron Siskind in directing photography at the Illinois Institute of Design which had evolved from the New Bauhaus established in Chicago by Moholy-Nagy.

Like many who are immersed at considerable depth in the medium, photography seems to give his life meaning as it has done for more than 40 years and from these visual experiences we are presented with the cool dreams of a major artist.

CAMERA CARE

Cameras are delicately made scientific instruments, and as such, need care and attention to maintain them at peak performance. They should be kept in a dust-free case away from excessive heat, cold or moisture. In tropical climates an aluminium case is best for long term storage for very expensive equipment and these cases should also contain some dehydrating crystals such as silica-gel to remove moisture from within the case. From time to time cameras should be opened up, lenses removed and a stream of low pressure air or Freon gas used to blow out dust. In an SLR camera do not touch the mirror or clean it. A soft brush could also be used, but care must be taken not to damage the shutter curtains and to avoid this, cameras should be set on B or T and the shutter opened while the body inside is cleaned. Lenses which are not on the camera should have a back and front lens cap always in place and, where possible, all lenses should have a colourless UV filter permanently placed over the front element as a normal precaution. To clean a lens, first invert it, remove the dust with a camel hair brush or a soft stream of air, then gently apply a lens cleaning fluid, a few drops at a time, using lens tissue or cotton-tipped swabs. Remove any excess with a clean swab and do not apply pressure to the surface of the glass. Dust once more to remove any lint and cap the lens. Breathing on the surface can often give enough solvent action to remove finger marks and a Colortherm lens cleaning cloth

may be used provided great care is exercised and no heavy pressure is applied.

If your camera is ever completely immersed in sea water, it should be immediately placed in several changes of fresh water at a temperature of 20–24°C (68–75°F) to flush out as much salt water as possible. Do not attempt to dry the camera out but keep it totally immersed in fresh water until it is possible to get it to a repair shop. Any film in the camera should be wound back into the cassette and also kept totally immersed in water until it is possible to process it. Do not let the film dry out until it is processed. Whatever action is taken after this kind of accident, it is usually not possible to avoid very expensive repairs or perhaps even a total loss of the equipment. A camera strap can usually prevent these happenings.

Modern automatic cameras should not be X-rayed

Cleaning the SLR camera.
a Invert the camera and dust off loose particles.
b Using lens tissue and perhaps some lens cleaner *gently* wipe the lens surface.
c Blow out the film chambers with air.
d To clean the shutter curtain, do not use a brush, but use pressurized air, at least 20cm (8 inches) from the shutter surface.
e Repeat these steps (a) to (d), at least monthly and before every important assignment.

a

b

c

d

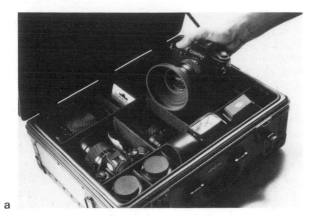

known to early Arab philosophers and mathematicians, that under certain ideal circumstances a tiny hole in the wall of a darkened room could produce an inverted image of the scene outside. Leonardo da Vinci in 1490 noted the possibilities of this phenomenon as an aid to artist and throughout the sixteenth and seventeenth centuries, as a lens was developed and the device became more portable, many artists used the camera obscura to assist their drawing and rendering of perspective.

Canaletto, Guardi and Vermeer are thought to be some of the famous early pioneers of its use. The fullest description of the machine was first given by Giovanni Battista della Porta in 1558, but improvements by Barbaro in 1568, Danti (1573) who managed to restore the image to its normal aspect by the use of mirrors, Risner in 1580 who suggested a portable design, and Kircher (1646) and Schott (1657) who suggested that the camera obscura could be reduced for hand carrying, all contributed to the early history. At the close of the seventeenth century Johann Zahn of Wurzburg illustrated several small types of camera obscura, including reflex models with dimensions as little as 25×60cm (10×24 inches). These machines of Zahn are generally considered to be the true prototypes of the nineteenth century cameras of the photographic inventors. (See *Alhazen*, *History of Photography*, *Pin Hole Camera*, *Basic Photography*.)

Camera care.
a Valuable equipment deserves a strong watertight and dust-proof case. Each piece of equipment has its own foam-lined compartment and the 'brief case' configuration is the best for rapid use and maximum protection.
b In hostile environments protect the camera with heavy but clean plastic. The lens should be further protected by a clear UV filter which is sealed into the plastic as an optical window.
c When travelling by air put electronic cameras in lead-lined bags to reduce the effect of x-rays on sensitive circuitry.

This is the camera obscura illustrated on the original Berry Patent, filed in London in 1839 for Louis Daguerre's process.

frequently, as happens at airport security stations, and should be kept out of direct sun, car glove compartments and freezing temperatures. In the event of prolonged exposure to very cold or very hot weather, all battery systems should be changed just before using the camera. If using a camera in the rain or in sea spray, a temporary protection may be easily made from a plastic bag and a UV filter (see fig. (b) above).

Cameras which are not used often should have all batteries removed and shutters should be fired and left unwound. Lenses should be taken off and capped at both ends and a cap fitted to the lens flange on the camera body to exclude dust.

CAMERA OBSCURA
The principle of the camera obscura depended on a fact well

CAMERA SUPPORTS

In order to achieve acceptable definition at any shutter speed below $\frac{1}{250}$ of a second the camera must be held very steady. As the shutter speed drops, so the camera support must become even more rigid and the same is true if the focal length of the lens is increased, even when shutter speeds for these lenses are comparatively high. If the camera is held correctly, and the shutter is released gently (see *Basic Photography*) reasonably good definition can result from speeds as slow as $\frac{1}{60}$ of a second. If considerable enlargements are to be made from images made at slower speeds than this a steady camera support will be a much used accessory. One of these is illustrated in fig. below.

The tripod is the most stable support and has remained largely unchanged since the inception of photography. Strangely enough it is rarely an inhibiting factor for the professional photographer or the subject and even if a 35mm camera is being used, it is often a good rule to mount it on a tripod, but non-professionals seem less inclined to use one. It seems pointless, however, to spend money on expensive lens systems and sophisticated cameras if they deliver less than the finest possible detail because of vibration at the moment of exposure. Tripods can also permit the use of slower lenses or film in a given lighting situation and this alone can make their use worthwhile. Professionals usually need a number of special tripods including very low level, very high rise, and lightweight location tripods. Those using large format cameras will need special heavy duty studio stands.

Any photographer contemplating using shutter speeds slower than $\frac{1}{30}$ of a second with normal, medium or long focus lenses in small cameras or any very long telephoto lenses for these formats, or who owns a medium or large format camera, will need a tripod.

Apart from conventional tripods, many unusual and useful camera supports may be found in photo stores. This one consists of a universal head welded to a c clamp and is both lightweight and strong.

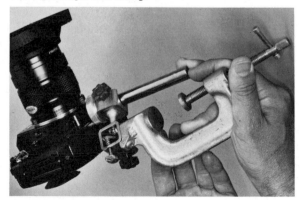

CAMERA TYPES

Modern cameras may be classified into three main types – small format, medium format and large format, and before purchasing a camera for the first time it is useful to understand something of their specifications. The *small format* cameras include 16mm, 110 size automatics, half frame 35mm and full frame 35mm. The 16mm and half frame 35mm cameras are rarely used today, but the tiny frame of the 110 size film is capable of yielding very interesting results. These cameras are possibly the most automatic, being programmed purely by the loading of a film cassette without any calculation by the operator. Certain systems cameras with motor drive and various lens lengths are available, notably from Pentax and Minolta, but in general the serious photographer will find that lack of image definition and mechanical flexibility will soon cause a change to larger sizes. This camera is ideal for recording family history by someone who finds the mathematics and concepts of larger cameras too difficult.

The most popular small format cameras are the 35mm, taking 36 exposures, 22×35mm in area, on a sprocketed, motion picture type film. This camera may be classified in two divisions – the rangefinder type or the single lens reflex (abbreviated in this book to SLR). Billions of pictures are being made each year by these cameras and a bewildering selection of brand names are available. The best known rangefinder 35mm camera is the Leica, a superb instrument, beloved by journalists and nature photographers because this camera is one of the quietest in operation of any type, large or small. Most professionals, however, would choose an SLR from major systems manufacturers, such as Canon, Nikon, Contax, Pentax, Minolta and Rollei, and these brands can all be bought with confidence. Dozens of other brands, mostly Japanese, are also fine quality instruments capable of excellent work of a committed nature. Before purchasing any camera, test it, price it at different suppliers and consider how its handling and facilities will affect your image making.

The primary difference between a rangefinder camera and an SLR is that the latter overcomes all *parallax* problems and a precise view of the subject is seen right up to the moment of exposure. Automation of all functions is more sophisticated and in general the SLR is the choice for most people. The rangefinder camera is less bulky, less intrusive in sensitive situations and can give sharper pictures in some adverse conditions.

Medium format cameras accept 120 roll of film, as a rule, and have formats measuring 6×7cm, 6×6cm, 6×4.5cm and, occasionally, 6×9cm. The most popular is the 6×6cm size taking 12 pictures per roll and typified by Rollei, Hasselblad, Bronica and Mamiya. For those who do not wish to use a square format, 6×7cm is an ideal choice, taking ten frames per roll and the best one of these is the large Pentax 6x7. Bronica and Mamiya both make excellent 6×4.5cm cameras with high quality lens systems. Because of the considerable cost of the camera, lenses and materials to be used in these cameras, medium format cameras are normally used by professionals for advertising, journalistic, scientific and portrait assignments. All those mentioned are SLR or twin lens reflexes and some have magazine systems to allow easy change-over in film types, even when halfway through exposing a roll.

Large format cameras are for specialists, and almost all professionals will require experience of them. They use sheet

There are five main camera types in use today.
a The motorized miniature 110 format.
b The rangefinder 35mm.
c The 35mm system SLR.
d The 6x6cm system SLR medium format.

e The monorail view camera.
Select the camera most suited to the type of photography which interests you. Note that (c), (d) and (e) types are often used professionally and are arranged here in an order of increasing weight and bulkiness.

or cut film and look almost like the pre-1900 cameras with bellows and focusing cloths. Most need heavy tripods and other accessories and are largely to be found in studios. Their particular advantage is complete flexibility with regard to focus and film material, while almost any lens type is available. Their movements permit considerable manipulation of perspective and depth of focus. Popular formats are 9×12cm (4×5 inch) 13×18cm (7×5 inch) and 18×24cm (8×10

inch). Film is loaded in double cassettes or dark slides and the operation of the camera is slow and meticulous. The cost of these cameras may not be out of reach of many photographers and as the care needed to operate them is considerable, many students will be asked to train with them. They are not ideal for portraits yet if that technique is mastered, results are superb, but they are more suitable for landscape or architectural photography or product photography. Many fine old

cameras of this type find their way into antique auctions and names like Deardoff or Gandolfi are excellent for modern usage. For professional use, Sinar and Arca-Swiss make excellent systems in all large formats, while Linhof, Calumet, Plaubel and Horsemann are also most suitable choices. (See further information under *SLR Cameras, Medium Format Cameras* and *View Cameras*.)

CAMERON, JULIA MARGARET (1815–79)

An eccentric Englishwoman of great spirit with a large measure of photographic talent, Cameron perhaps out of the necessity forced upon her by her limited interest in technique and her choice of extremely large format cameras (25×30cm or 10×12 inches and larger), produced shallow focus, lively portraits of the Victorian intelligentsia. These dynamic pictures, often of great men such as Tennyson, Longfellow, Darwin, Herschel, Carlyle, were made with five minute exposures on wet plates, the slow exposures creating an amalgam of expressions and soft edged diffusion. So strong was her control of the sitting, so sure her concept, that the personality of the sitter became absorbed by the photographic process and in these images we have a pioneering example of an artist reaching out to record the inner spirit and hidden structures of her subject, rather than being entirely content to record a surface. Cameron also undertook many allegorical and narrative photographs, some sentimental to the point of banality in the manner then very much in evidence in the 1860s in England. But these over-organized fictional exercises never reached the height of those simple, direct and revealing documentaries of her moments spent with vital or important people, for which she is now justly famous.

CARBON TETRACHLORIDE

A clear colourless liquid formerly used as film cleaner or a grease solvent. It is extremely dangerous to inhale fumes of this substance and death can easily result from its misuse. As there are many less toxic film cleaners on the market, the use of carbon tetrachloride or cleaners which contain it should be avoided at all cost. (See *Dangerous Chemicals*.)

CARBRO PROCESS

This is a photographic process arising from the work of Thomas Manley in the year of 1900 and refined by Howard Farmer 20 years later, whereby a bichromated paper was printed until a visible image appeared. This image was then applied by contact pressure to a pigmented gelatin paper for a period of up to an hour. The paper and the transferred print were peeled apart and the print washed in warm water to remove the soluble gelatin. The pigment for the monochrome image must also be water soluble, such as tempera or water colour and will produce single colour effects. Because the silver image is replaced by a pigmented image which is impervious to the usual destructive energy of light and pollution, the Carbro is totally permanent and by far the best method of archival printing.

Tri-colour, Carbro prints, based on the above process are very much back in fashion, even though they are somewhat tedious to make. It is still the only truly archival colour process known for the reproduction of modern colour photography and the slight relief image adds great beauty to the surface of the prints.

By making a set of bromide prints from three colour separation negatives and applying pigmented tissue of complementary colour (one each of red, blue and yellow) to the correct corresponding bromide print record from the separation negatives and then re-assembling them in perfect register, a truly permanent and beautiful full colour print is produced.

Further reading may be found in the works of Robert Demachy, Robert F. Green, Carlton E. Dunn, *Photographic Facts and Formulas* by Wall and Jordan and by contacting the commercial makers of pigment tissues: Hanfstaengl, Widenmayer Strasser, 18, Postfache 151, Munchen 22, West Germany. Non super coated paper which is necessary for the process may be obtained from: Kentmere Limited, Stavely, Kendal, Westmoreland, UK.

CAREERS IN PHOTOGRAPHY

Except in the USA, photography rarely offers the enthusiast a degree course of sufficient value to lead to a sound progressive career in the business and most who aspire to work in the somewhat hazardous area of professional photography will find that photographic education barely prepares them for the reality of the job and they must embark on a continuous learning process, which only begins on their first assignment.

Those whose interest is informational images, such as are needed for scientific, clinical or forensic use, have better prospects and can best find their way via a standard educational background with, as a parallel activity, intensive training in basic photography at a technical school as a part-time occupation. If a degree is taken in a scientific subject so much the better, for the discipline that this skill imposes upon the somewhat subjective activities of photography can be most helpful in any informational field of photography.

Those who wish to enter the more commercial areas of industrial, advertising, portraiture or photo-journalism, are advised to think very carefully before seeking a life-time in what has become an over-crowded and disorganized business, largely lacking real professional status in most communities. It is always desirable to have a good general level of education before looking for a career in these fields, with an accent on the humanities. This kind of photography is concerned with communication and any experience of that special subject which can be brought to a photographic background, so much the better. Skill in business administration is very much more important in these commercial career opportunities than perhaps is thought at first glance, as most photographers will be responsible for conducting their own day-to-day operation, with control over financial and commercial factors being paramount to survival. After any formal training is completed it will usually be necessary to join a working photographic organization in the chosen field, often at a very

Henri Cartier-Bresson has had countless exhibitions of his work throughout the world and this picture of Henri Matisse in 1944 typifies his empathetic portraits of famous people. It appeared in an exhibition at the International Center of Photography in New York in 1979. (*Courtesy International Center of Photography*)

mundane level and there, by close observation, learn about photography. This still seems to be the only effective way to learn even though the hours are long and arduous and the pay extremely low, Some famous photographers will hire free-lance assistants but often with pre-conditions which may be unacceptable to many. However the photographic skill is acquired it may be said that it usually takes about five years of inspired application to the learning of this craft before the photographer can confidently exist in his/her own entrepreneurial business. Usually a minimum of 25,000 to 50,000 dollars will be needed to capitalize such a business in the beginning.

Teaching photography is an even more over-crowded business than any of the above and academic aspirations with respect to photography may never be fulfilled. Certain posts do exist, particularly in the USA, where formal photographic studies are part of many school and university programmes. There are always many times the number of job seekers than positions vacant.

The artists who see their vocation in using photography as a full-time creative activity also face extraordinary difficulties. Very few artist-photographers today can support themselves entirely by the sale of their work direct to the public. Most have found it necessary to subsidize their earnings in this area by part-time activity in more commercial ways, such as advertising and photo-journalism. With the rising interest of the public in photography as an art and the increasing number of galleries willing to sell it, this is an expanding area for really talented photographers, but their experience is more dearly bought and their growth rate is considerably slower, with very little financial return during the long formative period. Many find it therefore essential in the beginning to protect their photographic and philosophical concepts by finding part-time work in businesses which have nothing to do with commercial photography, always provided that this activity allows them time for concentrated work on their chosen area of interest. It is not often that artist-photographers succeed in their own right under the age of 40 and usually it is much later in life even than that. (See *Fine Art Photography* and *Appendix*, 'Grants & Bursaries' and 'Photographic Schools'.)

CARTE DE VISITE

These were popular methods of portraiture in the last half of the nineteenth century and became a useful way of extending the business of the portait studio of those days. A Parisian photographer, Disderi, patented a process in 1854 whereby the front lens panel of the camera carried four, six or even more lenses. Corresponding masks in the film plane then allowed the photographer to expose small sections of the plate, one section for each lens. These multiple exposures were then contact printed as one single sheet and the small rectangular pictures cut up and used as a visiting card for social occasions. These cards have recently become collectable items among those interested in early prints and modern versions of the multi-lens camera are still used for identity and passport purposes.

CARTIER-BRESSON, HENRI (1908–)

A photographer to whom all serious photographers give pride of place as the greatest of documentalists, a serious and intellectual hunter for that slice of time which is classically timeless. Cartier-Bresson, a Frenchman, received his primary visual training from André Lhote, famous teacher, painter and pioneer of Cubism. His interest in the geometrical structure of the image, his disciplined technique with the

small format Leica camera and his unerring instinct for the decisive moment of tragedy, humanity, pathos or irony in the events to which he is a seemingly invisible witness, disclose this painter's eye. He celebrates his presence at real events by giving us real images which tell his audience with the amateur's loving fanaticism 'I was there' and his cool and penetrating lyricism discloses his respect and absorbing interest with those under observation.

But he is, of course, no amateur. Working with simple means, mastered to the maximum and normally in black and white only, Cartier-Bresson has roamed the world, gathering a professional diary of images, so personal yet so intensely relevant to all who view them that we, the observers, seem to enter a private world with a secret atmosphere, hand in hand with one of the greatest photographic artists of all time.

CELSIUS

A temperature scale, also known as Centigrade, was suggested by the Swedish astronomer Anders Celsius (1701–44) and has become the standard temperature measurement for photographers. A hundred equal intervals were selected between the freezing and boiling points of water, 0–100°C respectively. To find the Fahrenheit equivalent of Celsius temperatures (Centigrade is no longer a term used).

TEMPERATURE CONVERSION

Equation: $F = \frac{9}{5}(C) + 32$
 $C = \frac{5}{9}(F - 32)$

Practical: F = Celsius multiplied by 1.8, then add 32.
 C = Fahrenheit minus 32 and then divide this answer by 1.8.

CENTRE WEIGHTED

This is a descriptive term for many through-the-lens metering systems used in SLR cameras, where the meter reading is taken from the light falling close to the lens axis, rather than that from the outer edges of the field of view. It is based on the assumption that most amateur photographers place the main area of interest close to the centre of the frame. More complex meters will take average readings from around the frame even though they are usually designed to have a bias toward a selected area of the format which is normally not far off centre. (See *Exposure*.)

CHARDIN

Jean Baptiste-Simeon Chardin, master of Manet and Cézanne, was a remarkable French painter of the eighteenth century who interested himself in humble domestic subjects, particularly of still life compositions related to the kitchen. Brilliant rendering of light, magnificent image management and superb craftsmanship were brought to bear on objects of such docility that it raised questions in art that are still being answered. Photographers who are interested in the disciplines of still life will benefit hugely from a close study of his work.

CHEMICAL FOG

(See *Fog*.)

CHIAROSCURO

The effect of light and shade with small areas of contrast and relief is known in painting as chiaroscuro and it is a most effective compositional tool in photography. Back lighting often produces this phenomenon as a natural consequence.

An example of chiaroscuro in a backlit landscape.

CHILD PHOTOGRAPHY

The modern colour camera seems almost to have been invented for the purpose of recording the activities and events of childhood and once some skill has been acquired in handling the camera controls and observing the fall of light,

the average parent will achieve very fine pictures.

Children are best photographed in natural and relaxed situations, so the special event of a visit from a professional photographer sometimes creates an environment which does not achieve the best results. The camera to use for photographing children is undoubtedly the SLR, fitted with a lens of 80, 100, 135 or 200mm in length and preferably having automatic exposure control. Unless indoor happenings are to be photographed it is better to bring the subject outside, even on overcast days. The lens should be fitted with a UV filter, and to warm the skin tones a little a Kodak Wratten 81A gelatin filter could be slipped in between the UV filter and the lens (see *Filters*).

A low contrast, fast film such as Ektachrome 200 or 400 ASA daylight film, Agfa 21 or Fujichrome RD 400 should be loaded. Back-lit pictures will need a two stop increase unless fill-in light is used and cross lighting usually calls for a one stop increase (see *Lighting*).

Since there are certain to be many wasted shots from such active subjects, it is better to load with transparency film and then print only those pictures selected after careful scrutiny with the magnifier. Cibachrome or Kodak R prints are both suitable direct printing materials for such transparencies, or the Kodak or Agfa internegative technique may be used. Very little quality is lost with any of these methods.

Focus is the primary difficulty in child photography, the rule being to focus on the eyes of the subject. This is not easy if there is much close-up action in the scene but practice will improve the photographer's skill. Very shallow depth of field is often the case, as high shutter speeds of $\frac{1}{125}$ to $\frac{1}{500}$ of a second are often necessary in outdoor action situations and lenses must be opened up to compensate. One-touch zoom lenses are good for this kind of photography and they should be in the 70–150mm range and of wide aperture. A macro mode facility is an advantage.

In the beginning, unrehearsed action is difficult to photograph so choose an activity or situation that the subject can easily perform several times. Pre-focus, if necessary, on a selected spot and if it is a running action past the camera, pan with the movement of the subject (see *Action Photography*). It is best in all pictures of children for the camera lens never to be higher than the eye level of the subject, so that no dominating influence is present to inhibit natural action, or to produce an image which appears to look down on the subject. The photographer must also spend some time gaining the confidence of even extrovert children so that the session can go smoothly, and a helpful assistant is very useful to guide the subject, hold reflectors, or engage the children's attention.

No one is better fitted than the parents in devising events to be photographed, beginning with the tiny baby who sees the first flower (or kitten, or ball, etc.,) to the teenager's first pony ride. Picture sequences are especially good for children where a whole event is highlighted by several connected photographs and then these are displayed in albums, or on the wall, as a collective group (see *Finishing the Photograph*). Very young babies, under six months, should not receive direct flash light in their eyes and for them, bounce light, reflected or diffused light should be used.

In outdoor situations of bright sunlight it may be necessary to use a white cardboard reflector to bounce extra light into shadow areas if a portrait is being made. To overcome excessive contrast in taking pictures of groups, it is more advisable to use a synchronized flash fill-in light to lighten the shadows (see *Lighting*).

Indoors, bounced light on the ceiling or on special reflectors, about 1 metre square, is usually preferable to direct light, especially if that comes from a flash on the camera. If possible get the flash off the camera or use bright tungsten floods in capped reflectors. When photographing young children with flash, battery powered equipment with a very fast recycling time is preferable and it is advisable also that any bare lamp which is exposed to the air is suitably screened with a wire mesh in case of accidental fracture or explosion of the glass.

When the event to be photographed is the moment when a gift is first offered to the child, all photographic preparation of lighting, focusing and exposure estimation should be done in advance. If the subject is very young the camera can be pre-set and placed in position on a tripod. Older children are often

A classic statement of childhood. (*Courtesy Mayotte Magnus*)

shyer at this moment and the photographer, while being totally prepared, must be less obtrusive.

Portraits of children are usually better if they are taken during a reasonably stationary but active situation, as when large toys are used, or with favourite pets, or at meal times. Backgrounds for portraits should not intrude and pastel coloured walls are helpful, or by fitting longer lenses and wider apertures busy backgrounds may be thrown into soft focus (see *Focusing the Camera*).

Professionals who are asked to photograph children will have to keep all of the above in mind and have a clear working plan for getting the best from a quite difficult assignment. An assistant is essential in such a potentially fast moving session and equipment should be very portable and minimized. In order to cover each situation professionals will usually make many more exposures than is often the case if the photographer is from the family and may find that the extra definition of a 6×6cm ($2\frac{1}{4} \times 2\frac{1}{4}$ inch) automatic camera such as the Rollei SLX, may be well worth the investment, especially if much work is to be done in this field.

CHROMAGENIC BLACK AND WHITE FILM

Conventionally, metallic silver which has been created by the action of light on silver halide emulsion is reduced by developer action and stabilized by fixing to produce a normal negative. The new chromagenic monochrome films produce a dye image by using colour couplers which are activated by the local release of secondary chemical residues arising from developed silver. The more silver, and therefore by-products, the more dye is absorbed by the film. After development, residue silver is removed totally by bleaching. A three stage process is typical; develop, bleach, fix, although bleach-fix is combined often to produce a two bath process.

The characteristics of chromagenic monochrome films are: extremely fine grain, extraordinary tolerance of over-exposure and a very long scale of tonal values.

They do not respond well to push processing and when dye density goes down as in under-exposure, grain is more apparent, while really excessive density gives poor acutance but does not increase grain. For best control of harsh contrasts, over-expose slightly, rating a 400 ASA film at 280–320 ASA. Processing these films is similar to using colour materials. Timing is critical and temperatures are usually at $30°$C ($100°$F). Agfapan Vario XL and Ilford XP1 400 are two 400 ASA rated films of the chromagenic variety giving excellent results and available in 35mm and 120. Both can be developed in conventional colour negative chemistry or in monochrome developers.

CHROMATIC ABERRATION

An inherent fault in single lenses whereby the focal length of various colours of the spectrum do not focus sharply at the same point on the film plane, causing lack of critical definition and colour fringing which affects colour images in photography and is also quite noticeable in black and white work. Complex lenses combine a number of single lenses of different

a

b

B/W films which are compatible with chromagenic colour solutions are capable of excellent qualities.
a Ilford XP1 film greatly enlarged compared to **b** Ilford FP4, enlarged to the same scale and processed in May & Baker Promicrol. (*Picture (a) courtesy Ilford Ltd*)

refractive indices and nearly equal dispersions of colour in such a way that all colours of the spectrum are brought to critical focus at the same point on the film plane. Process lenses used for lithographic reproduction are corrected to a very high level in this respect and for photographers using large format studio cameras, apochromatic lenses, such as the Rodenstock Aporonar, achieve the same results. Colour photographs made with these lenses will appear warmer, more saturated and considerably sharper than other types and discerning photographers will always use the highest quality lens affordable in order to achieve this type of result. (See *Lenses*.)

CIBACHROME

A positive-to-positive print process introduced by the Swiss firm of Ciba-Geigy in 1963 and is now marketed by Ilford Limited, UK. It is a two or three bath dye destruction process, needing about 15 minutes to complete processing. Temperatures are in the vicinity of 30°C (100°F). Originally the print material was excessively high in contrast, needing either very soft diffused lighting in making the original transparency or careful masking in the print process itself. New material recently introduced is self masking and handles contrasts very well. The process is capable of rich, saturated colours and is one of the most permanent colour print processes available on the general market. (See *Archival Processing and Storage*.) It is quite suitable for home processing.

CIRCLE OF CONFUSION

The eye is capable of resolving fine detail in a proportion of approximately 1:2000 but the brain may perceive apparent sharpness in much coarser detail than that. The camera can resolve perhaps 50–100 lines per mm in small format cameras under optimum photographic conditions but there are many variables such as vibrations, camera construction, lens contrast, subject contrast, film type, processing, exposure, which all act upon the final result. After printing from the negative, resolution drops considerably and again it is conditional upon many variables: enlarger construction, processing, paper stock, contrast and print density. Finally, the viewing distance of the print, ambient light and the condition of the viewer's eyes and other psycho-physical factors, greatly affects the degree of detail observed.

Despite this fact that the eye adapts and the brain interprets detail in a very subjective manner, theorists still, however, try to define the minimum acceptable sharpness in photographs and support these definitions by complicated formulae to measure the so-called circle of confusion. Their circle of confusion rests on a theory that a point of light which is transmitted through a lens system will not reappear as an absolute point at the plane of sharpest focus but as a series of concentric tonal circles, in disc form, the centre of which is the brightest point. The eye will certainly accept that this microscopic doughnut is in fact a point and as the sharpest parts of the image are entirely made up of such pseudo-points, so we see an area of critically clear detail, when very little is actually present. In those areas less carefully focused, that is behind or in front of the point source, the doughnut spreads somewhat, with edge definition being lost more and more as the distance from critical focus increases. Stopping down a lens substantially improves the field of apparently sharp focus, restoring acceptable definition to the formerly unfocused disc-shaped points of light.

It is not necessary and is in fact confusing (to the photographer) to suggest any formula for calculating any optimum measurements of these discs of tone arising from sharply focused fine detail, but for practical purposes it could be suggested that a circle of confusion measuring 0.1mm (0.004 inches) would be seen as acceptably sharp on an 18 × 24cm (8 × 10 inch) print which is viewed from 30cm (12 inches) away in good light, say 200–300 lux. (See *Depth of Field, Hyperfocal Distance, Sharpness, Vision*.)

CLEANING

REEL CLEANER AND FOR STAINLESS STEEL SINKS

60g (2oz) sodium sulphite
90g (3oz) sodium carbonate
Per 4 litres (1 US gallon) hot water.
Let stand overnight, then wash thoroughly.

FOR NORMAL DISHES, PLASTIC, etc.

Use a proprietary cleaner for photograhic equipment such as supplied by Kodak, Patterson or May and Baker. Make cleaning a regular routine.

CLIP TEST

This is a term used by professional photographers and processing laboratories to describe a technique where part of the roll of film is processed, usually the last frame of a 120 film and the first four or five frames of a 35mm film. These processed frames are returned to the photographer for his inspection while the unprocessed film is held by the laboratory until final assessment is made. Many photographers will always shoot a test frame on each roll as this allows for plus or minus alterations to processing to be decided upon if necessary, once the general levels of exposures are seen on the test. (See *Basic Photography*.)

CLOSE-UP PHOTOGRAPHY

The camera is uniquely fitted to investigate the small world of macro images which most of us pass everyday without noticing. Close-ups may be achieved by using telephoto lenses, usually fitted with extension rings in order to isolate the image even more, but if the result achieved is not at least $\frac{1}{8}$ or larger of life size, it is not usually considered to be a close-up. 'Close-up' generally implies that the result is much nearer

In a clip test, cutting the first few frames from a film for test processing before the main film is processed is the best guarantee of developing quality. This is done in complete darkness of course.

to life size, which is expressed as a scale 1:1. Images which are half life size are considered to be scale 1:2, and so on. The revealing intimacy of this type of picture is most rewarding and well worth the trouble it takes to acquire the extra skill needed to produce them.

Although many new zoom lenses are being made with a macro-mode capability, really close focus on small objects will require that either the lens, or the camera, is fitted with an accessory to change the normal minimum focus restrictions. An easy way is to shorten the focal length by using a supplementary lens which is screwed to the front element of the camera lens. Focusing distance may be decreased, but the system is not very flexible and often lens definition is reduced in this way.

Far better results are achieved by using an extension ring behind the lens or a bellows attachment with which to rack the lens forward. View cameras with triple extension bellows are also useful for detailed close-ups even in the field and the lightweight Arca-Swiss 6×9cm, with roll film back is compact and effective for this work. The use of swing and tilt movements on these cameras can increase greatly the short depth of field which is normally inherent in macro photography. For the same reason it would be necessary to use at least medium speed film to achieve reasonably low f stops and in many cases, especially for colour subjects, high speed emulsions should always be loaded. Bright light conditions are usually to be preferred for the same reasons.

In all macro work there are three major areas where technique of a very high standard is needed to produce excellent results. These are sharpness, exposure and image composition.

Sharpness is achieved by first selecting a lens which performs well at close focus distances of less than 30cm (12 inches). Not all lenses will do so and it is better to seek advice from camera suppliers as regards types which will perform this task. For 35mm owners, Nikkor and Zeiss both make good macro lenses, slightly longer than normal focal length, some even compensating automatically by adjusting the aperture, the closer the focus point. This allows for the usual under-exposure present in macro work. Larger cameras should be fitted with normal length, apochromatic lenses if these can be found with wide apertures. Rodenstock, Schneider, Nikkor and the out of production Commercial Ektar, or the F4.5 Voigtlander Apolanthar are all good names. Macro lenses should be capable of stopping down to at least f22. Sharpness zones are improved by deepening the area of good focus by stopping down, or by using swing and tilt camera movements, or both. Sufficiently brief shutter speeds to stop all movement are necessary, as part of the beauty of close-up photography is the breathtaking detail to be seen, especially in commonplace objects. Electronic flash is obviously useful even for outside subjects, but for most focal plane cameras, SLRs in particular, the maximum shutter speed for synchronization may not be higher than $1 \times \frac{1}{125}$ of a second and is often much slower. This could, in any synchro-sunlight work, produce a secondary ghost image beside that of the flash if the object is in motion. Fast flying insects or birds can only be successfully focused upon by elaborate pre-focusing techniques and electronic shutter firing equipment. On all macro photography it is essential to use a magnifier for focusing in order to select the sharpest focus point in the picture and the camera should always be attached to a tripod as a standard practice.

Exposure problems in macro work arise because of the need for reasonably high shutter speeds coupled with maximum stopping down of the lens in order to achieve good depth of field which at such close distances, even at f22, is very shallow indeed.

For macro work a bellows may be attached to an SLR to focus at very close distances.

To those prerequisites must be added the fact that as lenses are brought to macro distances the aperture indicated on the lens barrel is very much reduced (see *Bellows Extension Compensation*). It will be seen that bright light conditions are needed, together with fast film emulsions. In calculating exposure, most automatic SLR 35mm cameras will perform well and if fitted with a bellows accessory this exposure automation can be most helpful. Other cameras will need to be supplied with complicated exposure data from a hand-held meter and this should be of a narrow angle, or even a spot meter type, such as Pentax make, or an incident meter fitted with a tiny probe. A useful generalization is that for all 1:1 (life size) images, exposure must be increased at least two stops above that normally used for head and shoulder portraits with the same lens and film combination, while anything which appears in the viewfinder at half size (1:2) will need at least one stop. Even with automatic cameras it is wise to make two additional alternate exposures at plus $\frac{1}{2}$ stop and plus 1 stop on any important pictures, remembering that on shutter preferred cameras this will slow the shutter speed considerably if the over-ride mode is used. An increase in light is to be preferred if this is at all possible. The use of small hand-held, electronic flash units can be of interest especially if very fast action-stopping exposures are needed. Many of these units have a flash duration of $\frac{1}{1000}$ of a second and this increases dramatically as macro distances are approached with shorter and shorter flash times in order to achieve the reduced exposure. This can rise as high as $\frac{1}{50000}$ of a second, freezing all action into intricate patterns. The unit should not be used on camera except for overhead bounce light. If the flash is over-exposing on these close distances, use a paper handkerchief or paper tissue, and add more layers as needed over the lamp head.

Image composition in close-up photography calls for premeditated care as the movement of object or camera, of as little as 1mm, can alter both focus point and design. Control of lighting is also vital and in most instances the more natural the mood of the light, the more satisfactory is the result. This does not of course include man-made objects, such as coins, carvings or small products, as these may be better lit by axial lighting from a ring flash (see *Lighting*). Tiny reflectors of foil and the use of small focusing cosmetic mirrors also can be helpful but be careful not to destroy the natural dignity of the object by too much fill light. Small objects usually reveal fascinating textures and these should be given suitable priority of lighting and viewpoint. Dramatic emphasis of small objects, especially insects, can arise from very low camera angles and conversely extraordinary abstractions can be achieved with organic material when it is cropped tightly to remove all references to scale or environment and is photographed from above. Pattern is also very eye-catching in macro subjects and, again, is obtained from relatively high angles of view but, for all compositional problems in close-up photography, reference should be made to standard image control practices (see *Image Management*). For this type of photography it is more important than ever to compose without waste of format space, that is to say, in the viewfinder rather than later at print stage.

In macro work a vital element in composition is *parallax*. This is not a big problem in any view camera or SLR equipment but can create great difficulties for those using Polaroid or rangefinder cameras. It is possible to make a fixed focus frame finder or to use mechanical aids to assist, but most serious macro photographers will equip themselves with a camera which allows the image to be controlled directly through the taking lens, that is, a view camera or an SLR.

COLLAGE
(See *Image Synthesis.*)

COLLOTYPE
A very fine quality lithographic print process, rarely to be found today because its plates are suited to short runs of no more than 2000 copies. This process pre-dated the dot pattern screen litho techniques and is capable of superb colour quality on a variety of paper-based supports.

A glass plate (or lately, an aluminium sheet) is coated with a bichromated gelatin emulsion which is then heated so that the gelatin *reticulates* into a random pattern of tiny cracks. A continuous-tone separation negative, without screen, is exposed to the plate which hardens in proportion to the light transmitted by the negative, the less hardened emulsion corresponding to the highlight areas. The harder shadow areas will retain the printing ink within the reticulated surface to some degree, while the softer, lighter areas will reject ink proportionately. When the inked plates are pressed or rolled onto paper a perfect replica of the image is transferred. The fact that no screen pattern is used gives richer, sharper tones of beautiful gradation. Full colour printing with collotype traditionally uses many more separations than the normal four of the standard litho processes.

COLOUR BALANCE
In order to reproduce what is in front of the camera in the most accurate colours of which the film is capable, light falling on the subject must be identical to that which is considered by the film manufacturer to be ideal. Generally colour films may be divided into two classifications: daylight type and tungsten type, or type B. Daylight type is usually exposed in daylight or by flashlight having colour temperature of 5000 to 5500 Kelvin, while type B is balanced for artificial light from tungsten or tungsten halogen lamps burning at 3200K. If photofloods are used, these burn at 3400K and therefore the camera will need a slightly warming CC filter to obtain perfect colour balance. (See *Colour Temperature, Filters, Fluorescent Lights.*)

COLOUR COMPENSATING FILTERS
Delicately coloured filters in precise densities ranging from 0.05 upwards, usually made in thin gelatin squares on a film base and for the colours of magenta, cyan, yellow, red, blue, green, brown and neutral densities (grey). They are attached temporarily to the lens to make small corrections to com-

pensate for imbalance in the lighting conditions during the making of the original photograph or the colour print. (See *Filters, Fluorescent Lights, Neutral Density Filters, Colour Enlarging*.)

COLOUR COMPOSITION

Use *colour harmony* to create a cohesive plan in the position of coloured objects within the frame.

Use colour symbolism to create psychological effects and to interact with the viewer's subconscious experience.

Remember the additional response caused by form, texture, patterns, structure and mood.

Use warm or saturated colours to advance towards the viewer.

Use cool or pastel colours to create distance and spatial depth.

Warm areas should be in front of cool and are best set against large areas of cool colours with little texture.

Aerial perspective is produced by receding greys and pastel blues, especially if detail is absent.

Light colours appear bigger, create active interest and eye fatigue; dark colours attempt to contract within their own area and cause relaxation.

Blue is the most psychologically preferred, but yellow is the most visually preferred; red is the easiest to identify and remember.

The eye physically alters focus in seeing colour; warm colours causing near focus, blues producing distant focus.

Colours alter actual responses of the body when they alter their size.

In orchestral terms warm colours are brass or percussive, cool colours symbolize the string or woodwind sections.

Strong complementaries cause visual noise and attract psychological attention if placed together in equal areas of significant size.

Food colours are red/orange, orange/yellow, browns, warm greys, cool greens and turquoise, rarely blue or purple. (See *Colour Harmony, Vision*.)

COLOUR ENLARGING

Enlarging colour prints, either from colour negatives or transparencies, has now become a simple matter, certainly no more difficult than B/W enlarging. The same basic needs are there: absolute cleanliness, correct temperature and mixing of solutions and accurate timing of each process. An added need, due to increased temperatures and slightly more toxic chemistry, is that the colour darkroom should have adequate forced draught ventilation such as from an exhaust fan or air conditioner. It is also vitally important to read the manufacturer's instructions each time a new package of materials is opened. This will give updated information on processing and an indication of the filter pack recommended for that batch of material. Printing operations are best conducted in absolute darkness. A good enlarger fitted with a tungsten halogen lamp of 3200K (see *Kelvin*) with a colour corrected lens is essential and the Omega range of enlargers from Berkey Technical is

most suitable. Remember that the dichroic head of the colour enlarger contains the filter combinations suitable for multi-contrast papers used in conventional B/W enlarging (see *Multi-grade*) and this can be a useful plus factor when considering such equipment. A voltage stabilizer should be fitted to the incoming electric supply to prevent colour changes due to voltage fluctuations during exposure. Although printing can be carried out in standard dishes it is more economical and successful if prints are processed in a special printing drum, discarding each solution as used. The drum can be motorized for ease of agitation. Drying is merely a matter of hanging the print in a dust-free cupboard or film dryer.

Standard enlarging controls (see *Enlarging*) can be used, such as dodging and burning in, but remember that while these operate as expected when colour negatives are being printed, i.e., holding back areas with the hand or dodging tool will lighten the print as it does in B/W, and burning in (increasing exposure in local areas during printing) will darken the print in those areas affected, the *reverse is true* when using transparencies and reversal print material such as Kodak R material or Cibachrome. Holding back exposure in local areas *darkens* those areas, burning in *lightens* them. For example with reversal materials, burn in shadows and hold back highlights. In both cases, whichever material is used, a useful addition to enlarger equipment will be a series of colour

Local control is possible with dodging wands of filter material.

.20y

.10y

.10m

.20R

Made from C P filter material

CORRECTING COLOUR BALANCE

The eye receives sensations from three basic primary colours which when combined form visible white light. These are the additive primaries of red, green and blue and all colours may be made from a selective composition of these colours of light. Photographic colour emulsions achieve their colours by the use of the subtractive primaries magenta (M) cyan (C) and yellow (Y) and these are the primaries used to derive CC (colour compensating) and colour printing filters. These filters are arranged in rising densities beginning at .05 and reaching .50 in the case of CC filters and .90 in the case of colour printing filters. For enlarging, the colour printing filters are the most used and generally only in magenta, cyan and yellow. CC filters are used only in colour printing if it is necessary to use filtration at the lens instead of in the lamphouse.

CORRECTING COLOUR BALANCE IN COLOUR PRINTS

Negative/positive process

Colour bias	Add	or	Subtract
Too much Y	Y		M+C
Too much M	M		C+Y
Too much C	C		Y+M equally
Too much B	M+C		Y+M proportionately
Too much G	C+Y		M
Too much R	Y+M equally		C

Transparency/reversal process

Colour bias	Add	Subtract
Too much Y	M+C	Y
Too much M	Y+C	M
Too much C	Y+M	C
Too much B	Y	M+C
Too much G	M	Y+C
Too much R	C	Y+M

For slight shifts in colour correction, change filters in .05 densities; for well defined shifts change in .20 amounts, and for major correction of excessive shifts begin with .30 to .40 densities of the necessary filter. Do not use more than two primary colours in the filter pack and keep the number of filters to the minimum possible.

printing filters cut to a suitable size and fixed to a thin wire (see fig. on page 75). These may be used to alter colour balance in local areas, improving skin tone for example, reducing blue highlights in shadows, etc. Judging print quality is best done when they are dry and it should take place with a viewing light, diffused, of about 4000K, such as would come from a cool white fluorescent. Sufficient strength in the light is needed and a 40 watt fluorescent at 120cm (48 inches) would be adequate illumination.

If a large amount of printing is to be done it is sensible to buy quantities of paper with the same batch code number. A neutral grey card can be photographed under controlled colour temperature lighting and this grey card original is then used to make the first test prints from the batch. When a perfect match of print and the original test card is reached, this is the ideal filter pack for this batch for the commencement of printing and holds good for any paper from the batch with the same code number.

To start from a conventional beginning, however, read the manufacturer's data sheet, make up the recommended filter pack and make a series of test strips which are processed normally and accurately and dried before being studied under correct viewing conditions. Print density must be assessed as well as colour balance and although they interact somewhat, it can be considered that exposure will control density, while filters control colour balance.

Dichroic filters contained in a special colour head for enlargers are ideal for changing colour balance, with the added advantage that little adjustment of exposure is needed when adding or subtracting filters. The average factor is zero for yellow filter changes, 1% for every single unit of magenta added or subtracted and 5% for every single unit of cyan changed.

Where normal colour printing filters are used in the light beam of the enlarger, they must be inserted above the carrier stage and below the lamp. A factor is available to indicate

THE PRIMARY COLOURS

Additive primary	Subtractive primary	Additive primary
Red (R) is white light minus	Cyan (C) which is white light minus	Red
Green (G) is white light minus	Magenta (M) which is white light minus	Green
Blue (B) is white light minus	Yellow (Y) which is white light minus	Blue

Cyan is a mixture of	Blue and green
Magenta is a mixture of	Red and blue
Yellow is a mixture of	Red and green

exposure changes when adding or subtracting filters and for yellow (Y) filters in the density range .05 to 50 the factor ranges between 1.0 and 1.1 thus being of negligible effect, making it unnecessary to alter exposure when adding in or taking out single yellow filters. The other two major printing filters cyan (C) and magenta (M) have factors as follows:

Factor	1.1	1.2	1.3	1.4	1.5	1.6	1.7	1.9	2.0
C Filter	.10	.20	.30	.40	.50				
M Filter		.10		.20			.30	.40	.50

Multiply exposure by the factor if filtration is added, divide exposure by it if filters are removed.

Where extra filters are added or subtracted the filter surfaces also alter exposure due to absorption or reflection and these are generally taken as needing an additional 10% in the case of one filter added or 25% in the case of two. Subtraction of filters reduces exposure by this amount. A photometer used on the enlarger baseboard can more easily compute these changes. Keep filters to the minimum and therefore, if possible, take out filters rather than add them to the pack and do not have three basic primary colours in the pack, otherwise a neutral density factor is introduced which reduces exposure without any corrective action of value. (See also *Enlarging, Colour Temperature, Colour Photography*.)

FAULT-FINDING CHART FOR NEGATIVE/POSITIVE COLOUR PRINT PROCESSES

Colour of fault	Indication of problem	Possible cause
Yellow	Flat or muddy yellow	Exhausted bleach-fix
Yellow	Overall stain on unexposed print areas	Bleach-fix contamination of washwater; imperfect washing or drying temperatures too high
Yellow	Yellow areas too dark	Bleach-fix time too short
Yellow	Mottles, streaks or stains of this colour	Drying temperature too high
Yellow	Streaks of yellow	Fog from white light in processing
Magenta	Overall stain in unexposed areas	Developer contaminated with bleach-fix or inadequate washing or oxidized developer caused by bad storage
Magenta	Print density increased and high bias to magenta seen in high density areas	Developer concentration too high
Magenta	Stains, streaks, mottles of this colour	Imperfect washing due to slow change of water or carry over of developer into bleach-fix
Magenta	Partial shift in colour balance	Moisture condensation on paper still cold from storage
Magenta	Staining in print area	Bleach-fix underactive due to low temperature or inadequate agitation, or developer overactive due to inaccurate mixing, temperature or timing
Magenta	Spots	Bleach-fix splashed on print at finish of processing
Cyan	Overall stain on unexposed areas of print	Developer contaminated with bleach-fix; developer temperature too high; developer carry over into bleach-fix
Cyan	Overall bias to cyan with decreased print density overall	Agitation too low
Cyan	Streaks, mottles or spots	Developer contaminated with bleach-fix; copper residues from plumbing; solutions incorrectly mixed
Cyan	Spots	Chemical dust in air from mixing dry chemicals in processing room

continued overleaf

Colour of fault	Indication of problem	Possible cause
Cyan	Partial staining	Inadequate agitation in bleach-fix; highly contaminated bleach-fix
Red	Red shadows	Underactivity of bleach-fix due to poor mixing or low pH values
Red	Stains or streaks	Inadequate flow rate of wash water
Red	Low values on red	Underactivity of bleach-fix due to low temperature, insufficient agitation, excessive developer carry over
Red	Red density too high, contrast increase in red	Contamination of developer with bleach-fix
Green	Density of print decreased, with bias overall to green in high density areas	Developer exhausted or too dilute or temperature too low
Green	Excessive green values	Developer overactive due to increased temperature or too much agitation
Blue	Streaks	Abrasion to emulsion surface; safe-lights fogging
Blue	Spots	Chemical dust in air near processing area; do not mix powdered chemicals near processing
White	Spots	Air bubbles trapped on emulsion during development; agitate sharply to dislodge; could be water splashes on unprocessed print
General	Light prints, low contrast	Under-development due to faults on timing, temperature, agitation or preparation of solution
General	Dark prints, high contrast	Over-development due to increased time or temperature or to over-concentration of developer solution
General	Blotchy areas in plain tonal values	Poor agitation
General	Images fail to print in small areas	Desensitized areas caused by excessive pressure on paper before exposure; store paper on edge
General	Rough or blistered surface of print	Temperature excessive during drying

COLOUR FADING

Dark fading

Even when not left in lighted areas, some exposed and processed colour materials will alter their density or colour characteristics. Factors which prolong fidelity in colour materials are: correct processing; prevention of spoilage by the action of chemicals or insects, or air pollution; and protection from excessive temperature or humidity. Foil and plastic lined packets, hermetically sealed and held in zero temperatures, are the only suitable containers for long-term dark storage, and the more this ideal is departed from the more likely it is that changes will occur. Metal boxes, painted inside and out with a vinyl-based paint, are probably the next-best substitute, provided they are kept closed and in a dry, cool place (see *Archival Processing and Storage*).

Light fading

Most colour materials, even when they are processed correctly, will show some evidence of change if they receive long

exposure to *any* light source. The sun is the most harmful and is usually, in descending order of risk: sunlight, indirect daylight, fluorescent light, tungsten spot and tungsten flood-lights. Air and chemical pollution also weakens the colour fastness of most photographic materials, and this includes the effect of tobacco smoke. Prints should be exhibited under controlled levels of light, the number of hours should be listed and each print or transparency should be properly sealed in a frame or lamination to prevent damage from polluted air. Important transparency originals should never be projected and, if complete accuracy of colour is desired, even their duplicates should not receive more than 20 minutes of total exposure through any projector with a lamp exceeding 250 watts. (See *Archival Processing and Storage* for information and tables.)

COLOUR FILM STORAGE
Unexposed colour film is rather like fish: for best results it should be obtained fresh as needed, kept as cool as possible, should be used and processed without delay and, for long term storage, is best frozen at zero temperatures.

The dyes used in all modern colour film and paper materials are fugitive to varying degrees and heat, humidity, moisture, chemical fumes, light and x-rays can hasten changes in their colour or saturation. For best results, keep all colour film or print material properly sealed against moisture, in a refrigerator. Storage over several months should be in a freezer at zero temperatures or less.

Materials taken from refrigerated storages should be separated into individual packs, spread out on a flat surface and left to warm up to room temperatures. If this is not done and film is exposed while still below normal temperature, 18–24°C (65–75°F), films or papers will lose speed and alter colour characteristics. For a table of warm-up times, see *Colour Photography*.

Black and white film paper needs less care in storage, but should be kept away from excessive heat, humidity or chemical fumes and, if storage of more than six months is contemplated, should be refrigerated or frozen.

Storage of *processed* colour material is, ideally, also refrigerated or frozen if archival times are being considered. Such material must be protected from moisture or humidity and this is best done by using special containers for the purpose (see *Archival Processing and Storage*).

COLOUR HARMONY
Artists and philosophers through the ages have sought to codify the language and symbolism of colour into theories which explain harmonic patterns. That no one system of colour harmony yet exists is an indication of its subtlety and complexity. The only inflexible rules when working with colour are *not* to be inflexible and if possible to depart from any arbitrary conventions of harmony in respect of its use in colour design. Those colours which energize and intoxicate one person and cause them to be enfolded within the image, will alarm and alienate another.

Naturally the eye will seek order and pattern and there are certain facts of vision which must be understood, but in general, provided the photographer uses colour at a level of the experience of the viewer and has expanded his/her own experience of colour practice sufficiently widely, he/she may be assured that what looks right, probably is right.

Unlike many artists, the photographer will work often with neutrals and will have to harmonize these greys, blacks and whites and control their size and position in the frame, just as one should for full colour schemes. These neutrals act like colours for the photographer, but more discreetly. People are attracted or repelled by individual shades of neutral tone, but there is less symbolism present and therefore considerably less to trigger introspective experiences. The photographer working only with monochrome, particularly if it is the cooler shades arising from B/W photography, depends more heavily on form, texture or implied spatial dimension in order to reach the viewer, while the colour photographer must not only be aware of these factors in image design, but must also know something of certain traditions in the organization of colour. Random patterns in B/W images, frozen eternally by the camera's mechanical eye, can be intensely boring, but uncontrolled colour presented to us by the saturated colour chemistry of modern photo print material can be thoroughly alarming and can create a visual noise which is unbearable.

CLASSIFICATION OF HUES

Psychological primaries
Red, yellow, green, blue.
These colours are basic to the spectrum and the act of seeing.
White and black are usually not included.

Additive primaries
Red, green, blue.
These are the physicist's primaries and apply to coloured light.
When mixed together, they make white light.

Subtractive primaries
Cyan (blue-green), yellow, magenta.
These apply to colour photography.
They are complementary to the additives and are formed by taking away one of these additive primaries from white light.
Cyan is white light minus red.
Magenta is white light minus green.
Yellow is white light minus blue.

Artist's primaries
Red, yellow, blue.
These apply to pigment and ink, and are used by painters and printers.
When mixed correctly almost any other colour can be made.

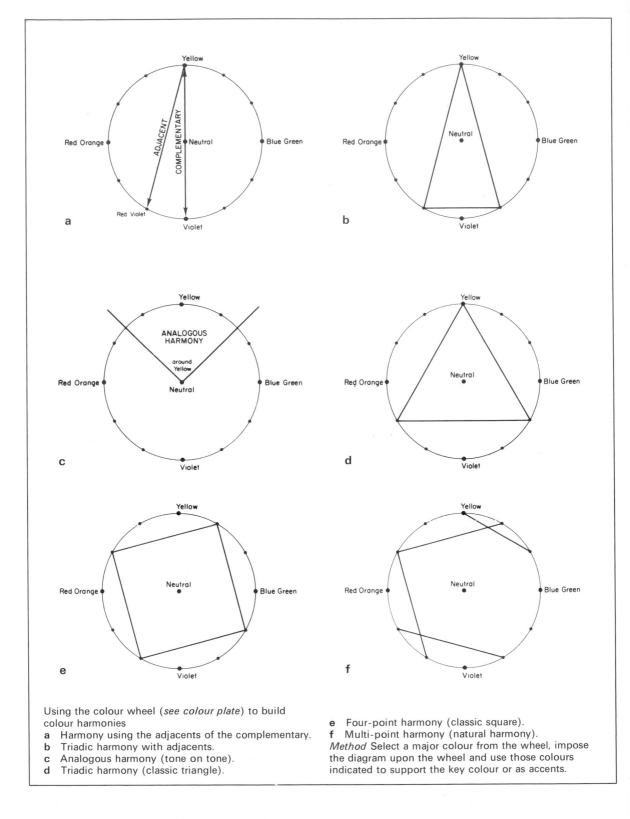

Using the colour wheel (*see colour plate*) to build
colour harmonies
a Harmony using the adjacents of the complementary.
b Triadic harmony with adjacents.
c Analogous harmony (tone on tone).
d Triadic harmony (classic triangle).
e Four-point harmony (classic square).
f Multi-point harmony (natural harmony).
Method Select a major colour from the wheel, impose
the diagram upon the wheel and use those colours
indicated to support the key colour or as accents.

When a beam of light is passed through a prism, the white light is broken up into a visible band of six major colours: red or longest wavelength, decreasing through orange, yellow, green and blue for the shortest wavelength to violet. This is called a colour *spectrum* (see *Light*). This spectrum can be divided into three or four primary colours which when combined simulate white light, plus secondary colours which are produced by intermediate mixes of these primaries. All are included in most colour theories. Shades of dark neutrals are added to deepen colours, while shades of white tones are mixed in to lighten colours.

In the 1660s when Sir Isaac Newton discovered the true nature of the visible spectrum, he had the idea of taking this straight line band of colours and turning it into a circular colour chart. From that time the colour circle or colour wheel has been the basis of most exercises in understanding colour theory and those attempting to turn the harmony of colour into a science.

During the eighteenth and early part of the nineteenth century, the primaries were identified by Le Blon, Harris and Chevreul, as being red, yellow and blue. Certainly artists found that these colours worked for mixtures of pigments. The famous poet Goethe chose to be influenced by early Greek philosophic thought and decided that red, yellow and blue were needed to produce all other colours. His study of colour cannot be supported today in terms of science, but his exploration of the philosophy of colour makes him a vital contributor to our knowledge of this subject. In Britain,

SUMMARY OF HARMONIC THEORY

Simple harmonies can be achieved by using a dominant colour and accentuating it with smaller areas of its direct complementary. Light colours surrounded by dark colours tend to make these dark colours richer. Dark colours placed within light colour environments make these environments appear brighter.

The effects of *after image* can modify a colour.

The area of a colour can change its physical properties.

Juxtaposition of brilliant colours can create visual noise, useful for moving the eye within the frame of the image, provided the colours have sufficient area to create impact or are arranged in a distinct pattern.

Juxtaposition of small brilliant colours confuses the eye and tends to produce neutral effects.

Most people prefer harmonies that are formed by adjacents on the colour wheel or when they are made up of complementaries. Other harmonies can be made by creating a dominant colour supported by weaker but contrasting colours or by using a triadic form (see left fig.) on the wheel or by using split complementary colours.

Harmony using analogies (adjacent colours on the wheel) creates introspection and feeling and can be either cool or warm.

Complementary harmonies can create action or reaction and evoke positive, extrovert responses to their intensely visual quality.

Nature favours analagous harmonies and these are more comforting when they based on a key primary or a secondary colour supported equally by two adjacent colours, one from either side. A red sunset enhanced by red-violet and red-orange looks better than a red with a red-orange and an orange combination.

Complementary colours in the image draw attention quickly, through a dynamic optical effect. Orange and blue intensify each other as does that vigorous combination of red and green and so on.

Harmonies based on neutrals or on minor complementaries suggest elegance and discretion.

More refinement and attraction may be found by using the split complementaries, that is a key colour not supported by its direct complement but by one colour from either side of that complement (see left fig.).

By using a selection of colours which form an equilateral triangle on the wheel, harmony can be achieved. If it is based on the primaries it will be more direct and compelling and if it is based on minor colours (intermediates) it will be more charming and self-effacing.

A harmony can be created by giving the overall colour scheme a dominant colour, perhaps by the use of a filter or using a different film stock which is out of balance for the type of light prevailing. For example, use tungsten film in daylight conditions.

Important areas of the image which are to be seen first are often best in light, warm colours.

Response to colour by the human eye is conditioned by psychological factors and is *always* subjective and symbolic. Every individual sees colours in individual ways.

a

b

c

d

a Draw in waterproof ink on acetate film each harmony system illustrated in the book.
b Cut circle out and pierce centre.
c Make colour wheel with 12 colour points and same size to fit acetate overlay (see colour plate).
d Place any selected acetate on circle colour wheel and rotate to find desired harmony.

THE SYMBOLISM OF COLOUR

All colours have meanings and it is significant that for every good and noble attribute there exists, for the same colour, one that is opposite, negative and undesirable.

Red This is a dark, masculine and positive colour, definite, warm and advancing, stable within its own area. It symbolizes autonomy, respect, percussion, daring, nourishment, appeal, love, sensual anger, vigour, friendship, primal thoughts, firmness, consummation, maturity, anarchy, hate, cruelty, martyrdom, disgust.

Orange-red An advancing, passionate and unstable colour, it signifies danger, domination, confidence, succulent or savoury food, practical wisdom, justice, rebellion, stress, ribaldry, impulsive conviviality.

Pink A diminished red, diluted and indicating the gentler side of red symbolism, it also can represent social wealth, bravado, inflexibility, pseudo intellectualism, predominating innocence.

Yellow This is the most visual of all colours, occupying only 5% of the spectral area but is the brightest. Understood and loved for its cultured nobility in the East, it is often mistaken in the West as a colour of negation and cowardice. It has the best recall value of all colours and produces a strong after image if surrounded by blue. It is very visible in poor light. It can also indicate excitement, latent energy, aspiration, intellectual wisdom, serenity, surface tension, imagination with self-expression, liberation, lack of structure, instability, scandal. A very active, constantly advancing colour.

Yellow-green By mixing the stability of green with the activity of yellow, the colour becomes less attractive although still advancing. It can symbolize vulnerability, superficial intelligence, cowardice, jealousy and, for food, has an inedible, unsavoury connotation.

Green A clear, fairly dark green, the colour of the deciduous forests of the temperate climate is a strong symbol of normality or psychological balance, stable within itself and offering visual rest and refuge for the eyes. Other meanings for this colour include freshness, naturalness, calm, ingenuity, compassion, charity, benevolence, sanctuary, conviction, versatility, self-determination. It can also indicate ambivalence, lack of action and disinterest.

Light green By adding white, a young, fresh and hopeful colour results, naive and full of sympathy and energy. A symbol of growth and newness. It can also indicate weakness and immaturity.

Blue-green (turquoise) A colour which is probably the most flattering to the human body, a bright advancing colour when used in shaded surroundings. Signifies confidence, discrimination, but also self-indulgence, inattention, narcissism.

Blue This colour is attractive to more people than any other, even though it is a receding colour, diminishing in area and actively putting spatial depth between itself and the viewer. It can, in larger areas, act as a tranquilizer and actually lower blood pressure, or relieve anxiety and fatigue. It symbolizes devotion, religion, reason, logic, water, distance, temperance, harmony, integrity, honourable love, holiness, diplomacy, hope, empathy, silence, boredom, unhappiness, despair and introversion.

Blue-violet This suggests ceremony, routine, idealism, feminine wisdom, self-esteem, mental concentration, meditation, mysticism, social grace, artistic aspiration, wit, sublimation, selfishness.

Purple An enigmatic colour, a joining of the passionate extroversion of red with the cool control of blue. This signifies hidden power, vanity, feminine characteristics in the male, exclusivity, anger, lack of convention, death, affectation.

Brown The colour of autumn, low key, signifying earthy, wholesome, rich appetizing attributes, suggesting sufficiency, respect, empathy, experience, academic accomplishment, duty, durability, but it can indicate obstinacy, exhaustion, decay or avarice.

Olive-brown This can signify jealousy, deceit, restriction, acceptance, obedience, mean nature and is the negative symbol of the darker side of brown.

Black This is a mysterious, haunting and majestic colour, masculine, due to its lack of light, feminine because of its mystery and suppressed sensuality. A structural, unifying and positive colour, unique and central. It can indicate conflict, horror, malice or emptiness.

White A positive, effervescent and advancing colour, also uniquely unifying. It can be very tiring in large bright areas but relaxing in modulated, uneven light. It symbolizes purity, health, lightness, spiritual strength, divinity, vitality, triumphant innocence, negation and boredom.

Grey Greys can either be warm or cool but are negative, receding colours. They suggest sophistication, faith, feminity, elegance, restraint, exhaustion, nervousness, fear, sadness or ambivalence. If used in well-controlled schemes, grey can create intense introspection.

France and the United States, artists philosophers and poets accepted the prevailing red, yellow, blue theory.

However, physicists, guided by the mid-nineteenth century discoveries by Hermann von Helmholz of Germany and James Clerk Maxwell of Great Britain accepted that red, green and blue primaries were necessary to re-constitute white light if actual light rays were being mixed instead of pigments. The most famous colour circle arising from the physicists' needs was that devised by Albert H. Munsell in 1898. These physicists' primaries are important to photographers and lighting specialists as they form the basis of additive colour synthesis (see colour plates) where mixtures of light rays emitted in the blue, green and red wavelengths can add up to an impression of white light. Pointillism and Impressionism were the first to apply this physical theory of colour to art.

Apart from these experimentalists, the normal art primaries of red, yellow and blue were applied to pigment and ink mixtures and are still used by painters and lithographic printers. When mixed correctly almost any other colour can be made but it is usually necessary to add black to get sufficient strength and depth in the other colours if they are to be applied to paper or white backgrounds.

Subtractive colour synthesis, which allows colours to be created by taking out selected elements from white light, is important because it applies to colour photography. The colours are complementary to the additive primaries and are formed by taking away one of these primaries from white light. They are given special names, cyan (blue-green) yellow and magenta (red). Cyan is white light minus red; magenta is white light minus green; yellow is white light minus blue. (See *Colour Synthesis*.)

Because the human eye is thought to see four elementary colours – red, yellow, green and blue primaries – a third important set of spectrum colours came into being as primaries for psychologists around the 1870s. With the neutrals, white and black, these colours principally influence the emotional reading of colour. The Ostwald system was devised by Willhelm Ostwald about the time of World War I and is based on this set of primary colours.

The photographer who is designing his image to achieve a pre-conceived impact will need to control colour as well as form, texture, mood, etc., and the right choice of colour and its positioning in the frame will assist and interact with all factors of image management. A familiarity with a painter's colour wheel (see the colour plates for *Colour Photography*) will be of use and trial harmonies can easily be constructed with it (see figs on pages 80 and 82).

Some general principles have begun to emerge in the deliberate use of colour as a means of communication and photographers should be more familiar with them. Response to colour by the viewer is always subjective and always modified by the individual's philosophy, psychology and experience. Colours should always be used at a level which will be understood by those with whom communication is desired. Colour harmony is the systematic management of area, brightness and position of colour to give a desired visual communication.

COLOUR NEGATIVE

This is a photographic film where the image from the camera is produced as a negative and the colours are recorded as the complementaries of those in the original scene (see the colour plates for *Colour Photography*).

COLOUR PHOTOGRAPHY

Colour photography is very recent in the history of the photographic medium and was pioneered by the Lumière Bros during the early years of this century. Today, colour materials are so easy to work with and produce such excellent results, that millions of people are forgetting the existence of black and white photography.

It is true that from a technical point of view it is now probably easier to produce aesthetically pleasing colour prints than B/W, and Kodak, Agfa, Fuji, 3M and the remarkable Cibachrome are names upon which to rely.

Those who have had a good grounding in serious B/W work will find it easier to begin colour photography and processing, as the precision necessary for the proper handling of

HOW TO EXPOSE COLOUR FILM FOR PERFECT COLOUR BALANCE

Buy bulk batches of film of the same emulsion number, correctly date stamped, from a reliable professional dealer who stores in good deep freeze conditions.

Hold in deep freeze at 0°C (32°F).

Warm up two hours to room temperature.

Read manufacturer's data sheet.

Test one sheet with spectrum held against flesh tones.

Process immediately.

Adjust exposure if required, test again with CC filters as necessary.

Make a note of filtration and batch numbers.

Begin to shoot and *list* exposure for *every* sheet or roll, together with subject matter.

Bracket exposures.

Always use the same processing routine or lab.

Always hold in reserve at least half of all exposed material until the client sees results.

Assess all transparencies on bright viewer with lamps at 5500K, with all excess light masked off.

Modern scanners will need half a stop under exposure for good reproduction.

Never store exposed film near heat or longer than one week even in cool conditions.

NIGHT PICTURES WITH 100 ASA FILM

Street scenes and rain	1 sec. f5.6	Tripod
Neons, no surrounding detail	$\frac{1}{15}$ sec. f5.6	Tripod
Shop window displays; bright	$\frac{1}{8}$ sec. f5.6	Tripod
Shop window displays; moody	$\frac{1}{4}$ sec. f5.6	Tripod
Buildings; floodlit, dusk	5 sec. f5.6	Tripod
Theatre, pop concert, circus, if spotlit	$\frac{1}{15}$ sec. f2.8	Tripod (do not use flash)
Ice shows; brilliant lighting plus spot	$\frac{1}{15}$ sec. f5.6	Tripod (do not use flash)
TV colour screen	$\frac{1}{8}$ sec. f2.8	Tripod (use Wratten CC 40R filter)

WARM-UP TIME TABLE FOR PHOTOGRAPHIC MATERIAL HELD IN COOL STORAGE

Film	From a refrigerator at 10°C (50°F)	From a deep freeze −18°C (0°F)
135mm cassettes	1 hour	2 hours
135mm bulk roll	3 hours	5 hours
120 roll	$\frac{1}{2}$ hour	1 hour
Polaroid s × 70	$\frac{1}{2}$ hour	1 hour
Polaroid other packs	1 hour	2 hours
25 sheet box large-format film	1 hour	2 hours
50 sheet box large-format film	2 hours	3 hours
Paper		
100 sheet box 20 × 25cm (8 × 10 inch)	2 hours	4 hours
50 sheet box 40 × 50cm (16 × 20 inch)	2 hours	3 hours
50 metre roll, any width	4 hours	10 hours

Lay all packages out individually, with some space between each, while thawing takes place.

monochromatic materials is only a little less than that needed for colour. Time and temperature control is more exacting, work must go on in complete darkness and cleanliness should be maintained to laboratory standards. By following precisely the manufacturer's instructions for the exposure, processing and printing of the chosen colour system and taking adequate steps to assure control as mentioned above, excellent results will be forthcoming.

Colour photography as an art form, however, is something different and presupposes a knowledge of the language of colour and a serious interest in using colour creatively as a force in itself, quite independently of the technical photographic production of the medium. Modern colour record, both professional and amateur, has now been reduced to a point of almost automation and yet in the billions of colour photographs taken each year few are memorable and so very few are art.

This is without doubt because, in the fascination of the mechanics of the process and the excitement of the result, the photographer often overlooks the fact that colour is a powerful symbol for all observers, has its own complex behaviour and can be used for its own sake in any industrial, leisure or art communication. Those who aspire to fully use the marvellous chemistry given to us in modern colour systems must embark on a lengthy colour education and in this book some relevant highlights may be found in the following sections: *Archival Processing and Storage, Colour as Seen, Colour Harmony*, the

colour plates for *Colour Photography, Enlarging, Fine Art Photography, Light, Vision, Colour Enlarging, Lighting, Colour Synthesis, Colour Composition, Colour Spectrum, Colour Temperature, Colour Balance, Colour Film Storage, Colour Fading*, the table *Night Pictures* here, *Filters*.

COLOUR AS SEEN

When an object absorbs all of the white light except red which it reflects, we see this as a red object; when only the blue wavelengths of light are reflected the object is seen as blue, and so on. If a mixture of equal amounts of the spectrum are reflected the colour we see is white.

Modern colour photography depends on the use of the additive primaries mixed in pairs to produce exact complementary primaries. Blue and green make cyan; blue and red make magenta and red and green make yellow and these are the names used for the colours formed in photographic colour film. These colours, plus black, are also the printing colours used to reproduce colour engraving for any lithographic illustration.

Only man, amongst all animals, possesses a comprehensive capability for full colour vision. The eye has a number of receptors (cones) capable of stimulation by the additive primaries of the red, green and blue. When these are energized by incoming light the brain can produce full colour

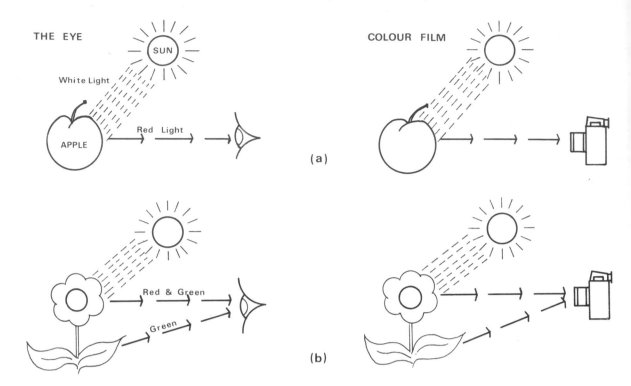

THE EYE

COLOUR FILM

White Light

SUN

APPLE

Red Light

(a)

Red & Green

Green

(b)

a The eye sees the red wavelength only as this is reflected from the object. Other colours are absorbed. Red is reflected to the film and the red layer acquires density while other layers do not.
b Red and green light reflected from a yellow flower are seen by the eye as yellow. Green reflected from the leaf is seen as green. Other colours (e.g. blue) are absorbed. Density, in the colour film, appears in the yellow and cyan layer to form green, in the yellow layer for the yellow flower.

vision (see *Vision*). There was considerable controversy among psychologists whether a fourth receptor exists, devoted to yellow, and many used to list the primaries of seeing as red, green, blue and yellow. However, none of these colours when mixed in simple patterns in the laboratory can produce the metallic colours such as bronze, silver or gold and recent experiments show that complex patterns symbolizing real life change the actual perception of colour and more colours are seen than really exist as component parts of the scene. It seems that certain colour sensations can correctly be produced in the brain only when the viewer decides, beforehand, on the nature of the object. A bar of silver, for example, will be seen as metallic colour only when it has been identified as being metal. In many situations the eye will award whiteness to those lights which are brightest even if, on analysis, they can be shown as light yellow or blue. Perceived colour is therefore an extremely complex matter and the relationship between vision and experience should not ever be forgotten. We all see the same physical colours in uniquely individual ways even though certain cultures have established reasonable generalizations about our reaction to colour. Seeing is a philosophical concept rather than a solely physical matter and this contributes enormously to the fact that, to an extent greater than any other medium, with perhaps the exception of music, photography can create mood. (See *Colour Harmony, Vision*.)

COLOUR SEPARATIONS

By using special filters which isolate a very narrow band of the spectrum in the primary colours of red, blue and green, it is possible to make on black and white panchromatic film, a full record of a transparency even though colours are condensed to these primaries. By using cyan dye for the red separation, magenta for the green filter and yellow for the blue filter record and then overlaying these colours in perfect register the original transparency is seen once more in full colour. This principle is used in the Kodak Dye Transfer Process and in many photo-mechanical print systems. (See the colour plates for *Colour Photography*.)

COLOUR SPECTRUM

The oscillating behaviour of electrons produces wavelengths of energy which constitutes the electro-magnetic spectrum, only a small part of which is visible to the eye and is called *white light*. Photographic film can be made to record some of the invisible spectrum also, notably infra red, ultra violet and x-rays.

White light is composed of a mixture of warm and cool colours, and can in fact be simulated by an equal mix of red, green and blue light. Wavelengths are measured in units one billionth of a metre in length, called a *nanometre*, longer wavelengths being characteristic of reds, oranges and yellows and shorter wavelengths identifying greens, blues and violets. Electro-magnetic energy, including light, travels in air at about 300,000km (186,300 miles) per second. (See *Colour as Seen, Light, Vision*.)

COLOUR SYNTHESIS

Additive colour synthesis
This is a method of creating full colour effects by combining correct proportions of primary colours, usually pure red, blue and green wavelengths of light which have been isolated from the visible spectrum. The eye synthesizes these into a full impression of colour. Pointillism, television and early colour processes such as that of Lumière use this phenomenon. (See the colour plates for *Colour Photography*.)

Subtractive colour synthesis
This begins with white light, then part of the total spectrum is removed by the use of a subtractive primary filter. A magenta filter will remove green light from white, leaving blue and red mixed, while a yellow filter will remove blue light leaving red and green, etc.

By combining filters in equal amounts, various colours result:

Magenta and yellow	=	Red
Yellow and cyan	=	Green
Magenta and cyan	=	Blue
Magenta, yellow and cyan:		
100% equally	=	Black
75% equally	=	Magenta
50% equally	=	Cyan
100% yellow	=	Brown
50% magenta, 100% yellow	=	Orange

Photographic colour processes and lithographic printing processes depend, for success, on the subtractive colour synthesis theory. (See *Colour Enlarging, Filters, Colour Harmony, Light, Vision*.)

COLOUR TEMPERATURE
This is a scale which is used by photographers to signify the warmth and coolness of light. It is based on the work of the English scientist Lord Kelvin (1824–1907) who found that when a black body, that is to say a perfect absorber of radiant energy, was heated to a selected temperature, part of the radiant energy absorbed was visible as light. For example, dark red was visible soon after 500°C (930°F) temperature was reached by the black body; yellow appeared at twice that temperature and blue at a higher temperature still. The colour of the light source is specified as degrees of Kelvin. For example, type B film should be exposed by a photo-lamp which burns at a colour temperature of 3200K, while most daylight films will reproduce colours accurately if exposed to a

APPROXIMATE COLOUR TEMPERATURE OF COMMON LIGHT IN DEGREES KELVIN

Fire light	1000
Candle flame	1500
House lamps	2500–3000
100 watt, tungsten-filament lamp	2850
500 watt, tungsten-filament lamp	3000
500 watt projection lamp	3200
Halogen floodlamp	3200
White, No. 2 photoflood, reflector flood	3400
Reflector floods (except R32)	3400
Warm, white, fluorescent lamp	3500
Foil filled flash lamp	3800
Cool, white fluorescent lamp	4500
White-flame carbon arc	5000
Noon sunlight temperate zone	5200
High-intensity sun arc	5500
Direct sunlight between 10 am to 3 pm (average)	6000
Blue expendable flash lamp	6000
Daylight fluorescent lamp	6500
Sunlight plus light from blue sky at noon	6500
Light from overcast sky	6800–7000
High speed electronic flash tubes	5800–7000
Light from hazy sky	7500–8400
Light from clear blue sky in afternoon	10,000–27,000

much colder light, for example that of noon sunlight or electronic flash, both of which radiate light energy in the vicinity of 5000 to 5500K. For exact colour reproduction it is important to read the manufacturer's data and balance the film's required colour temperature to that of the predominant light source, using filters on either cameras or lamps to reach equality.

A colour scale of the spectrum, including a grey scale, should be photographed in tests for colour balance. (See also *Filters, Colour Balance*.)

COMPENSATING DEVELOPER
This is a developer of a type which allows shadow detail to increase by restraining the developing action in the highlight areas. Minimum agitation is needed as the bromide released in the vicinity of dense areas on the negative must be left undisturbed to continue its inhibition of development. Some sheet films respond well to this type of development especially if the subject has been lit by flash and is of inherently high contrast, for example, people of pale complexion who are wearing dark clothing. Grossly over-exposed film can be rescued by using these developers, but development is very slow. Kodak D23 is a suitable and simple developer of a mildly

compensating type, introduced in 1944. Tank development is between ten to 20 minutes at 20°C (68°F). To make this developer use water 50°C (125°F), 1500cc; metol or Kodak Elon, 15g; sodium sulphite (anhydrous) 100g and cold water to make 2000cc.

While the above may produce mild compensating action the Windisch variation often is more effective. Again development is slow, nearer to 30 minutes for many films and there is some fall-off in emulsion speed.

Windisch metol formula
Water at 50°C (125°F), 1500cc; metol, 5g; sodium sulphite 50g; water to make 2000cc. Agitate only during the initial development and leave undisturbed. Discard this developer after each batch. An interesting experiment with this developer, if you use a view camera, is to take one sheet and leave it in the bottom of a tray of developer for as much as one hour. A very long scale, rich negative will result and after some experiment, exposures can be adjusted according to development. This is a useful technique in certain landscape photography.

COMPLEMENTARY COLOUR
This is the colour which is found directly opposite any chosen colour on a colour wheel or triangle. Complementary pairs are infinitely variable and can be strong or weak in saturation. Examples of complementary colours in the primaries are: red, the opposite of which is green, blue opposing orange, yellow which is opposite and complementary to violet. (See *Colour Harmony* and the colour plates for *Colour Photography*.)

COMPOSITION
(See *Image Management*.)

CONDENSER ENLARGER
(See *Enlarging*.)

CONTACT PRINT
This is a print made to exactly the same size as the negative, by placing the negative or a sheet of negatives in contact with photographic bromide or chloride paper and exposing it briefly to a light source.

The contact prints are important sign posts for serious photographers, as this is the first time the full positive image is seen. Before the expense or time of enlarging is undertaken, all negatives should be contacted and given a file number. A meticulous search of the images should be made by using a small *cropping* device and a magnifying glass to identify the best section of each frame. This is the second best time to edit a roll of film (the best being in the viewfinder while the camera is being used) and it is an essential part of achieving high quality enlarged prints and dynamic composition. (See *Enlarging, Basic Photography*.)

CONTAX RTS
This is a 35mm SLR format system camera, with superb handling and reliability. Excellent exposure estimation by automatic metering which is shutter preferred, with an infinitely variable speed range from 16 seconds to $\frac{1}{2000}$ of a second. A suite of excellent Zeiss lenses is provided, but the camera also takes cheaper Yashica optics. Motor drive is an added accessory, making the unit quite heavy, but still well balanced. Viewing is bright and controls are well placed for fast, professional operations. Manual controls, including exposure compensation, are included but the entire photographic system in all modes, including mechanical, depends on battery power, with no operation possible in the event of failure. Average professional use suggests a six month life to the battery power, but spares should always be carried. Adaptors are available for a bypass circuit that permits camera operation from AC household current. This is one of the really good systems at present on the market, giving the best of Japanese electronics linked to the finest German optics.

CONTRAST CONTROL
To achieve the fullest potential of the modern chemistry now available to photographers, it is usually necessary to understand how to control contrast in photographic film. Colour photography will certainly exaggerate the contrast in any normal sun lit situation and even the best of B/W film, however long scale the potential, will always require a very careful exposure and, subsequently, very careful processing in these conditions.

If the sun is behind and above the photographer during an outdoor session contrast will be reasonably close to the scale of tones which can be handled without special care, but in all other situations contrast can cause problems. Contrast in light creates a shadow-to-highlight ratio which often the film cannot reproduce so, in the case of colour, shadows must receive augmented lighting (see *Lighting*). For B/W materials, augmented lighting, plus processing control, may be required.

To improve shadow detail when working with colour film, there is only one affective solution: add light to the shadows. This can be done with flash on camera or with large white reflectors, about 1 metre (3 feet) square if the key light is from the sun, or by using a weaker and diffused secondary light, if artificial light is the main source. On overcast days it is often possible to use the main daylight as a fill light, but add a warming filter, such as Kodak 81A or CC .05R, to the camera, then use a strong, direct, electronic flash which is placed off camera and becomes the main key light.

For B/W photography the above is true also, but further assistance may be obtained by altering the normal processing times or using non-standard developers. By over-exposing B/W film, by about 20%, and under-developing by about 20–30%, great improvement is made in rendering shadow detail.

If a compensating developer is used also, such as Kodak 23, Patterson Aculux or May and Baker Promicrol (diluted 1:2), quite extraordinary detail is produced in the shadows while still retaining printable highlights. If either tungsten or

flashlight is used for B/W photography indoors, further control is possible, by adjusting lighting ratios.

Contrast may be reduced in any film by using diffusing filters or a gauze over the lens, although this will also lower definition. A colour image which is being made with a view camera may also be diffused and have its contrast lowered if the inside of the bellows are carefully lined with thin white card. This has the effect of bouncing light within the camera, producing considerable flare and therefore de-saturation of colours and lower contrast.

Films or enlarging paper may have their contrast altered by pre-flashing or post-flashing to a much reduced light source before or after exposure, but before processing. This technique is basically a fogging technique and the image is given a brief exposure to low intensity light, in the case of films equal to about 1% of normal exposure while the photographic material is removed from camera or is not being exposed to any image forming light. It is usually accompanied by a slight increase in speed. ND filters are often needed, possibly at 2.0 density, to help lower the light value which falls on the film, but tests are needed. (See *Filters, Neutral Density Filters, Flashing*.)

In colour copying if materials are being used which are not made especially for copying, pre-flashing is advisable to reduce contrast. Film speed will certainly increase, about two-thirds of a stop for colour, but if B/W is being exposed nearly two stop increases may be achieved this way.

Test and experiment if this technique is being explored, as each film-developer combination has different behaviour and, obviously, if too much flash fogging exposure is given, muddy, over-exposed and often unprintable negatives or transparencies can result.

For B/W bromide paper, a little skill can be acquired whereby a hard grade paper, 4 or 5 contrast, becomes the only paper used for all negatives, flash exposures being used to alter contrast according to need. Local flashing from a shielded torch can be used during development of the print to subdue unwanted detail and to lower contrast in selected areas (see *Enlarging*). The general rule for B/W is: expose for the shadows and develop for the highlights, while for colour, lowering contrast is only possible by augmenting shadow areas with more light. (See also *Flashing*.)

CONTRE JOUR

This is an outmoded term, once much loved by camera clubs and romantic pictorialists and means 'against the light' or 'back lit' photography. (See also *Chiaroscuro*.)

COPYING

It is surprising how many times photographers will find the need to copy other photographs or flat originals, and while the technique is simple some basic equipment is essential. Two lights at least, a sturdy tripod and a camera that can be operated without parallax problems can provide the basic set-up (see fig. C21). A view camera is by far the best means of working because of the availability of a wide range of

emulsions and the possibility of processing only one exposure at a time in various developer combinations.

For 35mm SLR cameras, vertical copy stands can be bought quite cheaply and some enlargers can be converted for the same purpose. The two primary problems are to achieve perfect stability of both camera and copy platform and to ensure that the film plane is maintained exactly parallel to the copy board at all times.

It could be necessary to use close-up photography techniques and the use of macro or process lenses will produce best optical results. If a normal length lens suited to close

Simple stands and small electronic flash units like these make professional results easy to obtain when copying 35mm slides to same size.

focus distances of 3 metres (10 feet) or less is not available it is advisable to use long lenses rather than shorter, as their flat field produces better edge definition and less fall-off in lens illumination. Better quality lenses will not generally produce flare which is another hazard to overcome in order to achieve good copies. Flare can come from dusty lenses, light bouncing around the inside of the camera, from light colours around the copy board or from the lights used to illuminate the copy itself. Lights should therefore be hooded in deep reflectors or barn doors should be used and a suitable lens hood should be on the camera. A view camera with box bellows makes by far the best copying camera, especially if it is fitted with a large compendium lens hood which also carries filters.

Long exposures should be made by the use of a cable release if slow tungsten light film is being used. Reflections of the camera or the operator may appear in shiny originals or in the glass coverplate, if one is used to hold the copy flat, and these must be avoided by cutting matt black paper masks to fit the front of the camera and by using the barn doors on the lights to prevent stray light from hitting the camera or operator. Black gloves may also be needed.

Polarizing screens are useful in reflection control, particularly if the original has a mottled or grained glossy finish. These are used over the light source as well as the lens and this can increase exposure ten to 20 times. Tests must therefore be made. Colour filters may be necessary to correct colour if a colour film is used or in B/W if certain effects are required (see *Filters*). A hand-held exposure meter fitted with a probe, such as the Minolta Autoflash, is useful to get precise, even illumination levels over the whole copy area as this is almost the only requirement of the lighting plan.

If the assignment requires the photographer first to make continuous tone prints and then copy them, it is advisable to make low contrast, long scale prints with maximum shadow and highlight detail. The print will look considerably flatter than a normal viewing print. Contrast gain in the copying will then restore them to very fine copies. Negative processing of B/W material can easily be adjusted to achieve contrast control and it is useful to have several developers available: D76 or ID11 developer for long scale copies, a DK50 or Qualitol type developer which produces crisp negatives from flat originals and a two-part lith developer for high definition line results. Various film stock is also needed and should include a medium speed, low contrast, panchromatic emulsion, an orthochromatic film with long scale (the best general one seems to be Kodak Gravure Positive) and a fast lith film such as Kodalith Type 3. For continuous tone, multi-coloured originals and for many B/W subjects Polaroid positive/negative film type 55 or 667 will produce highly acceptable results. The negative is almost grainless and the contrast excellent for subsequent printing, while the panchromatic emulsion renders all colours faithfully. It is usually necessary to over-expose this material by about half or two-thirds of a stop in order to get suitable density in the negative and this will, unfortunately, waste the print. This type of negative generally needs printing on a 3 contrast paper if the print is to be further reproduced by a photo-mechanical process.

Colour copying of transparencies is a frequent need for photographers and it is not always possible to use the special low contrast duplicating film made for this purpose. Pre-flashing each exposure before the copying exposure is a useful and predictable way to lower contrast. This technique requires that the original transparency is removed from the copy stage, a 2.0 *neutral density* filter (*not* a 0.20 filter) is placed on the camera lens and the first exposure given. The ND filter ensures that this exposure will be $\frac{1}{100}$ of the final exposure. Without moving the film (use the rewind button on SLRs while the shutter is re-set) the original is replaced on the copy stage and a slightly shorter than normal exposure is given. Contrast will be satisfactorily lower even if normal camera film is being used. Tests should be made before any quantity of work is done with this method. (See *Filters*, *Flashing*, *Contrast Control*, *Lighting*.)

COPYRIGHT

Anyone who anticipates receiving money for photographic material or uses photographs in any public way should be familiar with some general facts about copyright as it applies to photographic images.

In the United Kingdom, the law is still very complex and is undergoing some revision. At present copyright does not automatically belong to the photographer and unless agreement is made to the contrary, it can often belong to those who commission the photograph and pay for the materials and processing. Portraiture in particular awards copyright to the sitter and not the photographer, although the photographer owns the negative and no unauthorized print making can be done without his/her agreement. No use of the photograph, however, can be made without the permission of the sitter and in all such cases a written authority should be obtained from the person photographed. If the subject of the sitter is to be used for commercial or advertising purposes a more detailed release (see *Model Release*) should be used.

Photographers in the United Kingdom who wish to protect their work can do so by placing their name, the word 'copyright' and the date on the back, or front, or both, of the picture and indicating in all relevant invoices and contracts that copyright is retained by the photographer. In the USA a recent alteration of the law permits photographers to register their images at the Library of Congress Copyright Office, Washington, DC 20559. By sending details to the Registrar on Form VA, plus suitable copies of those pictures to be copyrighted and the correct fee, the photographer's work will be protected during his/her lifetime plus 50 years. Published and unpublished work will thus be protected. On each image, the photographer's name, date and the fact that it is copyright material should be indicated clearly.

As in the United Kingdom, where a photograph is used for its news value or for educational purposes, or in a critique of the work for art purposes, permission is not needed in the USA from either the subject or copyright owner. All other uses do require written agreement.

Copyright is a complex and important subject, so professional help should always be sought in preparing contracts,

invoices, agreements and releases. Use a legal expert in the field or, if based in the United Kingdom, seek the advice of an organization called Art Law, 358 The Strand, London WC2. This organization was formed to give advice to all visual artists on related legal problems. On all images which leave the photographer's care, it is important to place a clear indication of the date, owners' name and the word 'copyright', or its recognized abbrevation which is ©.

COVERING POWER

This term refers to the area of acceptable definition delivered by a lens and, in general, the use of longer lenses and stopping down will improve the definition for a given format. Special lenses are made, usually for view cameras, having a wide field and these normally are shorter focal length lenses yet which have large circles of illumination, thus permitting increased covering power and shifts in the camera movement (see *Large Format Cameras*). Wide angle lenses in small format cameras also have improved covering power but the fall-off of definition and illumination is sometimes very noticeable here, especially in the cheaper versions of ultra-wide lenses and it is necessary to use these far below their fastest aperture. When buying any lens shorter than the normal focal length, especially if these claim to be very fast, it is advisable to buy the best lens affordable but first camera-test it with medium speed film, making an enlargement of 18×24cm (8×10 inches) of the resulting negative. (See *Lenses*.)

C PRINT

This is an old fashioned name for a Kodak print process which needed an internegative to produce colour prints from positive transparencies. In a generic way it has now become an idiomatic description for any print which is made from a colour negative, whichever manufacturer's process is used.

CRITICAL DISTANCE

The deep subjectivity in man conceals primal feelings which normally rise to the surface only during stress, while in those who are nervous or psychologically upset this may be present more or less continuously. One of the most demanding of our unconscious primitive instincts is that of 'flight or fight', when we are approached by strangers who invade our personality by overstepping the critical distance.

Just as an animal in the forest will decide if new and volatile situations signal danger or reward, so even very sophisticated individuals will either intuitively accept or reject the approaches of outsiders. It has been suggested that animals and mankind are enclosed in a bubble-shaped, pericorporal space, which in man is a fluctuating, invisible envelope, 50–150cm (20–60 inches) deep, around the body. The size of the bubble varies according to social class, race, temperament, or mental health. When a stranger approaches this bubble we make a primitive, instinctive assessment of the situation and a response is triggered according to the degree of acceptance to the new circumstances. The stranger who proceeds past the

critical distance can often be considered hostile, creating nervousness, stress, evasion, etc., in the subject and even could cause tears and flight.

The bubble indicates the personal zone within which only those with whom we are at ease, can enter. Anglo-Saxons tend to carry an extended and rigid bubble with them, treating unknown individuals with reserve or resentment should they trespass on even somewhat distant spatial barriers. Latin people, however, are generally extrovert, embracing, touching, talking at close range to the stranger and they, just as those trained to overcome inhibition, such as actors, models or public figures, will draw the bubble closely about them, unafraid of close intrusion. Beyond the pericorporal space lies a second flexible zone, extending some $2-3\frac{1}{2}$ metres (6–11 feet) from the body. This is where eye contact or visual intimacy can either be acceptable or otherwise. In many people this secondary zone of inhibition can prevent effective communication unless approached obliquely. Hence conferences among strangers are better if they take place at circular or oval tables.

The photographer who is aware of these mysterious psychological factors can produce better pictures of people, especially the close-up portrait, than is otherwise possible. Faced with a reserved or extremely nervous subject, who extends the pericorporal space, the photographer will use a long lens to obtain close-ups without violating the zone. By the use of music, easy conversation and a relaxed environment, the sitter can be calmed, the bubble contracts and shorter lenses can then be used. If the subject is a professional model or actor or is used to being photographed or is well known to the photographer, rapport is easy and swift, making it more possible to make close-ups or wide angle portraits without creating tension. With shy or nervous people it is also advisable to place the camera in position but operate it from an oblique point, by long cable release, so that the photographer will stand or, preferably, sit at an angle of $45°$ to the sitter. Eye contact may be made then without effort but may be broken at will. The increased conversation and empathy generated this way will often contribute to spontaneous and delightful portraits. (See *Portraiture*.)

CROPPING

The photographer's term for shaping and restricting the image to its most important essentials (see fig. overleaf). Many photographs are too loosely composed and have much irrelevant detail which detracts from the subject. Before enlarging begins it is useful to see how much can be eliminated from the image without losing any communication. Often, vertical pictures can be made stronger by cropping them to a horizontal format or vice versa, or familiar things can be partly cropped out of the picture, enhancing their mystery and the internal structure of the image can be considerably tightened up by the sensitive use of the cropping frame. It acts for the print very much in the same way as the zoom lens does for the viewfinder image during the original photography.

The use of cropping L's at the contact and test print stage is

CUNNINGHAM, IMOGEN

Make two large L shaped pieces of black cardboard and always crop the work print to make sure that only the most relevant part of the image is used. Then return to the darkroom and make the final print.

habitual in most advanced workers and this seeking for simplification of the image until it contains its most striking and relevant components, is a basic need for all serious photographers. (See *Image Management*.)

CUNNINGHAM, IMOGEN (1803–1976)
Born in Oregon and a founder member of the F64 Group, she began to study photography at 17 by correspondence course. Later she was to become a well-known pictorialist, famous portraitist, respected teacher and succesful exhibitor. She is possibly best known for her clarity of technique, her lively portraits and her sensitive pictures of organic forms. Her original prints command high prices.

CUSTOM LABORATORIES
These are processing stations established usually for professional photographers but available also to the general public. Special attention is given to individual needs and the service is more costly than at normal bulk processing stations. For push processing, special effects or exhibition work, or any work requiring very high quality, it is advisable to use these custom processing laboratories.

CYAN
An important filter for photographers, this is considered a photographic primary along with magenta and yellow. Its colour is a light turquoise blue and it subtracts the red light from white, thus leaving green and blue.

D76
Invented by John Capstaff of the Kodak Research Laboratories in the late 1920s as a fine-grain motion picture developer, this formula is one of the most used and useful of all. In fact if no other developer than this were available for high-quality continuous tone results, most photographers could achieve perfect negatives. Although fine grain depends largely on the film used, this developer produces excellent gradation, moderate grain, full emulsion speed at normal development, keeps well in solution and can be replenished if necessary. Many advanced darkroom workers use D76 at a dilution of 1:1 as this greatly improves acutance and lowers contrast. Used at this dilution with judicious over-exposure and under-development, beautiful long-scale negatives may be made (see *Contrast Control*). When diluted, D76 must be discarded after every use. Ilford ID11 marketed in 1939 and Dupont 6-D are basically the same formula. Ilford have recently bought out a modified ID11 formula with a sequestering agent added. Results from tests indicate more brilliance in the shadow, or black areas, better grain patterns and more acutance.

D76 FORMULA

Water	1500cc at 50°C (120°F)
Kodak Elon or metol	4.0g
Sodium sulphite (dessicated)	100g
Hydroquinone	10g
Borax (granular)	4g
Cold water	To make 2000cc

DAGUERRE, LOUIS JACQUES MANDE (1787–1851)
A French scenic artist who specialized in the giant and gauzy murals used in his own Diorama theatre and who sought an easier method to produce them. He and Joseph Nicéphore Niépce are credited with the invention of photography, although a number of other workers in this field were also independently reaching the same point at about the same time.

Niépce was able to produce images on chemically treated metal plates almost a decade before photography was officially

given to the world by the French government, but these images were not really practical. After the death of Niépce, Daguerre accidentally discovered the technique of fuming silver iodide plates with mercury, leading to the invention of the Daguerreotype and to the public disclosure of the process on 19 August 1839. The process was quite functional and swept the world.

Only in England, Wales and the British Colonial countries was the process patented by Daguerre, therefore limiting its popularization to these areas. The Daguerreotype was a unique one-off image and was superseded ten or 12 years later by the negative/positive paper process invented by William Henry Fox Talbot, which allowed the mechanical and unlimited production of facsimile images from a master negative. (See photograph under *History of Photography*.)

DANCE PHOTOGRAPHY

Many photographers will find interest in using their skills to record dance movements and these could be as various as Balinese dancers in stately, oriental classics, a vivid acrobatic performer at a brightly lit disco, or highly developed rituals of ballet within the conventional traditions of the stage. In between, come impromptu moments in ethnic dancing seen while on vacation, local dramatic society performances and the appealing activities of the very young aspiring dancers at neighbourhood dance schools.

When photographing public performances a warning must be given – on any such occasion it is necessary to obtain permission from the recognized authorities who control the performance. It is not sufficient just to have the dancers' permission. All pictures submitted for publication will need to carry a release, properly signed by the right person and the onus is usually on the photographer to take all legal responsibility in the matter. Whatever the occasion, permission must, as a courtesy, be obtained from the dancers and their co-operation sought in the activity. It is also advisable for the photographer to arrange to attend rehearsals. It is essential to know something about choreography and, if at all possible, one should go to a professional dance centre and take some elementary lessons in order better to understand this subject. Dancers will always work to a given viewpoint, usually towards the audience and they will also work within a defined area of space. This will require the photographer to place the lens in that chosen viewpoint if the dancers' movements are to make sense or to be seen to best advantage.

Equipment for this type of photography should be minimal and as silent as possible, while flash should rarely be used except when the dancers are performing solely for the photographer, such as when publicity pictures are being taken at the direction of the management.

It is far better to use small 35mm cameras equipping them with fast lenses of at least f2, fast film of 400 ASA speed and above, and having lens focal lengths available which are longer than normal. If an actual theatre performance is being recorded it may be found that the photographer's best viewpoint is from the very front of the dress circle balcony and a long lens will be needed in order to fill the frame. The

photographer should take care in this instance not to disturb the pleasure of the audience and should use a lightweight tripod, a camera that is as silent as possible, such as Rolleiflex twin lens reflex with a leaf shutter or a Leica rangefinder camera. Many SLR cameras are far too noisy for this sensitive situation and the photographer who disregards the above advice may find him/herself removed by the ushers even if he/she has management instructions to take these pictures. The photographer's best position is an aisle seat in the centre section of the front row. Failing this, a crouching position in the aisle, with camera lens just clearing the balcony rail (take care to avoid spot lights as heat from these can sometimes diffuse an image) will create the least interference to those behind the photographer.

The beginner will not often get involved in the above public activities and can get great enjoyment in using outdoor situations. Here the biggest problem is the background, as the picture will look hopelessly mediocre unless the dancers' movements are sympathetically integrated into a suitable environment. Obviously a classic ballerina is less likely to be seen in an outdoor situation than a gypsy dancer and while the juxtaposition of the unexpected is an old trick of the professional, it takes skill and preparation to bring it off successfully. The classic dancer could, however, be placed against a simple woodland setting, the sky, or a calm lake, while the active modern dancer could be photographed in moody streets, old warehouses, or lonely highways. Background should be subdued somewhat in tone, simple in form and must always be supportive of the dancer rather than be a visual distraction.

Lighting and equipment is far simpler for these outdoor pictures than for any other, as poses may be struck and held and normal viewpoints may be taken. Medium-speed film, lenses of normal or only slightly longer focal length and natural light make the job easier. Back lighting with a synchro flash fill-in (see *Lighting*) can help in muting a busy background and adds considerable dimension to the figure.

In photographing dance movement, by far the most control is obtained when the action takes place in the photographer's own studio or a small rehearsal room. Mirrors are useful to both the dancer and the photographer in such a project and if the room has not been equipped with a large full-length mirror, one will be needed. In the studio this is placed immediately beside the camera so that the dancers can see the effect their bodies are creating and it allows the photographer to wait until they are satisfied that the line and position are correct. Even action dancing can benefit from this arrangement and the mirrors can have other uses for providing double or triple images when they are included in the actual picture.

Studio pictures can be posed and caught on slow film with large format cameras or can be made on medium or small format cameras using electronic flash or tungsten light. Action will usually need flash but professionals should note that many very large commercial flash units used in studios do not produce a flash of short enough duration to stop really fast action (see *Electronic Flash*). All action sequences should be rehearsed and run through, while the photographer decides

on focus points, lighting and image composition. To caption peak action the shutter must be fired moments before the limit of such action and some skill is required to achieve this anticipation.

Backgrounds, again, must not intrude and often the spatial effect of seamless photographic paper is used to achieve this in the photographic studio. The full roll width of 3 metres (10 feet) will be needed and of course something to suspend the roll well above the dancers' highest reach (see *Studio Planning*). A focus guide point is often useful on this featureless background and a small 2.5cm (1 inch) square of adhesive tape is quite sufficient. A trained dancer can always finish the most important movements on this guide point, using the camera as an audience viewpoint and hitting this spot accurately in many rehearsals and for the final exposure.

The use of multiple sharp images to produce a stroboscopic effect of movement or the blur of action by using slow shutter speeds, or a combination of these effects in one image, is often a productive area for experiment. Multiple colour effects can easily be obtained by the use of colour filters over several light sources, with the dancer being photographed on the one single frame as a montage (see *Image Synthesis*), by either firing the shutter each time to record the different positions of the dancer or by using multiple flash manually fired in sequence during a one second exposure. A totally blacked-out studio is usually needed for this exercise.

For those who find the difficulties of making photographs of performances too great, many charming and interesting pictures are found in the disciplined life of the dancer where quick, candid fragments of that life may be far more compelling as images than the actual dance. The elegant paintings and sculptures of Degas may serve as an illustration. The classroom, rehearsals, dressing room or the dancer buying shoes, all have moments when a sensitive photographer can obtain successful pictures in colour or B/W. In these assignments the co-operation of the subject, the research undertaken by the photographer, and his/her awareness of the subtlety in the mood of the subject will make for the most successful results.

DANGEROUS CHEMICALS

GLACIAL ACETIC ACID Vapour is flammable; causes skin burns. Harmless at working strength of 3–28%. Dangerous in concentration.

ACETONE Solvent liquid; *extremely* flammable. Damages skin, clothing and respiratory system. Use only in good ventilation.

ALCOHOL Solvent ethyl alcohol or methyl alcohol – highly flammable, can cause blindness if inhaled. Poisonous if swallowed. Use only in well ventilated area.

AMMONIA Do not mix with household bleaches. Vapour irritates sensitive skin and eyes. Use in adequate ventilation.

CHROME ALUM Causes cancer in respiratory membranes. Do not use. Substitute aluminium potassium sulphate.

FORMALDEHYDE Gas given off from formalin. Toxic if eyes and respiratory system receive long exposure. Ventilate area of use.

HYDROCHLORIC ACID Causes severe burns to skin and clothing. Vapours are toxic. Use full protective, industrial clothing.

HYDROFLUORIC ACID Etchant for glass, causes *extremely* severe burns; fatal if swallowed. Always use face mask and full industrial, protective clothing while in use.

HYDROGEN PEROXIDE Can explode and create spontaneous combustion when in highly concentrated state. Use eye protection and vinyl gloves when handling. Rinse empty containers and discard carefully.

NITRIC ACID Gives off toxic gas, causes severe burns. Full industrial, protective clothing is needed.

CYANIDE SALTS *Potassium or sodium cyanides are deadly poisons.* Acid and acidic fumes in contact with cyanide compounds produce lethal gas. Never handle these substances without full protective clothing, especially face and hands, and only in thoroughly ventilated rooms with proper first-aid facilities.

POTASSIUM BICHROMATE or DICHROMATE Used as a sensitizer, can cause cancer in respiratory membranes. Fatal if swallowed. Do not inhale vapours or dust. Irritates eyes and skin.

POTASSIUM PERMANGANATE Can be highly combustible, do not store near flammable material. Avoid contact with glycerine or glycol. Toxic if swallowed; irritates skin or eyes.

POTASSIUM CYANIDE Do not heat or contact with acid because toxic fumes are produced. Poisonous if swallowed.

SELENIUM Toxic, irritates skin or eyes. Vapour causes severe irritation of respiratory system. Cancer-causing if taken internally.

SILVER NITRATE Stains skin permanently. Causes deep burns; irritates skin, eyes and respiratory tracts. Probably fatal if swallowed; do not inhale vapour. Has a toxic or volatile reaction to many chemicals; mix only with compounds when safety is certain.

SODIUM HYDROXIDE (caustic soda) Generates considerable heat if dissolved in water; do not use glass mixing vessels unless Pyrex. Add chemicals slowly to solution. Protect eyes, skin and clothing. Possibly fatal if swallowed.

SULPHURIC ACID Causes severe burns on skin, or clothing. Has very toxic fumes. Keep container closed. Use heavy industrial protection on eyes, face and hands; do not use in poor ventilation. Add acid to water when making up solutions. Possibly fatal if swallowed.

BEFORE USING ANY OF THE ABOVE FOR PHOTOGRAPHIC PURPOSES, DISCUSS THEIR SAFE HANDLING, ANTIDOTES AND FIRST-AID PROCEDURES WITH AN INDUSTRIAL SAFETY OFFICER OR CHEMIST. HAVE THE NECESSARY EMERGENCY EQUIPMENT ALWAYS ON HAND. WHEN USING VERY TOXIC SUBSTANCES DO NOT WORK ALONE AND HAVE ACCESS TO LARGE VOLUMES OF RUNNING WATER.

DARK SLIDE

Sometimes called a cassette, this is a flat wood and plastic holder for two sheets of view camera film, held back-to-back on either side. When loaded it is placed into a spring back on the camera, a safety sheath is removed and the exposure is

made. The sheath is replaced and the dark slide can be removed from the camera. (See *Large Format Cameras* for loading technique.)

DARKROOM

The darkroom can be compared to a kitchen. It needs special equipment, functional design, safety features, wet and dry work areas and should be reserved largely for the purpose for which it was built. Emergency darkrooms may be made in bathrooms, home laundries or even kitchens, but serious photographers will need to set aside finance and space to build a darkroom to reasonably functional standards. Most amateurs can use a space 1.8 × 2.4 × 2.4 metres high (72 × 96 × 96 inches) for their entire life-time and, in it, produce very superior work with little need to compromise because of technical limitations. Professionals must be more concerned with quantity as well as quality and obviously space is an essential part of this increased throughput.

The space set aside for the darkroom must be capable of being completely dustproof, waterproof, ventilated and made totally light-tight. Electricity to the extent of about 5 to 6 kilowatts for amateurs and three times that for professionals should be available, and water supply and drainage lines must be accessible.

First the space should be cleaned thoroughly and then the walls should be lined to eye level with a waterproof material such as tile, vinyl paper, formica, or waterproof masonite or hardboard. Windows need removable black-out curtains or shutters, which are *completely* light-tight and doors must have key holes, edges and thresholds made light-proof when they are closed. A light-trapped ventilator (see fig. below) must be built in a door or a wall and the whole room should be painted with waterproof paint, preferably an oil-based enamel. Small darkrooms are better painted black while larger professional areas may be painted medium grey. Floors should be given special attention and the ideal solution is the one-piece waterproof floor covering, 2 metres (78 inches) wide, so that in small darkrooms, seamless floors may be made. Joins should be waterproofed or welded together and, if possible, covings installed in the areas where walls and floors meet. This precaution is even more desirable if the darkroom is built on an upper floor.

A sink large enough to take four, 30 × 40cm (12 × 16 inch), processing dishes is to be recommended, but a smaller sink at the right hand of a sturdy waterproof bench may be sufficient. The darkroom sink could be made of strong plastic or stainless steel, but also may be cast in concrete and water-proofed if weight is no problem, or made of bonded fibreglass construction in the manner of boat building. The sink should be properly supported and have a splash-back at least 30cm (12 inches) deep and should be itself at least 20cm (8 inches)

a Light lock for ventilation and access through a darkroom door. A is the open doorway or sliding door into darkroom. B is the open entrance. C is the light-proof covering for the rest of the box. D are the walls all painted black. E is the white guideline on black floor, which goes into the darkroom.

b Light lock for ventilation of darkroom wall. A hole is cut in the darkroom wall c1 and a light-proof box open at end A is built to fit over it. A light baffle B is fixed to stop light bouncing into the darkroom and a hole c is cut to match the one in the wall. On the inside of the darkroom a similar box is fixed, but this could also have a small exhaust fan fitted.

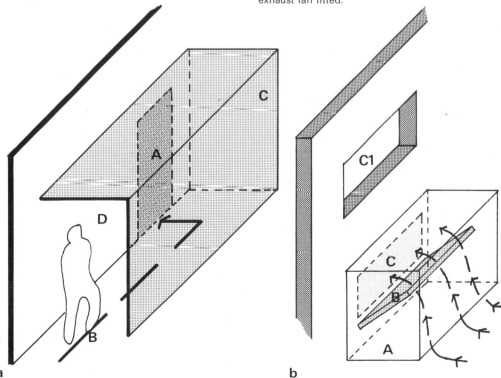

a b

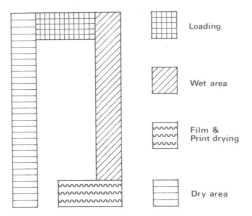

▦	Loading
▨	Wet area
〰	Film & Print drying
☰	Dry area

The darkroom must be divided into strictly controlled zones of activity which must have overhead electrical fixtures operated by ceiling-mounted cord switches and the dry area must always be kept dry. Darkroom design has much in common with kitchen planning and much can be learned from studying kitchen traffic patterns and counter layouts. The darkroom should be painted in medium grey oil-based enamel and the floor waterproofed.

deep. Instal the sink at a comfortable working height but higher than normal kitchen work-top height as this can minimize effects of splashing. Hot and cold water will be needed to service this point.

Safe-lights should be suspended above the sink, 1 metre (3 feet) at least from the surface of any solution in the processing dishes. These lights are fitted with 15 or 7½ watt pygmy lamps and changeable filters for both red and yellow. Inexpensive

and quite satisfactory are the Patterson safe-lights and several of these may be used in a small room. Switches for these fittings should be of the cord-pull type mounted on the ceiling. This is the only electric installation which should be permitted in the wet area and safety demands must be paramount in this potentially hazardous section of the darkroom.

The enlarger should be set up on a very solid bench, on the opposite side of the room to the sink if possible, and another safe-light, a power point, and some shelves added here; dustproof drawers are useful also to hold lenses and negative carriers.

White light which is also controlled by a pull-cord ceiling switch should be over the sink in the area of the print fixing tray and should be of daylight quality and a general, centralized white light will also be useful. In cool climates, heat is needed in the darkroom and an ideal solution is to use electric greenhouse radiators of the convector type. These take some time to raise the temperature, but are gentle in action, inexpensive to run, safe in wet areas and do not create photographic problems. Very hot climates will require that suitable cooling is installed in the air supply as many processes will not perform at their best in temperatures above 30°C (86°F).

Testing the darkroom for totally black conditions requires that seven to ten minutes is spent inside in total darkness during the brightest part of the day (does the sun strike the darkroom window in the late afternoon?), while the eye adjusts to the darkness. Faults in lightproofing can now be

Film drying cabinets make very satisfactory accessories for drying RC prints, usually needing less than 30 minutes to complete the process.

POINTS TO CONSIDER WHEN MAKING A DARKROOM

1. Plan in minute detail before any work begins.
2. Secure walls, floors and sink areas against spillage of solutions.
3. Arrange effective waste disposal, both dry and wet.
4. Filter water supply.
5. Provide at least one hot water and two cold water taps in the wet area.
6. Separate wet and dry areas.
7. Put all lights on pull switches, test safe-lights.
8. Keep all power plugs at least at bench height.
9. Ventilate, heat and cool as necessary.
10. Provide a dustfree area for film drying.
11. Make storage racks for dishes, chemistry and equipment.
12. Instal an electric and a manual timer.
13. Have a telephone extension installed if long working periods are normal.
14. Instal daylight colour white light in the print inspection area.

Some very important features in the wet area of the darkroom. The wet area must be carefully furnished with regard to safety, convenience and technical need. Organization is the key to successful processing work both for colour or B/W. Use professionals to install electricity and plumbing fixtures. A safe-light. B forced air extractor. C lights on pull switches. D main water access. E water filter. F spare filter seal. G locking hoses for taps. H negative inspection light. I plastic-tipped paper tongs. J precision thermometer. K acrylic splash back. L wall rack. M air channel, light trapped. N oil plant enamel on every surface.

seen and later corrected. An unsafe darkroom can be costly in terms of spoilt film and paper and if it is not possible to do otherwise, processing must be done at night. To test safe-lights initially, a small unexposed strip of bromide paper is placed (while the safe-lights are off) in the usual work areas – bench, sink area, etc., and a coin is left on each piece. Safe lights are turned on for five minutes. The test strips are reserved in a lightproof box and a second set is laid out as before and exposed, this time for ten minutes. These sheets are now developed in a covered dish or with safe-lights off for six minutes at $21°C$ ($70°F$), fixed, washed and dried. In white light conditions the paper is inspected for any signs of the coin

image and if any is discernible, the safe-lights are not safe. Orthochromatic and lith films are developed in red safe-lights and these may be tested in exactly the same way. Any unsafe lights must be modified by using less powerful, lamps, neutral density filters or by lifting the lamp away from the normal working areas or reducing their numbers.

The professional photographer will need to consider all the points made above and in order to obtain increased efficiency, perhaps may need to alter space allocations, consider work patterns more carefully in the normal use of the processing room and take more precautions to prevent costly processing faults or accidents during its operation.

Useful darkroom tips.
a Long term storage should be in metal cabinets.
b Short term storage can be in wall racks.
c Plastic-coated wire racks are ideal for paper storage.
d Wall racks are necessary for film holders and clips.
e Wet film must be hung in dust-free cabinets.
f Sophisticated hot water mixing may be needed for colour work.
g Magnetic knife racks will hold small objects safely.
h An ionizer, ceiling-mounted, reduces static and improves the air.
i Use a borderless easel and 4x5 holders for enlarging on to film.

DAYLIGHT FILM

Colour film is always balanced by the colour manufacturer to a certain colour temperature and that which is called daylight film should be exposed in daylight or to the light by electronic or blue expendable flash. If exposed to tungsten light at a Kelvin rating of 3200K, a red-ochre, brownish transparency is produced and to correct this colour balance, a blue filter (Wratten 80A) must be placed on the camera or a blue dichroic filter or colour gel can be attached to the tungsten lamp. Daylight film is balanced to a colour temperature of 5000–5500K (see *Colour Temperature*). Deliberate use of wrong colour balance for lighting certain subjects which are then photographed on daylight film is sometimes interesting for special creative effects. (See *Kelvin Scale*.)

DECORATING WITH PHOTOGRAPHS

Most photographers are pleased to display their images for public inspection but only recently have people become aware of the impact and relevance of photographs being used as decorative objects in domestic or commercial interiors. The advent of new technology such as the micro-jet, non-silver imaging process, the transfer techniques in ceramic and textile printing and the use of hand-coated emulsions, has meant that scale and basic substrate can be varied tremendously.

Photographic prints can be made to produce canvas and impasto effects, more nearly to bring them to recognized thresholds of easel art, but it is often better to consider them quite frankly as pieces of modern chemistry, as photographs in their own right. Very often a simple silver, gold or metal frame is best and the only presentation needed. An alternative is perhaps thin profile, anodized aluminium section in a complementary colour. Heavy, ornate picture frames are usually too pretentious, although some simple wood or lacquered frames can be found to give sympathetic treatment to modern images.

Photographs are usually made with fugitive dyes and must be handled somewhat in the manner of water colours. Strong light will fade them quickly and direct sun will destroy some prints in weeks. *Cibachrome*, Carbro and most B/W processes are considered nearly permanent (see *Archival Processing*) but care must be taken even with these. In all cases prints must be protected from all air pollution, particularly tobacco smoke, and if the collection is valuable, humidity and temperature needs to be controlled. In any case, don't place valuable photographs too close to spot lights, radiators or log fires or in kitchens, bathrooms or the sea air, unless they are protected in a sealed frame or a lamination sandwich.

If the decoration is being applied to domestic interiors the pictures must have relevance to the occupiers and must have very long, visual take-up value (see *Image Management*). Individual pictures will need a certain size in order to control suitable wall area around them. A careful appraisal of the position they are to occupy, the colour of the wall, the fall of both natural and artificial light in the room, and the dominant colour of the furnishings must be made. A good general size to be considered as a minimum for domestic interiors is a finished frame size of 50 × 70cm (20 × 28 inches). Groups of pictures can of course be individually smaller than this but their final size depends on the actual collective arrangement. Most pictures are better hung slightly below standing eye-level and over any large, isolated pieces of furniture are better centred. Small fine furniture, especially if it has strong horizontal direction in its form, can often be enhanced if the picture is slightly off-centre. Picture groups need to be highly planned but have a random effect. Kitchen decor demands that the print be protected and a heavy, non-yellowing clear laminate will do this. New technology has meant that colour photographs can now be fired into the surface of ceramic tiles and these of course are ideal in wet areas. For less permanent exhibition of photographs in the home, peg board, cork tile, magnetic bulletin boards and polystyrene foam all make suitable base materials.

For commercial areas there is even more need to consider the relevance of the subject to the business which is taking place near the picture or in the building and for the final size often to be considerably larger. Control over placing the image will usually rest with a professional designer or architect and they will have definite requirements in respect of size, format, aspect ratio, colour, communication and visual take up. Much preliminary discussion will probably take place before a photograph finds its way to the wall of such designed interiors.

A commanding single photograph, extremely large, is a useful solution to using photography in commercial interiors. (See *Abstract Photography* for more detail of the image used in this picture.)

DEKTOL

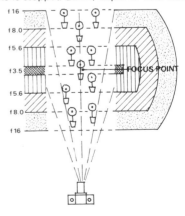

Using photographs in decor is aesthetically pleasing when properly placed.

a In spacious modern homes a single very large picture placed off centre to a main item of furniture will improve the appearance of the wall and provide a dramatic centrepiece to the room.

b A large collection can be used attractively in a room. Be sure to line up the top of every frame, even though sizes and placement can be quite random otherwise.

Scale alters an image dramatically, both physically and emotionally. In large commercial interiors very long sight-lines are usually available so that a big image can be viewed properly. As a generalization, photographs will need a viewing distance at least equal to their diagonal measurement, but this often depends on what detail is present and how important it is for the understanding of the image. Large-scale images are often left unframed, simply being stretched on wooden frames with the image wrapping over the edge. The use of the scannergraph, which is a computer controlled ink-jet print technique to enlarge the photograph to almost infinite size and print it directly onto a fabric substrate, has given the designer a useful new facility for using giant, seamless photographic images (see *Scannergraph*).

The use of straight B/W prints is rarely possible in designed interiors except when their exhibition is relatively transitory. They are so visually commanding that, if they reach reasonable size, these images can draw such attention to themselves that the harmony of the whole scheme is upset. If such pictures are needed they are usually toned sepia or in a tint to match the predominant colour of the decor.

Aluminium tile, ceramic tile, etching on stainless steel and glass, hand-coated prints, all offer the photographer interesting alternative techniques for bringing photographic images into the public and private buildings in which we live. (See *Emulsions, Archival Processing, Image Management*.)

DEKTOL

A very fine standard print developer, Dektol is made by Kodak USA and not generally available elsewhere. It has excellent keeping qualities in stock solution and its dish life and working strength is notable. It gives high-quality results.

DEPTH OF FIELD

The selective focusing ability of the camera is one of its most useful creative attributes and a clear understanding of the phenomenon of depth of field will be of constant use for photographers. When the camera is focused on an object, the focus point will be as critically sharp as the lens and the camera design permits, but lying within an area which extends from somewhere in front of the focus point to some distance behind that point is a zone where objects also are apparently sharp. This zone of acceptable sharpness is called the depth of field and can be expanded or contracted according to the focus point chosen, the lens used and the aperture selected. The zone of focus is greatest when the lens is stopped down to its maximum and the camera is focused on the *hyperfocal distance* for that lens and this area of sharpness is decreased if the lens is opened to wider apertures or the focus point is brought forwards towards the camera. This zone of acceptable sharpness is recognized only by the brain as such because small areas of unsharpness cannot be detected by the eye under certain viewing conditions (see *Circle of Confusion*).

View cameras and most SLR cameras have a facility available so that the actual depth of field may be previewed in the viewfinder before exposures are made, and other cameras usually have a depth of field scale built into the lens. The zone of sharpness does not extend equidistantly from the focused point but is generally considered to lie one-third in front of the object and two-thirds behind it. The ratio does in fact vary continually according to the focused distance, but for all practical purposes the scale on the lens barrel is a precise enough guide.

When a lens is stopped down, depth of field increases.

The zone of sharp focus is greatly extended by using shorter focal length lenses and small apertures and is made extremely shallow by use of telephoto lenses. This fact can be exploited for considerable creative effect as explained in *Image Management*. By using the movements on view cameras or the limited lens panel tilt on some cameras such as the Rollei SL 66, the *Scheimpflug* principle is brought into effect and the zone of focus is enlarged considerably. (See *Large Format Cameras, Lenses, Basic Photography*.)

DEPTH OF FOCUS

Depth of focus need not concern practical photographers very much as it refers to the shallow area of sharpness which lies inside the camera at the film plane. It is of importance mainly to lens and camera designers, technicians and theorists and it should not be confused with *depth of field*.

DERIVATION

This is a word used to imply that the photograph in question is not a simple mechanically processed image but has derived from one or more originals and has been deliberately changed by the photographer to move away from the objective, optical machine image which the camera normally delivers.

At one time derivation was deeply suspect among art photographers who prided themselves on the purity of the untouched photograph, but today many advanced workers are receiving critical praise for highly manipulated and derivative pictures. Most often these are built up by a synthesis of several images, controlled by the photographer to produce introverted and expressionistic symbols that often hint at a deeper reality than that produced by straight snap-shot techniques. Britain, once the leading nation in manipulative images when early attempts were being made to diffuse the borders between easel art and photography, still somewhat resents this modern movement, but the German, Swiss and particularly American photographers are increasingly involved in image synthesis. The work of *Jerry Uelsmann* and Todd Walker offers good contemporary examples and the pioneering photography of the Bauhaus, Moholy-Nagy, Man Ray and Max Ernst in the thirties of this century will be found to include many clues to early thinking in this kind of image. (See also *Posterization, Image Synthesis*.)

DEVELOPERS

These are the chemical agents used to convert the latent image which is lodged in paper and film emulsions when they receive light. Developers have a selective action, changing the silver salts which are suspended in the gelatin emulsion to metallic silver but only in proportion to the quantity of light reaching that emulsion. In areas where considerable light has affected the silver salts, development proceeds faster, producing more density while in the zones of less exposure, less activity in proportion takes place. Most developers consist of a developing agent, often metol or hydroquinone, an alkaline accelerator to speed penetration of the emulsion by the developer, a

preservative such as sodium sulphite to stop oxidization and a restrainer, usually potassium bromide, to inhibit chemical fog. It is always suspended in a solvent, which is usually water. (See *Black and White Photography, Basic Photography, Compensating Developer, Mixing Solutions*.)

DEVELOPING

(See *Basic Photography, Darkroom, Black and White Photography, Grain, Compensating Developer*.)

DIAPHRAGM

Another term for the moveable aperture which is fitted to the lens to control the quantity of light reaching the film (see *Aperture*).

DIFFERENTIAL FOCUS

The camera lens is able to select a plane of focus which it then renders in sharp detail while other areas are made progressively softer the further they are from the focus point. This is one of the most useful attributes of the camera, much employed by photographers to emphasize the main subject area while suppressing less important, unattractive detail elsewhere in the picture. It can be used most creatively at times and often in outdoor portraiture. (See *Basic Photography, Depth of Field, Lenses*.)

Unwanted detail may be suppressed by the use of wider apertures and consequent shallow depth of field. Such selective focus concentrates the observer's attention on the more sharply focused areas.

a **b**

Diffusion filters may be added on the camera or the enlarger lens. **a** Without diffusion. **b** With a glass diffuser.

The wider the aperture the softer the result. Filters which have no diffusing action in the centre may be used, but elsewhere are etched to diffuse the image. This type is used here and gives a degree of sharpness in the centre and a pleasing softness to the rest of the picture.

A deliberate use of a glass diffuser on the lens creates a distinct mood in the image, which is further enhanced by increased grain from a high speed film.

DIFFUSED HIGHLIGHTS

For mood or pictorial effects it is sometimes desired to create halation around the highlight areas of the image. This can be done by using commercial diffusion filters, such as may be purchased from Tiffen, Hoya or Cokin, on the camera lens, or gauze screens, or crumpled acetate over the lens, or by photographing through a very thin smear of vaseline on thin glass. It is possible, where circumstances permit, to use theatrical smoke and considerable over-exposure for the same effect, if the subject is outdoors. This is useful for illustrative subjects and large shiny objects like automobiles. High-contrast lighting from specular sources will help induce the effect of halation more easily and special lenses can be bought, such as the Rodenstock Imagon, which give a highly controlled effect.

DIFFUSED LIGHT

This is a light quality similar to that of overcast skylight where the sun is still faintly visible. It produces open shadows and broad highlights and is very suitable for rendering glossy surfaces, translucent materials or skin tones. Shadows have soft, indeterminate edges (see *Lighting*).

DIFFUSION ENLARGER

This is an enlarger equipped with a diffused light source behind the negative stage, giving somewhat softer prints and also minimizing scratches or abrasions on the negative (see *Enlarging*).

DIN SPEEDS

The two common scales used to rate the emulsion speeds on various films throughout the world are ASA and DIN, the last standing for Deutsche Industrie Norm, which is the association controlling standards of measurement or specification in Western Germany. To find the comparison between ASA and DIN speeds, see *ASA*.

DIRECT POSITIVES IN BLACK AND WHITE

These can be made, usually on special film, by the use of a process of first developer, bleach, clearing, re-exposure to strong light, second developer and final fix and wash, somewhat similar to colour processing techniques. This eliminates the intermediate step of a separate positive and produces extremely fine grain. Various manufacturers provide their own formulae to suit their special films and these are to be preferred rather than random reversal chemistry used with standard camera films.

Certain duplicating materials are made which do not require this elaborate reversal and bleach technique to achieve direct one-step positives and Kodak make several good ones. Their latest, direct duplicating film SO-015, which can be developed in DK50 or Dektol in the normal way, produces excellent results. The emulsion is orthochromatic, fast, very fine grain and is suited to continuous tone subjects. It should be remembered that in reversal work more exposure produces lighter densities and less exposure makes the resulting positive darker, just as in colour transparency material. Using this film some experienced workers will make enlarged duplicate negatives, for example size 30 × 40cm (12 × 16 inches), including on it all dodging or burning in that has been thought necessary. This is later used to contact-print the final image, making repetition more accurate and much faster. For limited edition prints or long-run multiple copies for com-

mercial use, such a technique is most useful and can easily be mechanized. (See also *Polaroid*, *Black and White Prints from Colour Film*.)

DISPOSAL OF PHOTOGRAPHIC PRODUCTS

While most chemicals used in photography are relatively harmless and in solution are even less toxic, it is always wise to dispose of them carefully. Once wet chemistry has been discarded down a drain, heavy flushing with plain water should follow. Dry chemicals in small quantities should be bagged in strong plastic, taped safely to avoid spillage and be discarded in the general household rubbish. Do not put any photographic material in septic tank systems as they can easily be ruined and avoid the disposal of harsh acids or alkalines in drainage systems which may corrode. Recover silver products wherever the volume of production makes this possible, and if involved in any commercial use of large volumes of photographic chemistry remember that it may be necessary to obtain special permission from a local authority for its disposal, rather than releasing it into the conventional drainage system.

DISTORTION

Lenses are usually designed to be as free of optical distortion as possible especially in normal focal lengths, but many users of 35mm wide angle lenses are aware of the flaring perspectives which can be created by certain viewpoints when these lenses are used. There can sometimes be an unreal beauty to such images but keen judgement must be exercised if good taste is to be maintained. Objects and landscapes can be sensitively treated with this technique, but if people are to be photographed for serious purposes, be careful that viewpoints which are too close or too low do not create ugly or ludicrous pictures. Distortion may also be introduced by photographing into concave mirrors, convex silver surfaces, ripple mirrors or crumpled mirror foil. The famous documentary photographer, *André Kertész*, created a series of nudes using ripple mirrors which took the art world of the 1930s by storm and this is probably the best example of that technique. (See *Image Management*, *Lenses*, *Nude Photography*, *Portraiture*.)

An elegant distortion, obtained by using a tiny original image 50mm in height, plus a convex mirror system in the subsequent enlargement. Optical distortion is often the beginning of photographic abstraction.

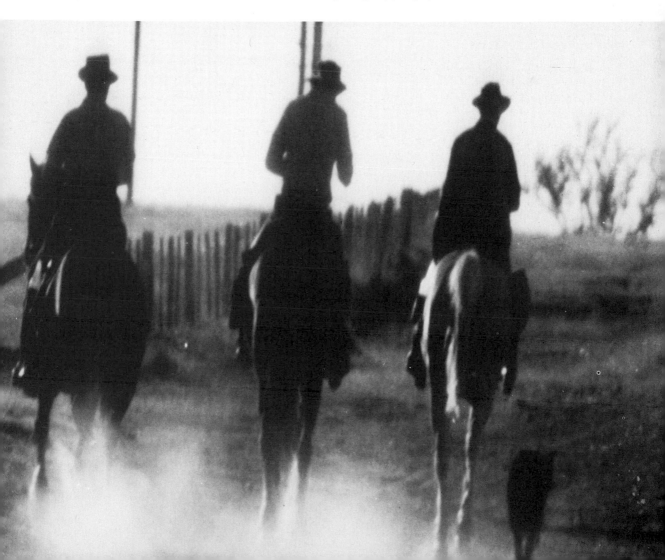

DOCUMENTARY PHOTOGRAPHY

Of all the areas of modern photography to be explored by serious workers, this speciality is regarded by some photographers and critics to be the most noble and the most pure. The cool objective realism of a straight, machine-made image seems to be the pinnacle of photographic art to these enthusiasts and the works of the pioneers in the field, *Cartier-Bresson*, *André Kertész*, Felix Mann, *Eugène Atget*, *August Sander*, Jacob Riis, *Lewis Hine*, *Walker Evans*, Dorothea Lange, *W. Eugene Smith*, Stieglitz and Bruce Davidson, amply support their argument. In the hands of lesser photographers, however, the pictures merely state the obvious, i.e. that the photographer was at a certain time and place and recorded a slice of that time within a selected action

The documentary photographer has always found the locality a physical challenge. Just being there is a major part of the assignment. This picture taken by Capt. Frank Hurley in Antarctica during the 1911–13 Mawson expedition at the South Magnetic Pole does not disclose the desperate conditions which prevailed during most of the 620 mile sledge haul. (*Courtesy National Library of Australia*)

sequence which took place. 'I was there' is not enough of a statement usually for an image of fine art to make, but such banal pictures sometimes draw lucrative scholarship awards or are hung in art exhibitions and are hardly ever deep excursions into this fascinating photographic territory.

Most interpretations of the word 'documentary' would suggest that its meaning is the furnishing of evidence and information, but in photography today it seems to have special application regarding subjects relative to social matters in both war and peace. Certainly the best workers in this field do have a deeply committed point of view and are socially concerned about their subject and in the case of Lewis Hine for example, the photographer could see social reforms flow from the public display of his work.

Those who work in this field must have the stamina for constant field work; be capable of very long hours of research, waiting and watching in respect of their subject; be fast, accurate technicians; use available light always and maintain a high level of concentration. Their markets are sometimes tenuous unless they are associated with an active photojournalist agency such as Magnum, Sigma, Black Star, and so on. The rich visual picture markets which were created by the

PHOTOGRAPHY, SUBMITTING TO EDITORS

Find out from the features editor if any special subjects are wanted *before* you submit work.

Monochrome prints should have cool black-and-white tone, clear white highlights, non-glazed glossy surface.

Such prints need a full scale of tones plus an emphatic black; this means full development; all shadow areas must have detail.

Sharp focus in the negative must appear on the print; use an easel magnifier.

Spot all prints carefully, in daylight.

Submit 18×24cm ($7 \times 9\frac{1}{2}$ inch) as standard size, with prints on glossy double weight paper, *unmounted*.

Mount 35mm and other transparencies in temporary black card mounts with your name, address and telephone number clearly to be seen on each mount.

All prints need 5mm ($\frac{1}{4}$ inch) white border all around and should be flattened by weighting or the use of anti-curl solution.

Put all photographs into a padded envelope, plus a strong cardboard stiffener.

Put your return name and address on the envelope, plus label to state: 'Photographs, do not bend'.

If prints are wanted back, include return postage.

general-interest picture magazines, such as *Picture Post*, *Life* and *Look* and which were always available to aspiring documentary photographers, have long since vanished. This seems to leave the documentary worker with the self-published documentary book, the occasional coffee table book, exhibitions and the rare newspaper or magazine page, if events and space warrant it.

Equipment for this work must be highly portable, easy to use and very unobtrusive. One camera beloved for decades for these attributes is the rangefinder 35mm Leica, with its quiet shutter, superb lenses and small size. Excellent, but bulky and noisy, certain automatic SLRs with motor drive are used by modern workers in this field. The best are made by Nikon, Minolta and Contax but most really committed workers will want to be less conspicuous than these cameras permit. The new Rollei SL 2000 35mm camera with changeable magazines and integral motordrive may be an alternative and ideal choice if an SLR is needed. Other equipment will include a good narrow angle exposure meter and compact tripod such as Gitzo, plus a suitable camera bag with both shoulder strap and carrying handle, but artificial lighting is not often carried. If a flash is part of such a photographer's kit it is usually small, powerful, fast recycling and running on dry cell batteries with a good off-camera extension cord available. Film is most often the fastest available, often exposed at double or treble the rated ASA speed and then push-processed. B/w development is often in a standard D76 solution or in a rapid working fine-grain developer such as Edward Edwal's G7, Ethol UFG, or Acufine. (See *Photo Journalism*, *Available Light*.)

DODGING

This is the name of an enlarging technique whereby the printing light is held back selectively by using small opaque discs on wire stems to interrupt the beam and induce print density in chosen areas (see *Enlarging*).

DRYING

For B/w photographers, drying used to be a tiresome business unless an expensive drying cabinet and print dryer was purchased. With the advent of resin-coated emulsions and compact hot-air dryers, prints at least may now be quickly and easily dried, while efficient drying cabinets for films may be also easily made (see *Darkroom*).

However, if fibre-based paper and archival qualities are needed, drying becomes a larger task.

Without doubt air drying with no heat and in a dust-free atmosphere is the ideal, if time-consuming method, for both prints and film. For prints this means the provision of very large racks if the darkroom is well-used and often after such air drying, a secondary operation is needed to flatten the print in a hot press. This drying method is the only way, however, of assuring that prints will last. A modification of this method is to provide a warming box at one end of the rack and this can improve print production somewhat. If full gloss prints are wanted excellent results may be achieved by squeegeeing the washed prints face down on 6mm ($\frac{1}{4}$ inch) plate glass after the

surface has been cleaned with metal polish. Both sides of the glass may be used and each piece is stacked, edge on, on prepared racks and left to dry naturally. Before such glazing, prints should stand a few minutes in filtered water to which a glazing solution has been added. As a safety precaution, edges of such glass sheets should be arrissed or ground smooth.

Negative drying is critically important and films should not be subjected to forced and heated air unless time is critical. The cabinet may be *gently* heated and must be dustproof. After washing, films should stand in a filtered bath of commercial wetting agent used at minimum strength, for no longer than three minutes. They are then hung up and excess water removed with a photographic sponge or chamois leather which has been soaked and squeezed dry. Larger films may be gently wiped with a straight-edged squeegee, but any treatment of the emulsion while it is in a wet state must be extremely carefully done as one tiny piece of grit can be carried the whole length of a roll or sheet of film, damaging the entire piece. If the operation is properly conducted, however, films will be clean and free of those water droplets which can cause permanent marks in the emulsion surface, thus eliminating a lot of spotting in dried prints. Any equipment used for wiping films should be stored in a dust-free place, possibly the drying cabinet, and washed in filtered plain water before being used. (See *Basic Photography*, *Darkroom*, *Wetting Agent*.)

DRY MOUNTING

This is a clean and stable mounting technique for photographs which secures a flat permanent bond between print and support. It usually consists of interleaving a resin tissue between photograph and mount and then applying both heat and pressure from a special press, which melts the tissue in order to fuse the whole sandwich together. There is considerable doubt among archivists about the wisdom of trusting this process for valuable originals which must last indefinitely and in this case other methods are to be preferred (see *Archival Processing and Storage*).

Because colour print is more easily damaged by heat, special low-temperature melting tissue can be obtained but this sometimes creates difficulties with lack of adhesion, especially with resin-coated papers.

3M have produced a very useful cold mounting material and a machine applicator and the West German company Neschen has also produced excellent materials, both low and high tack adhesives in rolls up to 125cm (50 inches) wide. A special advantage of the Neschen product is that it is acid-free with a neutral pH and will not react with photoprint or acid-free mount boards. This makes it ideal for archival use and, as it requires little pressure to create a good bond, equipment is fairly simple. This too is a cold bonding operation and excellent for all colour prints (see *Appendix*).

As in all things photographic, cleanliness is essential. Small pieces of dust and grit, trapped between the back of the print and the mount, can totally ruin good work as it may show through on the surface or if the platen of the press is not clean, dirt will transfer and spoil the appearance of the print. Too much heat will cause a poor bond and the print will begin

to fall away from the mount. This is true of too little heat if a hot bonding process is used. Mount boards which are too thin will curl unpleasantly and if these are used, a second piece of photographic paper of a similar weight to that of the print must be mounted on the reverse side as an equalizer.

One of the most attractive approaches to hot or cold dry mounting is simply to mount the photographs back-to-back with another photograph or fix and wash an unexposed sheet of photographic paper and then trim this blank print carefully for clean edges, using it as a mount. The tendency of the main print to curl is perfectly equalized and there is considerable elegance in the use of such a thin, strong support material.

There are a number of hazards in using wet paste, glue, tube adhesives or spray mounting products and these should be employed only as emergency measures. Low tack double-sided adhesive tape is also a good emergency technique but it must cover most of the mounting areas if air bubbles or buckling of the print are not to spoil the job. None of these temporary mountings should be used on any valuable prints.

DUCOS Du HAURON, LOUIS (1837–1920)

A prolific pioneer of colour photography processes, this French scientist, at the age of 32, outlined the theory of most modern colour systems for photography, long before even panchromatic emulsions had become possible. He was also a great experimentalist in practical photography and some of his strange distorted images are probably the earliest beginnings of photo-abstraction.

DUPE

An idiomatic word meaning 'duplicate', most often used when it applies to colour transparencies.

DUPLICATING SLIDES AND B/W NEGATIVES

If the project is to make a new negative from an original negative, two choices are open. One is to copy the negative by trans-illumination as would be done for colour transparencies, but using an auto-positive B/W film stock. This is a B/W film material capable of being processed by a reversal procedure into a direct one-step positive, thus eliminating the need for an intermediate negative and thereby improving the control and contrast of the copy. This kind of processing requires the use of a darkroom and considerable skill but it is worthwhile acquiring these if much work is to be done.

The more usual method is likely to be via an interpositive print with subsequent copying to produce a new negative. A very long scale print is made, considerably softer in contrast than is normal. This is then carefully spotted and generally cleaned up, removing as many faults as possible before the next step is made. The print is then copied on a long-scale B/W copy material, such as Kodak Gravure Positive, processed in D76 or DK50 or a medium-contrast, fine-grain material is used such as Kodak Plus-x, Agfa 100 or Ilford FP4, and an adjusted development is given to lower contrast a little (see *Contrast Control*). A new normal print can then be made from the copy negative.

Copying colour slides is best done on duplicating film specially manufactured with lowered contrast characteristics to improve the results. Contrast gain will usually be trouble-some in any event and it may be necessary to use the pre-flashing technique explained in *Copying*. Simple equipment, for attaching to the camera lens is sold to achieve 1:1 copies easily, but if much work is done it is very much to be recommended that the photographer invests in a small table-top copy unit such as Multiblitz, Bowens or Berkey and Polaroid have designed for this purpose. (See illustration under *Copying, Flashing*.)

DYE DESTRUCTION

In most photographic colour materials the dyes which show us the finished image are created by processing procedures which effectively cause solutions to add dye in the right proportion to the film or print. An alternative way of producing colour is to first make the photographic emulsion complete with its full complement of six dyes: the primaries, one to each layer, red, green and blue and paired to these, their direct complementaries, cyan for red, magenta (green) and yellow (blue). During processing, unwanted dyes are bleached out from the emulsion in proportion to the coloured image exposed upon it, leaving a positive, full-colour picture behind. These dyes are usually more stable and more brilliant than those used for other processes. *Cibachrome* is the best known product using this method of manufacture.

DYE TONING

This is a somewhat old technique which allows the B/W image to be bleached and then combined with a dye to form an insoluble colour which is proportional to the highlight-to-density ratio in the original print. The mordant or dye acceptor is created by the following:

Bleach Dissolve 100g of potassium iodide in 250cc water at 20°C (68°F). Stir in 30g of iodine, add 50cc glacial (pure) acetic acid and water to make 2 litres of solution.

Bleach the print as completely as possible, using a stain remover made as follows, if the gelatin retains any iodine stains:

Stain remover 500g sodium sulphite is dissolved in $\frac{3}{4}$ litre water, stirring well; then a little at a time of 100cc sulphuric acid is added stirring gently and constantly. This is a highly corrosive acid and should be handled with full safety precautions. (See *Acid* and *Dangerous Chemicals*.)

A commercial dye is added to an acid solution in the following formula:

Dye 0.5g of the selected dye; 10cc of 10% acetic acid solution which has been made by taking one part of glacial acetic acid and adding to nine parts of water. This acid-dye mixture is then added to 2 litres of water and stirred gently. These quantities are sufficient to give a working level of solution in a 30 × 40cm (12 × 16 inch) developing dish.

The print is then dyed and briefly washed to remove all residual colour from the highlights (see *Toning*).

DYE TRANSFER

The best known colour process using this technique is that of Kodak, and is still very much in use after many decades. It is prized by art photographers for its beautiful rendition of subtle tones and by commercial interests in the reproduction industries, because of its total flexibility. It is very labour intensive and expensive and has the reputation for being extremely light-fast. Kept in suitable temperatures and total darkness these prints certainly may last forever but if exposed continuously to normal high levels of light, such as in exhibitions, prints will, undoubtedly, quickly fade, showing very little more resistance to light damage than the normal, and much cheaper, internegative processes which are used for colour prints.

Dye transfers are made by producing separation negatives which are a B/W record of the three primary colours, red, blue and green, on panchromatic film. These are subsequently printed by enlargement or contact onto special matrix films which when processed become gelatin relief images of the primary colours present in the original. Each matrix is dyed to the correct complementary: cyan for red, yellow for blue and magenta for green, the absorption of dye being in proportion to the thickness of the gelatin relief image. These three dye images are then transferred precisely in register, to a suitable white support sheet and a coloured print results. A number of transfers may be made from the same matrices, usually not more than ten to 20 copies, before new material is needed.

Fuji also have a somewhat similar but more mechanized process capable of producing more from the original matrices, usually several thousand copies. This process has light and dark fading behaviour similar to that of Kodak. (See *Archival Prosessing*.)

Steps in the preparation of dye transfer prints from a colour transparency. (*Courtesy Kodak Ltd*)

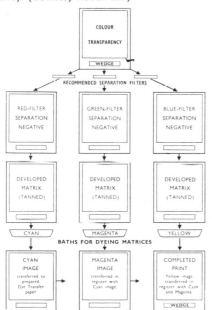

EASEL

This is a paper holder which is placed under the enlarging lens to hold the paper flat while printing is being carried out. Borderless easels make prints without a white border, using the total area of paper, while those with adjustable masks permit images to be centred in the sheet with whatever width of white border is required. Saunders of the USA, marketed by Berkey, is one of the best known makers of this equipment. (See *Enlarging*, *Appendix*.)

EASEL MAGNIFIER

This is an accessory for enlarging, and is a special focusing aid which allows the negative grain to be focused upon at high magnification, even when the enlarger is stopped down. Much sharper prints are made when this equipment is used. (See *Enlarging*.)

EASTMAN, GEORGE (1854–1932)

While Henry Ford was still a tradesman, Eastman was pioneering mass production and from the age of 24 he was engaged with great enthusiasm and technical skill in the blossoming photographic industry in the USA. In the next 24 years his company, Eastman Kodak, had outstripped the competition and was in 1903, earning a profit of more than 3 million dollars. Under his entrepreneurial guidance it went on to become the major influence in bringing photography to the mass market and at the same time he created a system of bonuses, dividends and a permanent welfare fund for his workers and staff which was a major innovation in the field of industrial relations. By 1929 this had been supplemented by a company sickness, insurance and pension fund that was launched with 6 million dollars of his own money.

He was greatly interested in music and art, donating 18 million dollars to the University of Rochester to build a theatre and music school, collected a gallery of paintings including Rembrandt, Van Dyck and Tintoretto. An organist played during breakfast in his large house and two evenings a week he arranged string quartet recitals at his home for himself and his friends. He gave considerably to charity, including 20 million dollars to Massachusetts Institute of Technology, 15 million to endow medical facilites at various clinics and universities and 30 million to four favourite educational institutions.

His influence on photography as a leisure pastime and a

George Eastman, photographed at the close of the nineteenth century as he used his early roll film camera which was to revolutionize photography. The first pictures with these cameras were circular. (*Courtesy Kodak Museum, Harrow*)

means of visual communication was enormous. In 1888 he put the first mass produced camera in the hands of his customers for 25 dollars, in 1898 the price had come down to 5 dollars and millions were using the Kodak, now with improved roll film facility, and by 1900 the Kodak Brownie was launched at 1 dollar using film at 15 cents a roll. The world and its millions, irrespective of income, culture or experience could make images of themselves and others of breathtaking clarity and with unbelievably little technical skill. The people's art had arrived.

Eastman's exit from life at the age of 77 was dramatic and, like his life, planned precisely. He had been advised by his doctors of an incurable spinal problem which began inhibiting his movement. On 14 March 1932, on an icy day in Rochester he signed a new will before witnesses from the Company, retired to his room soon after midday and took his own life by shooting himself in the heart. His last words in a note by his bedside were 'To my friends. My work is done, why wait?'

EASTMAN KODAK COMPANY

The Eastman Kodak Company has been synonymous with the mass use of photography for nearly 100 years. The Company dominates the world market in photographic chemistry, paper and film manufacture and has considerable

interests in metallic silver, industrial chemicals, plastics, electronics and other manufacturing operations. Their pioneering work in bringing millions of small cameras into the hands of amateur photographers has generated large, secondary industries in the photo-finishing market and made the use of photography a popular and ubiquitous activity throughout the decades. In 1878 George Eastman, at 24 years of age, began experiments with dry plate photographic emulsions using English technology. Two years later he began mass production of dry plates in Rochester, New York. In 1885 the Eastman and Dry Plate Film Company was also operating out of a London office and experimenting with roll film negative material. In 1888 the name Kodak was invented by Eastman and a 25 dollar Kodak roll film camera, taking 100 pictures, was put on the market. In 1890 a folding Kodak camera producing 48, 4×5 inch (9×12cm) pictures and using transparent negative film was introduced and a year later a daylight loading camera was offered, bringing photography to the millions of eager people who could record almost any outdoor subject with ease and amazing fidelity.

In 1900 the 1 dollar Brownie camera was introduced, with film selling at 15 cents a roll and a year later the present parent company, Eastman Kodak Company of New Jersey, was capitalized at 35 million dollars. By 1908 Eastman Kodak had produced the first practical safety film and was spreading its manufacturing operations internationally, had hired a British scientist, Dr C.E. Kenneth Mees, to head research (which he did with great distinction for the next 43 years) and in 1913 introduced sheet film to replace glass plate negatives.

Although motion pictures in colour became possible in 1928 with Kodacolor, it was not until 1935, after 20 years of unsuccessful experiment with two colour subtractive processes, that Kodachrome was available on the general market. This was a reliable reversal colour process for the amateur market invented by two musician-chemists, Leopold Mannes and Leopold Godowsky, in a part-time research laboratory. It still is one of the most stable and durable colour emulsions available.

George Eastman had died in 1932 leaving his estate to the University of Rochester. His home was eventually to become the International Museum of Photography.

In 1933 Kodak began marketing panchromatic films and went on to exploit and develop the movie market with cameras and colour film and also concentrated on serving the amateur still photographer, particularly in respect of 35mm cameras and improvements in colour transparency films. In commerce, the company was already a strong force in recording and micro-filming, it was a leader in x-ray film technology and was actively interested in supplying the professional photographic industry with its special needs in film and paper.

In 1941, colour enlargements were available for the first time and in 1942 colour negative film, for still cameras, was introduced. In 1946 Ektachrome colour reversal film, designed for home processing, was introduced and the Kodak Dye Transfer process of printing colour prints from three separation negatives was also perfected.

At the end of World War II many photographic developments which had been restricted for defence purposes became

available, as did secret information from German and Japanese technology, and all of this created considerable impetus in the photographic industry. Eastman Kodak now employed more than 60,000 people, worldwide, and was moving rapidly to leadership in many areas of photographic technology.

In 1958 Panalure paper, the first panchromatic printing paper for enlarging colour negatives, the Retina reflex camera and an automatic slide projector were all marketed; in 1959 high speed Ektachrome film was a significant world first and since 1962, Kodak products and special equipment have been used in Space exploration and have performed successfully under the high technology conditions prevailing in all subsequent missions. In 1963 the Kodak Instamatic brought big advances in amateur still photography, making it easier for non-technical photographers to get good results and seven years later more than 50 million such cameras had been sold. A few years after that, with the mass use of photography still very much a priority, the Company launched a photographic colour print machine capable of an output of 6000 completed photographs per hour.

Instant print, long the undisputed province of the Polaroid Corporation, was announced by Kodak, using the E4 and E6 cameras and continued improvements and miniaturizing of amateur cameras were made, finally producing a tiny Ektra camera, employing the 110 format and built-in electronic flash which truly brought the pocket-sized miniature automatic camera into the hands of millions of new photographers throughout the world. While other photographic companies have sometimes produced more innovation or been concerned with the restricted needs of professional photography, no other company has been able to match the huge investment and sophisticated marketing techniques which have spread the science and hobby of photography to such an extent in our modern world (see also *Eastman, George*).

ECLIPSE, PHOTOGRAPHY OF THE

When a solar eclipse occurs, opportunities present themselves for the photographer to make interesting pictures of a spectacular natural phenomenon. Certain precautions must be taken if serious damage to the eyes or the camera are to be avoided. *Do not look at the sun through a camera unless it has a protective neutral density filter of at least 6.0 density over the viewfinding lens.* This is especially needed if the camera is an SLR. Do not look directly at the sun at all unless through the protective viewing filter.

The protective filter must absorb the visible spectrum and the visible infra red and ultra violet rays. Normal filters offer no protection and one must be made. An ideal solution is to use litho film or other B/W photographic sheet film, exposed fully and developed to maximum density, fixed, washed and dried. Two pieces of this black and apparently opaque film will have a density of between 6.0 and 10.0 when sandwiched together and will offer the necessary protection to eyes and camera. It is not a photographic filter and is not used for the actual photography, but it must always be used while aiming the camera at the sun, or if the camera is not being used, over

the eyes whenever looking directly at the sun. Note that when the sun is focused the beam is stronger than that produced by a magnifying glass and heat will be generated. Do not make long exposures of the sun except at sunrise or sunset, keep the lens cap or opaque card over the lens except when actually viewing or taking, otherwise shutter curtains may be burnt or damaged.

For photographing the partial phases of the eclipse a photographic neutral density filter of at least 4.0 density is needed. This is best obtained from professional supply houses and is usually a Kodak Wratten Number 96 ND filter made of gelatin and acetate. Two such filters can be combined to reach the required density of 4.0 and they can be held in a simple plastic filter holder which clips on the lens, but do not use more than two filter thicknesses or sharpness will be impaired. *Do not use this ND filter as a viewing filter.*

During the total eclipse, if pictures are being taken of that phase, the ND filter is removed.

Although simple cameras with normal lenses can be used, they should have automatic exposure capability and the sun may be disappointingly small. Better images will be made by using longer lenses and a tripod will also be needed. Should the camera image be magnified to a size of 2.5cm (1 inch) by using a telescope or binoculars, a shutter speed of at least one-quarter of a second will be needed if blurring of the sun during exposure is to be avoided.

A daylight film should be loaded with an ASA speed of 200 or faster, which is a compromise in speed and grain so that during the total eclipse some detail may be recorded in the foreground and yet give an image which may be greatly enlarged if necessary. A lens of at least 135mm should be fitted if the camera is 35mm format, longer if possible and the photographic ND filter of 4.0 density placed on the lens after the viewing filter has been removed. Automatic cameras will not calculate the exposure correctly unless the sun happens to be situated in that part of the viewfinder where most sensitivity of the meter is to be found, for example, centred for a centre-weighted meter pattern. The approximate exposure with a 200 ASA film loaded and a 4.0 neutral density photographic filter in place will be $\frac{1}{250}$ second at f11 for clear atmospheric conditions during the time that the sun is partially obscured by the moon.

The moon will be seen to break into the disc of the sun about one hour before total eclipse and progressive sequential photographs of the partial phases may be made by putting the camera on a tripod and taking a picture every ten minutes or so, on the same frame, using the re-wind button to over-ride the film transport if the camera is 35mm and is not fitted with double exposure facilities.

During the totality of the eclipse when the moon exactly covers the sun, a bare five minute period, the ND photographic filter is removed and exposures are made with the same f stop as before but speeding up the shutter to $\frac{1}{500}$ second. To record details of the corona, or halo of light around the sun, open the lens to 5.6 and use a bracketed exposure for three frames at $\frac{1}{30}$, $\frac{1}{15}$ and $\frac{1}{8}$ second. For all eclipse photography a camera tripod must be used with the camera locked solidly into position and focused at infinity throughout. If the

landscape is included in the picture during totality an exposure of half a second at f8 should be adequate for the darkest moments and at this time the automatic exposure estimation of the camera would calculate as normal. The ND filter should be removed, of course. If watching the receding and brightening phases of the eclipse, do not forget to use the viewing filter over the eyes or camera viewfinding system, at all times. Exposures when the sun is partially covered will be equally as powerful as when the sun is totally unobstructed. (See *Filters.*)

EDGE EFFECT

This occurs during development at those points where high and low density areas meet. Exhausted developer from the heavy density area moves into adjacent thin areas of the image, diffusing the concentration of developer at these points. Developing activity is curtailed in the low density areas while fresh developer moves across into high density areas to create extra activity there. This produces a measurable difference at the borderline of such light and dark areas of the image when compared to densities nearby, giving an apparent increase in edge sharpness. Some special developers use this effect to achieve more detail but too much agitation can suspend the cross-over action. One of the purposes of proper development agitation is to diffuse rapidly the activity of development between high and low densities and therefore avoid an exaggerated edge effect which may produce uneven tones in the image.

EFFECTIVE APERTURE

While a camera is focused on infinity, the f stop is usually that actual value which it indicates, but as the focus point comes nearer to the camera the actual f stop value decreases so that f11 at infinity with a 100mm lens could easily become f16 or smaller if the object focused upon is less than 30cm (12 inches) from the camera. This effective aperture decrease can be calculated (see *Bellows Extension Compensation*), but also depends on individual equipment, film and processing techniques. It may usually be disregarded unless the subject is less than ten focal lengths from the camera. As a guide it may be a useful, practical generalization to say that when the subject appears on the focusing screen at half actual life size, exposure must be increased by one full f stop, and if actually on the screen at the same size as in real life, that is a ratio of 1:1, exposure compensation is two f stops increase. (See *Close-up Photography.*)

EFFECTIVE FILM SPEED

Manufacturers rate their films for speed on a widely agreed data base that is considered to be the minimum rating required to produce satisfactory results. This means that there should be reasonable correlation between brand names and the arithmetical variations in speeds for different films is probably accurate. However as practical conditions and the photographer's own subjective judgements bring in so many

unknown factors, it is good practice to test the films for effective speed as it applies to individuals and their specific equipment and darkroom technique. A new rating can then be made, valid until the change of routine or equipment makes another test necessary. This rating can be classed as an EI (*exposure index*) for the film chosen. (See *Nine Negative Test.*)

EINZIG, RICHARD (1932–80)

Born in London in 1932, read economics and architecture at Trinity College Cambridge. After several years in the disciplines of architecture, in 1963 he started business as a photographer, specializing in a service to architects and editorial enterprises devoted to architecture. His books have been published throughout the world and, until his death at 48 in 1980, he was regarded as one of the most important names in this specialist field. A posthumous book, *New Houses in Europe*, published in 1981 by Architectural Press, UK, is indicative of his outstanding style and unrelenting dedication to the craft of photography and to his informed approach to the illustration of architecture. His many site visits before

A brilliant example of Richard Einzig's sympathetic illustration of the detail in a modern building, the Beaubourg Museum, Paris. (*Courtesy Brecht-Einzig*)

photographing a subject allowed him to indulge his preference for rich cross-lighting which revealed the organic and spatial dimensions of the chosen building in the exemplary manner of a photographer-architect working to the demanding briefs of fellow architects. Copies of his work may be obtained from Brecht-Einzig Architectural Picture Agency (see *Appendix*). Another excellent example of Einzig's photography is to be found under *Architectural Photography*.

EKTACHROME

The trade name for a Kodak transparency colour film, suited to home or laboratory processing and one of the most useful and basic colour films on the world market. Available in sizes from 35mm through all camera formats up to 28 × 36cm (11 × 14 inch) it has become the standard for the professional photographic industry and is suitable for professional and amateur alike.

ELECTRO-MAGNETIC PHOTOGRAPHY

A new technique of turning light into electronic signals promises revolutionary techniques and equipment over the next few years. Resolution has been improved on video images by as much as 300% and ultra miniaturization of components is likely to be the trend. The CCD (charge coupled device) is the heart of most of these systems which provide a photographic still image and a hard print without the use of an original silver

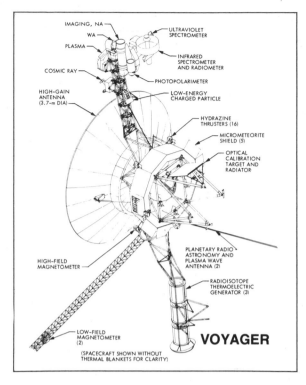

Pioneering research has been done by scientists using electro-magnetic photography to investigate the behaviour of the planets. This diagram of the Voyager project for photography in space indicates this new photographic technique as its most complex. (*Courtesy Jet Propulsion Laboratory, California*)

Sony Corporation and others are advancing rapidly with prototypes of video still cameras using CCD and IC semi-conductors. These possibly herald a revolution in communication almost as great as the invention of photography itself. The emergence of silver-free imagery, depending on advanced electronic technology to convert a light image into a signal which can be held on a tiny magnetic disc, later to be translated into either a video screen image or a hard copy print, is an innovation that must eventually widen the whole scope of photography, both as a leisure pursuit and as a commercial communication medium. (*Courtesy Sony Corporation*)

The Sony magnetic video still camera. The camera itself is somewhat like a conventional SLR, weighs only 800g (1¾ lb) and is equipped with F1.4 lenses and zoom optics. Fifty still photographs can be made on a single disc. (*Courtesy Sony Corporation*)

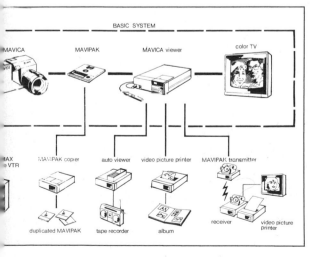

negative emulsion. Polaroid, Kodak, Fairchild, RCA, Phillips, Sony, Sharp, are just a few of the manufacturers who are currently at, or nearly at, prototype stage.

ELECTRONIC FLASH

This is a piece of photographic lighting equipment delivering a brief, high intensity flash of approximate daylight quality from a gas discharge tube which is triggered by a burst of high voltage electricity. The lamps have a useful long life of thousands of flashes and units can be tiny, portable on-camera fixtures or immensely powerful studio installations, several times stronger than sunlight.

In choosing a suitable unit the photographer must decide where his/her interests lie. For recording day-to-day home-life, on an intermittent basis, lightweight camera-mounted units are enough, preferably powered by dry cell batteries which are removed during periods when the flash is not in use. With this equipment, axis lighting is possible but more interesting or ambitious lighting will require an off-camera lead or a bounce facility (see *Lighting*). Fast recycling or charging time is a benefit, while the more expensive thyristor equipment conserves battery power. Automatic exposure estimation will greatly assist in obtaining properly exposed

Modern studios for professionals require considerable reserves of power in respect of flash lighting. Here is the very reliable Broncolor 606 flash generator, fitted with remote control, which is typical of the heavy equipment needed. (*Courtesy Laptech Photographic Distributors*)

Modern studio flash units are often made to deliver variable power in both the modelling light and flash tube. This makes them ideal for portraiture, as total control of the light intensity can be achieved without moving the unit. The result of more or less light can be seen precisely through the camera and can be measured with a normal exposure meter. Such lights use tungsten halogen modelling lights and therefore can double for use with artificial light film.

To diffuse a small electronic flash, carefully split a face tissue to one thickness and slip it over the flash head, attaching it with rubber bands. Particularly useful for close portraits in syncro-sunlight work.

The large studio flash used for this picture was discharging at a speed of $\frac{1}{300}$ second – fast enough to freeze controlled action but unable to stop the random speed of the falling letter.

pictures. Always buy a reputable brand name in these units and test it several times before taking it out of the store. Make sure it has sufficient power to work over the distances needed for groups of five or six people with the lens which is normally used and which gives reasonable f stop exposures, for example at 5.6 or f8 with the film most usually loaded. Some leading brand names of good units are Braun, Metz, Photax, Rollei, Soligor, Sunpak, Toshiba, Vivitar.

Owners of SLR cameras or other focal plane cameras will find that the maximum shutter speed possible to get perfect X-synchronization is usually not more than $\frac{1}{125}$ second, often lower. This will not affect interior work but can be a difficulty if synchro-sunlight photography on fast film is being produced (see Lighting).

Most lighting technology suggests that the professional photographer needs a tungsten illumination source of between 1000 and 2000 watts in order to separate the differences of form and texture in the subject and to render successfully contrast and colour. This is four to eight times the norm for well-lit offices and although to the eye it may seem a light of great strength, to the camera loaded with a 50 ASA film it may result in exposure times of as much as ten seconds at f8. For

studio work for clients of the advertising and commercial industries this combination of long exposures and short depth of field can rarely be used. It also has proved impossible so far to build tungsten lights of sufficient power that do not generate an unacceptable level of heat. Models would perspire, chocolates melt and salads wilt, long before the job was done.

The high intensity flash units with built-in modelling lights which have been developed to overcome these problems are both sophisticated and expensive. The professional will need to purchase these units to suit his/her own different needs. The portrait studio, using 6×6 medium format, needs only moderately low power, but multiple heads, possibly, delivering not more than 250–500 watt/second per head. The product and still-life photographer, however, with 18×24cm (8×10 inch) format could need a minimum of 10,000 to 20,000 watt/second split over four or five heads but with the added capability of putting at least half of it through one lamp only. The cost of such equipment is phenomenal.

Not all such lamps deliver a light of perfectly correct colour temperature and it is always necessary to use CC filters on the camera lens, colour gels on the flash lamps or colour reflectors to obtain ideal colour balance. Such units also do not often flash at the high speed of small portable units, most having a flash duration of about $\frac{1}{300}$ second which is not really an action stopping exposure for most moving subjects. This lower speed is chosen to reduce the effect of reciprocity, giving deeper, richer colour on colour film and normal brilliance without increased development on B/W film. Leaf shutters, with x-synchronization over a full range up to $\frac{1}{500}$ second, can be set at the maximum speeds even though flash is used, but focal plane shutters cannot. Some reliable, well known makes of studio flash are Balcar (French), Bowens (British), Bron (Swiss), Multiblitz (West German), Norman (USA). (See Lighting, Multiple Flash, Synchro-Sunlight.)

EMPHASIS

All images must be so arranged that the most important subject in the frame has decided visual priority over those parts which refer to accessories or supportive components. The establishment of a hero and a hierarchy of lesser elements in the picture presents the viewer with a point of view to consider and much modification is possible by the skilled photographer to make this event happen at the speed and level of consciousness which has been planned. (See Image Management.)

EMULSION

This is the photographic term which is used to describe the thin layer of light-sensitive chemicals which have been coated on film or paper for use in cameras or in darkrooms. The normal chemistry of emulsions consists of crystals of compound silver salts or halides from the bromine, chlorine or iodine family, all of them inherently receptive to the blue wavelengths of light and UK radiation. By the use of additives, sensitivity can be extended to all colours of the spectrum and

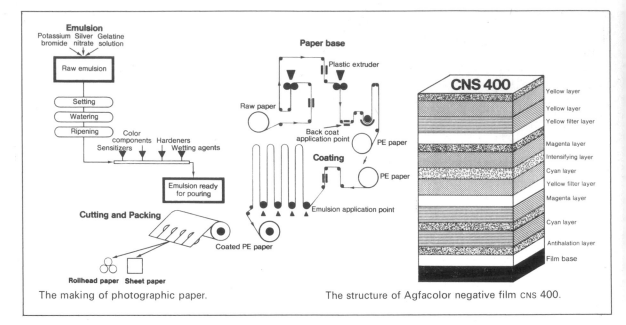

The making of photographic paper.

The structure of Agfacolor negative film CNS 400.

infra red. The silver halides are fairly evenly distributed in a gelatin material and are thinly coated to a base support, sometimes in multi-layers having different characteristics. The base support for films is usually a non-inflammable cellulose acetate and for papers a baryta fibre paper or a resin coated plasticized paper. All emulsions have a measured speed or sensitivity to light and an established colour sensitivity to different wavelengths of light, plus an inherent contrast and a defined grain structure. Although now improved in all these characteristics, modern photographic emulsions are very little changed from the original silver halide emulsion invented by Richard Maddox in 1871.

When light strikes such silver halides, a permanent, but invisible, change takes place in those salts activated, varying in effect in direct proportion to the different amounts of light reaching the emulsion. This is called a latent image because it cannot be seen until further processing takes place.

Hand coating of liquid suspensions of light-sensitive chemicals is possible in a normal darkroom and this may be done by using wood, paper, aluminium, leather, plastic, glass, ceramic or almost any other support material as a base. Rough, thick, water colour paper is one of the most attractive and one of the easiest to handle. Commercially available emulsions such as the ones Rockland Colloid Inc. make are excellent and have a fast enlarging speed. Enthusiastic workers can mix their own formula as follows.

Dissolve 50g of table salt in one litre of water and brush this onto one side of sized water colour paper. Dry. Make a solution of 15g of silver nitrate in 100cc of distilled water and flow this over the dry salted surface, using a paste brush with no metal parts, to help if necessary. Dry this in the dark. The paper will be very slow and should be exposed to sunlight or a high energy medium wave UV light source (safety UV glasses must be worn). This means a contact size print is made from a

film or paper negative which has been made to the same size as the desired finished print. The image will redden slowly during a long exposure of half an hour or so and does not need developer. When sufficiently dark, the positive print is fixed in plain, hypo-fixer for a few minutes, washed for one hour and dried. *Caution*: silver nitrate is poisonous and will react unfavourably with many other chemicals. Wear gloves and wash equipment immediately after use. Taken internally this chemical can cause death and is dangerous to the eyes and skin and will stain permanently. If it is brought accidentally in contact with the eyes, flush instantly with plain water and continue this for 15 minutes. Call a doctor immediately. (See *Basic Photography*, *Black and White Photography*, *Grain*, *Appendix*, 'Other Products'.)

ENLARGING

All serious photographers today need to understand the technique of enlarging which is a process whereby a negative is placed in an optical projector and enlarged for a final, bigger image, on either paper or film.

The equipment to do this could be either a horizontal or vertical mechanical arrangement, though most small darkrooms will have space only for vertical enlargers (right fig.). The light source behind the negative may be diffused, which minimizes scratches, abrasions and grain on the negative while delivering slightly softer, low-contrast prints. Alternatively it may be that the enlarger is of the condenser type with lenses used to concentrate the beam into straight line penetration of the negative (fig. page 116). Condenser enlargers require a thinner negative and have faster printing times and deliver slightly contrastier prints than diffusion enlargers. Reliable makers of enlargers include Leitz, for 35mm; Berkey, Besseler, Durst, Vivitar and Minolta for 35mm to 6 × 7cm;

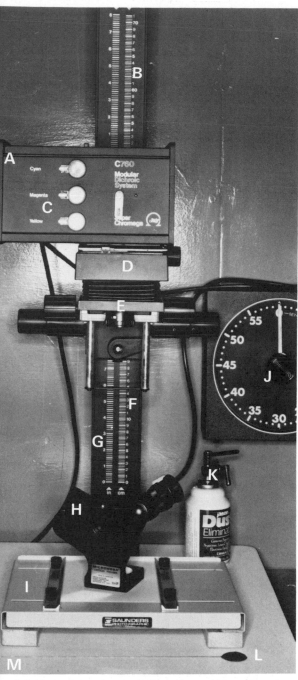

A 6x7cm enlarger in a typical working position. Note the various attributes of the equipment which most serious workers consider essential minimums. A built-in voltage stabilizer. B high-rise column. C dichroic filters for colour enlargement. D rotating negative stage. E tilting lens panel. F scale on column. G rigid column. H micro focusing aid. I paper easel. J electric timer on line. K canned air. L dodging tools. M stable baseboard.

Omega, Durst, Besseler and DeVere for large format professional sizes.

The enlarger head will rise on a long column which must be made in such a way that vibration is minimized and there must be a positive lock to keep the head in the selected position. The lens is moved by means of secondary focusing devices once the approximate picture is sized up and these too must have a positive locking action. The enlarged picture is projected onto a base board or easel and a timing device is connected to the lamp in the head. The negative stage and base board must be exactly parallel to each other in all respects. An enlarging lens is a specially made lens with flat field characteristics and it is better to buy this type than use camera lenses for the job. A different focal length lens is usually needed for each negative format to be used.

The enlarger should be in the dry area of the darkroom on a very sturdy bench, possibly in a black booth to prevent light spillage to other parts of the darkroom, and to shield it from safe light illumination. Such a bench should be 75cm (30 inches) from the floor and there must be sufficient ceiling height for the lamp house to go to the top of the focusing column. The routine procedures of B/W enlarging must be carried out strictly on a time and temperature basis, with developers at 21°C (70°F) for preference and developing times should not exceed four minutes. This means that a seconds timer on the line voltage to the lamp and a tray thermometer are essential for good prints.

Method

First clean the negative by using a Staticmaster brush or an ionized air stream, such as those of 3M or Dust Off, then make sure that the shiny back surface of the film is free of all water drying marks. If it is not, lay the negative on a clean sheet of glass and with a lens tissue lightly dipped in film cleaner gently rub the *back* of the film. Water marks on the dull, emulsion side cannot be cleaned off. Take care not to use undue pressure as this may cause abrasion marks. After cleaning, dust the negative once again before putting it in the enlarger. Turn on the enlarger, open the lens to the widest aperture and raise the lamp house on the column until the image reaches the desired size. Use the grain magnifier in the centre of the board and focus sharply on the film grain and stop down two or three stops. Some poor quality lenses may shift focus during this stopping down but this can be seen in the magnifier by watching the grain structure as the lens is stopped down. If any shift of focus is noticed, pre-set the lens to the right aperture and focus the negative while it is stopped down to this aperture.

Test strips will be needed, not smaller than 20 × 5cm (8 × 2 inches) and the first is exposed to increasing amounts of light from an average part of the negative, then developed precisely for two minutes at 21°C (70°F) in a standard print developer such as Suprol, Dektol or Ilford PQ Universal.

Examine it in daylight quality light. The correct exposure will give rich blacks with discernible shadow detail, slightly covered highlights (which retain their incident highlights) and a good long scale of tones between the two. If the tones are compressed, with poor separation between close values,

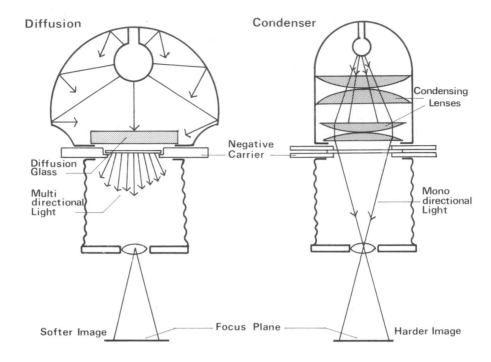

Enlarger types.

especially the darker areas, make a new test using the entire strip but with 25% less exposure and then extend the development to 2 minutes 45 seconds at precisely the same temperature. If the print has muddy blacks, no shadow detail and grey highlights, make a new test at 50% less exposure and develop for the same two minutes as the original test. If, however, the test produces shadows which are grey and highlights are non existent, the test is under-exposed and exposures must be increased. Double the exposure time for the next test. Once good separation in all tones can be seen in the final test strip, try one further test on a contrast grade of paper higher than normal, but increase the exposure from the final test by 15% and develop for exactly the same time as the best previous result. Compare these last two in daylight quality light and then proceed with the first print.

It may be necessary to use dodging or burning in, localized flashing, warm concentrated developer or warm air to restrain or build up local areas (fig. page 120). The print should not be left longer in the developer than 4–5 minutes, otherwise highlights may be fogged and staining of the image could take place due to oxidization. One of the basic mistakes made by most beginners in enlarging is that the print is made too light and the richness of the highlight detail is lost. This is why the negative must contain ample shadow detail and contrast should not be excessive. If the dark areas are important to the print and the highlights are not printing richly enough it might be worth trying the pre-flashing technique, as follows.

Take out the negative but keep the lens stopped down to f16 or f22; place 1.0 *neutral density filter* over the lens, put the enlarging paper in place and turn on the timer for one second, exposing the blank sheet. Remove this paper sheet to a light-proof box. Replace the negative, adjust the aperture to the correct setting from the test information, re-focus and stop down and then re-expose for 20% less time than the test indicated on the same sheet of paper which has been previously flashed. A high contrast paper and an increase and decrease of the pre-flash exposure can radically alter contrast. A simple shift to a lower contrast paper and a reduced exposure plus increased development may help for minor problems of extending the scale of tones but if in doubt, the negatives must be made again (see *Nine Negative Test*). Prints made for reproduction must take into account the loss of detail and contrast which is inherent in many photo-mechanical processes, especially the cheaper ones such as newsprint. These prints must usually be made on a contrast grade higher than normal with clear detail in all the blacks and crisp white highlights. Long scale subtlety in tones can only be reproduced by expensive art engraving and such reproduction prints should be made after proper consultation with the printer who will do the job. Enlargements being made as exhibition or art prints, where the final image is strictly for viewing only, can be extremely subtle in tone range and very rich in density particularly if they are to be spot lit.

After developing, the print should be left in a 2% acetic acid stop bath for 30 seconds, rinsed in water and placed in the fixer. Do not over-fix, especially with fresh solutions of rapid fixers, as these soon begin a bleaching action on the highlights. Good exhibition printers may make their prints 20–30%

a

b

c

d

For colour enlarging, equipment with dichroic filters built-in is the most useful. These can also be used for printing B/W multi-contrast paper. (See *Multigrade*.)
Some useful tips.

a Periodically check the negative stage and baseboard for absolute parallel.
b After cleaning the negative, just prior to fitting the carrier into the enlarger, clean each side of the negative with pressurized air.
c Use a focusing aid always and stop down afterward.
d Time all exposures precisely by using a lab timer connected to the enlarger.

darker than normal and after fixing and a few minutes' wash, place them in a weak *Farmer's Reducer* in order to clear the highlights. This can, if not carried too far, produce beautiful quality images with sparkling highlights.

Fibre-based papers need long, careful washing for real stability (see *Archival Processing*) but RC (resin coated) papers may be washed quickly and power dried by hot air in a few minutes. There is little discernible difference between RC and fibre-based papers, except that RC is not considered to have any great permanency, due to instability of the paper base and other factors. One notable enlarging paper is Ilford Gallerie which is an expensive exhibition paper of great beauty. It is fibre-based, heavy in silver, with a fine white baryta base. Photographs on this material stand out in terms of richness and tonal separation.

Any enlargement is not complete until it is spotted and any white marks are covered up. Using a ooo sable brush with a fine point and suitable spotting medium such as Spotone or a dry water colour, most dust specks and hair-lines can be removed (see *Spotting*). For black marks on the print a very sharp scalpel may be used to pare down the emulsion and leave a light grey area which is subsequently matched to surrounding tones by using the spotting medium.

Enlarging for colour is very little different to B/W except that coloured print filters must be added to the light above the negative stage and a voltage stabilizer should be fitted to the electricity supply to eliminate surge. Colour corrected lenses are also to be preferred (see *Colour Enlarging* for method of approach).

Contrast is often a problem in reproducing colour photographs on colour print material and the results of tests will sometimes indicate unacceptable contrast. A sophisticated process of highlight and shadow masking can restore the position but a technique worth trying is simply to flash the printing paper briefly with a second exposure before printing is carried out. This is done as follows.

After the test strip is produced and corrected for colour balance and density, a new sheet of paper is put in the easel and an exposure made but reduced by 20% on the test time. Leaving the original negative in place in the carrier and the unprocessed print still in the easel, the timer is set for 10% of

Right & opposite Steps toward good enlarging
a Examine the negative under a magnifier and assess its printing quality and physical condition.
b If these are below standard, make a new negative.
c Make a contact print of each complete film after cutting it into sets of not less than three negatives per strip.
d Examine contacts with a magnifier and mark those needing enlargement.
e Make a work print, free of dodging and control techniques. Study it when dry and decide how to improve print quality and where cropping will be made.
f Make the final print.

a

c

SETTING UP THE ENLARGER

1 Put enlarger on solid base and check electric supply for safety.
2 Using a spirit level, check parallels. Adjust and lock enlarger.
3 Blow air through the lamp house and bellows to dislodge dust.
4 Clean all glass surfaces with lens tissue and a soft brush.
5 Fit enlarging lenses, not camera lenses, for the correct negative format.
6 Use glassless negative holders except for large format negatives, unless the negative stage receives undue heat.
7 Use an easel magnifier to focus on film grain.
8 Time exposures by a seconds timer connected to the electricity supply.
9 Make a dust cover for the equipment when not in use.
10 Keep a spare enlarging lamp in the darkroom.
11 Be aware of vibration to the column, the bench or the floor.
12 Check all safe-lights for fogging.

Kodak Polycontrast paper is an excellent enlarging paper, particularly for reproduction prints. Special filters are used with only one grade of paper to obtain all contrasts but the dichroic head of colour enlargers can also be used for this purpose. The following table is based on the Berkey C760 enlarger.

Kodak filter	C760 filter pack
No. 1	25Y
No. 2	25M+5Y
No. 3	65M+12Y
No. 3½	140M+25Y
No. 4	200M+50Y

Exposure times increase progressively from 1–4 by 10% or more, according to the amount of magenta dialled in. These are guide times only and tests must be made. (See *Multigrade.*)

the test strip printing time. A 20 × 20cm (8 × 8 inch) piece of opal glass or thin opalized Perspex is held between lens and paper as a diffuser and the secondary brief exposure is given. The print when processed will have reduced contrast and better highlight detail and should be well balanced for colour. If the second exposure is reduced to 5% at the printing time, contrast is only slightly affected, if it goes to 20% it is very considerably reduced, possibly to fog level. There may be a noticeable increase in paper speed by this method and tests will be needed (see *Flashing*).

Judging colour prints must be done in the same quality of light in which they will finally be viewed and reproduction colour prints will need to be assessed during processing in daylight quality light. A reference table of faults in colour processing will be found in the section *Colour Enlarging*.

e

f

a

b

c

Enlarging paper is supplied in a range of contrasts from soft to very hard, in four or five steps. The most needed are **a** soft, for high contrast negatives, **b** medium for normal negatives and **c** hard for low contrast negatives.

Remember that this is print contrast and is very different from lighting contrast which is covered in the section on *Lighting*.

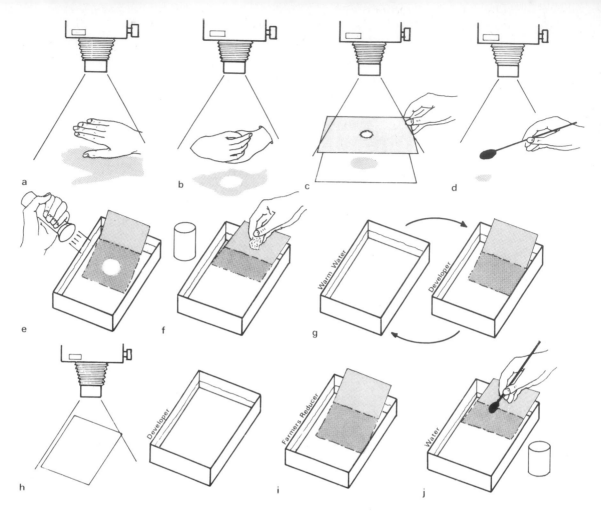

Enlarging controls.

a Hand in light beam, shadow reduces exposure. For general lightening of large areas.

b Two hands in light beam and fingers shaped to allow small area of light to reach paper. This darkens those areas because they get more exposure than the shadowed area. This is called 'burning in'.

c Black card with cut-out aperture allows more accurate repetition of (b). Three cards are useful, with different size holes, and this is the normal way of increasing exposure in local areas. Must be kept in constant motion during exposure.

d Thin wand with black card circle fixed at end. Must be kept constantly moving. Casts shadow in small local areas to reduce exposure in those areas. Three wands of different size are useful, 1cm in diameter, 2cm and 3cm. This technique is called dodging.

e Torch with long snoot to reduce size of beam, darkens areas during development by fogging the image in small local areas. Useful to conceal unwanted detail.

f Swabbing local areas with concentrated hot (30°C, 86°F) developer darkens image. Needs care, can cause fogging especially on RC papers.

g Water bath at 24°C (75°F) is used alternately with normal development. Reduces contrast.

h Very brief fogging to enlarger light before main exposure reduces contrast overall. Called 'flashing'.

i Overall reduction of print density and general clearing of highlights by immersing entire print in weak Farmer's Reducer.

j Local areas are swabbed with reducer to lighten small details. A water bath avoids patchy results and stains.

EQUIVALENCE

When looking at a photograph, often we see it unconsciously as something other than the object depicted and our response is triggered by memories or experiences which are entirely subjective and unequivocally personal to each of us. This accounts for the differences between individuals coming to terms with the subject matter of any photograph when it is presented for viewing. In addition, the image will evoke quite different emotions and reactions in each of us.

All memorable images are to some extent ambiguous and we endeavour to decode them by a process of intuitive, flickering inspection which produces unconscious hypotheses as to the essential meaning. This psychological testing and matching to hidden experiences begins a two-way stream of communication, quite outside the realm of intellectual analysis, which connects both the viewer and the creator to the image. When common ground is touched, a deep, intro-

spective understanding acts as a psychological mirror, in which the observer recognizes an emotional reality of which both he/she and the photographer are part. The completion of the image takes place in the mind of the viewer and this vital participation creates a mysterious and insoluble bond with the originator of the image. Abstraction of the photograph tends to heighten the symbolic meaning of it, and in viewers with some degree of visual sophistication, the subjective interaction between viewer, image and creator, is considerably more with such images than is the case of the straightforward photograph.

EROTIC PHOTOGRAPHY

From the earliest development of the camera, during the wet colodion plate era and later in the nineteenth century and especially now, with the arrival of the instant, peel-apart photograph there has been the possibility for photographers to explore the private and secret taboos of sex, as they apply to both themselves or the community in which they live. The borderline between eroticism, art or obscenity is dangerously elusive when one is armed with a camera and can take advantage of the factual representation at which this machine excels. Photographers who cannot, or will not, understand the difference between obscenity and eroticism should at least be aware that most communities establish considerable penalties for those who offend the public's taste by publishing or exhibiting pictures which are, by consensus, considered obscene. Penalties are usually severe but vary from place to place, and photographers should not use their skills unwisely in this matter.

Eroticism, however, has many legitimate associations with art and documentary images and is certainly a field of consequence for photographers to explore seriously and to publish and exhibit if so inclined. Taste, concept and flawless photographic technique are of paramount importance. Fashionable styles in erotic photography may be studied from the beginning of its history right to the present time and the photographer must approach this subject with a personal philosophy and moral concept which has been achieved after careful consideration of the various factors involved. The commercial response from specialist editorial markets and magazines to these images is substantial, but rarely moves far away from pretentious exploitation and is not usually open to the average photographer or the serious photo-artist.

Photographers who aspire to achieving fine art status in this field will be working with plenty of examples of past standards in both photography and easel painting, which may guide them to a better understanding of the subject. On close study these examples may reveal that enduring art images on this theme have a latent and diffused sexuality rather than any too clearly stated and there is considerable intellectual content in the image, as well as the emotional factor. The photographer may see also the degree to which abstraction plays a part and understand how the machine-made clarity of the photo-image can sometimes intrude upon the introspection which should often accompany the viewing of this kind of material. This then is a very difficult sphere of photography, needing responsible concepts, superb technique and mature sensitivity. It is very easy to offend and easier to fail (see *Nude Photography*).

EVANS, WALKER (1903–75)

Evans was one of the major photographic artists in the history of the medium, and his austere vision of highly inhabited, but empty architectural spaces became a reserved presentation of poetic subjectivity. His pictures have a personal complexity and a severe paternalism which, however, remain definitive in their understanding of the society which he observed so intuitively.

His body of work extends the tradition of Atget to the North American milieu and raises the documentary use of the camera to the very highest level. He is justly considered to be without parallel in US photographic comment and his images remain inspirational source material to all photographers who study them.

After his return from Paris in the late twenties, he turned his camera on his native USA with increasing distance, but with remarkable understanding and sympathy. His survey of Boston architecture of the late nineteenth century was exhibited in New York in 1933 at the Museum of Modern Art. He was an established artist in his early thirties by the time he joined Roy Stryker's Farm Security Administration programme which created such vivid documentary images arising from the agrarian resettlement problems in the USA after 1935–6. His uncomfortable and short stay with this famous photographic team was equally difficult for his employers and he was finally loaned to *Fortune* magazine for a three-month long assignment with the writer James Agee to produce a major story on white tenant farmers in Alabama.

In 1938, New York's Museum of Modern Art published his most famous work, *American Photographs*. This was a book arranged in a strictly sequential presentation in two parts, each picture numbered and intended to interact with each other, yet stand alone as a single page confrontation with the viewer. It became an acknowledged masterpiece of photographic art which has rarely been equalled. Not until 1941 did the Alabama work appear in print, finally also as a book with text by James Agee and entitled *Let Us Now Praise Famous Men*.

Walker Evans's photographs have exposed, with serenity and discretion, much of the structure of a deep, fast growing and perhaps tragic society, as it arose, level by level, during a defined period of its history, around both the observer who recorded it and those of its members with whom he shared centre stage.

EXISTING LIGHT

A condition of light which does not include any augmenting light source created by the photographer (see *Available Light*).

EXPLODED VIEW

These are usually technical photographic illustrations which

Exploded view. To photograph the components of a complex machine, they may be arranged on a translucent light box c in the order which they normally fit. An exposure is first given from below and then these lights are extinguished while the second, main exposure is given, with lights A and B (*Courtesy Rollei Photo Technik*)

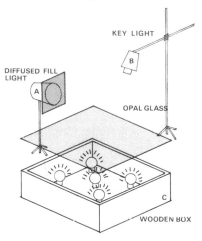

show many small components in place as they relate to a whole object. Certain special equipment and techniques can assist in making these photographs and this is explained in fig. above.

EXPOSURE

The most fundamental aspect of the photographic process is that the sensitive silver salts suspended in the gelatin emulsion must receive a controlled quantity of light. This causes a latent change in the nature of these salts which allows a metallizing action to take place during further processing and so the darkened image becomes visible. A camera is fitted with a shutter mechanism to control light from the lens and the enlarger is given a switch so that the light beam may be turned off after a desired quantity of light falls upon the printing paper. In order to be able to repeat these processes of control, the amount of light must be measured and related to the sensitivity of the photographic material.

a A meter which measures reflected light is held at the camera position and aimed at the subject or a grey card with 18% reflectance value. Take care that the meter's shadow is not included in the reading.
b A meter which measures incident light is held at the *subject* position and aimed along the lens axis. Note the white diffuser cone which is the distinguishing feature of incident meters.
c When it is impossible to obtain direct readings from the subject because of distance from the camera or other factors an average reading for middle tones may be taken from the back of the hand, with a reflectance type meter, to give a proxy reading.

This estimation of exposure is extremely important to successful work and so many variables are present that 'correct' exposure is often highly subjective and would be different for different photographers, even though they use the same film and equipment. Some of the variables affecting exposure are:

Measuring the exposure
Reflected light meters average the reading of many values reflected from the subject and reach a 'grey card' compromise; incident meters measure light actually falling on the subject; automatic metering in cameras may be biased to centre, top or bottom, or an average of the whole scene. Different readings are possible from common standard situations whenever different metering techniques are used.

Taking the picture
The shutter Camera shutters will vary, even within the same model and make. High speeds may not be accurately proportional and speeds may not be precisely correct in real time. Shutters should be tested electronically for accuracy.

Light quality If a light is biased to blue, ultra violet or infra red it may affect the actual speed of the film, especially B/W material. If orthochromatic film is exposed to daylight its speed is different from when it is exposed to tungsten light.

Duration A light of a very brief or long duration alters the speed characteristics of a film by virtue of the reciprocity effect.

Temperature Low and very low temperatures cause slow film speeds.

Exposure index The actual film speed is calculated by test and is usually different from the maker's published ASA speed and it varies for each individual according to subjective judgement.

Processing the image
Developers Crisp, vigorous developers load the highlight density with silver; compensating soft-working developers restore shadow detail; some formulas increase effective speed, others reduce it.

Density Large format negatives and informational subjects often need heavier densities in the negative; 35mm film requires extremely thin negatives for best results. Density affects acutance and grain.

Enlarging Condenser enlargers require less density in the negatives, diffusion enlargers generally a little more. Big magnifications are better if negatives are less dense.

Print quality Each individual decides his needs in print quality, for example low contrast negatives with thin density are often made by choice and printed on high contrast paper to make very rich prints with maximum detail. High key prints with reduced highlight detail require more exposure and a denser negative, and so on.

Judging the final image
The photographer will make a subjective decision on how his final image must appear and how much highlight or shadow detail is needed. If the image is for reproduction, more density will be required in shadow areas and blacks. If colour film is exposed, perhaps greater saturation is desirable, particularly if reproduction is to be considered, meaning less exposure than normal, to the extent of half a stop.

From the above it can be seen that deciding upon a correct exposure is not going to be easy and it may vary considerably from normal standards set out by sensitometric experiment. It must, however, be a repeatable measurement if the photographer is going to establish a basis on which to build a good technique. The first set-up is to establish the exposure index (EI) for each of the films which is preferred by testing these in the camera and processing with the chosen developer to a density suitable for the enlarging equipment on which prints are normally made. (See *Developers, Zone System, Exposure Index, Nine Negative Test.*)

Calculation of exposure may be carried out automatically by the camera or separately measured by a hand-held meter. Automation in modern cameras is reasonably reliable as regards exposure estimation and in the case of Minolta, Olympus, Contax, Canon and the Rollei SLX and SL 2000, it is quite exceptional. Under certain conditions, errors can be made, however, by automatic exposure circuitry and cameras will then give false readings. Compensation can be introduced by using over-ride buttons (see fig. E21) or by altering film speed to give more or less exposure. In general, it may be found that averaging meters, particularly in cheaper cameras, will over-compensate the blacks, rendering them as greys, white may be reproduced with too much tone as a grey, and large expanses of light or dark areas will confuse the meter. If the 35mm camera is loaded with film suitable for push processing, the easy solution to these problems is to take a bracket exposure of an average scene on the first three frames, after number one is wound into place, then *clip test* these for correct exposure. Do this each time a new roll is loaded unless the same type of scenes are being shot in each case. If 120 roll film is being used rather than 35mm it will be necessary to make the test bracket on the *last* three frames which are exposed.

Metering systems depend on the use of a photo-electric cell which converts light energy into sufficient electric energy

Film emulsions are rated in ASA or DIN speeds and these must be set on automatic camera controls to agree with the film which is being used. This is the first step after loading a different film.

The spot meter has a sighting device as well as a measuring device and reads exposures from an extremely narrow angle. This allows greater precision in estimating highlights and shadows, especially if they are some distance from the camera.

An incident light meter with probe.

to move an indicator or needle along a scale, which shows a progressive value in respect of the strength of light. Cells can be made of the old style selenium, which is slower in sensitivity but needs no battery, cadmium sulphide (or cds), smaller, more sensitive but slower in adjusting to quick changes of light or the tiny silicon or gallium cells, now to be found in expensive, modern equipment. These new cells set the standard for the best of all worlds as regards sensitivity and speed of reaction. They react very fast and are extremely sensitive to low light levels. Hand-held meters are still often preferred by many photographers and the choice is wide. Gossen, Minolta, Bewi, for general reading; Pentax, Minolta, Soligor for spot reading. The narrow angle spot meters are extremely helpful as they allow exact readings of small areas of a scene to be measured and a compromise exposure can be calculated to fit the *brightness range* of the scene to that which the film is capable of reproducing. Remember that when the shutter is set for a compensated reading, not only highlights and shadows will be affected but all values in the scene will be changed. A proxy reading is useful, if the subject is inaccessible, using the back of the hand or a grey card to read from.

If no meter is available for outdoor photography or there is a malfunction of the one in use, a general guide to exposures

USING A CAMERA WITH AUTO-EXPOSURE FACILITY

1 In good contrast light, measure shadow areas by a close-up reading, then re-programme the camera to compensate.
2 For back-lit subjects open up two full stops.
3 If the main subject is brighter or much darker than average and is off-centre, take a separate reading and over-ride the meter automation.
4 Beware of small, brilliant highlights in the scene and if they are present open up half a stop.
5 In very large, bright lit areas of back-lit expanses of sea, open up one to two stops if foreground detail is required.
6 For increased, general colour saturation, minus half a stop is needed.
7 Small, bright subjects in dark areas need separate readings.
8 Large back-lit sky areas need an extra stop if good detail is needed in foregrounds.
9 If the sun is in the frame add three stops to increase foreground detail.
10 If copying art objects at close distance open up half to one full stop.

can be found by setting the shutter speed to the figure nearest the ASA rating of the film and for average scenes lit from above or behind by sunlight, set the aperture to f16; if the sun is hazy bright set on f11; for bright cloudy conditions, but overcast, f8; open, tree shade on sunny days, f8; on cloudy days f5.6. If the light is lower and cross lighting the subject from left to right or vice versa open up a further half stop, if from the back of the subject, shining towards the camera, compensate by a two stop increase. (See *Basic Photography*, *Lighting*.)

How the automatic exposure meter of a modern 35mm SLR measures the subject. **a** Averaging meter reads the entire area of the viewfinder for a compromise exposure. **b** Spot meter works in a narrowly defined area at centre, top or bottom of the screen. **c** The centre-weighted meter reads with more emphasis to the centre, but includes other areas in its reading in order to get a more accurate result.

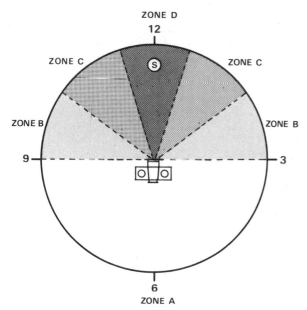

THREE-STEP OUTDOOR EXPOSURE GUIDE FOR COLOUR FILM WITHOUT A METER

1 Set the camera shutter speed to the number nearest the ASA rating.
On SLRs use the following table:

800 ASA	$\frac{1}{1000}$
400 ASA	$\frac{1}{500}$
200 ASA	$\frac{1}{250}$
100 ASA	$\frac{1}{125}$
80 ASA	$\frac{1}{60}$
64 ASA	$\frac{1}{60}$
25 ASA	$\frac{1}{30}$

2 Set the lens aperture according to conditions:

Light conditions	Lens opening
a) Bright or hazy sun on sand, sea, snow	f22
b) Bright or hazy sun on open landscape, definite shadows	f16
c) Weak sun, soft but discernible shadows	f11
Bright overcast but no shadows	f8
Heavy overcast	f5.6
Open shade on sunny days	f5.6

3 For conditions (a) and (b):
If the subject is backlit open up two stops from those indicated.
If the subject is crosslit open up one stop from those indicated.

For condition (c):
Backlighting open up one stop.
Cross-lighting open up half a stop.

Ready reference exposure guide without a meter. Using this guide, read the manufacturer's data sheet for normal exposure. No meter will then be needed to assess varying lighting conditions.

When the camera is in the centre of a clock reference and the subject is at 12 o'clock, if the sun is lighting the subject from
A zone, exposures are normal
B zone, exposures are + $\frac{1}{2}$ stop
C zone, exposures are + 1 stop
D zone, exposures are + 2 stops

EXPOSURE INDEX

The establishment of a precise ASA or DIN rating for a given film requires a standard developing technique using standard camera equipment, with processing adjusted to produce a given density. When a film is developed in any other developer and the image is made by other than standard optics, the published ASA rating may not be a true indication of the actual speed of the film in the new circumstances. A film speed rating arrived at by these non-standard techniques is known as the exposure index (EI). For practical purposes, such as meter setting, EI and ASA should be considered identical in any standard lighting conditions.

Calculating the EI in a practical test

Photographers who wish to re-rate their normal film to suit their own equipment and processing need only to expose the chosen film to a standard light source with a normal subject of their choice at the manufacturer's recommended ASA setting, then a third stop over that, then two-thirds over, then one full stop over. With exactly the same controlled circumstances the photographer needs to under-expose by uprating the film, one-third stop faster, then two-thirds, one stop and finally uprating the film speed by two stops. Process the results simultaneously in the developer normally used for the preferred time and dilution. Assess the results by viewing with a light source of at least 5000K or by taking densitometer readings of the negative. Choose the ideal negative and make a standard print at precise time and temperature in the preferred print developer. If the print satisfies in all respects of brilliance, shadow detail, highlight detail and contrast, refer to the original camera test to find the ASA rating used. Provided the same processing and printing techniques are used in the future this can be the EI at which that particular film is always rated. (See *Basic Photography*, *Exposure*, *Nine Negative Test*.)

EXTENSION TUBES

These are rings or tubes which extend the lens further from the camera body and are placed between lens and camera. They permit closer focusing than is normal and are usually used on fixed bodied cameras. Their main use is to cover the distances below the minimum close distance at which a given lens normally focuses but are not usually required for really close macro work, this being done by a bellows attachments (see fig. below). Extension tubes are extremely useful for medium/long telephoto lenses where these are being used for portraiture (see *Close-up Photography*).

For macro focusing on fixed body cameras such as SLRS an extension tube is often used to extend the main lens and so allow extreme close-ups.

F64 GROUP

This was an American photographic group founded by cine photographer Willard van Dyke and others in the early 1930s, taking its name from one of the smallest f stops on the lens of a view camera thus indicating an interest in detailed, deep-focus images. Famous photographers such as *Edward Weston, Imogen Cunningham, Ansel Adams* and *Dorothea Lange* were members and the first exhibition of the group was held in the M.H. de Young Memorial Museum, San Francisco, in 1932. Both critics and photographers saw it as an effective antidote to the cloudy, romantic and manipulated pictures which were then fashionable in the suffocating worlds of establishment and salon photography. It seemed particularly to flourish in the bright Californian sunlight.

This clear untroubled vision, independent of, but closely parallel to, the New Objectivity photographic movement in Germany, required great technical achievement in using photographic processes. A hallmark of all F64 Group members was superlative monochrome technique. Although later disbanded, their influence was considerable throughout the world at the time and still is today. Original members of the group continuing today to employ the same stringent values of 50 years ago are *Brett Weston*, son of Edward, and the patriarchal photographer Ansel Adams whose teaching, writing and practical photography brilliantly sustains the original theses of the pioneer movement. (See *Fine Art Photography, Depth of Field*.)

FAHRENHEIT

This system of temperature measurement was named after a German scientist of the eighteenth century, G.D. Fahrenheit. The scale begins at a zero base of a freezing mixture of equal parts of snow and salt, and continues to the freezing point of water at 32°F and on to the boiling point of pure water at 212°F. The 180 degrees between the freezing and boiling points of water compared with 100 degrees in the Celsius

TEMPERATURE CONVERSION

Equation $F = \frac{9}{5}(C) + 32$
 $C = \frac{5}{9}(F - 32)$
Practical F = Celsius multiplied by 1.8 then add 32.
 C = Fahrenheit minus 32 and then divide this answer by 1.8.

scale, makes direct comparisons difficult to calculate but the following formula can be used (see *Celsius, Weights and Measures*).

FARMER'S REDUCER

This reducing or bleaching bath was invented in 1883 by the English chemist E.H. Farmer (1860–1944). It is subtractive or cutting in action, giving slightly increased contrast and removes the silver image from highlight and shadow areas in roughly equal proportions, especially if it is mixed to a high concentration. The action on negatives is rapid and must be carefully watched in good light and it is advisable to use a light-coloured tray under a bright light while the process is carried out. A five minute soak in a pre-bath of plain water containing a little wetting agent assists the even absorption of the solution.

Prints to be bleached require a more diluted mixture than negatives and a pre-bath of 15 minutes is needed if the prints are dry.

Farmer's Reducer formula

Solution A

Potassium ferricyanide (anhydrous)	20g
Water	250ml ($\frac{1}{4}$ litre)

Solution B

Sodium thiosulphate (hypo)		250g
Water	to make	1 litre

Do not combine A and B solutions until needed, but separately they keep well in dark containers. For negative reductions take 30ml of A and add to 120ml of B solution and mix this into one litre of water. The bath remains active for only about five minutes so must be used immediately. For print reductions 3ml of A added to 12ml of B in one litre of water is sufficient for clearing highlights or for local reduction.

FASHION PHOTOGRAPHY

Students of photography and many amateurs often envy the photographer of fashion for, at its best, this speciality is glamorous and exciting. It is divided into two main categories: advertising and magazine fields and within those, it is often sub-divided into a further two, photography of garments and photography of beauty products.

Advertising fashion photography calls for considerable discipline and restraint by the photographer whose administrative abilities are often more contributory than his/her imagination. As with all advertising assignments, the objective is a commercial one – to sell the product, and there is often a large committee of creative people to collectively produce the image. The brief must be carefully established, preferably in writing, locations and props obtained, models booked and all the logistics properly understood and costed. The client and the art director will tend to dictate many of the visual concepts, one of which is usually that the product must be clearly identifiable.

Equipment for advertising varies according to client needs. For beauty products, especially close-ups, a large

The DOMENICA Collect

STYLE
SOPHISTICATION
INTIMACY

a **b**

Above In fashion photography, static poses are less attractive for displaying fashion **a,** and **b** the model in action always demonstrates a garment in a more attractive way, but is more difficult to photograph.

Right A typical fashion treatment for consumer advertising, stressing the style of the garment and associating it with the sunglasses, which were the main product.

Below A clever use of a single model and some carefully arranged mirrors. The fashion photograph must always be innovative. (*Courtesy Calvin Walker*)

format camera is often required and working with extremely shallow depth of field on such occasions will call for maximum technique. Where the texture of the garment is essentially part of the story, such as knitwear or furs, a camera format of $9 \times 12cm$ (4×5 inch) or larger will be needed. Active locations and multiple model shots are generally photographed on $6 \times 6cm$ ($2\frac{1}{4} \times 2\frac{1}{4}$ inch) or other 120 roll film formats. For advertising, the 35mm camera is not so often accepted by clients, but where mood is the primary function, rather than visual information about the product, this format will be ideal. The management of all the volatile situations arising from such fluidity in subject matter will often intrude into the photographer's thinking to the extent that his/her creativity is threatened and even technique has to be modified alarmingly.

Editorial or magazine fashion photography is a much more flexible affair, resting often on verbal arrangements between the editors and photographer and sometimes depending on impetuosity and wilful adventures during the actual session. The creativity of the photographer is much sought after and any gift of imagination he/she may bring is readily accepted. Except for the acknowledged 'stars' of the business, editorial fees, especially in the UK, are extremely poor, and the current trend towards smaller pictures with extensive copy means that there is rarely enough display of a photographer's work even to make it a worthwhile public relations exercise. The credit

line is no longer enough to reward the young fashion photographer, particularly as much art direction today is less enterprising in the way good photographs are handled. Editorial fashion is, however, often printed on high-quality paper to very high standards and this could be some consolation for those photographers who wish to improve their portfolio presentations.

In editorial fashion photography it is essential to be very clear about *copyright* as many magazines will syndicate the results of the commission, selling internationally to many other publishing sources. The photographer should establish, *in writing*, who owns the photographs submitted, and particularly should not accept gifts of film from the magazine. Acceptance of film could prejudice copyright by establishing ownership of the image in the magazine's favour on the basis of a 'work for hire' stratagem. Payment is often on publication date and monthly magazines work far ahead of publishing deadlines, so a clear arrangement must be made in respect of expenses. It is necessary, of course, to have signed model releases (in the photographer's favour preferably) on all work intended for publication.

Despite the difficulties and the far from glamorous realities of the job, many of the world's most notable photographers began their careers in this field and with suitable dedication and a sense of survival, plus enormous energy and imagination, it may still be the best route for a few photographers to take, even in the somewhat different circumstances which surround the production of today's fashion images. (See *Lighting*, *Multiple Flash*, *Image Management*.)

FENTON, ROGER (1819–69)

Born into a rich Lancashire family, Fenton by profession was a lawyer who became a gifted amateur photographer, intensely interested in the future of the medium. He had received art training from Paul Delaroche and was known for his versatility of subject matter and produced many fine studies of landscapes, cathedrals and flowers. In 1847 he formed the Calotype Club; in 1852 he completed an outstanding series of photographs of the USSR and in 1853 he was the principal exhibition organizer and founder member of the Photographic Society of London, which later became the Royal Photographic Society. In 1854 he temporarily abandoned the legal profession and for the next eight years concentrated on photography.

The following year (1855) he equipped himself with a horse-drawn caravan, complete with darkroom and living quarters, and took himself to the Crimea as the world's first war photographer. His 360 photographs taken in a period of a year were rather bland and often staged to conform to the needs of both slow 20 second exposures and genteel Victorian sensibilities. As half-tone reproduction in newsprint had not yet become a reality, many of his pictures were sketched by an artist before being presented in the daily press. He exhibited prints of his work, however, which the public bought in large numbers. He was one of the first serious documentary photographers to become successful but he returned to his legal profession in 1862.

A typical modern fashion photograph, emphasizing the shape of the garment. (*Courtesy Calvin Walker*)

FILING NEGATIVES

An orderly method of storage and retrieval of negatives will be necessary for any photographer who works often with B/W material or who has much exposed colour film on hand. 35mm film is best cut into strips of five or six exposures and put into 'print and file' sheets such as are made by Nicholas Hunter in the UK, Print File and Franklin Safe-T-Stor in the United States. These may then be examined or contact printed while remaining in their cover (fig. below). 120 film is treated in the same way, except that in most cases each exposed frame will need to have a clear number hand-printed in the margin, because film numbers printed at the time of manufacture do not often show clearly on the contact sheet. The best pen for writing this number is a permanent marker with a very fine point, such as the Schwan Stabilo Superfine 196P which is used for writing on overhead projection transparencies or a waterproof indian ink in a drawing pen. Each roll of film also carries a main filing number to identify the subject and this should be written on the file cover as well. All numbers must be written on the back of the film in order to reproduce correctly right way around.

Glassine or paper negative preservers are not considered suitable, particularly for archival storage, and certain types of plastic covers are also suspect as regards their use on valuable originals (see *Archival Processing and Storage*).

Large-format sheet film can be sleeved in plastic, should be numbered on the rebate edge but also could be placed in film boxes with plain paper interleaving if there are large quantities and archival storage is not needed. A file notebook listing numbers and an index of subjects, plus a shallow-drawer metal file cabinet are also probably necessary if quantities are high enough and reprints are common.

In filing, protect all colour slides from abrasion and dust by using an overlay of acetate.

FILL LIGHT

This is a secondary and weaker light placed to illuminate deep shadow areas which are created by a strong, main light source (see *Lighting*).

FILM

This is the base for all modern photographic emulsions, replacing glass supports on which the emulsion was carried prior to the 1880s. The flexible support is usually polyester or cellulose acetate and does not support combustion.

FILM BACKING

On roll films, a paper backing is attached to facilitate daylight loading of the camera and this is removed before processing. All roll films and sheet films also have an anti-halation backing to prevent flare by stray reflections reaching the emulsion through the film base. This dissolves during processing.

FILM DRYING

Film should be carefully wiped dry of excess water and slowly dried in still air. Wetting agent at very weak dilution is usually added to the last wash before drying and this tends to prevent water marks in the emulsion. In emergencies films may be thoroughly wetted in methylated spirits and dried in a moving stream of warm air, for example, a hair dryer. Drying takes only a few minutes, but there is a considerable risk of damage and staining to the film and it is useful only if a very fast print is needed from a negative with no value beyond the moment, such as may be the case in daily press work or camera testing (see *Darkroom*).

FILM HOLDERS

(See *Large Format Cameras*.)

FILM SPEED

A sensitometric term to indicate the film's sensitivity to light (see *ASA*, *DIN* and *Exposure Index*).

FILM, WRITING ON

Use a Schwann Stabilo pen 196P for writing on film. As each film is taken from the camera, notes may be made on the leader, or file details may be written on the back of processed film.

FILTER FACTOR

This is the number of times the exposure must be increased to compensate for the density of the filter material. It is expressed as 'times 2' to indicate a one stop increase or 'times 4' for a two stop increase and so on (see *Filters*).

FILTERS

Filters absorb colours other than their own visible colour, allowing absorbed light of the filter colour to reach the film. Objects in front of the camera, which are also of the same colour as the filter, will be reflecting a high proportion of that colour, which the filter allows to pass easily into the camera and so affect the film to a greater extent than any other colour. In B/W photography this is rendered as a lighter print tone and in colour film the filter colour creates an overall bias to that colour in the film. By modifying the normal image, filters can become an elementary step in abstraction and, as such, can increase subconscious communication between the photographer and the observer of the final image.

Filters are added in front or behind the lens to modify precisely the light which will act on the film and basically they will consist of contrast, corrective, selective and special affect filters. Contrast and selective filters are normally used only in B/W photography while all of the others may be used with any film type. Contrast filters can control light and dark tones in B/W photography, corrective filters control colour rendering in all films, selective filters isolate narrow bands of specified parts of the spectrum and special effect filters are added only to alter the usual optical rendering of the lens or film.

All filters will degrade lens performance to some extent and the thinner the filter the less is lost in optical quality by the lens. Scientific work requires specially ground, optically flat filters of glass, but much B/W work and all CC (colour compensation) is achieved usually by the use of cheaper plastic, or gelatin, filters. It pays to obtain the best filters possible and Tiffen, Hoya, B+W are all of fine quality. The industry standard is probably the Kodak Wratten filter system which has been indicated throughout in this book. The cheapest filters and the best for much work are the gelatin-based Wratten series. Ultra thin and easily carried, they are attached to the lens in special holders which allow quick changes. The CC filters are universally chosen in this medium by the professional industry. Gelatin filters are delicate and must be handled only by the extreme edges or corners and should be kept flat and free of moisture. To cut them, place them between two sheets of clean paper and cut this sandwich to the right shape with sharp scissors. High temperatures can change their performance and fading will vary with different colours over different periods of time, and it is therefore advisable to replace them from time to time. Colour printing filters are not used for camera origination, not being of high optical quality, and are used only in the light beam of the enlarger.

The special effects filter systems are popular as quick solutions to the need for an eye-catching colour image, but must be considered more as a trend rather than an exact aid for serious photographers. The Cokin system made of high-quality plastic squares is comprehensive and effective and, for

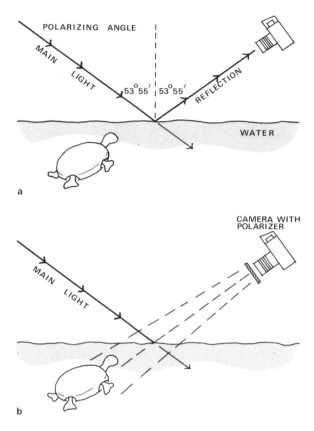

Using polarizing filters.
a Reflection of the main light masks the objects beneath the surface.
b Fitting a polarizer eliminates reflection, and objects below the surface become visible. This is useful for objects behind window glass also.

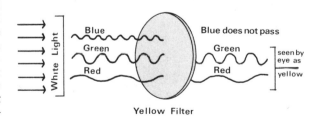

A filter absorbs light selectively. For instance, a yellow filter stops the transmission of blue light, passing only green and red, which the eye sees as yellow.

131

BASIC FILTERS FOR B/W AND COLOUR MATERIALS

	Filter colour	Absorption	Filter code	Filter type	Film used	Daylight factor	Tungsten factor
*	Clear	UV energy	1A	Corrective	All	–	–
*	Pinkish	UV energy	2A	Corrective	All	–	–
*	Yellowish	UV energy	2B	Corrective	All	1.25	–
§	Pale amber	Blue+cyan	81	Corrective	Colour	1.25	–
§	Pale amber	Blue+cyan	81A	Corrective	Colour	1.25	1.25
§	Pale brown	Blue+cyan	81B	Corrective	Colour	1.25	1.25
§	Brownish	Blue+cyan	81C	Corrective	Colour	1.5	1.5
§	Brown	Blue+cyan	81EF	Corrective	Colour	2	2
†	Pale yellow	UV+blue	3	Contrast	B/W, panchro	1.5	–
†	Yellow	UV+blue	4	Contrast	B/W, panchro	1.5	1.5
†	Yellow	UV+blue	8	Contrast+ corrective	B/W, panchro	2	1.5
†	Deep yellow	UV+blue	12	Contrast+ infra red	B/W+IR	2	1.5
†	Yellowish orange	Blue+green	15	Contrast	B/W, panchro	2.5	1.5
§	Light orange	Blue+cyan	85B	Corrective	Colour	2.5	2.5
†	Light orange	Blue+green+cyan	21	Contrast	B/W+IR	4	2
†	Light red	Blue+green	23A	Contrast	B/W	6	3
†	Red	Blue+green	25	Contrast	B/W+IR	8	5

* B/W or colour § Colour only † B/W only

f stop increase		Special effect	Remarks
daylight	tungsten		
–	–	Penetrates light haze	Absorbs UV light, penetrates haze in distant landscape, colour saturation is improved, colour warms lightly; protects lens from damage; use for colour and B/W
–	–	Penetrates average haze	Stronger than 1A, otherwise the same; reduces blue cast in open shadow or at 1000 metres (3300 feet); colour and B/W films
$\frac{1}{3}$	–	Penetrates haze very well	Stronger than 1A, 2A, used in aerial or mountain photography to absorb UV; used as a UV barrier in fluorescent and blacklight photography; colour and B/W films
$\frac{1}{3}$	–	Warms E6 emulsions especially for electronic flash; warms cold light for all colour film	Lowers colour temperature by 100K; cold bluish light is warmed; use on cloudy days with colour
$\frac{1}{3}$	$\frac{1}{3}$		Lowers colour temperature by 200K; cold bluish light is warmed; use in shaded areas with colour
$\frac{1}{3}$	$\frac{1}{3}$		Lowers colour temperature by 300K; cold bluish light is warmed; use for food photography
$\frac{2}{3}$	$\frac{2}{3}$		Lowers colour temperature by 400K; cold bluish light is warmed
1	1		Lowers colour temperature by 500K; cold bluish light is warmed
$\frac{2}{3}$	–	Improves blue skies	Mild contrast in blue sky on B/W film; used on outdoor portraits; partial correction to true tonal value on B/W
$\frac{2}{3}$	$\frac{2}{3}$	Improves clouds	Normal landscape filter; moderate contrast increase; good for snowscapes in natural B/W tones
1	$\frac{2}{3}$	Corrects B/W for contrast and brightness	Gives full brightness correction on panchro film; darkens blue skies; dramatizes clouds slightly, creates a natural effect on B/W film
1	$\frac{2}{3}$	Science filter for infra red	Must be used on infra-red colour film for proper balance if scientific accuracy is needed; also exaggerates (lightens) yellow and red objects in conventional B/W panchro
$1\frac{1}{3}$	$\frac{2}{3}$	Cuts haze	Dramatizes clouds, darkens blue sea and sky, absorbs all blue and part of green
$1\frac{1}{3}$	$1\frac{1}{3}$	Corrects daylight for using type B films	Lowers 5500K colour to 3200K to allow use of type B films in sunny daylight; use it also to photograph pine furniture in B/W
2	1	Improves B/W of wood grain	On B/W of furniture especially dark wood this filter provides contrast, cuts blue highlights and enhances grain and texture
$2\frac{2}{3}$	$1\frac{2}{3}$	Good for dramatic skies	A useful filter for improving detail in reds and browns and for dramatizing skies in architecture and landscapes
3	$2\frac{1}{3}$	Standard for B/W separation process	Standard filter for colour separation work; cuts heavy haze but blackens skies; dramatic for architecture, sand or snow; improves wood grain detail, or stone textures; good for B/W infra red

continued overleaf

BASIC FILTERS FOR B/W AND COLOUR MATERIALS

	Filter colour	Absorption	Filter code	Filter type	Film used	Daylight factor	Tungsten factor
†	Dark red	All except red	29	Selective	B/W + IR	16	8
†	Black	All except IR	88A	Very selective	IR only	Test 2.5	Test 2.0
†	Yellow-green	Red + blue	11A	Corrective	B/W, panchro	4	4
†	Dark yellow, green	UV + blue + red	13	Corrective	B/W, panchro	5	4
†	Green	All except green	58	Selective	B/W, panchro	6	6
†	Dark green	All except green	61	Selective	B/W, panchro	12	12
§	Pale bluish	Red + yellow	82	Corrective	Colour	1.25	1.25
§	Pale bluish	Red + yellow	82A	Corrective	Colour	1.25	1.25
§	Light blue	Red + green + yellow	82B	Corrective	Colour	1.5	1.5
§	Light blue	Red + green + yellow	82C	Corrective	Colour	1.5	1.5
§	Blue	Red + green	80A	Corrective	Colour	4	4–6
§	Blue	Red + green + yellow	80B	Corrective	Colour	3	3
§	Blue	Red + green + yellow	80C	Corrective	Colour	2	2
†	Dark blue	Red + green + yellow	43	Selective	B/W, panchro	5	10
†	Dark blue	Red + green + yellow	47	Selective	B/W, panchro	8	16
†	Blue-black	Red + green + yellow	50	Selective	B/W, panchro	20	40
*	Grey	Admits polarized light	Pola	Selective	All films	Test 2.5+	Test 4+

* B/W or colour § Colour only † B/W only

f stop increase		Special effect	Remarks
daylight	**tungsten**		
4	3	Moonlight effect in B/W	Turns blue sky black; with B/W infra red, turns foliage white; copies blueprints well; moonlight effect in noon-day sunlight if slight under-exposure
Test $1\frac{1}{3}$	Test 1	B/W infra red in studio	Used to block all visible light when only 'light' source is infra red emission and B/W infra red film is used
2	2	Dramatizes landscape	With B/W good for dramatic skies, lightened landscape; helps flesh tones in outdoor portraiture; greens rendered naturally, reds darker; panchro film only
$2\frac{1}{3}$	2	Lightens foliage	To make foliage stand out against buildings, to make skin tones simulate tan under tungsten light; use only with panchro film
$2\frac{2}{3}$	$2\frac{2}{3}$	Photomicrography	Makes green ultra light in B/W photography; standard process filter for colour separation, all colours except green rendered as black
$3\frac{2}{3}$	$3\frac{2}{3}$	Colour separation – B/W	Stronger than 58, separates weak greens from green background in B/W panchromatic process work
$\frac{1}{3}$	$\frac{1}{3}$	Use with colour film to cool off light which is too reddish	Portraits in tungsten on B/W to correct skin and lips
$\frac{1}{3}$	$\frac{1}{3}$		Use when exposing colour in morning and late afternoon for natural colour
$\frac{2}{3}$	$\frac{2}{3}$		Cooler than 82B
$\frac{2}{3}$	$\frac{2}{3}$		Cooler than 82B
2	2–3	For use of daylight film with tungsten 3200–3400K	When daylight colour film must be used with tungsten light, filter changes 3200 to 5500K
$1\frac{2}{3}$	$1\frac{2}{3}$		When daylight colour film must be used with tungsten light, filter changes 3400 to 5500K
1	1	For use of daylight film and clear flash lamps	For using daylight colour film with clear, flash, M type
$2\frac{1}{3}$	$3\frac{1}{3}$	Accentuates haze; improves detail in sea	On hazy days renders haze to greater effect
3	4	Stronger haze effect; lightens blue objects on B/W	For sea water, use this for lower contrast, improved detail, with B/W panchro; blues rendered as white, all other colours as black
$4\frac{1}{3}$	$5\frac{1}{3}$	Colour separation	Stronger than 47B, separates weak blues for B/W process work
$1\frac{1}{3}+$	$2+$	Darkens colour films	Darkens blue sky on B/W or colour film, without changing other colours; removes reflections in glossy surfaces, improves colour saturation and texture

see Note overleaf

Note Using the basic filter table, remember that the lens can be opened to the indicated f stop increase to accommodate the filter factor, or the shutter speed can be reduced by multiplying it by the factor, thus leaving f stop settings and therefore depth of field unaltered. For example, if the selected shutter speed is $\frac{1}{60}$ of a second and the filter factor is times two, the shutter speed will be $\frac{1}{30}$ of a second; alternatively the same effect could be obtained by opening the lens one stop instead. To increase contrast in B/W photography choose a filter of a complementary colour to the main colour found in the subject; to decrease contrast and show more detail choose a filter of similar colour to that of the main subject. Automatic cameras will not always make adequate compensation for filters in place, so separate calculations are advised for critical work, using hand-held reflectance type meters. Kodak Wratten filters are specified as standard in this table and throughout the book.

COPYING WITH FILTERS

Materials	Film	Filter
Faded prints	Orthochromatic	Blue
Stained yellow	Panchromatic	Yellow
Blueprints	Panchromatic	Red
Paintings	Panchromatic	Yellow-green
Old documents	Panchromatic	Deep yellow

To eliminate unwanted coloured backgrounds or coloured stains and render them invisible choose a filter of a similar colour to the colour to be dropped out and panchromatic film. In faint or highly detailed originals in low contrast with their background where they must stand out clearly, use a filter of an opposite or complementary colour and panchromatic film.

To render type material or line drawings in colour as either black or white images, use panchromatic film and the following filters:

Colour	Filter for black	Filter for white
Blue	25 (red)	47 (blue)
Turquoise (cyan)	25 (red)	58 (green)
Green	47 (blue)	58 (green)
Yellow	47 (blue)	58 (green)
Red	58 (green)	25 (red)
Pink (magenta)	58 (green)	25 (red)

SPECTRAL REFLECTANCE

Spectral reflectance of colours in natural objects in noon sunlight registered on B/W panchromatic film. Considerable reflectance***; average**; poor reflectance*.

Object	Blue	Green	Yellow	Red
Red	*	*	**	***
Orange	*	**	***	***
Yellow	*	**	***	***
Green	*	***	**	**
Blue	***	**	**	*
Brown	*	**	*	***
Skin (tanned)	*	**	**	***

To *lighten* a colour in 'Object' column choose a filter of a colour marked ***
To *darken* a colour choose a filter colour *
To render as *normal* choose a filter colour marked **

Objects will reflect different colours in amounts which vary according to the object colour and their surface condition. The table indicates how well certain coloured objects reflect the primary colours of the visible spectrum, and choosing a filter to lighten or darken the object becomes a matter of making the photographs with an analogous colour (to lighten) or a complementary colour (to darken).

FILTERS ABSORB THEIR COMPLEMENTARY COLOURS

Filter colour as seen	Colour of light absorbed
Red	Blue and green
Yellow (green and red)	Blue
Blue	Red and green
Magenta (blue and red)	Green
Cyan (blue and green)	Red
Black	All colours except UV or infra red
Clear	None
Grey	Equal amounts of all colours

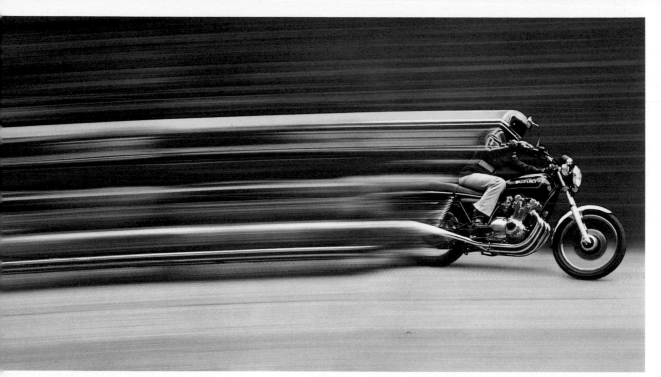

△1

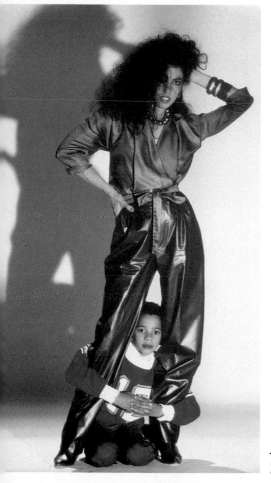

◁
2

△3

◁ 4

▷ 5

▷ 6

◁ 7

▷ 11

◁ 8

▷ 12

10 ▽

▷ 13

BLUE/GREEN
CYAN
GREEN
BLUE
YELLOW/GREEN
VIOLET
YELLOW
PURPLE
ORANGE
MAGENTA
RED/ORANGE
RED

△14

◁
15

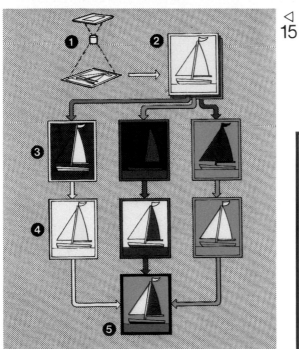

▷
16

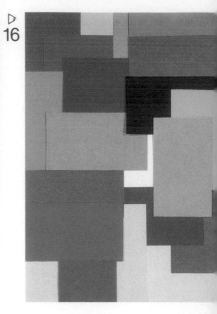

▷
17

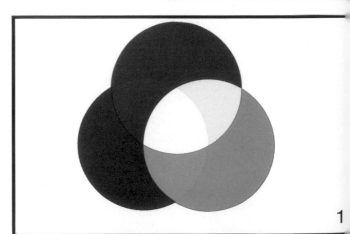

1

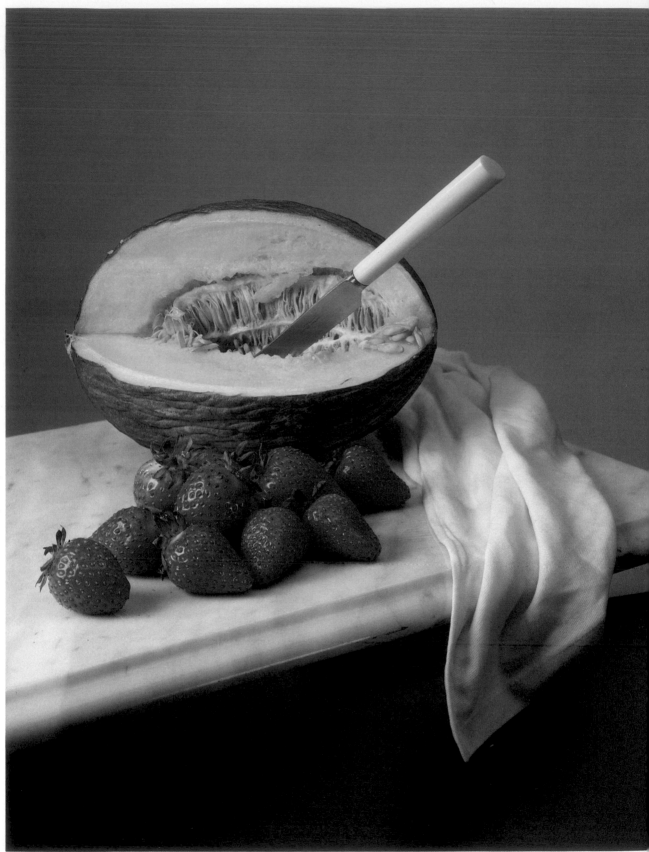

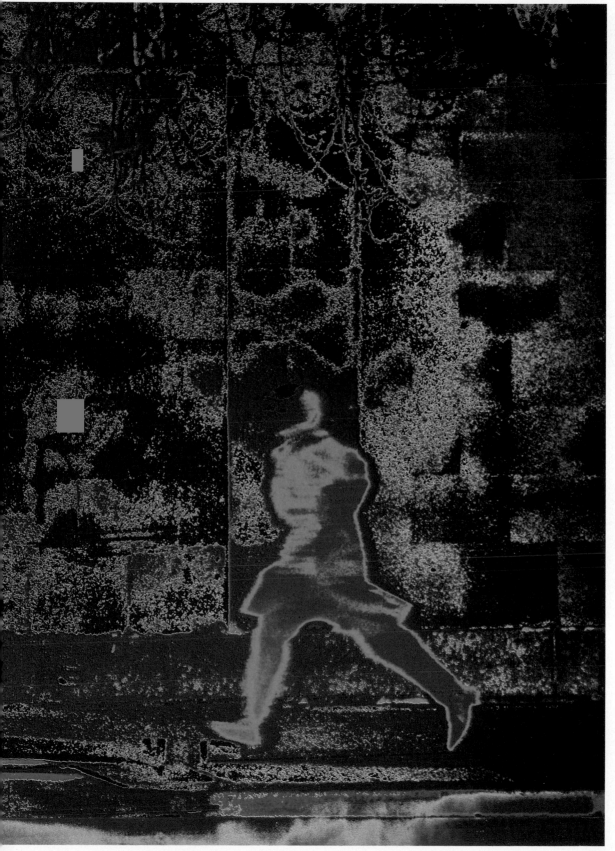

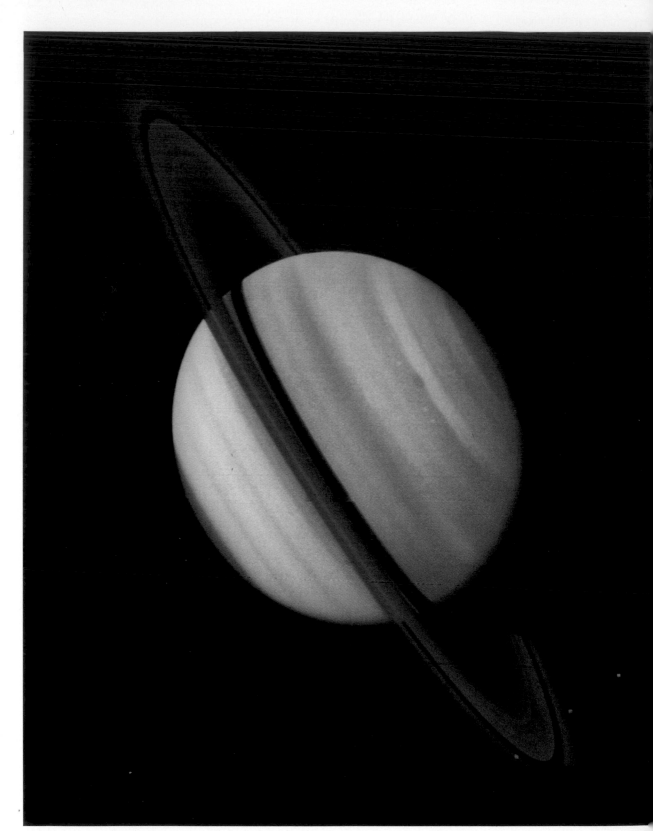

CORRECTIVE FILTERS FOR COLOUR FILMS

Conversion filters for large shifts in colour temperature

Filter number	Exposure increase	Degrees K	Filter colour
*80A	2	+2300	Blue
80B	$1\frac{2}{3}$	+2100	Blue
80C	1	+1700	Blue
80D	$\frac{1}{3}$	+1300	Blue
85C	$\frac{1}{3}$	−1700	Amber
85	$\frac{2}{3}$	−2100	Amber
†85B	$\frac{2}{3}$	−2300	Amber

*converts daylight film for tungsten use
†converts type B film for daylight use

Conversion filters for small shifts in colour temperature

82	$\frac{1}{3}$	+100	Pale blue
82A	$\frac{1}{3}$	+200	Pale blue
82B	$\frac{2}{3}$	+300	Pale blue
82C	$\frac{2}{3}$	+400	Pale blue
81	$\frac{1}{3}$	−100	Brownish yellow
81A	$\frac{1}{3}$	−200	Brownish yellow
81B	$\frac{1}{3}$	−300	Brownish yellow
81C	$\frac{1}{3}$	−400	Brownish yellow
81D	$\frac{2}{3}$	−500	Brownish yellow
81EF	$\frac{2}{3}$	−650	Brown

Where cold or bluish light (daylight) is used to expose type B colour film, *use the minus filters* to balance colour correctly.

Where warm or reddish yellow light (tungsten) is used to expose daylight colour film, *use the plus filters* to achieve colour balance.

NEUTRAL DENSITY FILTER CHART WITH f STOP INCREASES

Density	% of transmission	Increase factor	f stop increase
0.10	80.0	1.2	$\frac{1}{4}$
0.20	65.0	1.5	$\frac{1}{2}$
0.30	50.0	2.0	1
0.40	40.0	2.5	$1\frac{1}{3}$
0.50	32.0	3.1	$1\frac{2}{3}$
0.60	25.0	4.0	2
0.70	20.0	5.0	$2\frac{1}{3}$
0.80	16.0	6.2	$2\frac{1}{2}$
0.90	13.0	7.7	3
1.00	10.0	10.0	$3\frac{1}{3}$
1.20	6.3	15.8	4
1.50	3.2	31.2	5
2.0	1.0	100	$6\frac{2}{3}$
3.0	0.1	1000	10

clear special-effect filters such as star, prism, chromatic, soft focus and desaturation, Tiffen of USA and B+W of West Germany are leaders (see *Appendix*). Filters may be added together temporarily for special reasons and placed on the camera as a filter pack, the thinner the pack the less optical interference caused. Filter packs are better made of gelatin filters and kept to a maximum of three separate filters at any one time. To find the new filter factor for a combination pack, multiply individual filter factors together.

For B/W photography, the most useful filters to begin with are probably a yellow no. 8 for natural effects in daylight of almost any scene; a yellow-green no. 11 for rendering of green landscapes with darkened skies, floral subjects and outdoor portraits; a 23A red for dramatic clouds with black skies, good texture and detail in wood and other organic material, improved mid tones in sunsets, penetration of the distant haze; a 1A or 2A UV filter for general haze correction; and a double pola filter with variable screens, to act as a neutral density filter system and to polarize light or darkened skies (see *Polarizers and Polarized Light*).

For colour, the UV filter 1A is usually always in place on every lens, the pola screen is useful and a few warming filters in the 81 series and a like number of cooling filters, in the 82 series, can be most helpful in improving results during photography other than at mid-day. It is often sensible to have an 85B conversion filter so that type B film may be used in daylight, and an 80A so that daylight film may be used in 3200K (tungsten light). A limited number of *neutral density filters* may be needed so that wider apertures than normal can be used with fast colour film, especially in bright conditions, but this can be achieved effectively with a variable pola, double screen filter.

FINE ART PHOTOGRAPHY

'Photography is the bad dream of art – as it is the sweet day dream of society at large.' Douglas Davis writing these words in a special photography feature in *Newsweek* in 1974 put his finger on a central dilemma facing those who wish to decide the fine art status of what is a deceptively easy and facile technique for producing images. Traditionally the acceptance of an object as a piece of fine art depends on the pronouncements from experts or arbiters of fashion and taste, also on the commercial judgement of the market place and finally, on the test of time, as it slowly unreels over several generations.

Photography, even as a technique, is very young. As an art form it is still breathlessly naive. Experts and critics of other forms of art are rarely schooled in the intricacies of the machine-made image to any degree of competence and therefore should avoid the arbitration of this debate until they acquire knowledge in depth of the possibilities and techniques of photography. The fine art market is caught between recognizing the undoubted significance of the newcomer and accommodating the wayward democratization of an image which reproduces itself in perfection, in which the copy is no different from the original, and even the 200th impression is identical with that of the primary original. Such is the special characteristics of machines and images made by machines. For the art market and its need for commercial rarity and intrinsic exclusivity, fine art photographs may defy manipulation, certainly in the case of living photographers. And the test of time? Are we to award status only to antique photographs, severely limited in number and therefore prized, or by destroying all but a few copies of significant modern images, create in them a pseudo-status, to be cynically and commercially manipulated? Do we dismiss the huge body of serious contemporary fine art photography, simply because it is machine-made?

For many guardians of cultural taste in other more established art forms, photography's greatest sin is that it is popular and appears easy. It is a working tool in commercial communication. But just as a stonemason can make a graveside or create a *Pièta*, so may the photographer produce a passport picture or a moving work of art.

Since the invention of photography, artists have been affected by the ease of the mechanical image and the appeal of its instant geometry, and have been using it for preliminary steps toward conventional easel art. Canaletto and Vermeer probably used the newly invented camera-obscura to aid their startling realism and everywhere since, painters have been influenced by the fleeting, forthright silver-toned abstracts of the real world which photography can produce, often, as in the case of Max Ernst, Richard Hamilton and Robert Rauschenberg, expertly integrating photo-fragments into a melange of other hand-painted images. Many painters of today express, in the Photo Realist movement of art, an explicit desire to paint what the lens sees and half the painting world, with varying degrees of respect, has attached itself (only sometimes inadvertently) to the camera image – the other half fleeing to deeper abstractions wherein they hope to find sanctuary from the glass-eyed monster. Why not eliminate the tentative half-world of mixed media, stand unequiv-

CHARACTERISTICS WHICH CAN CLASSIFY THE PHOTOGRAPH AS ART

Certain characteristics may be found common to all works of art, others may be seen exclusively only in a given medium of expression. The following are attributes, all or some of which may be identified in photographs which perform as art objects:

Simplicity The art in art is the art of omission.

Asymmetry Symmetry and perfection is complete, leaving nothing to be discovered; asymmetry is mutation at the peak of transition.

Innocence The artlessness of spring conceals the raw power of innocence, growth and naturalness.

Peace Inner stability is the dynamic partner of subjective communication and visual contentment.

Originality Unfamiliar, even uncomfortable, imagery which arises from unconscious experiences in the creator.

Surprise A sense of wonder, revelation, awe. A presentation of unexpected things by familiar means.

Mood Volatility, a sense of theatre, tension, pathos or ecstasy. A cosmic ripple of emotion.

Maturity Timelessness, ripeness, incontrovertible truth and, ultimately, connection to cosmic man.

Latency This is hidden energy and the incompleteness of potential growth, the dynamism of controlled flair, the vitality and force of an authoritative but subdued promise.

Freedom To be original, to have none of these listed attributes. To be symmetrical, immature, aggressive, convoluted, extrovert or self-contained but, above all, to be new and to be original.

Sexuality Man and the world in love, the world and the cosmos inextricably linked, man and woman unified, a voluptuous celebration of tactile virtues.

Paradox Duality and polarity, juxtaposition and surprise. Intuition and reason, the occident and orient interacting, female versus male.

Relevance Consistency and affinity to the present, coincident with space–time dimensions of past moments and memories.

Felicity Happiness, joy, contentment and harmony and an element of playfulness. Art for art's delightful sake.

ABSTRACTION

Photography has lately become increasingly subjective, yet even so, offers a magic revelation of reality.

Just as dimming the room lights or using candle light can assist conversation and emotional communication, so can a slightly obscure photograph increase involvement with those who view it.

This destruction of the totally sharp image can be by simple diffusion of selected areas and edges with zone focusing and wide apertures, or could be as complex as local screening, tone compression or surrealistic juxtaposition of elements within the image.

The all-embracing eye of the lens can often inhibit deep communication and sharp-edged design has often become more important than viewer participation at emotional levels.

The accidental arrangement of elements within the image, so beloved of purists and social documentalists in photography, is, except in the hands of a master artist, often banal.

These and designed images will always gain attention from the intellect, but visual boredom can follow quickly unless great intricacies are built into the image at emotional levels.

By removing areas of critical definition or apparent form, by the use of abstraction techniques, the image can not only become a compelling graphic design, but also a satisfying event for the beholders, who must complete the suggested forms from memories and unconscious levels of their own experience. The photograph is one of the most readily understood of all visual media even when its abstraction is carried to extreme levels and it is highly acceptable and intriguing to a broad spectrum of society.

Because abstraction, in either colour or black and white, is quite easily controlled from a technical point of view but requires considerable taste and fine judgement in respect of concept, interest is rapidly deepening in both photographers and their viewing public, in what appears to be a major reversal of those stylistic trends established in the 1920s.

somehow mitigates the dreadful sin of using a wholly mechanical image, making it respectable by some magical transformation into a hybrid technique that finally can be received as art. It seems a desperate argument. After all it is the image that is consequential, not how it is made.

Susan Sontag, in a widely read critique of still photography, insists that it is emotionally soporific, duping the senses and pretending to be a macrocosm of reality while in fact being only a symbol. But since the Aurignacian cave painters of 10,000 BC relevant art consists of symbols. And even the most realistic photograph does not masquerade as reality itself, but as a symbol of that reality, and this is intuitively understood by most who view it. If millions of people pay homage to the natural or pure photograph as an abbreviated, but nonetheless, unshakeably honest, trace of true experience, then this is the delusion created by the public, not the artist who uses the camera. All those who work with photography know its power of suggested reality and its ability to capture those almost unheeded moments in time so that they can be examined at leisure, perhaps to become timeless. Experienced photographers also see their images unreservedly as symbols, carefully edited and produced, linking the originator's own sensibility and experiences with those of the observer of the picture. Surely, this then, can be art.

It is easy to take a photograph, but not easy to make a memorable image. Because of the mechanical simplicity of production, the training of the artist-photographer is correspondingly more arduous, particularly as the photo-image will expose the psychic fingerprint of the artist more directly than most other art media. There is no overlaying of mysterious technique or arcane construction to conceal inadequate concepts, no echo of past centuries of image making to confuse the intuitive response from the viewer. The photographic image is of now – it is the experience laid bare, suspended within a two-dimensional ultra-flat piece of chemistry, accessible to almost anyone who stands before it.

All cultures and even children are intensely aware of photographs and exercise intuitive and subjective judgements of them, particularly in respect of technique. So the first rule for the photographer who seeks a fine art career is to acquire a flawless technique. Without a sparkling competence in the mechanics of image making, communication is considerably dulled, so conscious efforts must be made to learn the full depth and capabilities of equipment, chemistry and materials in order to ensure that no image falls short of its technical potential. This means continual practice in the very mundane disciplines of development, printing, mounting, presentation and in the proper understanding of optics and image management.

Because the life of the artist is inextricably enmeshed with the life of the art image and because photography, unlike most easel painting, is a costly, high technology activity, the photographer who aspires to a performance in the art world would do well to create an economically defensive existence. Commissions are usually slow to materialize, years may pass before critical acclaim brings success, and high material costs, particularly if work is done in colour, are often desperately

ocally before reality and use the photographic machine frankly to relate the field reality of direct experience? Perhaps more painters should become photographers, but critics still argue fiercely that the motor action of the artist's hand

PHOTOGRAPHY

Photography is a visual language created as a statement of emotion, technique or design, by an individual. The beholder will interpret this image in the light of his experience of the technique or by intuitive involvement with the hidden structure within this image. All images that conform to established rules of perception are easily accepted, unfamiliar images will be reclassified by time and economics or by cultural convention.

inhibiting of experiment. Such aspirations are best achieved by the aid of a patron or a grant or by obtaining an income from activity unrelated to photography. For example, it is better for the photographer-artist to acquire income from packing boxes at a supermarket than to enter the seductive world of advertising photography, where skills must be adjusted to fit expediency and pure vision is soon lost. Be aware of the extremely long time-lapse between effort and reward which is inherent in fine art photography and do not compromise heroic dreams and creative imagery by failing to cope with the day-to-day economic facts of life. Ten years may easily pass before enough sales are generated to provide a good living and there could not be, at present writing, more than one hundred photographers worldwide under 40 years of age who live entirely by print sales of fine art photographs direct to the public.

Once technical and economic matters are under control, the photographer-artist must turn his/her attention to widening the experience of worldly matters, and to image making. An understanding of basic philosophies and religions is useful, an awareness of man's slow climb towards cultural emancipation, the signposts of great art throughout the centuries, an appreciation of the soft intuitive wisdom of oriental thought and how it may inter-relate with the brittle heritage of European rationality – these exercises for the mind will enhance visual concepts, and condition the life and therefore the images of the fine art photographer.

Be open to experiment. Do not confine activities to black and white techniques solely because of its durability. Colour is, under proper conditions, durable. The general availability of good colour material is barely 30 years old and technical advances in this area are still swift and to the artist, vitally important. Be open to the expanding world of abstraction, using colour for colour's sake or try suppressing form in order to increase the interaction between the image maker and the viewer's imagination. Consider the impact of non-silver imaging processes, electronic images, holography and other three-dimensional techniques. Modern image technology is inevitably linked to the photographic process, and the potentiality for the photographer-artist to use these new techniques opens vast new possibilities. In the face of such advances and in the growth of opinion from more informed critics, the rumbling antagonism in the art world to photography which began in 1839 and has spasmodically emerged

ever since will probably cease, with an acknowledgement that the youngest of art media has come of age. Photography is most suited to the art needs of the late twentieth century and must be considered for its individuality, relevance and enduring power in the long narration of man's art images which as always, venerate the past and prophesy new and future facets of our culture. (See also *Abstract Photography*, *Archival Processing and Storage*, *Colour Harmony*, *Image Management*, *Image Synthesis and Vision*. Also refer to *Appendix* for list of photographers in this book.)

FINE-GRAIN FILM

This is film which has been manufactured with a fine-grain pattern in the emulsion, creating local, but minute, variations in density within the film. Such films are slower, higher in contrast and appear sharper than faster, more sensitive films and are used where great enlargement is desired without grain pattern becoming too obvious. An ASA speed of 50 or less is characteristic of fine-grain films but the fast chromagenic Ilford film XP 1–400, by using different manufacturing and processing methods, has achieved comparatively fine grain and considerable speed. (See *Grain*, *Chromagenic Black and White Film*, *Black and White Photography*.)

FINISHING THE PHOTOGRAPH

No good print is completely ready for presentation to the public or private viewer until it has been carefully finished. This means that all blemishes such as spots, hairs or lines are covered up by spotting medium (see *Spotting*), borders or edges are trimmed square, the picture mounted, if necessary, and perhaps even matted or framed.

Many photographers find that creating a white border 5cm (2 inches) all around the picture and a thin black line inside it is an elegant and satisfactory way to help presentation. Incidentally, it improves the keeping quality of the print. Dry mounting to a fixed, washed and dried piece of photographic paper of the same weight as the print is perhaps a further refinement and one which produces a perfectly stable, flat print.

Framing is a matter of personal taste but in general, photographs should be treated unequivocally as the tangible conclusion to a process of modern chemistry. They should be presented frankly and with as little embellishment as possible, in simple frames, with simple mattes of neutral colour. The warmth or coolness of image tone can guide the choice of frame but most photographs look very handsome in narrow silver or gold anodized aluminium frames or clear plastic box frames. Simple wood frames are sometimes complementary, particularly those with black Japanese lacquer finish, but heavy gold ornate frames can impose a severe devaluation of the mood of the image and create pretentious distraction rather than compatibility with the photograph (see also *Mounting*).

FIREWORKS, PHOTOGRAPHING OF

To photograph fireworks successfully requires that the

shutter be equipped with a B or T setting (see *Shutter*). The camera is set at infinity focus, locked solidly onto a tripod and, for preference, a cable release is used to make an exposure. A 64 ASA colour film is ideal, and as time exposures are necessary to allow the burst to register, exposures are controlled by the f stop setting only. For this film speed, a setting of f8 is suitable for most aerial displays of fireworks and if the sky alone is in the picture, five seconds is enough time for the shutter to be open.

If the landscape is wanted as well, 30 or 60 seconds may be needed on the time exposure, and remember that all moving lights such as cars or aeroplanes will register as a streak of light. If they are not wanted, the lens can be capped as they pass the camera. Loading faster film requires that the lens is stopped down further, for example a 400 ASA film needs f16 or 22, but shutter times need not be altered. It is often more interesting to record several aerial bursts on one sheet of film, and this is done by keeping the shutter open while using a locking cable release or the T setting, or alternatively creating double or multiple exposures on each frame by depressing the re-wind button while the shutter is wound or using the special switch on the camera body to override the mechanism.

Kinetic displays fixed to ground frames which do not move can be taken with snap shot exposures if wide lens apertures are possible. ASA 64 film will need $\frac{1}{30}$ second at f3.5 or f2 but better results will be obtained by loading 400 ASA film and making the exposure at $\frac{1}{60}$ second at f5.6. If a tripod is used the shutter speed can be dropped to as low as $\frac{1}{8}$, depending on the movement present, with a consequent gain in depth of focus because of the smaller f stop.

In order to dramatize these events, it may be possible to include buildings or even people in silhouette and as many such events are conducted over water for safety reasons, the subsequent reflections are an added interest in the image.

FISH-EYE LENS

These ultra-short, ultra-wide lenses usually cast a circular image with excessive barrel distortion. They were much used by photo essayists in the 1960s, when the 35mm colour camera was used to explore the world in documentary pictures under the auspices of the big American picture magazines of *Life* and *Look*.

Provided the linear distortion is acceptable the lenses can still be used when maximum field of view is needed. Photographers may find difficulty in keeping themselves out of the picture, so wide is the angle of view, and tripods also create problems in this respect. Lens hoods are not possible. For practical reasons the 8mm focal lens used for many 35mm cameras is too short, and better results, with edge-to-edge coverage of the format, rather than the circular image, can come from using the 15, 16 and 17mm lenses currently available from optical manufacturers. Even with these lenses there will be an enormous angle of field covered, but with distortion reduced somewhat. Illumination levels of the optics fall rapidly at the edges of the field of view and many lens makers offer a graduated neutral density filter with a central

disc of increased density, fading to clear at the edges, in order to improve this defect. With ultra-wide lenses, always buy the best affordable since expensive, but desirable, optical corrections are at their highest in leading brands such as Zeiss, Leitz, Nikkor, Rokkor and Zuiko. (See *Lenses*, *Wide Angle Lenses*.)

FIXERS

These are the solutions which dissolve away any silver halides or salts in the photographic emulsion which have been unaffected by light. After their use, light cannot rapidly alter the image and in the case of B/W, if all the fixing solutions are totally removed from the film or paper by washing, a very permanent image is obtained. The most common fixing solution is sodium thiosulphite, abbreviated by all photographers to 'hypo' and discovered by the English scientist and photographer Sir John Herschel in the late 1820s, even before photography officially began. A 30% concentration of the hypo solution is normally used with a fixing time judged to be that of the time taken for the negative to become transparent. In heavily used baths the fixing time must be extended and is usually taken as twice the time the image takes to clear. Hypo baths oxidize rapidly and a preservative is usually mixed into the fixer. A typical bath would contain $1\frac{1}{2}$ kilos hypo crystals, 100g potassium metabisulphite, 4 litres water.

A 3% acid *stop bath* is used prior to fixing and hardener can also be added to the stop bath to prevent abrasion to the finished film.

For archival processing and volume printing an A and B two-bath system can be used, the first reaching exhaustion quickly by virtue of the alkaline carried over by the developer which takes place even when an acid stop is used, while the second has a long and active life providing absolute fixing. The two-bath system will process 14 square metres (150 square feet) of enlarging paper and when A is exhausted, it is replaced by B and a fresh second bath mixed. A further similar throughput is obtained from this, and so on, until five complete changes of the first bath have been made. All are then discarded and two completely new baths mixed.

Rapid fixers mixed from concentrated solutions supplied by photographic manufacturers are convenient and thorough, and Kodak, Ilford, May and Baker and wholesale chemists have various proprietary kinds. Fixing is much faster than with hypo and it is not advisable to exceed the stated fixing times as most of these fixers contain ammonium thiosulphate which has a definite bleaching action on the silver image after a few minutes. In fact if a little citric acid is added and the somewhat unpleasant smell can be overcome with good ventilation, a most effective reducer can be made this way. It is important, as in all photographic chemistry, to time the operation of such fixers and follow the manufacturer's instructions precisely, otherwise reduced highlight density will be obtained on negatives or prints. Splashes of this fast fixer on sinks or trays are extremely difficult to remove, forming an almost insoluble substance which is unsightly. Wipe up any excess immediately or flush liberally with water. It is best to use stainless steel equipment where possible.

FLARE

This can be created on purpose in the camera or can be an annoying by-product of technical shortcomings in the equipment. Wherever it appears in the image, fogging takes place because of over-exposure. The interior of the camera or lens often reflects light on to the film, particularly in the case of back-lit subjects and this can be cured by blackening any shiny surfaces found inside the equipment. Modern lenses are coated to reduce flare but they should be really clean and free of dust and finger grease. A clear UV filter kept permanently on the lens can help to protect them and is far easier cleaned than expensive lenses before taking the final photograph.

An effective lens hood is essential for all photography where the light tends towards backlighting or the sun is near the edge of the viewfinder frame, or a *gobo* (see *Large Format Cameras*) can be mounted to shade the lens. If this is not done, it is easy under these circumstances to obtain a secondary ghost image of the iris diaphragm in the lens, especially where small f stops are used in wide angle lenses.

Flare will lower contrast in the B/W image and desaturate colour and, for this reason, it is sometimes deliberately induced for creative effect. Special filters can provide 'star burst' flare from any small light sources, or even the sun can if it is in the frame. Halation can be achieved around bright light areas in an image by over-exposing considerably and using special filters to diffuse these areas, or with bellows-type cameras white paper may be fixed inside to desaturate the image. If the sun is to be included in the picture during the day and it is after sunrise and before sunset an ultra-wide angle lens will give the most interesting flare results. Long lenses aimed at the sun will result in heavy fogging in the frame unless neutral density filters are used, in which case no flare is seen.

FLASH METER

An instrument to measure the amount of light delivered to the subject when lighting is solely by flash. It is usually an incident meter and can be even more flexible if it is fitted with a probe to read selected areas in small subjects such as still life (see *Exposure* for an example of an incident flash meter).

FLASH PHOTOGRAPHY

Artificial light photographs, by arc light, were made in France in the late 1850s by *Nadar*, and the first flash pictures using an exploding ribbon of magnesium to create the exposure took place in Derbyshire, England, five years later. The usual method over the next three decades required that a measured amount of magnesium powder was placed in a tray and ignited while the shutter was open, but today we use magnesium wire sealed within a glass lamp and fired by a battery contact or alternatively, an electronic flash. The expendable lamp, as the non-electronic flash is called, is often contained in cubes or joined in repeatable magazines so that rapid firing may take place. The tremendous power of the larger lamps is still used by photographers working in cavernous interiors or outdoors

(see *Wire Filled Flash Lamps*), who prefer the added advantage of compact battery fired equipment and light weight found in this equipment, especially when it is compared with the light-to-weight ratio of large electronic flash units.

Synchronization of the shutter for these expendable lamps requires the M setting to be used (see *Shutter*), if a full range of speeds is to be used on a blade shutter. Focal plane shutters will need a slow speed, $1:\frac{1}{60}$ of a second or less, and the X setting unless an F setting is possible. The F setting can be used with long peak lamps, which are now rarely obtainable. Blue-covered lamps producing light of 5500K must be used for daylight coloured film, but clear lamps require a bluish CC filter, a Kodak Wratten 80B, if daylight film is loaded. Clear lamps with tungsten film rated at 3200K need a brownish filter such as a Wratten 81C for good colour rendition and both filters need approximately a half stop increase in exposure to compensate for filter densities (see *Filters*).

If a large number of expendable lamps are arranged to fire together to cover a big area, such as happens in some professional jobs, do not in any circumstances connect the camera sync. cord to AC household current supplies. The shutter synchronizing mechanism is not made for high voltage which will melt the contacts immediately, causing electric shock to anyone holding the camera and considerable damage to the camera. A qualified electrician should be asked to connect the circuit, with lamps wired in parallel and protected from the main supply by a separate fuse. A switch should be provided for manual use and the shutter control moved to a B or T setting. On this setting the shutter is opened and the lamps manually fired before closing the shutter. Only those lamps known to be suited to AC operation should be included in such a set-up. As with electronic flash, exposure control requires that guide numbers must be found for the flash and film combination which is used, and the reflective qualities of the subject area must be taken into consideration. This is best done by testing on Polaroid B/W film or an actual camera test which is completely processed for analysis.

When a flash of any kind is placed on, or very near, the camera, axis lighting (see *Lighting*) is produced and for live subjects this can produce a phenomenon called 'red eye' in colour pictures. The retina of the eye reflects the light directly back through tissues which carry an abundance of blood, making the pupil unpleasantly red. The effect can be minimized by the subject looking at a bright light or the photographer firing a test flash just a moment before the actual exposure is made and this will tend to close the pupil and the effect will be less noticeable. It is far better, however, to move the flash off-camera with the help of an extension cord or use *bounce* light. Flash on-camera can also be the cause of distracting reflections from the flash light on windows or glossy surfaces which are behind the subject and facing camera, and these are avoided by the off-camera flash arrangement too. (See also *Electronic Flash, Guide Numbers, Lighting, Multiple Flash*.)

FLASHING

Tone and contrast are thought to be inherently inseparable in

the photographic processes, but by the use of the flashing technique they can be made to operate independently. This technique uses a brief secondary exposure either before or during development to extend the tonal gradation of the image and reduce contrast. The longer the secondary exposure is, the longer the tonal scale becomes, but highlight fogging will be noticeable with even quite brief flashing exposures. Testing, therefore, is necessary for a fog threshold and this is a matter of fogging a blank sheet of paper with the enlarger clear of negatives, reducing each successive exposure until a barely discernible grey is produced.

To increase tonal scale the short secondary exposure is increased, and to increase contrast the primary exposure is increased. Decreasing these two factors is done by reducing exposures either in parallel steps or independently, according to choice. For bromide enlarging it is possible to use a contrast grade of 4 or 5 as the only paper stock carried and obtain from it the printing contrast and scale of grades 1 or 2. Difficult negatives are handled with ease. The procedure is as follows.

Set up a 15 watt tungsten lamp in a reflector at least one metre (40 inches) from the inside surface of an empty developing dish which has been placed in the normal position in the sink, and beside it make the usual preparations for print processing of developer, fix and wash. Mask the lamp with a 0.3 Kodak Wratten ND filter number 96 and connect the lamp to a repeatable timing device such as used for enlargers.

Test for fog thresholds in the paper chosen and note this data in the darkroom logbook. Place the selected negative in the enlarger and, by test strips, obtain a suitable exposure. Reduce this ideal exposure by 10% as flashing usually increases emulsion speed, then make another test. To alter contrast, vary the main normal exposure; more for more contrast, less for reduced contrast. Do not alter the first exposure more than 30% on either side of normal.

Take this unprocessed test strip and place it under the weak secondary exposing light and expose for the number of seconds estimated from previous tests. It is essential to time this accurately. To get maximum tonal gradation it will be necessary to flash the second exposure at just under that which creates fog in the highlights, reducing this exposure for less tonal steps. From this test, final computations on the first and second exposures can be decided upon and the print then made. A modification of this process, where flashing takes place after development begins, can increase the quality and richness of the blacks and the shadow area while increasing tonal separation in the mid tones and highlights. For this technique the print is exposed in the enlarger as a normal print would be and development is commenced in a dish which has been placed in position under the secondary exposing lamp. After 30 seconds in the developer the flash exposure is given, and continuous gentle agitation of the developer, for a total of $2\frac{1}{2}$ minutes, completes the process. Exactly on that time, place the print in the stop bath, then fix and wash. If fog is discernible, reduce the flash exposure. If highlights are only slightly veiled (and this is true for the dry flashing technique also) place the print in a bath of weak *Farmer's Reducer* which will remove the veiling and restore brilliance.

Local flashing can be delivered to selected areas by the use of a torch to which a long snoot has been attached, or by a dodging or vignetting technique (see *Enlarging*), where the shape of the dodger can be made to cast a shadow on the paper during the secondary flash exposure, thereby reducing the exposure in those shadow areas. This technique can be used to darken and alter contrast around the subject in order to create emphasis.

Lower contrast in colour printing can be obtained by the flash method explained under *Enlarging* and colour films may also benefit from pre-flashing technique to lower contrast especially in reversal enlarging. For film, a flash exposure of 1% of normal exposure will be found serviceable without inducing fog and for transparencies made from transmission originals.

This can be achieved by placing a 2.0 ND filter over the copy stage with the copy removed and then giving a first exposure equal to normal, followed by the actual copy exposure, double exposing on the same frame. Film speed may increase two-thirds of a stop and tests are needed. Flat art copying, using floodlights, can achieve lower contrast if the first exposure is made to a neutral grey card of 18% reflectance which is thrown slightly out of focus before exposure. The card is placed to cover the full format area instead of just the copy size, and the exposure is for the same time as that which has been calculated as normal for the copy. Exposures 1 and 2 are double-exposed on to the same frame.

Whole rolls of B/W film can be flashed after exposure by using the printing light described above. Replace the 0.3 ND filter with *3.0 filter*, carefully masking all stray light so that the only white light in the darkroom comes through the filter. Place the film, emulsion-side up, stretched flat at the one metre level under the lamp and expose for one second, or less, if the film is a 100 ASA film. Process normally. Contrast will be seen to be lowered but tests are needed to find the optimum flash exposure. If highlights or film rebates are visibly fogged add more ND filters. If contrast is not changed, increase the secondary flash exposure. (See also *Enlarging, Colour Enlarging, Contrast Control.*)

FLAT FIELD LENSES

In projectors, enlargers and copy cameras, lenses having a very flat field are used in order to improve sharpness at the extreme edges of the flat subject matter. This is possible because of the shallow depth needed in these activities. Process and apochromatic lenses also have flat fields to a greater extent than usual, with the blue-violet, green and red wavelengths of light focusing exactly in the same plane. This produces better colour correction than is otherwise possible (see *Lenses*).

FLUORESCENT LIGHTS

The numerous interiors which are lit by fluorescent light cause no problem for the B/W photographer, but because the lamps emit a discontinuous spectrum compared with

TRIAL FILTER PACKS FOR EXPOSURES TO FLUORESCENT LIGHT

Tube colour	Daylight film	f stop increase	Tungsten 3200K film	f stop increase
Cold blue	50C + 30M	$1\frac{2}{3}$	85B + 15Y + 20M	2
Daylight spectrum	40C + 20M or FLD filter	$1\frac{1}{2}$	50M + 50Y + 80B	2
Blue-white	30M	$\frac{2}{3}$	40M + 50Y	$1\frac{1}{2}$
White	15C + 30M	1	40M + 40Y	$1\frac{1}{3}$
Warm white	20B + 10M	$\frac{1}{2}$	30M + 20Y	1

Note Table is based on shutter speeds of $\frac{1}{30}$ second and is for tubes in diffusers. Kodak Wratten CC filters are indicated.

tungsten or photographic lamps and are weak in red, they require filtration when colour photographers are using them as a major light source. Because they are powerful energy sources for UV and other highly actinic light, they are particularly useful for the B/W photographer using only available light. Generally these lamps will be found in a ceiling and a high contrast, top lit picture will result unless some fill light is added from a diffused source, on camera, or low-contrast processing is undertaken. (See *Available Light* and *Contrast Control*.) A high-speed, low-contrast film is desirable for B/W photography when fluorescent lighting is the main source.

This is true also for the colour photographer who must, of need, use a fairly dense filter pack, and if the grain structure of fast 400 ASA film is acceptable this should be loaded in the camera, so that reasonable shutter speeds can be set. Filters will vary with the warmth or coolness of the tubes in the scene and whether tungsten or daylight film is in the camera. The table gives a series of trial filter packs. The ready-made composite filters, usually designated FLD for daylight film or FLT or FLB for artificial light material, may also be tested. As an average beginning for many types of cool fluorescent light, a CC 20 magenta filter may be tried if daylight film is used and a CC 40 red if tungsten light is used. To get nearer to correct balance, add the 10Y filter also in each case and increase exposure by two-thirds of a stop at least, but a full processed test must be made before any important assignment in order to be sure of the right compensation for the different types of film and light.

Large interiors lit by fluorescents are best photographed by using tungsten (3200K) film and supplementary tungsten halogen floodlights. The correct filter pack for the fluorescent light (don't forget the 85B filter) is found by testing on a previous visit and an exposure decided upon which is only 50% of the full exposure. Tungsten floods are arranged to cross-light important parts of the subject area, making sure that none are seen in the picture and that all wires and electric cables are hidden from camera viewpoint. The 50% exposure is given with fluorescents on, filter packs in place and no tungsten lights on. Then all fluorescents are turned off and photographic floods turned on, the filter pack used to compensate for fluorescent lighting is then removed and a full

tungsten exposure is made. Note that because of discontinuous energy emission of fluorescents, they need a warm-up time of five to ten minutes to reach full colour and brightness and therefore must be switched on before the actual exposure. For the same reason, shutter speeds should not exceed $\frac{1}{30}$ to $\frac{1}{60}$ of a second if possible (a tripod must be used), because higher speeds might catch the peak pulses of light emitted and give unpredictable colour or density results.

Photographing people is best done on high speed, daylight film, with magenta filtration, allowing the fluorescents to be only 50% of the complete exposure and with a diffused flash, at least 1.8 metre (6 feet) off-camera, to create the key light. Shutter speeds are set at $\frac{1}{60}$ second and there is no preliminary partial exposure given, but fluorescent lights must be given the ten-minute warm-up time if they have been switched off. For tubes not in diffusers, less yellow filtration is needed and more magenta should be in the filter pack. (See *Filters, Colour Compensating Filters, Colour Temperature*.)

FOCAL LENGTH

Focal length is computed for camera lenses by measuring the distance between the centre of the lens or its rear nodal point, and the plane of sharp focus on the film, while the camera is focused on infinity. Longer focal lengths produce larger images and have a narrower angle than short lenses, although contrary to many photographers' beliefs, geometric perspective remains true for all lengths, even very wide-angle, short lenses. Aerial perspective is altered, however, very long lenses compressing spatial depth and the very short ones extending it. A normal lens is one which has a length equal to the diagonal measurement across the format (see *Lenses*).

FOCAL PLANE

This is the position of critical focus inside the camera where the image which is cast by the lens is rendered at its sharpest. It is here the light-sensitive material is located and held flat while the shutter is operated to make the photograph. A special type of shutter, a focal plane shutter, which is a type common to most 35mm SLR cameras, is also located in this area (see *Shutter, SLR Cameras*).

FOCUSING THE CAMERA

Cameras may be focused by the use of a scale which usually appears on the lens barrel or camera bed but this is not always a sensitive method for accurate work. The longer the lens, the more accurate must be the focusing and if a scale is to be used, measurement should be by tape measure to the desired focus point on the subject; if that is 7 metres (20 feet) or less for normal lenses, or 20 metres (65 feet) with long lenses. It is more normal that cameras are fitted with either a *rangefinder* or have a through-the-lens reflex method of viewing such as in the SLR *camera*. Rangefinders are quite effective when properly maintained and frequently checked and are easy for glasswearers to get positive focus. A split image is seen when the subject is not in focus, with a properly aligned single image seen when sharp focus of the lens has been found. The lens is linked by cams to the focusing rangefinder mechanism.

The SLR is much more useful, much more adaptable to different lenses and allows precise vision of almost the whole frame right up to the moment of exposure, plus the opportunity to close the lens to the operating f stop and obtain a preview of the depth of field for that stop. Glasswearers sometimes have difficulty in seeing all the viewfinder image but this can be obviated by adding a modifying lens to the rear viewfinder eye piece, which has been manufactured to agree with the photographer's glasses. This modifying lens is left on the viewfinder and glasses are not worn while focusing.

Focusing screens vary greatly in SLRs but many are interchangeable and the photographer can find one that suits his/her personal taste and vision. One of the best for general lenses is the microprism collar with the split image rangefinder facility. The microprism breaks up the image unless it is finely focused and the rangefinder gives a tiny diagonal split-image to any out-of-focus subject, aligning the two halves to match perfectly only when sharp focus is struck. The remaining viewfinding area is most often a fresnel lens giving a bright image for rough focusing for depth of field information and rapid alignment of the camera.

When using reasonably small apertures, focusing should be a little in front of the main interest point, using the depth of field to encompass the subject in its own zone of sharpness which will extend then some way into the background. When people are being photographed, the eyes are the most natural point of interest and must always be crisply sharp, especially if the face fills a large part of the format. Always focus sharply on the eyes and in close ups, on the eye pupil itself.

If a *bracket* of exposures is being made, refocus quickly before each new exposure, particularly if working with telephoto lenses, because either the photographer or subject may have moved slightly. To obtain a critical focus when the SLR camera is used at its nearest possible distance, it is better that the lens is set for this prefocused distance and the photographer and camera move slightly back from and toward the subject, making an exposure at the moment critical focus is found. This will produce better results in such circumstances than if the focusing mechanism of the camera is used to obtain critical sharpness while everything is kept rigidly still. (See *Hyperfocal Distance, Depth of Field, Lenses*.)

FOG

Fog is discernible as increased density in random areas of the image and arises from the action of light or chemistry. Light reaching the emulsion surface but bypassing the lens system causes fog: through light leaks in the camera body (especially prevalent in well-used bellows cameras), through careless loading or unloading of roll film or through unsafe safe-lights or poor black-out conditions in the darkroom. Test the darkroom by standing for at least ten minutes in complete darkness at the time of day when light is brightest on any outside walls. Watch for sunlight on blacked-out windows or through keyholes, under door thresholds or through ventilation shafts. This may only happen once for a short time during the day and can be a puzzling factor behind fog. Camera bellows which are damaged on the peak of the fold often create a tiny pinhole effect, very hard to detect, which can produce a strange secondary, ghost-like image. To check such cameras put a 15 watt lamp inside the camera, turn out the lights in the darkroom and gently push and squeeze the bellows to reveal any damage. Temporary repairs can be made with opaque cloth tape or black rubberized solution, but it is better to seek qualified help from a good repair shop as a permanent answer to the problem.

View cameras are particularly prone to light leaks at the point where the slide is gripped by the spring back or in the mouth of the double dark slide. This is light-trapped but in certain circumstances light can enter. In bright sunlight, holders which were perfect in the subdued light of the studio may be unsafe, or if strong studio flash is brought close to the opening of the slide this also can cause problems. Outside in bright light use the black focusing cloth to cover the back while the safety slide is withdrawn and keep it in place during the exposure. With flash in the studio, use the safety slide as a mask to cover the opening while the shutter is tripped.

Fog on unexposed film is usually caused by outdated film, radiation, sulphide fumes or other chemical vapour or heat. Dichroic fog is often caused by fixer accidentally mixed with developer solution or similar contamination and is more often seen on slow, fine-grain rather than fast film. *Farmer's Reducer* can be used to bleach away the worst effects of dichroic fog. Aerial fog appears in partially or fully developed images before they are put in stop or fixer and arises from an oxidizing action due to excess exposure to the air, usually from repeated inspections while wet. It can appear on print or film material, manifesting itself by greyed highlights. If the development is carried out by time and temperature method with no visual inspection and the material is always submerged in sufficient volume of solution, no oxidization occurs. A restrainer or anti-foggant, added to the developer, can also reduce stains from such oxidizing.

In colour materials fog is also caused basically by the above problems with perhaps more chemical fog arising because of processing faults. Increased fog density on transparency material shows up as a thin, desaturated veiling of the image with clear film in the worst affected areas. Fog on negative colour shows up as darker patches as it does on B/W negative material.

FOG EFFECT

In black and white photography some impression of fog can be given by taking the picture through a fairly heavy blue filter (see *Filters*), especially if this is done in early morning or evening when haze is greatest and long lenses are used. No UV filters should be used in the filter pack. Fog effects in colours are more difficult to achieve but in outdoor situations theatrical smoke from smoke tablets or fog liquid can be used, or a fog machine can be hired from movie equipment hire departments. Dry ice is not very manageable as it gives off a vapour which stays close to the ground but it will work inside in small studio sets and rooms if a fan is used to move the vapour. It should be handled carefully with leather gloves as skin burns are easily caused by dry ice and the room should be ventilated as quickly as possible after the shot. All fog effects are enhanced by back lighting.

FOLLOW FOCUSING

This is a technique used by action photographers who, while using long telephoto lenses, constantly shift focus to where the peak action is to be found, while keeping the main subject centralized within the viewfinder. It calls for considerable skill and anticipation. The Novoflex series of lenses has a movable slide or bellows built into the lens barrel, with a trigger and pistol butt device to alter focus and these offer considerable control in using the follow focusing technique.

FOOD PHOTOGRAPHY

Photographing food requires comprehensive and fairly complex studio facilities and most work is done on large-format cameras. Although fresh food arranged as still life in the manner of genre painters of the eighteenth and nineteenth centuries may be attempted as a low cost, non-commercial assignment, most cooked dishes and product pictures are, of necessity, carried out by a professional specialist photographer and the results usually find their way into advertising or packaging which is used to create demand for the product or service.

The photographer will need a compact but very well-planned kitchen, preferably with direct access to the studio floor. The kitchen will need two ovens, two separate cooking hobs, preferably one gas, one electric, refrigerator and freezer space at least double the normal for home use, a dishwasher, garbage disposal unit and adequate cupboards and work tops. Enough pots and pans, especially of the non-stick variety, a wide assortment of knives, which are kept extremely sharp; several sizes of brushes, including two or three artist's brushes of the 0 and 00 size and a flat bladed camel-hair brush, 1cm ($\frac{3}{8}$ inch) wide. Small electric accessories which are useful are a deep fryer, with smoke filter, electric blender and mixer, and electric can opener. A large supply of plain linen kitchen towels is essential and adequate ventilation must be provided in the kitchen. Commercial rolls of foil and 'cling film' should be on hand as well as a considerable supply of strong paper kitchen towelling.

The photographer will rarely have the time or skill to prepare the food for the camera and will usually employ a highly trained, freelance home economist or cook to prepare everything. As the home economist, the assistant, the photographer and art director are often needed in the kitchen all at one time, space must be available, while work is in progress.

The studio will need at least one 3000 watt second flash unit delivering this power through one lamp head or through various lamp heads and with a strong tungsten modelling lamp in each flash head; plus two other smaller units of at least 1000 watt seconds each and a variety of reflectors for these lamps, including a diffusing box 1-m² (40 × 40 inch), and a very tight snoot (see *Lighting*). Silver paper, both matt and glossy, light reflectors and small adjustable angle cosmetic mirrors are also essential items.

Most food photography must be made in colour and in order to get precise results, it is generally made by flash photography. Although excellent work can be achieved with tungsten lighting, this has disadvantages in being very hot, creating wilt in fresh vegetables, drying out freshly cooked surfaces and in hot or boiling products, creating lack of sharpness due to the diffused and blurred steam. Certain warmth and greater lighting control is a positive factor with tungsten lights, but the lamps must be very powerful and used some distance from the subjects. Exposure should not exceed five seconds, if possible, in order to avoid *reciprocity* prob-

The high point of action is always the most interesting and the most difficult to photograph. This is taken from a colour transparency.

lens. All colour pictures of food must show the colour as correctly as possible but with a slight bias towards warmth in the light, therefore testing the film is important and adding of CC filters, so the brownish Kodak Wratten 81 series is often necessary. Cold high-contrast bluish light is not suitable for illustrating food, except perhaps with certain items, such as fresh fish.

Cameras most used for this subject are 9 × 12cm (4 × 5 inch) or larger; very often an 18 × 24cm (8 × 10 inch) format with a provision for reducing this to 13 × 18cm (7 × 5 inch) or to 9 × 12cm (4 × 5 inch). Lenses are usually longer than normal, for example 210mm on a 9 × 12cm (4 × 5 inch) format, and if they are *apochromatic* so much the better. Their performance should be at best when focused under 2 metres (6 feet) and this can be verified by the supplier, using the manufacturer's data sheet for the chosen lens (see *Lenses*).

For location photography, but still taking advantage of the view camera movement to align verticals and increase depth of field, it is perhaps advisable to use the smaller view cameras which have a roll film capacity, such as those which Arca, Sinar or Linhof make. Some very modern food photography may be made with fixed body cameras such as the 6 × 6cm (2¼ inch square) or 35mm, but editors or printers do not always readily accept the limitations this equipment imposes in an optical sense. Certainly more immediacy and rich documentary style is possible with these small formats, which are in fact highly suitable for today's special interest in factual illustration of commercial products.

Finally, a mobile work trolley should be located near the camera in the studio with special items immediately to hand. Working with food demands extreme speed by the photographer when the final dish is before the camera, and there should be no hold-up while equipment is brought to the shooting area. The subject itself is best placed on a large, 120 × 150cm (48 × 60 inch) compacted wooden board at least 25mm (1 inch) thick. This is put on trestles of varying heights so that all work can be carried out easily and the camera can be kept at reasonably low levels. High-angle shots or plan views are best made with the board only 30cm (12 inches) off the floor. These placements of camera and subjects do require, of course, that light must frequently be at floor level and lighting stands should accommodate this need. A strong, counterweighted boom stand is ideal for this purpose (see *Lighting*).

The photographer's job begins with careful researching of the subject and the environment which best enhances it. If these are unfamiliar, time must be taken to talk to experts, chefs, product manufacturers and to read books on the subject. Test cooking of difficult items is often needed several days ahead of the actual job, so that there are no problems on the day of actual photography.

All props, accessories and styling material must be assembled at least one day before, and fresh food should be ordered for delivery in the early morning of the shooting day. Food photography demands that food should not have blemishes, scorch marks or unsightly shape and this will mean that every main subject must be backed up by two or even three of its kind. Difficult items, such as chicken, turkey and fish, must be bought in larger quantities still, to provide a

This picture demanded a location background for authenticity, but it was created in the studio by the use of giant transparencies. Taken from a colour transparency.

safety factor in case of cooking damage and to allow some alternative exposures to be made. These foods can remain in front of the camera only for a few minutes before they become unsightly, because the lens will emphasize all faults in presentation while reproduction by photo-mechanical methods will destroy the appeal even more when blemishes are to be seen.

Consumer laws in most countries demand that for photography there should not be a too selective choosing of food products and that no special artifice should be applied to glamorize falsely the product or its immediate environment. Photographers should be aware of this and act accordingly. Fastidious attention to detail of the food, such as cleaning, trimming, cutting and superb lighting technique to reveal textures, plus extremely rapid execution of the exposures once the food comes to camera, will usually mean that the legal constraints may be strictly adhered to and no artificial or trick effects are needed even for food which is not perfect. Poor handling of kitchen processes, which show as overcooking, undercooking, too much oil or liquids of wrong consistency, is not acceptable and cannot be covered up by technique.

Appetite appeal is the primary objective of all good food photography and apart from the foregoing remarks, more must be understood to make this quality obtainable. Appetite appeal is, of course, quite subjective but certain factors can

147

The end result of many food pictures is that they appear as advertising material in magazines. In this example, careful positioning of the main photograph was needed in respect of the text and the photographer also prepared the small inset pictures.

influence most people in the way that they react to a food image. These are as follows:

Viewpoint
The camera angle alters appetite appeal in a very significant way. The most natural appearance of the food is at table level, as it would appear in real life. This means a viewpoint a little above eye level when seated is ideal. Higher camera angles begin to destroy appetite appeal, until the bird's-eye image promotes an intellectual appreciation of design, form and texture. This may possibly be acceptable in certain editorial situations which correspond with a more exclusive market, but it can alienate many viewers, particularly if they are experienced in food matters. For the same reason, design histrionics should not overshadow the feeling of warmth, wholesomeness and naturalness in the subject. Photographers and art directors can become interested in elegantly designed food images which may offer certain food for thought in their viewers, but very little sensation for their empty stomachs. The glossy single cherry on the end of a beautifully lit carving fork may sell forks to the public, but not cherries. Food must always be presented with a degree of voluptuousness and abundance in order to create appetite sensations in those who see the picture.

Close-ups of food, isolating the few peas, the amazing cake texture or the bubbling soup, do not generate appetite appeal if they are too large in the final picture. They should not, for example, appear in finished print larger than 20% above life-size if they are for magazine or package reproduction. Because of the long sightlines available for street posters, these are often larger than normal. The lens excels at this close-up larger than life revelation of texture, but it must be avoided almost always if appetite appeal is to be generated quickly and with any degree of recall.

Lighting
Particularly in the case of food, lighting must reveal textures and adequate form but it must also indicate the time of day at which the food is to be seen. Low light, beaming from a narrow key light, can indicate morning as can an open diffused light with a high key effect. Midday lighting can be suggested by a high-contrast light from the top. The evening time of day is best illustrated by suggesting the cosiness of domestic lamps or candle light and can be created by using very diffused snoots on the flash and adding pastel-coloured gels to these to warm the light considerably, but care must be taken not to make this colour too theatrical. A broad overall fill light is added, to avoid deep shadow. No back lighting as a key light should be used with food subjects, but top back lighting (and it is very different) (see *Lighting*) can often be used to reveal the receding forms or to highlight texture. A large amount of fill light must be used with this key light, along the lens axis, to prevent heavy shadows. Light for food must be happy light: fresh and clean and generally totally lacking in blue mood.

Action
Food should be seen in action where possible. This action may be fast, such as pouring or boiling, or slow as with the frothing beer glass, the frosting on cold drinks or the slight melting of butter on hot foods. In all actions to do with food, movements must not be blurred in the main subject as this will destroy appetite appeal and identification. Steam demands a special mention, as of course it is ideal that it should be seen rising from hot foods. However, it will not show in light, airy settings or against white backgrounds and if produced artificially with cigarette smoke, incense, ammonia vapour, and so on, can require a vastly increased number of exposures to counter its unpredictable behaviour. It can also be decidedly the wrong colour – blue smoke curling around a hot cup of soup can look bizarre and unappealing. Steam also moves very fast and requires back lighting to some extent for best effect and this can cause complications in the lighting plan for the main subject, particularly if large flash units are needed for adequate depth of field. These have a flash duration of between $\frac{1}{175}$ and $\frac{1}{400}$ of a second and this is not normally fast enough to freeze the action of steaming completely. It is usually better to use retouching to produce the precise effect of steaming required as otherwise the whole photographic exercise revolves around the demonstration of steam, needing darker backgrounds, different lighting and increased cost of shooting, usually all at the expense of beautifully rendered and tasty food.

148

Presentation

Food is at its most attractive in a clean, relaxing environment with a suitable ambience in lighting and atmosphere. Appetite appeal is at its highest when food is rendered naturally in something of a believable, documentary manner and where the styling of the accessories near the main subject does not compete for too much attention. Unwisely selected props will become eye traps, diverting the viewer's concentration and diffusing the sought-after communication. Anything added to the picture must, of course, have a right to be there. If a particular item is out of context, or indicates an unconventional association with the main food subject, it may create subjective distraction. Surrealism and juxtaposition tend to engage the intellect rather than the appetite, so rarely have a place in food compositions intended for commercial use. All accessories must be perfectly clean, napkins well pressed, tablecloths carefully stretched for a completely smooth appearance, and so on. Heavy textured cloths should be avoided close to the main focus point, selective focus should be employed to soften other areas particularly backgrounds; colours should be modulated so that although there is a spread of colour throughout the composition, bright colours do not move the eye to the edge of the frame; the main subject must remain dominant. White on white or tone on tone harmony can create problems in accurate reproduction in modern high-speed printing, and technical clearance from a production specialist is normally necessary before using such colour schemes.

The presence of human action is not often a desirable part of food composition in the actual frame, but it is advantageous if a suggestion is found in the picture that human action is not far away. This does not mean that half-eaten food is ever attractive, but the action of slicing, with knife lying nearby, the crumbs fallen from the cake onto an otherwise clean plate, and the casual fold of an open napkin can suggest a momentary interruption that has taken the human away briefly, thus heightening the documentary feeling and adding life to the image.

The quality of the light should be such that suggests warmth, abundance, relaxation and should be generally more open than for many other subjects, with no harsh, deep shadows or tense contrasts. Good food photography must project a feeling of immaculate preparation, immediacy and sensuality.

Special foods will need specific techniques from the photographer. For example, sparkling liquids, particularly beer, must be photographed in a perfectly dry, absolutely clean glass. Beer must be brought to a temperature above that of the camera area, heating it if necessary; liquids must have translucency and therefore tiny reflectors to produce this effect should be placed behind each glass (see *Lighting*) and every time there is a need to make a new exposure, a new dry, clean glass will always be required if effervescent liquids are being photographed. Ice in liquids can be made of acrylic as well as real ice and the artificial material is convincing except in very close up or where the ice must be seen to float on the surface. Acrylic ice usually sinks. For close-ups, real ice will always be necessary and it should be made from distilled

CHECK LIST FOR PHOTOGRAPHING FOOD

Research the subject and its environment; talk to experts.

Assemble all props.

Establish normal viewpoint, i.e. as is seen at table.

High camera angles remove appetite appeal.

Construct lighting to indicate time and place in which the meal is to be taken.

Have food prepared by experts from *best* ingredients obtainable.

The camera *must* await the food, as a guest should.

Do not indulge in design histrionics with food.

Do not over-enlarge food.

Render, superbly, every texture, i.e. a minimum size of 9×12cm (4×5 inch) film.

Create steam, frost, or natural life of any kind in food subjects.

Cook all meats lightly, otherwise the film will see them as overdone.

Food should be presented to the camera in a documentary way, ready to eat.

Beware of excessive eye traps which unwisely selected props will produce.

Every accessory to food must be fastidiously clean.

Indicate human action where possible, but without human form.

Use selective focus to identify main themes.

Tend always to rich, quality lighting; never over-expose food pictures.

The best food photography has a feeling of immediacy and sensuality.

water to avoid cloudiness and in sufficient quantity so that continuous shooting is not interrupted. Iced drinks will need to be presented to the camera in glasses which are frosting slightly and these are prepared by at first chilling them for an hour, at least, in the refrigerator and then spraying the front, camera side, of the glass lightly with dulling spray, then dribbling a little sugar syrup down the glass to simulate water runs. The whole front side of the glass is now sprayed with a fine mist of water and glycerine mixture. Care must be taken to keep the back of the glass clean and this final dressing of the glass must take place just before the exposures are to be made. All lighting tests are done on 'stand-in' glasses beforehand.

Ice cream is extremely difficult to work with but no

substitute looks quite as appetizing as the real product. The camera area must be kept cool if possible; therefore turn all tungsten lights off when not actually in use, particularly those in the flash modelling lights. Prepare a number of small caves of dry ice on a long table, and into each one of these put individual ice cream items as they are constructed by the home economist, making sure that stand-in food is also made. When needed, and after complete lighting, focus and all camera movements have been finalized, place the ice cream on the marked spot, turn on the modelling lights and wait a few seconds while the dull frost on the ice cream surface begins to glisten as it melts, then shoot quickly. Ice cream for use in food photography should, if possible, be frozen extremely hard so that it may be scooped off with a broad, flat spoon for arranging in the dish. Ice cream desserts which are ready-made and pre-packed by a manufacturer must first be examined for dents or damage. This happens often during machine processing and many samples must usually be obtained. A little powdered dry ice added as a dusting to the top of these confections right at the last minute before exposure can restore some of the lost texture.

Meat looks deceptively easy to photograph but if the subject is a roast beef and it must be cut open to reveal a slightly underdone interior, the photographer should make sure that plenty of time and three roasts are available, apart from the stand-in food used for preliminary focus. If the meat is too rare, colour photography will render it a violent unappealing red. If it is too well done it will photograph an equally unappetizing grey. Grills and hamburgers should not be cooked until the normal appetizing brown colour appears, but should be left slightly underdone. The film, especially if it is filtered with a CC 81 series filter to add warmth, will tend to over-emphasize the colour and therefore will appear just right. Poultry can be cooked to the point of normal visual appeal and birds must be really fresh. If they are too long in refrigeration, water in the tissues can add to the problems of wrinkling skin and blistering.

Gravies, soups and sauces, if they are to be poured in action, must be thinner than normal. They must not stand for very long and gather a skin but can sometimes be cooled first and then the skin removed. A few oil bubbles can often be placed on selected areas of the surface of gravies as evidence of naturalness and immediacy.

Froth on liquids, on fried meat or desserts can be made from a little egg-white, a few drops of detergent and a few drops of liquid from the food itself. Hot beverages just poured have a circlet of bubbles near the rim of their container and sometimes at the point of pouring also and froth gives the necessary feeling of life and freshness.

Highlights on food are a matter of taste and convention. Food should never be brushed heavily with oil before the moment of shooting and a little hot water is all that is needed. Drops of water applied with a 1cm ($\frac{3}{8}$ inch) flat camel-hair brush to vegetables will heighten freshness and induce sufficient highlight, but this must be done constantly while exposures are being made. Highlights in surface liquids help in giving life to the image but they can mask the clarity of the solution and must be handled with great care. A highlight sheen on ceramic containers for food is most acceptable but the accent light which is producing this may also destroy the surface quality of the food itself. The shape of the highlight is quite vital. Tiny specular lights are often disturbing and this is true also of very large highlights from giant diffuser boxes which may create a false note and can indicate the photographer's presence. *Gobos* may be needed to control the highlight area and its shape. A little highlight is desirable; too much is disastrous and produces an ugly over-lit effect.

Location photography
Location is not frequently a factor in food photography, but with the growing interest in the documentary style it is becoming more common. For editorial needs it is possible, on location, to make most interesting and compelling images

A location still life of fresh food requires great attention to logistics and weather.

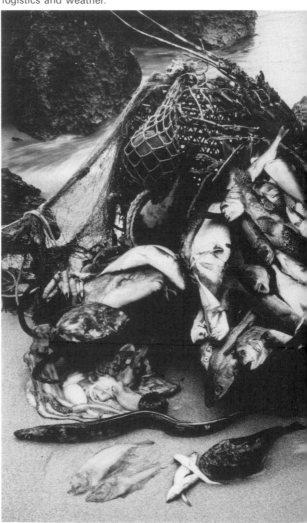

even under the necessarily difficult circumstances which are inherent. Certainly the changing light can be a thing of beauty, but it is as well to remember that sunlight is in fact a *rapidly* changing light. The cook and photographer must work with great speed and harmony and it is always important for the photographer to research the fall of light in the chosen spot and note the best time of day, well in advance of the actual shooting. Wind can be a decided hazard: all cloths, paper reflectors and lightweight articles must be firmly fixed in place with adhesives. Extra lighting should be on stand-by in case of need and the whole affair must be orchestrated on a very definite schedule. Mixing tungsten light with subdued daylight is a functional and dramatic change from studio lighting and, on overcast days, a strong key light from flash or filtered tungsten light can give a sunny impression to the image. This kind of photography is best done in a reasonably equable climate not far from adequate kitchen facilities, with two-way radio contact between photographer and home economist, if there is any distance between the two.

Food photography requires of the photographer considerable logistics, impeccable technique and a very well informed background of the subject. If the objectives include broadly based communication to the mass market, then the constant endeavour will be to create maximum appetite appeal in the most believable circumstances. The intellectual and emotional exploration of food as still life in the fine art sense is another and different exercise (see *Still Life*).

FORMAT

This describes the actual sizes and shapes of the image recorded by the camera and can similarly refer to the dimensions of a photographic print. The common camera formats with films are given in the table. European sheet film sizes, expressed in centimetres, will not fit the nearest US and English inch size slide holders or the racks in some colour processing units, and therefore special equipment must be bought. Sheet film has notched codes cut out of one corner which correspond to printed codes on the package and identify film type.

Aspect ratios, that is the width in proportion to the height, are important so that camera formats will fit print material formats with the minimum of waste. The ideal is taken usually as 1.25 to 1 and this is close to the aspect ratio of 6×7cm format, 9×12cm (4×5 inch) and 18×24cm (8×10 inch) all of which will fit on 20×25cm (8×10 inch), 40×50cm (16×20 inch) and 50×60cm (20×24 inch) printing paper with minimum waste. To find the aspect ratio, divide the shorter dimension into the longer; for example in 35mm frames which are 36×24mm format, the formula is $\frac{36}{24} = 1.5$ to 1 (see *Camera Types, Large Format Cameras, Medium Format Cameras, Small Format Cameras*).

FRIENDS OF PHOTOGRAPHY

This is a group of photographers based in the Carmel area of California who have gathered together since 1967 to provide a non-profit organization with a permanent staff and permanent exhibition facilities in Carmel. Their policy is to increase awareness of photography as a fine art, promoting an uncompromisingly high standard in both traditional photography and experimental photography, in this field. Basic sponsors are obtained for a variety of activities such as exhibitions, seminars, master classes and festivals and the Friends have begun an awards programme and a publishing list of visually excellent books, catalogues and portfolios. The Friends are supported by many of the most outstanding names in modern photography.

Image size		Aspect ratio	Actual image area	Film type	Format diagonal		Normal lens
mm/cm	inches		cm		mm	inches	mm
13×17mm	.51 × .67	1.33:1	Full	110	22	0.9	25
24×36mm	1 × 1.5	1.48:1	Full	35mm	43	1.8	50
28×28mm	1.10 × 1.10	1.10:1	Full	126	39	1.54	40
4.5×6cm	1.8 × 2.4	1.54:1	Full	120 (16 exp)	75	2.9	75
6×6cm	2.4 × 2.4	1.00:1	Full	120 (12 exp)	85	3.4	80
6×7cm	2.4 × 2.8	1.22:1	Full	120 (10 exp)	92	3.7	90
9×12cm	3.6 × 4.7	1.33:1	8.7 × 11.7	Sheet (Europe)	149	5.9	150
10.16×12.7cm	4 × 5	1.27:1	9.86 × 12.4	Sheet (USA/UK)	162	6.4	
12.1×16.5cm	4.75 × 6.5	1.36:1	11.8 × 16.2	½ plate (UK)	198	7.8	210
13×18cm	5.1 × 7.1	1.38:1	12.7 × 17.7	Sheet (Europe)	221	8.7	210
12.7×17.7cm	5 × 7	1.41:1	12.4 × 17.4	Sheet (USA/UK)	218	8.6	210
16.5×21.6cm	6.5 × 8.5	1.31:1	16.2 × 21.3	Whole plate (UK)	272	10.7	275
18×24cm	7.1 × 9.5	1.33:1	17.6 × 23.6	Sheet (Europe)	301	11.9	300
20.3×25.4cm	8 × 10	1.26:1	19.9 × 25	Sheet (USA/UK)	325	12.8	325

Golden rectangle aspect ratio = 1.62:1
'Ideal format' aspect ratio = 1.25:1
Root two rectangle aspect ratio = 1.44:1

FRONT PROJECTION

This allows a second image to be projected along the lens axis and therefore be added to the original camera image at the moment of exposure. Professional work requires the use of a commercially made projector which preferably utilizes flash, as a light source. Key light for the subject (keep it off the background) is sufficient to eliminate any fill from the background image and naturally, for colour work, this light and the projector light must match in colour balance and be compatible with the film used. The lenses of both projector and camera should also be compatible and closely correspond in angle of view.

Such lighting set-ups are used in catalogue photography and portraiture to give a wide range of instantly changing backgrounds to the main subject without the need for location photography and are reasonably believable if the subject is lighted in such a way which duplicates that of the scene projected. Fastidious photographers will not accept the black line effect which sometimes can be seen, almost as if a cut-out has been made and the subject pasted to the background. If the limitations of the equipment are understood and it is precisely aligned with matching lenses and if the background screen is severely directional, reasonably successful integration of subjects and backgrounds can be made.

F STOPS

These are numbers on the lens barrel which designate the size of the variable aperture. On all high-quality lenses of whatever focal length the numbers indicate diaphragm apertures which admit the same quantity of light, but differences between brand names may not give a constant relationship. The scale on the lens indicates a gain or loss of one full stop at each f number, the larger numbers indicating less light and the smaller numbers showing that a wider aperture is selected and therefore admitting more light. Altering the f stop not only alters the quantity of light but radically changes the appearance of the image (see *Depth of Field*). The normal f stop range is f1 (fastest), f1.4, f2, f2.8, f4, f5.6, f8, f11, f16, f22, f32, f45, f64, f90 (slowest). Many lenses do not use apertures in the largest or smallest sections of the scale and some have intermediate f stops such as f3.5, f4.5 or f6.3 (see *Lenses*).

FUNGUS ON FILMS

Growth of spores of mould can take place in the gelatin emulsion of films wherever relative humidity is in the 55–60% area. This occurs frequently in the tropics or heated damp cellars such as sometimes are used for occasional darkrooms and can also be encouraged by storage in envelopes of PVC which contains excessive plasticizer. (See *Archival Processing*.)

It is less troublesome to correct damage on B/W negatives as this can be spotted or retouched on the negative or print, and a copy negative made. Damage to colour film from fungus affects all layers and can release complex impurities which finally attack much larger areas.

The best preventive is to place valuable original films in archival storage envelopes and seal them while in a low-humidity environment, making sure that no dust or other impurities are allowed to enter the envelope. If the storage room humidity cannot be controlled, a metal filing cabinet can be gently heated by locating an *enclosed* element convector radiator of the lowest possible rating in the base. These radiators may be found in greenhouse or garage supply stores. Silica gel, a dessicating agent, should not be used for long term storage but is practical for short storage in high humidity conditions.

To remove fungus, use film cleaner on lens tissue or on cottonwool swabs such as Q-tips. Wipe gently with lens tissue to dry and remount slides in glassless plastic frames such as those manufactured by Gepe. Do not wash or soak fungus-damaged films in water. In general, really extensive fungus damage cannot be treated satisfactorily and it is better to prevent it by proper storage.

GAS BURST AGITATION

In large volume tanks, such as used in professional dark-rooms, a means is provided at the base of the tank to introduce bubbles of inert gas, usually nitrogen, to create ideal agitation around the films. This has the advantage of being predictable and cycles can easily be changed for different needs.

GAMMA

When a film and developer combination are being theoretically investigated, a graph in terms of density and exposure is produced, sometimes called a 'characteristic curve'. This is a flattened s-shaped line having a foot, straight-line portion and a shoulder. If the gradient in the straight-line portion is steep it indicates a high contrast with consequent compression of tone. The slope may be expressed by a number which is called *gamma* (see fig. below), and this can indicate a compression factor between the tones in the original subject and those recorded in the film. Gamma is therefore used as a theoretical expression of contrast. Any investigation of gamma values by practical photographers is usually aimed at fitting the brightness range of an average original scene (usually about 1000:1) to the brightness range of the negative and print material selected. Generally a B/W panchromatic film will accommodate a brightness range of at least 1000:1, and a colour transparency film will accept something in the range of 125:1 or 200:1. Print material is much less, perhaps as low as 30:1. Measurement of highlight and shadow reflectance values and consequent adjustment of exposure values, plus compens-

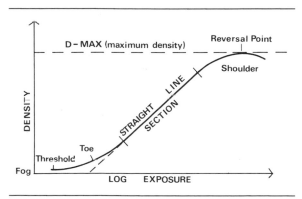

Characteristic curve from which gamma is calculated.

ation in development, can usually result in successful negatives. (See *Exposure, Nine Negative Test, Brightness Range, Zone System.*)

GELATIN

This is the commonly used medium to suspend all silver salts in any silver-based light-sensitive emulsion, whether it is coated on a film or a paper base.

GLASS, PHOTOGRAPHY OF

Translucency must be evident in any photograph of glass or similar material if its major characteristic is to be suggested. This will mean a reduction of light falling on the camera side of the subject, with a graduated, comparatively bright, diffused light from behind to act as a lighted screen (see *Lighting*).

GLYCIN PAPER DEVELOPER

For producing warm tones directly on enlarging papers a glycin developer, formula Gevaert 261, is interesting.

Formula

Water at 15°C (120°F)	1500cc
Sodium sulphite (dessicated)	80g
Glycin	12g
Hydroquinone	12g
Sodium carbonate	70g
Potassium bromide	4g
Cold water to make	2000cc

Used undiluted, brown/black tones will appear on most ordinary papers, further dilution producing progressively warmer and redder tones. Developing time is increased to compensate for dilution and at 1:6, a 20-minute development may be needed. Chloro-bromide papers should be experimented with also, as the effect can be very pleasing.

GOBOS

These are opaque screens used to mask areas of a lighting plan to prevent an excess of light reaching parts of the subject. They can also be used to shield the lens from direct light and reduce flare when it is impracticable to use a lens hood, such as when working with super wide-angle lenses in sunlight or backlit studio situations. (See *Lighting, Flare.*)

GODOWSKY, LEOPOLD (1902–)

In 1922 Leopold Godowsky and Leopold Mannes, both American, began a liaison with the Eastman Kodak Company which was to produce the ultra-thin emulsion colour film, Kodachrome, first marketed as a 35mm film in August 1936.

Both men had previously studied physics and chemistry and even in their school days were attempting to invent improvements in colour photography. Their final refinement of the Kodachrome transparency film contributed enorm-

ously to the popular use of colour photography by millions of amateur photographers and for almost half a century the film has remained the standard by which other colour reversal processes are judged. (See *Mannes*.)

GOLDEN MEAN

Considered by the ancient Greeks as a most perfect form, it was a divided line of which the ratio of the smaller dimension to the greater equalled the ratio of the greater to the sum of the two. Based on the classical proportion of the golden mean, the golden rectangle is considered to be almost universally pleasing and will have the short side relating to the long side in the same proportion as the long side compares to the combined length and width. This could be expressed as a ratio of 5:8 and is sometimes a suitable proportion for exhibition prints. (See *Image Management*, *Paper Sizes*, *Format*.)

GOST SPEEDS

These are film speed ratings used for films made in the Soviet Union and areas under its influence. They are sufficiently close to ASA ratings as to be interchangeable (see *ASA*).

GRADATION

A term used in photography to describe the change from highlight to shadow densities for photographic material. High-contrast pictures have a rapid change of densities, producing a short scale, while low contrast is apparent in long scale changes of density giving an expanded range of tone between highlight and shadow.

GRADES OF PAPER

Most modern photographic printing paper is offered in different contrast grades of paper, ranging from 1 to 5, with 'soft', low contrast paper coded as zero or 1, and maximum contrast paper as 4 or 5. Speeds may vary slightly between grades and re-testing may be needed when switching grades, during enlarging. Some experienced workers will process negatives to a very low contrast for subsequent printing on maximum contrast paper, gaining some added brilliance and tonal range, but most photographers will find that negatives for general use should be printed on medium contrast, grade 2, except in the case of photographs for reproduction which normally benefit by increased contrast from a grade 3 paper to compensate for the inherent loss of contrast due to the photo-mechanical process.

Multigrade paper, such as Ilford Multigrade, Kodak Poly Contrast or Dupont Varigram, uses the same emulsion for all contrasts, achieving its differences by the use of colour filters on the enlarger. The benefits to a good printer are considerable as different contrasts may be obtained in a single print, in various parts of the image, by simply changing filters while that part of the picture is printed. Only one stock of paper is needed to handle all types of negatives and the professional darkroom printer can produce a quality of reproduction print not possible in any other way. (See *Multigrade Paper*, *Enlarging*, *Flashing*.)

GRAIN

The grain in photographic film is caused by the action of development on the particles of silver halides in the emulsion. The black metallic silver tends to accumulate in random colonies of crystals, invisible to unaided vision but becoming apparent as the negative is enlarged. Developers have much less to do with graininess than most people think but fine grain developers can create an even pattern and can reduce contrast in the grain structure, while active or acutance developers can raise contrast and edge definition which then make grain more noticeable.

During the manufacture of the film, however, grain structure may be varied and so we are provided with fine, medium and coarse-grain films which also have a different response to light and contrast. Fine-grain films are slow in speed and high in contrast, coarse-grain films are generally high-speed, low-contrast materials, and the medium-grain films have a speed normally in the range of 100–200 ASA and are of average contrast. Over-exposure will make grain more

This is a simulation of grain as it may occur in different emulsions of different speed.
a Slow film (25 ASA) is fine grain, barely discernible.
b Medium speed film (100 ASA) is likely to show grain only on enlargement.
c Medium to high speed (200–400 ASA) shows definite pattern even in small enlargements.
d Ultra speed film or film pushed in development (400–5000 ASA) will show considerable grain and sometimes increased contrast.
Another characteristic of film is that slower speeds generally offer better definition and higher contrast than high speed emulsions.

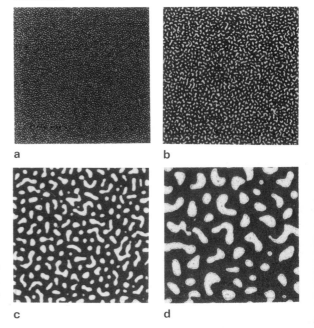

a b

c d

This is a characteristic grain pattern from 400 ASA film processed in May & Baker Suprol and considerably enlarged.

visible, and thin negatives achieved by under-exposure will minimize it, particularly for large magnifications.

The search for fine grain therefore begins with film choice and then the photographer must reach a compromise with the contrast characteristics of the selected film by choosing a low-contrast developer which also produces even distribution of the grain pattern. Such developers include Promicrol, diluted 1:2; Rodinal, diluted 1:50; Edwal Minicol II, diluted 1:7; or Ethol UFG. Agitation must be sufficient but not excessive, as this can alter grain patterns. Condenser enlargers tend to produce more apparent grain structure than diffusion types, due to the slightly increased contrast produced by the optical system, and high contrast papers should be avoided if grain is to be minimized. Having chosen and tested a suitable film and developer combination, the photographer should endeavour to work with the minimum negative density possible if he/she is to avoid grain in magnifications exceeding 20 times. Heavy negatives make printing difficult and accentuate grain pattern.

The creative use of coarse grain is popular with some B/W photographers and it can improve greatly the effects of immediacy in certain available light pictures, particularly where many large, bland areas of grey are present in the image. Large grain structure provides visual background noise, acting as a screen for the main components of the image to rest upon, increasing interest levels in the viewer. This technique should not be used if the photograph is to be reproduced by coarse, photo-mechanical dot processes, such as newspaper, but it is most attractive for exhibition and fine-art applications. Kodak Tri-X film, developed in DK50, D76 or Suprol, can produce good results and an attractive grain pattern. (See *Black and White Photography*, *Enlarging*.)

GREY CARD

In exposure estimation, the normal starting point is to find average conditions, then make changes if abnormal conditions are faced on later occasions. Reflectance meters, such as those in SLRs, and many hand-held meters, are calibrated to such normal readings, these readings being taken from a grey-coloured card which has a measured reflectance of 18% of the white light falling upon it. This has been found to be the statistical average reflectance of light from most average outdoor and indoor scenes. Such a card may be used for a proxy reading, if the subject is inaccessible (see *Exposure*), when the card is used as a substitute for the actual subject but is placed in light values similar to those falling upon the subject.

The card should be angled half-way between camera and light source and the meter brought to 20cm (8 inches) from its surface. Care must be taken to avoid a shadow from the meter, camera, or operator falling on the card, otherwise false readings will follow. Outdoor use of the card will, with most

155

reflectance meters, require a compensating half-stop increase in exposure. In colour copying the card is used to pre-flash the film to reduce contrast or to obtain a correct reading from very light or very dark originals (see *Copying*). Kodak make a suitable card called the Kodak Neutral Test Card.

GREY SCALE

A monochromatic series of steps in progressive densities which is often used to evaluate the tonal response of a film. The grey scale can be used when testing film, developer and printing combinations and should always be included in the subject if processing responses are unknown during initial tests of new material (see *Nine Negative Test*).

GROUND GLASS

View cameras have a translucent focusing screen the same size as the film format, made from specially treated glass which provides a matt, etched surface facing into the camera. In an emergency situation good quality greaseproof paper or tracing paper could be substituted for a broken screen, but a spare screen should always be on hand.

GUIDE NUMBER

This is a number which is used to obtain approximate f stop settings when flash is the main exposing source. Each film type and expendable flash lamp or electronic flash unit will behave differently and individual numbers must be found for each combination. When a guide number is given by a manufacturer or data table, it is usually for average conditions. The reflection characteristics of the environment in which the flash is fired will alter the effective f stop, and allowance must be made.

The number is calculated by making test exposures with a selected film, over a precisely measured distance, bracketing with the f stop setting, not the shutter. For example, load the film with a 100 ASA film, measure with a tape a distance of 3 metres (10 feet) from the lens to a suitable subject, such as a person seated against a medium-toned (not white) wall and take all exposures on the recommended M or X synchronized shutter setting, say at $\frac{1}{60}$ second. Begin the first exposure at f5.6 then move the f stop setting through f8, f11, f16 and f22. Process this test and choose the best exposure; look up the record of what f stop produced it and then multiply the f stop number by the distance. Working in metres from the foregoing example, if the ideal f stop is found to be f11 the guide number is three times 11, which is 33. In future when this 100 ASA film and flash combination is used, a new f stop setting may be calculated as needed by dividing this guide number, 33, by the flash to subject distance, in metres. If the flash is 4 metres (13 feet) from the subject the f stop becomes $\frac{33}{4} = $ f8; if it is much closer, say 2 metres (78 inches), the aperture is set at $\frac{33}{2} = $ f16. For light, small rooms, stop down a further half a stop and for large rooms, open the aperture half a stop to allow more exposure. Measure distances accurately.

If the first film processed appears over-exposed use a larger guide number, if under-exposed substitute a smaller number and then test again. Guide numbers expressed in metric terms may be multiplied by 3.3 to give the equivalent in feet, while those expressed in feet may be converted for metric distances by multiplying by 0.3.

If a particular f stop number is required to provide a certain depth of field, the flash-to-subject distance is altered accordingly. This is essential where flash is used in a synchro-sunlight situation when calculation of shutter speed and f stop is needed to control the daylight. In this case the *f stop* is divided into the guide number to give a figure which represents the distance at which the flash must be from the subject. (See *Synchro-Sunlight, Multiple Flash, Flash, Electronic Flash, Lighting*.)

Where depth of field is not an important factor divide the guide number by the flash-to-subject distance. The answer is the correct f stop setting.

Where depth of field is a factor, divide the guide number by the necessary f stop. The answer is the flash-to-subject distance.

and this colour rating remains constant to the end of the lamp life. Halogen lamps must never be handled by the unprotected fingers as grease from the skin will shorten the life considerably. Use paper tissue or plastic to protect the new lamp while it is being replaced. These lamps also burn with considerable heat and can damage nearby surroundings unless these are protected and, for the same reason, efficient lamp house ventilation is required. (See *Lighting*, *Colour Temperature*.)

HALF TONE

In the photo-mechanical reproduction of continuous tone images it is necessary to include an overall dot screen in the entire image so that ink may be applied to the printing paper in such a manner that a continuous tone effect is obtained. The dot size varies considerably according to the print process, the larger dots giving higher contrast and much less subtlety, such as in newspaper print, while in art-book reproduction the dot screen is very much finer, producing greater brilliance, tonal range and detail.

When preparing photographs for half-tone reproduction, compensation is needed because of the loss of contrast inherent in many of the photo-mechanical processes. A higher contrast print is often desirable, sometimes as much as one contrast grade above that used for exhibition prints or normal viewing, and if shadow detail is important this must be enhanced well above normal, but without losing control of the deepest blacks. (See *Reproduction Print*, *Enlarging*, *Photo-mechanical Printing*.)

HALATION

This is generally evident to some extent in high contrast conditions where areas of the image are intensely bright and are adjacent to very dark areas. It manifests itself as a slight spreading of the highlight into the dark area, creating a diffused fringing effect which can be expressive of mood. Special filters can increase the effect (see *Fog*) and over-exposure helps to exaggerate it.

Film manufacturers go to considerable trouble to prevent this phenomenon by coating a light-absorbent backing to the film which prevents any light bouncing back into the emulsion. The halation backing dissolves in the developing process.

HALOGEN LAMP

The tungsten halogen lamp, much used by photographers as an incandescent source of light, is made by enveloping a tungsten filament in a thin quartz walled tube and introducing into it a halogen gas. The halogen prevents the burning tungsten from escaping the filament area and allows it to be re-deposited, thus increasing lamp life and preventing ageing of the light source. The halogen lamps in photographic light sources usually produce a colour temperature of 3200K which is the correct balance for artificial light or type B colour film

HAND COLOURING

At one time, hand colouring of photographs was the most practical way of providing colour prints and as such prints are extremely permanent and have pleasing delicacy of colour, it is not surprising that there is a modern day interest in the technique. The best method is probably that which uses transparent oil colours obtainable from John G. Marshall Inc. in the USA, and Windsor and Newton in Britain (see *Appendix*).

First a thoroughly fixed and washed print is carefully sepia toned and dried. It should be made on fibre-based paper, not too dark or high in contrast, with open shadows and some highlight detail, and should be made on a matt surface paper, not glossy. Sable hair brushes oo and ooo and cotton swabs, such as Q-Tips, and some sharpened wooden tooth picks are also needed. Oil colour is put into a palette or saucer and mixed to the desired hue, always a little darker than that expected in the finished result. Gently rub the oil colour into the surface of the print in the area chosen, wipe off excess. Use a very light touch. Edges must not be overlapped and colour entering untouched image areas may be cleaned out with turpentine or solvent. Blending edges to avoid a hard line is one of the skills of the technique and practice will soon achieve good results. The fine brushes are used to colour very tiny lines or catch lights in the eyes but using solid colour in anything but really small areas is not generally successful. The finished print may take a week or more to set, depending on the thickness of the oil colour, and the surface may be sprayed with a matt or glossy, non-yellowing, varnish as a final protection.

HARDENING BATHS

During fixing or if processing is carried out in the tropics it is sometimes necessary to use hardening additives in fixing solutions or as a separate bath afterwards. (See *Fixers*, *Dangerous Chemicals*.)

HASSELBLAD

The Hasselblad 6×6cm ($2\frac{1}{4} \times 2\frac{1}{4}$ inch) camera has become the worldwide standard 120 camera for the professional industry and is characterized by interchangeable film magazines with Polaroid backs, interchangeable viewfinders and prisms with magnifiers, and the comprehensive series of interchangeable lenses each with its own complex shutter which is automatically wound when the film is advanced. The lenses are usually

The Hasselblad 6×6 cm (2¼×2¼ inch) camera.

designed specifically by Carl Zeiss of West Germany.

The firm of F.W. Hasselblad and Company began in Sweden just two years after photography was officially introduced in France and by 1908 had become the Kodak general agent in Sweden. During the 1940s Hasselblad produced aerial cameras for the Royal Swedish Airforce and by 1948 had introduced the 1600F camera, the world's first 6×6cm SLR, with interchangeable lenses and magazines, beginning the firm's long contact with the professional photographer. Many refinements followed: 1952 the 1000F succeeded the 1600F, in 1954 the Super Wide camera with a 90° angle of view was introduced and the 500C, still used by many photographers, followed in 1957.

In 1962 a modified 500C was chosen by NASA, the US space organization, for use in the Gemini and Apollo projects, culminating in the moon landing which was recorded by Hasselblad cameras. The Hasselblad is still used on sky-lab missions, reinforced by the 500EL battery powered models which were introduced in 1965 and the camera was also used to record details of the historic 1975 Apollo/Soyuz space rendezvous.

Over many years professionals, scientists and advanced photographers have found the Hasselblad to be an outstanding mechanical camera for continuous heavy usage and the recent introduction of a certain amount of electronic metering and automation is adding further improvements to its excellent specification.

HERSCHEL, SIR JOHN F.W. (1792–1871)

He was an English astronomer and scientist and a vital figure in the early development of photography, which name he invented from the Greek *photos* (light) and *graphos* (drawing). He also suggested the terms 'negative' and 'positive' and discovered the use of hypo (sodium thiosulphate) as a fixer of silver halides. He invented the blueprint process which he called 'cyanotype' and experimented with sensitizing glass plates. He was a close friend of Fox Talbot and delivered lectures, with exhibitions of his own images, during the early development of photography (see *History of Photography*).

HIGH CONTRAST MATERIALS

These materials, usually film, are made to compress or eliminate many intermediate values of tone. Commercially

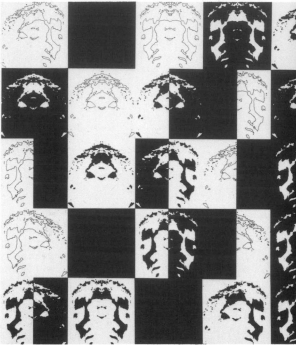

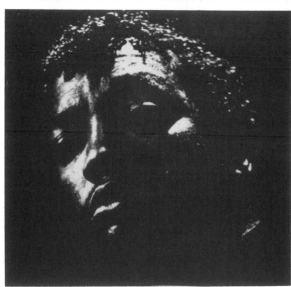

Picture (a) began as a high contrast, low key portrait, as shown in (b). (*Photograph courtesy Ben Helprin*)

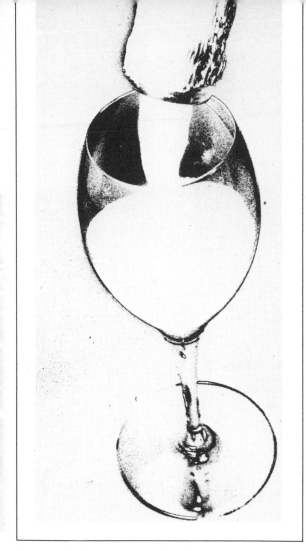

An example of high contrast using lith film and print developer for processing.

a

b

Low key pictures have a few brilliant highlights which disclose the main features of a subject and large areas of dark tone as in (a). Conversely high key pictures (b) are light in tone, suggesting a softer mood and disclose more information. Very few blacks exist in such pictures.

they are used by printers for preparing half-tone screens, line artwork or text. Copying sometimes requires the use of some of these special high contrast films. Of particular interest to photographers are lith films, very high contrast and mostly developed in an active two bath developer for maximum contrast and density (see *Lith Film*). Document copying paper, Kodaline, Kodak Linagraph and Kodak Photoplast plates are useful for extending the scope of imaginitive darkroom work and the ultra fast Kodak 2475 recording film (speed rated at 1000–5000 ASA, according to development procedure) provides perhaps the fastest emulsion generally available in 35mm format. (See also *Posterization*, *Tone Line*, *Copying*.)

HIGH KEY

This describes a photograph or a lighting plan which is extremely low in contrast and generally long scale in tone, but predominantly light toned in character, in which only a very few small, dark areas are to be found. High key negatives must

be processed to achieve a slightly heavier density than normal and lighting, while it has definite direction, should be extremely open from diffused light sources (see fig. above and *Lighting*).

HIGH SPEED GAIN

(See *Push Processing*.)

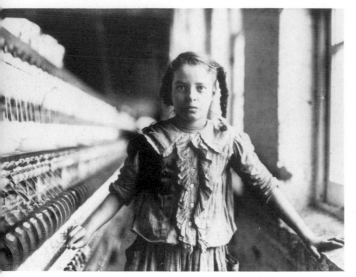

Hine's sensitive pictures, particularly of children, which disclosed the distressing working conditions in US factories were responsible for changes in social laws in that country. This picture from the collection of the George Eastman House was exhibited at the International Center of Photography in New York and was taken in 1909. (*Courtesy International Center of Photography*)

HINE LEWIS (1874–1940)

A highly trained sociologist who used the camera as his most supportive tool in his survey of US factories at the beginning of this century. His work pre-dates much of the early documentary work which was to follow the improved cameras having been introduced in the mid 1920s. Under great difficulty and some danger from hostile management, he recorded candidly the sorrowful social conditions prevailing, paying particular attention to the plight of children forced to work in these circumstances. His sincere and direct images confronted the public with simple and graphic truths so compelling that new labour laws were devised to produce more benign conditions for the many unwitting victims of the industrial might of the country. His strong, unromantic visual comments are easily transmuted into art and are today a considerable inspiration to many young photographers who see the camera as a powerful, unblinking witness of social events.

HISTORY OF PHOTOGRAPHY

In the eleventh century a famous Arab scientist and mathematician *Alhazen* described the principles of the lens, the camera obscura and the theory of human vision.

1515 Leonardo da Vinci described the camera obscura in his notes.

1558 Giovanni Battista d'Ella Porta published details of the camera obscura and showed an improvement with a suggestion for its use to aid drawing.

1636 Schwenter in Germany made a portable camera obscura.

1676 A portable reflex camera obscura was being used in Europe.

1725 Professor J.H. Schulze found that light would darken silver salts but he could not fix them.

1750s Canaletto was using a camera obscura as an aid to painting his perspective pictures of Venice.

1782 Scheele from Sweden found that cool rays in the blue and violet end of the spectrum affected silver salts more rapidly.

1790s The Niépce brothers made images but were unable to fix them.

1790s Thomas Wedgewood, son of the English potter, made photograms by placing objects on leather which had been sensitized using silver nitrate.

1790 Sir Humphrey Davey produced images using silver chloride emulsions but could not fix them.

1816 *Nicéphore Niépce* made a paper photographic image of his courtyard but could not fix it.

1826 Niépce made photocopies of engravings on a sensitized glass plate using asphalt. In the same year he also made the world's first photograph from nature on pewter plates using a camera obscura made by Chevalier and eight hours of exposure.

1827 Niépce came to London and detailed his entire process to Francis Bauer, a painter.

1829 Niépce joined with Louis Jacques Mande Daguerre for experimental research.

1835 *L.J.M. Daguerre* accidentally discovered mercury vapour would develop an image made on a silver iodide emulsion and it could be fixed in hypo sulphite of soda. A 20-minute exposure was needed and this was a positive image from which no copies could be made.

1839 The French government awarded Daguerre an annuity and gave his process free to the world.

1840 The world's first Daguerreotype portrait studio was opened in USA with 60-second exposures.

1841 *Fox Talbot* patented a negative/positive process, sensitized with silver iodide. This was the first multi-copy method of photography and with much shorter exposures. It was called the Calotype process.

Frederich Voigtlander marketed a Daguerreotype camera with a Petzval 3.5 lens, giving 90-second exposures.

Doctor George Keith took photographs of Petra in Jordan on Daguerreotype.

Facing page The view from Nicéphore Niépce's window. (*Courtesy Gernsheim Collection, Humanities Research Center, The University of Texas at Austin*)

Top right An early Daguerreotype, taken four years after the invention of the process. Note the active pose and the clarity of the portrait, despite the very slow shutter speeds. Taken on a Voigtlander no.3 camera. (*Courtesy Rollei Photo Technik*)

Below 'The Ladder', a photograph by Fox Talbot, 1844. (*Courtesy Kodak Museum, Harrow*)

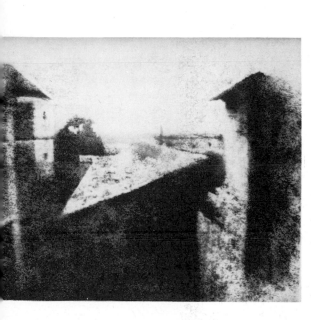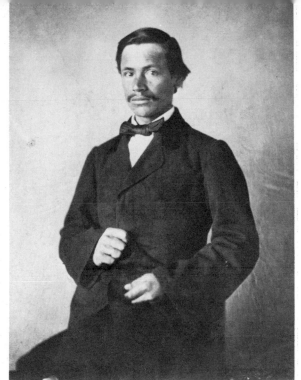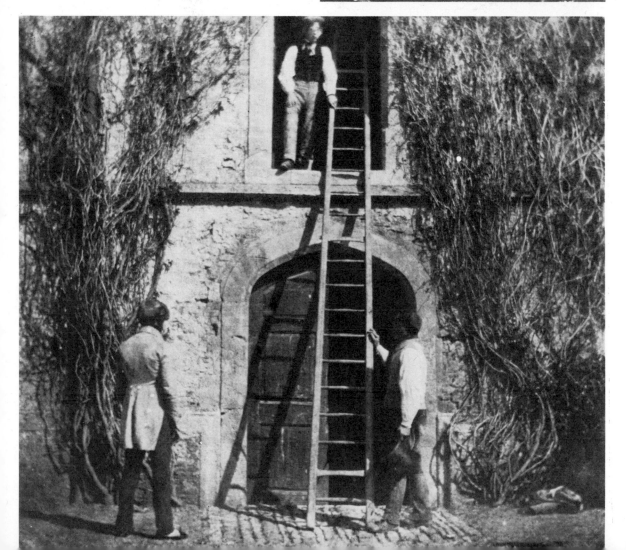

1842 *Hippolyte Bayard* became a founder member of the French Photographic Society.

1844 Fox Talbot published the first photographic book, *The Pencil of Nature*.

1845 David O. Hill and Robert Adamson were using Fox Talbot's process for portraits in Edinburgh.

1851 Fox Talbot demonstrated high-speed photography using a spark exposure of $\frac{1}{100,000}$ of a second.

Negre, a pupil of the painter Ingre, used photography for candid street scenes.

Sir David Brewster designed the stereo camera.

Frederick Scott Archer introduced the *wet collodion process* which was used by photographers for 40 years. It had one second exposures and 45 kilos (100lb) of equipment.

1852 Hippolyte Bayard used a montage technique to combine clouds and landscape from separate negatives.

1854 The English courts ruled that Archer's process was free of patent.

Queen Victoria was photographed opening Crystal Palace.

Disderi patented *Carte de Visite*, the multi-print portrait technique for calling cards.

Melhuish and Spencer invented rolled paper spools for taking photographs.

1855 Roger Fenton used documentary photography for reporting the Crimean War and made sales to the general public of his pictures.

1856 Dancer improved the stereoscope and Victorian England bought it in large numbers.

Francis Frith began taking pictures of Egypt, on 40 × 50cm (16 × 20 inch) negatives made on wet collodion plates, working in temperatures up to 50°C (122°F).

1857 Documentary pictures were made of Brunel, the steamship designer, at the site of launching the *Great Eastern*.

Rejlander, the Swedish photographer, made posed snapshot pictures of rural life in England similar to genre paintings from the Great Masters.

1858 Henry Peach Robinson made a famous pictorial image 'Fading Away', which created huge response in Victorian England.

Dallmeyer invented an f1.1 lens for $1\frac{1}{2}$ inch diameter, circular pictures.

1859 Napoleon III was photographed by Disderi for a *carte de visite*, beginning the social trend which lasted many decades for this kind of image.

Silvy, a Frenchman, opened a famous portrait studio in London specializing in elegant, society pictures.

Nadar in Paris made the first photographs underground by battery powered arc lights.

The world's smallest camera was produced by T. Morris of Birmingham, taking an image of 2cm square ($\frac{3}{4} \times \frac{3}{4}$ inches), the whole camera could be contained in a cube of 5cm.

1860 Queen Victoria was photographed for a *carte de visite* by the American photographer Mayall.

Matthew Brady, the American photographer, photographed Abraham Lincoln and it was used for political campaigning.

A sun portrait by Hill and Adamson of Alexander Ritchie, 1845. (*Courtesy Kodak Museum, Harrow*)

The camera recorded the meeting of these four last members of an entire race, decimated by the Colonial expansion into distant Tasmania. This picture was made in 1866. (*Courtesy National Library of Australia*)

1861 Paris had 30,000 people working in the supply or manufacture of photographic materials.

Timothy O'Sullivan showed the horrors of the Civil War in the USA with realistic photographs.

Auguste Bisson made photographs at the summit of Mont Blanc at 5000 metres (15,000 feet).

Sir James Clerk Maxwell demonstrated the additive colour process in London, using red, blue and green colours to make white light.

Thomas Sutton patented the single lens reflex plate camera.

Matthew Brady began to photograph the Civil War in the USA.

The London Stereoscopic Company showed the first focal plane shutter.

1862 The world's first successful aerial pictures were taken of Paris by Nadar in a balloon, the event being lampooned by Honoré Daumier, the painter.

1864 The first pictures by magnesium flash light were made at Devonshire, England, by A. Brothers.

1865 Patent No. 1791 was granted to Joseph Swann for a halftone process.

1866 Three hundred portrait studios were already operating in London.

1868 Samuel Brown took photographs at 6200 metres (18,600 feet) in the Himalayas.

1869 Louis Ducos du Hauron proposed a negative/positive colour process using a subtractive colour process and intermediate separation negatives.

1870 Julia Margaret Cameron was revolutionizing Victorian portrait photography with long lenses and subjective styling of the image.

John Thompson began a striking series of travel pictures of the Orient.

1871 Richard Leach Maddox published details of the modern gelatin-silver halides emulsion in the *British Journal of Photography*.

1872 The US Senate was persuaded by the photographs of William Henry Jackson to create Yellowstone as a wilderness area and a National Park.

1873 Professor Vogel, in Berlin, pioneered orthochromatic sensitometry.

1878 Mass production was begun in Britain of a fast, dry, emulsion glass plate, coated with the Maddox emulsion.

Eadweard Muybridge, an English resident in the USA, analyzed the movements of a galloping horse, using a series of cameras.

1880 A silver bromide emulsion was fixed in hypo.

The half-tone engraving process to reproduce photographs in newsprint was introduced in New York.

The first twin lens reflex was made by Beck of London using plates.

1882 E.J. Marey began photographing animals and birds by high-speed techniques for analysis of movement, using a disc shutter which produced stroboscopic images on a single film.

1885 Professor Ernst Mach, in Prague, photographed bullets in flight at 1000kph (700mph).

1886 *Le Journal Illustré* published the first candid photo-interview which was between Nadar and Chevreul the physicist.

1887/8 Jacob Riis, a New York press photographer, often using flash powder, photographed slum areas of New York arousing social consciousness in the city.

1887 Eadweard Muybridge published a book, *Animal Locomotion*, which contained 800 analytical photographic illustrations of movement.

1888 A celluloid cut film with gelatin emulsion was produced in the USA.

1889 Eastman Company in the USA introduced a thinner nitro-cellulose roll film and the *Kodak* No. 1. camera with 100 pre-loaded exposures taking round pictures and costing, at that time, ten dollars. The film speed and small camera made hand-held snap-shots easy, so that men, women and children began to produce images of good technical quality with consumate ease. The mass use of photography really began at this point.

Doctor P.H. Emmerson attacked Victorian sentimentalism in his book *Naturalistic Photography*, pleading for candid, clear naturalism to return to photography.

The influence of Impressionism and its interest in soft edges and subjectivity reinforced the dichotomous movement in photography which was separating naturalism from romanticism in camera images.

The fast anastigmat lens was made by Rudolph of Zeiss.

1890 Alfred Stieglitz returned to the USA after training in Germany as a photographer.

Paul Martin made candid street pictures of London by day and night.

1891 Lord Rayleigh made high-speed pictures of a bursting soap bubble.

Ives of Philadelphia made a colour separation camera for instant one-shot separations.

1892 The Linked Ring Brotherhood, 20 years later to become the London Salon of Photography, was formed to foster interest in pictorial photography worldwide.

C.V. Boys photographed a bullet travelling at Mach 2 (2000 kilometres per hour).

1895 Gum bichromate printing, and other similar printing processes where the camera image was manipulated by hand, became popular.

Exposures by electric spark were made at one millionth of a second.

1898 At the age of 42, the Frenchman Eugène Atget began a 30-year project photographing the City of Paris in what was later to become, for the world, a seminal example of documentary photography.

The first salon exhibition of photography in a US art gallery was held at Pennsylvania Academy of Fine Art.

1900 There were 250 photographic clubs existing in Britain and 10% of the population of Britain and the USA owned cameras.

1902 A prototype leaf shutter was invented by Deckel of Germany.

The Zeiss Tessar lens, on which many modern lenses are based, was introduced in Germany.

Alfred Stieglitz and others in the USA formed the Photo-Secession Movement to promote photography as a fine art and to explore expressionism in its images.

Stieglitz began *Camera Work*, a fine-art magazine of outstanding quality and influence in matters of photography.

Edward Steichen, in the USA, made a synthesized photographic portrait, 'The Thinker', of Rodin the sculptor, which set an inspirational example to many photographers.

1904 The autochrome colour process was patented by the Lumière Brothers.

1905 Alfred Stieglitz opened '291', a gallery promoting fine-art photography and modern art. '291' introduced many modern European artists to the USA for the first time, including Picasso, Braque, Brancusi and Arp. Contemporary photography was often included and '291' had a seminal influence on both art forms in the USA.

A sociologist, *Lewis Hine*, used photography to expose the exploitation of children in industry in the USA. New protective child labour laws were passed as a result.

1906 Wratten and Wainright of Croydon, England, produced the first commercial panchromatic plates using the dry process. George Eastman later bought this company.

1907 The Autochrome process, using potato starch grains and the first single plate process for colour, was factory produced and set commercial standards for colour material for the next 20 years.

1908 Dufay additive colour process became widely available.

Clarence White, the US photographer, exhibited natural, innocent and unselfconscious nudes, photographed outdoors, which set examples and trends in style and are still influential today.

1912 Deckel of Germany invented the Compur leaf shutter using gears and clockwork to operate overlapping leaves.

Aerial photographs were made in Germany using single exposure, remote control cameras in rockets.

1914 Kodachrome, a two colour subtractive process, was introduced by Kodak but discarded soon after.

A prototype Leica, designed by Oskar Barnack, was shown by Leitz of Germany.

1916 *Agfa* produced its first colour plate.

1917 Alvin Langdon Coburn made the first non-objective camera images.

Abstract patterns of natural objects were published in *Camera Work*, identifying a rising tide of interest toward subjectivity in photographic images.

'After the relief of Ladysmith'. A photograph by Nicholls, 1902. (*Courtesy Kodak Museum, Harrow*)

1918 Christian Schad attracted complimentary attention from the Dadaists with his photograms and montages.

1919 Quedenfeldt, in Germany, experimented successfully with photograms and photo abstractions.

1921 *Man Ray* created Rayographs (photograms) in Paris.

Edward Steichen began making abstractions by photographing natural objects in very close up.

Transmission of a camera image by radio was successfully demonstrated in the USA.

1923 *Moholy-Nagy* started teaching at the *Bauhaus*, breaking traditional links with the photographic style of the day, experimenting with montage, collage, photograms, x-rays and movement.

1924 Leitz launched the first 35mm system camera, the Leica, destined to change the photographic image irreversibly from an arcane art object into a major means of communication.

The Ermanox $6 \times 4\frac{1}{2}$cm plate camera was built in Dresden with a 1.8 lens permitting 'snap' shot exposures in room light and opening new possibilities for photo-journalism.

Neue Sachlichkeit (New Objectivity) began to influence photography. Renger Patzsch and others used unsentimental, superbly crafted photographs of commonplace objects as their subject. The search for the absolutes of essential realism in the camera image countered the work of Moholy-Nagy at the Bauhaus and became the dominating influence on modern photography for 20 years. Photographers began to see photographically.

1925 Moholy-Nagy published an important book of his theories, now of great importance to photographers in the 1980s, entitled *Painting, Photography, Film*.

1928 The twin lens roll-film reflex camera, the Rolleiflex, with a 6×6cm format was produced in Germany by Francke and Heidecke and was very well suited to the new realism.

Erich Salomon took reportage pictures in a Berlin court room with a concealed miniature Ermanox camera.

1929 Felix Man pioneered a reportage style of portraiture and the picture story.

An exhibition of photographic realism in Stuttgart established New Objectivity as a primary movement in photography worldwide.

Man Ray created increasingly subjective, synthesized images using the Sabattier effect, starting a fascinating and far-reaching rebellion against realism which finally resurfaced in the USA after World War II.

Duxochrome, a subtractive colour process, was invented by Herzog in Germany for making permanent colour prints in a refined Carbro technique.

Ostermeier, in Germany, made a self-contained foil-filled expendable flash bulb that was commercially viable.

1932 The Western Electric Instrument Corporation of USA produced a photo-electric exposure meter which measured reflected light.

The F64 Group was formed in the USA.

1935 Mannes and Godowsky, amateur photographers, devised a subtractive three-layer emulsion colour film using

Albert Renger Patzsch began to explore the geometry of the real world under the rising influence of Germany's New Objectivity art movement. (*Courtesy Rheinisches Bildarchiv*)

dye coupler developers which, named as Kodachrome, became the basis for reliable, small-format colour photography using reversal (transparency) film.

Electronic flash was invented in the USA.

1935/6 The Farm Security Administration, in the USA, elevated the social documentary photograph to world attention using photographers Dorothea Lange, Margaret Bourke-White, Arthur Rothstein, Walker Evans and others.

1936 Agfa colour reversal film was introduced using dye formers within each emulsion layer.

Life Magazine was begun in the USA.

The social reportage of *Bill Brandt*, the English photographer, was published in the form of a book, *The English at Home*.

Robert Capa took photographs of the Spanish Civil War, setting new documentary standards.

1937 Agfa published details of a workable negative/positive colour process which was marketed two years later.

Moholy-Nagy was a co-founder of the New Bauhaus in Chicago.

1938 In the UK, *Picture Post* was begun.

1940 Multigrade enlarging paper was introduced in the UK by *Ilford Limited*.

1942 Kodacolor negative/positive film was launched.

Phenidone, a very active developing agent, was introduced by Ilford Limited.

1943 *Irving Penn* had his first photographs published in American *Vogue*.

The first positive colour print process was introduced by Ansco in the USA.

1945 *Ansel Adams* published *Exposure Record*, a book in which he discussed the Zone System.

1946 The Kodak Dye Transfer colour printing technique was marketed.

1947 Doctor Edwin H. Land introduced the B/W *Polaroid* instant process.

Dennis Gabor established the principles of *holography* in England.

The Magnum Group was formed, a co-operative syndication organization for photo-journalists. Founder members were David Seymour (Polish), *Cartier-Bresson* (French), Robert Capa (Hungarian/US) and George Rodger (English).

1950 *Life Magazine* published *W. Eugene Smith*'s picture story, 'The Spanish Village,' which clearly demonstrated the power of the photo-essay.

1951 Professor Otto Steinert promoted 'Subjective Photography' as an alternative to New Objectivity theories of realism. His creative teaching and writing were a dynamic influence on the growth of abstract photography.

1955 Kodak introduced Tri-x as a 200 ASA B/W film.

The 'Family of Man' exhibition of photographs arranged by Edward Steichen opened in New York and was eventually to be seen by nine million people in 38 countries.

1959 Voigtlander in Germany invented the zoom lens.

Robert Frank published a watershed book of documentary images about the USA of everyday life, entitled *The Americans*.

1960 The laser was invented in the USA, making holography possible.

1960 Polaroid demonstrated Polacolor, a self-processing, 60-second colour film using a dye diffusion technique.

1961 Bill Brandt astounded the art world with the publication of his photographic book *Perspective of Nudes*, after 15 years of experiment and preparation.

1962 Photography from 15 miles away detected missiles in Cuba.

1963 A dye-destruction reversal colour material was made by Ciba-Geigy of Switzerland, and made available for self processing.

A test ban treaty between the USA and Soviet Russia was a catalyst in the development of astro-photography and satellite photography.

The camera is a witness to all the great and small events in our lives. (*Courtesy Agfa–Gevaert* AG)

Less than a generation after the first practical roll film cameras were first used on Earth, a roll film camera recorded the first tentative steps of man on his neighbouring planet, the Moon. (*Courtesy Hasselblad, Sweden*)

Left War brings its countless victims to the notice of those photographers who follow its path. Robert Capa, one of the most famous of such photographers, found this young refugee from the Spanish civil war in 1937. His picture tells, in sad dimension, of the less violent but inevitable consequences of those trapped by the conflict. It was exhibited by the International Center of Photography in its exhibition of 'Spain 1936–1939'. (*Courtesy International Center of Photography*)

'THIS IS A MIRACLE'

The year of 1839, when Fox Talbot and Daguerre struggled to be first to announce the process and Herschel, the great English physicist, prophetically alluded to its miraculous possibilities, was the explosive and exciting year when photography was officially offered to the world and when the world fell in love with photography.

The year of 1839

7 January François Arago reported Daguerre's discoveries to the French Academy of Science.

29 January Sir John Herschel took his first photograph on paper sensitized with carbonate of silver, fixed in hypo.

31 January William Henry Fox Talbot read a paper to the Royal Society on photogenic drawing, which demonstrated the first photogram and the first negative/positive technique.

2 February Frederick Gerber, Berne University, announced a paper technique using silver salts as a sensitizer.

3/4 February Herschel recorded in his notebook the term he invented for the process: 'photography'.

5 February Hippolyte Bayard announced negative images on silver chloride paper.

14 March Herschel read a paper, 'The Art of Photography' (the first public use of the word) and showed 23 paper photographs, some positive and some negative.

20 March Hippolyte Bayard made direct paper positives in a camera, exposing for one hour.

2 April The Reverend J.B. Reade, using a solar microscope, made photo-micrographs on white leather using gallic acid as a sensitizer, fixing in hypo and showed them to the Royal Society, London.

13 April Franz von Kobell and Karl Auguste von Steinheil reported their successful trials of Fox Talbot's techniques to the Bavarian Academy of Science. They made the world's first miniature pictures 4cm square ($1\frac{5}{8}$ inches) on paper fixed with ammonia after a three to four hour exposure.

June Hippolyte Bayard held an exhibition of 30 photographs of still-life and sculpture subjects.

Francis West, a London optician, advertised the first camera for sale to the public.

July The French Government acquired Daguerre's process in order to give it free to the world.

The world's first photo-manual was published in Leipzig on both Fox Talbot and Daguerre's techniques.

14 August Daguerre patented his process in England only.

19 August Daguerre's process was made public in France.

20 August Daguerre published a manual on his process.

August Alphonse Giroux marketed the first Daguerreotype cameras with sliding box focus at a cost of 500 dollars (today's price by adjustment).

9 September Herschel produced the first photograph on glass, coated with carbonate of silver.

16 September D.W. Seager made the first Daguerreotype in the USA of an architectural subject.

October Alexander Wolcott, Samuel Morse and J.W. Draper, in USA, successfully experimented with Daguerreotypes for portraiture.

23 November First public exhibition of Daguerreotypes in the USA was held in New York.

December Sir John Herschel used publicly the terms 'positive' and 'negative'.

Séguier introduced a lightweight leather bellows camera, a tripod and the universal tilting head.

Karl Auguste von Steinheil showed the world's first miniature camera taking Daguerreotypes, $8 \times 11mm$ ($\frac{5}{16} \times \frac{7}{16}$ inch) and which could be viewed only by a magnifier.

1969 Neil Armstrong of the USA landed on the moon and took photographs, using semi-standard equipment.

1972 Polaroid introduced the automatic SX 70 system, an SLR camera without disposable, peel-apart film components.

1977 Voyager I, a remote space probe, was launched from Earth to explore and photograph distant planets.

1980 Ansel Adams sold an original print for 45,000 dollars in the USA.

Voyager I sent remote photographs of Saturn back to Earth with breathtaking quality across 1 billion kilometres of space.

HOLOGRAPHY

In 1948 in Britain, the Hungarian physicist Denis Gabor discovered the theory of reproducing three dimensional objects on film by the use of holography but it was not until 12 years later, at Hughes Aircraft Research Laboratories in the USA, that the first laser was built following the published theories of two American scientists, Charles Townes and Arthur Schawlow.

Holograms can be produced only by the use of coherent light, that is light of a single wavelength and frequency (see *Light*) and only lasers can produce this kind of light and in sufficient strength (see fig.). The laser beam is split by a beam-splitter, to form an object beam and a reference beam. The reference beam is directed to a sensitive plate at a specific angle and the object beam is steered toward the subject by mirrors, and after passing through an expanding lens, the object beam strikes the subject. The subject then reflects light in different intensity, according to the shape of its surface and these reflected waves are intercepted by the reference beam, precisely at the surface plane of the sensitive holographic plate. An interference wave front is formed by the overlapping light waves from the two sources, which is recorded on the plate as an image with full three-dimensional properties.

The sensitive plate is developed in fairly conventional chemistry, including a bleach to remove unwanted silver and leave bromide crystals to form the diffraction grating necessary for reconstitution as an image. The plate remains transparent until this diffraction grating is exposed to a reconstituting beam of light which is placed at the same angle as was the original reference beam and is monochromatic in character. With transmission holograms it is usual to have a laser beam to reconstitute the image but for reflection holograms a bright, narrow-beam tungsten halogen lamp, such as those from the Osram Mini Spot or from a projector, will give a good quality image.

Holograms can give apparent dimension in front of the plate, called a 'real' image, which is convex, projecting the image towards the viewer or the image can appear behind the plate which is termed a 'virtual' image and is concave, with the third dimension appearing to retreat from the viewer. A third configuration is possible, that of the 'plane' image, established within the shallow plane of the plate. A curious feature of holograms is that small pieces of the plate appear to have a memory of the whole and can therefore be used to reconstitute the entire image even though only a portion of the plate is placed in the viewing beam. Under certain circumstances it is also possible to see around, below or above the object, into three dimensional space which was not in the original hologram. Passing such a hologram gives an incredible dimension of the whole object.

Holography so far has limitations as regards colour and the size of the plate and at present most holograms are able to reconstitute only on a scale of 1:1, that is to say the same size as the object photographed. Texture is rendered well but during the exposure movement or vibration must be totally absent in the subject or apparatus, as the merest hint will destroy the

This is a typical arrangement of laser equipment for creating holograms.

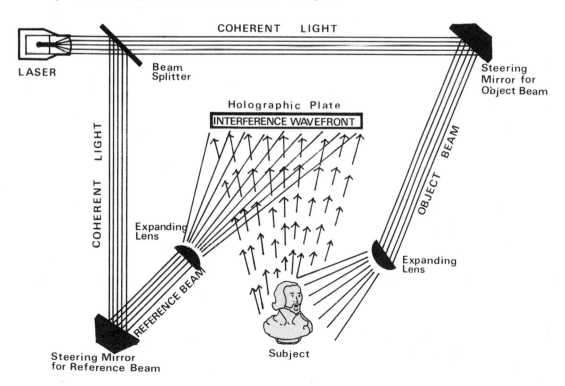

COHERENT LIGHT

LASER

Beam Splitter

Steering Mirror for Object Beam

Holographic Plate

INTERFERENCE WAVEFRONT

COHERENT LIGHT

OBJECT BEAM

Expanding Lens

REFERENCE BEAM

Expanding Lens

Steering Mirror for Reference Beam

Subject

image totally, giving no image on the plate whatever. For this reason elaborate concrete benches on pneumatic dampers are built and although the exposure is often relatively short, perhaps between half to two seconds, the whole arrangement is left for several hours to settle and so be completely free of vibration before exposures are made. Even a gentle air stream can dissipate the image. This also means that considerable difficulty will be found in making holograms of lightweight or potentially mobile objects, such as flowers. There is a beginning use of pulse lasers of sufficient strength to permit the photograph of people and, no doubt, this area of experimentation will overcome the problem of vibration and movement.

By using a rotating stage and sequential exposures with a pulse laser and eliminating either vertical or horizontal parallax, a rudimentary impression of movement can be obtained and there are increasing examples of holographic movies, particularly arising from Russian experiments.

The rendering of the internal space and external volume of an object and the viewing of it without any optical aid has long been the dream of those interested in stereoscopic images and it is certain that in art and commercial photography in the next few years, the hologram will begin to play an increasing role.

HYDROQUINONE

Introduced as a developing additive by Sir William de Wive-leslie Abney in 1880, these shiny crystal slivers are mostly combined with active developing agents such metol, and often used only as a preservative. High contrast, caustic developers do, however, use hydroquinone as a developing agent in its own right (see *Developer*).

HYPERFOCAL DISTANCE

This is a particular application of the depth of field characteristic of the lens, when a lens if focused upon infinity. The distance to the nearest acceptably sharp object is called the hyperfocal distance and naturally decreases as the f stop is

Hyperfocal distance using the camera lens scale to calculate greater depth of field.
a Focus on the main feature of interest, e.g. at 10 metres, the depth of field, at f22, extends from 20 to about 6.5 metres.
b Find the hyperfocal distance (H–fD) by placing the selected aperture opposite the infinity mark. H–fD is indicated at about 8.5 metres, which includes the desired focus point, but it is getting to dangerpoint in the zone of focus where it may be unsharp if enlarged to any degree.
c To use the maximum zone of focus around the subject, re-focus now on the H–fD. This now indicates a depth of field from about 5.5 to 20 metres which substantially improves focus on the subject compared to the case of (b) above, and offers a large zone of sharp focus in front and behind the focus point. Use this zone method of focus on action subjects needing pre-focusing.

made smaller (see *Depth of Field*). To obtain the maximum depth of field for a given aperture, first find the hyperfocal distance (see left fig.) then re-focus upon this point. Depth of field or the zone of acceptable focus will then extend from half the hyperfocal distance to infinity.

HYPO

This is a photographer's term for sodium thiosulphate, and an abbreviation of the incorrect, common name of hyposulphite of soda. It was discovered at the dawn of the photographic era by Sir John Herschel in 1819 and used as a fixitive for photographic images by J.B. Reade as early as 1837. It is obtained as crystals and is dissolved to form a 30% concentration for prints and a 40% solution for negatives. Fixation is completed in fresh baths when the negative is completely transparent in the shadow areas or after five minutes for print material. Fast fixers have now been introduced as an alternative to hypo, but these are made from ammonium thiosulphate (see *Fixers*).

HYPO CLEARING BATHS

The tenacity with which even modern fixers adhere to photographic print fibres can cause serious fading and staining in poorly washed prints, especially if the final environment is one of high temperature and humidity. Commercial additives are available to produce a mildly alkaline water bath which will increase the solubility of the thiosulphates and silver salts and assist the passage of water more easily through the emulsion. This pre-wash bath does shorten washing times but does not eliminate or neutralize residues of fixer in the paper (see *Hypo Eliminators*). A suitable and inexpensive hypo clearing bath is made with sodium sulphite. Mix 40g of anhydrous sodium sulphite with two litres of water to prepare a bath which is used after fixing and before the final wash. Amended washing times could be about five minutes for film after half a minute in such a bath, 30 minutes instead of one hour for double weight, fibre-based paper, after it has had three to four minutes in the bath. (See *Fixing*, *Archival Processing and Storage*.)

HYPO ELIMINATORS

This is a post-washing bath which oxidizes residues of thiosulphates to make them into inert simple sulphates which therefore do not damage the remaining silver image. It does not shorten washing time but wherever maximum permanence of the print is needed, it is advisable to include this routine in processing procedures. Films will not normally require such treatment as archival permanence is easily obtained by normal washing methods. Kodak, May and Baker and Ilford make excellent hypo eliminators (see *Hypo Clearing Baths*).

HYPO TEST

A simple test for the presence of fixer in partly washed prints

is to mix an alkaline permanganate solution according to the formula below. Make up the solution in a clear *glass* beaker and then take an 18×24cm (8×10 inch) print from the washing tank and allow it to drip into the violet coloured test solution. If the colour rapidly changes to orange or yellow, hypo is still present in the print, and further washing is required. For archival purposes or if long-term tropical storage is contemplated, a hypo eliminator should be used.

A rapid test for the presence of silver salts in processed photographic material, which also will cause deterioration of the image during long-term storage, may be carried out as follows.

After thorough washing, squeegee the print to clear off surface water, take a drop of sodium sulphide solution at a concentration of 0.2% and deposit it on the white border of the print. If silver compounds are present the sulphided area will begin to show discolouration after three minutes. Unwanted silver may remain in the print or negative if fixing baths are exhausted, or insufficient time in them is allowed, or if washing is incomplete.

Formula for hypo test

Distilled water	350cc
Potassium permanganate	0.6g
Sodium hydroxide	1.2g
Distilled water to make	500cc

The working solution is made by taking one part of the test solution and adding it to 250 parts of pure water. This should not be considered as an absolute test for hypo residues as impurities in tap water can create anomalies.

ILFORD LIMITED

Eight years after the first description by R.L. Maddox of a gelatin dry plate process appeared in the *British Journal of Photography*, Alfred Hugh Harman founded the embryo dry plate manufacturing business which was to become the worldwide company now known as Ilford Limited. Harman, who had great entrepreneurial skills in presenting photographic services to the public, took photography out of the experimental and amateur market and placed it firmly within a skilled industrial and marketing context. A public company was formed in the late 1890s, just after George Eastman had met with Harman to try and form a composite international business. A more determined bid by Eastman in 1902 was accepted, but finally rejected by the Board.

Fortunes varied for the company during the two world wars and intervening years but in the 1950s and sixties, with the entry of Imperial Chemical Industries of the UK, who held a patent for integral masking of colour negative film and who obtained a 32% share holding in Ilford Limited, great activity was evident. More and more their reputation as specialists in the black and white photographic industry grew and they improved X-ray films and experimented with making and selling cameras and colour films. In 1966 Ciba Photochemie of Switzerland and ICI jointly bought more than 90% of the company and in 1969 Ciba bought the ICI interest and became sole owner of Ilford. A year later Ciba merged with Geigy and the large Ciba-Geigy conglomerate took on an active role in management of Ilford Limited.

With the introduction in the 1970s of Ilfospeed, resin coated B/W paper, the remarkable Cibachrome positive-to-positive colour print process, HP5 fast film, a re-introduction of an improved multigrade paper (which was the first variable contrast paper on the market, in 1940) and new X-ray film needing lower dosage, Ilford continued to service the professional markets by their traditional intense interest in it and enviable technical strengths to solve its problems.

Recently a fine archival quality exhibition paper, Gallerie, has been introduced, a revised and vastly improved Cibachrome professional colour paper which now handles contrast very effectively and an unusual chromagenic, high speed B/W emulsion, compatible with colour negative chemistry, indicates their continuing and expert activities in the quality end of the professional market throughout the world.

Optical centre of a vertical format.

IMAGE MANAGEMENT

Within an image which, in photography, is generally enclosed by a rectangular frame of reference known as the *format*, individual components of that image may be located, analysed and identified so that their behaviour in the process of visual communication may be understood and manipulated. Our psyche is computed to react quickly to innovative techniques, and surprise, emotion and relevance are the basis of rapid visual communication.

The photographic image exists in a flat plane with a geometrically defined perimeter. The physical nature of the flat photograph, whether it is shiny or matt surfaced, coloured or monochromatic, thick or thin, plays a part in composition as do the proportions of the format which carry the image and the very near environment immediately outside the format boundary. Classic inspiration suggests the use of a 'golden rectangle' where the long side is in the same proportion to the combination of length and width as is the width to the length. This aspect ratio of 1.62:1 is said to produce a pleasing proportion, but others prefer another Greek classic 'the root 2 rectangle' with an aspect ratio of 1.44:1. Photographers sometimes find the 'ideal' format with an aspect ratio of 1.25:1 most pleasing and practical because many film and paper formats are designed to these proportions. The tactile quality of the print is intricately connected to the size and shape of both image and print – documentalists and purists tending towards the use of glossy paper, unequivocally chemical in nature, while pictorialists often use heavily textured material, reminiscent of canvas finishes and easel painting.

Images do not recreate reality: images are images and are symbols of reality. Surface and visible differences exist within the image and these interact with identifiable psychic elements of symbolism and also with unconscious responses in the viewer to the hidden structures beneath these physical and psychological characteristics. Such differences will include:

Tone The image will show differences of light and dark.

Area Such tones will have surface area.

Edge Where areas are adjacent to other areas of different tone an edge is created, which may be seen as a line.

Contour An area by its disposition of tone and its edge definition can create an effect of contour or three dimensional form.

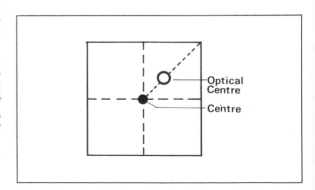

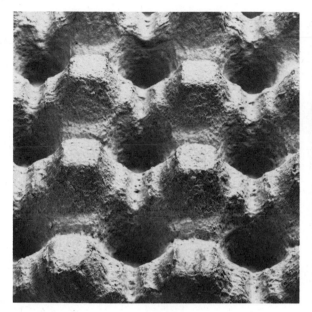

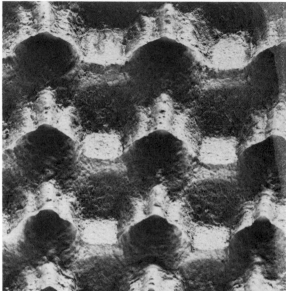

Look at picture (a) and note that it shows a highlight as the topmost contour. Now study (b) looking at the highlighted contour. The contour looks as if it has been cut in section to reveal a different configuration and the picture looks different. (a) and (b) are the same picture, but (b) has been inverted. Images change their visual properties according to how they are viewed.

Tension Dynamic tension between elements within the image creates harmony and interest, or instability.

Illumination Quality of light and its behaviour within the image contributes in a major way to perception.

Position An area of tone will have a point of location in the frame of reference.

Unity Self-contained tonal areas or groupings of image fragments can have optical unity. Size and area of tone will have magnitude and scale. Areas of similar tone and shape in the image may be repeated and can be counted. Colour areas may be coloured. Perspective distorts, or creates, impressions of reality (see *Perspective*).

Texture Areas will show surface structure or texture.

Space Aerial perspective and quality of tone can suggest spatial separation. Space must both enfold us within the image yet impose distance between it and ourselves.

Depth Illusion is created by depth clues and geometric perspective in the image.

Balance Tonal areas will need to acquire equilibrium within the format by relationship with its boundary and with other tonal areas.

Dominance Tonal areas can dominate by virtue of size, colour, unity, position and so on, standing very much alone in the format.

Ambiguity Image fragments are designed to confuse the viewer so that hidden psychic symbols may be felt. Ambiguity encourages unconscious vision.

Emphasis Tonal areas can be emphasized to stand apart but be supported by a hierarchy of lesser values.

Juxtaposition Unlikely elements are put together in an image to create attention.

Motion Fragments of the image can give an illusion of movement using either a soft edge or a hard edge of tonal area.

Pattern Similar areas and tonal shapes can be repeated to form patterns. The human mind seeks to organize all visuals into patterns before further understanding. Pattern represents stability.

Rhythm Where contour is repeated rhythm is found. Rhythm is comforting to viewers. Asymmetry is symbolic of life and energy and creates a flow of responses in the viewer. Tension can be created by ambiguity, imbalance, incompleteness of form, overlapping, juxtaposition. Rhythm can contain these elements.

Mood Emotion can be suggested by the interaction of symbols and visible image differences. The camera is uniquely capable in this respect.

Latency An image can have a potential, a hidden meaning which is coded for eventual discovery by the viewer. Finding and understanding the meaning allows the viewer a sense of ownership in respect of the image while in the creator, its discovery by another is a major acknowledgement of skilful work.

Separation The clarity with which a fragment within the image area may be seen, how easily and quickly its characteristics may be understood, depends on a definite separation from its tonal environment. Without visible separation, full perception is impossible.

When any one of these 22 visible differences are present and definable in a photograph, the image will be more interesting than when none of them are there. When a properly orchestrated selection of these controlling factors is manipulated by the photographer, there will be a considerable

Left Areas of tone advance and recede according to their relationship with other tones and their actual size.

Above right Contour.

Above Texture.

Below Aerial perspective with tonal differences and visual separation between planes creates space within a flat image.

Right Pattern. (*Courtesy Agfa-Gevaert* AG)

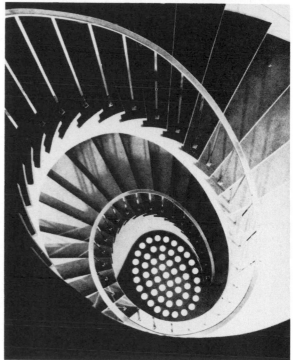

We are dominated by visual concepts.

Faced with visual stimuli we seek patterns.

We then seek concepts.

We are primarily aware of change.

Movement is change.

Contrast is change.

Asymmetry is change.

Variable intensity is change.

Size difference is change.

Pattern is imposed by the viewer, then grouped together.

We seek evidence of humanity in pattern.

Constancy is sought by identifying the dominant stimuli.

Constancy and rhythm encourage fantasy and imagination.

Perceptions are organized into figure and ground.

Ground is neutral, figure is not.

One is separated from the other by edge.

These processes are reflex, unconscious and subjective.

Too much security, too little mystery and no introspection, generates boredom.

We try to understand the universal before the particular.

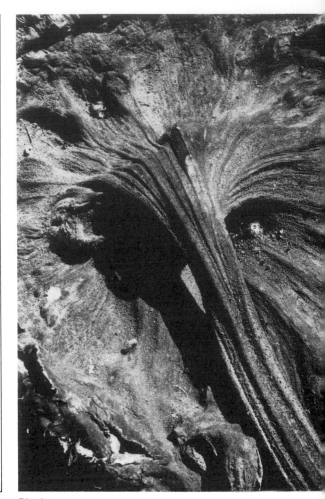

Rhythm.

Rhythm, pattern and texture.

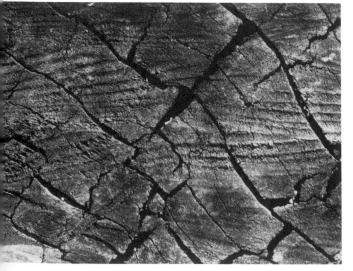

deepening of attention by any observer of the image and an increased understanding of the visual concept. The invisible differences which are more remote and subjective but powerfully active, are less easily identified and more rarely deliberately used. These will include:

Image symbolism Suggestions within the image of cultural symbols of a generic nature, intensifying communication. These include sex, humour, appetite, religion.

Colour symbolism Symbolic colours can trigger deeply moving responses which are quite unconscious (see *Colour Harmony*). Colours also physically interact with each other and this increases when texture and form are suppressed.

Size symbolism A comparison of the image size with the real life size of the object can create feelings of alarm, contentment or vivid interest. The visual reference is usually orientated to the viewer's own size and position.

Time symbolism Photographs are tiny slivers of real time recorded as an image. Sometimes they are encapsulated, sometimes infinitely expanded. Photography is the only art form which is truly analytical in matters of time and explores

time within the image structure.

Space-time symbolism An image may be symbolic of simultaneous interaction of space and time which is one aspect of our cosmic position in the universe. The photographic image is capable of producing extraordinarily subjective responses to such designs, particularly when they are made by employing a sophisticated synthesis of several images to make a single image/concept.

Beneath the surface of the image, hidden within the visual concept, lie the subliminal clues which await the staggering acuity of unconscious vision. This displays scanning powers superior to those used in conscious vision and while decoding and monitoring all surface information in the image, the subjective, unconscious vision is inter-relating to it and to the deeply concealed psychic and cosmic implications in the image. Here the observer's brain seeks motivations in the creator of the image, suggests lightning hypotheses prompted by concealed symbols, accepts or rejects hidden aspects of image quality or responds unconsciously with memories and experiences of the observer's own dreams and culture. Low-level vision of this kind is the basic underlying characteristic of complete perception and communication. (See *Fine Art Photography, Lighting, Perspective, Still Life, Vision, Visual Literacy.*)

Below Contrast.
a Dark and light of equal area and strength do not create harmony or interest. Each area is unrelated, existing for itself alone and viewers lose interest.
b Unequal areas, even of plain or solid contrast, create interest.

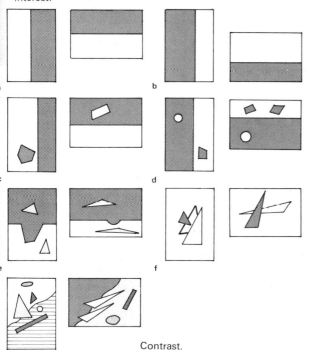

Contrast.

c Allowing irregular shaped, small areas of one tone to appear in larger areas of contrasting tone creates more sophistication and therefore interest: light against dark, dark against light, large against small, narrow against wide.
d Heavy tone in small areas of highlight can soften the high contrast effect and create dynamic tension and therefore interest.
e Interpenetration of contrasts and the addition of mid-tones significantly lowers contrast, increases subtlety, sophistication and therefore interest.
f Dynamic relationships between contrasts is increased by superimposing one form on the other.
g Unequal areas and uneven shapes and a range of tonal values create dynamic harmony and interest. It is necessary for photographers to learn how to balance each fragment of contrasting tone against other tones and these against the whole frame of reference.

Overleaf, top Depth clues.
a Warm colour advances, cool colour recedes.
b One-point perspective with vanishing point in picture.
c Two-point perspective with vanishing point outside picture.
d Overlap.
e One-point perspective and overlap creates great depth.
f Cast shadows create depth.
g Objects appearing on definite and receding planes exaggerate depth.
h Familiar objects appear more distant when smaller, even when other clues are not present.

Overleaf, bottom Compositional structure.
a Angles suggest agitation, insecurity.
b Contrast of line and shape gain emphasis and attention.
c Rectangles suggest stability.
d Verticals are for dignity.
e Circles are equality, eternity and space.
f Heavier masses or visual weight should be near centre line.
g Place important visual elements in balance as on a fulcrum lever.
h Obliques suggest confusion or combat.
i Spirals add motion, power or excitement.

Page 179, top Optical composition.
The focal length of a lens radically alters the image even though it does not necessarily change geometric perspective. Viewpoint is altered to give constant size and position to the main figure. Spatial differences change (A) with change of lens. Space is compacted with long lenses, expanded with wide lenses which also alter depth of field. Zone of focus is deepest with wide lenses but very shallow with long lenses.

Page 179, bottom A summary of image management and how elements within the format interact to enhance communication and understanding. The visible differences interact with each other or directly with symbolism, unconscious vision, or the viewer's/creator's unchanging or changing modifiers. Visual communication is a two way 'dialogue' between the creator of the image and the one who observes the image. Total perception puts us in close touch with reality but is also unstable, constantly shifting and subjective. It is also uncontrollably affected by the unconscious mind.

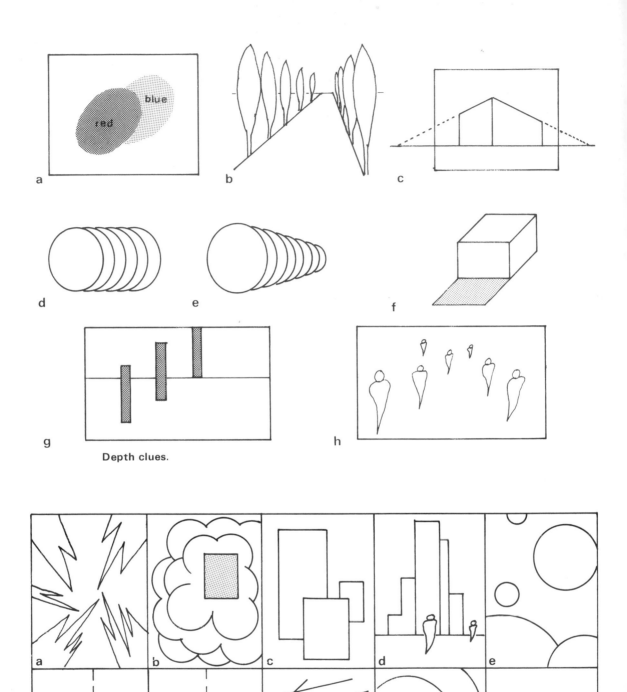

Depth clues.

Compositional structure.

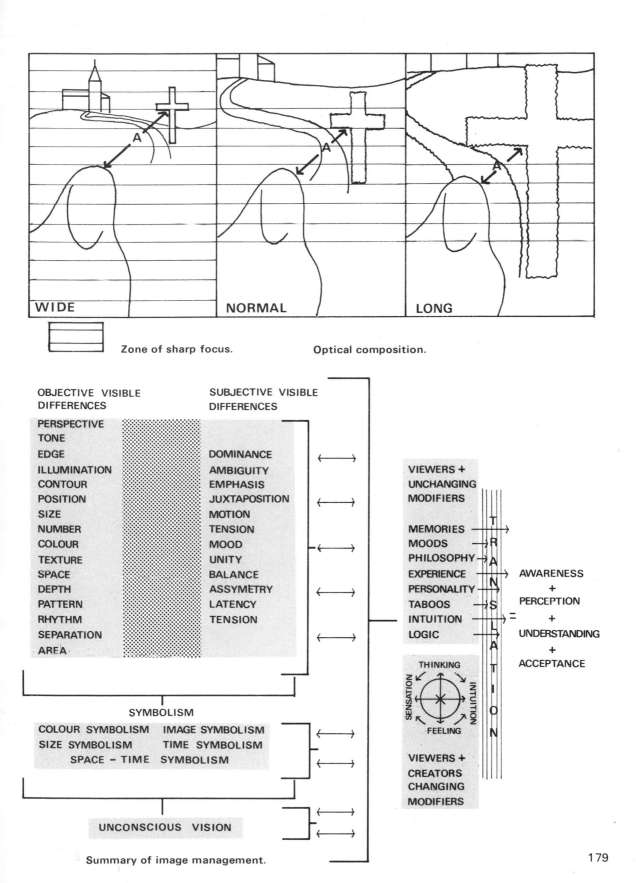

WIDE NORMAL LONG

Zone of sharp focus. Optical composition.

OBJECTIVE VISIBLE DIFFERENCES

PERSPECTIVE
TONE
EDGE
ILLUMINATION
CONTOUR
POSITION
SIZE
NUMBER
COLOUR
TEXTURE
SPACE
DEPTH
PATTERN
RHYTHM
SEPARATION
AREA

SUBJECTIVE VISIBLE DIFFERENCES

DOMINANCE
AMBIGUITY
EMPHASIS
JUXTAPOSITION
MOTION
TENSION
MOOD
UNITY
BALANCE
ASSYMETRY
LATENCY
TENSION

VIEWERS +
UNCHANGING
MODIFIERS

MEMORIES
MOODS
PHILOSOPHY
EXPERIENCE
PERSONALITY
TABOOS
INTUITION
LOGIC

T
R
A
N
S
L
A
T
I
O
N

AWARENESS
+
PERCEPTION
+
=
UNDERSTANDING
+
ACCEPTANCE

THINKING
SENSATION INTUITION
FEELING

VIEWERS +
CREATORS
CHANGING
MODIFIERS

SYMBOLISM

COLOUR SYMBOLISM IMAGE SYMBOLISM
SIZE SYMBOLISM TIME SYMBOLISM
SPACE – TIME SYMBOLISM

UNCONSCIOUS VISION

Summary of image management.

179

IMAGE SYNTHESIS

The physical manipulation of an image, whereby it becomes a synthesis of various parts of other images, allows us to separate unconnected glimpses of the world, isolate individual experiences of time and then reconstitute them as one multi-faceted image of our own choosing – often far more interesting than a single photographic image. It has been a commonplace technique of photographers since early this century, but is now reaching new heights as colour photography becomes easier and film and television mixes make us more familiar with the potential power of multiple images contained in one frame.

To create a synthetic image, one which is not natural or the result of standard camera technique, the photographer must first consider the component parts, their individual role within the new image and the final, total visual concept. This is done by *pre-visualization* and research once the technique has been decided upon. Techniques of synthesis include the following:

Chemigram A method of combining standard photo-chemistry with the action of light but without an optical image, in order to create abstract shapes or colours. Quedenfeldt in 1919 used the technique and Kepes explored it further several decades later.

Photogram Much loved by the 1920–30 photographers; this method uses objects to interrupt a focused beam of light before it strikes the sensitized material. A two-dimensional image results with no contour evident in the objects. It was one of the earliest photographic images ever made, being the subject of experiment by Fox Talbot in the 1830s (see *Photogram*).

Collage/montage This is a method of assembling compound images by printing various individual images to a common scale on single weight paper. A sharp designer's scalpel is used to cut out the relevant section of each, the whole is pasted together to a pre-determined plan and then rephotographed, usually after retouching. The advertising industry uses this method constantly, but creatively it is also a powerful and interesting extension of photography. Max Ernst, Max Burchartz, George Grosz, Moholy-Nagy and John Heartfield all used this technique to considerable effect and modern workers include Kennard, Bennett and Staetz.

Kinetic collage This is an attempt to synthesize movement so that viewers may experience the effect of movement

A masterly synthesis of image elements by Jerry Uelsmann. (*Courtesy Jerry Uelsmann*)

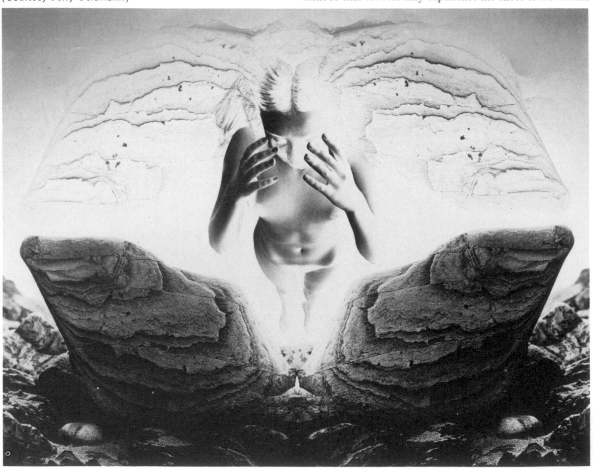

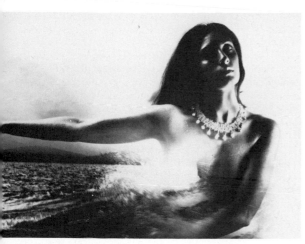

Synthesizing by the use of a true filmic montage requires skill in the darkroom but the results are often the most convincing in photographic terms compared to other techniques.

rather than see an image of it and requires two or three same size prints of single action subject. The selected image is printed on single weight paper and then each print is carefully sliced into thin, similar sized strips. These are then re-assembled to form a sharp but shattered image of movement. The technique works best with 'frozen' action and very bold composition.

Overlay A collection of images brought together by overlaying two or more negatives or transparencies and then using this composite image as the basis for the final print. There is a fusion of images which sometimes make them extremely complex and hard to read and density build-up where images cross each other can cause loss of continuity in the visual concept.

True photo-montage Based on the film or TV technique of mixing one image with several others to integrate them closely and tell a composite story in the space of one sequence or one frame. For the stills photographer it is a matter of exposing several images on the same piece of film, keeping backgrounds dark and simplified. The montage can be done in-camera with a matte box or more easily in the darkroom, using an enlarger and mutually exclusive masks. Of all the special effects possible with the camera, this one is the easiest, now that many 35mm SLR cameras are made with a special double exposure switch to allow the film transport to be bypassed while the shutter is wound. It is necessary to under-expose each individual image, so that successive images will accumulate to a total of nearly normal density and to include areas of black in each image which will then receive the main part of the following image.

Metagraph Possibly the most synthetic of photographic images and the one which perhaps involves both the creator and the viewer of those images in the deepest of communion. It is a sophisticated camera and darkroom technique to suppress form, increase attention to area and edge and to change colours arbitarily from the expected. At its best it

remains a photograph, yet bridges both photography and painting. These images appeal very much to the subconscious in those who observe them and arise largely from subconscious and intuitive experiences in those who make them. As well as making a commanding camera image for the origination, the technique requires considerable darkroom skill with mutually exclusive masks and solarizing, tone line compression and posterization all playing a part. They are not, however, happy accidents, but a planned attempt in creative synthesis in order to strengthen communication and explore the dimensions of space-time, destruction and construction, fragmentation and synthesis. (See colour plate.)

Subjective and introspective vision is often released by the fusion of several diverse images into one composite whole, which cannot be grasped by a single rational inspection by those who approach it.

This fragmented image, built up from multiple components, imposes a strange new visual concept deeply touching the intuition, emotion and unconscious experiences of both the creator and the observer of the image.

IMPRESSIONISM

The painters who began a revolution in image making in France during the latter half of the nineteenth century were greatly intrigued with photography and created theories which still influence photographers today. They were primarily interested in outdoor subjects, interpreted these freely in the light of their own inner experience rather than any accepted or classical rules and tried to capture the vitality of natural light itself. They strove for immediacy of mood and intensity of colour. Had the 35mm SLR camera been available to them, with modern colour emulsions, they need not have deviated from their precepts or principles at all in order to produce their fragmented, soft-edged impressions of life around them.

Photographers who are interested in the 35mm format will benefit by studying the masters of impression, particularly Manet, for his narrative, Monet for his shimmering light, Degas (who was much influenced by photography and sometimes used it to aid his paintings) for his bold cropping of the image and his masterly use of arrested action, Signac and Scurat for their use of scientific principles to use granular, pointillistic impressions based on the laws of contrast, Van Gogh (who is perhaps more of an expressionist) for his passionate use of reticulated colour, Renoir for his uninhibited portraits and frank nudes. All can be studied for their use of hidden structure and their understanding of colour. (See also *Fine Art Photography*, *Surrealism*, *Image Management*, *Action Photography*.)

INCIDENT HIGHLIGHT

The incident highlight is the tiny spectral highlight within the

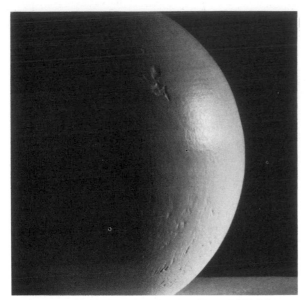

The incident highlight is found within the main highlight and should be discernible in correctly processed B/W prints.

main highlight, usually a mirror image of the shape of the light source which throws the key light. In B/W processing it is a sign of good printing density in negatives when this incident highlight is easily discernible and separates clearly from the main highlights. Such highlights can be objectionable, however, as when they may be seen in the eyes of a person photographed in close-up and for example the popular umbrella reflectors on professional flash equipment should be carefully positioned if this is to be avoided. (See *Exposure, Lighting, Nine Negative Test.*)

INCIDENT LIGHT METER

This is a meter which measures the light falling upon the subject plane. The meter is placed on the subject plane and aimed at the camera lens, whereas a luminance meter is held at the camera position and aimed at the subject in order to measure light reflected from it. (See *Exposure* for an illustration of such a meter.)

INDUSTRIAL PHOTOGRAPHY

The freelance called upon to produce good photographs of an industrial environment will need first to research the project very carefully. This requires a methodical approach with ample note taking. First discuss the assignment with the principal client and set out the objectives and general briefing and obtain the name of the person on the industrial site who will be the liaison between all parties, then arrange a convenient date for a site visit. Make sure to be cleared through the company security system and take a 35mm or small Polaroid camera along with all the background notes that have been made up to that point. Before entering the

working area, take time to go through the briefing with the site contact and make sure the comprehensive needs of your client are understood by all concerned. Make a list of sub-headings of sites or programmes to be investigated and full safety requirements for each section. Only then ask to be taken through the manufacturing process, preferably sequentially, from base raw material, step by step to the finished product and packaging. Fill out the briefing notes with more sub-headings for each stage and, beneath each, note the available light conditions, type of artificial light, if any, electric plug sites for your own lighting, quantity and type of power available to and distances from the source of power to the area in which photography will be produced, etc. Note all overhead hazards, production line hazards, foot traffic areas if they are near your power cables and also shift-times, regular meal breaks or regular stand-down times. Select several possible camera angles, noting camera height and lighting needs and enter these on the briefing sheet under the respective sub-headings.

After becoming thoroughly aware of the assignment's scope, potential and any pitfalls, return to a quiet office area with your guide and arrange a suitable provisional shooting schedule, noting possible times that you and your equipment would enter a chosen section and when it is planned to depart from it. Have this agreed by factory management before leaving the site. After returning to the studio, re-read the programme, shooting schedule and briefing, giving each item

Modern industry often will require very different pictures from those formerly thought of as industrial photographs. The photographer will be working faster and in a cleaner environment.

new thought in the light of your research and make notes to cover any changes. Only then and not before, call the client to discuss the project and agree a final shooting schedule.

This written schedule, as far as possible, will become a cast iron programme for the actual photography, and from it a full list of equipment, film, special effect needs, back-up equipment and protective supplies may be made. It is vital to maintain the schedule as strictly as possible when work is begun in the manufacturing area. Industrial production depends on split second co-ordination and the presence of a stranger is often an extreme complication, which will have been thoroughly discussed by the people concerned in each section to be photographed and, often, for the sake of a good picture it is common practice to hold back on any spectacular process until the photographer can be there to capture the complete action. Production cannot, however, be held up too long and if the photographer's schedule is not accurately maintained, many preparations are wasted.

For the photographer who is 'in-house' and attached continuously to an industrial organization, much of the research is not needed or will be known beforehand but, whatever the photographer's situation in this respect, it will soon be discovered that industrial photography calls for a multitude of craft skills which must be performed in sometimes hazardous, but always difficult, circumstances.

Small and large cameras are needed, lighting can be by available light, expendable flashlight, electronic flashlight or a

A more conventional industrial subject.

tungsten flood or a combination of these and it will need to be very powerful. A tripod is usually needed and often camera platforms must be made to reach high off the ground. Vibration is sometimes a considerable problem as even a large fork lift truck working nearby can create heavy vibration which will affect slow exposures. It will often be necessary to place the camera in a hazardous position or a hostile environment and it must therefore be protected. Remote triggering by radio will sometimes be useful also. Do not forget to attend to all relevant safety precautions at every work station where photography is taking place.

There is usually high drama to be found in manufacturing, especially in heavy industries, but even in the most mundane operations it is essential to seek a dynamic viewpoint and capture peak action in the illustrations. Industrial photography will require sharp focusing and concentration on form and texture rather than subtlety of tone and mood and the photographer must produce bold compositions, yet these must often be made at great speed.

Apart from acquiring a skilled competence with equipment and processing, it cannot be stressed too strongly that the photographer working in this field must research the industrial process intimately and use careful logistics and written schedules to guide the whole assignment. (See *Large Format Cameras, Lighting, Exposure, Insurance of Equipment.*)

INFINITY

A photographic term expressed on camera lenses by the sign ∞ indicating the very far distance at which, for practical purposes, all light rays reaching the lens are considered parallel and therefore sharply focused.

INFRA RED PHOTOGRAPHY

The invisible area of the electro-magnetic spectrum, just outside the visible long wave red band, contains infra red radiation which will affect special photographic material which can be loaded in conventional cameras. Black and white emulsions either achieve a negative record of self-radiating objects or produce an image by infra red reflection from outside sources. Sunlight is an active source of radiation and outdoor IR photography is much more effective under bright sun, rather than clouds. Indoors, flash or tungsten lamps, provided they are properly filtered to exclude visible light and ultra violet emission, are the usual sources of IR energy. Exposure meter readings can be taken with standard equipment while the IR filters are removed from lamp heads, but photographic tests must be made for final accuracy. The filtered exposure index for daylight is considerably less than that of tungsten light, for example a number 25 Wratten filter with an exposure rating of about 50 ASA in daylight will need 160 in tungsten, while the opaque 88A a rating for daylight of 25 and a tungsten rating of 80. Actual developed tests are essential for assessing exposure indices and filter factors. Normal electronic flash units, filtered to pass only IR radiation are also a good source of illumination especially for colour

Infra red photography can see beneath surface details and this is useful for scientific, forensic or art investigations. These stolen stamps were said to be bought from different post offices by those charged with the theft, but infra red transmission showed a perfect mechanical fit of the perforations and matching watermarks and that therefore they were from the same block of stamps as those stolen. (*Courtesy Scotland Yard Public Information Office*)

photography or when there is any action in the subject.

Filters suitable for B/W infra red work include a Wratten no. 15 (orange), no. 29 (dark red) and no. 88A (black). Special filters exist for improved haze penetration during air to ground photography. Surveillance photography in the dark, requires a source of radiation – possibly an expendable IR flash, which is coated with a special filter and no filter is used on the camera. Small electronic flash units are a good source of IR radiation and could be used with a number 87C opaque filter, possibly in a conventional bounce lighting technique.

In B/W, outdoor scenes will be rendered with dark shadows, black skies and brilliant white clouds and foliage, with considerable haze penetration. There is a slight difference between focus points for visual light rays and infra red, but stopping down to f8 or f11 will generally cover this. The sharpness will not be as acute as with normal B/W emulsions. All high-speed infra red film in cassettes must be loaded into the camera in a darkroom, because IR radiation can evade conventional light trapping on film containers. Unloading the camera also must be done in the dark. Some large-format film holders are not safe to IR energy and it is wise to test these before important assignments. B/W negatives should be processed to a heavy density in a D76 type developer for about ten minutes at 21°C (70°F), in *total* darkness.

For consistent results with colour, IR film must be exposed through a Kodak Wratten number 12 (yellow) filter, either on the camera or over the source of illumination, but experiments are interesting with no. 15 (orange), no. 21 (dark orange), 23A (light red) and 25 (dark red). To achieve a shift toward any desired colour use Kodak CC filters (density 0.10 or 0.20) in the cyan, blue or magenta colours, as well as the basic filter chosen. If developed tests show excess green, add cyan, if too much cyan, add blue to restore reds and if more yellow is wanted from cold or bluish transparencies, add the magenta CC filter, and so on. Testing will be necessary and data should be noted in the log book.

INSURANCE OF EQUIPMENT

Most optical and mechanical items related to photography are expensive and often are once in a life-time purchases by their owner. They are also prime targets for the street thief or house burglar and should therefore be insured. This is not always as easy as is sometimes thought and it may take considerable research to find a responsible insurer who is willing to accept the risk for a reasonable fee. It is sometimes possible to add the camera to existing household policies but each piece of equipment should be itemized carefully with replacement values listed. It is important to update this value annually as under-insurance often draws penalties in the event of a claim. Insurance costs may be lessened by restricting it to cover only the geographical residence such as USA, or United Kingdom, extending cover to other areas as needed for each journey. Whatever policy is written it should be of the more expensive, all risks type.

Professionals must take special care in selecting an insurer as a long working relationship will certainly ensue. If the

photographer loses equipment while on a distant location it will be vital for completion of the job to be able to arrange instant replacement or payment by telephone or telex. This can usually be done only by the few experienced insurance brokers who specialize in this particular area. A well-known insurer, with worldwide facilities, used to dealing with professional photographers is Bayly, Martin and Faye Limited (see *Appendix*).

INTAGLIO PRINTING

A system of image reproduction using recessed, rather than relief, plates to ink the printing paper (see *Photo-Mechanical Printing*).

INTENSIFIERS

Chemical intensifiers are available which can increase negative densities in under-developed or under-exposed material, generally though, not more than three times the original values. At best it is a poor compromise resulting in a general degradation of the image quality. Before resorting to the use of chemical intensifiers, if it is at all possible, re-shoot the subject and correct the exposure or processing. Intensification is somewhat hazardous to a negative and a valuable image should first be printed to the best of your ability on at least two different grades of paper so that if damage or staining is produced on the negative it will be possible to make a copy negative.

It should be noted that many intensifiers contain extremely dangerous materials and they should be stored in locked cabinets. None should come in contact with the skin, particularly those containing mercuric chloride, sodium cyanide or silver nitrate. These chemicals will also prove fatal if swallowed and must be carefully disposed of after use. Always wear gloves when handling them. Many intensifiers do not give a permanent image and some increase graininess considerably. Most intensifiers have a softening action on the emulsion, therefore it is wise to pre-harden the negative, possibly in an alkaline formalin hardener. Kodak and some other manufacturers supply ready-made intensifiers but if it is desired to make up your own solutions you may proceed as follows:

Pre-hardening bath

Formalin	20cc
Sodium carbonate	12g
Water to make	2000cc

Method

Only completely fixed and well-washed negatives should be placed in this bath for a period of three minutes. Rinse in running water for 30 seconds then place in a fresh acid fixer for two to five minutes, then wash thoroughly for about ten minutes.

A single solution intensifier is made up from this formula:

Mercuric iodide	40g
Potassium iodide	40g
Hypo crystals	40g
Water	2000cc

Method

The negative is placed in the dish of solution and rocked gently. A gain in density is progressively apparent and the action is stopped when desired and the negative washed for 20 minutes. This image is not permanent but after washing, the negative may be stabilized completely by immersing it in a 1% sodium sulphide solution or a suitable non-staining developer.

INTERNATIONAL CENTRE OF PHOTOGRAPHY

This is a young and highly noticeable organization based in New York, dedicated to extending and elevating the position of photography as an art form. The practice and appreciation of one of the youngest art forms, yet one of the most popular, is encouraged by major exhibitions of individual photographers' work, travelling exhibitions, both in the USA and elsewhere, plus an education programme enrolling more than 1000 students per semester for workshops, seminars and symposia in very diverse photographic specialities. ICP also offers a portfolio review, where advice, criticism, and encouragement is offered in a practical way to photographers and an enlightened community programme is operated where schools and community organizations are helped towards a practical knowledge of photography and its many-faceted influences on a modern community. This is creating considerable interest particularly for general school students and senior citizens in retirement clubs, who are both main beneficiaries of the programme.

A constantly growing archive of important work by leading photographers with audio tapes explaining their concepts is available to students and researchers and the ICP seems to be an energetic yet stabilizing influence, increasingly important to all who are involved with photography and who hope to see it accept its proper role in modern society. (See *Appendix*; see also *Cartier-Bresson, History of Photography, Lewis Hine, W. Eugene Smith*.)

INTERNATIONAL PAPER SIZES

An internationally agreed series of paper sizes based on an A0 sheet, measuring 1 square metre, which allows the ratio of the long and short sides of the different sizes to remain constant in proportion whenever it is cut or folded in half. Each lower size exactly halves the area as well. Photographers should be aware of the standard sizes of photographic paper in relation to these printing paper sizes (see *Format* and *Paper, Photographic*).

Size	Millimetres	Inches (approx.)
A0	841×1189	$33\frac{1}{8} \times 46\frac{3}{4}$
A1	594×841	$23\frac{3}{8} \times 33\frac{1}{8}$
A2	420×594	$16\frac{1}{2} \times 23\frac{3}{8}$
A3	297×420	$11\frac{3}{4} \times 16\frac{1}{2}$
A4	210×297	$8\frac{1}{4} \times 11\frac{3}{4}$
A5	148×210	$5\frac{7}{8} \times 8\frac{1}{4}$
A6	105×148	$4\frac{1}{8} \times 5\frac{7}{8}$
A7	74×105	$2\frac{7}{8} \times 4\frac{1}{8}$

INTERNEGATIVE

Negatives which are produced at intermediate stages in a process are called internegatives. In making a positive/ negative colour print from a colour transparency, which is a very normal technique in professional laboratories, the internegative is a means of increasing print control and quality. In large magnifications especially from 35mm formats, it is also needed as a partial enlargement. The image is projected up to 9 × 12cm (4 × 5 inch) or larger and then this negative is used with further magnification to make the final print. A copy *negative* of a colour negative may be made on *positive* colour transparency duplicating film, keeping the colour saturated and relatively dense. The loss of quality is considerably smaller by using this method (see *Copying*), rather than making a print and then a negative of that.

In B/W photography, large prints and especially murals, being made from small negative formats, must be partially enlarged onto an intermediate negative and this is best done by the use of a direct reversal procedure such as is possible when using Kodak Direct Duplicating Film so-015.

INVERSE SQUARE LAW

It is a physical law that light reaching an object from a given point will be *increased* if the distance is reduced or it will be *diminished* if the distance is increased, but the variation is according to the square of the distance, not according to the linear measurement. Thus a light placed four metres from a subject will be illuminating it with only $\frac{1}{16}$ of the amount of light from a similar light source one metre away. The theory holds precisely true only for small, specular lights for narrow beam reflectors, but large variations of distance will require this calculation whatever the character or size of the light source (see *Lighting*).

IRIS DIAPHRAGM

This is another name for the controlling mechanism in the lens which selects the f stop to admit a given quantity of light (see *Aperture*).

The International Center of Photography maintains a considerable presence in North American photography. This picture of Cambodian refugees by Burk Uzzle, *left*, was exhibited at their New York exhibition center in 1979. (*Courtesy International Center of Photography*)

KELVIN SCALE

This is the notation suggested by Lord Kelvin, a British scientist who lived through the early development of photography and died in 1907, and is a scientific unit of temperature measurement which can be related mathematically to the Celsius scale. Photographers require knowledge of the Kelvin unit as it relates to *colour temperature*. The abbreviation is written as a number followed by capital K, thus: daylight colour film is balanced for a light source having a colour temperature of 5500K and tungsten colour film is balanced at manufacture for 3200K (see table accompanying *Colour Temperature*).

KERTÉSZ, ANDRÉ (1894–)

When he was barely 18 years old, Kertész was using his camera in his native country of Hungary to produce shrewdly observed photographs which today still have infinite charm. He was involved in the 1914–18 war, taking his camera to the front but did not choose to photograph the horrors of war. Instead he made images of undistinguished participants in 'little happenings', and this has characterized his work ever since. By 1925, encouraged by modest success in exhibitions and magazines, he decided to move to Paris. Here he photographed among the artists and writers, always seeking the documentary element in his nearby environment. Since 1928, when he began using the Leica, he has been concerned with the 35mm format and is an acknowledged master with this camera. In 1933 following a month of intensive work he produced a famous set of distortions of the nude figure, but did not persist in this area. It was never published, but is remarkable for its anticipation of the work of Brandt and some of the work of US photographers in the 1960s.

His natural style has always been suited to the revelations which can be made by the unobserved observers who carry these unobtrusive little cameras and, in his long life, he has brought us richly detailed, sometimes slyly humorous, visual anecdotes from the many little happenings in his experience. He has exhibited widely, particularly since the late 1960s and his work is keenly sought by collectors.

KEY LIGHT

The main light falling upon a subject and the one which establishes its form, texture, character and mood (see *Lighting*).

a

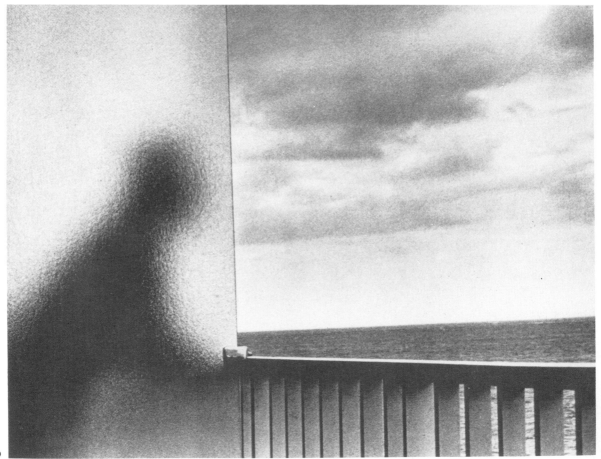

b

188

KIRLIAN PHOTOGRAPHY

Although Walter Kilner, an English scientist, wrote convincingly in 1912 of his ability to see the human aura through special di cyanine lenses, it was not until 1939 that the Russian husband and wife team, Semyon Davidovich and Valentina Kirlian managed to photograph something which they described as the aura. For more than a decade these two scientists then led the world in experimental photography of what was in fact a corona of energy, sometimes called bio-electric energy, which is discharged from organic subjects under the influence of a high voltage, high frequency electrical field, which creates a curtain of ionized air in the immediate vicinity of the subject.

This corona has been shown to alter in appearances in relation to the health of the human subject or the organic development of living substances and recently successful diagnostic experiments have been conducted, particularly in Italy, the USSR and the USA, using electro-photography such as the Kirlians pioneered, to record the results. There is also growing world interest in the techniques of Kirlian photography among parapsychologists who are convinced that psychic energy can be made visible by this method.

Two techniques may be used to photograph the corona discharge. The first is expensive and potentially extremely dangerous, requiring that the object to be photographed is placed in a darkened room and activated directly by a very high tension current. The subsequent discharge of energy is photographed by a normal camera. Because of the hazards and expense, this method is rarely used and a Kirlian photograph is usually made by applying high tension voltage to one or two flat electrodes, arranged like a capacitor (see fig.).

The image can be rendered on photographic materials which are sensitive to colour, B/W, infra red or ultra violet sources. The discharge effect remains stable with most inanimate objects but will vary considerably in living substances particularly if the same living subject is photographed at different intervals. The system requires a means of accurately controlling the time of the exposure and also a stabilizer to prevent current fluctuations. Exposures are often best at about one minute duration and results are usually particularly good when positive colour paper, such as Kodak R14 is used. During such long exposures the gas, ozone, is given off and live subjects will be subjected to mild electric shocks.

Those who have little skill in the use of electricity or electronics should not experiment with Kirlian photography in a serious way but for the purposes of pleasure could use Kirlian camera kits, such as those sold by Edmund Scientific Company of New Jersey. (See *Appendix* and the colour plates for *Colour Photography*.)

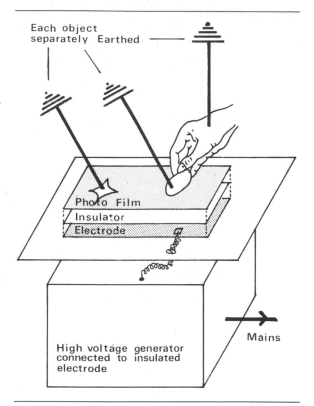

Diagram of typical Kirlian equipment.

Labels: Each object separately Earthed — Photo Film — Insulator — Electrode — High voltage generator connected to insulated electrode — Mains

KLEIN, WILLIAM (1928–)

Klein worked as a painter in Paris in close association with Fernand Léger. Much of his work was commissioned by European architects and he had a number of successful exhibitions. His interest in photography was awakened in the early fifties and in 1955 he was given a seven year contract by *Vogue* in the United States. A few years after this expired he left still photography and concentrated on cinematic and video images, making notable contributions in this field and, in the late seventies, began again to be interested in still photography being featured in an exhibition at the Museum of Modern Art in New York. He has published a number of books on the life of cities including New York (1955), Rome (1956), Moscow (1960) and Tokyo (1961). His sometimes aggressive documentary images can be a startling departure from the accepted docility of much of contemporary photography in this particular field and his volatile style is one of the most unique in evidence today.

KODACHROME

Invented in 1935 by two Americans, Mannes and Godowsky, both film making and processing techniques have been improved by Kodak over the years. This is a positive (reversal) film of great acutance and rich colour quality. Available in slow 25 ASA and medium 64 ASA speeds, exposures are made

Left A master photographer such as André Kertész will often change his approach as his life unfolds, but each image will belong always to an indentifiable style. These were taken in 1917 (a) and 1972 (b). (*Courtesy André Kertész*)

with daylight or electronic flash. This film, designed for the amateur market, is beloved by professionals. The film is more stable under adverse storage conditions prior to exposure, and considerably more stable in an archival manner, than many other colour films after processing. It is not possible for it to be self-processed and it should be sent to Kodak in the country of residence for development. Excellent prints from this material can be made from a positive to positive process such as Kodak R 14 or *Cibachrome* and the film, once available in professional sheet film sizes, is now sold only in miniature and sub-miniature formats of 35mm, 126 and 110.

KODACOLOR

This is a very reliable negative colour film made by Kodak, popular with many amateurs and made in speeds of 80 ASA, 100 ASA and 400 ASA. It provides excellent colour prints when printed on any negative/positive colour print material and B/W prints can easily be made on Kodak Panalure paper.

KODAK LIMITED

The British and European subsidiaries of the *Eastman Kodak Company*.

KODALITH

An easily processed B/W Kodak high-contrast film of reasonable camera and enlarging speed, useful for graphic and special effects (see *High-Contrast Materials*).

LAMINATING

This is mechanical process where a thin, clear overlay of PVC film or other plastic is bonded directly in contact with the surface of the print. The hot process can sometimes be destructive and often ages rapidly with a yellow cast appearing in the PVC. More satisfactory is the cold pressure process such as that of 3M, where self adhesive film is rolled on under pressure. Neschen of West Germany (see *Appendix*) make a very suitable 99% clear, non-yellowing film with a totally neutral pH and therefore unlikely to affect the photographic process. Lamination films can be obtained in glossy, matt, or textured surfaces. It has been noted by some photographers that laminated photographs, shipped by air in unpressurized cargo holds, sometimes arrive heavily crazed or with a milky pattern obscuring the image. Removing thin film so damaged usually destroys large areas of the print emulsion.

LAND, DR EDWIN HERBERT (1909–)

One of the few modern pioneers in photography, making brilliant, practical contributions and dazzling theoretical research in the field of instant photography and colour vision. Land, an American, devised the first polarizing material in plastic sheet form, using microscopic crystals embedded in the surface to produce the effect. He made the world's first instant camera and dry print process in 1947 and the first instant colour system in 1963. He set up the Polaroid Corporation to make and market these products and the company has proved an effective mainstream influence on both the professional and amateur photographic markets. (See *Polaroid Corporation*.)

LANDSCAPE PHOTOGRAPHY

Photographing the sweeping magnificence of nature is largely a meditative matter and also one for large format cameras. A certain style, dependent on impressionistic, moody or starkly graphic structures may make it possible to use medium or small format cameras, but the classic landscape image will require the use of a large format camera, at least 9 × 12cm (4 × 5 inches) and the solution of the attendant problems that this field use of a large tripod mounted camera seems to produce.

The ultra-lightweight wooden cameras which are produced by Japanese manufacturers, the lightweight but robust Arca-Swiss camera, the dependable Linhof and the un-

beatable, rugged Speed Graphic of former times, are all excellent field cameras, albeit delicate and susceptible to damage on harsh locations. A common factor to these cameras is that they have large bellows areas which can, when exposed to gusty winds, produce considerable unsharpness. A wind shield is easily made (see fig. below), from cardboard or thin aluminium and shutter speeds should also be kept as high as possible in windy and unstable situations.

Other equipment which the landscape photographer will use includes a sturdy, but reasonably lightweight, tripod with a suitable universal head. If a tripod centre weight is used, the tripod can be lighter than usual (see fig. below). A focusing cloth, with some means of attaching it to the camera for windy conditions, will be needed and as many double film holders as can be carried plus a changing bag for field use, a long lens (on 9×12cm (4×5 inches) it will need to be a 300mm (12 inch) lens) with a shutter speed of at least $\frac{1}{200}$ second. Lens hoods are not always sufficient in the intense light of nature unless they are of the compendium bellows type, especially if desert locations are used or if the photographer is working in snowy conditions. It is advisable to make an effective flat folding gobo (see fig. page 192), to shield the lens from flare. Normal and wide angle lenses are sometimes useful, but if only one lens can be carried it should be at least 210mm for 9×12cm format or 300mm for 18×24cm (10×8 inches).

An exposure meter which measures reflected light rather than incident light is to be preferred. It should have a narrow

The historic moment in 1947 when Dr Land first demonstrated a Polaroid negative/positive process, size 20×25 cm, to the Optical Society of America. (*Courtesy Polaroid Corporation*)

Below left A windguard, which folds flat, for the large format camera.

Below right To weight a tripod in windy weather, suspend a plastic bag of sand, rocks or water from beneath the centre post.

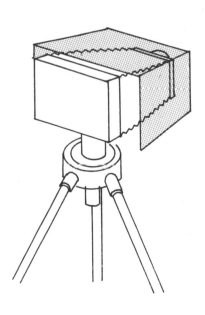

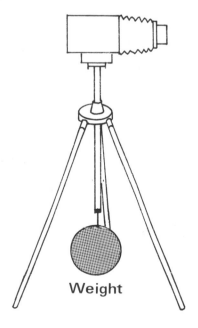

Weight

A folding gobo which is fixed to the camera body with gaffer tape or Bowens clips.

angle of view, 10 degrees or less, and possibly the best instrument for measuring exposures in landscapes is a 1 degree spot meter such as Soligor, Pentax or Minolta make, because very detailed readings may be taken of distant tonal values. It is essential to use a cable release to minimize vibrations during long exposures, to have a focusing magnifier to obtain critical focus and to exactly record all relevant information about each exposure in a field log book.

The landscape photographer also will need a variety of *filters*: a polarizer to darken skies and increase saturation for colour materials, a UV filter to cut through haze, a collection of black and white filters, including yellow-green to lighten green foliage, orange for dark dramatic skies and blue to increase the effects of haze and exaggerate aerial perspectives.

Using such equipment means taking considerable time to select the viewpoint and this can involve much walking, sometimes arduous climbs or precarious camera positions, so all equipment, both personal and photographic, must be in secure, portable and preferably padded shoulder sacks. Nothing should be carried in the hands if the photographer is moving in wilderness areas or mountainous terrain.

B/W films suitable for landscape use are Ilford FP4, Kodak Plus x Pan (ASA 125), Agfapan ASA 100. The characteristics of them all are moderate speed, fine grain, long scale, high acutance with good rendering of shadow detail. Developers suitable for these films used outdoors on scenic subjects are Kodak D76, Ilford ID11, May and Baker Promicrol, Rodinal, Edwal FG7 or Ethol UFG.

Colour film is also best if it is in the slow speed range, 50–100 ASA, and it is worth experimenting with tungsten type films using a Kodak Wratten 85B CC filter to convert the daylight into correct colour balance, whenever exposures longer than one second are called for.

For any colour subjects where engravings are to be made, colour film should never be over-exposed. Shadow detail may easily be enhanced by the scanner, but thin highlights are lost forever. In landscapes it is generally a good rule to under-expose by half a stop. B/W negatives, however, must have suitable shadow detail and these are often over-exposed by half or two-thirds of a stop and development is cut short accordingly (see *Nine Negative Test*). This reduces contrast

and in most film/developer combinations an increased scale of brightness will be seen in the resulting black and white prints. Certain landscapes, where huge forms are present and brightly lit, such as sand dunes or snow-covered mountains, may benefit from considerable under-exposure and long development times in very dilute developer, where agitation is almost totally avoided. Such treatment can produce up to 60 minute development times and tests must be made on film materials of choice. Compensating developers are the most effective or those that use Amidol as a primary developing agent, but consistent results will require a very methodical series of experiments.

Photographing nature can generally be divided into two distinct categories: the close-up, where the natural organic form is explored in sharp detail and the topographical, where distance and semi-distant features are photographed, usually with very long lenses. In either case, considerable contemplation of the subject will be necessary, without even unpacking any equipment. Finding a good viewpoint will take time and it is essential to experience some feed-back from the subject, some excitement. Time must be taken to establish an empathy with the natural forces presented to the photographer.

For the close-up, a long, slow walk in the chosen area will usually disclose several possible viewpoints. A viewing mask cut out in the same aspect ratio as the camera format may be helpful (see fig.). Rhythms must be identified and isolated, patterns which are part of nature's wonderful tapestry must

Make a large black frame in correct format and aspect ratio to correspond with the film being used. Walk about with this viewing frame to select the best position for the camera.

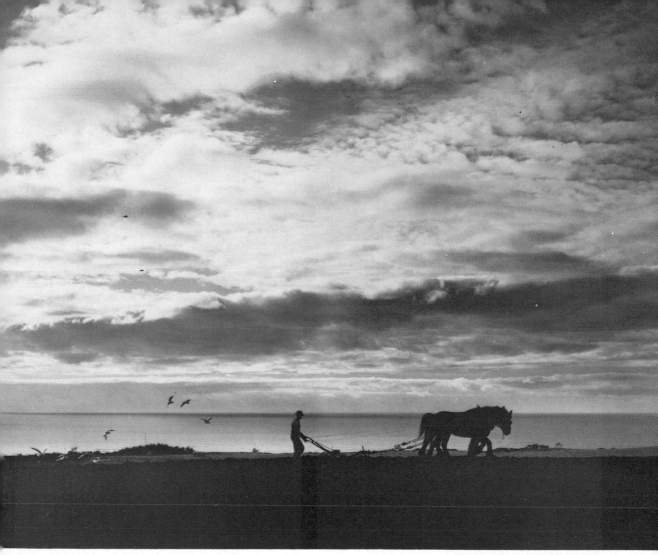

Cloud forms are a vital part of good landscape pictures. An informed use of filters is often needed to record such subjects properly. An orange filter was used here.

be sought out, for it is intuitive for us to seek order out of chaos and simplify any complex visual clues and in the frozen frame of a well executed landscape picture of closely organized natural textures, such patterns and rhythms are certain to delight the viewer.

On such forms the fall of light is of the utmost importance and it may be that once a particular rock, tree or dune has been identified as a suitable subject, the photographer will find it necessary to return at another hour, or even another day, to obtain optimum conditions of light and contrast.

For the more distant landscapes, pattern recedes to some extent and rhythm becomes the structure on which the drama of nature rests. The probing attention of weather and geological activity is more apparent, the scale is more expansive. Contours must be rendered vigorously, which often means waiting for the long, low raking light of sunset or sunrise. Even reaching the viewpoint may take hours and these more remote subjects may require the photographer to

wait many hours in the field for weather, cloud and light changes to intensify the effect, so suitable precautions should be taken to ensure that reasonable, personal comfort can be maintained and that equipment is properly protected while the day passes. Good landscape photography, as has been said, demands a degree of meditation but also considerable practical experience of being there for very long periods.

For the photographer of landscapes it will immediately become apparent that the geometric perspective which is automatically drawn by the lens can be further broken down to include linear perspective, where advancing and receding lines and lateral lines are identifiable in the image, also planar perspective where forms are found on different planes, often overlapping. These different dimensions in the subject may be isolated or suppressed by changing viewpoints and locating the camera at the ideal spot becomes the first task. A further perspective is useful to the photographer of landscapes, that of aerial perspectives, where receding depths gain in highlight values but lose definition. These foggy, bluish, tonal changes were first used by Leonardo to enhance the depth in his distant landscapes, but the camera records them effortlessly and automatically. They can be exaggerated in B/W photo-

Landscape photography in active conditions of weather will produce interesting and different images.

LACQUER
Photographic lacquer is available to spray on the surface of photographs to act as a protective coating but it should not be applied to important or archival quality prints. Most such lacquers cannot be guaranteed to remain totally clear for more than a few years under normal well-lit exhibition conditions and will also begin to yellow even in dark storage.

LARGE FORMAT CAMERAS
A male figure, head plunged beneath a black cloth while standing behind a large and cumbersome box of wood and leather which was attached to a trio of spidery legs, was a familiar sight in the nineteenth century landscape, when large format photography was the only kind available. Today the view camera has changed very little, still being an entirely flexible bodied camera capable of comprehensive swings, tilts, rises and shifts of both its lens panel and film back. Most, however, now use the optical bench principle which is a modern innovation (see fig. below) to permit easy extension of the system, and some of the most advanced now use electronic accessories to increase the practical performance of the camera in professional circumstances.

The large format camera is mostly considered to be a professional instrument, perhaps because the film material is expensive and the ability to use its flexible optical control is only obtained after considerable practice. The accessories needed for such a camera are heavy in weight and costly and it is also normal to find them confined to a permanent studio. Such cameras are usually considered to qualify as large format when they use 9×12cm (4×5 inch), 14×18cm (7×5 inch), 18×24cm (8×10 inch) or rarely, 28×36cm (11×14 inch) sheet film.

A typical modern view camera, made on the optical bench principle.

graphy by the use of light blue or violet filters and in colour by avoiding UV filters and adding desaturation or fog effect filters.

It is an important factor of landscapes that they always relate to human scale and the figure of a person is sometimes included to provide a reference point and increase the illusion of depth. The figure should be relatively small in the image area, anonymous and subdued so that the landscape retains its heroic nature and if possible the person should closely identify, in a natural way, with the scene itself. People who are included in good landscape photography must either be seen to have a right to be there, as in the accidental inclusion of a farming figure, or they must be most carefully dressed and selected for their appropriateness to the landscape if they are to appear as directed by the photographer.

Dramatic compositions of landscapes are always difficult, because of the over abundance of light. Mood is hard to maintain in such conditions. Back lighting on water subjects or mountain subjects, evening light on large land contours and crisp side lighting on snowy scenes are often productive of atmospheric images. Great detail in textures, very sharp edges and flawless technique will always provide a degree of elegance in any image of organic form and when confronted with the awesome patterns and contours of nature, captured and contained within the rectangular image of the beautifully crafted landscape photograph, most viewers will respond with intense pleasure and awareness. (See *Large Format Cameras, Filters, Perspective, Image Management, Ansel Adams, Lighting, Exposure*.)

The optical flexibility is essential for many professional assignments and this is shown overleaf. The nature of the camera and its complexity make it ideal for taking pictures that are highly planned, premeditated and visualized, such as are to be found in still life, product photography or advertising photography. It is not considered to be ideal for use with live models or very mobile situations, but master photographers, past and present, have dramatically proved exceptions to this rule. Wherever the primary design of the image depends on form and texture then this camera should be the first choice. Reliable brand names are Sinar, Arca-Swiss, Linhof, Calumet, Plaubel and Horsemann, while older, wooden cameras obtainable second-hand are Deardorff and Gandolfi, both beautiful and efficient cameras but not built on the optical bench principle. Fixed-bodied large-format cameras, useful for certain special work, are still available second-hand, notably the Speed Graphic and Graflex press cameras and the Linhof and MPP drop bed cameras.

For those beginning with such cameras either as professionals or students, it would be advisable to use the 9×12cm (4×5 inch) format equipped with longer than normal lens, for example a 210mm ($8\frac{1}{4}$ inch) focal length lens, five double film holders, a Polaroid back to fit, a solid tripod and an efficient bellows type lens hood (see right fig.). Processing can be carried out in print developing dishes or in special tanks.

The total optical control which is possible with this camera and the fact that the composition of the picture is reached by selecting and placing of the subject in front of the lens, makes the photographer entirely responsible for what finally is seen in the image. There are no happy accidents. Texture, form and image structure come only when the photographer understands each of them and can place the camera, lights and subject in positions which create them. So the large format

View cameras require elaborate lens hoods to shield lenses and carry filters. Such an accessory improves contrast and definition.

camera, despite its expense and complexity, is an excellent camera for learning about photography and students who enroll for formal training with photographic schools should be very wary of those who do not insist on basic training at the start with large format cameras before switching to fixed body cameras of smaller format.

For those who use these large formats professionally, it will be a matter of mastering the control techniques of camera movements and then securing adequate lighting power and accessories to make working with these cameras an easy, practical and expressive technique, free of tentative habits and which is easily repeated on request. Such cameras and the accompanying craft skills to use them will be essential to the photography of architecture, still life, small products and much of the advertising industry's needs. (See *Lighting, Lenses, Camera Supports, Landscape Photography, Scheimpflug Principle.*)

Where the view camera is used professionally, layout details are often drawn on clear film in correct proportion to the camera format and attached to the focusing screen. This permits very precise positioning of elements in the picture, particularly where they must relate to type matter.

SETTING UP A LARGE FORMAT CAMERA

1 Level the subject.
2 Level the camera.
3 Angle the camera and select the viewpoint.
4 Adjust the camera swing back towards vertical.
5 Tilt the lens panel toward the selected plane of focus.
6 Swing the lens panel laterally toward the main plane of interest.
7 Watch all movements on the ground glass.
8 Make each adjustment fractionally.
9 If total control is elusive, zero all controls to normal and begin again.
10 After the photograph is complete, zero all controls to normal.

Loading film for a large format camera. The notch is kept to the top right hand corner, in order to load the emulsion facing out.

To check the image being received by a large format camera without a viewfinder, it is advisable to check the results with Polaroid before exposing the actual negative. Polaroid can be used as an end result in itself also.

The modern view camera now comes equipped with digital shutter and an exposure metering probe which reads light from the film plane. This Sinar camera is one of the most advanced available. (*Courtesy Sinar* AG)

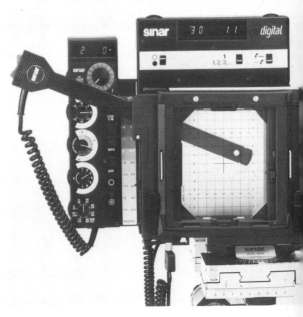

a When the camera is tilted up, perspective is altered and vertical lines converge.

b The problem is corrected by swinging the back of the camera more nearly parallel to the subjects vertical planes.

a When the camera is tilted down, perspective is altered in the opposite way to (a) on page 197, vertical lines converging at the bottom of the frame.

b Using the swing back, the film plane is placed more nearly parallel to the main vertical planes.

a When the major subject plane is horizontal, but is angled away from the film plane, distortion of perspective occurs.

b The distortion is corrected by the swing back, which is placed so that it is more nearly parallel to the main subject planes.

a b c d

Using the swing and tilt movements on a large format camera.
a Camera uncorrected.
b Camera back swung to control horizontal perspective.
c Camera back normal, lens plane swung in direction of horizontal plane to increase depth of focus.

d Camera back is swung to control perspective, lens panel swung to control focus. Both movements are performed while watching the focusing screen.
It should be remembered that to control focus and depth of field, the front of the camera is swung, while to control perspective, the back of the camera is swung.

The large format camera is capable of increasing the normal depth of field by the use of camera movements.
a Camera is focused on point of arrow, no attempt made to improve focus.

b Lens panel is tilted in direction of plane of subject to improve sharpness.
c If the focus point is taken further back, improved overall depth of field will be the result.

a b c

a Camera is focused at arrow point. No attempt to use movements. Very shallow depth of field.

Note To improve sharpness and depth of field use the front of camera movements. To control perspective and horizontal lines, use the back of camera movements.

b Lens panel tilted toward main plane of subject towards a parallel position. Increased depth of field is the result. The film plane has also been adjusted slightly towards the vertical.

LATENT IMAGE

The photographic image is said to be latent because it remains invisible unless subsequent chemical action changes the nature of the metallic salts so that they may be seen. The exposed but undeveloped latent image may remain in suitable storage for many years before final processing, but colour film will begin to alter colour characteristics unless stored at sub-zero temperatures. (See *Basic Photography*.)

LATITUDE

A characteristic of film which allows a limited deviation from absolutely accurate exposure. Colour film and slow, thin emulsion films have less latitude than fast or medium speed B/W films and certain developers can affect this factor considerably.

LEICA

A famous name for an elegant and sophisticated 35mm camera available in rangefinder or SLR modes. The rangefinder camera is much used by photo-journalists because of its relatively quiet operation, small size and dependability. The Leica prototype, built in 1914 by Oskar Barnack who was at the time a 34 year old tool maker with the firm of Ernst Leitz at Wetzlar, Germany, was designed to use the recently introduced 35mm sprocketed motion picture film. Because of World War I it was ten more years before the camera was

a The original Leica 1, of 1924 which went on sale after the Leipzig Spring Fair of 1925.
b The 1980 version of the same rangefinder camera.

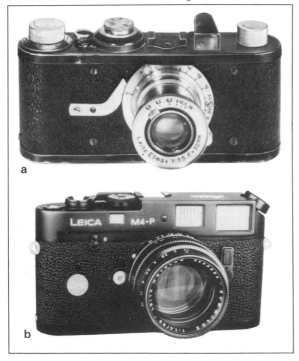

actually marketed, but by using precision, ultra speed lenses and a 'system' of lenses and accessories, it introduced to modern photography for the first time, the concept of a basic body design plus a range of organized attachments. With the arrival of this camera, a huge boost was given to documentary, journalistic and available light photography. The company products still rank among the top in the industry.

LENSES

Light travels in straight lines from every point source of visible electro-magnetic energy and only when the pathway is interrupted does this behaviour change. Light entering a glass object slows down and alters direction. If the glass object is a lens, made of sections of spheres compounded together in an arrangement decided upon by the optical designer, the ray is bent towards the lens axis (see fig.) reaching a point of best focus at a predetermined place within the camera, at which place light-sensitive material is held flat to receive a sharp image.

Lenses are, therefore, collectors of light rays and depending upon their sophistication, they will image any object in geometric perspective and with sharp edges and in colour. *All lenses have inherent faults.* At the most open apertures where they pass considerable quantities of light they display faults known as aberrations which are found in all lenses, but these only show up in cheaper optical equipment to a point where they are noticeably a nuisance. When a lens is used at very small apertures, loss of sharpness occurs also, this time due to diffraction, and it will be found that lens types have a zone of best definition usually in the f4 to f11 range for small format cameras and f16 to f32 in larger formats. Lenses also have a best performance distance, and on studio cameras this is often about ten times the focal length or less while on smaller cameras it is about 40 or 50 times the focal length upward to infinity. Small cameras are supplied with special lenses for focusing on nearby objects of 20 times the focal length and closer, particularly if 1:1 macro images are to be made at their sharpest. Expensive lenses are designed and tested to behave well in most circumstances and it pays to obtain the finest quality optics affordable, especially for small cameras. Names such as Leitz, Zeiss, Rodenstock, Schneider, Nikkor, Zuiko, Rokkor, Vivitar and Ektar, can certainly be trusted.

Lenses are measured in focal lengths and this is the distance from the rear of the lens to a plane of sharp focus, when the lens is focused on any object standing at infinity or which subsequently is imaged in the camera at life size or a ratio of 1:1 (see fig.). For the camera to perform adequately this focal length must at least equal the diagonal of the film format (see *Format*), otherwise unsharpness will be evident at the edges of the image.

All lenses have an angle of view and these can be used to take in a wide sweep of the subject, but with objects appearing smaller than normal on the negative, or they can be of narrow angle, isolating the subject or part of it and increasing its size on the negative (see fig.). Shorter than normal focal length lenses are called wide angle, and longer than normal, taking a very narrow view, are called telephoto. Altering the

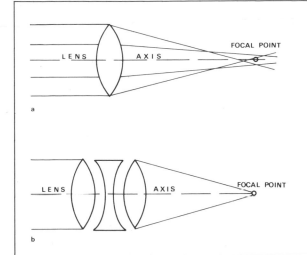

a A simple lens does not bring all light rays to coincide with the focal point for sharp focus.
b A complex lens brings all light rays to focus sharply on a point of sharp focus.

A typical multi lens system, in this case the Zeiss s-Planar 60mm lens for 35mm cameras.

focal length changes characteristics of the image, but does not change geometric perspective *unless the viewpoint is also moved*. Characteristics which are radically changed include spatial separation, size constancy and depth of field. (See *Image Management, Perspective*.)

Special lenses

Certain lenses usually designed for 35mm SLR cameras are designed for special effects:

Zoom lenses are variable focal length lenses usually with a moderate wide angle 65° to moderate-narrow angle of 29°, or normal angle 45° to telephoto 15°. The best of them have a single sliding collar to alter both focal length and focus simultaneously and many may be focused from infinity through to extremely close macro distances, giving half life-size images on the format. Zoom lenses are useful for volatile situations, sports, children or action photography, where no

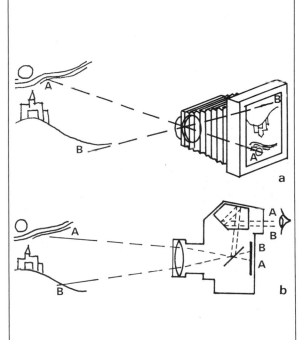

Above This is a diagram of how the single lens reflex (SLR) camera works.
a Light travels in straight lines A to A and B to B, therefore the image is inverted and is seen in the camera upside down.
b Modern small cameras use a system of mirrors in the viewfinder to turn the image right way up, but the *film* receives the image still upside down.

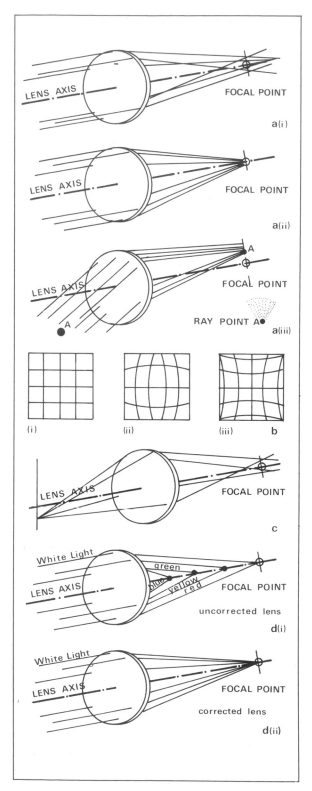

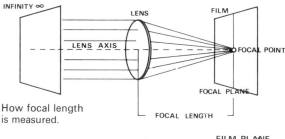

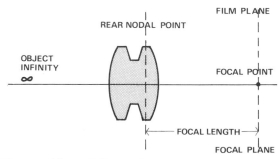

Left **a** (i) Uncorrected spherical aberration does not focus all rays of light at one coincident focus point. This is a common fault in cheap lenses.

(ii) Corrected spherical aberration focuses all rays near or at a common point. Stopping down improves any image suffering spherical aberration. For all critical view camera work, focus with lens stopped down as no lens can be made perfectly free of faults.

(iii) Coma is a form of spherical aberration where point sources which are oblique to the lens axis are refracted to slightly different focus points as they pass through different zones of the lens, making a point appear with a blurred trail. Stopping down can improve this defect.

b Curvilinear distortion does not affect definition of the image, but the shape. (i) Normal object, (ii) with barrel distortion, (iii) with pincushion distortion.

c In astigmatism, image points farther from those central to the lens axis are not brought to a coincident focus point in the camera, resulting in unsharp edges to the format which are not improved by stopping down.

d In chromatic abberation, when light enters a lens, each wavelength or colour is refracted at a different angle. Shorter (blue) waveforms are refracted most and focus further from the film plane, longer (red) rays focus more nearly on the focal plane.

(i) An achromatic lens is compounded from convergent and divergent glass types and allows blue and green (shorter) rays to coincide.

(ii) An apochromatic lens is compounded from several elements to allow all colours to be focused together and is more suitable for critical colour work. Stopping down improves deficiencies due to chromatic aberrations. Each aperture decrease (larger number) has half the area and reduces light reaching the film by one half. Moving to smaller numbers doubles the amount of light reaching the film.

How focal length is measured.

When an object at infinity is focused at its sharpest on the film plane or focal plane, the distance from the rear nodal point to the focal point, measured along the lens axis, is known as the focal length for that lens.

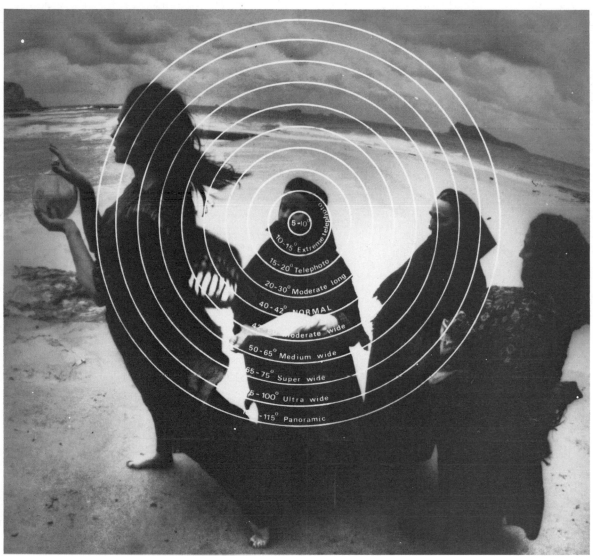

Angle-of-coverage comparisons 50- to 15-mm

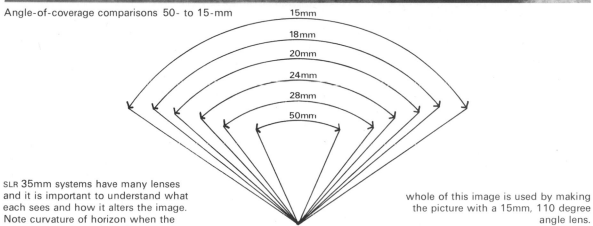

SLR 35mm systems have many lenses and it is important to understand what each sees and how it alters the image. Note curvature of horizon when the whole of this image is used by making the picture with a 15mm, 110 degree angle lens.

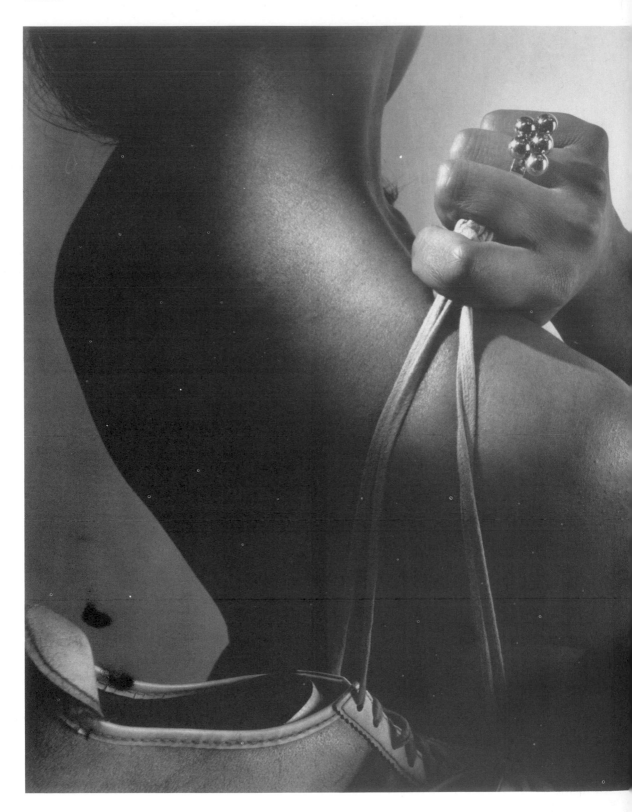

extremely long lenses are needed and are also useful for special effects (see fig.). It is rare that zoom lenses will equal the optical quality of fixed focus lenses for critical work and their weight is usually considerably more in comparison to standard lens types. Excessive internal lens flare is sometimes a contributory cause of poor definition in zoom lenses. They can be very useful for portraiture in a studio, where maximum lens definition may be disadvantageous.

Perspective control lenses allow the front half of the lens to shift in parallel to the film plane, giving it one attribute of the view camera and allowing lateral and vertical shifts to help avoid distortions and converging angles, which occur when the camera is aimed up or down or is displaced right or left of a subject.

Variable curvature lenses act rather like the eye, and for

Left Although wide angle lenses distort forms unnaturally, this fact can be used creatively to make startling new images for editorial, art or advertising purposes. Here a Hasselblad 40mm lens has been used to make a dramatic sculptured shape for a jewellery advertisement.

Below Zoom lenses are designed to provide multiple lengths in one lens. By using slow shutter speeds while zooming, interesting effects of movement can be obtained as in (b). This is especially effective in colour but remember that the camera should be on a tripod.

Above A super wide lens of more than 100 degree angle of acceptance usually causes barrel distortion in any near straight line subject matter, but distant horizons may be acceptably level if the camera is carefully aligned.

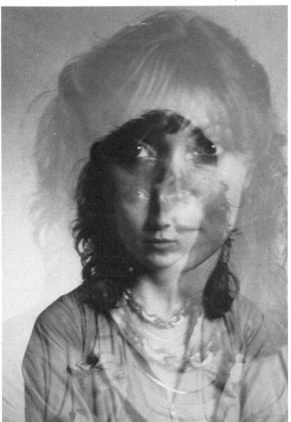

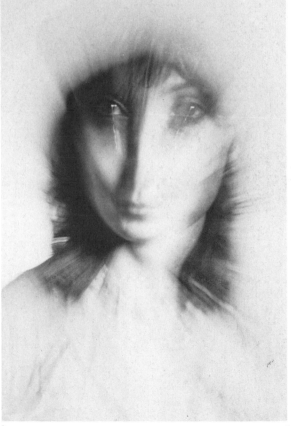

a

b

wide angle situations allow the edges of the lens to be curved to increase focus and decrease distortion.

Tilting lenses allow the front element to be tilted in the manner of a view camera so that focus can be increased by the *Scheimpflug* effect.

Lens converters The primary lens on the camera may be changed by adding a positive or negative lens to alter the effective focal length, either to produce a wide angle or a telephoto image. Definition when using these attachments is significantly less than optimum when compared to similar focal length complete lenses, but matters can be improved by stopping down to f8, 11 or 16. Converters should be obtained specifically for each lens type and make, preferably from the lens manufacturer.

Supplementary lenses These are usually positive, of a single element and are screwed into the front element of the primary (camera lens) to permit macro focusing on close-up subjects.

Extension rings are not lenses in fact, but tubes of different lengths which extend the primary lens so that close focusing on macro subjects is possible. Image quality is better than with most supplementary lenses, particularly if longer than normal primary lenses are used with such extenders. (See *Close-up Photography*.)

Flat field lenses These are made to focus critically on flat surfaces from edge to edge which are close to camera and are therefore suitable for copying or enlarging.

Mirror lenses These are compact telephoto lenses of very long focal length usually with fixed apertures which have internal mirrors to reduce the size and weight of the lens (see fig. on opposite page).

Process lenses These are apochromatic lenses, corrected so that all colours focus at one point and are used in copy cameras, photo-litho cameras or studio cameras where maximum colour correction and definition is required.

Buying a lens is a matter of spending as much as is affordable to purchase the optical equipment corrected to the degree

When the focal length is changed, the image is reduced (wide angle) or magnified (telephoto) giving the effect of a change in camera-to-subject distance, even though the camera does not move. This example is for 35mm, comparing changes with a normal 50mm lens at 15 metres (50 feet).

Lens length	Magnification factor	Apparent distance (in metres)	
21mm	.42X	36 (120 feet)	
25mm	.5X	30 (100 feet)	wide
28mm	.56X	27 (90 feet)	angle
35mm	.7X	21 (70 feet)	
50mm	1.0	15 (50 feet)	normal
85mm	1.7	9 (30 feet)	
105mm	2.1	7.5 (25 feet)	tele-
135mm	2.7	5.5 (18 feet)	photo
250mm	5.0	3 (10 feet)	
500mm	10.0	.75 (30 inches)	

required. Expensive lenses from reputable makers tend to operate at maximum or minimum apertures with the least noticeable defects while cheaper lenses will behave best when used stopped down to mid-range. Colour and contrast is noticeably different from maker to maker, with more contrast usually seen in West German lenses and slightly warmer colour often to be found in the Japanese lenses. All lenses should be camera tested before final purchase if possible, unless the seller provides a service. It is advisable to test at least two of the same focal length before choosing.

For care of lenses, see *Camera Care*. (See also *Perspective, SLR Cameras, Large Format Cameras*.)

NEGATIVE FORMAT AND ANGLE OF VIEW⁺ FOR METRIC SIZES AND OTHER USUAL SIZES

35mm	6 × 6cm (2¼ × 2¼ inches)	6 × 7cm	9 × 12cm (4 × 5 inches)*	13 × 18cm (5 × 7 inches)*	18 × 24cm (8 × 10 inches)*
16mm=98°	30mm=90°	30mm=98°	45mm=112°	65mm=115°	90mm=115°
21mm=81°	40mm=74°	40mm=82°	65mm=85°	90mm=90°	120mm=90°
25mm=72°	50mm=62°	55mm=65°	90mm=67°	120mm=74°	150mm=77°
28mm=65°	75mm=44°	75mm=50°	165mm=40° †	210mm=46°	270mm=48°
35mm=54°	80mm=41° †	90mm=42° †	210mm=32°	240mm=41° †	320mm=41° †
50mm=40° †	150mm=23°	150mm=26°	240mm=28°	270mm=37°	360mm=37°
85mm=24°	250mm=11°	250mm=18°	320mm=21°	320mm=31°	540mm=25°
135mm=15°	500mm=6°	500mm=8°	360mm=18°	360mm=28°	720mm=18°
200mm=11°	800mm=3°	800mm=5°	540mm=12°	540mm=18°	1000mm=14°

+Angle of view is here considered to be based on the long dimension of the format, not the diagonal.
*UK and US equivalent inch size. Give increased angle for all lenses listed.
†Normal lenses.

The mirror or catadioptric lens.

LETTERPRESS PRINTING

This is a relief process where the photograph is converted to a dot screen image on a metal plate. Highlight areas are seen, under magnification, to be tiny dots of black ink on white paper while shadow areas are formed where dots of clear paper break up a dark surrounding area. This is the half tone image which makes the reproduction of photographs possible in books, magazines and newspapers. (See *Photo-Mechanical Printing*.)

LIFE MAGAZINE

A famous American general interest magazine born in November 1936, renowned for the generous and intelligent use of photographic picture stories. They were responsible for nurturing many famous photographers, particularly those arriving from Europe during the exodus prior to World War II. Their sponsorship of rich experiment by these documentary and avant-garde photographers contributed much to the evolvement of modern world photography. Important photographers on their staff at one time included Larry Burrows, Margaret Burke-White, Robert Capa, Douglas David Duncan, Alfred Eisenstaedt, Eliot Elisofon, Ernst Haas, Gjon Mili, Lennart Nilsson, Gordon Parkes, George Silk, W. Eugene Smith, and Burke Uzzle and they have featured many photo-essayists whose work has become a seminal influence on photographers of the present day.

LIGHT

Light which is visible is part of a long spectrum of radiant energy (see fig. below), and itself may be split into a spectrum of ten colours; violet, blue, blue-green, green, yellow-green, yellow, yellow-orange, orange, red-orange and red. In a vacuum, light travels at 299,783km (186,282 miles) per second. In air it is a little slower, and when it is refracted by absorption into a translucent body it slows down further still. When it emerges from such a body it resumes its original speed. It is probably nature's most absolute energy phenomenon.

Light is emitted as charged particles of energy, called photons, which by changes in speed and direction create very narrow wave forms which, although travelling in straight lines, oscillate minutely. It is measured in units called a nanometer (nm) which is equal to 1,000,000,000th of a metre. The red end of the visible spectrum has wavelengths in the vicinity of 700nm and the cooler, bluish colours about 400nm. For photographers, notice must also be taken of long wave, infra-red radiant energy and the short wave, ultra violet and x-ray areas of the electro-magnetic spectrum, as these also affect photographic material.

Light may be reflected, absorbed or transmitted. If they are *reflected*, those rays returned to our eyes as they bounce off the object are seen as colours. Light energy which is *absorbed* is changed to heat energy and most *transmitted* light will pass through any transparent object. The sum of the reflection,

The visible spectrum and the electro-magnetic spectrum.

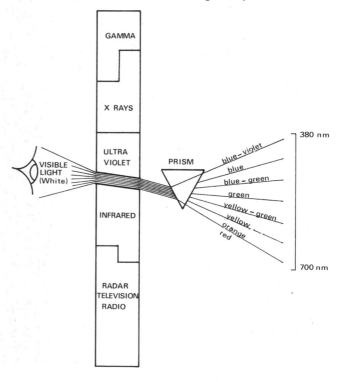

absorption or transmission of light energy equals the original incident output from the source after it falls on an object.

The eye contains in the retina three cones each receptive to one of the red, green or blue wave forms. The brain responds to these signals to identify such incoming light energy as colours and thus light becomes visible (see *Vision*).

Photographic film responds to light energy in pre-determined ways and by changing the density of the silver halides embedded in the emulsion, selective areas of spectrum will activate the material and form an image.

Certain line films are sensitive for example only to blue, but orthochromatic emulsions exclude red sensitivity, while panchromatic and colour films respond widely to most colours. By using the transmission and absorption characteristics of *filters*, this sensitivity can be changed at will by the photographer during exposure.

Light for photographers may be categorized as follows:

Natural existing light Light emanating from the sun but it can be direct with hard shadows, or reflected, diffused by cloud, coloured by the sky or combinations of these. It is an abundant, desirable light source.

Artificial existing light Light reaching the subject from a fixed, existing form of incandescence which the photographer uses without augmentation or modification. It is by nature usually low level, requiring high film and processing speeds.

Fluorescent existing light A cool, fixed, overhead artificial light, often diffused. Such fixtures emit a discontinuous spectrum and special filters are needed to photograph in natural colour when using this source.

Photographers' tungsten light Controllable, very bright usually portable light from a source especially made for photography, precisely designed to emit warm light at a level of 3200K which matches the balance of type B film. This is a continuous source of emission.

Photographers' flash light Small, portable, very powerful, usually of daylight colour and often harshly specular in character. Such lights give an instant source of emission.

Existing light may be direct, diffused or reflected by nature. Photographers' light must be direct, diffused or reflected by the choice of the photographer. (See also *Basic Photography*, *Filters*, *Inverse Square Law*, *Lighting*, *Photography as Seen*.)

Left The contemplation of the fall of light will help the photographer who must use it as the major creative tool. Natural light behaves in an ideal and absolute manner and is one of the few constants ever to be discovered by scientists. (*Courtesy Agfa-Gevaert* AG)

LIGHT LOCK

A construction in the darkroom wall to permit easy entry and exit without letting in light. It is also necessary to construct small light locks to allow ventilation (see entry under *Darkroom* for illustrations of this).

LIGHTING

Light is a law of nature, one of the most absolute. It may be reflected, absorbed, diffused, deflected, refracted, its visible colours transmuted, its waves collected or dispersed, but it moves inexorably in space according to an ageless, undeviating law at 299,783 km (186,282 miles) per second.

It is possible for the photographer who understands light and the fall of light, to reveal form, establish mood, disclose texture and to suggest dimension, volume and space all within the limitations of a two-dimensional medium. For this, an awareness of light must be developed and practised until it becomes intuitive. A comprehensive skill in this field could take six months of steady learning.

The contemplation of light and the magic of its revelations can best begin outdoors, in nature, watching the sun and the shadows it casts as it embraces the organic substance of the living world. For the illusion of dimension, light and darkness is required. The positive highlights, drawing the edges and contours of an object, will always have a matching negative: the shadows which are needed to complete the tactile experiences of our mind's eye. The shadows disclose the nature of the light source, its size, distance and direction. Always watch the shadows.

Take a common object, say a cheap teacup, to a point where the unobstructed sunlight can reach it. Set it up at breakfast time when the light is at a fairly low angle but crisp and clean, observe how form is revealed. Watch it again at noon and note the change in the intensity and direction of the shadows, the diminution of spatial volume within the cup. Go once more at evening, well before sunset, and note how texture is revealed by the long, low cross light, observe the change in mood, the strong rendering of three dimensional form and volume. Take the cup early, before sunrise, to the same spot and watch the rising sun bring to life the lifeless object.

Notice the subtle difference in mood from evening light, even though the angle of light is much the same. When the sun is overcast, place the cup once more in the same position. Be aware what this diffused light does to the shadows, volumes and surfaces.

Think about what you have seen. Only after this exercise go once more, but this time with the camera loaded with black and white film and record the teacup as the day passes. Make 18×24cm (8×10 inches) prints of the result and keep them as reference. In future, at any time when it is possible, take a quiet, long look at the living earth under the rolling, revealing touch of natural light.

The first lesson which may be learned from this meditative exercise is that the position of the sun in relation to subject and camera can easily be identified and given some kind of notation. Sunrise and sunset could be a back light, morning and evening a cross light, noon a top light, 3.00 pm a top back light, and so on.

Formalized lighting positions follow a theoretical hemisphere (see overleaf), with the camera on the equator and the subject level with it but at a central point. These are the key light positions, named as: left or right cross light, top centre, top back, top front, top side, back light and three others not found in nature – grotesque lighting from below the level of the subject, axial lighting which is light beamed directly along

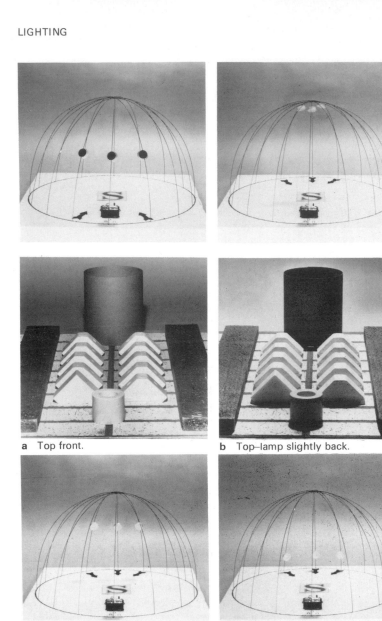
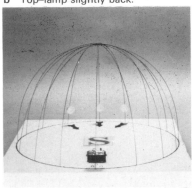
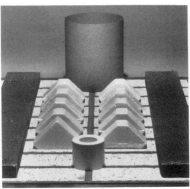

a Top front.

b Top–lamp slightly back.

c Top–lamp slightly forward.

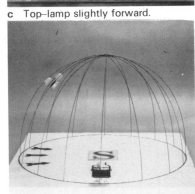

d Top back.

e Back.

f Top left.

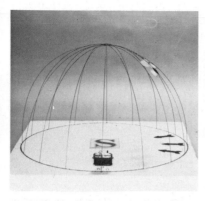

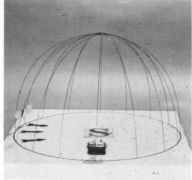

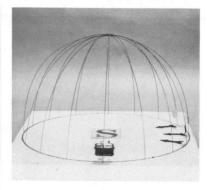

g Top right.

h Side left.

i Side right.

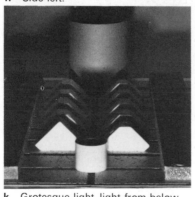

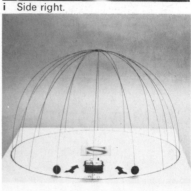

k Grotesque light–light from below the horizon.

l Copy light–equal intensity of light from each side of camera.

j Axis light–light along the lens axis.

In placing the key light, consider that a hemisphere surrounds subject and camera, note the basic key light positions and the effect which such a position has on separation, texture, form and volume.

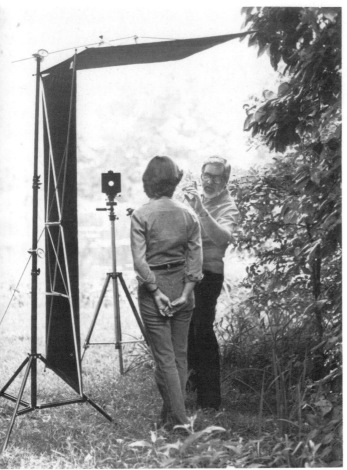

Working with daylight often becomes a matter of subtractive lighting plans where the abundance of daylight must be controlled by dark screens. Larsen Enterprises make the Reflectasol range of portable equipment which is ideal for the purpose. (*Courtesy Larson Enterprises*)

the lens axis and copy light coming equally from either side of the lens.

The key light establishes mood and primary dimensions and is the main light source. It can be harshly specular in character as from strong tropical sunlight, casting deep, sharp shadows; or broadly diffused as that which falls from a bright overcast sky, rendering glossy textures at their best and shadows in a soft-edged, open grey.

Many photographers will choose to work with daylight, where it often becomes a subtractive process of controlling an over abundance of light. If the forms are too open and mood is lost, a negative black reflector can be used to deepen the shadows (see fig. above). If strong, cast shadows are confusing or mask important areas, a white reflector will restore a natural balance. The main problem for the photographer using available daylight is that it is constantly changing in position and sometimes in intensity. When daylight is the key

light the photographer must act quickly to preserve the best moments on film.

It is always far easier and quicker to establish mood by using available light, as we all have a subliminal intuition in interpreting anything seen by natural light. It is necessary for the photographer who wishes to make precise use of natural light to visit each location at the time of day thought best, watch the light, consider the mood, note exactly the time when all factors are ideal and return next day for the actual photography, hoping for similar conditions.

Daylight, of course, has inherent colour characteristics and these can complement and enhance mood considerably. Morning light is fresh and a little yellow; noon light is clear white and neutral; evening sunlight is gold, tending towards red, but shadows are distinctly blue. The photographer would find it a lengthy business to recreate these subtle shifts of colour in the studio with filters.

Experienced photographers, particularly the professionals, will learn, however, to construct elaborate lighting plans in the studio so that photography may be carried out irrespective of weather or time of day, but it is not of course a haphazard affair. Key lights should be placed in the same positions as learnt whilst watching the sun move through its hemisphere. Zones of cross, back, top, top back, top front, top side, grotesque and axial lighting must be established according to need.

Artificial light is different in colour (see *Colour Temperature*), and subtly different in behaviour from daylight, but in the hands of a master photographer is perhaps capable of more finesse if the subject is not too large. Artificial light can be created by incandescent or tungsten lamps which contain much red and yellow light or alternatively by flash, either of daylight quality bluish light or yellow-white. Flash is either an expendable once only lamp or electronic and re-usable and of daylight quality, giving thousands of flashes.

Whatever the source of artificial light, manufacturers have produced a wide variety of reflectors which radically change its character (see fig. page 216), and these give the photographer wide scope for skilled rendering of form, texture, mood and spatial values.

Lighting plans in a studio are built up in an additive manner, the key light is placed first to establish a definite priority of lighting direction and to cast a shadow of the required size, tone and edge. Ancillary lights or reflectors are added to restore detail to shadow areas, these are the fill lights which must never become obvious or equal to the intensity of the key light and must never produce their own secondary set of shadows. To emphasize individual elements in the subject, accent lights are placed, again supportive to the key light. These could be lights on the hair to give it texture and life, a 'catch' light to bring expression to the eyes or a 'chisel' light to delineate and sculpt the profile (fig. page 217).

Whenever multiple light sources are used, a definite hierarchy must be established with the key light as the dominant and only discernible light source. One set of incident highlights, one set of cast shadows.

The function of the lighting plan is to disclose the photographer's concept and establish a response to the image

Correct lighting of an object in the studio by artificial light will have these elements showing in the finished print.

A Background light against dark

B Background in transition

C Shadow side with detail

D Cast shadow, darkest area in picture

E Highlight

F Incident highlight

G Background dark against light

H Lighting core

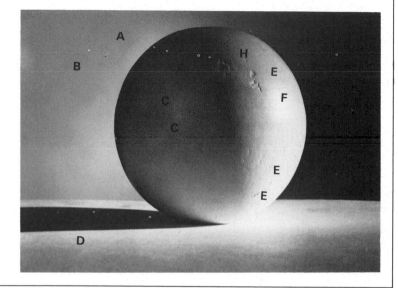

LIGHTING PRECEPTS

Follow the example of nature.

Separate, separate, separate.

Visualize every lighting plan.

Work only with one light source apparent.

Light areas must appear against dark, dark against light, all in transition.

Quality of light affects the mood.

Direction of light affects structure and form.

The nature of the shadow indicates the quality of light.

Shadows *must* all fall in one direction.

Highlights should have incident highlights within them.

Fill lighting is always subordinate to the key light.

Long throws produce small highlights.

Specular light is active yet introspective.

Diffuse light is passive and descriptive.

Planes must show sharp differences in tone.

Spheres must show gradual tonal changes.

When the edge of a form is seen, separation is present.

Lighting is correct when the photographer's concept is clear.

Planning is at least half the job.

Portraiture is a marketing exercise; use discretion with lighting.

Give each surface its inherent characteristics.

Match film colour balance to key light colour temperature.

Tungsten light gets warmer as it ages.

The eye uses scanning and dilation to see.

The camera sees in fixed light values.

The eye sees a brightness range of 10,000:1.

Film can record a brightness range of 200:1–2000:1.

Photographic print can record a brightness range of 60:1 down to 20:1.

Newsprint can record a brightness range of 10:1.

The best lighting plan needs informed processing techniques.

Take every precaution against accident. Electricity kills.

a

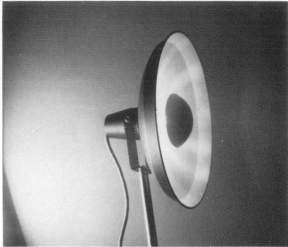

c

b

a Snooted reflector to restrict the fall of light.
b Normal reflector.
c Capped reflector to diffuse and soften the light.
d Box reflector, 1 metre square, with a diffusion screen, to give maximum spread of light and maximum softness.

d

in the mind of the viewer. This is only possible if separation is present. Separation of form from form, texture from texture and tone from tone. Separation, it must be understood, is the most important visual characteristic to be seen in professional lighting plans. Light areas are placed against dark, dark against light, tonal transition in the background produces spatial dimension. The correct key light, correctly placed and exposed, will always produce maximum separation. Accent lighting may be needed to define edges where tonal values are similar, such as black on black, or white on white, but unless the key light creates the separation, the image content will be obscured.

Key lights for the best separation are:

Top back light This is most revelatory of form, but needs a wide diffused fill from the camera position. Multiple forms often need such light.

Top side light A texture light and it too reveals form well.

It is also a heroic light, uplifting the mood, with a tendency toward masculinity and simplicity.

Top centre light In certain objects where contours project toward camera, such light is needed. It can also produce edge accents along the top contours of multiple forms. It gives a degree of outdoor feeling and naturalness and needs soft but strong fill light from the camera position.

Cross light The skimming texture light from low down on the horizon separates textures dramatically, is a positive, optimistic light when used with sufficient fill light from the opposite direction but when shadows are unrelieved by fill light, the mood is more negative, mysterious and compelling.

Key lights for mood are:

Top back light This tends to create a romantic mood, somewhat theatrical, when the fill light is used sparingly.

Back light Produces sentimentality rather than drama, and separating dark forms from dark backgrounds, it is used

a　　　　　　　　**b**　　　　　　　　**c**　　　　　　　　**d**

Using different reflectors.
a Normal reflector without diffusion.
b Normal reflector with Colortran Silk diffuser.
c Large reflector diffused with Rosco Frost.
d Small reflector without diffusion, with extra fill on box face.
Notice how the shadow changes.

Below A 'chisel' light, an accent light to define a profile. If it is positioned quite high it also lights the hair.

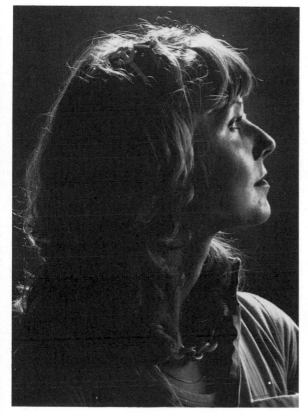

only rarely as a key light, but often as an accent.

Top front light Reveals frontal forms well, but is notable as a glamour light. Diffused and not too large, placed a short distance above camera position, this light can be very complementary to women, producing soft shadows under the nose and mouth but sufficient light in the eyes and thin shadows on the outer edges of the face to enhance and sculpt the planes of the cheeks. It does not often need a fill light.

Grotesque light This light, from below the lens axis, produces a highly theatrical mood of unreality. It is a light not seen in nature, but can be used to dramatize an object, especially if it is translucent and in dark surroundings.

Axis light A light beamed along the lens axis often from a ring light (fig. below). It flattens form unless the contours project well towards camera, but gives edges a distinctive thin shadow line especially if the object is touching a flat plane in the background. It is sometimes appearing today as a trend in fashion photography, but can also be seen occasionally in the nude photography of Edward Weston and Man Ray in the

This is a Bowens ring light, which places an equal amount of electronic flash evenly around the lens.

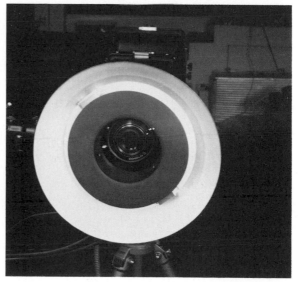

Key light is diffused box reflector 1 x 1.5 metre in area Top back position

Sharp spot with snoot to bring out texture on sleeve

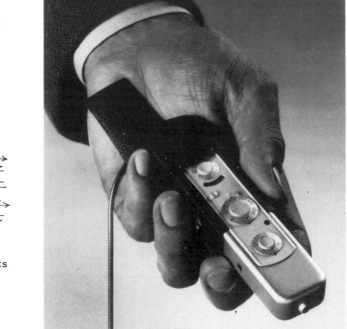

Small diffuser box for highlights on metal

Small diffuser box

White reflector 1 x 2 metres for soft fill

A comprehensive lighting plan for this product shot is shown.

a

b

Reflected or diffused light is added in (b) to produce a fill light which enhances shadow detail.

1930s It has a special application for the photography of medical, forensic and numismatic subjects, and can be used as a fill light to open up shadows or increase colour saturation in shadow areas. If used on close-ups of people it can sometimes produce the undesirable *red eye* effect.

Once a key light is placed, it is mostly necessary to add a fill light (see fig. above), a considerably reduced light in strength and often diffused to a greater extent than the key light. This reduces the light-to-dark ratio so that the film may record a full scale of tones from highlight to shadow, with sufficient detail being seen in the blacks and rich detail still to be seen in the lightest areas. Low contrast lighting for soft, glamorous, delicate or informational subjects will have a highlight-to-shadow ratio of 2:1 or 3:1. More theatrical, heroic, heavily contoured subjects or those with fine textures, will need a higher contrast and a lighting ratio of 3:1 upwards, to 10:1 in the case of b/w photography, but for colour, ratios even for such subjects rarely exceed 5:1. The fill light must not throw a discernible shadow and in low contrast lighting where a strong fill light is used, it must be very much wider and more heavily diffused than the key light.

Where forms overlap or tone on tone is present or texture must be seen in the fill light area, an accent light may be needed. This is most often a heavily snooted (see right fig.) undiffused light, operating as close to the lens axis as possible without producing flare. Hair lights, skid lights, chisel lights are other names for accent lights, producing finely drawn pencil lines of light which increase separation and give life to the subject (see *Portraiture*).

Reflected light is often used as a soft shadowless fill (see fig. above) and this can come from large reflectors, 1 metre (1 yard) square which are covered with white paint (most diffused), matt silver foil (harsher but softly directional) or mirror foil (very directional). Light bouncing from such reflectors is biased to the colour of the reflector, not the key light, and it is therefore possible to warm or cool shadows at will by

A 'snoot' is a long narrow tube which allows the light to fall on a very restricted area. Useful for accent lights.

Umbrellas of different materials are used over lighting units to diffuse and reflect light and are also convenient to create overhead lighting in portraiture. This is a non translucent aluminium-lined umbrella which produces a slightly diffused, but very directional, light.

changing the reflector colour. *Bounce light* as a main key light is used to create an open, diffused light and is much used on portable electronic flash units with tilting heads. Where a ceiling is used for bounce purposes, the colour of the paintwork will produce a visible change in the colour of the light reaching the object. In an outdoor situation, bounce light is the most frequently used source of fill light, with a reflector catching the rays of the sun and turning them back into the shadowed areas of the subject.

Reflected light is often needed to augment lighting on very small sections of the subject, particularly in still life photography. This can be easily directed by small cosmetic mirrors on flexible mountings, but where increased translucency of small objects is needed, such as for bottles and glasses, a tiny silver reflector is fixed to the back of the glass and twisted to catch the key light.

The broad, but distinctly directional, light of a bright overcast day produces definite forms and contours and is very suitable for active subjects such as children because no intricate fill light or key light placement is needed, with consequently no inhibition on movement of either the subject or photographer. To produce such a light quality in the studio requires very large diffused light sources of reasonable power. It is called a 'wrap around' light. A large diffuser box is hung from the ceiling so that it lights the whole of the subject area, including the background and two less powerful but equally diffused light sources are placed on either side of the camera, angled in to cover the whole foreground. With such lighting the photographer can select any single part of the subject or the whole and also a viewpoint through a large arc, without

any change in lighting. For photographs of groups in action, children and animals in action or any large set where fast movement is going to take place, this lighting is needed. It is useful also for closely detailed informational photography of multiple objects, such as in catalogue photography.

The individual portrait will require a lighting plan which is based on the above information but modified to reveal the best features of the face and mask any which are not desirable. Lighting ratios are generally moderate, in the 2:1, 3:1 or 4:1 vicinity producing translucent shadows and creamy highlights. Women will very often be best portrayed in lower contrast or *high key* lighting, with skin tones slightly overexposed, while men traditionally might have a harsher contrast lighting, less shadow fill in and full skin texture.

The most frequently used key light positions for portraiture are the top front light producing the glamour or butterfly light and the top side light which can be used as *short lighting* to make round faces look slimmer and here the key light falls only on that side of the face farthest from camera, or it may be used as *broad lighting* where most of the key light falls on the side of the face turned towards camera. This can soften blemishes and wrinkles and can often add weight to thin faces.

Brilliant accents to hair can be added by top back lights in snooted reflectors or those with barn doors and these are named as 'hair' lights or 'kicker' lights. Back light, which on portraits produces a halo behind the hair and separates the figure from any dark backgrounds, is sometimes called an 'edge' or 'rim' light. The figure must totally mask such a back light source from the lens, otherwise *flare* will result. (See *Portraiture* and fig. opposite.)

In the studio certain materials will need special lighting

A typical small portraiture lighting set for the advanced amateur or young professional, with three lights and stands, barn doors and reflectors. Made by Multiblitz of West Germany. (*Courtesy Keith Johnson Photographic*)

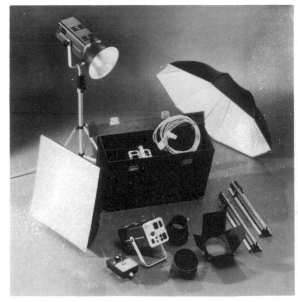

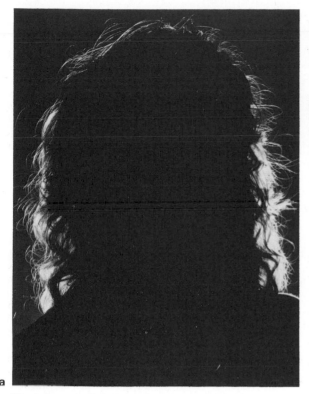

a

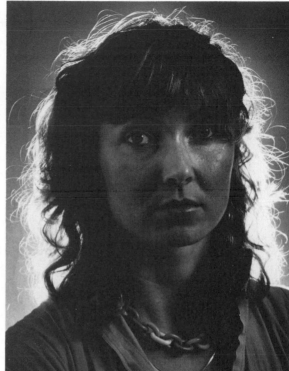

b

The halo or rim light is used to surround the subject
with a thin band of bright light. Example (a) shows
the effect, (b) the same subject with more front fill
light. It is a somewhat unreal light and should be used
with care. Example (c) demonstrates how the full figure
may be lit this way, suppressing detail in the subject
and emphasizing edges.

and this is particularly true of metallic or glass objects. Shiny
metal or other glossy materials will reflect specular light as
harsh, shiny pin points of bright tone which are very
disturbing in any visual harmony. It may be that there will
also be heavy blacks which are reflected from unlit areas
outside the subject and camera positions. For a shadowless,
high key camera lighting, suitable for jewellery, metals or very
glossy surfaces, 'tent' lighting is employed (see page 223).

Photographing black objects requires special techniques
also. Shiny black surfaces will need tent lighting for best effect
but with increased exposure, 25% at least. Matt black or dark
fabric will need accenting with very strong, very directional
cross lighting to bring out its character and a light which is
snooted or controlled by barn doors so that only the dark areas
receive this extra light. B/W photography of such a subject will
be helped by 30–50% over-exposure and subsequent under
development to compensate. (See *Nine Negative Test*.)

The translucent tent or cone is constructed, to totally
surround the subject and is connected to the lens or lens hood.
This tent is then lit with no direct light falling on the subject
itself. Used on light or dark glossy objects, including metal,

c

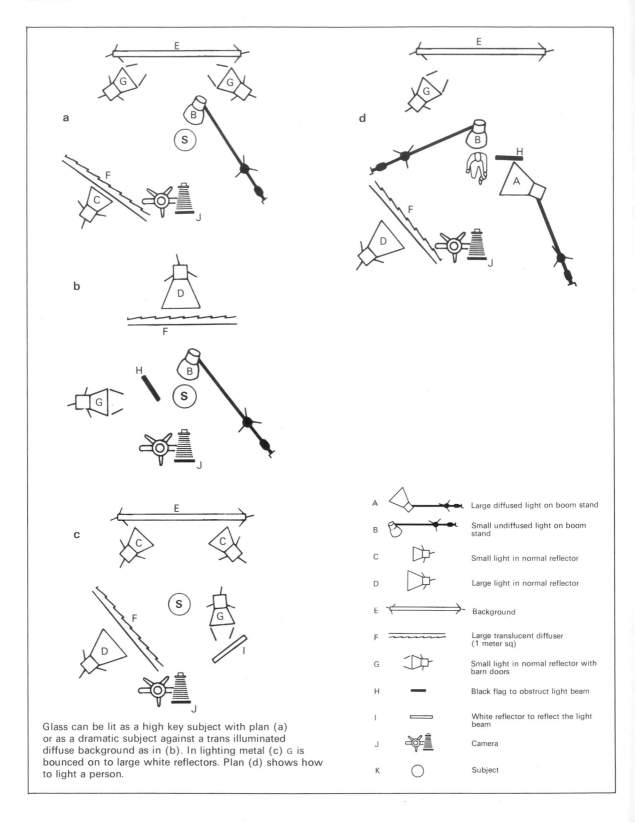

a

b

c

d

Glass can be lit as a high key subject with plan (a)
or as a dramatic subject against a trans illuminated
diffuse background as in (b). In lighting metal (c) G is
bounced on to large white reflectors. Plan (d) shows how
to light a person.

A		Large diffused light on boom stand
B		Small undiffused light on boom stand
C		Small light in normal reflector
D		Large light in normal reflector
E		Background
F		Large translucent diffuser (1 meter sq)
G		Small light in normal reflector with barn doors
H		Black flag to obstruct light beam
I		White reflector to reflect the light beam
J		Camera
K		Subject

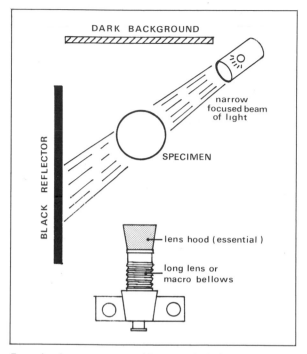

For colourless transparent objects particularly in close-up situations, it is often best to photograph them against a dark field or background.

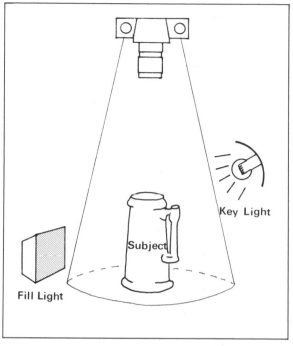

Tent or cone of translucent plastic or Rosco Frost, with the subject within it and lighting positioned outside.

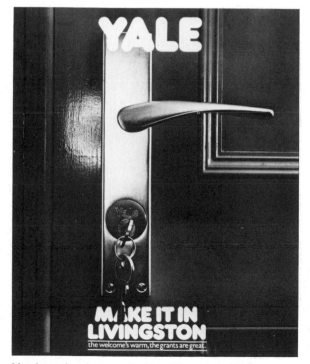

Metal may be photographed by diffused axis lighting from a ring flash.

Lighting glass which must appear translucent.

223

To cover very large interiors or night time exteriors.
Bowens Ltd of London make this most efficient
battery-operated flash unit. Using four powerful wire-filled
expendable flash bulbs, maximum light is delivered for
minimum weight.

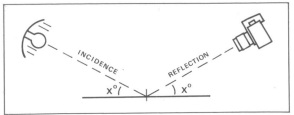

Angle of incidence.

In placing and balancing light and judging exposures, photographers should understand two important laws relating to the behaviour of light. The first: that *the angle of incidence equals the angle of reflection*. This means that when light strikes a plain surface at a particular angle, it will be reflected at precisely the same angle. This is important in acquiring a sensitive understanding of the use of reflectors as fill light sources and in calculating highlight reflections versus camera viewpoints when dealing with glossy surfaces or polarizing filters.

The second law is that point source *light* reaching a subject *varies inversely to the square of the lamp-to-subject distance.* This means that if a given quantity of light is falling on the subject, when the lamp is moved twice as far away, only one

The inverse square law of illumination. Subject at A receives all available light requiring increased exposure of no f stops. Subject at B receives $\frac{1}{4}$ available light requiring increased exposure of 1 f stop. Subject at c receives $\frac{1}{9}$ available light requiring increased exposure of 2 f stops.
Subject at D receives $\frac{1}{16}$ available light requiring increased exposure of 4 f stops.

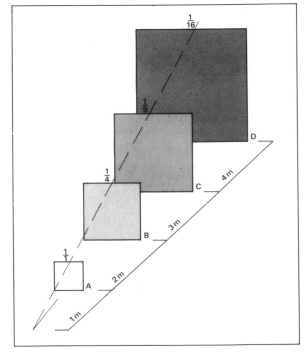

full textures and tones are beautifully rendered. Metal may also be successfully lit by axis lighting from a ring flash or from two reflectors placed on either side of the lens and almost touching it (see fig. page 223) without the use of a tent. Glass and other translucent objects must display their major characteristics, that is thinness and translucency. This is done by using a back light, highly diffused, as the key light with very little fill light, plus a small specular reflector aimed at the surface nearest the camera to disclose the nature of that surface (see fig. page 223).

Copying of flat originals needs a lighting plan where diffused lights of equal strength are placed on either side of the camera at about a 45° angle to the flat surface of the copy. Totally even distribution of light over the entire area is desirable (see *Copying*).

Very large interiors can be successfully lit by using an additive technique where, from a single light source, a full coverage of the subject is made. The shutter is left open on T setting, or a locking cable release is used and a hand-held flash is fired from a position which is concealed from camera viewpoint. With the shutter still open the photographer moves again to a further concealed position, firing the flash once more. A giant key light effect can be created by always pointing the flash in the same relative direction. When using tungsten light, the beam of light is thrown progressively and continuously over and slightly overlapping sections of the subject, while the shutter is left open throughout. This 'washing' or 'painting' with light can sometimes be the only way some interiors can be lit, but the photographer must be careful to exclude interior windows or other continuous light sources from the picture or excessive over-exposure of these areas will spoil the result. When adding multiple quantities of light in this manner, the reciprocity effect will often mean that the actual, effective light reaching the film is less than the cumulative total reaching the subject. Polaroid testing before the actual exposure is therefore desirable.

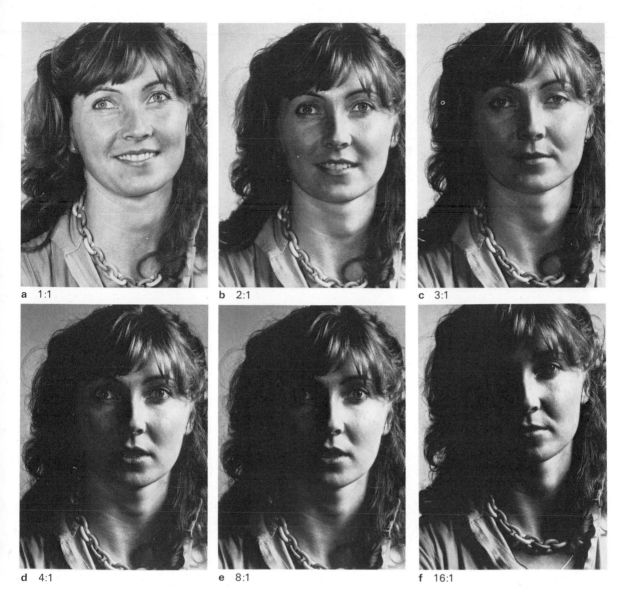

a 1:1

b 2:1

c 3:1

d 4:1

e 8:1

f 16:1

The highlight to shadow ratio can be changed by contrast control in processing, but is more easily altered on a portrait by increasing or decreasing the fill light in the shadow areas. Ratios of 2:1 and 3:1 are the best for normal colour photography, 4:1 to 8:1 are suitable for B/W. The higher the ratio, the more dramatic the final result. Ratios of 1:1 are often obtained when a flash is on the camera and produce brilliant colour but little modelling of contours.

quarter of the amount of light is reaching the subject. When it is moved closer, to half the distance, the light on the subject is two times brighter. This law does not follow if broad, diffused light is used on moderately small subjects but comes into effect whenever the dimensions of the light source are 10% or less than the area which is to be lit (see fig.).

It is important to understand this rapid alteration of light values when finessing the lighting ratios to obtain a subtle fill light balance. An easy guide to placing two lights of equal strength to provide a 3:1 ratio (ideal for colour reversal film) is to use the f stop scale which happens to be calculated on the inverse square law. Select any f stop number and designate it as a metric or other measure. Place the key light at this distance from the subject. A fill light of the same strength and character is placed at the next highest number on the f stop scale and will produce a 3:1 lighting ratio. For example, place a key light 2.8 metres from the subject and a fill light at 4 metres (f4) and this balance is the result. Placing the fill light at 5.6 metres (f5.6) or two stops away produces a harsh, high contrast 9:1 ratio.

When handling hot flood lights, use oven gloves to allow precision aiming of the light.

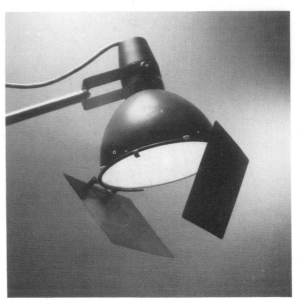

Barn doors to control light spillage.

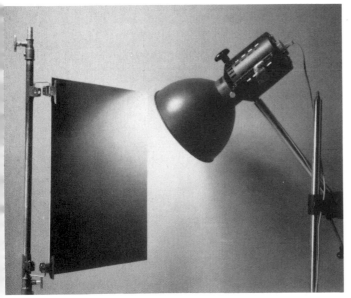

A 'flag' of black cardboard is used to control the fall of light on a subject when a sharp cut-off of light is needed close to the camera.

To make a flag, gobo or temporary barn door out of black cardboard, to control the fall of light more precisely, use pinking shears to cut a saw tooth edge which makes the light pattern more natural.

Placing a gobo over a lens, using a Bowens clip to hold black card in place, shielding the lens from the bright light which causes flare.

A wire mesh or 'scrim' is placed over lights to reduce their intensity and to act as a partial diffuser. Usually found on tungsten lights.

Broad source tungsten lights of lightweight construction are useful for lighting large areas on location.

A boom stand is a means of getting light over the top of a subject and is one of the real essentials in any studio.

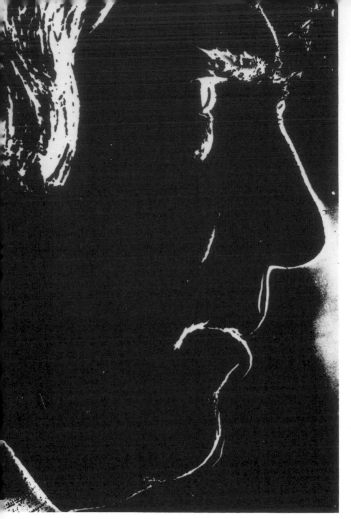

Lith or line film reduces all intermediate tones to black or white thus creating absolute contrast.

Other lighting accessories which are used by the professionals, apart from the series of reflectors, are those which intercept light falling from the lamp. Those attached to the lamp are called *barn doors* (see fig.). These can be arranged to control the spill of light from the edges of the lamp reflector in order to produce transitions of light of great delicacy. They also prevent flare by concealing the actual light source from the camera viewpoint. A 'flag' is a flat opaque sheet (see fig.) which is on a movable stand and somewhat larger than barn doors. This can cut off considerable areas of light from large light sources or create denser shadows in the image area. A 'gobo' is a rectangular or irregular shaped black card used on a small boom or goose-neck stand to control key light falling on the subject or to obstruct any light which may fall on the lens and thus create flare (see fig. page 227). A 'scrim' is a wire or fibreglass gauze which is put over a lamp reflector to reduce the intensity and to diffuse the light. Wire cuts intensity quickly and diffuses less than fibreglass. In handling any hot lights, it is advisable to have a pair of insulated oven gloves nearby, particularly if tungsten halogen lamps are fitted to the lighting units (see fig.).

Lighting stands should be very stable, have a low floor position of about 60cm (24 inches) if possible and a high rise capability of at least 3 metres (10 feet). A boom stand which permits a lamp to be swung over the centre of a small set, while the main stand is well outside the area, is one of the most useful pieces of lighting furniture (see fig.). Suitable tungsten halogen lighting units are made by Berkey, particularly the rugged Mini-Pro Colortran and a compact reliable studio flash system with bright modelling lights and very reliable power source is the Vario made by Multiblitz of Germany. The Vario has a totally variable output over a two stop range and with 500 watt tungsten halogen modelling lights fitted as well as 1000 watt/sec. flash tubes they are suitable for artificial light exposures as well as for daylight flash. A heavy duty studio system by Broncolor of Switzerland or Norman of the USA would provide compact, sturdy and high powered professional flash equipment. Remember when using artificial light: *electricity kills*. Have all studio wiring or lamp house wiring installed and checked by a professional electrician. (See *Appendix*, *Light*, *Vision*.)

LINE FILM
Very high contrast film processed usually in high energy caustic developers to obtain maximum density of exposed areas and clarity of the unexposed. Most often needed for subjects consisting of fine black lines, such as drawings or type where no intermediate grey tones exist. It can be exposed by the camera for an original negative or by the enlarger for intermediate steps in high contrast processes (see *High Contrast Materials*).

LITH FILM
An idiomatic name for high-contrast film emulsions used often in the lithographic trades (see *High Contrast Materials*).

LITHOGRAPHY
This is the mechanical printing process using a dot screen and if necessary, colour separations, to produce continuous tone photographs on paper for books, brochures or wall prints. The image is photographed onto a printing plate and then transferred to the final paper, often via a blanket of rubber or plastic. (See *Photo-Mechanical Printing*.)

LOCATION PHOTOGRAPHY
One wise photographer said of unfamiliar cultures and places, 'when you reset your watch, reset your head' and it is indeed vital for all photographers to accept the differences to be found when visiting strange places. Be polite, observe local customs, conceal overt photography where it is religiously or socially abhorrent to the local people, ask permission of anyone who is to appear in a portrait. Do not expect to maintain precise schedules and act only on face-to-face meetings rather than on telex, telephone or written instructions. Most action will start only when the photographer actually enters the client's office. Be prepared to initiate your

own back-up on all matters which arise before that time and then wait patiently for other events to unfold.

Many countries will require that an official sanction be given even for street photographs and this is especially true of the Arab countries who enact an official embargo on photo-journalism. It is also true of South Africa and the Eastern block countries where even tourist photography may be subject to official attention. Tripods used on the streets will normally require licences, even in London, and these permits are mostly obtained from police officers but this will take time. Be prepared for the considerable delay and many questions.

Large amounts of equipment should be notified to the customs officer at your point of departure (or duties may be charged on your home coming) and to your first point of entry in the country of destination. In preparing for long distance locations, equipment should be dusted, cleaned, checked, identified on all insurance policies which are also checked to assure validity for the areas of travel and then the equipment must be packed in suitable cases or containers for travel which usually means custom-cut beds of foam which fit tightly into a strong outer case. If that case measures $45 \times 20 \times 38$cm ($18 \times 8 \times 15$ inches) it will fit under most aircraft seats as carry-on luggage. If equipment is sent in the cargo hold, take sufficient basic cameras and film on board as hand luggage so that in the event of baggage lost or misdirected the assignment can still be completed.

x-rays at many airports are a hazard, but many more countries have now installed very low radiation machines. x-rays can have, however, a cumulative effect and can also create abberations in automated cameras and the least number of stop-overs and therefore x-ray exposures, is advisable. Place all cameras and film in lead envelopes such as made by Film Shield (see *Appendix*) and, where possible, seek hand searches of equipment cases. In many European countries these will be absolutely refused, authorities blandly insisting that their equipment is harmless. Accept graciously; it probably is, unless many stop-overs have generated a cumulative x-ray charge. Exceptions to the above benign situations are to be found where powerful x-ray machines mean hand searches are advisable.

Take limited variations in film stock, for example Kodachrome 25 for sharp saturated daylight work, Ektachrome 400 daylight for coping with difficult ambient light situations and a tungsten light film of at least ASA 200. A small tripod is essential, plus at least one ultra fast lens and one of a wide angle which allows generosity towards the errors of covert shooting and also permits slower, hand-held speeds in low light conditions.

Develop a system of loading cameras so that when changing film stock it is easily identifiable, mark each camera with a label to show its contents, number each completed film and note that number and processing instructions in a field notebook which always stays in hand baggage. Each night, unload all cameras, even half completed rolls, list all films, clean out cameras, check filters for finger marks, reload fresh stock, etc. Keep all films and cameras away from central heating or sunlight and allow 30–60 minutes warm-up time when taking automatic cameras from air-conditioned rooms into high tropical heat. Carry spare batteries for all functions and begin each journey with new batteries in every system as a standard rule.

Housekeeping matters like wake-up times, sufficient food, drink, transport, etc., must be very closely organized. Delegation of these problems to local personnel may produce misunderstandings or negative results. Always be in place well before any chosen event begins, especially if it is a natural phenomenon like dawn, but create your own, absolutely safe technique for achieving this. If you have spare time on location, spend it photographing outside of the client's brief. It can be a relaxation and even a latent source of income.

Minor locations nearer to the home base will need just as much care and preparation if you are professional, with back-up equipment for all main items. Those photographing purely for pleasure should also note the information about professional location assignments, as much of it applies to very simple but serious work when away from home.

For professionals, the logistics of going to a location with a large team of specialists often becomes a more difficult part of the assignment than the photography. When planning foreign location photography the following must be organized and checked beforehand: customs documentation for all equipment; special hazard insurance; back-up equipment for every key item in regular use; film in protective wrappings to keep it cool, dry and free of radiation; a means of returning finished film for rapid processing; spare batteries for all cameras and motorized equipment; and so on. Last minute weather reports are often needed and effective ground transport must be provided to suit the local conditions. The hours worked on location are usually considerably longer than normal and the photographer must negotiate a fee with the client to reflect this and the costly preparations. (See *Available Light*, *Camera Care*, *Camera Supports*, *Lighting*, *Optics*.)

LOW KEY

A picture which consists mainly of tone from the dark areas of the spectrum is named as a low key image. Highlights are usually made up of spectacular, but small, splashes of light and the blacks carry immense detail. (See also *High Key*.)

LUMEN

A basic measurement of lighting falling on a given area which indicates the strength of the source of that light. A standard light source of one candle would theoretically emit 12.6 lumens, while a one candle power light source would provide incident light of one foot candle on a surface which is one foot from it. This is the equivalent of one lumen per square foot. The preferred unit of illuminance measurement now is the lux which is equal to 10.75 foot candles or one lumen per square metre.

MACRO PHOTOGRAPHY
(See *Close-up Photography*.)

MAGENTA
A pinkish red, one of the subtractive primaries used in colour photography and photo-mechanical printing processes.

MANNES, LEOPOLD D. (1899–1964)
An American, Mannes was a collaborator with Leopold Godowsky in a musical sense and also as an industrial chemist during a long search for an improved reversal colour film which resulted in the invention of Kodachrome film. During further work in the Kodak Research Laboratories, the team laid the foundation for negative/positive colour photography which, as Kodacolor, was launched by Eastman Kodak in 1941.

MAREY, ÉTIENNE JULES (1830–1904)
As a physiologist in France, Marey was interested in animal locomotion. His work, to some extent, ran parallel to that of Muybridge, but his equipment differed considerably. He recorded a multi-image flow of action on a single plate rather like the stroboscopic effect which is now created by rapid, repeated flashing of a light source, but he used a rotating shutter to achieve this result. Muybridge made repetitive pictures on single frames from multi-lens systems connected by elaborate electronic triggering of the shutter mechanisms. Much of Marey's work became the forerunner of motion picture and slow motion cameras. Even before the end of the nineteenth century, he had operated his camera at 700 frames a second to produce slow motion pictures.

MARTIN, PAUL (1864–1942)
In the beginning of his long life, Paul Martin chose the road of pictorialism just as many others of Britain's early photographers had done, but with the advent of smaller, hand-held cameras, he took to the streets of London to record memorable and socially important events or simple and humble moments in the lives of very ordinary people. His visual comment is direct and acutely observed, possibly some of the earliest documentary photographs ever taken in Britain, with what could be classed as a modern immediacy in style.

MASK
A negative and/or positive mask is used when assembling a number of images (see *Image Synthesis*) and in matte boxes when producing montage images in camera. A photographic mask for such purposes is usually made on lith film and processed in high contrast developers. Highlight and shadow masks are sometimes used to control contrast, especially in colour materials and these are normally made on panchromatic camera film.

MATTE BOX
This is an attachment for the lens, derived from motion picture special effects equipment, but now appearing increasingly for still cameras. By using positive and negative masks, simple in-camera montages can be made in the field.

MEDIUM FORMAT CAMERAS
Since George Eastman introduced the first mass market Kodak camera in 1889, the medium format has been available and popular, usually making use of 120 roll film. The Rolleiflex twin-lens reflex camera, produced in 1929, opened up sophisticated possibilities for the professional and, in later years, as the small format, 35mm cameras flooded into the amateur market and cameras such as Hasselblad and Rollei single lens reflexes became available; this format, using 120 roll film, has been that most commonly used by the professional industry wherever subject movement, problems of portability and large numbers of exposures have made the use of sheet film cameras impractical. There is also now an increased interest by amateurs in the medium format.

The 120 camera is essentially a fixed body camera usually with interchangeable lenses and film magazines, making this a systems camera, albeit a heavy one. Best known manufacturers are Hasselblad, Rollei and Bronica, all taking 12 pictures per roll measuring 6×6cm ($2\frac{1}{4} \times 2\frac{1}{4}$ inch); Pentax, Mamiya and Linhof take 6×7cm ($2\frac{1}{4} \times 2\frac{3}{4}$ inch), ten per roll and Bronica and Mamiya also have a system with 16 pictures per roll, with dimensions of 4.5×6.0cm ($1\frac{5}{8} \times 2\frac{1}{4}$ inch). Most large format sheet film cameras have a reducing back accessory which allows the use of a 120 roll holder instead of cut film and this of course allows the full use of camera movements and close-up functions with the advantage of unlimited exposures without darkroom facilities. The 6×7cm format is the most practical for view cameras. All 120 cameras are more useful to the professional if they have Polaroid facilities.

The medium format, fixed bodied camera in skilled hands can produce breathtaking clarity in form and textures, particularly where slow or medium speed B/W film is used, coupled with fine grain, high acutance developers. Mood is somewhat sacrificed when compared with that which is obtained with 35mm and as they lack optical corrections, these cameras are less suited to architecture, product and still life subjects, but for much of the professional's working life and for most landscape and industrial photography and

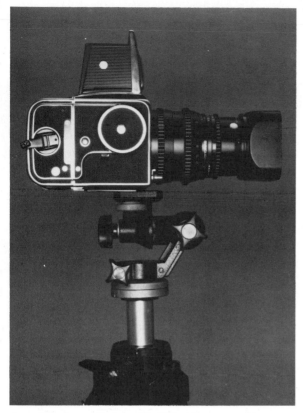

A medium format 6×6cm (2¼×2¼ inch) camera taking 12 pictures per 120 roll.

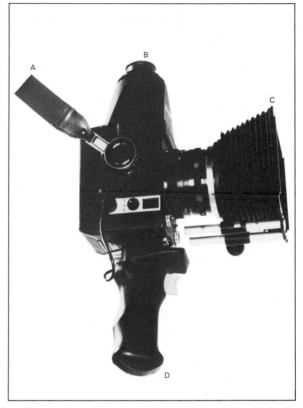

Accessories necessary on a medium format camera if used professionally. A neck strap, B focus magnifier hood, c bellows lens hood, D shutter release hand grip.

portraiture, they are ideal. Processing in bulk is possible by the use of 13 litre tanks using reels as illustrated under *Darkroom*. (See also *Rolleiflex SLX Cameras, Hasselblad*.)

MEES, CHARLES EDWARD KENNETH (1882–1960)

An Englishman, Mees was one of the great photographic scientists who by the time he was 21 was co-author of an important paper on sensitometry, dealing with the concept of gamma. Together with his colleague Samuel Sheppard, a dozen important theoretical papers on photographic chemistry had been published by the time he was 25.

He became a joint managing director of a small, but successful, English dry plate makers, Wratten and Wainwright, and when George Eastman offered him work in the United States, the entire firm of Wratten and Wainwright were absorbed by Kodak. For more than 40 years he headed the Kodak Research Laboratories and during that time published the *Theory of Photographic Process*, a standard work of reference on that subject. Doctor Mees was also instrumental in founding the educational and historic institution, George Eastman House in Rochester, New York.

METACHROME

A colour abstraction made by employing standard photo-chemical techniques largely based on the well known *Sabattier effect* and the derivative techniques to be found in the black and white work of *Moholy-Nagy*, *Man Ray* and *Christian Schad*.

The photographer is able to produce a controlled synthesis of selected elements from normal, optically correct photo-images. The final print or transparency, usually characterized by hard edges and brilliant colour, becomes a completely new image with changed colours and forms, arbitrarily altered to illustrate the photographer's memories of subjective experiences. It is expressionistic rather than impressionistic and usually communicates strongly with viewers of widely differing age groups and culture. (See *Abstract Photography*, *Metagraphics* and the colour plate for *History of Photography*.)

METAGRAPHICS

Synthesizing photographic images by abstracting them into line, posterization, solarization, bas relief, etc., by the use of graphic derivation techniques, can create changes of form, texture, colour and mood. From the Greek word *meta*

(change) some photographers working in this field have invented a generic name which seems aptly to describe their special interests. (See *Image Synthesis, Metachrome*.)

METOL

This is a developing agent used alone or in combination with other agents and in certain compensating developers to produce increased shadow detail. Some photographers are allergic to metol which can cause a form of dermatitis, evidenced by a bright red rash on the face, neck, hands and abdomen. Switching to the use of thin, rubber gloves or print tongs can usually prevent problems, provided the darkroom is well ventilated. If this is not successful, metol-free developers must be used, such as those containing *Amidol*.

METRIC SYSTEM

The world of photography has almost totally switched to the

An example of a metagraph, taken from a colour original. (See colour plate 21.)

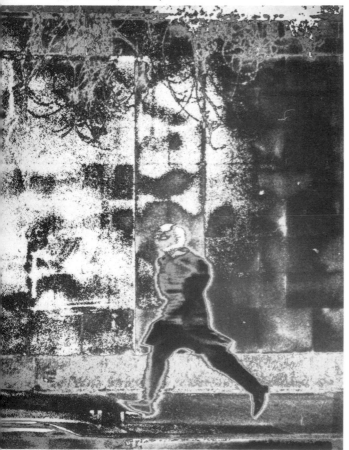

European or metric system for measurement of weight, space, temperature and distance. It is a simple decimalized method, most useful, provided the equivalent American or British measures can be visualized. Prefixes are used to indicate the numbers of multiple units involved as they relate to basic measurements: the litre (volume), the gram (weight), the metre (length). Milli indicates the fraction of $\frac{1}{1000}$ of a unit; centi, $\frac{1}{100}$ of the unit and deci, $\frac{1}{10}$. Kilo indicates one thousand times the unit; mega, one million times. Temperature is indicated in degrees Celsius, written as c, and 'centigrade' has been dropped from modern terminology. Conversions must be accurate especially when mixing a chemical formula. (See *Weights and Measures* for tables, conversions and equivalents.)

MICHALS, DUANE (1932–)

Known for his use of sequential photography to present his own fantastic whimsies, Michals, an American, often also feels the need to add lengthy and enigmatic captions to his work. This combination of literary, theatrical and photographic skills has become influential with a number of young photographers and critics. Michals exploits the ability of the camera to create multiple images, each with common reference points, in order to explore the flow of time. He obtained a BA at Denver University and began to be seriously concerned with photography when he was 26.

MICRO PHOTOGRAPHY

The science of making tiny images has many modern applications, chiefly in matters concerning filing pictures, photographs, documents and engineering drawings. Now being linked by electronics to computer processing, the miniaturization of images is rapidly finding its way into very sophisticated storage, retrieval and transmission techniques which will permit satellite communication to transmit entire image banks instantly anywhere in the world.

For many people the micro fiche or micro card, which can carry several thousand tiny photographs within the space of 105 × 148mm (6 × 4 inch) card, will be their first contact with micro photography or micro graphics. Special cameras are needed to miniaturize the original image, often reducing a picture area 20,000 times or more, and a special optical reader is needed to reconstitute the image in usable form. Several inexpensive readers, small enough to be carried by hand, are now available as well as the console models used by scientific institutions. (See *Photomicrography* for comparison.)

MINIATURE CAMERAS

This term usually is taken to refer to 35mm cameras (see *Small Format Cameras*) but smaller formats exist and are much used in amateur markets. The fidelity of these tiny images is quite amazing and very satisfactory for family pictures, especially if the lens systems of the more expensive

Kodak, Minox, Minolta or Pentax cameras are used. For serious work, however, there are shortcomings and the flexibility and sophistication of the bulkier 35mm camera is needed.

MIRROR LENS

The compacted mirror lens, usually a telephoto but possibly a zoom, reduces weight and length on long focus lenses especially those intended for 35mm format cameras. The optics are folded (see *Lenses*) and produce adequate definition in long focus but compact lenses. Apertures are normally fixed, exposure variation being possible only by using the shutter or filters which are built into the rear of the lens. A characteristic of these lenses is that they record out-of-focus, pin point light sources as doughnut ring-shaped areas with a dark centre. Such long lenses also add considerable visual weight to subjects, making faces rounder and heavier and even very slim people appear much bigger than in real life. They normally should be used only on a tripod, at high shutter speeds and at a time of day when haze or heat is not present. Their technical description is 'catadioptric'.

MIRRORS FOR LIGHTING

Small cosmetic mirrors are convenient for directing light from the key light source into confined space or restricted shadow areas (see *Lighting*).

It is advisable to use plastic measuring beakers in the darkroom. To avoid frothing of solutions, which can lead to inaccurate measuring, concentrates are poured down the inclined edge of the vessel.

MIXING SOLUTIONS

Normal photographic solutions are fairly benign but it is wise to take precautions against spillage, fumes and contamination. Filter the water supply to control impurities. Be aware that airborne crystals or even fumes, particularly those of the more volatile developing and toning agents, can be deposited in the atmosphere and later on affect unexposed film and paper, fogging or staining them. If possible, do not hold or mix chemicals in the darkroom. Wash all equipment thoroughly in hot water after use and again just before using. Pour acidic substances into water, not vice versa. Use glass stirring rods for mixing, estimate temperatures accurately. Use gloves when handling caustic or corrosive chemicals. If the eyes are affected by any accidental spillage, flood them with plain, cool water and call a doctor immediately. Follow the manufacturer's instructions precisely. Keep all long term solutions in dark bottles, tightly closed against the air and properly labelled. (See *Basic Photography* and *Dangerous Chemicals*.)

In mixing solutions, run the water into the tank first (a), add the concentrated stock solution (b) and mix well (c).

% strength of stock solution

parts of B required

A

BB

% strength of working solution required

X

B

AA

% strength of solution used for dilution

parts of A required

CHECKLIST WHEN MIXING SOLUTIONS

1 Keep dry areas of the darkroom dry.
2 Wipe up spillage immediately.
3 Wash hands thoroughly to be free of chemicals before touching clean or dry areas.
4 Do not smoke or eat in mixing areas.
5 Read the formulae carefully.
6 *Read manufacturers' instructions.*
7 Measure quantity and temperature accurately.
8 Use wide-mouthed mixing containers.
9 Use distilled water where possible.
10 Dissolve chemicals in order of listing.
11 Agitate and stir *gently* to prevent oxidizing.
12 Avoid skin or eye contact with any strong chemical.
13 Label all stored chemicals clearly.
14 Work in adequate ventilation.
15 Acid *must* be poured into water.
16 Alkalies produce heat when mixed; use cold water always.
17 Do not mix near any open flames.
18 Be aware of dangerous substances and their antidotes.
19 Wash all mixing equipment after use with several changes of hot water.
20 Discard dangerous substances very carefully.

A simple way to make dilutions. To find the number of parts of a stock solution which must be diluted with an unknown number of parts of a diluting agent in order to make a working solution.

At x write the % strength of the working strength required, at A the % strength of the stock solution and at B the % strength of the diluting agent. (Water is zero %.) Method: Subtract x from A and write this number at AA. This is the number of parts needed of the stock solution. Then subtract B from x and write the number obtained at BB. This is the number of parts needed of the diluting agent required. Then if AA is diluted with BB, the % solution at x will result.

A model release form.

RECEIPT AND DISCLAIMER

I hereby declare that under Commission to Messrs

...

I have received/will receive the sum of

...

for pictures from

...

taken by the photographers

...

...

Payment: Cash/cheque nr. / on account

At the same time I hereby give my consent for the above pictures or portraits of myself, or altered or unaltered reproductions of these pictures, to be distributed and published for advertising purposes without restriction to any particular sector by the above-named firm or by third parties acting with the latter's consent.

I hereby ~~declare further~~ that the fee paid to me today satisfies all claims I have or may have on the above firm and on third parties who, in producing, distributing and publishing the above pictures (or film shots), act with the latter's consent.

I waive the right to have my name stated, but I also give my consent for my name or another name to be mentioned in connection with my picture.

.................................., the

...

Signature of the model (For minors, signature of parent or guardian)

Advertising Account/Product:

Attendance Fee:

Publication Fee:

Address

...

...

MODEL RELEASE

When anyone appears in a photograph which is made for commercial purposes, it is necesary to have written agreement from them that the photograph may be so used. Even in editorial photography it is a wise precaution to prevent an 'invasion of privacy' action, to ask any person who is identifiable to sign a general release. A fee must be paid, however small, to legalize the document. The wording on the release should be produced in consultation with a professional legal adviser who has a special interest in copyright or commercial law, so that it may conform to legal needs of the country of residence. An example of a British model release appears opposite, but is should be revised by a competent legal adviser to suit local needs.

MOHOLY-NAGY, LASZLO (1895-1946)

Born in Borsod in Hungary; studied law in Budapest; did his military service; 1920–23 artist and writer on visual media in Berlin; 1923–8 master at the Bauhaus, director of the preliminary course; 1928 research in Berlin on light and colour in respect of painting, photography, film, graphics and stage design. During 1935–7 he was in London; in 1937 he co-founded the New Bauhaus in Chicago; 1946 died in Chicago.

The bare structure of his life in these above statistics does not disclose his seminal influence on twentieth century photography. He clearly understood what is today still only dimly recognized by many photographers and critics – the power of the camera machine to discover a new reality. Photography, he decided, could alter our insight into conventional reality in a way not possible with other art forms. He created theories of light, of colour and vision which have changed the whole style of visual communication and his love of photography brought forth brilliant experimental work in photograms, photo-montage, solarization, x-rays, negative images and transparency effects, which even then offered a revolutionary alternative to conventional photography, but now, with the added dimension of reliable colour photography, these examples provide the art photographer with a challenging but well signposted route towards the discovery of most unusual photographic territory.

Those who accept his theories and leadership in the avant garde of modern photography can set out to explore the fascinating inter-play of picture plane, depth illusion and space-time configurations, which the radical but prophetic Moholy-Nagy has offered to the high artists of Europe since the 1920s. His transplantation of these ideas to Chicago in 1938–9, when he helped found the New Bauhaus, saw that his ideas were not lost during Europe's dark years.

Although his theoretical work on art education and painting had fairly immediate effect and continues to do so, his vivid influence on subjective and expressionistic photography is only now, four decades after his death, nearing its full potential among serious photographers.

MONTAGE

An assembly of images, some overlapping others, which forms a unified visual concept within the frame of reference. True filmic montage, where the images are interwoven with sufficient skill, will suggest elapsed time and a degree of fantasy. (See *Image Synthesis* and *Multiple Exposure Technique*.)

MOOD

'A frame of mind or a state of feeling', is the definition in the Oxford English Dictionary and this suggests the emotional content which is uniquely present in many photographs. The cold mechanics of photography seem a strange catalyst for such elusive characteristics but the photograph, more than perhaps any other media or art form, captures and reveals mood convincingly and easily. Even unskilled viewers will quickly grasp the unseen essence of the visual concept which mood exemplifies, making it vital that photographers learn how to control mood in their pictures and use it as a vital element of good design. (See *Image Management*, *Available Light*.)

MOONLIGHT, PHOTOGRAPHY OF

Photographing the moon itself requires that a lens of 200mm or longer, for 35mm format, is used to obtain an image of reasonable size. Exposures are, for a 400 ASA film, likely to be $\frac{1}{500}$ at f11 but it is wise to bracket downwards on such subjects so $\frac{1}{250}$ and $\frac{1}{125}$ shutter settings should also be used. These exposures do not record detail in the foreground, but the slower speed $\frac{1}{125}$ may pick up the reflection of the moon over water. The best time to photograph the moon, if land or water details are also required, is at dusk if moonlight should fall at a convenient time. Some skylight remains and is especially useful if colour film is being used.

Photographing by the light of the moon, when detail is wanted in the foreground and the moon is not in shot, requires much more exposure. Using the same 400 ASA film a one minute exposure at f4 is a good starting point for experiment. Bracket exposures by two and three stops over exposure. Reciprocity effect will further lengthen long exposures and if the meter is sensitive enough to give a reading in moonlight, these exposure readings must be substantially adjusted, for example a five second reading from the meter requires a one stop increase in camera, above the indicated f stop, a 20 second reading a two stop increase and a 60 second reading three stops. A tripod, of course, must be used. Very high speed film is required therefore to keep exposure times short and any ambient light or reflected light from snow, buildings or water is always useful, so seek it out.

MOTION STOPPING

(See *Action Photography*.)

MOUNTING

Photographs for copying, exhibition and display should often be mounted to a stable sub-mount so that perfectly flat

Clean Iron

Clean Paper

a

b

Cover Paper

Print (face up)

Mount Board

c

d

Dry mounting technique.

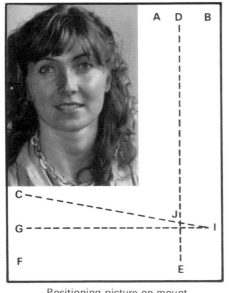

A D B

C

G I

J

F

E

Positioning picture on mount.

surfaces are presented to the viewer or the copy camera. Wet mounting of large fibre-based paper murals is still the best method and only needs care and cleanliness to achieve good results. Use a paste of low or neutral acidity, first wipe the back of the print well with a clean, damp, lint free cloth, apply paste thinly and quickly with a large brush. Lower the pasted print gently on the mount and with a clean, slightly damp cloth, beginning from the centre, press the print into contact. Do not wet the print excessively before pasting otherwise it will stretch, but a totally dry print will not adhere well. Wipe off all excess paste on the edge of the print immediately and do not let paste touch the print surface. This wet mounting process is hazardous to colour prints, therefore it is advisable to use dry mounting as a technique and paste will not work with RC papers at all well.

Dry mounting uses a tissue which melts under heat and is the cleanest and safest method for smaller photographs and all colour photographs, but some pressure is needed while the bonding takes place. This is usually created by a special machine called a dry mounting press but, by the use of a household iron, small prints may be successfully mounted. Again, clean mounts, pictures and working areas are essential (see fig.).

Cold mounting with special double-sided adhesive film, obtainable in rolls, such as 3M or Neschen of West Germany supply, are also good methods. Spray adhesives from aerosol cans can be used for very small pictures but this method should be considered more of a temporary technique. Do not

inhale the spray from these aerosol adhesives as it is very damaging to the lungs. Archival mounting, which is a separate issue altogether, is discussed in *Archival Processing, Storage and Presentation*.

Photographers can mount important pictures attractively by using another piece of photographic paper of the same weight, either fixed to a clear white without exposing it, or after exposure fully to light, developed and fixed to a maximum black and then washed and dried. The dried backing sheet is tacked to the mount tissue and the photograph bonded to it. Curling of prints is neutralized and thin, strong mounts are aesthetically very pleasing.

Exhibition prints sometimes need an over mount, or window mount, but generally this is too pretentious for modern photographs and need not be considered except in decor schemes where designers need to harmonize the picture more easily with wall finishes.

MOVEMENT

The photograph can analyze movement in two ways, by selecting a precise segment of time and isolating this very clearly and sharply with high speed, action stopping techniques (see *Action Photography*) or by allowing movement to blur into an unsharp trace of the path of action over a much longer period of time. Sharpness and unsharpness have different roles to play in the illustration of movement. Sharpness is best used for informational purposes, where analysis of the action is needed or clear identity of the performer is desirable, such as in sports photography, training pictures and wherever there is a need to particularize a situation involving movement and its environment.

Unsharpness suggests the rhythmic qualities of unfolding movement, a sense of continuity and tends to illustrate the action and transient nature of that action in a generalized way, rather than identify any personality or performer in the midst of such action. Stroboscopic effects, where multiple sharp images are formed on one exposure, can create both analysis and flow information and where they are also coupled to blurred movement, very interesting creative images may result. (See fig. overleaf and *Action Photography, Basic Photography*.)

Above left These are the steps in mounting.
a Lay mounting tissue (larger than the print) on the *back* of the print.
b Fix together by *gently* touching the point of a medium/hot iron to the tissue. Trim off excess tissue to fit the print precisely.
c Lay clear, strong, unprinted paper (such as brown wrapping paper) over face of print and mount, with print in a pre-determined position. Tack two corners together by *gentle* pressure of the iron for 10 seconds on the cover paper along the edge of the print.
d Lift the cover paper, check that the print is still correctly positioned, return the cover paper to cover the entire print and mount and with *gentle* pressure and a slow ironing motion continue to pass the iron over the whole area of the mount. Fibre-based papers need a medium/hot iron and 10-20 seconds of ironing for small prints, while RC and colour pages need a much cooler iron and low melting temperature mount tissue.

Left An easy way to find a pleasing position for the photograph in relation to the mount format. Place picture in top left corner of mount, measure remaining space and divide it with a faint line DE and GI. Take a diagonal line from C to I and where it intersects DE (J) place the bottom right hand corner of the picture on this point, make sure the print is squared up in relation to the mount and then fix firmly in position.

MOVEMENTS OF THE CAMERA
(See *Large Format Cameras*.)

M-SYNCHRONIZATION
Most leaf or between lens shutters have a synchronizing switch marked with two positions, M and X. M is used when firing expendable flash bulbs and X is for electronic flash.

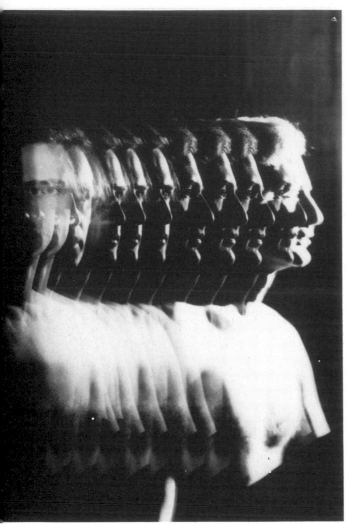

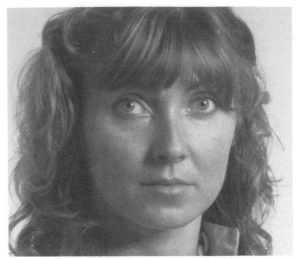

a

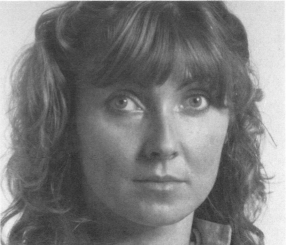

b

c

Sophisticated equipment allows the photographer to make pictures of movement in sequence on the same frame, but pseudo-stroboscopic effects may be achieved by using the sliding back of a view camera, as this picture shows.

MULTIGRADE PAPER

This is enlarging paper which, in a single sheet, embodies a potential for all grades or contrast which are normally to be found in separate emulsions. The chosen contrast grade is selected by filtering the light source with special filters and if certain areas are carefully masked during successive exposures on one sheet, different filters can be used to produce different contrasts in a single image. Many professionals use this paper and consequently reduce their need for multiple stocks of paper but also gain added printing potential for difficult negatives. (See *Enlarging*.)

d

e

Ilford Multigrade paper is useful for those who also use colour enlargers as the filter head can be used to alter print contrast, requiring the photographer to carry only a single grade of paper for B/W enlarging. These prints were made on a Berkey Omega C760 enlarger.

a 120 yellow filter, exposure 20 seconds, for low contrast prints or to compensate for high contrast negatives.

b 80 yellow filter, exposure 18 seconds, giving a slight increase in contrast.

c No filter, normal white light, 8 seconds. Gives a soft-to-medium contrast for normal negatives.

d 80 magenta filter, 18 seconds. Medium-to-hard contrast for making reproduction or exhibition prints from normal negatives.

e 200 magenta filter, 20 seconds. Maximum contrast for making reproduction prints from normal negatives. Note the change in exposure time when filtration is increased or decreased. Of course intermediate filtration is possible to give the best contrast from any individual negative. Safe-light should be that which Ilford recommends, as some normal bromide safe-lights cause fogging. (See *Enlarging, Kodak Polycontrast table,* page 118.)

MULTIPLE EXPOSURE TECHNIQUE

By exposing successive subjects on the one sheet of film, interesting creative results are obtained. It is easiest to do this on a sheet film camera or a non-automatic roll film camera but the latest SLR cameras are now fitted with a switch which turns off the film transport mechanism while the shutter is wound. If 35mm cameras are not equipped in this way, it is usually possible to keep the frame in place for extra exposures, if the re-wind button is held down while the film winder is activated to prime the shutter (see *Image Synthesis*). Sufficient dark areas must be left in each image to allow the succeeding images to be visible or each image is under-exposed to allow the next image to inter-mix. Where this effect is wanted, it is customary to divide the normal exposure by the number of multiple exposures planned. Thus if three images are being overlaid on one frame, the normal exposure is reduced to one-third of normal and each image under-exposed at this setting. This will produce a well balanced montage effect and where they overlap, normal full exposure is obtained.

This is a typical filmic montage where each form enters the other. Taken from a colour transparency.

MULTIPLE FLASH

It is the rule in professional studios to use several flash heads to light the subject, and on field shooting, indoor family pictures or other occasions where flash provides the main sources of light, it is certain that multiple flash will improve the photograph.

For the professional, all of the studio equipment and flash generators permit the use of several lamps, synchronized from a central point. Where portable or battery fired flash units are used away from the studio, synchronization is important and a little more difficult. Multiple flash is best attempted with electronic flash, as synchronization is more certain. Synchronization may take place through the use of long wire cables, slave cells, infra red transmitters or radio pulse transmitters. In bright light or sunlight, only radio sync. or wire cables can be used and wire cables are always a hazard if many people are nearby. If they must be used, take them above the crowd if possible, using strong cloth tape so that main traffic areas are clear. Radio pulse sync. is possibly the best, but its use is generally regulated by the communication authorities. Synchronizing multiple sources by cable requires a multi-point fitting for the shutter socket or extension plugs in the main flash unit, interconnecting to the satellite flash units.

Where ambient light is low, photo cell *slave* units, triggered by the master flash, are connected to each flash unit to fire in synchronization or an infra red transmitter is connected to the shutter and a receiver is placed with each flash unit. This avoids using cables to each unit but flashlights from other photographers may trigger the slave cell at an inappropriate time, if photo slave sync. is used in crowded press conferences or similar events.

Placing flash lights in multiple set-ups is no different from normal lighting techniques (see *Lighting*) except they must be aimed very accurately and sighted at the subject to make best use of their concentrating reflectors. A key light must dominate and all other lights must be used to support this main source. If flash is left on camera this often becomes a suitable fill light but should be diffused. A facial tissue, pure white, over the flash head, one normal thickness, should reduce the light approximately half a stop, two tissues will diffuse more light and reduce it one stop. A one stop reduction of this on-camera flash light, with a key light placed off camera at the correct distance for normal exposure, is the simplest and most effective way to use twin flash units to produce strong rendering of form. More flash is required to light large areas or groups and these lighting plans also must conform to general lighting practice. Bounce light on the ceiling, as a key light, creates a broadly diffused flash, or direct flash reduced two stops by several thicknesses of facial tissue placed over the reflector can cover large areas successfully (see *Bounce Light*).

Estimating the exposure for multiple flash is surprisingly easy. Using flash units with matching guide numbers, place the key light and estimate correct exposure by accurately measuring the distance from this main source to the subject. Divide the distance into the GN (guide number) to obtain the f stop setting. Place fill lights in position, masked with two thicknesses of white facial tissue, at precisely the same

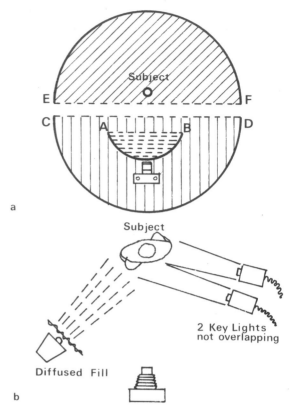

a

b

Calculating exposure for multiple flash.

a Any key light, located in the arc A-B will determine the exposure. Additional lights in the arc C-D which do not overlap the light-fall from the key light will add light and require a reduction of half a stop if one extra light is used or three quarters of a stop less if two extra lights are used. Accent lights in the arc E-F or fill lights in the key light area do not require exposure changes. To calculate exposure, use the guide number of the key light(s) and if other lights are in an area C-D but not in the segment covered by the key light, reduce the exposure as needed. Disregard accent lights or hair lights.
b In this example use the guide number from the most powerful of the key lights to calculate the exposure then reduce by half a stop.

distance from the subject as the key light. Accent lights from the back, or extreme side, also need to be the same distance from the subject but without diffusion. The fig. above shows a typical set-up. If two lights are placed so that the flash is the same distance from the subject and overlapping, reduce the aperture by one full stop. If the light throw does not overlap from two such lights the GN from one unit is used to estimate such exposure.

If the flash is kept off camera it leaves the camera free to move nearer or further from the subject without affecting lighting or exposures. If one flash must be kept on camera, therefore creating fixed distances of flash to subject, changes in image size are best obtained by using a zoom lens.

MUNSELL SYSTEM

Albert H. Munsell, an American scientist researching colour, invented a systematic notation of colour as regards hue, value and chroma. It follows closely the perceptual psychology of normal vision and has been used widely since 1915 as a background to colour research and harmonic theory and for the popular identification of colour. His own book and those based on his system are useful to photographers (see *Colour Harmony*).

MURALS

Very large (in excess of 100 × 150cm; 40 × 60 inch) photographs are generally classed as murals and they are displayed in commercial areas, offices and public buildings. Usually they are constructed to fit closely to the brief decided upon by a designer or architect and the image is therefore commissioned to fulfil a very precise need. Printing such images may be done by the *Scannergraph* method for large seamless photographs or by more conventional means of photo-print mounted on wall board and butt-jointed to cover large areas. Such images are seen from considerable distance and often fleetingly, therefore they can afford to be simple, colourful and bold, with an uninhibited use of symbolism. Care must be taken to locate murals in such a manner that light does not reflect off the surface too strongly and that they are not easily vandalized or accidentally damaged. For the occasional mural maker using black and white materials, large, temporary tanks may be constructed, but filling, emptying and washing etc., creates formidable logistics. It is usually easier, cheaper and more effective to give these jobs to a custom printer who has the right equipment for large prints.

MUYBRIDGE, EADWEARD (1830–1904)

An Englishman living and working as a photographer in the United States since his early twenties, Muybridge became interested in the photography of nature. In the 1870s he began a series of analytical photographs of the movement of the horse at the instigation of Leland Stanford, Governor of California. Using as many as 24 cameras he was able to show that, at speed, the animal was often momentarily not touching the ground. This, and the position of the horse's limbs during motion, re-directed the attention of animal painters to the subject and caused them to revise their drawings greatly.

Muybridge went on in the early 1880s, under the auspices of the University of Pennsylvania, to explore the motion of humans, birds and animals. This was published as a monumental book by Lippincott, analyzing the sequential actions of live subjects and considerably revising the established theories held at that time by doctors, painters, biologists, engineers and all who derived a livelihood from the observation of animal locomotion.

An example of the photography of movement by Eadweard Muybridge taken in the 1880s. (*Courtesy Kodak Museum, Harrow*)

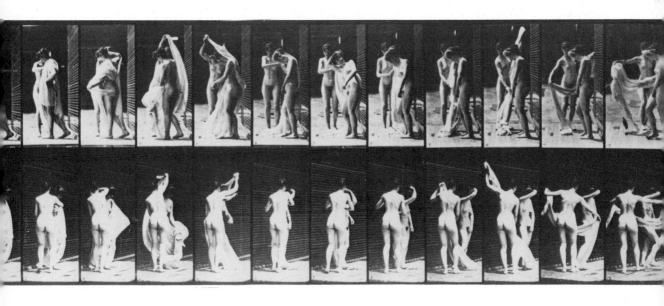

NADAR, FELIX TOURNACHON (1820–1910)

Nadar, a Frenchman, was a latecomer to photography, having been concerned with journalism until 1852. He was, though, a born entrepreneur and showman, who was also an adventurous and extremely sensitive photographer.

He was a friend of the Impressionists in their bleak, early years and fought, successfully, for photography to be exhibited as art in Academy events. He took the first photographs underground by artificial light in 1859 and the first photographs from a free-flying balloon about the same time. His magnificent portraits of such people as Daumier, Delacroix, Victor Hugo and others, frankly reveal the humanity and vitality of the French intelligentsia of the day and are some of the most sensitive examples ever made of photographic portraiture.

In 1886 he and his son Paul created the first photo-interview with the great French physicist and colour theorist, Eugène Chevreul. Nadar senior was 66 years of age and Chevreul 100. A verbatim text was published with the pictures, creating the world's first photo essay.

NATURE PHOTOGRAPHY

Photographers are basically trophy hunters, keen to capture tangible evidence of their experience and today's modern cameras seem to be a more comfortable way of securing this than the gun or net. It is necessary first to develop an ability to discern the active elements of the nature scene before you, to develop an awareness of the sounds and sights of natural life and penetrate its subtle camouflage.

The equipment necessary will depend very much on the degree of concentration on any one area of interest, but in general it is normally the 35mm SLR which will be chosen for its precision and flexibility.

Lenses will tend to be long and have wide apertures, and possibly favour zoom optics with a macro mode. A medium wide angle could be useful and of special use is a slightly longer than normal macro lens, for example a 60 or 100mm. These macro lenses perform at their very best at short and very short distances and will offer rapid focusing to very near distances with exposure compensation being automatically adjusted. Both Zeiss and Nikkor supply excellent lenses of this type. Those whose interest is flora, insects and the sublevel of activity to be found in ponds, will need also a bellows attachment to allow for macro focusing and very close up work (see *Close-up Photography*).

A good example of nature photography in close-up. For this shot of a locust chewing a piece of lettuce leaf, a standard lens mounted on an extension tube was used. One flash unit and a small reflector provided the illumination. (*Courtesy Arnold Wilson*)

For the photographer wanting bigger game, such as wild animals or flying birds, long lenses will be best, even though shallow depth of field is inherent in these optics. The Questar lens, which is in reality a small telescope, is ideal for very sharp results in the 800–1200mm focal length range. This lens must be used on a tripod if shutter speeds of less than $\frac{1}{500}$ second are contemplated and heat or haze mirages are greatly exaggerated by lenses of this power. For general work and when using lower, hand-held shutter speeds, a 200mm lens would be ideal. It should be the fastest lens of good quality which can be afforded. Zoom lenses also have their place especially if they have a close focusing capability, but results may not be as crisp as the individual lenses and colour saturation is often much less. Tele-converters do assist in adjusting one lens to different focal lengths but optically they are often poor performers.

Colour emulsions chosen by most wildlife photographers will be in the 200–400 ASA range with possibly a Kodachrome 64 ASA film for fine grain and high acutance in colour when the light is sufficiently bright or shutter speeds are slow. There is generally a high wastage of exposures in much of wildlife photography as the subject is such a volatile one and therefore it is often advisable to load with colour reversal film and make

transparencies rather than negatives. This allows the photographer to edit carefully with a magnifier and discard all but the few really good images. Prints could then be made on Cibachrome, which is a direct reversal paper, and gives very sharp, richly saturated colour, or on the Kodak reversal material, R14. It is also possible, by using an internegative, to make positive/negative prints from the chosen slides or to simply project them. If, however, you value the images, do not expose them for longer than a few minutes maximum in the projection gate as fading is very rapid under such bright light.

The camera is best equipped with a motor drive to advance the film, but in many situations the combined sound of shutter and winder is so loud that the hand lever must be used for silent film advance. An excellent compromise as regards sound seems to have been found in the Rollei SL2000 which is reasonably quiet in its motorized functions. For very quiet operations the use of a twin lens, 6×6cm ($2\frac{1}{4} \times 2\frac{1}{4}$ inch) Rolleiflex or a rangefinder type 35mm Leica, may be advisable despite some of their limitations.

Flash in the field is enormously useful, particularly if it is the dedicated kind, but it should have a telephone cord extension cable of at least one metre so that it may be operated off-camera. A small stand will also be needed for the flash, and a reflector of white cardboard, with aluminium foil on one side, about 30×40cm (12×15 inch) and a cable release. This should complete lighting arrangements. A small, but strong, tripod with a ground level operating mode as well as operating positions for normal heights should be carried.

Remember that in close-up situations, or all wildlife activity taking place in the shadows of a sunny landscape, the camera can easily be defeated in terms of automatic metering. A spot meter is most useful as a separate hand-held instrument (see *Exposure*). In these difficult lighting situations it will often be necessary to override the meter and increase exposures by one or two stops to offset the high contrast conditions.

For shy animals and birds, remote cable releases, either operating by radio or infra red pulse, may be needed so that the camera may be pre-focused on nests, drinking pools or food bait and, for fast flying insects or birds, highly sophisticated electronic triggering may be found necessary. Whenever using remote triggering devices, an automatic film winder is usually an advantage as it allows the photographer to remain in suitable cover for a number of exposures.

As with landscape photography, all equipment must be protected from rain, direct sun, abrasions or falls and the photographer must wear comfortable but protective clothing for the particular environment and weather of work. Dark clothing is obviously better than brilliant colours or white, but this camouflage should not be worn in any area where gun sports take place. Those photographers with natural skills of stalking and the ability to move slowly and quietly will get the better pictures because getting close is the major difficulty in making memorable images in the field and, despite telephoto lenses, it is not always easy to get the subject full frame in the finder.

All those who enjoy nature should never be careless of the

A simple composition of a mute swan incubating its eggs on a nest of sticks and seeds. (*Courtesy Arnold Wilson*)

environment, leaving it always as near its primitive state as possible. No unnecessary sacrifice of wildlife or flora should ever be attributed to the nature photographer, no film wrappers, foil, packages or any of civilization's refuse should be left when work ceases. The beauty of looking at nature with a camera is that we can have the thrill of the chase, the aggressive act of capturing the trophy, but there is no victim. We have our prize record and nature returns again to its eternal rhythm, unharmed. (See *Action Photography*, *Animal Photography*, *Basic Photography*, *Location Photography*, *Underwater Photography*.)

NEGATIVE

This is the precise complementary or reverse record of the set of values found in the original scene. Highlights or light tonal areas reflect more light which affect the film emulsion to a greater extent, darker and shadow areas reflect very little light to the film and result in clear unaffected image areas. By printing this negative, values are again reversed, restoring the original scene and its tonal values. (See *Basic Photography*, *Enlarging*, *Developers*, *Grain*.)

NEUTRAL DENSITY FILTERS

These special filters are used over the lens to reduce the quantity of light reaching the film but without affecting colour. The most serviceable are the Kodak Wratten ND 96 filters, made of gelatin and in a wide range of densities. These very thin filters may be used in pairs to gain added density but if critical sharpness is important not more than two filters should be fitted to the lens at one time. Graduated ND filters, where maximum density gradually fades to a clear filter, are generally made of glass and are useful for under-exposing foregrounds or skies while leaving other image areas unaffected.

NEUTRAL DENSITY FILTER CHART WITH f STOP INCREASES

Density	% of transmission	Increase factor	f stop increase
0.10	80.0	1.2	$\frac{1}{4}$
0.20	65.0	1.5	$\frac{1}{2}$
0.30	50.0	2.0	1
0.40	40.0	2.5	$1\frac{1}{3}$
0.50	32.0	3.1	$1\frac{2}{3}$
0.60	25.0	4.0	2
0.70	20.0	5.0	$2\frac{1}{3}$
0.80	16.0	6.2	$2\frac{1}{2}$
0.90	13.0	7.7	3
1.00	10.0	10.0	$3\frac{1}{3}$
1.20	6.3	15.8	4
1.50	3.2	31.2	5
2.0	1.0	100	$6\frac{2}{3}$
3.0	0.1	1000	10

NEW BAUHAUS

The famous Bauhaus school which contributed so much to modern photography was finally closed by political action in Germany in 1933. It was re-formed as the New Bauhaus in Chicago in 1937 with Moholy-Nagy as a co-founder and director, whose leadership then in avant garde photography created an influence which is still changing the attitudes and styles of many modern photographers. With the added impetus of faculty members Aaron Siskind and Harry Callahan, who remained to teach when it became the Illinois Institute of Design, the theories of the original European movement were absorbed deep into American photography. The frank acceptance of the mechanical image, the constant search for new and experimental techniques, banished all of the romantic puritanism of the leading art photographers of the day to the uninspiring salon circuit. With growing confidence and with the increasing sophistication of equipment and materials, the new photographers, particularly those active in the USA, looked clearly at the world of photographic images, probably for the first time since the invention of photography, and an international movement began which transformed the commercial and artistic presen-tation of photographs in a manner which still penetrates photography today. (See *Bauhaus, Moholy-Nagy*.)

NEWTON'S RINGS

Tiny prismatic wave forms are sometimes visible if very glossy surfaces are tightly compressed. This is noticed if glass negative carriers are used with glossy backed film or if colour slide glasses for projection are not etched or have air space between slide and glass. Small format films, where the phenomenon is most noticeable, should be enlarged in glassless negative carriers or in those which have a microscopically etched surface. Slides can be bought with anti-Newton ring cover glasses. Glossy, light toned copy material under weighted glass can also suffer this problem and a thin spacer, half the thickness of a small coin, will generally introduce enough air space into the copy-to-glass area to prevent deformation.

NICKEL CADMIUM BATTERY

A special long-life battery, usually re-chargeable, having a good cost-weight-energy ratio which makes it highly suited for use as a power source for photographic purposes.

NIGHT PHOTOGRAPHY

The best time to obtain a night effect with reasonable detail in the darker areas and separation of foreground and sky is at dusk, while skylight is still strong, but lights are all blazing. Snap shot exposures with 400 ASA film could be made in the region of $\frac{1}{30}$ to $\frac{1}{60}$ at f4, but if a sensitive CdS. meter is not available to you for exposure estimation or the camera meter is not of this type, it will be necessary to guess and test beforehand.

Rain, water, large glass buildings, bright mercury lights, all assist in getting better looking and better lit pictures. A tripod will be needed for exposures longer than $\frac{1}{30}$ second and the photographer will also need a cable release.

Night photography generally produces very high contrast lighting problems, bright highlights and inky shadows with no detail. If B/W film is loaded, low contrast processing can help, by over-exposing 30–50% and developing in a compensating developer such as Kodak D23 or May and Baker Promicrol diluted 1:2, developing 20% less than normal times. For colour film some help may be found by using 20% over-exposure and low contrast filters, but the only really successful way is to shoot in the early dusk when skylight acts as a giant fill light. Many night shots, of course, can stand considerable over-exposure in the highlights and dark areas may therefore be exposed fully with a burn-out effect in all brightly lit areas of the picture.

When time exposures are being used, all lights from traffic moving past the camera will record as trails of light and this can create interest in some city scenes. However, if this is not wanted, cap the lens while the light passes. Very expressive night pictures can be made by gently moving the camera

during long exposures, creating patterns and traces around any bright light source.

Shop windows can cause a problem when it is essential to render them clearly without reflections from passing traffic or nearby buildings. Polarizing filters and acute camera angles to the window plane sometimes will help, but exposure is increased considerably. The only effective way for the professional to do the job is to have a very large screen of black fabric held up behind the camera by two assistants. Failing this it may be possible to arrange that window lights are turned on in the very early hours of the morning for the areas to be photographed, hoping that neighbourhood buildings by that time are not lit.

Floodlit buildings are generally best photographed by short exposures with the camera on a tripod but, again, in the few minutes around dusk just as the lights are switched on, snap shot exposures are possible with high speed film and good sky detail then assists separation. Choose dark forms to break into the edges of such brightly lit buildings to add dimension or use traffic ways to give added interest with streaks of light. If it is not possible to work with perspective corrections, such building often look interesting at night from very close, looking up with a moderately wide angle lens. Special filters, called star filters or diffraction gratings, can be used over the lens to spread specular light sources into interesting halos, star points or prismatic bands of colour. These can add drama to dull scenes, but should be used with some restraint. Their effect is greater as wider apertures are used (see *Exposure*).

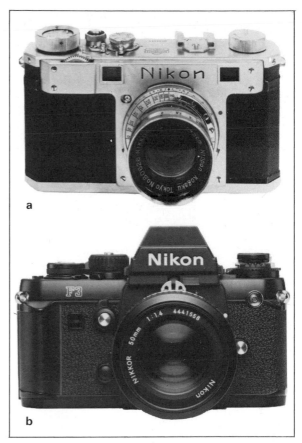

The evolution of a famous camera. The first Nikon, (a) strongly resembling the Leica, produced in 1948 and (b) the 1980 model, a unique design in its own right. (*Courtesy Nikon UK Ltd*)

SUGGESTED EXPOSURES FOR COLOUR TUNGSTEN (3200K) FILM, USED AT NIGHT WITHOUT FLASH

Film is push-processed to achieve a one stop increase above the rated film speed.

Kodak Ektachrome 160, rated 320 ASA		3M – 640, rated 1200 ASA	
City streets	$\frac{1}{60}$ sec. f2.8	$\frac{1}{60}$ sec. f5.6	
Signs	$\frac{1}{60}$ sec. f5.6	$\frac{1}{60}$ sec. f11	
Shop windows	$\frac{1}{60}$ sec. f4	$\frac{1}{60}$ sec. f8	
Stadiums	$\frac{1}{60}$ sec. f2	$\frac{1}{60}$ sec. f3.5	
Spotlit stage	$\frac{1}{60}$ sec. f4	$\frac{1}{250}$ sec. f3.5	

These are considered as the slowest speeds possible without using a tripod. If possible run a test film under these conditions and process the result. Fast movement will be blurred.

NIKON

Of all the 35mm SLR cameras to make an impact on the market, none has been more influential in the professional segment than Nikon. From its early beginning in 1917 with the Nippon Kogaku KK Optical Company, the camera evolved as a useful addition to the growing 35mm technology, but from 1950 onward the SLR became known for rugged dependability, ease of operation and professionally successful results. More than 30 years later the camera is still a favoured brand for many professionals and experienced amateurs worldwide, with many accessories now available to extend the camera's universality.

In 1973, NASA, the US space organization, used Nikon equipment on Skylab missions. The Company also fosters a general promotion of photography by its wholly owned activities in the photographic gallery field and also with the Nikon club which co-ordinates photographic activities of users of their equipment.

Nikkor technical lenses for large format cameras are particular favourites for the type of precision work needed in scientific and studio photography (see *Appendix* for addresses).

NINE NEGATIVE TEST

When faced with an unknown B/W film or B/W film-developer

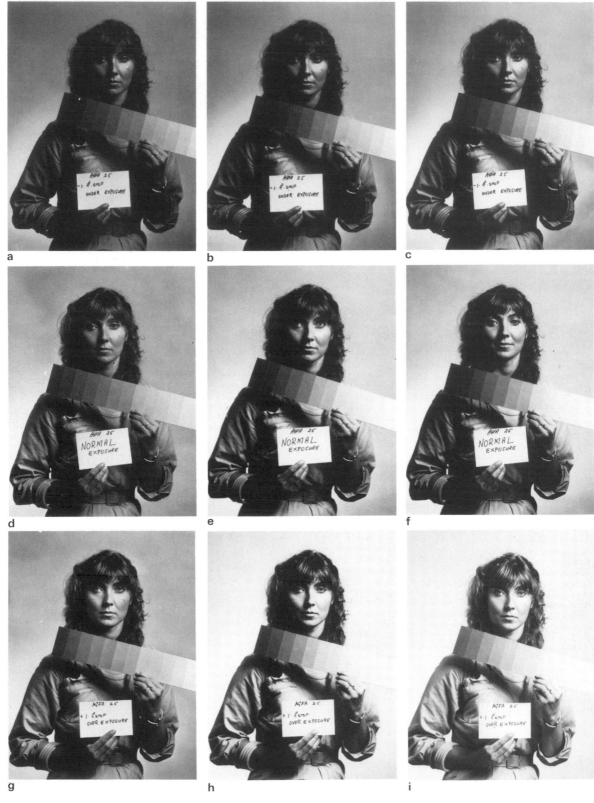

combination, or if personal exposure indices are being worked out, it is possible to test methodically for the best combination. Nine sheets of film are used or nine pieces of roll film. Three of each are exposed normally; three over-exposed one stop and three under-exposed by one stop. Each piece is then developed singly, one at normal, one at 30% under normal times, one at 50% over normal time. For a complete record the exercise can be repeated with daylight, tungsten and electronic flash.

The best subject is a head and shoulder portrait of someone wearing neutral colours and holding both a grey scale and colour scale slightly angled to camera to prevent flare on the scale surfaces facing camera. Data should be noted and a normal contrast, 18 × 24cm (8 × 10 inch) print made of the results. A large grey scale could be photographed close up instead of using a human subject, as in fig. opposite, for nearly the same result.

Left The nine negative test.
a One stop under exposure with 30% less development.
b One stop under exposure with normal development.
c One stop under exposure with 50% more development.
d Normal exposure with 30% less development.
e Normal exposure with normal development.
f Normal exposure with 50% more development.
g One stop over exposure with 30% less development.
h One stop over exposure with normal development.
i One stop over exposure with 50% more development.

NOTCH CODES

Large format film carries a series of notches in the corner of the sheet. It is used to identify different emulsions in the dark and to assist loading dark slides correctly. (See *Large Format Cameras*.)

Notch codes for loading. If notches are kept in the top right corner, the emulsion faces out.

NUDE PHOTOGRAPHY

The successful photography of the male or female nude requires considerable discrimination and taste. The borderlines between eroticism, obscenity, art or the banalities of voyeuristic images are ill defined and the photographer must consider carefully all the implications and complexities of this type of work before making a beginning. Each community exercises substantial control over the public use of such pictures and it is well to understand this matter.

Selecting a model is a matter of negotiating either with specialist commercial agencies who will supply professional photographic models, usually at double the normal advertising rates, or by direct arrangement with a model who may be a professional dancer, an artist's model, or an amateur who is interested in such work. In the initial stage of any discussion with any prospective subjects for nude photography a clear agreement must be made between model and photographer about usage of the pictures, fees and working conditions. It is often wise to offer the model the right to review all photographic material arising from the sessions and assist in selecting the final pictures.

In deciding where photography will take place, attention must be given to the matter of privacy and comfort for the model so that a relaxed atmosphere is evident in the final pictures. Close-ups of torsos or limbs may require a warm environment so that skin is smooth and a light oiling of the skin will produce an attractive sheen. This is best obtained from the use of a body cream which disappears quickly into the skin, rather than a conventional oil. It should also be remembered that lenses longer than normal will add considerable visual weight to a nude person and if more than twice the usual focal length lens is used, very slim models are needed in order to obtain pictures which appear in normal proportions in the final print.

Perhaps there is no other field of photography where it is so essential to achieve a really flawless photographic technique and there is no quicker way to produce indifferent images, if photographic skills are poor. Lighting will be vitally important, very often depending on broad source key lights placed in the top front zone (see *Lighting*) with considerable fill, often enough to produce a high key effect. Harsh spectral light, revelatory of contours, may be chosen for dramatic effect or for the origination of graphic images. The aim must always be to arrive at maximum quality of print and if skin texture and contours are part of the visual concept, over-exposure is the most likely fault. Richness of texture in the skin will be evident only if the skin is treated as a highlight, at the top of the brightness range, and exposures adjusted accordingly. In colour photography, skin tone is often surprisingly difficult to achieve, needing careful filtration with cc filters to arrive at a right balance of healthy, slightly warm tones and the selection of those films best orientated to natural flesh tones must be made with care. Agfa is notably good in this respect.

Location work with nude models imposes certain problems in respect of privacy and weather conditions but if these are solved a good beginning in nude photography can be made. The model must appear relaxed and project a mood of frankness and normality. Remember that posing the model

Left Bill Brandt startled the art world with his inventive use of a wide angle lens to distort the female form. He took more than 15 years to complete this particular assignment. (*Courtesy Bill Brandt*) (See also the entry under *Brandt*.)

The creative use of a large screens in front of the figure can produce most unusual images, especially in colour. The figure is defined sharply but with distorted forms whenever it actually touches the screen and several lights are used to cast multiple shadows.

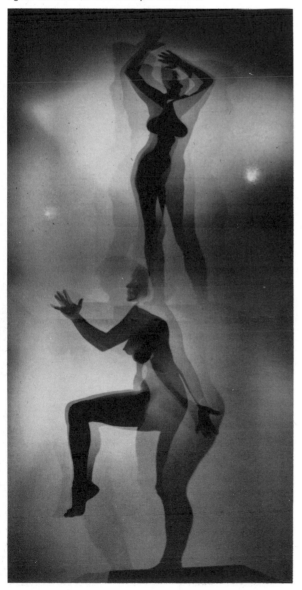

The beach is a natural environment for the nude. Here the bright light is countered by strong fill light and use is made of drift wood textures to contrast against the smooth contours of the body. (*Courtesy Terry Fincher*)

requires care and constant verbal direction from the photographer in controlling the negative spaces created by differences in contours and backgrounds. Hands and feet are especially significant and models should be chosen who have a degree of elegance in these features as they greatly enhance body movement.

In the interests of anonymity which may be desired by the model or the publisher of the picture, identity can be concealed by close-cropping, although this often looks a little coy, or by head movement. Contours may be dropped out by using rim lighting around the figure, graphic abstractions or under-exposure, and these techniques are often needed if the photograph is to appear in very public places or, for example, in family magazines. Generally, commercial clients will be bound by the law and their companies' aesthetics. Beginners will find good examples in the art of photographers such as Edward Steichen, Edward Weston, Clarence White, Harry Callahan, Irving Penn, Bill Brandt, André Kertész, Emmett Gowin and Jean-Loup Sieff.

For the artist photographer the concept must be free of commercial inhibition while exploring photographically the sensuality of the naked body, or using it for its graphic and intellectual purity, to produce a poetic narrative of subjective imagery. Whatever the reason for its creation, photography of the nude asks of the photographer a maturity of vision and photographic skill which is not easily attained. (See *Image Synthesis*.)

Graphic treatment of the nude figure, using high contrast film.

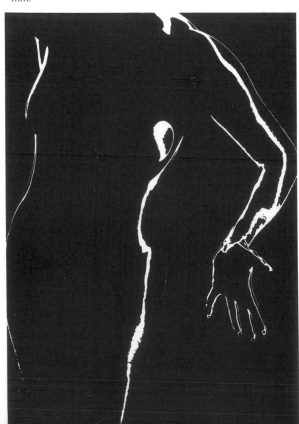

OFFSET LITHO
(See *Photo-Mechanical Printing*.)

OPAQUE MEDIUM
This is a dark red or black viscous liquid which is applied to negatives to black out unwanted light areas.

OPEN FLASH
When the shutter is open on the B or T setting and the flash is fired manually this is an 'open flash' firing. If there is doubt about synchronizing, this bypassing of the synchronizer switch will result in good exposures and it may be found that slightly more light is reaching the film this way than when synchronizing is catching only the flash peak. This technique is also frequently used when long time exposures are combined with the need for flash light in certain areas, such as is necessary in large dark interiors.

OPTICAL CENTRE
The optical centre of a rectangular format is generally to be found midway on a diagonal line drawn from the centre to the top right hand corner. A primary centre of visual interest can be created here to emphasize the visual concept (see *Image Management*).

OPTICAL SCANNING
The scanner is a device which focuses a tiny bright beam of light onto a print or a transparency which is being reproduced by photo-mechanical means. The transparency spins on a hollow glass cylinder and the focused point of light scans the picture minutely for information which is required for separation negatives or positives.

OPTICAL VIEWFINDER
This device clips to the accessory shoe on the camera to provide a bright optical image of the subject. It often has adjustable positions to use with other lenses but it is not connected to the focusing mechanism.

OPTICS
An image is made by collecting reflected light from the subject into a transparent object called a lens which then modifies the rays of incoming light to some degree and passes this light to a

light-sensitive surface which then makes the image visible. A crude image can be formed without a lens by the use of a *pin hole camera*, or even by accidents of nature where tiny holes are formed in otherwise opaque substances, such as when large leaves are blocking the sun's rays and are moved by the wind. Images of the sun may then be seen on shadowed ground.

The lens forms a point image of those rays of light parallel to its axis which is called a real image and the distance from this point image in the lens to the film is called the focal length. Such lenses for photographic use have a control to reduce the transmission of light through the lens. This is called an aperture or f stop. The f stop number is found by dividing the diameter of the aperture at that point, into the focal length of the lens. The lens is said to have a certain speed and this is the maximum aperture which passes maximum light through the lens.

When a lens is focused on a far point, the image of sharp focus is formed close to the lens, but when focus is struck on a near point the lens-to-image distance must be extended to obtain sharp focus (see fig.). This variable dimension is known as the image distance. When the image distance is equal to the focal length of the lens, objects at infinity are sharply focused. Optical glass is made from a mixture of sand containing oxides, plus sodium carbonate and various metallic additives which are heated in platinum crucibles to intense temperatures of up to 1600° Celsius.

Lenses, however expertly made, are all subject to some faults and optical designers use increasingly complex assemblies of multiple lenses to cancel these faults from the image, but lenses are strictly expected to cover only certain format areas. Aberrations are found to some degree in all

x = the image distance

The image distance in the camera increases sharply for close subjects, altering the true aperture values of indicated f stops, requiring exposure compensation.

lenses and some of these are illustrated under *Lenses*.

It is a good practice, therefore, to buy always the best lenses affordable and only those from reliable makers. (See *Light, Lenses, Vision, Basic Photography*.)

ORIGINAL

This is considered to be a camera image in all cases or the first generation transparency or print in graphic techniques. Copying or duplicating the originals creates loss of tonal quality due to an increase in contrast and, in colour materials, it is normally necessary to use CC filters to compensate for colour shifts and perhaps contrast control techniques to lower contrast ratios.

ORTHOCHROMATIC

Photographic film or paper which is orthochromatic is not sensitive to red light and can therefore be processed under a red safe-light. Red objects photographed on orthochromatic material appear much darker than normal and because of an increased blue sensitivity, blue sky will be rendered much lighter.

OSTWALD, WILLHELM (1853–1932)

A German photo-physicist who won the Nobel Prize for chemistry in 1909 and specialized in chemical theory and sensitometry. He is also known for producing a Colour Atlas which established a system of colour classification and for scientifically linking colour with the psychological and physiological responses of the body.

OVER–DEVELOPMENT

When a negative or print is left in the developer for longer than normal it is over-developed, thus increasing contrast and density and, possibly, also separating dark tones to a greater degree. (See *Nine Negative Test, Developers, Contrast Control*.)

OVER–EXPOSURE

This is when too much light is allowed to reach the film by design or a faulty estimation of exposure needs, or if the shutter is not in good repair. Increased density and lower contrast are generally coupled with increased grain except in the case of *chromogenic* monochrome films. Colour reversal (slide) film is lighter and desaturated when over-exposure is present. (See *Contrast Control, Developers, Nine Negative Test*.)

OXIDIZATION OF DEVELOPERS

Developers oxidize rapidly in contact with air and this is increased where stirring or agitation is excessive. Oxidizing tends to cause muddy results with greyed-out highlights and poor contrast in shadow areas.

PAINTING WITH LIGHT

Washing large interior areas with light may sometimes be the only way to overcome the problem of sufficient exposure and this is done with a single strong light source aimed in overlapping strokes over the subject or with overlapping flash exposures while the shutter is held open throughout. (See *Lighting*.)

PANALURE PAPER

This is a Kodak panchromatic enlarging paper with a warm, black image, suitable for making B/W prints from colour negatives or for making paper negatives in large format cameras. Grey tones are rendered in approximate proportion to the visual brightness of the colours being translated. A Kodak safe-light filter, number 13 (dark amber), with a 15 watt bulb may be used, but total darkness is to be preferred. It is processed in normal B/W print solutions.

PANCHROMATIC FILM

This film is manufactured to be sensitive to all the visible spectral colours and to render them proportionately in grey tones. Some manufacturers suggest the use of a safe-light, often a dense amber or dark green, but fogging is still a risk, especially with high speed material. It is far better to consider that panchromatic film is always developed in total darkness.

PANNING

The act of swinging the camera from a fixed viewpoint to follow the path of action of a subject is called panning. The subject then remains comparatively sharp but backgrounds are blurred. A better technique is to follow the action on a parallel path, keeping pace with the subject by placing the photographer and the camera on a moving platform, such as a four-wheel trolley, a car, helicopter, boat or whatever is most

Two ways of panning, from a fixed viewpoint (a) and from a moving viewpoint (b).
In (a), A is the path of movement of the subject, B is the pre-focusing distance, C the position of the camera at exposure, D the arc of the camera as it follows the subject approaching and leaving exposure point, and X is the exposure and focus point. Use long lenses and slow speeds. In (b), X is the exposure and focus point. Parallel panning allows many pictures to be taken during action. If speed of platform matches speed of subject exactly, very slow shutter speeds may be used, e.g. $\frac{1}{4}$, $\frac{1}{2}$ or 1 second. Use ND filters if possible.

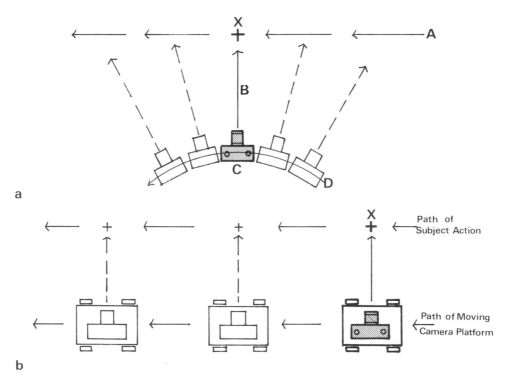

suitable to the nature of the action and the subject. Where panning from a fixed point only allows a few opportunites for good pictures, parallel panning allows the photographer to select from a flow of action. Much slower shutter speeds may be used in both of these methods than is usually recommended for stop action situations (see *Action Photography*).

PAPER DEVELOPER
Special developers are made to produce the best standard results on enlarging and contact papers and these differ from negative developers. Kodak Dektol is an exceptionally good choice as is Patterson Acuprint, Ilford PQ Universal and May and Baker Suprol, all of which are excellent. Sophisticated darkroom workers often experiment with other self-mixed formulae, such as Amidol, Pyrocatechin and so on, to obtain different image tones or other effects. (See *Enlarging*.)

PAPER NEGATIVE
Using fast enlarging paper a camera negative may be made on paper instead of film but it must be printed as a contact print and cannot be enlarged. More conventionally paper negatives are made by first making a positive film contact of the selected image which is then enlarged to the size chosen for the final print and a paper negative made. When this negative paper print is dried it is placed in contact with normal enlarging paper *emulsion to emulsion* and a print made. This positive print will have a distinctive fibrous texture and can be pleasing, particularly for portraits.

A useful short cut is to use positive reversal colour film images and expose these to a sheet of panchromatic paper, such as Kodak Panalure. This will record all colours in their correctly proportional grey tones but, of course, work must be done in total darkness or with Kodak safe-light no. 13

An example of a paper negative, showing the usual heavy paper texture which is typical of the process.

(amber). It may be necessary to oil or wax the back of the paper negative to increase translucency and pencil retouching may be carried out on the back of the negative before printing.

It is perhaps of interest to note that the first positive/negative process ever invented was that of *Fox Talbot*, the English scientist-photographer who was using sensitized paper to produce negatives even before the arrival of *Daguerreotype* in 1839.

PAPER, PHOTOGRAPHIC
To achieve a print from a B/W negative or negative colour material it is necessary to transfer this translucent negative image to a paper which has been coated with a light-sensitive emulsion, usually a gelatin compound which carries silver halide salts suspended within it. By altering the emulsion chemistry the paper can acquire different characteristics of sensitivity, contrast and image colour. The paper is also given widely varying surface textures and thicknesses.

B/W contact printing papers are slow in speed, while B/W enlarging and colour materials are very fast. Some emulsions are coated to fibrous paper which has been treated with a baryta (barium sulphate) layer to control texture, base colour and maximum densities. Others are coated to a resin coated (RC) base to minimize chemical absorption and reduce washing and drying times. Colour papers have dye forming or dye receiving multiple layers of emulsion and in the case of Cibachrome II-PS, a very stable film base is used to carry the colour emulsion. For monochrome emulsions, manufacturers produce different base tints ranging from pure white through cream and light beige, to bright red, greens, yellows and metallic fluorescent colours. With B/W bromide papers, image tone changes radically in certain developers, but emulsions are also available in image colours ranging from blue-black to warm brown and these are inherent as a characteristic of the paper.

Papers vary in thickness or weight, the most common being single and double weight. SW papers are suitable for collages or multiple runs for PR or informational use, but are not generally used above a size of 25 × 30cm (10 × 12 inches). SW papers reduce washing and drying time and handle quicker and create less bulk in filing systems but are subject to damage if handled too much. DW papers are used for larger sizes and exhibition prints or if the print requires much handling. DW paper increases the washing and drying times by as much as 50%. Lightweight papers are extremely thin, but useful if weight or bulk is a problem.

RC papers are designed to resist absorption of liquids so that chemistry is easily washed out and drying of the print is rapid. For normal reproduction work or proofing or work prints it is ideal, saving enormous time in handling.

The RC paper base is, however, still suspect for archival life times and it is recommended that in B/W, a good fibre/baryta paper, such as Ilford Gallerie, is used for long life and in colour, film based material such as Cibachrome II-PS is obtained for archival colour prints (see *Archival Processing, Storage and Presentation*).

Textured paper used to be very popular when pictorialists were trying to emulate painting surfaces in their quest for

respectability in art, but since photography has exercised its own rights in this field and is not afraid to admit to its chemical and mechanical nature, many of the more exotic surfaces have been discontinued. Portraits do look well on a matt or textured paper and in B/W, particularly if it has a warm toned image on a creamy based tint, but for fine detail, maximum image density or reproduction the print should be made on an unglazed, glossy surface such as Kodak F, Ilford, Agfa or glossy colour papers.

B/W photographic paper is made in various contrasts so that a choice may be exercised in increasing or decreasing the tonal scale in the negative. Paper speeds may vary between contrast grades and may require different exposures with the same negative but Ilford, for example, have matched speeds in all its grades. Multi-contrast papers where one emulsion is used for all grades, changes contrast by filtering the light from the enlarger. A good printer will use such papers to obtain wide ranging contrasts in the same print, stopping exposure in certain areas and changing filters part of the way through. For reproduction prints this has many advantages and for professionals it greatly reduces the need to carry stock in all grades of contrast. Kodak Polycontrast, Ilford Multigrade and Dupont Varigram are examples of this type of paper. (See *Enlarging* and *Archival Processing, Storage and Presentation, Multigrade Paper*.)

PARALLAX

The human eyes depend on the phenomenom of parallax for three dimensional vision, each eye seeing a slightly different viewpoint some 70mm ($2\frac{3}{4}$ inches) apart. The image seen by the left and right eyes is not identical but the brain interprets the differences as spatial depth (see *Vision*). Parallax is present in cameras where the image seen through the viewfinder is different from that seen through the taking lens and even a finder displacement of one inch from the camera lens axis can cause problems in some circumstances.

Distant objects do not produce any significant differences but under 3 metres (10 feet) and particular under 1 metre (3 feet), parallax becomes a factor requiring compensation. Many twin lens cameras have built-in parallax compensation as do certain rangefinder cameras, but at close and very close distances (under 75cm or 30 inches) these are rarely sufficient.

For very close work the image must be viewed through the taking lens and an SLR camera or a view camera with a ground glass back must be used. (See *Large Format Cameras, Close-up Photography, SLR Cameras*.) It should be noted also that when special effects filters are being used, or precise control of

INTERNATIONAL PAPER SIZES

Size	Millimetres	Inches (approx.)
A0	841×1189	$33\frac{1}{8} \times 46\frac{3}{4}$
A1	594×841	$23\frac{3}{8} \times 33\frac{1}{8}$
A2	420×594	$16\frac{1}{2} \times 23\frac{3}{8}$
A3	297×420	$11\frac{3}{4} \times 16\frac{1}{2}$
A4	210×297	$8\frac{1}{4} \times 11\frac{3}{4}$
A5	148×210	$5\frac{7}{8} \times 8\frac{1}{4}$
A6	105×148	$4\frac{1}{8} \times 5\frac{7}{8}$
A7	74×105	$2\frac{7}{8} \times 4\frac{1}{8}$

SOME USEFUL STANDARD SIZES OF PHOTOGRAPHIC PAPER AND FILM

USA and UK		EUROPE	
Centimetres	Inches	Centimetres	Inches
8.3×11.4	$3\frac{1}{4} \times 4\frac{1}{2}$ (C7 envelope)		
8.7×13.8	$3\frac{7}{16} \times 5\frac{7}{16}$ (postcard USA)		
8.9×11.4	$3\frac{1}{2} \times 4\frac{1}{2}$		
8.9×14	$3\frac{1}{2} \times 5\frac{1}{2}$ (postcard UK)		
10.2×12.7	4×5	9×12	3.54×4.72
12.1×16.5	$4\frac{3}{4} \times 6\frac{1}{2}$ (half-plate UK)		
12.7×17.8	5×7	13×18	5.12×7.09
16.5×21.6	$6\frac{1}{2} \times 8\frac{1}{2}$ (whole plate UK)		
20.3×25.4	8×10	18×24	7.09×9.45
21×29.7	$8\frac{1}{4} \times 11\frac{3}{4}$ (A4 page)		
21.6×28	$8\frac{1}{2} \times 11$ (USA page)		
25.4×30.5	10×12	24×30	9.45×11.81
27.9×35.6	11×14		
30.5×38.1	12×15	30×40	11.81×15.75
40.6×50.8	16×20	40×50	15.75×19.69
50.8×61	20×24	50×60	19.69×23.62
50.8×76.2	20×30	50×65	19.69×25.59
61×91.4	24×36	60×90	23.62×35.43
76.2×101.6	30×40	75×100	29.53×39.37

reflections is important, and viewing is not through the lens, parallax becomes a problem even over distances in the mid-focus range, increasing with the use of long lenses. Parallax compensation is built-in on some reflexes or viewfinder type cameras and with a little practice, even if it is not, compensation can be achieved by tilting the camera up by the amount of distance by which the viewfinder is displaced from the lens (see fig. below).

a In parallax, the viewfinder axis A is displaced from the camera lens axis B so that the image seen is not the image photographed. (b) SLR cameras see through the taking lens and the image is photographed precisely as seen, thus avoiding parallax.

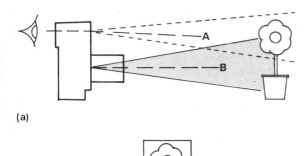

(a)

VIEWFINDER

CAMERA

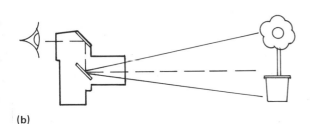

(b)

PARAPHENYLENEDIAMINE

Once the basis of all serious 35mm photographers' efforts to produce high acutance and minimum grain, this formula was perfected by the American, Sease in the 1930s. For B/W processing the developer is now rarely used because of its toxic effects on the skin (gloves must be used) and its serious loss of film speed. Other developers have superseded it, notably Promicrol, the May and Baker fine grain developer which almost attains the same grain structure as the Sease formula but without toxicity and with considerable gain in film speed. P-Phenylenediamine is used in many formulas for colour developers.

PAYMENT FOR PHOTOGRAPHY

In the professional, or part-time freelance side of photography, care must be taken to protect the photographer from irresponsibility or misunderstandings on the part of clients. It will be helpful to take note of the following essentials:

1	Be sure the client is aware of the copyright status of the images before agreeing a final fee.
2	State, *in writing*, the rights awarded by the fee agreed and the precise number of reproductions permitted, their nature, size and the time limit on those rights.
3	Do not endorse a settlement cheque if your signature, in any way, is part of a waiver or disclaimer in respect of copyright.
4	Work only to a prior order or contract which covers the entire job or fee.
5	Avoid the 'work made for hire' contract or one where the client pays for all material costs. Both types may automatically award the copyright to the client, not to the photographer.
6	Invoice promptly and state the settlement terms and due date.
7	Do not hesitate to make strong requests for payment after the due date.
8	Do not allow any invoice to be outstanding longer than eight weeks, unless by mutual agreement between photographer and client.

PENN, IRVING (1917–)

Born in New Jersey, USA, in 1917. At 26, after several years as an art director and painter, he became a photographer. In 1943, just before he joined the American Field Service during World War II, *Vogue* published his first editorial photographs. Lionized by young photographers everywhere, he was successful in advertising and was brilliantly productive for the Condé Nast publishing group, especially *Vogue*. He and Richard Avedon totally revolutionized the world of fashion photography and editorial portraiture and the style which evolved 30 years ago influences much of the commercial and advertising imagery in use today. He has exhibited widely, including the Museum of Modern Art in New York and lately

with the Marlborough Gallery. One of his most well-known early series was portraits of the Indians in Cuszco in Peru, 1948, while the most recent is a series of graphic images of cigarette ends and other dross from the sub-level of civilization.

He uses photography for its own unique qualities rather than for any imitative painting attributes, accomplishing his simple, masterly images with very minimum means, superb lighting control and strong concept. His large body of work endures as an example of commercial, advertising, editorial and fine art photography which constantly inspires photographers of today.

PENTAPRISM

Invented by the West German firm of Carl Zeiss in the 1950s, the pentaprism is a viewfinding device used on SLR cameras to enable the photographer to see 'right way round' through the taking lens, right up to the moment of exposure. Even though the extra bulk and weight added to the camera is significant, the advantages far outweigh any defects. Changeable screens, exposure meters and LED displays of photographic exposure data are often now part of the pentaprism. (See *Parallax* and *SLR Cameras*.)

PERCEPTION

(See *Vision*.)

PERMANENCE OF PHOTOGRAPHS

(See *Archival Processing, Storage and Presentation*.)

PERSPECTIVE

The representation of distance came late in the long history of art, and geometric perspective was unknown until the Renaissance and still largely remains an attribute of Western art only. Modern painters in Western culture sometimes dispense with geometric perspective. The perspective the camera sees is the same as that which the eye sees, but whereas perception restores a measure of reality into a picture of true perspective by subjectively modifying the image according to the viewer's experience, the camera cannot do this. The mechanical but true rendering of normal perspective can look banal or wrong unless the photographer also modifies the simple perspective drawing of the lens by changing lenses or viewpoints, image tone, form and so on.

For painters, perspective was established as a principle by Brunelleschi (1377–1446) who was a famous Florentine architect, but the principles of perspective and the lens were known long before that time. The famous Arabic scientist, Abu-Ali Al Hasen Ibn Al-Haytham (965–1038), known to Western science as *Alhazen*, wrote clearly of the total concept of perspective on his treatise on optics. He first recognized that a cone of rays is directed from each point of an object and that the cone becomes wider in angle if the object is nearer. Nearer objects would therefore appear to be larger than more

distant ones. Leonardo da Vinci (1452–1519) also mentioned, and formally set down in his notebooks, the principles of geometric perspective but this was probably for his own private use. Painters and architects continued to develop the guiding rules of perspective over the next century but the first master of perspective to use a lens as an aid to drawing was Canaletto (1697–1768), who used a camera obscura to assist his brilliant perspective paintings of Venice.

Perspective is always attached to a fixed viewpoint, and when this viewpoint is changed, so is the perspective. Contrary to general belief, when viewpoint is maintained but a different focal length lens is substituted, perspective is unchanged even with wide angle lenses. Perspective changes take place when the lens-to-subject distance is varied by displacement laterally or along the lens axis, even if the lens is not changed. Image size is also changed in this case. The eye will then see nearer objects as larger and will see increased spatial depth between larger (nearer) objects and smaller (distant) objects. The photographer can therefore increase apparent depth in his pictures by placing important parts of the subject close to short focal length lenses and putting other elements somewhat further away. This also creates emphasis.

To summarize: the camera produces perspective as the eye sees it, more distant objects are diminished in size progressively as distance from the viewer increases. This perspective remains constant for the camera unless the lens-to-subject distance, or angle of view, changes.

The most important other form of perspective for photographers is aerial perspective. Formally discussed by Leonardo in his notebooks in the sixteenth century as 'sfumato' painting, it referred to a veiling of distant objects to create spatial depth. Leonardo had observed that in nature, haze and mist create a blue, diffused tone in distant parts of the landscape, which suggests receding depth. For the

Geometric perspective. AB and XZ are of equal height, seen by the camera C.
The apparent height of AB will be YZ.
The base of triangles ABC and XYZ varies inversely in proportion to the distance BZ in relation to ZC.
If the nearest object distance ZC is 10 metres and the farthest object distance BC is 40 metres, the relative sizes of the object will be 10:40, the more distant object being only a quarter the size in camera than the nearer.

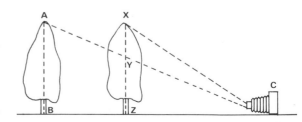

a An example of single point perspective where lines converge to a vanishing point outside of the picture.
b Single point perspective converging to a vanishing point within the picture.

photographer, the camera produces this effect quite easily, particularly in B/W emulsions. By working in hazy weather with a blue filter and B/W film, great depth can be suggested in middle and far distance, but in colour photography it is necessary to remove all UV filters and perhaps substitute a low contrast diffusion filter. Long lenses and very long mirror telephotos can spectacularly enhance aerial perspective, particularly at sunrise or sunset or if the landscape is back-lit. Such lenses also compress the distance between objects and their backgrounds. Wide angle lenses expand spatial depth but generally tend to minimize aerial perspective. Aerial perspective can be created in a studio for some objects, by placing plain backgrounds very far, at least 10 metres (33 feet) behind the subject and creating soft transition of tone to take the eye back even further. In colour this background should be bluish and pastel toned. (See *Aerial Perspective*, *Basic Photography*, *Lenses*.)

Spherical perspective from fish-eye lenses and panoramic perspective from super wide lenses are deformities of normal geometric perspective but they can interest the viewer for a short time and create unnatural depth. Cast shadows, overlapping forms and the use of advancing and retreating colours can also enhance the illusion of three dimensions. Two other variations in perspective, oblique and isometric, are useful for product photographers and these are discussed in the section *Large Format Cameras*. Perspective in *portraiture* is included in the section on that subject.

The automatic depiction of perspective by the camera can be defeated to a certain degree by flattening form and texture. This is done by the use of axis lighting (see *Lighting*) to remove texture and the use of cool, retiring colours for main subjects against warm, advancing and saturated background colours (see *Colour Harmony*). Perspective can be further flattened by graphic effects which abstract form and replace it with solid, featureless colours. It must be remembered that the brain interprets what the eye sees, in the light of the observer's experience. While the eye is seeing in the normal geometric perspective of diminishing forms or increasing distances, the brain can, and often does, re-scale distant objects and award them priority of size over nearer, less important things. The camera cannot do this unaided, but a skilled photographer can. (See *Image Synthesis*, *Viewing Distance*.)

PETZVAL, JOSEPH M. (1807–91)

A pioneer of early lens design, Petzval worked closely with the Voigtlander firm in Austria to produce fast lenses for the slow speeds of Daguerreotype and Calotype. As a mathematician he established theories and methods of using this discipline for lens design purposes and, until very recently, modern makers of optics still used these principles in lens manufacture, particularly for special portrait lenses. His work greatly assisted the rapid acceptance of photography and led to truly instant exposures.

pH

A scale used to denote acidity and alkalinity, numbered from 0–14. A reading of 0–7 indicates acidity and 7–14 indicates alkalinity. A reading of 7 on the scale denotes neutrality and a balance between the two. Pure water has a pH of 7. Precise readings of the pH values are obtained from a special voltmeter converted to show the direct pH values on the index.

PHOTO-CHROMATIC GLASS

A full colour, photo-sensitive glass has been produced by Corning Glass, by means of sensitizing various silicate glass types with colloidal silver halides or photo-sensitive sodium fluoride. An ultra violet light of some strength in the 280–340 NM band activates the sensitizers and a photographic mask protects those areas from exposure which require subsequent, different irradiation. These later exposures of masked areas of glass are precisely timed, as colours vary according to the amount of UV radiation the glass absorbs. Finally, to produce the colours, the glass is heated in a furnace to 300–410°C. These colours are brilliant and totally impervious to destruction by light and are extremely fine in the resolution of detail.

PHOTOCHROMIC PAPER

This is an unusual daylight proofing material which can be exposed by UV light and, if necessary, by infra red heating to 100–140°C for less than one second, this image can be erased and the paper then will accept further UV exposure. This cycle is repeatable for up to 1000 times. Light sources can include a Philips UV tube TLADK, or a 150 watt/second electronic flash. The eraser could be a hair dryer or infra red lamp, an oven or a glazing drum. Images can be photocopied. The makers, Roval of Switzerland, are listed in the *Appendix*.

PHOTOFLOOD

This is a lamp the size and shape of many 100 watt household lamps but is manufactured to operate at a very high temperature and thus increase efficiency. A photoflood lamp rated at 275 watts produces light equivalent to 500–700 watts of ordinary household lamps, but has an extremely short life, two to three hours, and the heat generated can be a hazard to soft furnishings. These lamps should be used in metal reflectors, or the large lamps with in-built reflectors may be used in any lamp holder with a porcelain socket. Photofloods used outside or anywhere susceptible to cold draughts should be screened with a broad gauge, wire mesh as they can sometimes explode in these situations. The photoflood burns at 3400K colour temperature which drops (warms) rapidly as the light ages. They should not be confused with tungsten halogen photographic lamps which burn at 3200K and have a longer life.

PHOTOGRAM

Since the invention of photography, the photogram has always been an alternative means of making the photograph, but without a camera. In 1839 Fox Talbot, the English pioneer of the calotype process, produced his example of photogenic drawing, using natural objects placed on a light-sensitive paper and then exposed to a suitable light source. Modern photograms are made in the same way, placing translucent or opaque objects in contact or near contact with

Left This is a photogram, made without camera or enlarger.

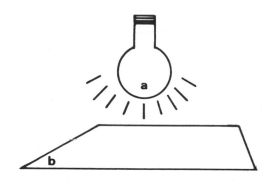

The items necessary to make a photogram: exposing light (tungsten), removable red filter for setting up, and photographic paper, with objects placed directly on the surface.

sensitive photographic material and then exposing the entire area to light. This technique can be used for B/W or colour subjects. A further refinement is to assemble a suitable array of objects on the enlarging paper, then project a conventional negative or positive over the sheet to create multiple images, plus the photogram (see *Image Synthesis*). Christian Schad, the Swiss photographer, is world renowned for using photograms as an expressive art form and his startling images in the 1920s were readily accepted as part of the Dadaist movement's early body of work. His photography in this field influenced *Man Ray* and also some of the *Bauhaus* experimental photographers to use these interesting techniques. See fig. above for a method of producing photograms.

PHOTOGRAPHIC CHEMISTRY

Most chemistry used in modern photography is fairly free of risk, but colour photography and some of the more ambitious B/W processing techniques of toning, etching, photo-resists and other specialized activities are not without hazard. Some sensitive skin can be damaged by even very normal solutions and proper protection of gloves, print tongs, aprons and the essential precaution of good ventilation are necessary points to consider when dealing with any chemical materials. (See *Mixing Solutions* and *Darkroom.*) If dangerous substances are being used, full industrial protection must be worn (see *Dangerous Chemicals*).

Special containers should always be used for measuring, mixing or storing photographic chemistry, never any of the household equipment which is later returned to domestic use. Clear plastic containers for mixing, plastic graduates for measuring, plastic mixing rods, are safer than glass because if accidentally upset during total dark operations no dangerous breakages result. A very accurate thermometer and a battery or spring wound timing clock with a bell will also be needed. Extreme precautions should be taken with electricity lines which pass into or near a wet area of the darkroom and installation of these must conform to safety codes (see *Darkroom*).

Storage of photographic chemistry should be according to manufacturer's instructions and for made-up solutions this will generally be in light-proof containers, tightly closed. For most photographers, at least with basic chemistry, it will be found better to buy ready mixed, concentrated solutions. They are perhaps slightly more expensive, but are likely to keep well and perform to optimum needs with minimum waste and results are very consistent. (See also *Basic Photography*, *Developers*, *Enlarging*, *Pouring Liquids*.)

PHOTOGRAPHIC LIBRARIES

Agencies and photo-libraries exist to sell photographs on a commission or fee basis to advertising, editorial or public relations markets and although many have files holding hundreds of thousands of images there always seems to be room for more material. For those who wish to submit work to agencies, it is better to seek out those who belong to reputable or national and international groups (see *Appendix*), as they have established rates and reliable sources for markets. Most picture agencies or photo-libraries who accept a photographer's work will tend to keep it three to five years as it may take this time to find suitable buyers. The picture can be sold many times, both the photographer and the agency sharing the fee each time and copyright should *not* be given away by the photographer. Those who aim to offer work for the first time should follow the information listed under *Publication of Photographs* in this book and then seek out a suitable agency, show them a portfolio and discuss likely subjects. Subjects often most in demand· are pretty girls, children, sports, sunsets, exotic holiday spots, cliché pictures of romance and striking pictures of animals or birds.

Sequential pictures or picture stories should be handled by the features and syndication type of agency rather than photo-libraries and these often require considerable research before they are made. Whereas photographs intended for library use over five year periods must be taken in such a way to exclude trends or material which quickly makes them outdated, news pictures or features must be very much of the latest. News agencies are a special case where the photographer must work very fast indeed to supply images which are news worthy at the moment. Whatever agency or library photographs are chosen to be submitted, it is important to get full caption material, names, addresses and telephone numbers of news subjects and model releases on everything possible. The fees are a matter of negotiation between the agency and the client and it is usual to split payments on a percentage basis, often 50/50 between photographer and agency, or even 60/40 in the photographer's favour. Where much promotional work is involved for the agency or any funding for the photographer, fees could be split 40/60 in the agency's favour. Payments for the one time usage of the agency or library material can range from 50 to 5000 dollars per image, each time it is used. (See *Photo-journalism*.)

PHOTOGRAPHIC PRINTING
(See *Enlarging*.)

PHOTOGRAPHY AS ART
(See *Fine Art Photography*.)

PHOTOGRAPHY FOR THE FIRST TIME
When an unskilled person is faced with taking a photograph for the first time, it is a confidence booster to know that if the camera is a modern or an automatic type, very little can go wrong. If it happens to be a fixed focus, small format camera of the Kodak Instamatic type, even less can go wrong. The basic need is to look into the viewfinder and frame the picture so horizons are level and heads are not cut off by the top of the viewfinder frame. Do not stay far away from the main subject but try to get as close as the camera permits and your taste dictates. Many viewfinders on simple cameras are not always accurate and for this type of camera, after framing the subject in the finder to your liking, *take one more step*, then reframe the picture, brace yourself, feet apart, hold the camera firmly and *gently* press the release. The camera does everything else. It helps to hold your breath while releasing the shutter.

If the camera is more complex, focusing is necessary and this can be done by pre-focusing on a certain spot with the focusing scale or, in the case of the single lens reflex (SLR) focusing on the eyes of the subject or just in front of the main area of interest. A steady support and gentle, but confident, release of the shutter will again be essential. If it is intended to deepen your interest in photography or to use a camera on a regular basis *read the manufacturer's instructions* for all equipment and film to be loaded, make several rehearsals of picture taking with an empty camera and then make test exposures which are developed and printed, before going on to the actual photography which is planned. Do not hesitate to re-read the manufacturer's data sheets and brochures if any point is in doubt. (See also *Basic Photography* and *Focusing the Camera*.)

PHOTO–JOURNALISM
With the introduction, on 4 March 1880, in New York, of the B/W half-tone process, employing a dot screen to reproduce a photograph in something like continuous tones, it became possible to produce printed news with a relevant image, for the first time in history. The increased communication and heightened sense of immediacy arising from the use of

a

b

c

d

If you are using an automatic camera such as the small 110 format here, follow these steps.

a For a vertical picture, support the camera from below and keep it pressed against the face. Thumb is on the shutter button. Keep the other eye open.

b For a horizontal picture, support the camera on a steady platform of the two thumbs. Rest the elbows on a table or solid support and use the second finger to operate the shutter.

c Take the camera from the eye, look again at the subject and consider: is it possible to come closer?

d Re-frame the picture in the viewfinder, hold the breath and *gently* squeeze the shutter button.

pictures has been a major factor in reporting news ever since.

The camera was to prove to be the perfect medium to support the journalist in his quest for news and narrative about world events and although *Roger Fenton* in 1855 and *Brady* and *O'Sullivan* in 1861 were pioneers in war photography it was not until 1924, with the introduction of the Leica 35mm rangefinder camera, the Ermanox ultra-fast plate camera in the same year and the 6 × 6cm Rolleiflex using roll film, in 1929, that the right tools for the job became available.

The German camera industry provided the means for the photographer to work quickly, unobtrusively and in all conditions of light and these precepts still govern the thinking of the photo-journalist today.

'A picture is worth a thousand words', or so runs the old saying and the compaction of information is still at the heart of the use of photographs in editorial matters. The photographer must clearly understand the background and concept of every image supplied for press use and this means thorough research before the photograph and with fill-in data often provided after the event, especially if it is 'hard' news unfolding at the time. It is essential to obtain all names, addresses, telephone numbers and other caption material and, if necessary, a picture release from the subject. If the concern is with a natural happening, realism and quick recognition is of paramount importance, so the photographer must anticipate events and place him or herself in an advantageous position to record the complete action. This can be hazardous sometimes but is always eventful.

All equipment must be at the finger tips and in prime condition. In heavy action areas, several cameras are usually strung around the neck, while in less tense situations they are contained in a flat suitcase, already set up for instant use. Very few photo-journalists will use the tote bag except for long haul carrying of the equipment where it is not expected to be needed quickly.

The Leica rangefinder camera is still one of the most compact, quiet and unobtrusive of instruments; the Rolleiflex twin lens, 6 × 6cm, camera still one of the most reliable, but systems cameras from the Japanese makers probably now dominate the photo-journalist market. Nikon, Canon, Minolta, Contax, Pentax and Olympus all make extensive and suitable equipment. The new Rolleiflex 2000 SL 35mm camera, with the facility of mid-roll changes by the use of removable magazines, may be one of the most flexible pieces of equipment for this work now to become available.

Lighting is usually that which is available, plus perhaps some augmentation from a portable electronic flash. Fast film, push processing and exotic high speed developers are technical aids often needed in this field. Because of the sophistication of readers in photographic and visual matters, a greater degree of technical excellence is expected of today's photojournalist. Pictures are tending also to be smaller with much more supporting text, perhaps never to go back to the grand sweep of the double page image often found in the magazines of the 1960s. Photo-journalists of great originality and skill may now find an outlet for their best work to be in the pictorial book, rather than the magazine.

The photo-journalist's work will generally fall into three categories: 'hard' news, where results are instantly available for a daily paper and its worldwide syndication; features, where a considered topicality generally controls the approach and there is more time for preparation with weekly or monthly deadlines; or the photo-essay of a sequential series of pictures which must have a universality in theme and a narrative blend of words and images, which may take months to prepare. Occasionally, as in pictures for a cover or as a single full page image inside the magazine, the works of the photo-journalist

PHOTOGRAPHY FOR EDITORIAL USE

Find out from the features editor if they want any special subjects before submitting work.

Monochrome prints should have cool black and white tone, clear white highlights, non-glazed glossy surface.

Such prints need a full scale of tones plus an emphatic black. This means full development. All shadow areas must have detail.

Sharp focus in the negative must appear on the print. Use an easel magnifier.

All prints need 5mm ($\frac{1}{4}$ inch) wide border all around and should be flattened by weighting or the use of anti-curl solution.

Spot all prints carefully in daylight quality light.

Submit 18×24cm ($7 \times 9\frac{1}{2}$ inch) as standard size, with prints on glossy double weight paper, unmounted.

Mount 35mm and other transparencies in temporary black card mounts with your name, address and telephone number clearly to be seen on each mount.

Put all photographs into a padded envelope, plus a strong cardboard stiffener.

Put your return name and address on the envelope, plus label which states 'Photographs, do not bend'.

State copyright details in a separate letter, enclosed with prints.

If prints are wanted back, include return postage.

are used to dress the publication and give it more impact. Such pictures are very high in photographic quality and have a high degree of subtlety in them, not usual for this type of work.

Copyright is a vital matter in this field and in both the USA and in Britain, the image maker does not always own full rights to the picture. 'Work-for-hire' contracts and the purchasing of film and processing material often vests ownership in employers or those who have commissioned the photography. Written agreements are always necessary to protect the photographer's copyright and an experienced commercial lawyer should be retained to read important contracts.

The next decades will probably see the advent of electronic or electro-magnetic cameras for still pictures, bypassing silver-based emulsions and wet processing altogether and allowing editorial pictures to be instantly transmitted from the photographer in the field by the nearest telephone, direct to the picture editor's office, even if it is a continent away and this will perhaps radically alter the technique of the photo-journalist, but will not alter the fact that in photo-journalism the picture must have imagination, direct realism and, above all, significance. (See *Available Light, Small Format Cameras, History of Photography, Lighting, Documentary Photography, Location Photography*.)

PHOTO-MECHANICAL PRINTING

Many photographs are reproduced by mechanical rather than optical methods, printing the image down onto unsensitized paper instead of photographic paper. Reproduction is more controllable, much cheaper for multiple copies in excess of 500 from the same image, but as there is usually a dot screen present in the mechanical printing plates, definition is sometimes lost and mood is easily altered in the final image. These printing processes normally require a half tone dot

screen, where highlights have tiny, microscopic dots of solid ink on a surround of white paper and shadows have tiny dots of white paper on a surround of solid ink. To print colours, four such screens are made, being inked in cyan (blue), magenta (red), yellow and black. The dots vary in size and distribution to produce tonal effects and the eye, when stimulated in the retinal cones by the corresponding colours (see *Vision*) in the print, sees a full colour image. Because the *subtractive primaries* used in printing inks do not fully saturate, the black printing plate gives an undertone or key which adds depth to the image. Increasing the strength of the black plate can increase contrast or, if too much black is present, a dull muddy print results. Various types of mechanical printing are listed below.

Letterpress An older process than the others, whereby a metal relief plate is inked, with greasy ink, and applied under pressure directly to the paper. Used for very detailed but somewhat shorter runs.

Lithography An aluminium plate is made, with a half tone screen and highlight and shadow areas in the same plane, but differing in their ability to accept water and ink. When such a plate is coated with greasy ink any wet areas will repel it, while dry areas accept the ink, and when the printing plate is applied under pressure to the paper, the inked dot patterns print while the wet areas do not.

Offset litho The lithographic process is the beginning for this technique but the image is transferred or 'off-set' onto a rubberized or plasticized blanket and it is this blanket image that is the one which prints the final image onto paper. On very long printing runs this process is very economical and fast and the plates last a long time. Four colours can be printed simultaneously and varnished finishes can easily be applied. Quality can be controlled to equal or exceed other processes, but in general practice, many compromises are made on fast, long runs which somewhat degrade photographic quality.

Gravure or intaglio printing Here the image is formed by

depression in the plate surface, making microscopic wells to carry the ink in accordance with the dot pattern. Copper is generally used and a cylinder carries the curved plate. Tonal differences are obtained by varying the depth and size of the dot. Some custom printing houses, specializing in short run work, can achieve superb quality with this process, but its major use is for high quality, high speed colour runs, of reasonable length, such as for magazines and brochures.

Serigraphic or silk screen This process does not generally produce subtlety of tone or good edge definition in photographs but short runs are relatively inexpensive and the broader, visual effects can be pleasing. There is considerable ink density and the image can be applied to many different substrates with varying textures. Metal is not used to carry the ink but a half tone dot screen of a very coarse type is needed for the reproduction of photographs. A photo-resist is coated to suitable silk material and the image printed from a film positive. Areas activated by UV light harden while other unexposed areas are subsequently washed out of the screen. Ink is forced through the clear areas of the screen to the paper underneath.

Serigraphic printing is excellent for line or solid colour work but continuous tone is less successful. Limited edition prints are sometimes made this way because of the reduced cost on small runs or if unusual photographic effects, which do not depend on subtle tonal changes, are wanted.

Collotype This is an early method of reproducing photographs in B/W and colour and still to be found occasionally. Collotype printing actually predated lithographic printing. No screen is used but a reticulated gelatin plate is made for each colour required. The random pattern of the reticulation cannot easily be defined by the eye so continuous tone reproduces with great subtlety and saturation. Edge definition is excellent. The plates rapidly wear out and not more than 2000 impressions are usually made before they are renewed. With its screenless image of great clarity and depth, the collotype process is ideal for low run, fine art prints but unfortunately only very few commercial printers now use this technique.

Photography for reproduction by any of the photomechanical processes does require that some compensation takes place in creating the original print or transparency. Colour reproduction can easily lose highlight detail but in producing the half tone plates there is ample control of shadow areas. This means that highlight areas in colour photographs, for reproduction, must be slightly 'covered', showing the incident highlights. Bleached out highlights are always exaggerated in printing, but shadow detail may be enhanced at will. The best camera images for reproduction therefore will be from colour transparency material, half a stop under-exposed from normal for increased density in the highlight area. Shadows should be softly lit and translucent, with a light to dark ratio of not more than 3:1.

B/W prints for reproduction can afford more contrast, however, as some is lost in the process and a light to dark ratio of 5:1 is acceptable. If sufficient contrast does not exist in a negative, harder grades of paper must be used. The coarser the screen, the more highlight and shadow detail will be lost. Highlights must be crisp and clean and shadows well lit. Any detail which is wanted in black areas must be exaggerated considerably by texture lighting or low contrast processing.

Newsprint, which uses a very coarse screen, and high speed presses, will not generally produce subtlety of tone. Highlights become grey, blacks muddy and clogged. Images for such reproduction should depend on simple structure and bold concepts rather than delicacy of tone. Photographs for reproduction are best printed on an unglazed, glossy surface paper. (See *Enlarging, Publication of Photographs, Lighting, Nine Negative Test*, the colour plates for *Colour Photography*.)

PHOTOMICROGRAPHY

A fascinating microcosm of life is revealed by the microscope and photography was used as early as 1839 to record such images. Those who wish to experiment in this area should, of course, be thoroughly familiar with a microscope and have access to one, plus a vertical or horizontal camera stand of some sophistication, to allow the vibration-free placement of the camera at the eye piece.

The primary image is created by the objective, which is the microscope lens nearest the specimen and is projected within the body tube to the secondary lens, or eye piece, creating a 'virtual' image, focused approximately 25.4cm (10 inches) behind the eye piece lens and *outside* the microscope. Magnification is calculated by multiplying objective power by eye piece power, thus a 50 × objective and 10 × eye piece create a 500 × magnification of the specimen.

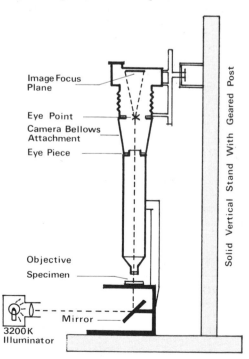

A vertical rig for normal photo-microphotography.

Modern scientists use scanning microscopes to investigate the sub-microscopic life of our planet. This illustration demonstrates the use of Polaroid 4×5 film with such an instrument. (*Courtesy Polaroid Corporation*)

As an alternative to viewing with the eye, the image can be projected as a 'real' image to the plane of focus in a camera by the use of a special photo eye piece. The quality of this image governs the quality of the photograph irrespective of the camera system employed, which is largely used for exposure control and holding the film in the focus plane.

The camera lens is set at infinity and at its widest aperture, then brought precisely to the correct eye point for the eye piece in use. This will be about 25.4cm (10 inches) outside the eye piece lens. For tests with simple cameras, load with 100 ASA film and expose at $\frac{1}{30}$ second using a cable release. A preferred method when using an SLR camera is to fit a bellows extension to the body and remove the camera lens entirely, bringing the front of the bellows into the eye point zone of focus. Many camera makers have special attachments for photomicrography. Cable releases should always be used and preferably motor winders, to advance film and all vibration must be eliminated from the rig before firing the shutter. Exposure control by an automatic shutter system is usually effective but ground glass screens may need to be replaced by special clear focusing screens in order to secure precise focus.

Lighting is best provided by tungsten halogen illumination of 3200K with a condenser lens to project the beam and with an iris diaphragm to control the field of light coverage and this very concentrated beam can be positioned to produce light from the sub-stage area along the lens objective axis to illuminate the specimen from behind, or can be cast on the surface of any opaque object to make the image by reflected light. Compensating filters are placed in the light beam if needed, not attached to any of the lens systems.

PHOTO-MONTAGE

This is an assembly of multiple images, overlaying but not wholly masking each other, forming one cohesive visual concept. (See *Montage*, *Image Synthesis*.)

PHOTO-RESIST

This is an emulsion coated to a non-flexible base such as glass, metal or acrylic and often only sensitive to exposures of strong UV light, although Rockland Colloid of New York (see *Appendix*) do make one which responds to the light from an enlarger. When a high contrast mask is placed on the dried resist and then the whole exposed to UV radiation, areas protected by the mask remain insoluble during the subsequent development or washing out. This results in covering the base material with defined areas of hardened resist proportional to the mask. Consequent etching of the plate will only take place in areas clear of the resist. Very high resolving power is possible with most resists.

Note If exposing by UV radiation, protective eye filters *must* be worn and some photo resists will require gloves to be worn while coating the plate. Some resists are very toxic and it is important to seek safety advice from the manufacturer.

PHOTO-THERAPY

Photo-therapy is the use of photography as an assistance to diagnosis of mentally disturbed patients and also as a direct therapeutic activity to help them rejoin society. Psychiatrists who are themselves experienced photographers can make up a series of subjective, ambiguous images, low in recognition clues as far as normal reality is concerned but abstract, unstructured and rich in symbolic colours or form. These are shown to patients rather in the manner of a Rorschach Test and responses noted. Using a collection of the family snapshots, which generally represent high points of pleasurable experience for the patient, the skilled photo-therapist can often find a link to the understanding of a deep-seated problem. Hidden cameras are used sometimes to photograph body language of disturbed people to aid diagnosis.

For those who have advanced beyond treatment and are nervously awaiting a return to normal life, practical lessons in photography as an art form, for groups of patients, are given to help attain craft levels in making their own images. As a group they are then subsequently involved in oral critique of the results. This has a mysterious and beneficial affect on confidence and also acquaints them with a hobby of considerable depth and interest. It is often superior to painting as a therapeutic catalyst as the photographer cannot withdraw into reverie and then create in solitude, but must stand in the field, in contact with direct experience, in order to make a

successful image. A journal for photo-therapists and a loosely knit organization has recently been formed (see *Appendix*).

PICTURE AGENCIES

A picture agency is a peripheral business in photography which maintains large files of images which are offered to advertising, publishing and editorial markets. A photographer may be asked to send his/her work to an agency or may submit it independently for evaluation. The agency will attempt to sell the image over a period of years, often many times over, on behalf of the photographer, usually retaining 50% of the fee received and passing on the balance. It is highly desirable that a contract should exist between photographer and agency and that a time limit should be set on such a contract. Most agencies require originals rather than duplicates and will need to be reassured on the photographer's right to assign copyright. Considerable time will often elapse between sales, but the better agencies will commission work from photographers who regularly contribute. Images are generally classified into broad subjects such as landscapes, snow scenes, beach scenes, flowers, sunsets, girls, sports, exotic travel, special effects, etc. and photographers who have specialities in these categories can find lucrative additions to their normal income. All transparencies should be mounted and be given suitable protection by using plastic covers before offering them to agencies or picture libraries. It should be noted that except under unusual circumstances, copyright is always retained by the photographer, with the client-user only renting the material for specified uses. News agencies are a different operation altogether and will require very fast presentation of immediate news events, together with very detailed copyright options and model releases. In all cases, agencies will demand superb technical quality and imaginative composition. New pictures of familiar subjects – mother and child, domestic pets, seaside holidays – are always in demand. The primary question usually asked by all agencies when accepting suitable photographs which include people is, 'Do you have a model release?'. No picture may be sold commercially in the USA or Europe and most other places unless those identifiable in it have signed a separate *model release*, permitting the use of their likenesses. Failure to do this can result in heavy legal penalties arising for the photographer, agency and user. Except where the subject can be classified as news or falls within the public domain, it is absolutely necessary to get individual releases from everyone in the picture, including professional models.

PIN HOLE CAMERA

A camera may be made from a simple light-proof box with a tiny needle hole instead of a lens at one end and sensitized film or paper at the other. Definition is not always acceptable and exposures are lengthy, running two to four seconds with 400 ASA film to five to ten seconds with 100 ASA film. Paper negatives (which are easiest to use) are exposed for about five minutes in daylight conditions. Depth of field is extraordinary, objects nearby being almost as sharp as those at infinity. The camera must be mounted on a firm support and left untouched during the exposure. The fig. overleaf illustrates how to make an elementary pin hole camera from a shoe box.

PLATINUM PRINTS

This is an antique method of producing B/W photographic images using platinum salts as a sensitizer and although *Herschel* was interested in it as early as 1832 it took 40 years more before a workable process was presented by William Willis. The process, called platinotype depends on the light sensitivity of iron salts (feric oxalate) which, after exposure to light, reacts with the platinum compound in the emulsion during development to form pure metallic platinum. It was very popular during the early days of this century and again during the late 1930s and early 1940s, with a revived interest among leading photographers at the present time, because of beauty, permanence and the expensive connotations of platinum.

The use of platinum on hand-coated paper gives a beautiful, long scale, monochromatic print with rich blacks and is totally permanent. The slowness of the sensitizer means that it must be used as a contact process, exposing to arc light for as much as ten minutes, or alternatively exposing to sunlight. Enlarged negatives are often used for large prints and direct warm tones can be obtained during development. The best results are found from using mould-made or pure rag papers and extreme care and cleanliness are essential for success.

POLARIZERS AND POLARIZED LIGHT

Light travels in waves, vibrating in all directions around the axis of the light source. The polarizing filter has the unique ability to pass only those light rays which are lined up with the linear nature of the filter grating.

Polarizers are filters applied to the camera or also to artificial light sources, to intercept or increase polarized light which is reflected from the subject. Unlike all other filters, the results are not always predictable. The amount of polarized light reflected from a surface depends on the nature of that surface and the composition of the material which produces the reflection. Glass and water always reflect polarized light – metal does not. Diffused or matt surfaces reflect little, or no, polarized light, therefore there is no advantage in using a polarizer for those subjects. Some plastics reflect polarized light unevenly, causing colour shifts in highlight areas. When the sun is overhead a polarizer will darken the sky only near the horizon and when a slight overcast is present no effect is found through the use of the polarizer. In an SLR camera with a meter located behind a half-silvered mirror, polarizers can create serious exposure errors, because the measuring cell is not being activated by the same quantity of light that reaches the film when the mirror flips up. The mirror at rest transmits a portion of the polarized light upwards to the finder and some passes through the mirror to the meter. A hand-held meter will give more accurate results in this circumstance.

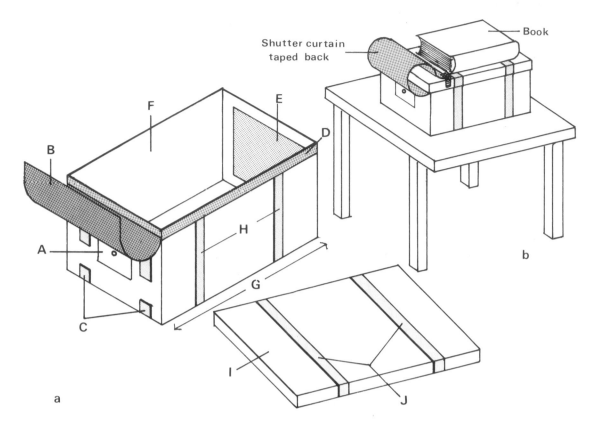

a Making a shoebox camera.
A Pinhole made in alufoil with a diameter of .58mm (.023 inches).
B 'Shutter' to close pinhole, made from dense black paper or plastic.
C Velcro tabs or adhesive tape to keep shutter closed.
D Thick pile material or black foam strip to keep box lid light-tight.
E Ektachrome Daylight 6117 sheet film, ASA 80, fixed inside box by double adhesive tape.
F Box lined throughout with dense black paper, matt surface.
G Box length from pinhole to film must be exactly 25.5cm (10 inches).

H Velcro tabs.
I Box lid.
J Velcro tabs or large rubber bands for closing box.
Note: Load box in total darkness or if red safe-light is wanted change colour film loading and use enlarging paper cut to size and alter exposure accordingly.
EXPOSURE: EKTACHROME 80 ASA = 2 minutes
ENLARGING PAPER = 10–15 minutes.
b Using the shoebox camera.
1 Place on flat, level support.
2 Sight over box from back and line up subject.
3 Place heavy book on box.
4 Open shutter and leave box untouched during exposure.
5 Close and secure shutter curtain after exposure.

Trial and error and direct observation through the filter will help evaluate the possibilities of what is one of the most useful filters for colour photographers. It is also advisable to buy the highest quality polarizer possible and one that is calibrated on its rim and also has a locking lever.

The degree of polarized light reflected from, say, glass, is at its maximum at $33°$ but for some other materials, e.g. those with a refractive index of 1.5, the angle could be increased as much as $55°$. For maximum glare control place the camera at the same angle in relation to the subject as the suggested optimum angle of incidence of the polarized light which strikes the subject.

The filter is made up of crystalline, sub-microscopic particles, sealed in a translucent sheet and which have the unique ability to transmit polarized light in one direction, thus forming a grating which selects a single wavelength of polarized light while still transmitting all other diffused and unpolarized light. If a second similar filter is mounted with a rotating ring in front of this filter, the degree of polarized light reaching the filter is totally controllable. By placing the camera at the point where maximum polarized light is received, glare can be extinguished, blue sky darkened or haze penetrated by rotating the filter until the desired effect is seen in the camera. This means that objects behind glass can clearly be seen; underwater subjects can be photographed from above the surface; blue sky can be darkened to the

deepest black; all without affecting the colour of any other part of the image. The rotation of a second front filter cuts off light reaching the film in variable degrees so this type filter has a variable filter factor from 2 to 4.5, requiring increased exposure depending on the darkening effect seen through the filter. It can be used also as a variable *neutral density* filter.

To photograph metal objects in the studio by direct or specular light or to copy subjects under glass or glossy oil paintings, it may be necessary to put polarizers on the lamps as well as on the camera. This can avoid the desaturation of colour or glaring highlights normally associated with this type of photography and produce richer more detailed results. A filter factor of up to 10 × or 20 × can result with this kind or lighting treatment when used also with a polarizing filter.

In outdoor scenes the maximum effect of polarized light in clear blue sky takes place at a 90° angle to the sun. Therefore, as the sun drops lower, the sky is lit by more polarized light. For colour photographers this means that dramatically rich blues can be produced to enhance cloud formations without changing any other colours in the scene (see fig. overleaf).

A further area of experiment for the creative photographer is to photograph various crystals by using polarized light.

a

b

c

A polarizing filter is a selective grid which passes light only in the direction of the grid pattern, causing light which has been polarized to vibrate only in one direction.

Light is emitted in all directions from a given point

Polarized light with filter

Polarizing and polarizers.
a Unpolarized white light has a multi-wave form which, when it strikes glossy non-metal surfaces, is polarized into a single wave form.
b Polarized light vibrates in a single plane. Polarizing crystals in the polarizing filter will pass the single wave form as a knife could be passed through a grating.
c When the filter grating is rotated 90 degrees, the single waveband of polarized light cannot pass, but multi-directional wave forms from other ambient light do. Polarized highlight reflections are eliminated, but the general subject is recorded.

Brilliant colours and beautiful abstract patterns may easily be recorded on film using the set-up shown overleaf. Each crystal will have a unique structure which behaves in an individual manner dependent on the alignment of the polarized light ray and its filter analyzer. Particles in the crystal set up interference effects in the light beam reaching the camera when the analyzer is rotated to a position at right angles to the correct angle of the polarizing first filter. Use a light source of 5500K or bluer to illuminate the crystals for best effect.

To produce suitable crystalline subjects for experiment the easiest solution is to buy prepared rock and mineral sections, mounted on microscope slides. These may be obtained from scientific or educational suppliers. Alternatively, certain crystals can be *gently* heated on thin glass slides (try heat absorbing slide cover glass). Care must be taken that

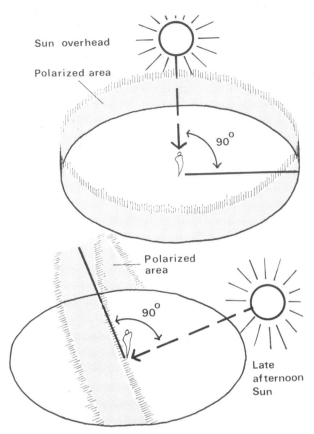

Sun overhead

Polarized area

90°

Polarized area

90°

Late afternoon Sun

Polarizing angles in sunlight.

substances chosen do not give off noxious fumes but suitable, easily obtained chemicals could include benzoic acid, citric acid, glucose and urea. Always heat *gently*, using perhaps, a candle flame, with the glass held in a pair of tweezers, kept moving constantly. Although only a few grains at a time are heated, do not inhale fumes. When the crystals are soft, press a second thin glass slide on top and allow to cool under pressure. Excellent results, but from a much slower technique, can be obtained by placing other substances in water and allowing evaporation to produce a thin crystalline growth. A trial method that seems effective is to dissolve a 5ml of the chosen chemical in 20ml of water which has a miniscule amount of *wetting agent* added. Smear on thin glass, such as a slide cover glass, and leave for several hours. Drop a second cover glass on top at this point and allow the glass sandwich to dry out, without pressure. This could take several days. Possible substances to experiment with are: powdered developers, vitamin c tablets, Epsom salts, Alka Seltzer and sugar. When using any industrial or photographic chemicals beware of corrosion or toxic effect on the skin or eyes. If accidentally in contact with such chemicals, flood the affected part with water. Keep all such experiments out of reach of children and if the melt method is used for other than extremely benign chemicals, wear protective goggles and use gloves. (See also *Filters*, *Light*, *Optics*.)

Below Photographing crystalline forms by polarized light.
a Shows a vertical set-up, in which A is a polarizing filter on camera, B is the specimen crystals on thin glass surrounded by 20 cm (4 inches) black card, C is the analyzer (second polarizing filter), and D is the electronic flash or tungsten light.
b Crystal patterns photographed by polarized light.

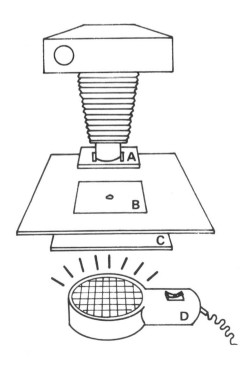

a

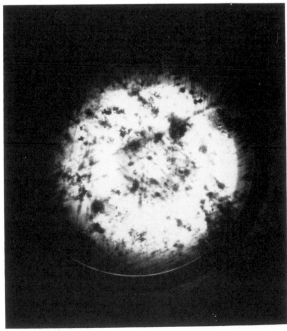

b

POLAROID CORPORATION

At a meeting of the Optical Society of America on 21 February 1947, when Dr Edwin H. Land announced his invention of the instant process system of photography, the Polaroid Corporation of the USA began a remarkable contribution to photography which, as it unfolds, continues to amaze and intrigue both amateurs and professionals alike, and each decade they appear to leap into brilliantly new and most wanted technology, in the service of man's leisure and communication needs. In 30 years they have sold more than 80 million cameras since they marketed the first camera, model 95 (using sepia film) in 1948.

In 1955 they produced film of 400 ASA speed, 1957 saw B/W transparencies, in 1959 came film with a speed of 3000 ASA, 1961 saw the production of a print/negative system, type 55, making it possible to produce, in 20 seconds, both a good print and a permanent, long scale negative. Colour came to the system in 1963 when the automatic 100 camera, with transistorized electronic shutter and exposure estimation was marketed. The year 1967 saw the instant half-tone system introduced, making screened half-tone images instantly on line prints, in the camera. In 1968 Dr Land demonstrated full colour transparency film, but marketing was deferred. In 1971 the identification system, ID3, was put on sale worldwide to aid documentation and security in industry.

The SLX 70 system, revolutionary in that it did not use peel-apart film and delivered a hard dry colour print from the

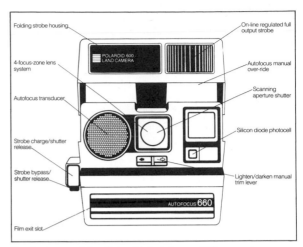

The features of the Polaroid Autofocus 660 camera.

Polaroid Instant film may be used to check lighting and camera function or be used as the finished print in its own right. (*Courtesy Polaroid Corporation*)

camera with a barely discernible image, which developed outside the camera, was shown to startled shareholders on 25 April 1972. In 1974 there was a demonstration of a research product, the instant colour negative. Improvements in the late seventies have included the introduction of Polacolor 2 film, a long life colour film print systems using metallized dyes, the introduction of an instant system for 18 × 24cm (8 × 10 inch) professional studio cameras, the establishment of cameras and studios to use the new 50 × 60cm (20 × 24 inch) instant colour print material and the continuing improvement of all colour materials. Already in the 1980s, Polaroid have introduced the 660 camera using 600 ASA colour film and designed with an integrated, computerized electronic flash and exposure metering system, plus automatic sonar focusing.

With this camera the entire process of photography from taking to processing, including the use of flash, is totally automatic. An entirely new concept of picture taking has also recently been patented whereby images are recorded on electronic tape, previewed on a built-in VDU and printed either instantly or at a later date. This will also be a small, hand-held camera.

While the Polaroid systems appear to fulfil the dreams and fantasies of the nineteenth century pioneers in photo technology, they form a separate but main stream of photographic experience for all serious photographers today. The benefits of instant and simplified photography to amateurs is obvious, but almost no professional in the world will work for long without using some Polaroid product. For checking lighting, camera operation or visual concept during an assignment it is essential, for research and as an aid to visualization it is ideal, for filing, copying or mark-ups it is the easiest, fastest and often the cheapest. Fine art photographers are interested in the system as each print becomes a unique item, small but capable of significant contribution to this area of interest.

The professional who uses a view camera will normally use a 545 or 550, 9 × 12cm (4 × 5 inch) film holder or the 800 series of films and equipment for 18 × 24cm (8 × 10 inch) cameras.

POLAROID INSTANT FILMS

Result	Product name	Format	Image area
Colour Print	Polacolor ER, type 809	8×10 sheet	19×23cm ($7\frac{1}{2} \times 9\frac{1}{2}$ inch)
	Polacolor 2, type 808	8×10 sheet	19×23cm ($7\frac{1}{2} \times 9\frac{1}{2}$ inch)
	Polacolor ER, type 59	4×5 sheet	9×11.4cm ($3\frac{1}{2} \times 4\frac{1}{2}$ inch)
	Polacolor 2, type 58	4×5 sheet	9×11.4cm ($3\frac{1}{2} \times 4\frac{1}{2}$ inch)
	Polacolor 2, type 558	4×5 pack	9×11.8cm ($3\frac{1}{2} \times 4\frac{5}{8}$ inch)
	Polacolor 2, type 108	$3\frac{1}{4} \times 4\frac{1}{4}$ pack	7.3×9.5cm ($2\frac{7}{8} \times 3\frac{3}{4}$ inch)
	Polacolor 2, type 668	$3\frac{1}{4} \times 4\frac{1}{4}$ pack	7.3×9.5cm ($2\frac{7}{8} \times 3\frac{3}{4}$ inch)
	Polacolor 2, type 88	$3\frac{1}{4} \times 3\frac{3}{8}$ pack	7×6.3cm ($2\frac{3}{4} \times 2\frac{7}{8}$ inch)
	Time Zero Supercolor SX-70	Integral pack	8×8cm ($3\frac{1}{8} \times 3\frac{1}{8}$ inch)
Black and White High speed print	Type 57	4×5 sheet	9×11.4cm ($3\frac{1}{2} \times 4\frac{1}{2}$ inch)
	Type 107	$3\frac{1}{4} \times 4\frac{1}{4}$ pack	7.3×9.5cm ($2\frac{7}{8} \times 3\frac{3}{4}$ inch)
	Type 084	$3\frac{1}{4} \times 4\frac{1}{4}$ pack	7.3×9.5cm ($2\frac{7}{8} \times 3\frac{3}{4}$ inch)
	Type 667	$3\frac{1}{4} \times 4\frac{1}{4}$ pack	7.3×9.5cm ($2\frac{7}{8} \times 3\frac{3}{4}$ inch)
	Type 87	$3\frac{1}{4} \times 3\frac{3}{8}$ pack	7×6.3cm ($2\frac{3}{4} \times 2\frac{7}{8}$ inch)
	Type 47	$3\frac{1}{4} \times 4\frac{1}{4}$ roll	7.3×9.5cm ($2\frac{7}{8} \times 3\frac{3}{4}$ inch)
Positive and negative	Type 55	4×5 sheet	9×11.4cm ($3\frac{1}{2} \times 4\frac{1}{2}$ inch)
	Type 665	$3\frac{1}{4} \times 4\frac{1}{4}$ pack	7.3×9.5cm ($2\frac{7}{8} \times 3\frac{3}{4}$ inch)
Fine grain print	Type 52 Polapan	4×5 sheet	9×11.4cm ($3\frac{1}{2} \times 4\frac{1}{2}$ inch)
	Type 552 Polapan	4×5 pack	9×11.8cm ($3\frac{1}{2} \times 4\frac{5}{8}$ inch)
	Type 42 Polapan	$3\frac{1}{4} \times 4\frac{1}{4}$ roll	7.3×9.5cm ($2\frac{7}{8} \times 3\frac{3}{4}$ inch)
High contrast print	Type 51	4×5 sheet	9×11.4cm ($3\frac{1}{2} \times 4\frac{1}{2}$ inch)
Low contrast print	Type 611	$3\frac{1}{4} \times 4\frac{1}{4}$ pack	7.3×9.5cm ($2\frac{7}{8} \times 3\frac{3}{4}$ inch)

Speed ASA and DIN equivalents	Normal development time at 24°C (75°F)	Special characteristics
80 ASA (20 DIN)	60 seconds	Medium contrast; extended dynamic range. Balanced for daylight and electronic flash.
80 ASA (20 DIN)	60 seconds	Balanced for daylight and electronic flash.
80 ASA (20 DIN)	60 seconds	Medium contrast; extended dynamic range. Balanced for daylight and electronic flash.
75 ASA (20 DIN)	60 seconds	Balanced for daylight and electronic flash.
80 ASA (20 DIN)	60 seconds	Balanced for daylight and electronic flash.
75 ASA (20 DIN)	60 seconds	Balanced for daylight and flash cubes.
75 ASA (20 DIN)	60 seconds	Balanced for daylight and electronic flash.
75 ASA (20 DIN)	60 seconds	Balanced for daylight and flash cubes.
N/A	Self-timing 7–35°C (45–95°F)	Balanced for daylight. Image visible in 10–15 seconds; print 90% developed in one minute.
3000 ASA (36 DIN)	15 seconds	General purpose, high speed film.
3000 ASA (36 DIN)	15 seconds	General purpose, high speed film.
3000 ASA (36 DIN)	15 seconds	For Cathode Ray Tube recording.
3000 ASA (36 DIN)	30 seconds	General purpose, high speed film. Prints do not require coating.
3000 ASA (36 DIN)	30 seconds	General purpose, high speed film. Prints do not require coating.
3000 ASA (36 DIN)	15 seconds	General purpose, high speed film.
50 ASA (18 DIN)	20 seconds	Negative requires brief clearing in sodium sulphite solution, washing and drying before use.
75 ASA (20 DIN)	30 seconds	Negative requires brief clearing in sodium sulphite solution, washing and drying before use.
400 ASA (27 DIN)	15 seconds	Wide tonal range, superb detail.
400 ASA (27 DIN)	20 seconds	Wide tonal range, superb detail.
200 ASA (24 DIN)	15 seconds	Wide tonal range, superb detail.
125 ASA (22 DIN) tungsten 320 ASA (26 DIN) daylight	15 seconds	Sensitive to blue light only.
	45 seconds	Extended dynamic range and exposure latitude. For video image recording.

continued overleaf

Result	Product name	Format	Image area
Continuous tone transparency	Type 46L	Lantern slide roll	6.4×8.9cm ($2\frac{1}{2} \times 3\frac{1}{2}$ inch)
High contrast transparency	Type 146L	Lantern slide roll	6.4×8.9cm ($2\frac{1}{2} \times 3\frac{1}{2}$ inch)
Ultra high speed print	Type 410	$3\frac{1}{4} \times 4\frac{1}{4}$ roll	7.3×9.5cm ($2\frac{7}{8} \times 3\frac{3}{4}$ inch)

Spectral sensitivity of all black and white films is panchromatic, type B sensitization, unless otherwise noted.

13×18cm (7×5 inch) cameras can have their whole format reviewed by using 4×5 Polaroid, taking half the frame on one film, then shifting the back laterally to take the second half of the format on the second Polaroid sheet. The two halves can be cut and registered to form one image.

When estimating exposure of Ektachrome 6117 by the use of Polaroid, better judgement is made by using B/W type 55, positive/negative film. It has a speed of 64 ASA and tonal characteristics compatible with the finished transparency. Colour Polaroid, besides being more expensive, can mislead precise reading of exposure and often needs *neutral density*

A diagram of the Polaroid sx70: (a) viewing. (b)exposing. The film pack is at the bottom of the camera. (*Courtesy Polaroid Corporation*)

a

b

filters to produce compatible speed. It is, however, useful if colour design problems of the image are being assessed.

For proofing colour transparencies or producing cropping guides for clients a copy approximately 7×9cm ($2\frac{3}{4} \times 3\frac{1}{2}$ inch) can be made on a Polarprinter, using type 665 for B/W, 668 for colour or the darkroom set-up, using a modified Saunders borderless easel illustrated under *Darkroom*, can be used. If colour is used in this darkroom method the tungsten lamp in the enlarger must be filtered with a Kodak Wratten 80A filter in the light beam above the transparency to bring the colour balance to that of the film, namely 5500K. Further filtration may be needed after tests and shortened development to reduce contrast may be beneficial. Time all development by electric clock.

Polaroid are extremely active in providing hard photographic copies of computer graphic material and by the use of sophisticated camera consoles connected to new computerized scanners, brilliant colour copies of incoming visual data are easily produced. The process employs a system of separating colours via a B/W flat surfaced video monitor and remarkable fidelity and saturation are evident, even though edge definition is a little diminished. As such systems are perfected it will become possible, no doubt, to transmit studio or location pictures immediately, by satellite, converting them into hard, dry colour copies instantly at the receiving station. Such a compression of time and distance for the transmission of colour visuals will radically alter the professional photographer's working methods and concepts in the next decade and involve us all in truly instant photographic systems. (See *Edwin Land*, and *Large Format Cameras*.)

PORTFOLIOS

For professionals or for those who freelance occasionally or for photo-students, the sales portfolio is an essential item in seeking work. Most potential clients use it as the major guide to final judgement when awarding assignments. It should consist only of the best of the photographer's work including tear sheets of magazine reproduction of actual jobs, some creative experimental solutions to usual problems which are considered likely to arise in the photographer's area of interest and some sound indication of the photographer's ability to handle the possibly unexciting, exacting basic work which is

Speed ASA and DIN equivalents	Normal development time at 24° (75°F)	Special characteristics
800 ASA (30 DIN)	2 minutes	Image must be stabilized and hardened in Dippit solution before use.
100 ASA (21 DIN) tungsten 200 ASA (24 DIN) daylight	30 seconds	Sensitive to blue light only. Image must be stabilized and hardened in Dippit solution before use.
10,000 ASA (41 DIN)	15 seconds, 15–32°C (60–90°F)	For Oscilloscope trace recording.

often the foundation of his/her business. It should also include a significant number of transparencies to indicate the original quality of which the photographer is capable. All work included in any portfolio must be immaculate. No dust, scratch marks, no creased prints or dirty borders, no muddy tones or poor craftsmanship should be seen on any original material and so on.

The assembled material should be carried in a brief case or zippered artist's portfolio case, not larger than 40×60cm (20×24 inch), and labelled inside and out with the photographer's name, address and telephone number. It should be insured for its full replacement value.

Tear sheets and loose prints are best laminated with clear film onto a thin plastic backing with the photographer's name and reference on a label on the back of each. Transparencies should be presented in black cut-out mounts which mask out unwanted detail and, again, have name and address on each separate mount. None of the material included should need a lengthy explanation about it, visual concepts should be self-evident. Each item should be separate so that the sequence of presentation can be rearranged as needed.

A general advertising portfolio could include people in fashion, beauty or real life situations, still life and product pictures and beauty or glamour close-ups relating to the cosmetic industry. However, many photographers will specialize in one area of interest such as food, still life, cars, household products, beverages or fashion, etc., and it is easier to be remembered for a speciality rather than an all encompassing collection of photographs. Even though the major part of a portfolio is given over to a speciality, it is always a good idea to include a few diverse pictures to show ideas in other fields.

An editorial portfolio will need to include many examples of imaginative visual concepts, none of which have any commercial point of view, all of which reflect the photographer's craft and ingenuity and are strong on mood, immediacy and documentary concepts. Do not include long sequences or picture stories which require too much time to view, these are often better reduced to fit on one portfolio page or two at the most.

Be on time for meetings with potential clients who wish to see the portfolio and, as far as possible, never leave the material for any length of time with clients unless an exact

Transparencies are best presented in black cardboard frames with a strong acetate sleeve slipped over the whole assembly. These are obtainable from professional photo stores.

duplicate portfolio is available for others who may need to see examples of the work at short notice. It is important to take a notebook to such meetings in case specifics are discussed and of course it is essential to know exactly what projected assignments will cost the client, unless these matters are handled by a photographic agent on your behalf. Leave a business card with each person who views the portfolio and follow up the presentation with a low-key enquiry about prospective work not more than one week later.

Make additions to the portfolio from time to time and take out work which is poorly received.

The organization of the portfolio is often dictated by the client who views it and the market he/she represents, so prior research can be useful. Lead the presentation with good, basic work, follow with some experimental items to show ideas and end with the most dramatic pictures in the area known to interest the client. Sometimes during the presentation an idea can be gained of special interests of the client and if these are represented in the portfolio it is advisable to

quickly rearrange the sequence to bring these images out last, so that more time may be spent in discussion. Learn to fit the portfolio to the needs of markets likely to produce work and never show too much improbable material for the market sought, even if it is photographically interesting.

Fine art photographers also produce portfolios but these are usually for re-sale and consist of costly productions of sequential or related images, bound or unbound and offered as limited editions. Enormous care must go into the preparation of these with archival processing of the images, creative book binding and mounting techniques and absolutely immaculate prints, which will all reflect the photographer's skills, concepts and aspirations. Very little advice can be given on preparing these portfolios as it is essentially a matter of personal choice with the individual and perhaps some influence from someone in the sales conduit selected.

PORTRAITURE

Unlike many other forms of photography, portrait photography exists on the uncomfortable premise that it is the subject who makes the final judgement on the merit of the exercise, rather than the creator of the image. More often than not the sitter's hazard is only a small fee, while that of the photographer is an in-depth commitment of time, materials and good will.

Portrait of an artist (Bridget Riley), disclosing something of her character and examples of her work. (*Courtesy Mayotte Magnus*)

Frequently the photographer submits a portrait which flatters the client in a genteel way by contriving an art image through the use of retouching, canvas mounted pictures and ornate gilt frames. Occasionally the photographer will venture toward an extreme opposite, producing an imperious image, full of his/her own ego and loaded with optical mannerisms which practically obscure the character of the subject.

The first approach is lacking in courage but does not lack for expressive qualities in the hands of skilful workers. The second is foolhardy and this pseudo-creativity usually results in infrequent sittings and financially miserable relationships with prospective clients. One of the basic rules of portraiture is that the sitter should find the results pleasing, but André Malraux unconsciously defined the higher aesthetics of the business when he wrote about his interest in the human condition; 'in a great man [to find] the form and essence of his greatness; in a saint, the character of his saintliness. And in all of them certain characteristics which express not so much individual personality as a particular relationship with the world.'

Obviously, we all have in our mind's eye an impression of ourselves and how the world sees us. The good portraitist has always had the capability, though not necessarily the duty, to mirror this self-perceived imagery of the sitter. The camera can also shatter this confident dream, penetrate any depth of vanity and reveal the subject in coldly analytic reality.

Generally, judgement must be exercised and artists must cover their integrity with a little commercial sugar-coating, if there is to be repeated business, unless they aspire to the lonely peaks of genius where their own clear vision and superb technique find enough admirers and clients to join with them to explore the intriguing essence of each personality who comes before the lens, in a creative effort to contact them more deeply.

Do not be apologetic about the medium of photography. It is a machine-made image, so why invalidate its very virtues by masking it in the guise of hand-executed art? In equating the artist's painted portrait with that of the photographer's mechanical image it must be said that, in both cases, they will rarely reach the status of art but, equally it is certain that they both sometimes do. No easel painter with weeks of skill could hope to equal the immediacy and dynamism of the photographic portrait when it is executed by a dedicated master of photography imbued with unfettered imagination and faultless technique.

Look for the best photographic and optical solution; render the image as a flat sheet of chemistry; present the image in a modern way, perhaps in metal frames with no window mounts or perhaps in book form, sequentially; or even multiframed segments to cover large areas of wall space (see *Decorating with Photographs*).

Equipment for portraiture is a very personal matter. A few great photographers use large format sheet film camera; many seeking candid, documentary or informal portraits use the 35mm SLR, but the standard for the professional industry is probably the medium format camera using 120 roll film. Lenses play a distinctive part in rendering natural perspective, particularly in close-up situations and a good rule would

be to use focal lengths of normal for full and three-quarter length figure shots, two times normal for head and shoulders or double portraits and a lens two and a half to three times normal for head shots only. Soft focus attachments, filters or lenses, may be found helpful in reducing the harsh, optical, mirror quality of high performance lenses. Colour film may sometimes be better exposed through a desaturation filter such as Tiffen make, as well as fitting a 'centre-sharp' filter to diffuse the optics even more.

Lighting will come from available light, tungsten (artificial light) or flash light. More control in lighting for concealment of faults may arise when tungsten is used but it is less comfortable for the sitter, while natural daylight in portraiture considerably enhances the communication between photographer and subject, often resulting in more believable and attractive results which are pleasing to both. The best compromise, however, is possibly a small professional flash generator with a facility for using several flash heads, such as Bowens or Balcar market, or several Multiblitz Vario units which have infinitely variable flash output. These are also fitted with strong tungsten halogen modelling lights which are directly linked in intensity with the flash tube control, therefore allowing a precise preview of the fall of light from the flash (see *Electronic Flash*).

The nature and placement of the key light characterizes a great deal of the special expressive qualities of a portrait photograph. Broad source lamps or reflectors fill in and de-emphasize texture, coating the skin with a healthy sheen, very suitable to female subjects or children. A diffused key light in the top front position (see fig. page 278) generates a touch of high glamour, a strong, narrow-beam light from the side creates texture and form, especially suitable for male sitters. Low placed lights and overhead lights impose somewhat theatrical over tones on the session, while back light suppresses contour but dramatizes edges.

Accent lights are important (see fig. page 278) particularly hair lights to separate hair from background and give it a healthy look, skid lights to skim across textures to increase tactile qualities and chisel lights to define profiles. Rim lights may be needed to separate the form from backgrounds or for special halo effects. Such lights are always considered to be 'tight' lighting, meaning that the sitter cannot move freely and the photographer, by the use of constant direction, must encourage the subject to adopt the best position for most effective use of accent lights. Where movement is a problem a broader 'wrap-around' lighting plan is probably needed, which is blander but does not impose restrictions on the subject (see *Lighting*).

Lighting ratios are generally kept in the 3:1 (highlight to shadow) range for children, female subjects or most colour transparency material and can be 4:1 or 5:1 for male sitters. In B/W for special dramatic effect in colour this can rise to 8:1 or 16:1. Estimating these ratios is easiest with a separate narrow angle meter such as the Minolta Autometer or a 1° spot meter such as Soligor or Pentax and adjustment of fill lights or reflectors must be carried out with care. Automatic camera meters are not useful for precision studio lighting in portraiture.

A sensitive double portrait of Mary Quant and Alexander Plunkett-Green. (*Courtesy Mayotte Magnus*)

There must appear to be one main key light and all other lights must be subordinated to it and not cast secondary shadows (see fig. page 279). Highlights will advance and shadows recede, so the illusion of three dimensional realism is increased if the frontal plane of the face receives the key light, while sides of the face, neck and underside of the chin are more shadowed. To widen narrow faces, *broad* lighting is used to light that side of the face nearest the camera and to reduce the width of round faces or to apparently reduce weight in a face, *short* lighting is used to light that side of the face furthest from camera. In both cases the shadow side remains comparatively dark. With broad lighting it is usually necessary to use a flag or barn doors to reduce light falling on the ear or back of the head exposed to camera viewpoint (see fig. page 278).

On seamless paper backgrounds, a background light is necessary to create spatial depth behind the figure in order to wrap the subject in an atmosphere suited to the nature of the final picture. This light is usually tightly snooted and perhaps scrimmed to soften it and is placed out of camera view behind the sitter. It is washed over the background to create a more intense light behind the *shadow* side of the subject, dropping away to a darker tone behind the *highlight* side of the sitter. This transition of tone in the background and the play of light against the dark, dark against light, increases dimensional effect and heightens visual interest. Background light is

a

b

d

e

g

h

c

f

Different focal length lenses alter the appearance of the sitter. Choose the correct lens to render the subject at its best. These examples are taken on a 35mm format, all at f8.

a Taken with a 25mm lens, which is too short and causes ugly distortion.

b A 35mm lens, still too short for close-up use, but could be used to thin down a face.

c A 50mm, normal lens. In close-up there is still some distortion which can be used for altering the shape of the face.

d A subtle difference from the normal lens. Note the widening of the jaw line. This is a 60mm lens.

e The perfect lens for portraiture, showing the face exactly as it is. An 85mm lens.

f Another excellent portrait lens, the 135mm. There is some compacting features which could, for example, reduce a prominent nose. Working distance is comfortably increased.

g A 200mm lens produces further compacting of perspective and a more arresting look to the face. Such a lens allows the photographer to be a considerable distance from his subject, but it is usually the maximum lens length normally used for portraiture.

h When a very long 500mm lens is used, contours projecting towards the lens are reduced in emphasis, and a more dramatic picture results. Contrast this picture with (e), taken with a normal lens. Depth of field is very much restricted and it is important to focus on the eyes when using this lens, as most of the head could be unsharp at wide apertures.

usually 50–75% in strength compared to the key light, highlight for highlight. For high key effects, this background light is increased to two to four times the value of the key light and diffused considerably by the use of a broad source reflector or translucent screen background (see fig. page 282). Specular highlights in the eyes can be produced by a weak, bare bulb light placed near the lens axis but well behind camera.

The height at which the camera is placed in relation to the sitter is an important aspect of controlling perspective. Normal perspective in a head and shoulders portrait is found by using a slightly longer than normal lens and locating the lens axis at the level of the mouth. Raising the camera will lengthen the planes of the face towards camera, make the top of the face broader and the chin and jawline narrower. Lowering the camera will reduce the width of the face at the eyes, make the chin stronger, accent the neck and reduce the

Portraits of people may not always be conventional. Here rim lighting and the Sabattier effect make an unusual image.

Above The butterfly or 'glamour light' is often used for lighting female subjects. It produces very little texture and a pleasing emphasis of the bone structure by creating shadows on the edge planes of the face. (See top front light, under *Lighting*.)

Below The hair light, an accent light, is much softer than a halo light and separates the hair from the background and gives it character. In this example the face has been under lit to show the effect more clearly, but in practical work the key light would at least equal the intensity of the accent light.

a

b

To set up a general portrait lighting plan follow these steps.
a Decide if the key light is to light the main part of the face nearest camera. This is 'broad' lighting and subdues textures to some extent. Or
b The main light can fall mostly on that part of the face farthest from the camera. This is 'short' lighting, often used for male portraits.

c Place the background light to be lightest at the point where the face will be darkest.
d Place the key light.
e Place the accent lights for hair or increased separations from the background.
f Add the fill light to increase detail in shadow areas.

c

d

e

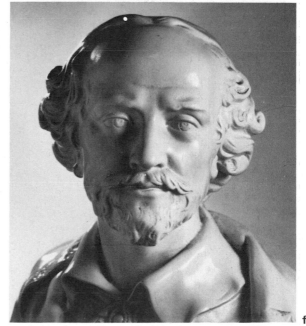

f

SOME WAYS OF CORRECTING SPECIAL PROBLEMS IN CERTAIN FACE TYPES

Type	Problem	Treatment
A	Receding forehead, prominent nose	Camera slightly above sitter's eye level, chin up, face toward lens, top front light. Use wider angle lens, lighting ratio 4:1.
B	Receding chin, prominent nose	Camera at sitter's shoulder level, chin up, face toward lens, top light. Normal lens, lighting ratio 4:1.
C	Protruding chin	Camera at sitter's eye level, chin slightly down, normal lens, lighting ratio 3:1.
D	Long nose	Camera at level of chin; face toward lens; telephoto lens, lighting ratio 3:1, top front light.
E	Double chin	Camera level with forehead; raise chin, top light, face to $\frac{3}{4}$ position, lighting ratio 8:1.
F	Large nose	Camera level with mouth; face turned away from camera; short lighting, lighting ratio 4:1.
G	Wrinkles	High key lighting; fill from lens axis, diffuse lens, $\frac{3}{4}$ view of face.
H	Large ears	Turn face from camera to hide one ear; half profile; key light along line of profile, nearside ear in shadow. Lighting ratio 8:1.
I	Wide jaw, narrow forehead	Raise camera to level of forehead, chin down, normal lens. Lighting ratio 4:1.
J	Wide forehead, narrow jaw, small chin	Camera at level of bottom of throat; chin up pointing at lens. Short lighting, 3:1 ratio, normal lens.
K	Narrow chin, wide cheekbones, receding forehead	Camera at mouth level; chin down; $\frac{3}{4}$ face; short lighting, ratio 4:1. Longer than normal lens.
L	Baldness	Camera at mouth level, chin up, make up on bald patch, no hair light, side-light ratio 3:1.
M	Glasses	Chin up or down to avoid reflection of lights, use key light and fill at opposite sides of face, use SLR for precise control.
N	Cheekbones wider than chin	No real problems, use longer than normal lens, chin up; camera at chin level.
O	Long narrow face, hollow cheeks	Camera at nose level, head $\frac{3}{4}$ turned, use broad lighting with 4:1 ratio.
P	Square jawline, masculine features	Face to $\frac{3}{4}$ position, camera at forehead level, normal lens; use short lighting 3:1 ratio.
Q	Full chin, round hairline	Chin down, camera at eye level, face $\frac{3}{4}$ position; short lighting, ratio 4:1.

length of the nose. A three-quarter length figure will need camera located at chest level for normality with such a lens and a full length figure should be photographed from the sitter's waist level. The effects of changing camera heights should be watched through the taking lens if possible, while the camera is racked up and down on a tripod. The sitter should be asked to slowly turn his/her head while the changing perspective can be brought to bear on different features. The best angle can easily be found this way.

The above considers to a large extent studio portraiture under highly controlled conditions, but much of the experience in the studio can be translated for use in outdoor situations or interior locations away from the studio. Always there must be only one key light, use soft diffusion plastic screens, or minus 'reflectors' where needed, controlled camera positions and reasonable lighting ratios. Backgrounds often must be diffused by differential focus and wide apertures. (See also *Lighting*, *Critical Distance*, *Synchro-Sunlight*, *Multiple Flash*, *Theatre Photography*.)

Look at these face types and find how each should be treated from the accompanying table.

A
Receding forehead and prominent nose

B
Receding chin and prominent nose

C
Protruding chin

D
Long nose

E
Double chin

F
Large nose

G
Wrinkles

H
Large ears

I
Triangle (i) Wide jaw, narrow forehead, round chin

J
Triangle (ii) Wide forehead and narrow jawline

K
Diamond: Narrow chin broad cheekbones receding forehead

L
Baldness

M
Glasses

N
Oval: Forehead wider than chin

O
Oblong : Long narrow face hollow cheeks

P
Square: Square jawline, masculine

Q
Round Full chin, round hairline

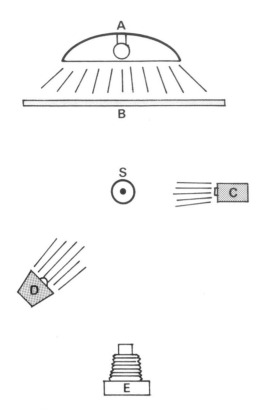

To create high key light. A is the large, bright background light, B the large translucent screen of Rosco Frost, C the strong key light, D the strong fill light, and E the camera position. S is the subject.

POST FLASHING

This is a brief secondary exposure to light after the original full exposure has been made and sometimes takes place during actual development of that original exposure. It is generally used for lowering contrast or increasing shadow detail (see *Flashing*).

POSTERIZATION

This graphic technique uses line or lith film to reduce fully contoured tonal gradation, simplified flat tones and edge lines, to indicate area rather than depth, creating a so-called poster effect. It is a purely photographic technique, employing basic films and chemistry. It is perhaps better to use high contrast films in the beginning, such as Kodalith, Fuji LO-100 or Dupont CLF 4, processing in lith two-part developers for maximum contrast if needed.

Expose a negative on successive sheets of high contrast film:

a) An under-exposure to record shadows only
b) A normal exposure to produce mid-range tones
c) An over-exposure to block out all tones except highlights
These positive records are then contact printed also on high

contrast film but processed in an active print developer, producing three separate negatives. When dry these are printed one after the other, using registration pins to position them accurately on the one sheet of enlarging paper.

The cumulative effect will produce different flat tones in highlight (white), mid tone (grey), shadow (black). Colour can be introduced by using the same basic technique, but with positive and negative separations to produce mutually exclusive masks for all of the image except the colour desired, which is introduced into the light beam by arbitrarily chosen filters. (See *Tone Line, Lith Film, Image Synthesis*.)

POTASSIUM BROMIDE

Added to the developer, this substance restrains chemical fog levels in the emulsion and inhibits development activity to some degree, also causing loss of emulsion speed. It is not always needed in developers for use with today's film, as manufacturers have considerably reduced fog levels in negative materials and during development some bromide is released anyway by the emulsion during the action of development, being encouraged to do so by *agitation*. This small amount of bromide so liberated is often sufficient to control any fog levels in most modern emulsions.

POURING LIQUIDS

Narrow diameter measuring graduates sometimes cause false measurements when a U-shaped surface is produced on the solution. A wide-mouthed cylinder is better suited to measuring. Very viscous liquids such as Kodak HCI10 developer must be first diluted in order to accurately measure out a working solution. Foaming of the liquid, which causes miscalculations, can be avoided by pouring gently with both containers angled towards each other (see also *Mixing Solutions*).

PRE-FLASH

This is a technique used in colour copying to reduce contrast and it can also be used to lower contrast and increase shadow detail in enlargements on film or paper. A preliminary, very brief flash is given to the unexposed material before the full exposure is made. It can increase emulsion speeds one to two f stops. (See *Flashing, Copying, Contrast Control*.)

PRE-VISUALIZATION

Successful photography can generally be divided into two categories. The impromptu snap-shots of passing events where the accidental, but pleasing, arrangement of picture components is largely what attacts us or, the second category, where deliberate and knowledgeable organization of the picture components creates planned effects on the viewer.

The first category requires only that the photographer knows the equipment well, is ready to use it instantly and is aware of the activities before him/her. The second requires considerable thought beforehand. The best aid to designed or

planned photographic images is to pre-visualize the final result, long before the event takes place. This means acquiring a technique a little like meditation, whereby the total image can be conjured up in the mind, complete with lens angles, camera angles, lighting, colour patterns and mood. In the best of photography there is always the actual final high point of action or inspiration, even in still life subjects and it is usually too late then to make any consideration of structure or specific manipulation of the subject. It is better by far to manipulate the subject in the mind's eye and note the possibilities of the image, before getting involved with the eventual photography.

Pre-visualization takes place more easily in a quiet, relaxed, even soporific surrounding, just as meditation does. Deep breathing and soft lighting, plus suitable low key music may be essential during early attempts. A notebook or sketch pad is needed. First list the subject, its accessories, environment, colours, etc., and then decide if the picture will be in a horizontal or vertical format. Then conjure up an image of the subject, using the items on the list to supplement the picture in the mind. Think how the image looks from a single camera viewpoint, with a normal lens, under a particular lighting situation. When the vision of the image is sufficiently clear in the mind, quickly sketch the outline of the components on the paper in a stamp size sketch.

Thumbnail sketches of proposed subjects help to clarify visual concepts. (See colour plate 20.)

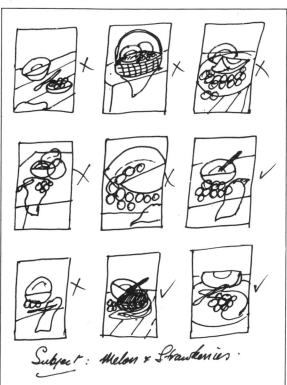

Look at what you have sketched, imagine that the position of the components has been changed, other things added, different colours, different lighting, changed viewpoint, different lenses. Note these newly visualized alterations in successive small sketches. Deliberately think in opposites or laterally, potholing for ideas in unlikely computations of the subject and its component parts. If one image is visualized with wide angle effect, conjure it up again with a telephoto. If you have a plan of the normal viewpoint, try the possibility of a very high bird's-eye view and sketch that.

When the exercise is complete, a number of sketches should present prospective guides to interesting images. Note the best of these and think deeply around these few, making changes or new sketches as needed. Finally, when one image is chosen, list all the subject details and photographic needs, assemble these following closely the small sketch, now elevated to a layout sketch to guide the basic design of the picture. In actual photography if you have planned action in this image, work very hard to direct that action until it conforms as nearly as possible to the pre-visualized idea. Use the lighting decided upon and the colours chosen, in the areas and quantities selected by the meditative exercise earlier. Do not be unaware, however, of the contribution which the subject itself makes to the success of the picture. Watch for any pattern, rhythm or character emerging while photography takes place and while keeping as far as possible to the basic, pre-visualized image, allow these new and volatile qualities to express themselves and be captured on film.

All intentional photography benefits by pre-visualization and the technique is easily learned. It depends, of course, on how well the photographer understands his/her craft so that when imagery in the mind is changed by adopting a different technical element, the new potential image is correctly translated into practical possibilities. Working in this way, images may be closely designed to perform a task or precisely to illustrate the photographer's concept and thus increase greatly the communication with viewer (see *Image Management*).

PRIMARY COLOURS

The visible spectrum may be split by a prism into a band of primary colours which allows us to see those which form the basis for re-constituting the impression of full colour in vision, photography painting or photo-mechanical processors. The agreed minimum three colours, which are generally red, green and blue are the primary colours affecting the human eye, but photographic processes use the subtractive primaries of cyan (blue-green), magenta (pinkish red) and yellow. (See *Colour Harmony*, *Colour as Seen*, *Vision*, *Colour Photography*, *Photo-Mechanical Printing*, the colour plates for *Colour Photography*.)

PRINT TYPES

Daguerreotype Direct image on a silver-coated copper plate. The bright image can be seen clearly only from certain angles, and it is a reverse, mirror image of the subject. Such images

are made without negative and therefore are unique one-off prints.

Talbot-type or Calotype This is a paper print from a paper negative and was the first positive/negative photographic process. Invented in the year prior to the Daguerreotype and used widely thereafter.

Albumen Used widely in 1850 to 1890 period, has a sensitizer made from egg-white. The print is sepia coloured with a high gloss.

Ambrotype An improvement on the Daguerreotype, produced in the 1850s and sixties, which avoided the mirror image and the need for viewing only from certain directions. This was an image on glass.

Carte de visite A portrait on thin card, patented in France in the 1850s and used as a calling-card. Slightly smaller than half a postcard.

Tin type A much cheaper version of the Daguerreotype, made on a black, lacquered iron plate which was placed in the camera. It could be hand coloured and was invented in the 1850s.

Platinum A soft silver-grey image on paper sensitized by metallic platinum instead of silver, used from the 1870s to the 1930s. A modern revival is now in progress despite its slow speed, because of its total permanence.

Palladium A 1914 war-time substitute for platinum, using palladium salts.

Salt A slow, contact paper sensitized with table salt. The image could be hand coloured.

Cyanotype A print made by a sunlight exposure on a blue-based paper, giving a white image.

Gum Sensitized with bichromate, self-coated by the photographer and capable of monochromatic colours and much surface manipulation. Permanent to light.

Carbon Introduced in the 1850s, paper carried carbon pigments in a gelatin medium. Colour could be added to the pigmentation.

Carbro Perfected in 1874, similar to carbon printing in many respects, now capable of permanent full colour images on a bichromated and pigmented gelatin emulsion.

Bromide A gelatin-coated paper base, sensitized with silver salts, introduced in the late 1880s and now the basis of much of today's photographic enlarging.

Chloro-bromide A slower, paper-based material, using silver chloride plus silver bromide as a sensitizing agent, producing a warm tone, full separated image with a long range of densities.

Dye transfer A Kodak process popular 40 years ago and still in use. Colour separations are made and a dyed matrix is used to transfer these sequentially on to a final paper or plastic support. Colours are very slow to fade in dark storage but are visibly affected in a few years of constant exhibition to light.

C print An original Kodak positive/negative colour process now superseded by other types, but the term is used by professionals today to describe any positive/negative process from all makers.

R print A reversal colour print process from Kodak of a very high standard, for positive-to-positive reproduction.

RC print A monochromatic or colour print manufactured on a plastic, resin-coated paper base to minimize absorption of solutions and thus hasten processing.

Cibachrome A film-based colour print process from Ciba-Geigy in Switzerland, giving the highest colour saturation and resistance to light fading of any commercial colour process. Formerly of very high contrast but new refinements have improved the tonal scale which is now greatly extended to give colour prints of great beauty.

Polacolor A print from the Polaroid Corporation using metallized dyes, some of which are very long life, available in giant sizes up to 50 × 60cm (20 × 24 inch). Each print is a unique original.

Fresson A unique colour process produced by the Fresson family in France. Somewhat related to carbro, prints are not an accurate record, being muted and biased to warm colour shifts, but the final image is of great beauty and permanence, much prized by exhibition and fine art photographers.

PRISM

A device which will split visible white light into a continuous band of its component colours of the spectrum (see *Colour as Seen* and *Light*).

PRODUCT PHOTOGRAPHY

For many professional photographers, especially when beginning their career, photographing commercial products and packages will be a necessary part of their activities and a good source of income. It is always performed with a large format camera, usually in a studio with powerful electronic flash. Lighting is of critical importance and obtaining the correct geometry and perspective after the viewpoint has been selected will also need time-consuming attention. All surfaces of the product must be given their correct characteristics, which should be sharp and clear, small specular highlights can be used as accents on glassware but must not spill on to paper labels. Translucent, or transparent, products must show this attribute by the use of small back reflectors, but these must not burn out the highlight.

Rectangular packages must sometimes be shown with oblique perspective, where the front is perfectly squared up, but one side and a top surface is also seen. Isometric perspective is also used where two sides and the top show equal amounts to the camera and this is also achieved by the use of the view camera movements.

Most products, particularly packages, must be carefully hand picked from factory stock or, if empty closed packs are to be photographed, a number of knocked-down packs are obtained directly from the printer and carefully rebuilt by hand to get perfect edges. All bottled goods should be supplied to the studio unlabelled, with at least three perfect labels for each bottle, unattached and uncreased. Foil sachets, containing dry goods, can be a particular problem because of indented surfaces which catch light, causing flare and these are also obtained empty, being filled in the studio with coarse powder and sealed with the correct crimping effect. Cigarettes

will have to be photographed precisely as the client requires as research on presentation has reached the ultimate in sophistication with this product. Watches will generally have their hands set to 10.10 if they are analogue designs and other products will be given credibility by simple actions, such as pouring.

Focus control and geometric control being so stringent on this type of photography, active situations often call for complex off-camera preparation and planning. (See *Lighting*, *Advertising Photography*, *Large Format Cameras*.)

PROMICROL

An unusual fine grain developer made by the well known photographic chemists, May and Baker, of the United Kingdom (see *Appendix*), which produces a grain somewhat similar to the ultra-fine grain results formerly obtained with para-phenylenediamine. Emulsion speed is enhanced as much as 100% and a compensating action also takes place whereby shadow detail is enriched during development, without greatly increasing density within medium and highlight tones or overall contrast.

Used undiluted it cannot be said to be of high acutance with some films, but diluted 1:1, 1:2 or at most 1:3, edge sharpness of the image is excellent with good printing contrast and extremely fine grain. Once the developer is diluted it becomes a one-shot solution, to be discarded after each batch but, used at full strength, replenishment is possible. When diluted, increased times of development are required and it is advisable to lift the temperature of the solution to 22–24°C (71–75°F), to reduce the time factor to a more comfortable level. Correct *agitation* (moderate) is essential for good results and one litre of Promicrol will process 12–120 or 135/36 roll films without replenishment or 50, 9 × 12cm (4 × 5 inch) sheet films.

PROOF

A first print of a photograph or a contact sheet of a number of images, made to guide photographer and client toward the final image.

PSEUDO-SOLARIZATION (SABATTIER EFFECT)

True solarization, where an increase in exposure results in an actual decrease in density, requires that increase to be at least 1000 times greater than normal before the reversal is seen and modern emulsions often resist even that degree of gross over-exposure. It was first noticed by early Daguerreotypists and the reversed tonality was seen to be produced only by the intensity of sunlight, hence the use of solarization to describe the phenomenon.

Pseudo-solarization, where the image is partly reversed, is better called the *Sabattier effect*, but both terms are in current use, and *Armand Sabattier* himself described his discovery as 'pseudo solarization reversal'. The Sabattier effect depends on a re-exposure to light during development of an earlier

Using a 35mm colour transparency as an original, a film negative was made and solarized (see *Sabattier effect*). The characteristic fine edge lines occur wherever dark and light tones meet and are called Mackie lines.

exposure. The partially developed primary image acts as a mask which shields part of the image during the second exposure, and during the continued development a secondary reversed image appears. Between the areas of extreme contrast, especially on film images, a thin, clear line is formed, called a Mackie line, and this is characteristic of the Sabattier effect.

Materials differ markedly in their behaviour to this treatment and many tests of emulsions and developers will be needed before a predictable and repeatable result is to be obtained. Controlling factors for good images from this technique include the contrast of the emulsion used, the dilution and age of the developer, the degree of over-exposure of the primary image, the length of the first stage development before the reversal exposure, the length of that exposure and the amount of second development which takes place after the reversal exposure.

The best print material to use is a high contrast paper such as Agfa Brovira grade 5 or document copying paper, developed either in a special solarizing developer such as Solarol or in well used print developer such as Kodak Dektol or May and Baker Suprol used at normal working strength.

Film stock for successful solarization is usually high contrast lith film or medium contrast, continuous tone copy film processed in a diluted print developer or in an active negative developer such as Kodak DK50 or May and Baker Suprol. Amidol print or negative developer also is particularly good for the purpose. Films effective for many subjects are Kodak Commercial 6127, a fast continuous tone copy film; Kodak Gravure Positive film; Fuji 1.100 or Dupont CLF4. A 3% stop bath is needed to arrest the developing action immediately.

Ten steps to good results:

1. Position a 15 watt clear lamp, connected to foot switch, 1 metre (40 inches) above the surface of the developing dish.
2. Turn on red safe-light.
3. Test the first exposure and develop for two minutes exactly.
4. Set the print timer for $1\frac{1}{2}$ minutes.
5. Make the first exposure.
6. Develop, emulsion-side up with continuous agitation.
7. After 30 seconds, let the developing dish rest for 15 seconds.
8. At 45 seconds re-expose for five seconds to the white light.
9. Agitate very briskly and develop 45 seconds more.
10. Place the film immediately in stop bath.

Experiments and variations must be made until the subject chosen is getting optimum treatment. Lith films produce very interesting high contrast effects and over-exposure of the secondary image when using this film introduces intermediate greys (see *Image Synthesis*).

PUBLICATION OF PHOTOGRAPHS

When submitting any photographs to editorial sources for possible publication it is important to follow some basic rules. Before submitting work ask the features editor if any special subjects are of interest and if any of this type of image is in your collection offer these first. All monochrome prints should be on unglazed, smooth, glossy paper of cool tone, be approximately 18×24cm (8×10 inch) with a 5mm ($\frac{3}{4}$ inch) white border and be unmounted. Captions should be typed on separate slips of paper and glued to the reverse side which must also carry the photographer's name and address and copyright details of that image. All prints, B/W or colour, must be sharply focused (use an easel magnifier) and have good shadow detail and emphatic black where it naturally occurs plus good highlight separation. Contrast can be slightly higher than normal especially for black and white reproduction. When the print is dry, spot all prints and reprint any which have been damaged. Transparencies can be mounted on temporary black card mounts which must also carry the photographer's name and address, copyright information and a key to caption numbers which are listed on an accompanying sheet. A covering letter should set out copyright information and state what rights are available in that respect, plus a definite value on the consignment should it be lost or damaged while in the possession of the publishing client. The entire material is put into a padded security envelope, with return postage for unwanted items and the photographer's name and address written on the outside of the envelope. Send all valuable work by registered mail if possible, or have it hand delivered and obtain a receipt.

It should always be clear between the parties concerned what rights of publication are available upon acceptance and the photographer should rarely offer to dispose of his/her copyright entirely. This must be the subject of a letter or written contract. A *model release* may be needed wherever any person is clearly recognizable except in the case of photographs relating to hard news. Do not forget to seek the return of original material after publication (see *Photo-journalism*).

PUSH PROCESSING

When a B/W or colour film is given extended development to increase apparent film speed it is said to be push processed. This generally increases grain and contrast, but does compensate for under-exposure and adds some brilliance to the highlights. If used as a deliberate technique to increase highlight separation, it is vital that shadow areas receive more light than normal by additional diffused fill light or the use of large reflectors.

The amount of push processing that may be acceptable to a particular film will depend on the various film and developer combinations, but 50–100% is obtainable with most materials. Colour negative films do not respond well to push processing unless for special effects of grain or harsh contrasts and then it is sometimes better to use high speed Ektachrome reversal film, but process it as a colour negative. A harsh, grainy, somewhat pointillistic effect is the result. Low contrast lighting or outdoor scenes or groups under cloudy conditions, can benefit by push processing one to two stops in B/W, half to one stop in reversal colour films. Where extra B/W film speed is needed, but not in high contrast situations such as night shots or theatre or pop concerts, a 100% increase in development can give a two-stop benefit to the photographer. All push processing should proceed from an initial trial, or *clip test*, of a few frames cut from the film to be so treated and processed first for evaluation.

For B/W film, a 50% increase in development would mean a one stop reduction in exposure or doubling of film speed. A 100% increase in developer time could increase film speed by a factor of four or an *under*-exposure of two f stops. It should be remembered that many B/W developers are formulated to provide an increase of film speed at normal developing times and this can considerably boost total film speed on B/W material when combined with push processing. For Kodak E6 reversal colour films an increase in the first developer of two minutes would allow film speed to be increased by two times, or an additional $5\frac{1}{2}$ minutes in the first developer, would allow film speed to be multiplied by four, giving a two stop reduction on camera, but tests must be made. It should be noted that shadow detail, which is under-exposed in B/W

Unusual angles and innovative points of view are essential for the editorial photographer. (*Courtesy Calvin Walker*)

films, is subsequently lost entirely in push processing techniques, whereas colour reversal film holds latent shadow detail when under-exposed. Push processing of colour reversal film will therefore restore this detail with little damage to highlight areas, but with some loss of maximum density (black) and an increase in contrast.

PYRO CATECHIN

Pyro catechin, introduced in 1887 as a developing agent, is more active than hydroquinone but it is little used today. It gives direct brown tones on bromide paper but is used at 37°C (100°F). Before placing in the fixer after immersion in a *warm* stop bath, the emulsion must be allowed to pass through progressively cooler water baths before fixing and washing in the normal way.

Formula

Pyro catechin	8g
Potassium carbonate	90g
Water to make	2 litres

Dr Julian Smith, a well-known Australian amateur portrait photographer who also ran his own medical practice, would often select his subjects from strangers in the street. Putting them into a large, fast car, he would whisk them to the studio for a brief, but active, photographic session. His prints were notable throughout the world for their superb warm colour, quality and rich tonal range and his pyro catechin formula was often used by others.

Doctor Smith would often obtain his best exhibition results by developing the image to an overall maximum density until almost unreadable. He would then carefully bleach the print back to its ideal density with Farmer's Reducer. With such an active developer, very reduced enlarging exposures are possible.

QUARTZ LAMPS

(See *Tungsten Light* and *Halogen Lamp*.)

QUESTAR

A small telescope which can be adapted to most 35mm cameras, supplied in the focal lengths ranging from 800–2000mm. It is a mirror lens, compact and delivering superb images. (See *Appendix*.)

RANGEFINDER CAMERAS

These cameras are fitted with a rotating mirror or prism to alter an incoming image seen through both the viewfinder and a secondary window. When focusing on an object nearer than infinity this causes the lens to move and the two halves of the image also move in a linked system. When the two disparate rangefinder images are brought together in perfect harmony, the lens is known to be sharply focused on the chosen point.

SLR cameras often have a split image rangefinder in addition to the focusing Fresnel lens screen and this added feature is a desirable aid to rapid, precise focusing. The outer focus image will often appear to vibrate or to sparkle until focus is precisely aligned, or a lateral or diagonal displacement occurs until sharp focus is reached (see *Camera Types*).

The Leica is a famous example of a rangefinder camera. (*Courtesy E. Leitz & Co.*)

RAPID PROCESSING

It is sometimes necessary to speed up wet processing in order to print an image quickly and this can be done by taking a negative from the fixer, rinsing it for 30 seconds in running water then placing it on a glass plate the same size as a normal negative carrier. A squeegee or roller is used to press the negative firmly to the glass and to remove excess liquid and any air bubbles. The print is then made on a single weight RC paper, fixed for 30 seconds and washed for three minutes.

Drying under heat will take a further two to four minutes. Using a rapid developer such as Suprol, processing dry to dry, would not be longer than six minutes. The negative can then be lifted from the glass carrier and re-washed for the correct time. An alternative method, if a dry negative is needed instead of printing from wet film, is to bathe the film for one minute in methylated spirits, drying it in warm, fast moving air, such as that from a hair dryer. Drying is extremely rapid but occasionally staining may result. No important negative should ever be rush-processed in this way, but should receive proper and complete attention in all wet stages and should be dried slowly in air not above 27°C (80°F).

RAY, MAN (1890–1976)

Ray came under the influence of photographer Alfred Stieglitz in 1911, during lunchtime visits to the famous 291 Gallery in Fifth Avenue, New York. Although fascinated by photography, he was determined to become a painter. From the beginning he was interested in abstraction and the fragmentary two dimensional painter's images coming out of the studios of France at that time. He was also particularly affected by the rising influence of the machine on modern art and it was natural that although he continued to paint and was closely involved in the Dada movement and Surrealism, he began to devote considerable time to the machine-made image produced by photography.

He brought to photography the soaring imagination and experiment which already characterized his painting, graphics and sculpture and, in the early 1920s, became internationally famous for his Rayographs, photograms and solarizations which offered new dimensions to photographers at the time

and are only now being understood by a rising tide of young photographers in the 1980s. He spent the war years in Hollywood, painting, exhibiting, teaching photography and longing for Paris. He returned to Paris in 1951 to take up again his close friendship with painters, including Picasso, Max Ernst and Duchamp.

Man Ray continued to use photography as he did any other medium of art – as a servant of his mind. He was very aware that although the machine had many intrinsic beauties, it could easily become an unbridled monster if it was treated with too much reverence. In many ways he explained photography to his fellow artists and was one of the few painters who stepped surely between the two media, using each for its own inherent value and yet interweaving the very different images with imaginative borrowings from the other art form. He is one of the rare photographers to have his work exhibited in the Louvre, in 1971, and his photographs are exhibited widely throughout the world.

REAR PROJECTION

Where a subject must be surrounded by a background which enhances its character, but it is impossible to place it in the most suitable real environment, this can be done in the studio by rear or front projection which casts a projected scene

Using rear lighted transparencies as a background. A is the diffused backlight, B the large transparency, C the middleground objects, D the subject, E the camera and F the overhead key light for subject only. (See the section under *Food Photography* for an example of this type of photography and colour plates.

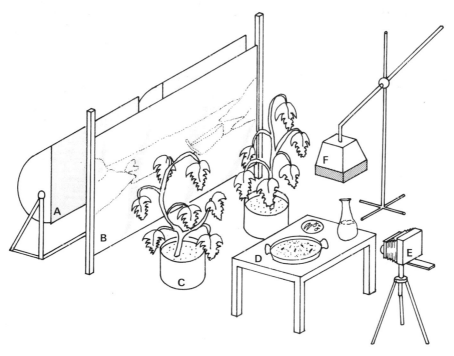

around the object to be photographed. Rear projection is not an easy solution for the problem, as there is a considerable loss of image intensity due to absorption by the screen material and, unless very long lenses are used, a hot spot is evident around the projector lens axis with a very sharp fall-off at the edges of the screen. Even if very long lenses are used, needing considerable back space behind the screen and great power from the lamp (1000–2000 watts would be normal), the method only suits small backgrounds, say 75cm (30 inches) square. A much better way is to have large transparencies made, e.g. 2 × 1 metres (78 × 40 inches) on print film from a chosen background scene and suspend this, stretched tightly over a thin metal frame, behind the subject. This is then back-lit by a large diffuser to create the impression of a real and integrated background (see fig.). If middle distance objects such as plants are placed properly between subject and background, the illusion is heightened. All stray light from subject lighting must be excluded from the background image whether it is projected or in a transparency. (See *Front Projection*.)

RECIPROCITY EFFECT

The reciprocity law as it relates to photographic sensitometry states that $E = I \times T$ or that *exposure* is equal to the *intensity* of light source *multiplied by* the duration of *time* which elapses while that light source illuminates the subject.

The law usually applies to exposure ranges of between $\frac{1}{10}$ and $\frac{1}{1000}$ of a second for most films but does not necessarily hold true outside these times. For B/W, some compensation may be needed when the exposure does not fall in this range and the accompanying table sets this out. Colour emulsions, due to multi-layers of different sensitivity, may react very differently, not only needing increased exposure but requiring cc filters to be added as well. This is usually covered on manufacturers' data sheets. Special emulsions are available in both colour reversal and negative which have had certain characteristics altered to make them more suitable for long exposures and these should be used when times are likely to exceed one second.

Long exposures in B/W film tend to increase contrast needing therefore reduced development (15–25%), while very brief exposures of $\frac{1}{1000}$ to $\frac{1}{2000}$ of a second, or less, will need increased exposure (half a stop) and increased development (15%) in order to off-set a lowering of contrast and highlight density.

RED EYE

Due to the retinal tissues of the eye, which carry large amounts of blood, lighting along the lens axis, such as is typical with a small camera with a flash attached to the body by hot shoe, can be reflected back to the lens as a ring of red light around the pupil. To avoid this undesirable affect, the flash should be taken off-camera and held at arms' length from the lens, be bounced on the ceiling or overhead reflector, or be placed on a hot shoe extension bracket at least 25cm (10 inches) long, all of which methods remove lighting from the lens axis. (See *Flash Photography*, *Electronic Flash*, *Multiple Flash*.)

REDUCERS

Chemistry may be mixed to reduce the density of a negative or print image, increasing or decreasing contrast as desired (see *Farmer's Reducer* for the most usual formula for such a solution).

REFLECTANCE RATIO

The variations of reflected light from objects can be measured and expressed as a ratio. White may reflect 90% of all light reaching it, black perhaps 10% or less and this would be given as a ratio of 9:1. Subject contrast ratios are decided upon by combining the product of a lighting ratio with that of a reflectance ratio. For example, if a lighting contrast ratio is produced at 3:1 (highlight to shadow) and the reflectance ratio is known to be 9:1, subject contrast ratio is therefore 27:1.

REFLECTED LIGHT

Light which is indirect is reflected or bounced from a diffusing substance of some kind, causing shadows to lose intensity and edges to soften. Reflected light absorbs colour characteristics of the reflecting substance and influences the final lighting of the object. (See *Lighting*, *Bounce Light*.)

REFLECTORS

These silver, white or coloured lighting accessories are used to bounce light back into shadows or restore brilliance to underlit areas in lighting plans (see *Lighting*). Minus reflectors are totally black and absorb all light, producing deeper shadows.

CORRECTING RECIPROCITY LAW FAILURE

Exposure time	Exposure compensation	Development B/W or colour	Other actions B/W	Other actions colour
2 minutes	+ 4 f stops	−25%	none	cc filters
10–20 sec.	+ 2 f stops	−15%	none	cc filters
1–10 sec.	+ 1 f stop	none	none	cc filters
$\frac{1}{2}$ to $\frac{1}{1000}$ sec.	none	none	none	none
$\frac{1}{1000}$ to $\frac{1}{2000}$ sec.	+ $\frac{1}{2}$ stop	+ 10–20%	none	cc filters
$\frac{1}{10,000}$ sec.	+ $\frac{2}{3}$	+ 20% Not Polaroid	none	cc filters

REFLEX CAMERAS

The single lens reflex camera (SLR) has a viewfinding system which reflects the image entering through the taking lens to a viewfinder generally of the same dimensions as the camera format. The twin lens reflex, however, has a viewing lens mounted above and parallel to the taking lens, of the same focal length and angle of view. Such an arrangement allows maximum brilliance in the viewfinder, especially in dim light, but creates parallax problems in situations under one metre (39 inches). Reflex cameras are available in most formats, including 13×18cm (7×5 inches), 9×12cm (4×5 inches), 6×7cm, 6×6cm, 6×4.5cm, and 35mm. (See *SLR Cameras, Parallax, Twin Lens Reflex Cameras, Rolleiflex SLX Cameras, Small Format Cameras* and *Medium Format Cameras*.)

REMOTE CONTROL

Control of cameras, flashlights and other equipment from remote distances is often needed for comfort, security or special effect and it can be done by the use of either radio or infra red pulses. In studios or small areas where equipment is placed in line of sight, infra red transmitters or receivers are the preferred method, especially for flash synchronization without cables. Over long distances, or through glass screens or masonry walls, radio pulse is needed. It should be noted that many radio devices are banned from public use and therefore care must be taken to comply with the law. Some radio synchronizers are also accidentally fired by passing mobile short-wave transmissions and this can be a considerable disadvantage.

REPRODUCTION PRINT

Transparencies or prints to be reproduced by photomechanical means need modification, usually in terms of contrast, to compensate for losses and gains of contrast which are inherent in some methods of reproduction. In general, colour will gain in contrast when reproduced and B/W will lose, particularly if it is a coarse screen process and poor quality paper. (See *Photo-Mechanical Printing, Enlarging, Publication of Photographs, Photo-journalism*.)

RESIN-COATED PAPER

The RC paper is a paper usually coated on both sides with a plastic resin which is used as a support for the silver gelatin photographic emulsion. The resin coating does not absorb solutions as readily as fibre-based paper does, making fixing, washing and drying much quicker. In dark storage, after processing, RC papers behave well, but require controlled humidity and temperature for long life and if exhibited under normal conditions they cannot, at present, be expected to last as well as film or fibre-based print material. (See *Archival Processing, Enlarging, Papers, Photographic*.)

RESOLUTION

The resolving power of an optic or an emulsion can be measured and expressed in lines per millimetre. The final effect of sharpness, however, is extremely subjective and depends on many modifying factors such as camera shake, mirror vibration on SLRs, enlarger lens and lamp house design, image contrast and colour of light, viewing distance, exposure, processing and so on. The combined behaviour of the photographic system employed, plus the health and viewing techniques of an observer of a given image, so affect apparent resolution that there is little practical possibility of establishing any scientific guidelines of use in normal photography.

A good lens, used in the range of f5.6 to f16, would be expected to resolve at least 100 lines per millimetre, with a fall-off of resolution as the aperture is opened wider because of aberration and a poorer resolution as the lens is stopped down below the middle range, but this time because defraction inhibits performance of the lens. The larger the format and the longer the lens, the greater is the distance at which fine detail can be resolved by the camera. Panchromatic film of high speed resolves about 50–200 lines per millimetre, and high contrast lith films often in excess of 200. Slow speed, panchromatic films such as Ilford Pan F and H and W Control Ultra Pan VTE (very thin emulsions) film, which has an ASA speed of 16 to 25, can resolve between 150 and 200 lines per millimetre, which, when coupled with the best lenses, can mean exceptional resolution from even 35mm formats.

To calculate the resolving power of a lens-film combination as a guide to the maximum resolving power of the system, add together the resolving power of each. For example, if an excellent lens, resolving 100 lines per millimetre is used with a fine resolution film of 150mm, this is expressed:

$$\frac{1}{100} + \frac{1}{150} - \frac{5}{300} = \frac{1}{60}$$

and as the eye can resolve $\frac{1}{1000}$ of a millimetre under many circumstances, it can be seen that photographic resolution is well below usual expectations.

RETICULATION

The gelatin image of negatives can be caused to wrinkle if abrupt changes of temperatures are introduced during processing. It is not a normal occurrence with modern emulsions but can be induced, if wanted, by using developer in excess of $24°C$ ($75°F$) and plunging the finished negative into a water bath containing ice cubes, before fixing takes place. (See fig. overleaf.)

RETOUCHING

This is a term for the physical work done on a negative or print to repair damage to it or to change its appearance. Many advertising photographs require retouching in order to satisfy a visual concept which is impossible to realize in the original photograph and the photographer is asked to provide only basic images for the retoucher to work upon. These must of course be taken to optically coincide with each other and have matching tonal gradations.

Retouching of a minor nature to repair spots, scratches and blemishes is part of finishing almost all photographs.

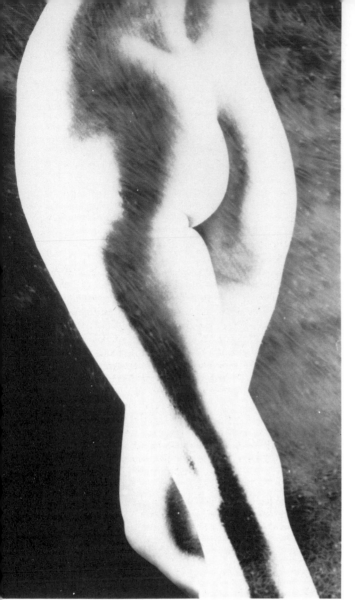

An example of reticulation.

Retouching to modify faulty work should not take place with the images of any photographer who prides himself on his technique. Such errors should be discarded and the picture re-shot even if this causes considerable difficulty and expense.

The old idea of portraiture always required that extensive retouching be carried out to minimize any physical shortcomings in the sitter and to flatter the client into taking a larger order of prints. With the advent of the small format camera such hand work cannot easily be done and there is also a trend towards accepting the naturalism and immediacy of an un-retouched portrait. Much can be done by lighting and make-up to conceal any major problems and the visual concept itself can eliminate any need for mechanical work on the image. (See *Portraiture, Spotting*.)

REVERSAL FILM
Colour and B/W film emulsions can both be obtained as a direct reversal or transparency material which is used for projection or printing on a positive-to-positive print material. Such emulsions capture the original scene in a positive image, which is produced by two stage chemical processing, rather than with the intermediate negative image.

RIM LIGHTING
This is back lighting which throws a thin highlight around the form and it is known as 'rim' or 'halo' lighting (see *Lighting*).

RODINAL
This is a liquid concentrate B/W developer from Agfa which can be diluted 1:25 up to 1:100 depending on the desired contrast. The developer is used as a one shot solution and discarded after each batch. It has been in use for more than 60 years and gives a tight grain pattern, high acutance and is a compensating developer as well. It is most suitable for slow speed, fine grain film.

ROLLEIFLEX SLX CAMERA
6×6cm ($2\frac{1}{4} \times 2\frac{1}{4}$ inches)
This is a partially computerized automatic camera with electronically controlled film transport, exposure mirror release, shutter timing and shutter release, either remotely, by left or right handed body release, or by attached cable switch. A linear motor built within a very complex body design drives all motive functions and power is supplied by a replaceable, rechargeable Ni-Cad dry cell battery. A separate rapid charger restores full charge within about one hour. Film is loaded by using pre-loaded cassette inserts and is automatically advanced to number one frame and is also wound off at film end. Exposure estimation is notably good under difficult conditions, is aperture preferred and shutter speeds are based on normal ratios from 30 seconds to $\frac{1}{500}$ of a second. Interchangeable Zeiss lenses are provided with rapid bayonet release, but interchangeable magazine backs are not provided in the 1980/81 model. This is a distinct handicap for some kinds of professional assignments where mid-roll changes are needed. Polaroid facility is provided by removing a somewhat awkwardly designed downward opening hinged back and replacing it with a modified Polaroid 600 series film pack back. In early models there is no dark slide on this back, so removal of the back to return to roll film loading will automatically waste one frame. Notwithstanding the professional drawbacks noted above, this camera system offers the technical, studio, scientific and advanced amateur photographer a superb, compact automatic camera with brilliant viewing, for the production of superlative, medium format images.

Note: As of this writing, Rollei Technik have announced modifications to the SLX which provide for mid-roll change magazines, probably appearing in the 1982/3 models. (See *Medium Format Cameras*.)

A cut-away model of the electronic Rolleiflex SLX camera, which is totally automatic and takes 6 × 6cm ($2\frac{1}{4} \times 2\frac{1}{4}$ inch) pictures on a 120 roll film. (*Courtesy Rollei Photo Technik*)

SABATTIER EFFECT (PSEUDO-SOLARIZATION)

In 1862 Armand Sabattier, a French physicist, described a strange, partial reversal of a developing negative, which on one plate gave him both positive and negative tones. He called it pseudo-solarization as it differs form true solarization caused by gross over-exposure in the camera. Modern films are designed specifically to tolerate considerable over-exposure, making true solarization a rarity, but photographers working with derivative images and graphic techniques often induce the pseudo effects by interrupting development in a secondary exposure to white light before going on to complete development. The degree of contrast and reversal can easily be controlled (see *Pseudo-Solarization*). The Sabattier effect on negative material produces a narrow line of clear film between adjacent high and low contrast areas, called a Mackie line and is typical of the process. During the period 1916–35 the Sabattier effect was much used by photographers such as Christian Schad, *Man Ray* and *Moholy-Nagy* to explore the manipulative B/w image as a fine art form and today enjoys a considerable revival among leading fine art photographers. (See fig. overleaf.)

ROYAL PHOTOGRAPHIC SOCIETY, THE

Beginning in 1853, in London, during the rising interest in all things photographic, the Society has now become a solidly established and highly organized international influence in many aspects of photography. Recently removed 100 miles from London to historic Bath, which is itself connected to the birth of photography by reason of early associations with Herschel, Fox Talbot, Friese Green and John Rudge, the Society is housed in an eighteenth-century building of considerable architectural interest. Here they publicly exhibit somewhat conventional photography of a very high standard, maintain an excellent library and a collection of apparatus and prints and regularly award distinctions to qualified photographers on the basis of submitted portfolios. Her Majesty Queen Elizabeth II is patron. The permanent collection is of great interest to students of photography both from the point of view of style and historic technical achievements, consisting as it does of more than 25,000 prints, many from the formative years of photography, and a great many actual examples of equipment (see *Appendix* for address).

SAFE-LIGHTS

In order to perform processing with great precision or comfort, special darkroom lighting fixtures are made with coloured lamps or filters which may be considered to emit relatively safe light for short periods of time with regard to sensitive photographic material which is being handled. Print material, such as bromide enlarging paper is generally safe in dark yellow or amber-brown lights or light red; orthochromatic film is only safe in dark red light. Panchromatic film is said to be safe in very dark amber light or dark green, but levels of light are so low as to contribute little to processing techniques, while the risk of fogging valuable negatives is extremely high. It is better to learn to work in absolute darkness while handling panchromatic film. All safe-lights must be tested (see *Darkroom*), and generally must be fixed one metre (39 inches) from the nearest point at which sensitized material could be exposed for any length of time. Safe-light power is rarely more than 15 watts and even at this rating and distance, exposure to safe-lights for longer than 10 to 12 minutes can often produce significant highlight fogging. (See also *Enlarging, Developing, Time and Temperature*.)

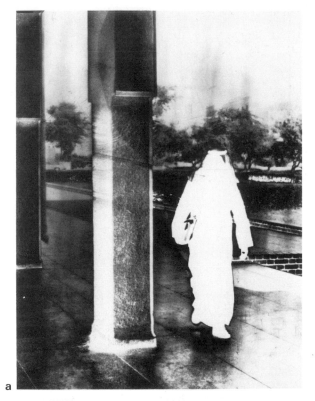

a

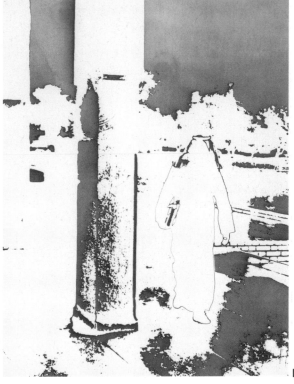

b

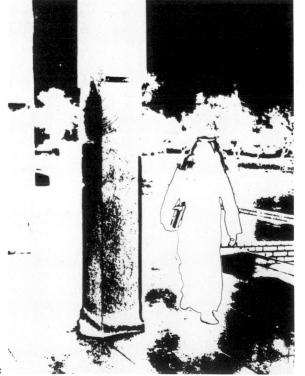

c

An example of the progression which takes place in pseudo-solarization, after the second exposure which is needed to create the Sabattier effect, and during final development. This is from a colour transparency.

a Some continuous tones still retained, also negative and positive still seen in the same image.

b Continuous tones are gone, but half tone greys remain and reversal is beginning.

c Reversal is complete, form is absent, the characteristic line is seen between adjacent dark and light areas.

From point (a) to point (c) generally takes approximately 20–30 seconds of elapsed time in the developer.

SANDER, AUGUST (1876–1964)

An outstanding professional portrait photographer in the first decade of this century in Germany, Sander set himself the huge task of creating a vast multi-image portrait of his country. His skill and sensitivity produced such a warm, but revealing, documentary of the groups and individuals who made up German society, that the Nazi regime saw the intended publishing of the material in a number of photo-books as a political act worthy of harsh repression. Much of his work was destroyed and all his original prints were confiscated. Many negatives remained, however, and his photographs are keenly sought today by collectors. Irving Penn was considerably influenced in his early days by Sander's masterful portrayal of ordinary people.

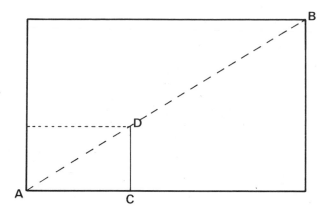

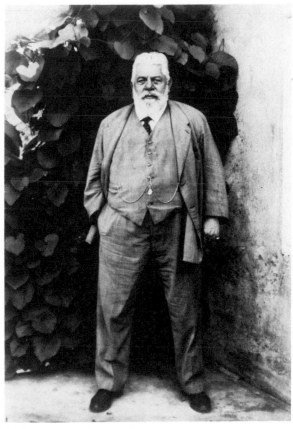

A photograph by August Sander of 'The Apotheke'. (*Courtesy Rheinisches Bildarchiv*)

Steps in scaling down a large format to fit a camera format.
1 Rule diagonal AB on the original.
2 Measure the longest dimension of the negative in use and transfer it to the original at AC.
3 Take a right angle from C until it meets the diagonal AB.
4 The small dimension of the scaled down format is the line CD.

SATURATED COLOURS

The richness of colourful subjects can be emphasized in colour photography by endeavouring to expose for maximum colour saturation. A polarizer will certainly help in most conditions of light and a third to half stop under-exposure will add to the effect. Texture is improved and mood is enhanced by the use of this darker, fully saturated colour. (See *Polarizers, Filters*.)

SCALE OF PRINT TO IMAGE REPRODUCTION

It is often necessary for product photographers to scale down layouts or pack sizes to the format of the camera and this can be done most easily by the use of a proportion wheel, available from art or graphic supply houses. An alternative is to rule a diagonal line, corner to corner, on a tracing of the final reproduction format and find the camera format proportion from this, measuring the longest dimension of the camera format along the base line of the print format. A right angle connection is then made to the drawn diagonal and this then gives the short dimension of the format to be used on the camera.

SCANNERGRAPH

Invented in the late 1960s by a young Japanese electronics specialist, Taro Suenaga, the process was the first commercial method to permit screenless reproduction of continuous tone photographic images straight on to textile-based materials, thus bypassing silver dependent imaging techniques.

Using a conventional scanner but sophisticated computer techniques to modify the digital signals, simultaneous, one-pass colour separations are made in red, yellow, blue and black. The electronic information so obtained is used to monitor the air flow to four corresponding micro-jets connected to the ink reservoir. In the manner of a tiny air brush, an enlarged facsimile colour image is formed of each of the separations, all four colours being printed simultaneously and in perfect register.

The jets are carried on a moving gantry, held closely to a large drum which carries the fabric substrate. Seamless images, as large as 4.5×3 metres (175×120 inches), may be made with pigments which are probably the most light-fast used in any photographic process. The process does not handle excessive contrast well and transparencies for such a method of reproduction should not exceed a 3:1 highlight to shadow ratio, but considering the diffused edge which is inherent in the air brush image and the spreading due to

295

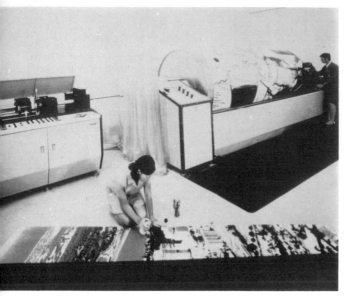

By the use of sophisticated computer and scanner technology, unlimited scale enlargements are possible on textiles or paper.

absorption by the fabric base, photographs are reproduced at very large scale in a very satisfactory way. Suitably long sight lines to the image are of course essential to create the impression of good definition.

SCHEIMPFLUG PRINCIPLE

Theodore Scheimpflug investigated the alignment of camera and object planes and that of the subject, with reference to optical geometry, which would produce maximum image sharpness. He discovered that if the object plane is not parallel with the film and lens plane, the lens plane can be manipulated so that the three planes intersect. This will then produce maximum sharpness and depth of field with the least linear distortion of perspective. Fixed body cameras do not have the facility to make these corrections, but view cameras and most large format cameras are equipped with bellows and swinging, tilting and shifting lens and film planes, making it possible to improve considerably the optical performance of the camera. (See *Large Format Cameras*.)

The Scheimpflug principle. (a) The uncorrected, fixed-body camera cannot obtain coincidence of image plane XY with object plane XX to YY, and the zone of sharp focus Z is very shallow. (b) When the lens plane is tilted to be more nearly parallel with the object plane, angles will coincide, bringing objects, image and film planes into sharpest focus. Zone of sharp focus is substantially increased to take in all of YY to XX. This is the Scheimpflug principle.

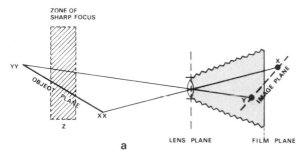

SCHLIEREN PHOTOGRAPHY

This method of scientifically exploring data about the movement and flow of gases, uses a condensed, brilliant, back-lighted illumination source, controlled by two razor edges which intercept the light beam on either side of the field of gas flow which is the subject of investigation. Variations in brightness in the photographic image are linked with the differences of the refractive index of the gas emitted in the light path. Rocketry, aeronautics, industrial combustion and weapons ballistics all use this photographic technique to aid research and practical application.

SEAMLESS PAPER

It is often necessary to photograph subjects on a large expanse of plain or graduated tone or in a whited-out 'limbo' and this is achieved by the use of wide rolls of heavy quality background paper made in 3 metre (10 feet) or 4 metre (12 feet) seamless widths. These are rolled down from special ceiling or wall brackets to give a smooth 'cove' effect, without horizons. A wide range of colours is available from professional photographic dealers.

SEEING

(See *Vision*.)

SELECTIVE FOCUS

Critical focus may be struck sharply on any selected point in the subject and by using a wide aperture and therefore a shallow depth of field, areas around the critical focus point are rendered with soft, diffused edges. This emphasizes the centre of the subject considerably while giving it a tentative environment which contributes subconsciously to the viewer's experience of the image. Differential focus is another name for this technique and it belongs, uniquely, to the camera, as no other art seems to seek to use the effect. (See *Image Management*, *Depth of Field*, *Differential Focus*, *Basic Photography*.)

SEPARATION

The way in which a chosen subject stands out from other forms or its own background contributes to the whole nature of perception and three dimensional perspective. There can be no easy perception without separation and the whole exercise of controlled lighting and processing in photography seeks to establish good separation. The figure (subject) must stand away from its ground (environment) and if the photographer's technique is indifferent this cannot happen. The result is ambiguity bordering on vacuity with vague cross currents of subjectivity destroying emphasis or any planned hierarchy of composition and adding a buzz of visual noise to the picture which can only destroy the image maker's concept. *Separation is essential to clear perception.*

SEPARATION NEGATIVES

When preparing *Carbro* or *dye transfer prints* from colour originals it is necessary to produce separate negatives for the major primary colours present. This is done by exposing the colour image to a B/W panchromatic film and using a special filter to eliminate all but one of the single primary colours in the group: red, green and blue. The original is then subsequently filtered to produce an individual B/W negative record of each of the three primaries and this set of negatives is used as a basis for assembling a series of coloured matrices which correspond with the primaries present in the original and which are then transferred to become a full colour print. Lithographic photo-mechanical systems employ the same basic procedure but add black to the primaries to give depth and contrast. (See the colour plates for *Colour Photography*, *Photo-Mechanical Printing* and *Dye Transfer*.)

SHARPNESS

Considerable discussion often takes place among photographers and their friends or clients about sharpness and it must be emphasized that there is no way the sharpness of an image can be measured. Seeing is a psycho-physical function of the body, requiring considerable subjective judgement and the degree to which an image appears sharp is dependent on many modifiers including acutance, resolution and contrast in the print, viewing distance, ambient light when viewing, the health and psychological reaction of the observer and so on. Deliberate unsharpness of edges in the image can draw attention to apparently sharper areas, while overall unsharpness can diffuse attention from the particularity of an image and focus the mind, rather than the eye, on the hidden structure and any universality present in the subject.

Activities affecting sharpness run the whole range of photographic technique but will include any, or all, of the following: poor lens quality, high speed film, coarse developers, lack of negative contrast, lens flare, highlighting contrast, camera shake, mirror shake, poor focusing, over-exposure, poor enlarger lens, enlarger vibration, misalignment of the enlarger, textured print surfaces, poor viewing conditions. (See *Depth of Field*, *Circle of Confusion*, *Acutance*, *Developers*, *Enlarging*, *Camera Supports*, *Basic Photography*.)

SHORT LIGHTING

When the side of the face turned away from camera receives more light than the side nearest the camera, this is referred to as short lighting (see *Portraiture*).

SHROUD OF TURIN

One of Christianity's holiest relics, still an enigma and surrounded by fierce debate, the Holy Shroud of Turin bears discolouration of the fabric which unmistakably presents the negative image of the front and back of a human figure. How it got there is a mystery and subject to passionate controversy, but the image has a striking resemblance to what the West has for centuries imagined Jesus Christ looked like. In 1898

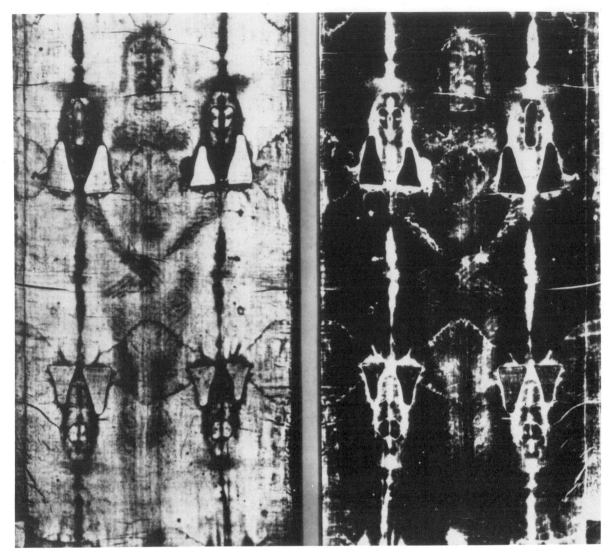

The Holy Shroud of Turin. On the left the negative image of the Shroud itself, on the right the reversed positive image made by photographing that negative image. (*Courtesy Holy Shroud Office of Information*)

Secondo Pia, using a large Voigtlander glass plate camera, made the first photographs of the shroud. The negative image of the actual relic was reversed by the photographic process into positive tones, leaving the figure and face easily readable in the photographic light and dark greys. So, after long centuries, the form of Christ was revealed to the assembled Church dignatories as an easily read image of vitality and power. How it was made on the cloth is open to various interpretations, but the fact seems clear that long before photography had been invented or even perspective, a relic which was held in considerable security and very limited access also contained the first negative image in existence showing true optical perspective and photographic characteristics.

Before 1839 there was no technical term for negative and the negative/positive process did not exist prior to that time. In 1898, the photographic process made it clear what the image portrayed and reinforced both the reverence and the contention surrounding it. In the 1980s, investigative methods attempting to authenticate the relic are also employing photography, but this time it is extremely sophisticated image enhancement techniques which are being used, the very same which are used in stellar exploration and astro-photography.

SHUTTER

To control the period of time which is needed for a quantity of light to affect the film, a mechanism is fitted inside the camera so that the entire film format is uncovered completely at the

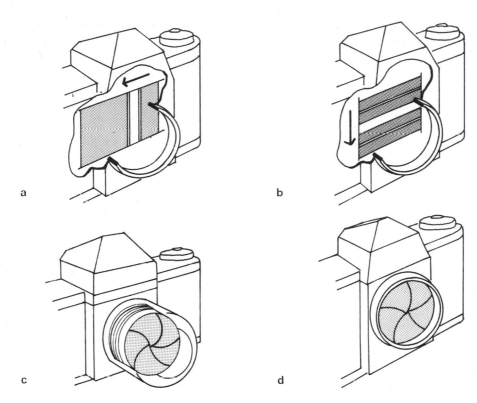

a

b

c

d

Types of shutters. (a) Cloth focal plane. (b) Metal focal plane. (c) Between the lens. (d) Behind the lens. (c) and (d) are leaf shutters.

chosen moment. Two main types are in use today, the leaf or blade shutter which operates near or within the lens, and the focal plane type which is located close to the film plane in the back of the camera and is much favoured by SLR camera manufacturers.

Leaf Shutters (see fig.) of the more complex type tend to have slow speeds measuring one second ranging upwards to a top speed of $\frac{1}{500}$ of a second, plus a B and T setting for opening the lens during exposures. The leaf shutter is designed to uncover the entire format the instant it is triggered and this prevents distortion, especially of any objects moving at speed across the lens axis. Other advantages are that such shutters will cover very large formats, exposing them evenly and all speeds can be synchronized for flash. Copal and Compur are two well-known makes.

Focal plane shutters (see fig.) use a moving slit in a rolled curtain of fabric or metal which passes across the film format, and variations in the width of the slit create different shutter times. Synchronizing for a flash of short peak such as with electronic equipment can only take place when the full format is uncovered at once and this generally only happens at speeds of $\frac{1}{125}$ of a second or slower, action stopping then depending on lamp flash speed. Apart from this disadvantage, focal plane shutters allow much higher daylight exposure speeds with much less shutter energy needed and as a main advantage, allow interchangeable lenses to be fitted to the

camera without each needing an expensive shutter. Small and medium format cameras, especially 35mm, are fitted frequently with focal plane shutters with speeds ranging from 30 seconds to $\frac{1}{2000}$ of a second and these do not usually distort the image. Larger formats, where the shutter curtain must travel over much wider areas, create unevenness and will often produce distortion in fast moving subjects. Cameras larger than 6×6cm ($2\frac{1}{4}$ inch square) are prone to such

This is a focal plane shutter on a modern SLR camera.

distortion and notably the 9 × 12cm (4 × 5 inches) Graflex and Speed Graphics will create this effect.

Standard marked settings on all shutters halve the quantity of light each time the shutter is set at the next highest speed and double the quantity of light reaching the film as the speed is progressively set slower. Compensation to balance the exposure correctly is made by altering f stop numbers accordingly, as these are arranged in similar matching progression. The T or time setting keeps the shutter open until the release is pressed a second time and B or bulb setting is used for brief time exposures, the shutter staying open only while there is pressure on the release. With slow film, in emergencies, the shutter can be opened on a B or T setting and a tight fitting lens cap can be used to let light into the camera. (See *SLR Cameras, Basic Photography, Camera Types.*)

SHUTTER PREFERRED EXPOSURE SYSTEM
On automatic cameras of this type the shutter speed is selected by the user with the camera adjusting the aperture to the opening required for correct exposure. The alternative system where the lens setting is chosen by the operator, while the shutter exposure is arranged by automation, is called the *aperture preferred system.*

SILVER HALIDES
The light-sensitive agent which is suspended in modern gelatin emulsion is generally a silver salt containing one or more of the halogens. The most common are silver nitrate, silver bromide, silver chloride and silver iodide.

SILVER SULPHIDE
The residue left in poorly washed photographic material can turn to silver sulphide which, as it oxidizes, turns to sodium sulphate, causing fading, staining and finally, disappearance of the image.

SINAR
This is the brand name of one of the most famous modern view cameras, made in Switzerland. Recently it has become notable for increasing use of electronics in its various components and accessories. (See *Appendix, Large Format Cameras.*)

SISKIND, AARON (1903-)
With Harry Callahan, Siskind has as a teacher influenced the course of changing style in modern US photography. He was part of the early Chicago experiment of the New Bauhaus with Moholy-Nagy and since the 1940s when it became the Illinois Institute of Design he has continued to expand the visual awareness of many dedicated photographers. His own images often explore the minutae of city fragments – peeling paint, torn posters, graffiti and fading commercial signs, perhaps reflecting a tangential influence from his early

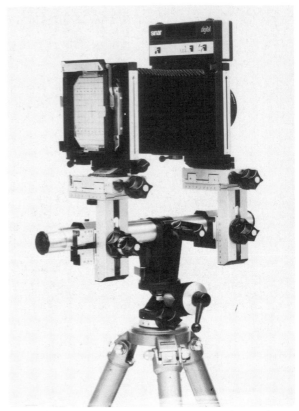

The Sinar Digital monorail camera. (*Courtesy Sinar AG*)

interest in the photography of architecture. His abstract images of this urban dross are often of great beauty, yet suggest a decay and decadence in a sophisticated but impermanent society.

SKYLIGHT FILTER
A filter which by removing ultra violet light from the spectrum increases richness in colours in photographic film and cuts through mist and haze without causing any colour shift. Extremely important at high altitudes for air-to-ground photography or mountain photography, the filter is often left in place on 35mm cameras which are used in the field, in order to protect lenses from finger marks, dust and abrasions. It is a common practice for professionals to fit one UV filter of a light-to-medium strength to every lens they own, as it is far easier and less dangerous to clean such filters than the expensive lenses which they protect. When working in sea spray, snowy conditions or rain, covering the lens in this manner is essential. (See *Filters.*)

SLAVE
The slave cell is a photo-electric cell used for the remote triggering of multiple flash units by utilizing the light from

one camera-attached flash. The photo cell fires other flash units in synchronization with the master flash, but obviates the need for cables to complete circuits on extensions or extra flash units. The slave cell may be built in to the flash generator as with the large studio flash units or may be a separate accessory plugged into the normal sync. socket on generator or flash head. It is highly useful in studios, has little real value outdoors and can be a source of irritation if used near other photographers who are also using flash, as this will probably also set off the circuit.

SLR CAMERAS

The single lens reflex has become the most widely used fixed body camera today, usually in 35mm format, and is, possibly, the most popular camera ever made. It is also available in larger and smaller formats, ranging from 110 size to 9×12cm (4×5 inches) and in the Hasselblad and Rolleiflex 6×6cm ($2\frac{1}{4}$ inch square) format has become the professionally favoured camera type. The image is seen through the taking lens, right up to the moment of exposure by the use of a flip–up mirror and a pentaprism through which the image is viewed and which turns the image around to that of normal vision. This

The remote control photo-cell or slave unit is a light-sensitive cell which is connected to the synchronizing cable.

SLR cameras. This diagram shows the lightpath as it enters the lens of an SLR, then is reflected by the mirrors in the pentaprism and reversed so that the eye sees the image right way around.

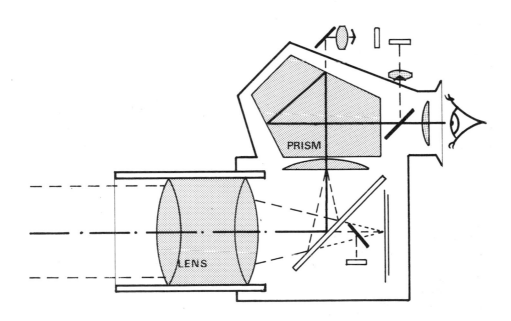

PRISM

LENS

An entirely new concept for a 35mm SLR camera, the Rolleiflex SL2000F has shutter speeds ranging from $\frac{1}{2000}$ down to 16 seconds, integral motor drive and magazine for changing film stock in mid-roll. (*Courtesy Rollei Photo Technik*)

eliminates *parallax*, maximizes focusing control and gives the photographer extraordinary contact and control in respect of composition. (See *Medium Format Cameras*, *Small Format Cameras*, *Reflex Cameras*, *Rolleiflex SLX Cameras*.)

SMALL FORMAT CAMERAS

Since 1924 when the Leica camera system, using sprocketed movie film and a format of 24 × 36mm was released to world markets, the small format camera has grown in acceptance until it is now the most popular of all sizes in the amateur market and has a strong following in the professional fields, particularly for documentary or journalistic work, macro or micro photographics or any image making which requires mood or immediacy. The marketing, in the early thirties, of Kodachrome, the first of the really practical colour systems for small cameras, and the current proliferation of self-processed colour films, has reinforced its reputation and wide use.

These are fixed bodied cameras incapable of optical or geometric correction except where a rudimentary lateral lens shift or restricted Scheimpflug facility is offered by some lens makers. They are designed to be fast, automated and not too bulky even when fully accessorized. So interesting has the hardware become in this type of camera that it sometimes is worn purely for effect, rather like an item of jewellery. The use of 20, 36 or 70 exposure film cassettes or bulk loading of 250 exposures makes it easy to build up excessive material which all must be processed, filed, printed and edited, often to a point of tedium. Those who have not trained with large format cameras before beginning with these small, deceptively simple cameras will tend to lose contact with the subject in a hurried, shallow, multi-exposure exploration of the possibilities without thought to optical structure, visual concept or even content.

The correct way to use these cameras is to be forever thoughtful of the image *before* releasing the shutter, omitting irrelevant subject matter away at this point, rather than at a later, more expensive stage when processing has taken place. Under difficult lighting conditions, or for contrast control reasons, it may be necessary to *bracket* exposures and thus use more film, but that is another matter. In searching creatively for the essence of a subject especially a volatile one, such as in portraiture, it is also a valid technique to make many exposures in order to capture subtle changes of attitude and expression and this will require a considerable amount of film, only possible with the small camera, but again this is a deliberate and often contemplative technique and not to be confused with the 'machine-gun' approach.

In selecting a camera of the smaller format, it is as well to think about the real reasons for owning it. For family pictures and casual holiday happenings, the 110 format which is only 13 × 17mm ($\frac{1}{2} × \frac{5}{8}$ inches) in area is sufficient: simple, automatic and small. Optical quality is not usually good enough for more than a 20–25 time magnification however and then only if sophisticated cameras, such as Minolta, Pentax and the top-of-the-range Kodak Instamatics are used. For better quality in family pictures the 126 with a 28mm sq. format or, perhaps, the half frame 35mm format (18 × 24mm), may be used, but while these are economical, very few accessories are available to extend the performance of the camera.

The full frame 35mm format, 24 × 36mm (1 × 1$\frac{1}{2}$ inches), is now the universal choice for small format images both for amateur and family pictures and wherever a professional needs to use this type. With slow film of high acutance it is not uncommon to produce magnifications of 40–50 times in B/W or 30 times in colour, sufficient for most purposes either amateur or professional.

35mm cameras fall into two distinct categories: the rangefinder type and the SLR. *Rangefinder* cameras are usually quieter, smaller and much lighter than SLR types and the most famous brand having this specification is still the Leica, made by E. Leitz of West Germany and Canada.

The makers of SLR cameras are too numerous to mention more than a few: Nikon, Canon, Pentax, Minolta and Olympus from Japan; Contax with electronics from Japan and lenses from Zeiss, Germany; and from Germany, the Rolleiflex range, the most sophisticated of which is the SL 2000, with unique specifications including interchangeable film magazines. These are recognized leaders as far as professionals are concerned, but Konica, Chinon, Ricoh and Fujica, Hannimex and Yashica have cheaper but very useful specifications and accessories.

The direct contact with the subject, free of parallax, which is obtained by the SLR and the fact that in the viewfinder it is right way round as the eye sees it, makes such cameras the perfect choice to capture mobile or volatile events and retain the feeling of immediacy and reality. For this reason it is the choice of the photo–journalist, the war photographer or the sports photographer.

The mood and extraordinary subjectivity which is inherent in the 35mm image makes these cameras very much the choice of those photographers who are concerned with people

and their life, hopes and expectations. Many of the acknowledged modern classics in photography have been taken with this format and, as more and more sophistication is built into both cameras and film emulsions, it seems probable that it will reach the point which those early pioneers of photography sought in vain, where the machine is merely an extension of the eye, to be used as simply as the pointing of a finger in order to fully indicate the physical structures and dimensions, as well as the psychic and cosmic essence of whatever comes before it. (See *Available Light*, *Lenses*, *Action Photography*, *SLR Cameras*, *Rangefinder Cameras*, *Parallax*. Addresses of principal manufacturers are listed in the *Appendix*. See also *Basic Photography*, *Camera Types*, *Grain*.)

A most moving picture from the series by W. Eugene Smith which disclosed the tragedy of man-made pollutants in the environment of a small village in Japan. This picture was exhibited at the International Center of Photography, New York, in 1975 and is to be found in a combined book and exhibition on the subject. (*Courtesy International Center of Photography*)

SMITH, EUGENE W. (1918–78)

One of the most outstanding photo-essayists of all time, he was an American who was brought to world attention since the late 1930s through the catalyst of the big spending picture magazines. The integrity, openness and sincerity of his photographs is evidence of his unbiased vision while he portrayed the emotional dramas of great and small events. Believing in the powerful influence for good, which photo-journalism could exert on millions who were exposed to the images of picture magazines, he sought to illustrate the unthinkable intangibles by way of subtractive visual concepts brought to conscious vision by virtue of an objective, golden technique. His heroism has often been noted and his painful pursuit of his last great essay in 1972, about the effects of mercury poisoning at a fishing village in Japan, showed both his craft and courage at its highest. His death was no doubt hastened by the deprivation and physical violence which came to him during the years this story took to make. The searing images of the Minemata essay and the implacable rage of the photographer are an example of documentary art at its most compelling best.

The high drama of a climber among ice cliffs imposes risks and stress on both subject and photographer. Such occasions demand great care and faultless equipment. This picture was taken by Capt. Frank Hurley in 1911. (*Courtesy National Library of Australia*)

Opposite Great delicacy of tone is possible when photographing snowscapes, particularly when working with the late evening light and high resolution 35mm film. This has been processed in Promicrol diluted 1:2.

SNOW PHOTOGRAPHY

Alpine photography produces striking and memorable pictures of mountain sports, vacation memories or sweeping landscapes. There is always an over abundance of light, even on overcast days, due to the very high reflectance from snow and the increased actinic quality of high altitude light. For colour, the best filters to use are a medium UV (skylight) filter or a polarizer which darkens skies without changing other colours. In some cases a *neutral density filter* may be useful to allow the use of wider apertures or slower speeds for special effects. For B/W film, yellows, oranges and pale green filters are needed to improve sky and cloud rendering or blue to increase the visual rendering of haze or mist (see *Filters*).

Some contrast control may be found desirable when using B/W materials by over-exposing 20 or 30% and under-developing to compensate and it may be noted that SLR cameras fitted with automatic metering will tend to give false readings in these bright light conditions especially if snowscapes are back-lit. A full stop over-exposure could be needed to override the meter and achieve correct exposure. Snow-

scapes need most careful exposure and processing and it is advisable to run clip tests of a few frames before processing the whole roll of film.

SODIUM SULPHIDE

This is a toning chemical, used to re-develop the image after bleaching in a ferricyanide solution, to a rich brown colour. It has a fairly unpleasant odour, can quickly stain fingernails dark brown and vapour from the solution will fog unexposed film and paper very badly. Care must be taken in discarding sulphide solutions as it reacts with acids to produce toxic gas. Less dangerous or unpleasant toners are available, one of which is Embasol available in the UK from May and Baker, and Kodak Poly-toner (see *Appendix*).

SODIUM SULPHITE

A mild alkali used as a preservative in developers and in some cases to neutralize excess acid in hypo fixers. The anhydrous (dessicated) chemical is preferred for photographic chemistry.

SOFT FOCUS

By using a special colourless filter with an etched surface on all but a clear centre spot and fairly wide apertures, hazy edges may be obtained on any strong forms, creating an eye-catching image and suppressing any unwanted detail. The technique is especially useful for portraits (see *Filters* and *Portraiture*). A special lens may be used instead of a filter, usually with varying degrees of softness or, at the other end of the economic scale, a piece of black, fine-meshed stocking may be stretched over the lens, or even a crinkled piece of clear cellophane from a cigarette or candy packet, will do the trick. Each type of material will produce its own special characteristics of colour and softness, so tests should be made. Studio photographers will often suspend a thin, glass sheet in front of the lens and smear it thinly with Vaseline jelly, or vegetable oil, to get a controlled effect. Remember that glass will often have a bias towards green and CC filtration may be needed to offset this. Soft focus can also be created during enlarging even when using sharp, camera originals (see *Enlarging*) by using similar screens on the lens. (See *Differential Focus, Depth of Field*.)

SOLARIZATION

(See *Pseudo-Solarization, Sabattier Effect*.)

SPECULAR HIGHLIGHTS

These harsh and brilliant hot spots of light are often to be seen on glossy surfaces where the main light source is very far away or of narrow diameter, or is emitted from a lens-condenser lamp system. A diffusion screen of muslin or frosted plastic will soften them, or they can be exaggerated by the use of star filters or wire gauze used over the lens. (See *Incident Highlight*.)

SPEED SYSTEMS

Film is rated at various speeds to indicate its sensitivity to light, the main systems in use today being ASA, GOST, DIN (see *ASA*).

SPHERICAL ABERRATION

A major fault in cheap lenses, this aberration is caused by the unequal refraction of light rays passing through the edge of the lens compared with those at the centre. Such lenses cannot be sharply focused, although image definition is improved somewhat by stopping down. Expensive, compound lenses correct this fault to a large degree by combining negative and positive lens elements.

SPORTS PHOTOGRAPHY

(See *Action Photography*.)

SPOT METER

This is an exposure meter of the reflectance type, having a very narrow angle of measurement, usually as small as 1°, but certainly not greater than 10°. Precise measurements may be taken even of distant objects, helping the photographer to make complicated calculations for exposure of difficult subjects (see *Exposure*).

A typical 1° spot meter made by Minolta. Other reliable models are made by Pentax and Soligor.

SPOTTING

By using a tiny oo or ooo paint brush with its tip covered lightly with almost dry colouring medium, minute spots may be made on white areas of a B/W print or coloured areas of colour prints which have been caused by dust or scratches. The minute spots are carefully aggregated to cover larger areas and are matched to the surrounding tones of the unblemished image. (See *Basic Photography*.)

In spotting, large white areas are covered with fine lines using an 00 brush brought to a fine point. Smaller areas are covered with tiny random dots from a smaller 000 brush. Dots and lines must match the colour and density of nearby tonal values.

'Lining' large areas to be filled

Random 'pointing' for small spots

STATIC

Static electricity is of concern to photographers, mainly in the darkroom where dust is attracted to film surfaces, particularly during enlarging, and can cause a considerable amount of spotting and retouching on the finished print. Darkrooms should be dust-trapped at entrances and air vents and benches and floors must be cleaned regularly with a damp cloth. If darkrooms can be kept at a relative humidity of 40 to 50% it will also lower the incidence of static, as will the deliberately slow handling of all dried film, particularly when removing it from plastic sleeves. Irradiated material implanted in brushes or air jets is often used to alter the polarity of dust particles when cleaning negatives, thus removing them easily from film surfaces, but even a wide, soft camel hair brush, slowly wiped over the negative on both sides, can help. A most useful accessory in the darkroom is the ionizer, which continually changes the positive air ions to negative, dissipating static. The ionizer can be fitted centrally in the ceiling and be used

The Medion air ionizer which helps to reduce static and also keeps the darkroom and studio air in good condition (see *Appendix*). Mount on the ceiling for best effect.

for one hour before printing begins and throughout the session. An added benefit is that the air is cleaned of stale chemical smells and all air-borne dust finds its way to the floor. (See *Appendix*.)

STEICHEN, EDWARD (1879–1973)

Born in Europe, interested in painting before coming under the influence of Alfred Steiglitz in the beginning of this century, Steichen has been a dominant influence in the growth of clear-sighted, frankly optical photography throughout the world of art images. Serving as a photographer in both world wars, Steichen in the 1930s was noted as a stylish professional photographer for the fashionable women's magazines. He was always an innovator of image style, beginning with his early Impressionistic work, then his highly structured, graphic portraiture during his middle years which was revolutionary and the unflinching images of his later years, deeply detailed and remorselessly straight in technique. His active photography spanned more than half a century and as the curator of photography at the New York Museum of Modern Art, soon after World War II, he created great and influential exhibitions which were seen by millions around the world. His 'Family of Man' exhibition was one of the most notable.

STEINERT, OTTO (1915–78)

Beginning as a portrait photographer with a clean, clear vision of his subjects, Steinert turned in late life to manipulative and derivative images, including solarization, bas relief and photograms. In the 1950s he introduced a movement called Fotoform which he saw as a means of allowing the photographer to make personal expressionistic statements. His work was soundly based on the experimental successes of earlier photographers such as Man Ray, Christian Schad and Moholy-Nagy and with his own gifted imagination added, his teaching influenced a move away from the crisp realism of

Neue Sachlichkeit (New Objectivity) which had been heavily influential since the early 1920s. Many devotees of Steinert's 'Subjective Photography' found satisfaction in exploring abstraction in the organic forms to be found in nature. Steinert's provocative exhibitions on expressionistic photography greatly influenced designers and graphic artists using other media such as textiles, ceramics and illustrations, and possibly reawakened post-war photographers to the deep messages lying dormant in the extinct Bauhaus movement in relation to photo-abstraction.

STIEGLITZ, ALFRED (1864–1946)

After studying photography in Germany, Stieglitz returned to the USA at the age of 26, determined to devote his life to photography and art. In 1903, after forming the Photo-Secession he began a quarterly magazine, *Camera Work*,

Recruitment posters photographed by Otto Steinert in 1950. (*Courtesy Rheinisches Bildarchiv*)

destined to be highly influential on photography in the USA and elsewhere and in which photography was presented effectively as an art form in its own right. At his gallery, '291', in New York, Stieglitz imported the astounding images of Cézanne, Toulouse-Lautrec, Rousseau, Rodin, Picasso, Picabia, Matisse, Brancusi and others, showing them for the first time in the New World. With these vital images he also showed the best in modern photography at the time. His vivacious efforts, ranging over three decades, no doubt brought modern art to North America, and with it established photography as an accepted art form on that continent.

STILL CAMERA MOVEMENTS
(See *Large Format Cameras*.)

The modern photographer can learn from the classical still life painters of past centuries. This is a careful attempt to produce a picture in the manner of Oudry, using the same quality of light and antique props from the period.

STILL LIFE
How can life be still – how can still objects have life? This apparent paradox is the essence of good still life photography and creates a dynamic, but subconscious, tension in the observer which considerably increases communication and the retention of the concept. The hint of human activity when none is seen in the picture, the feeling of immediacy or urgency or instability, all contribute to the breathless action which must be found in the best of still life subjects and certainly may be seen in the most famous paintings of that genre.

Of all the painters who should be studied, probably there is no better mentor than Jean-Baptiste Simeon Chardin, the French painter who lived in Paris for nearly 80 years of the eighteenth century and elevated the still life subject to the lofty levels of art, by the humility of his approach to it, coupled to a dazzling technique which must still be the envy of painters and photographers who work in this area of interest today.

Matisse, with his vibrant individuality shining through a flamboyant use of colour, also teaches the photographer much about the psychic finger print of the originator which must be found on the best work. Even Picasso and Braque, with their difficult, fractured images, reveal the essence of a subject by displaying its innermost and secret structures and photographers can learn from their work. The fascinating imagery of the Frankfurt photographer Walter Peterhans who became director of photography at the Bauhaus in the closing years 1929–33 and later went on to teach in the USA is worthy of close study. Some of the photography of Man Ray, Moholy-Nagy and Gyorgy Kepes guide the student in unconventional areas, and the 1920–30 work of Edward Steichen has many magnificent examples of organic still life. New directions are indicated in the examples of Otto Steinert's work in the 1950s, while the classic images of *Irving Penn*, in the decade following, return us to Chardin's example and contain many fastidious still life photographs which have set trends throughout the commercial and advertising industry for the last 20 years.

The building of a notable still life requires several things. The first is studio space equipped with a large format camera (preferably which has Polaroid facility) and sufficient suitable lighting to produce a flawless technical rendering of the subject. The second is a thorough understanding of the visual concept (see *Pre-visualization*), the third is patience, the fourth is an assembly of all the props, colours, accessories and accompanying objects which will help to illustrate the concept.

Once it is known what the subject will be, it is necessary to simplify and edit the image as it builds in front of the camera until nothing is left within the frame of reference except those things which establish the story and extend the narrative. This can take hours, or even days, of deeply contemplative and concentrated work, but nothing must look studied or contrived. A feeling that human activity is about to begin, has been interrupted or has just ended, is the essential ingredient. Action must be apparent whether it is evanescent, as in the steam from an open cooking pot, or infinite, as in the ageless

patina from an old table top. Objects which are wet should glisten and drip, those that are dry must crackle with their dessication, soft textures must invite a touch, metallic surfaces must reflect the cool or cosy glow of the ambient light, which itself will indicate the time of day and therefore the action of time passing.

Every object, every texture and surface characteristic of everything in the frame is solely the work of the photographer and is deliberately placed. The dynamic structures and tensions, spatial depth, emphasis and de-emphasis can only be attributed to the photographer, so this makes still life the most complete of photographic exercises. Those who work with the mobility and flexibility of small format cameras can do nothing better than undertake regular sessions in the still life studio with a large camera and learn the discipline and image management inherent in this technique, and those who see their objectives in the end result of the still life itself can rest assured that there is no more demanding field of photography, because success or failure bear inescapably the finger print of the image maker. (See *Large Format Cameras, Lighting, Image Management, Lenses*.)

STOP BATH

An acetic acid stop bath with a pH of about 3.0 is often needed immediately to neutralize developing action during print and negative processing. This acid in its purest (glacial) strength of 99.5% will freeze at low temperatures of approximately 15.5°C (60°F). The pure acid is quite corrosive and can harm sensitive skin. The fumes of the concentrated solution are flammable. Glacial acetic acid is normally reduced to 28% pure as a working and storage solution (which is much less harmful), by taking three parts of glacial acid and adding it carefully to eight parts of water, stirring slowly and constantly. A general purpose stop bath is made by taking this 28% solution and further diluting it in the proportion of 75ml to 1 litre of water. Always add acid into water and not vice versa. (See *Basic Photography, Black and White Photography, Enlarging*.)

STOPPING DOWN

Lenses are corrected to perform at their best over a range of apertures, usually in the vicinity of f4 to f11. A lens used wide open at maximum aperture will lose definition because aberrations (spherical and chromatic) are emphasized. As the lens is stopped down, most aberrations disappear, but when the aperture is reduced beyond the optimum point, definition again falls off, due this time to defraction. View camera lenses and special process lenses tend to perform at their best at smaller apertures – f22 and f32 – while certain special ultra fast lenses produce good definition even at very larger apertures. (See *Aperture, Basic Photography, F stops, Depth of Field*.)

STORAGE OF SENSITIZED MATERIAL

Unexposed B/W film and photographic paper are not so

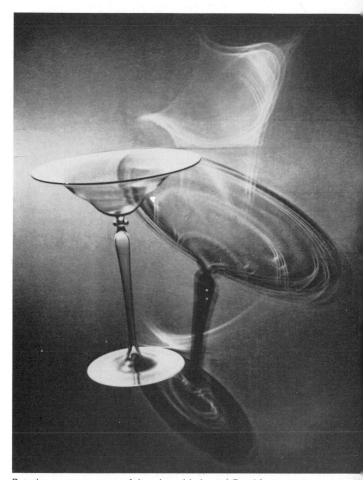

Peterhans was a successful and sophisticated Frankfurt photographer who later became a tutor at the Bauhaus. His still life photography is some of the best ever produced in this genre, this one being made in 1930. (*Courtesy Bauhaus Archive*)

susceptible to change as are colour materials and, provided that they are not stored in the darkroom where chemical vapour or dust can harm them or near radiators or in sunny rooms where heat is destructive, they will last very well. Deep storage for lengthy periods is still best carried out in a frost-free refrigerator. Colour materials, both paper and film, must be stored in a refrigerator in the short term but at sub-zero levels, in deep freeze conditions if the keeping time is to be longer than a few weeks. This will prevent colour shifts or speed shifts in the dye layers. Before using any photographic materials which have been held in refrigerated or deep freeze conditions they must be allowed to reach room temperature before the package and sealed wrappers are broken. Return partially used material to its original foil packaging, exhaust the excess air by pressing flat and re-seal tightly with tape, before boxing it and returning it to the refrigerator. Do not deep freeze after opening. (See *Colour Photography* for film warm-up times.)

STRAND, PAUL (1890–1976)

A most influential American photographer who in the years leading up to the early 1920s made a notable contribution to the beginnings of abstract photography with a number of rich organic images of man-made and natural subjects. Strand more and more turned to the purism to be found in using the large format camera with superlative technique in the wilderness areas of North America. His photographs were highly organized in internal structure, particularly those in a series of close-ups of natural objects which he made in the closing years of the 1920s. In later years of his long and active life he worked exclusively with straight photography, bringing simplicity and intensity and uncompromising aestheticism to his work which is a continual source of inspiration to serious photographers everywhere. In the 1950s and sixties he began to use a smaller format, in a very assured documentary style, still with the same care and photographic wisdom which he displayed with large formats. He was also a noted documentary film maker and travelled widely.

STUDIO PLANNING

The studio is a place set aside permanently for the practice of photography but it can be lit by daylight, artificial tungsten light or flash. For amateur use and occasional portraiture or still life pictures it should not be smaller than 4 × 4 metres in floor space with a ceiling height of 2.5 metres (13 × 13 × 8 feet) and contain three or four professionally installed power points and means to exclude all daylight when necessary. The ceiling and walls should be free of all fixtures including light fittings and the floor should be of a washable hard surface, such as

vinyl or linoleum, preferably of a neutral, mid grey colour. In such a small studio it is possibly an advantage to paint walls and ceilings black. Furniture must be kept to a minimum but should include a low stool or backless chair, a trestle table and a means to hold a roll of seamless background paper. It should be kept clean and free of obstruction with all equipment neatly packed away in between sessions.

The professional studio is a much more comprehensive room and should have a shooting area of not less than 6 metres wide by 8 metres long by 3 metres high (20 × 26 × 10 feet) (see fig. below for a typical design).

Such a professional room could be painted white with black minus 'reflectors' available to screen walls where bounce light is not desirable. The floor should be grey or beige, usually vinyl covered, but could be fitted with an antistatic artificial fibre covering such as Flotex. This absorbs sound, is easier on equipment, and for long periods of standing is less tiring. This is a very tightly woven material which is also washable, so maintenance is easy and being thin and applied directly to the floor base without underlay, very smooth surfaces are obtainable for easy rolling of lights and heavy equipment. Depending on equipment needed, such rooms will usually have at least ten power points, strategically located, with a capacity of at least 30–40 kilowatts. Ventilation and heating is needed and professional studios are generally constructed without access to daylight, except when they are located in areas of almost constant sunlight and even then, this is on a very controlled basis.

Professional studios require considerable extra space for model changing, storage of props and accessories, background paper and equipment and office administration. These must be located away from the main shooting area so that nothing intrudes on, or restricts, the working space. All overhead or other hazards, electric cables, lighting booms and so on, must

A typical professional studio with the minimum lighting and furniture indicated. (*Courtesy Polaroid Corporation*)

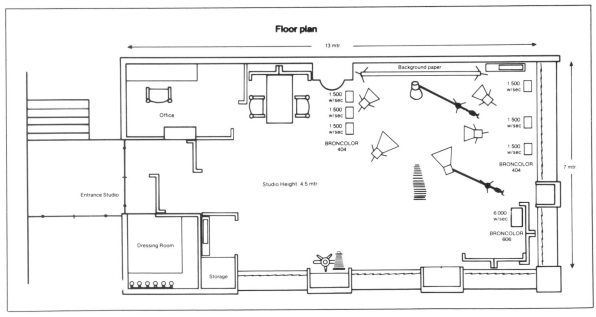

A typical small studio set-up for photographing still life sets.

be secured to ensure the safety of all those who use the studio and, at the end of each session, the whole room should be restored to meticulous order.

The one vital aspect of the professional studio is that provision must be made for top lighting. This can be by means of a boom stand, ceiling boom or rolling ceiling gantry, but it is certain that any busy professional will use such facility almost constantly. It must be sufficiently steady to carry the heaviest light fitting with complete safety.

Furniture must be kept to a minimum and be easily stacked or stored whenever space is at a premium. Trestle tables are a sensible choice and several hard chairs which fold, plus two or three substantial and soft chairs, easily moved so that clients who must sometimes wait for long hours before the photographer is ready to shoot can be comfortable. Aluminium steps, seamless paper holder for backgrounds and wall racks for any equipment often in use, should complete the furnishings. It should be so arranged that visitors to the studio do not have easy or immediate access to the shooting area, but can be held in reception until it is convenient for them to enter. Full and comprehensive insurance, including third party indemnity, must be carried at all times by professional studios.

SUBTRACTIVE LIGHTING

In conditions where there is an over abundance of light, it is necessary to take away selected amounts near the main subject. This can be done by muslin or frosted plastic screens or by the use of black or negative reflectors, or with large opaque flags. Outdoor portraiture in bright, sunny conditions will often require this technique. (See also *Portraiture* and *Lighting*.)

SUN, PHOTOGRAPHY OF THE

Do not look at the sun through an SLR system without first fitting a neutral density filter of at least 4.0 factor. (See Eclipse, Filters.)

An example of the use of a 1000mm lens on a 35mm format camera. Exposure was $\frac{1}{1000}$ of a second at f8 on Ilford FP4.

Table of sun sizes, with various lenses, magnified ten times, as would happen if 35mm format was enlarged onto an 18×24cm (8×10 inches) paper print:

Lens length	Actual sun size on print
50mm	4.55mm
100mm	9.0mm
135mm	12.0mm
200mm	18.0mm
500mm	45.0mm
1000mm	90.0mm

SUPPLEMENTARY LENS

This is a lens which is attached to the front element of the camera lens to alter its focal length, usually so that closer focusing may take place for macro subjects. Very high quality supplementary lenses are available but it is preferable to use the camera lens with extension bellows to achieve the same effect. (See *Close-up Photography*.)

SUPROL

A most effective universal developer prepared as a liquid concentrate by May and Baker of the UK (see *Appendix*). At 1+12 it is an excellent print developer; at 1+4 it gives very crisp results on lith film; at 1+20 up to 1+49 it is a vigorous negative developer, very fine grain and very fast, giving a result somewhat like Kodak DK50 but with fine grain. It works well as a solarizing developer at 1:15 and in stock solutions keeps exceptionally well for months.

SURREALISM

In the art of Europe during the early years following the 1914–18 war, an art movement arose, phoenix-like from the ashes of shattered aspirations and the vibrating tenuousness of the aftermath of war, which sought a super reality by the fusion of poetry and knowledge. Within one frame of reference lay a dissolving and resolving visual concept which attempted to link the dreamer's deepest wish with harshest reality and it created images of ambiguity and violence, suffused by both tenderness and sadness. It was dream fantasy made solid by the artist's vision.

It is important that photographers understand more of Surrealism where images become symbols of subjective experience, where juxtaposition and montage of common objects can create dynamic tension and where the lush, temporary and temporal photographic realism of the world can be enhanced by the poetry of the photographer's own inner experience. Artists who should be studied include *Renée Magritte, Max Ernst, Pablo Picasso, Salvador Dali, Paul Klee, Juan Miró, Jean Arp, Man Ray*. Photographers who are interesting in this context include *Man Ray, Christian Schad, Leslie Krims, Christian Vogt, Jerry Uelsmann*. Much of modern advertising photography has a derivative link with Surrealism.

Right A simple, haunting photograph by world renowned US photographer Jerry Uelsmann is a superb example of surrealistic photography. (*Courtesy Jerry Uelsmann*)

SYMBOLISM

Images of all kinds represent real things and the camera image, when rendered sharply in normal perspective, easily reminds us of the reality in the original scene. However sharp and clear it is, it must be remembered that it is not real life, but a *symbol* of it. As the image becomes less easily recognized and a guess must be made as to its content or form, the viewer will supply a subjective hypothesis, more clearly to understand the symbol. This subjectivity is drawn from the unconscious experience of the viewer and it is applied to any ambiguous areas of the image displayed, making the viewer's link with the image stronger and more personal. Strong and universal symbols within a photograph create an automatic reaction, while mysterious paradoxes or optically vague symbols ask more of the observer, who must resolve the image by the use of imagination. Colour is one of the most basic and moving symbols in image making. (See *Colour Harmony, Surrealism, Image Management*.)

SYNCHRONIZING

For exposing flash light accurately, cameras are fitted with an electric contact to fire the lamp when the shutter is fully open. Different lamps require different settings, but on modern cameras it is usual to find only two – M or X. M settings are for expendable lamps and often only appear on leaf shutters, while X settings, for electronic flash use, are found on leaf and the focal plane shutters fitted to most SLR cameras. Focal plane

shutters are usually only synchronized up to speeds of $\frac{1}{125}$ second, relying on speed of the flash to stop action, while leaf shutters, such as the Copal or Compur type, are synchronized even on x settings up to their maximum speeds. If there is any doubt about synchronizing accurately, the shutter should be set on B or T setting and the flash fired manually while the shutter is held open. Many 'dedicated' flash units are connected by the hot-shoe accessory clip on the camera body to a sophisticated camera metering system, separate from the usual film exposure meter. This flash system turns off the lamp the moment sufficient light for correct exposure is reaching the film plane (see *Shutter*.)

SYNCHRO-SUNLIGHT

In sunny conditions when contrast ratios may be too high for the chosen film, shadows can be dispersed or softened by the use of flash, synchronized to expose at the same time as the sunlight exposure is made. Care must be taken when working with powerful flash units or in close-up situations, otherwise the subject will appear harshly overlit in the shadow areas. When photographing people it is advisable to mask the flash head with one thickness of pocket tissue in order to soften and reduce the light. Many 35mm SLR cameras with focal plane shutters do not have flash synchronizing speeds above $\frac{1}{60}$ or $\frac{1}{125}$ of a second and in bright light conditions such as beach or snowscapes, where synchro-sunlight technique is often most needed, it may be necessary to load with film rated at 64 ASA or slower. (See *Flash Photography*, *Lighting*, *Multiple Flash*, *Exposure*, *Contrast Control*.)

An example of the use of electronic flash to soften harsh shadows when photographing people in bright overhead sunlight. (*Courtesy Polaroid Corporation*)

SYSTEMS CAMERA

Many modern cameras have a multitude of accessories, lenses and attachments which can be linked together to enhance the performance of the camera. Starting from the concept that a fixed body camera box can be made light-proof so that lenses may be changed mid-roll without damaging the unprocessed film, the systems camera will have compatible attachments to take care of exposure reading, flash firing, data input, remote triggering, motorized film transport, close-up extensions, and so on. The first systems camera was the 35mm Leica introduced in 1924 in Germany and at present writing, the most comprehensive is the new Rolleiflex 2000 SL 35mm format with integrated electronic function. It is usually the 35mm cameras, particularly the SLR type, which are highly systemized, but 120 formats are represented by Hasselblad, Rolleiflex, Bronica and Pentax, while Sinar has introduced systems photography to a very sophisticated degree with large formats.

The SLR is usually characterized by interchangeable lenses and a system of accessories. Viewing is directly through the camera lens, made possible by a series of mirrors and prisms. (*Courtesy Photax Ltd*)

TALBOT, WILLIAM HENRY FOX (1800–77)

A constant activity and interest in photographic chemistry led the Englishman Fox Talbot to begin making successful paper-based photographs or, more correctly, photograms, at least four years before Daguerre's invention was announced. His process became known as Calotype and as it used a wax paper negative to originate the image it was the first example of the negative/positive process. In 1844 he published the first book ever to use photographic illustrations, *The Pencil of Nature*. He also patented, in 1852, a method of photo-etching on steel and was concerned with exploring the sensitivity of silver bromide as an emulsion. He was a close friend and collaborator of Sir John Herschel whose own spectacular contributions to the birth of photography, no doubt, were contributory to Fox Talbot's success. (See photograph under *History of Photography*.)

TELEPHOTO LENS
(See *Lenses*.)

TELEVISION SCREEN, PHOTOGRAPHY OF

Adjust the brightness and colour controls so that highlights are not too harsh and detail is clearly seen in the shadows. Colour should be adjusted to be pleasing to the eye. The room should be as dark as possible with no window or room lights showing and nothing reflecting in the screen. Place the camera on a low tripod and wrap a black cloth around the bright metal of both camera and tripod to prevent screen reflections. Use an SLR camera for best results and extension rings if necessary to achieve a screen size which fills the format. If a viewfinder type camera is to be used remember to tilt the camera lens slightly upward to compensate for *parallax*. Select $\frac{1}{30}$ second or slower on leaf shutters and on a focal plane shutter select $\frac{1}{8}$ second, otherwise, as the electron beam is scanning the tube, frame bars may be caught in the camera image. Focus on the tube lines, not the image. A suggested exposure for 400 ASA film would be $\frac{1}{30}$ second at f5.6 and, in colour photography, it may be advisable to add a CC 30R filter or a Kodak Wratten 81B which requires a two-thirds stop increase. Try and photograph images which are not too mobile and use daylight colour film for colour results.

TENSION

Tension may be found, in a graphic sense, in a still image which has opposing elements of dynamically mobile components. (See *Image Management*.)

Not all theatrical photography takes place in the auditorium. An actor could require a casting photograph in full make up or costume as in this picture.

TENT LIGHTING
This is a method of eliminating specular highlights or dark shadows from highly reflective subjects (see *Lighting*).

THEATRE PHOTOGRAPHY

Much of what has been written under *Dance Photography* applies to the photography of theatrical events and probably the two most important factors to remember could be stressed again: obtain permission beforehand from the management and do not disturb the actors or audience. This means no flash, no motor winds for film transport and using leaf shutters where possible, with the photographer finding a viewpoint which is sufficiently unobtrusive so that the audience does not have any interruptions to its vision of the stage.

Long lenses, fast film and a camera support of some kind will generally be needed, despite the apparent abundance of light. The timing of the shot will be critical. Choose a moment

when action is at its peak and the actors are relatively still and then expose the film, preferably using a cable release. The best cameras for theatre use are probably twin lens reflexes such as the Rollei or rangefinder cameras such as the Leica because they are by far the quietest. Exposure judgement can be left to camera automation, but this is risky and a narrow angle spot meter offers the best means of achieving accuracy of exposures. Typical exposures using 400 ASA film will be around $\frac{1}{60}$ at 2.8 or f4 if the stage is a professional auditorium and brightly lit, about $\frac{1}{125}$ for ice shows at the same apertures, with $\frac{1}{250}$ being possible if a performer is under a strong spot light. Amateur performances often require at least one stop more exposure due to reduced light levels.

Remember once more: do not photograph a theatrical event without management permission and never use flash in the auditorium unless you are $4\frac{1}{2}$ metres (15 feet) or *less* from the performer. (See *Dance Photography*, *Multiple Flash*, *Lighting*, *Available Light*, *Contrast Control*.)

Left An editorial portrait of the actress Glenda Jackson. Here the needs are very different from those required for the casting photograph. (*Courtesy Mayotte Magnus*)

THERMAL PHOTOGRAPHY

Radiant energy emitted by live or inanimate objects when it rises to the high frequency end of the spectrum (700–1000nm) is considered to be infra red energy and may be photographed by emulsions which are sensitive only to this region of energy. Thermography takes place in special areas from which all actinic light has been excluded and, in the case of live subjects, an electronic amplification is needed of the infra red emission before it can be photographed.

THREE-DIMENSIONAL PHOTOGRAPHY

True three-dimensional photography requires more than one image, as we see with the aid of *parallax* in a binocular way. Usually simultaneous pictures are taken from viewpoints about 66–70mm (2.6 inches) apart and a mechanical device is used to display them in such a way that the left eye can see only the left-hand viewpoint image while the right eye sees the other. The brain fuses these images into one, perceiving a spatial dimension between objects and their height, width and depth.

Depth dimension can be suggested and symbolized by evidence in the image of cast shadows, textures and the use of exaggerated geometric and aerial perspective, but apart from the stereoscopy of Victorian times, when, in 1849, Sir David Brewster perfected the stereoscope and four years later, when Dancer improved it and built an advanced two lens camera, a popular system has not been devised.

Recently a British company, Nimslo, with considerable backing from various investors, has begun manufacture of a four lens camera and the making of colour prints embodying a modified lenticular screen surface. It is possible that this may be the first to break into the mass market with a system of viewing which does not require mechanical devices to aid the eyes. (See also *Vision*, *Perspective*, and *Image Management*.)

TIME AND TEMPERATURE

For every film and developer combination, time and temperature charts may be worked out so that at a given time and given temperature, a chosen quality of negative may be produced in respect of density and contrast. Especially useful for panchromatic films, which are developed in total darkness, it is the preferred method of processing both film and print. (See *Developing*, *Enlarging*, *Archival Processing and Storage*, *Storage of Sensitized Material*.)

TINTYPE
(See *Print Types*.)

TONE LINE

When a long scale negative film image is contact printed in precise register, base to base, with a perfectly matched positive film image and the exposing light is off-centre, tone and form is suppressed and only a thin edge line will print, outlining contours (see next page for a method diagram). A further extension of this technique is to make separation masks on lith film to record highlight details, middle tone and shadow detail all on separate films. Make reverse masks of these and match the most interesting pairs in perfect register base to base. Contact print on high contrast paper or film, with an off-centre exposing lamp in a narrow reflector. A wider line may be created by slowly spinning the contact sandwich on a confectioner's turntable, while the exposing lamp is lower and held to the side. If no turntable is available the lamp itself may be moved around the contact sandwich. (See *Posterization*, *Sabattier Effect* and the fig. overleaf.)

TONING

By dyeing or bleaching with a following redevelopment, normal silver images may be toned into a wide variety of colours. The most popular in the past for prints has been sepia, a brownish-red conversion of the black areas in the print and commonly achieved by the use of a ferricyanide bleach with redevelopment in sodium sulphide. Only properly fixed and thoroughly washed prints respond to this process without staining and each paper type has its own characteristic brown tone. Images so treated are absolutely permanent. Platinum, gold and selenium toning are also popular for the permanence of their final images. To sepia tone an image, fix normally and wash for 50% longer than usual. The print should be rich but have good shadow and highlight detail. Prints which are fully developed in the original developer will be colder in tone than those which have come up briskly. To make the stock solution of bleach, dissolve 100g of potassium ferricyanide plus 100g of potassium bromide in 1 litre of water. Immerse the print with

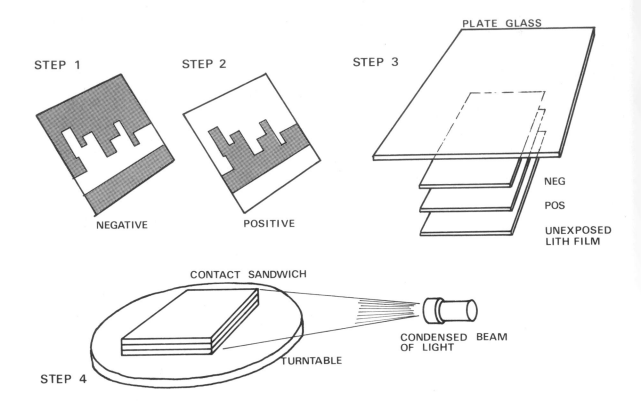

STEP 1 — NEGATIVE

STEP 2 — POSITIVE

STEP 3 — PLATE GLASS / NEG / POS / UNEXPOSED LITH FILM

STEP 4 — CONTACT SANDWICH / TURNTABLE / CONDENSED BEAM OF LIGHT

This is one way of obtaining a tone line effect, using a turntable and a negative/positive master.

constant gentle agitation in a dish of this solution which has been further diluted 1:10. Keep the print in this until shadows are only just discernible and highlights and mid-tones have disappeared. Rinse in running water for 20 seconds and immerse in the second solution. The stock solution of the redeveloper is made by dissolving 50g of sodium sulphide in 1 litre of water to produce a concentrate which is also further diluted for use at 1:10. A few minutes in this sulphide solution will restore the image and stain it brown. The bleacher may be re-used if it is stored in tightly stoppered bottles in the dark, but the sulphide solution should be discarded. Sodium sulphide has an unpleasant smell and its vapour can fog unexposed film or paper in its vicinity. When disposing of sulphide solutions in sinks or drains be careful to flush well, do not allow contact with any acid solution and, to minimize the odour, flush a suitable disinfectant down the drain immediately afterward.

Toning of a different kind can be accomplished by preparing the image to accept a dye of a chosen colour by immersion in a bleaching mordant bath. This will allow the coloured dye to be taken up in proportion to the strength of image tone, strongest colours appearing in shadows and faintly in the highlights.

An interesting blue toner where only shadows respond and accept blue colour, leaving mid-tones to accept an acidified dye of a contra colour, while leaving the highlights to wash clear, can be made by mixing the following:

Ammonium persulphate	1g
Ferric ammonium sulphate	3g
Oxalic acid	6g
Potassium ferricyanide	2g
Hydrochloric acid (10%)	2ml
Water to make	2 litres

The print is immersed in this until the shadows are a darkish blue and then washed for 20 minutes. A dye solution of another colour is made by dissolving 0.5g of a selected dye, plus 10ml of 10% acetic acid (1 part glacial to 9 parts water) in two litres of water. The washed print is transferred to this dye bath for 10 minutes and then, when sufficient dye has been accepted in the mid tones, the print is washed in running water until the highlights are clear of dye. Always dry any toned print by natural unheated methods.

TRANSPARENCY

A slide film is another name for a transparency, and is usually on colour film. Being a positive image, it looks like the original

An example of the tone separation technique produced through the use of separate masking.

scene. Also called a reversal film image due to the nature of its processing, it can be printed directly on such colour papers as Cibachrome or Kodak R Type or it can be printed on any *chromogenic* paper by the use of an *internegative*. (See *Colour Enlarging*, the colour plates for *Colour Photography*.)

TRIPOD
(See *Camera Supports*.)

TRAY CLEANER
Mix a two solution bath, solution A consisting of 4g of potassium permanganate dissolved in 2000ml of water to which 8ml of sulphuric acid is *slowly* added. Solution B is made from 60g of sodium metabisulphite and 60g of sodium sulphite, added to 2000ml of water. To clean dishes, give them a two minute bath in solution A followed by a rinse in running water. Then immerse them in solution B for three minutes, after which, wash very thoroughly. (See also *Cleaning*.)

TUNGSTEN LIGHT
Continuous light emitted from an artificial source if it is below 3500K is usually classed as a tungsten light and a special film, balanced for 3400K or 3200K is used. Tungsten *halogen* lamps are becoming almost universally used because of their many advantages and these are employed for exposing to Type B (artificial light) film, balanced to 3200K. (See the fig. overleaf *Kelvin, Lighting, Halogen Lamp*.)

TRI-X
A B/W high speed, 200–400 ASA film of high resolution, moderate grain, moderate contrast and extremely suitable for exposing to available light in difficult conditions. It was introduced in 1955, is manufactured by Kodak and is used by many professionals as a standard all-purpose film.

TWIN LENS REFLEX CAMERAS
This is a camera which has been built with a viewing lens above and parallel to the taking lens, but matching it in general characteristics. Such cameras have amazingly bright and large viewfinders to aid focusing and composition, and the subject does not disappear from the finder at the moment of exposure, which is the case with all SLR cameras. This is often

319

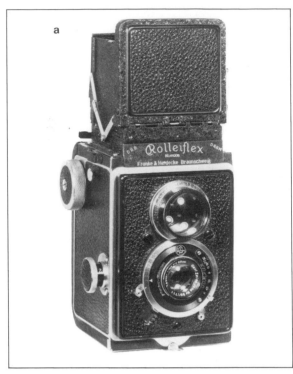

Above **a** The original Rolleiflex (circa 1928–9) which revolutionized professional photography. (*Courtesy Rollei Photo Technik*)
Right **b** A diagram of a modern twin lens reflex, the Rolleiflex. (*Courtesy Rollei Photo Technik*)

a A typical floodlight used with artificial light film. Very bright and generating considerable heat, these can also be used with blue filters with daylight film.
b Tungsten halogen lamps should never be handled with the fingers as lamp life is considerably reduced. Use a tissue when inserting new bulbs.

critically important in fast moving action or press photography, but in close work, under 1 metre (39 inches), parallax can create problems. (See *Reflex Cameras*, SLR *Cameras*.)

TWO NEGATIVE TECHNIQUE

In B/W photography, to mask or partially suppress a background for any intricately shaped product it is possible to create a mechanical overlay on lith film and register it with a continuous tone negative, printing the two together as a sandwich. Quite flexible and creative results are possible. The subject is placed on an unobtrusive stand and lit as normal, while the background is separately illuminated by lighting which does not fall on the subject. The camera (it should be a view camera) is placed on a solid tripod and locked while one exposure is made of the subject, with foreground lighting only, on continuous tone film such as Kodak Plus-x. These lights are then switched off, the background lights are turned on giving a silhouette of the subject and an exposure is made on fast lith film such as Kodak Kodalith, Agfa Ortho, or Fuji L-100.

Develop the Plus-x in a normal active developer, such as D76, and the lith film in a hyperactive caustic developer such as Kodalith liquid or, for maximum contrast, any two solution lith developer. High contrast film is quite slow, usually ASA

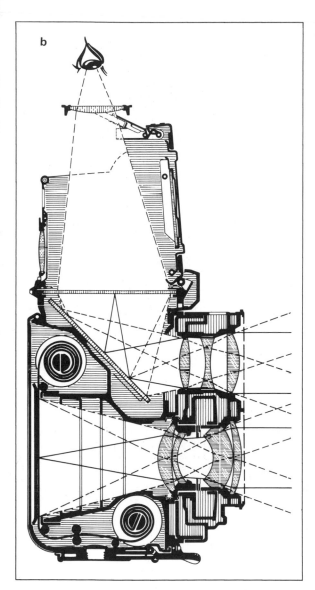

6–10 and some experiment will be needed to get solid density in the exposed areas. Under-exposure will cause pin holing. Remember that to get perfect registration of the two negatives the camera and subject must not move between exposing the lith film and subsequently, the continuous tone negative.

UELSMANN, JERRY (1934–)

With a BA in photography and a Masters degree in both audio-visual and fine art photography, Uelsmann is now Graduate Research Professor at the University of Florida and is deeply involved in creating his own intriguing images which are highly regarded by discerning collectors and exhibitors of contemporary photography.

His synthesis of many images forms a powerfully structured whole and is executed with great technical precision. His dream-like photographs are expressive of the constant interaction between himself and the multiple facets of the assemblage, but the observer quickly joins the artist's reverie, becoming entirely involved in a complex communication between the photographer, the photograph and the intuitive forces and hidden experiences in the observer's own unconscious mind. (See the figs. overleaf.)

ULTRA VIOLET LIGHT

UV light is invisible but nevertheless affects all sensitized photographic materials. Long-wave UV radiation in the 320 to 380 Nanometer (nm) band of the spectrum is transmitted readily by camera lenses, modifies the effect on films considerably and is relatively harmless. Middle-wave UV in the 280 to 320nm will cause reddening of the skin and is not transmitted by camera lenses while short-wave UV transmission, below 280nm, is extremely dangerous to skin surfaces or eyes. Safety glasses must be worn whenever this radiation is employed and the body should be protected from burning.

In natural light, especially at high altitudes or misty conditions, when abundant UV radiation is present, a skylight or UV filter is used on the lens to absorb any excess. This will, on colour film, give darker blue sky, better penetration of haze and richer colours.

Special interest areas of photography may be developed in the field of UV and fluorescence photography, where the subject is totally illuminated by UV radiation. All visible light is excluded in this type of photography and the use of so-called 'black light' will produce the image. The practical use of long-wave UV illumination of the subject is usually to be found when it is used in black and white photography to disclose hidden factors in documents, stamps or art pieces, or in the forensic or medical field. Fluorescence photography has many scientific applications, but is also interesting for its creative and intriguing colour forms. (See also *Light*, *Vision*, *Black Light Photography*, *Filters*.)

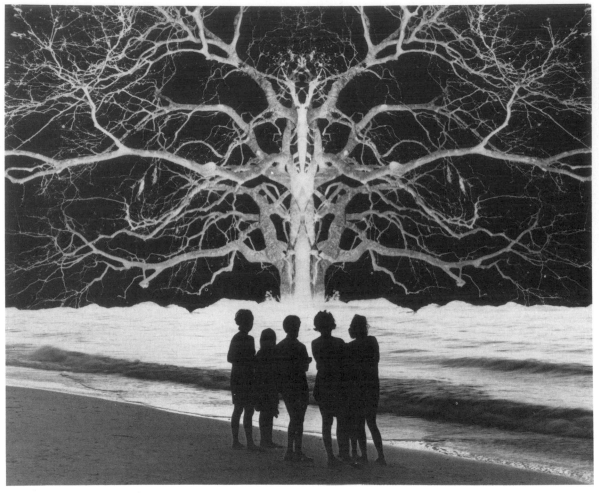

a

Photographs by Jerry Uelsmann taken in 1967 (a), 1975 (b) and 1979 (c). (*Courtesy Jerry Uelsmann*)

UMBRELLA

This is a lighting accessory, made in the form of an umbrella, which can be attached to tungsten or flash lamp heads to diffuse and spread the light. It is made of translucent or opaque reflective materials (see *Lighting*).

UNDER-EXPOSURE

When light falls on any sensitized photographic material in insufficient quantity to register the image in correct tonal gradation and density, it is considered under-exposed. *Push processing* can restore density to some extent, but must be kept below the level of chemical fog. B/W film generally loses details in shadows entirely if under-exposed, but colour reversal film tends to retain shadow detail even in very dense areas. Push processing, plus highlight masking if needed, can very often restore under-exposed transparencies to normal contrast and density. Highlight masking requires a low density film mask

to be contact printed from the transparency and then slightly diffused and spaced away from the original by a matt diffusion sheet, the sandwich is then precisely registered and taped together and a reversal print or copy made. Push processing of black and white will decrease detail in shadow areas unless a compensating developer is used. (See *Basic Photography*, *Black and White Photography*, *Exposure*, *Nine Negative Test*.)

UNDERWATER PHOTOGRAPHY

The equipment used in this activity is notably specialist, needing depth protection, waterproofing and protection against salt corrosion and, possibly, some degree of buoyancy to be built into the equipment. The camera can be housed in a special outer shell to achieve this or be itself treated by the manufacturers to be usable without extra precaution. The most generally acceptable underwater cameras will be 35mm and, of this type, Nikonos is possibly the best known. It does not need extra casing and has interchangeable lenses and powerful flash units, plus all kinds of accessories, but it is not an SLR and could therefore be a source of difficulty in close-up

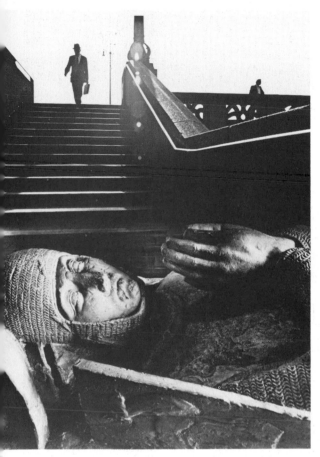

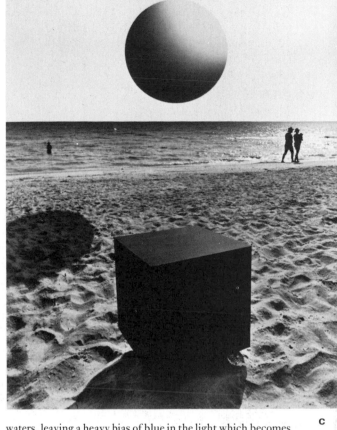

c

situations, or fast changing action sequences. SLR cameras will require a separate diving outer case which is proof against pressures to be found at the proposed depth of dive. Spherical lens covers are to be preferred for the camera housing as they eliminate refraction, even in fairly wide angle lenses. Through the lens focus control is also likely to diminish the confusion brought about by objects appearing closer than they really are, due to the refraction of the water itself.

Fast film should be loaded and even uprated 100% for subsequent *push processing*, as light falls off very quickly under water because it is reflected off the surface and also refracted by the water as the angle of the sun moves from the perpendicular or the depth of water increases. The most brilliant conditions would be found in noon sunlight in clear shallow tropical waters and as conditions deviate from this ideal, so it becomes more difficult for good photography.

The deeper the water, or in conditions obscured by sea algae or rising sediment, the faster the light will decrease, with a considerable colour shift out of the reds and yellows. Over five to eight metres (15–25 feet) a CC 30R filter will be needed, especially if the water appears visually bluish at that depth, or a Kodak 81A Wratten amber filter is possibly better. Greens and yellows will tend to disappear from the underwater light below 15 to 25 metres (50–80 feet) except in the clearest of

waters, leaving a heavy bias of blue in the light which becomes dark violet as depth increases still further. At such depth auxilliary lighting is needed if any object is to be seen in anything approaching true colours. A waterproofed colour chart should be taken to the working depth if possible, while test exposures are run with different filtration. Metering should be by reflectance type equipment.

Auxilliary light is often best provided by electronic flash, but this must be off-camera on a long bracket and angled in to intercept the lens axis at about four metres (14 feet). This will prevent light reflecting directly back into camera from tiny particles of sediment or algae suspended in the water. Guide numbers for surface photography are not viable under water, so actual tests of flash unit and film types must be made at depths chosen and with filters in place. To do this, accurately measure the lamp-to-subject distance, select a suitable synchronized shutter speed and expose a five stop bracket in sea conditions considered as normal for the final photography. Process the film, decide on the best result, then multiply that f stop number by the lamp-to-subject distance to find the GN. Future accurate estimation of actual distances can be made difficult by refraction of the water and some practice is needed.

Should equipment be flooded due to leakage in depth

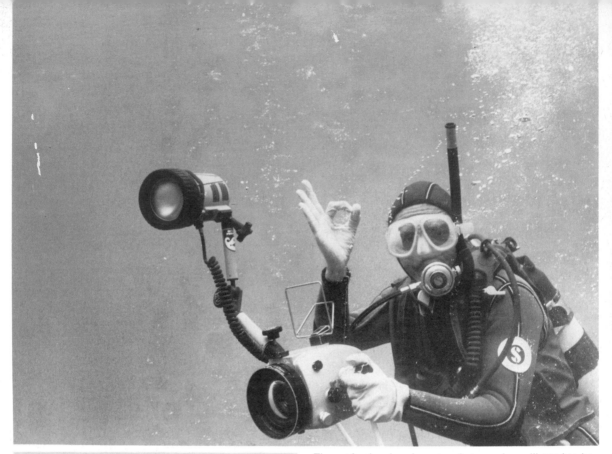

The professional underwater photographer will need to be equipped like this. Note the long extension arm for the flash which produces some angle in the light. Artifical light should not be beamed along the lens axis for underwater photography. (*Courtesy Derek Berwin*)

protection cases, as soon as possible flush clean, fresh water through every working part, taking accessories off and firing and winding shutters and film transport mechanism. Exposed film can possibly be saved by slowly re-winding it back into the cassette in complete darkness once the inside of the camera is full of fresh water. Put both film and camera in a strong plastic bag, fill it with fresh water, tightly seal the bag and then get it immediately to a camera technician. Keep the undeveloped film in water until it is possible to process it, but softening of the emulsion will take place rapidly so this must be done as soon as possible. Such water damage to a camera, especially if it is salt water, can require total strip down and re-building of the equipment – a very expensive job, so check all casings regularly for faults.

UNIVERSAL HEAD

To attach a camera to a tripod or other mechanical support so that it may be tilted in any direction and rotated laterally for 360°, a special ball jointed accessory is made to screw into the

A universal ball joint, strong enough to hold the camera normally used and in any position, will be needed and is attached to the tripod head. This is often the weakest link in the tripod support system and it is wise to buy the best affordable.

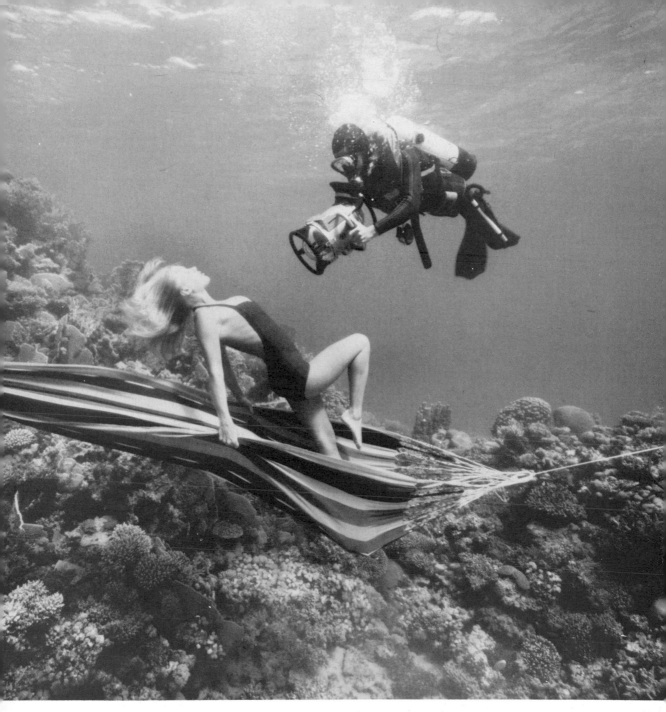

tripod bush on the camera body and to be attached subsequently to the tripod head. This universal head is a very necessary piece of equipment for all *tripod* users, even for small format cameras and it must be large enough to take the weight of the camera and have a positive locking system to hold the camera steady even in a vertical position.

Tremendous technical skill and faultless teamwork is necessary for this kind of picture to succeed. The photographer Derek Berwin was making a series of underwater pictures for a calendar client, the model had only seconds to achieve the relaxed pose required. *(Courtesy Derek Berwin)*

UV FILTER
(See *Skylight Filter* and *Filters.*)

VARIABLE CONTRAST PAPER
(See *Multigrade Paper*.)

VIEWFINDER
(See *Rangefinder Cameras*, SLR *Cameras*, *Reflex Cameras*, *Large Format Cameras*, *Parallax*.)

VIEWING DISTANCE FOR PHOTOGRAPHS
To see the correct perspective and apparent sharpness which relate the photograph to the photographer's original intention, viewing the photograph should take place at certain distances according to the size of the finished picture and the lens used to make it originally. Correct perspective can be seen only if the picture is viewed with one eye closed while looking along the central axis of the image at a distance equal to the focal length of the taking lens, multiplied by the magnification of the enlargement. An enlargement of 20 times from a full 35mm negative, made with a normal 50mm lens, would therefore require a viewing distance of 100cm (39 inches). Such a print would be approximately 48 × 72cm (19 × 28 inches) in size. A rough guide to viewing large prints and murals (but not necessarily in perfect perspective), is that they are best seen at a distance not less than their diagonal measurement. Both of these calculations of viewing distance take care also of the acceptable sharpness of the image. Viewing large prints at under the minimum distance will often create an apparent unsharpness or lack of detail in the zone of central focus (see *Depth of Field*). If a print is viewed too closely, perspective appears expanded, if too far away, perspective and spatial separation between objects appears to be compacted. (See *Perspective*, *Circle of Confusion*.)

VIEWING MASK FOR PICTURE FINDING
It often helps to look for suitable subjects without setting up the camera, especially for landscape or nature photography where patterns and rhythmic designs are sought among complex forms. A viewing mask is an aid to this and is easy to make.

Take a piece of thick, black card, 40 × 30cm (20 × 16 inches) and cut a central rectangular opening in it in the same aspect ratio as the camera *format*. A 35mm camera format could be multiplied by four, giving an opening of 14.4 × 9.6cm ($5\frac{7}{8} × 3\frac{3}{4}$ inches), 120 formats could be multiplied by two and

A viewing mask for picture finding.

larger formats could be that which the camera is taking. To see a subject with the same field of view as the lens, close one eye and place the frame at a distance which equals the focal length of the chosen lens, times the factor used to multiply the format while making the mask, thus: using a 100mm lens on a 35mm camera, looking through an opening which is four times the format size, the mask should be 40cm (16 inches) from the eye. Where the mask is made with an opening exactly the size of the format, such as when using an 18 × 24cm (8 × 10 inch) camera, the eye is placed at a distance equal to the focal length of the lens used (see *Landscape Photography*).

VIGNETTE
By using a mask between enlarger lens and paper, which has a saw-tooth oval cut out of it, a vignette can be made around the main subject so that full exposure is limited to the chosen area, with distracting background details fading into white unexposed paper. This was sometimes used in old-fashioned portraiture and became very popular in the early days of photography. It can also be done in-camera, using a matte box, but this permits less control.

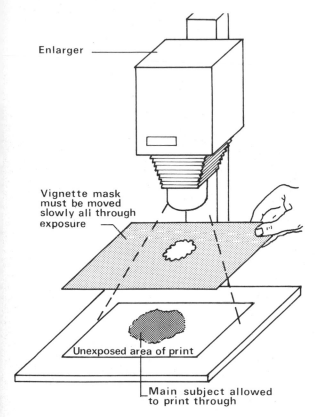

Enlarger

Vignette mask must be moved slowly all through exposure

Unexposed area of print

Main subject allowed to print through

Using a black cut-out mask for vignetting.

VISION

We see because our eyes receive a pulsation of electro-magnetic energy, arising from a burning filament, fire light, candle flame or other artifical source, or we see by the brilliant, direct light from the combustion of the sun during the day, or by night with the help of a low level of sunlight reflected from the moon and stars. *Alhazen*, the eleventh-century Arab mathematician, who first unravelled the secrets of perspective and gave us the first theoretical means of constructing cameras, says in his treatise on optics: 'Nothing visible is understood by the sense of sight alone, save light and colour'. It remains true that in the act of seeing, we identify only light and colour, shape and contour.

To understand what is visible requires a further act, that of 'perception' which is far more complex. The eye collects information for controlling basic physical or psychological activity, vital originally as signals for survival in time of danger or during the quest for food. This information in modern man is filtered and modified by past experiences of perception and eons of cultural progression. Vision becomes, to some extent therefore, a philosophical concept.

The eye contains three sensors, each sensitive to one primary colour: red, green and blue-violet, and from these three receptors the entire range of possible hues and their range of lightness and darkness can be assessed. Each of us will perceive colours as physically different entities according to our individual experiences and cultural backgrounds and this is true of all visual cues, clues or codes which come before our eyes. Understanding what we see is therefore, a *translation*

and it is different for each individual, except where the object seen is something so generic that its properties are not called into question. For example, the most durable forms of art have a universality in their symbolism which subconsciously affects many people in the same way.

The Gestalt psychiatrists suggest we perceive the whole substance and concept of a visual experience before we begin assessing the parts and that the analysis and separation of each elementary part cannot later be restored to exactly equal the sum of that first sweeping generalized perception. So perhaps vision itself is an act of synthesis. Doctor Edwin Land, famous for his pioneering of the instant Polaroid system, has recently demonstrated that we perceive colours differently if the same colours are arranged in simple colour swatches or if they are arranged in complex image patterns which have some added meaning. He has also shown that the brain can draw on past experiences and invent colours which are not actually present in the image and can see full colour under some circumstances when as few as two of the brain's receptors are activated.

Vision then, it seems, is a highly subjective experience and personal to every individual, depending to some extent on illusionary factors and this is particularly true when looking at a manufactured image, such as a painting or a photograph. Just as the eye sees an objective reality and then the brain translates it into something else which conforms to the observer's expectations and experience, it must be understood that the camera does not re-create reality but an *image* of that reality and when we view the resulting picture we make still further modifications according to our own subjective skills with images, thus removing real life still further away.

Unlike the single fixed stare of the camera, the eyes are constantly in motion. They seek to find a pattern by an involuntary series of jumps responding first to movement, colour, changes of illumination, outline, form and so on, exploring the scene by a point-by-point examination of its most obvious parts. As well as this intermittent eye movement, the eye also has a continuous eye tremor of minute pendulum shifts of direction at between 30–150 cycles per second and a further movement of blinking, which closes off visual stimuli and rests the receptors. The blink rate rises under tension and falls to low levels when deep interest is found in the visual material before the eye. The eye acts as a satellite micro-processor, pre-treating basic information and feeding this to the brain for further refinement before understanding takes place. Under good illumination, this transmission of information along the neural fibres occurs in about two milli-seconds or at a rate of 6.5km (4 miles) per minute. In low level light, or in the presence of ambiguous visual clues, the speed of information transfer drops. We understand visual matters by absorbing the visual energy of the active, transitory present and modifying it with stored memories of our past.

The retina has been found to consist of several distinct parts (fig. overleaf), which in fact equate two separate aspects of vision. The outer or peripheral area of the retina, filled with rod receptors, only sensitive to changes in brightness, cannot perceive in the strict sense, at all. It can discern movement and monochromatic greys and is highly sensitive to low level light, but on the outer edges of the

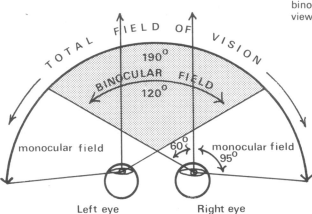

The total field of vision, showing the monocular and binocular sections. The brain synthesizes the two viewpoints from both eyes to create three-dimensionality.

Below The eye sees a large part of life as monochromatic tone and blurred movement. Photographers can exploit this fact in their use of low recognition images and those which appeal to unconscious vision.

A Fouvea cones only.
B Macula rods and cones+.
C Rods and cones mixed equally.
D Rods only.
E Visual noise.

HOW WE SEE

Electro-magnetic waves (LIGHT) enter the cornea of the eye (CAMERA LENS) in amounts controlled by the pupil (LENS APERTURE) and focus on the retina (FILM), stimulating rods and cones which transfer sensations to the optic nerve (NEGATIVE) and then the brain. This sensation is then interpreted by each individual (PRINT) according to personal psychology. Seeing is translation.

HOW WE SEE COLOUR

When light strikes an object it is absorbed, transmitted, reflected or a combination of these.

If the red and green rays are absorbed within an object, the remaining waves are blue and are reflected. We see the object as blue.

If the light is reflected totally from a surface with no change, colour is seen as white.

If almost all rays are absorbed and none are reflected, the colour seen is black.

If the light is reflected impartially and contains most of the spectrum, the object appears grey.

periphery cannot even understand these basic visual clues. Strangely, however, at these far boundaries of peripheral vision, where the retina is filled with visual noise from the nervous system, unconscious signals report to the brain, offering deeply subjective and primal hypotheses for the brain's consideration. The primordial, peripheral area and its concentration of rods, behaves like a primitive eye before evolutionary changes took place and its modern purpose is to act as a pathfinder, sweeping and scanning the world for general clues to interesting visual events, which once found, are then probed by the devastating acuity of the inner eye. Rod vision, ultra sensitive in the twilight world of dimly lit greys, is considered to be nocturnal, 'scotopic' vision.

'Photopic' or daylight vision is restricted to the centre of the retina, in an area known as the macula, measuring about 100 millionths of a metre. Here rods and cones are still present but cones by far predominate. Cones are sensitive only to high levels of light and may be activated by red, blue or green light which the brain transposes into full colour vision. Deep within the macula, packed entirely with cones is the tiny fouvea, a hot spot of acuity capable of resolving detail to an extreme degree. This sophisticated inner eye together with the primitive outer eye from which it perhaps evolved, makes up an amazing optical device capable of a complex psychophysical appraisal of the most ephemeral of visual phenomena

resolving it in minute detail and in brightness ranges of up to 10,000 to 1.

The camera cannot of course perform in the manner of the human eye, but if it is considered that the camera and film may be equated with the inner eye seeing with deep concentrated acuity and the photographer to be the primitive outer eye acting subjectively on the periphery, then the viewer of the image perhaps could become the neural computer, introspectively receiving and decoding the visual signals from the photograph. Unless these three elements are allowed to act autonomously and yet harmonically together, understanding in vision is just as absent as it is in image making. (See *Image Management, Perspective, Movement, Lenses, Image Synthesis, Light, Optics, Basic Photography*.)

VISUAL LITERACY

Seeing is the beginning of the learning process and visual symbols are the most acceptable of all forms of communication. The eye grasps – almost as a tactile motor impulse, but the action takes place only in the mind. Vision is the quickest route to understanding a complex field of interest, establishing its dimensions and meaning at intuitive speed. Visual literacy acquaints us intellectually with this form of communication, permits us to analyze it, explore it, exercise it and improve it. Images have a language. Imaging technique begins the process of learning by making, the finer the technique the more the visual noise is reduced. With less visual noise, the easier it is for observers to reach the visual content and hidden structure of the image, allowing them to understand the underlying concept. Visual literacy permits us to make or translate visual events, including photo imagery; pictures involve and engross us while words tend to decorate our minds with wisps of meaning, merely signposting the way to wisdom and enlightenment. The comprehension of symbolic imagery comes to us only through increased awareness by 'reading' many, many pictures, then learning by making them. This is the first stage of visual self-expression which is followed by literacy. (See also *Image Management, Perspective, Vision, Symbolism, Colour Harmony* for colour symbolism.)

VOGEL, HERMANN WILHELM (1834–98)

Vogel led a team of chemists who devised an orthochromatic plate – sensitive to all colours except red, and laid the foundations into research of panchromatic emulsions – sensitive to all colours – which made possible their later use in colour photography. His *Handbook on Photography*, published in 1867 was an important contribution to the photographic knowledge at that time.

VOGT, CHRISTIAN (1946–)

A young Swiss photographer with a distinctive Surrealistic style whose images are exhibited widely in North America and Europe and are beginning to interest collectors of contemporary photography. (See figs. overleaf.)

The famous camera built by Voigtlander in 1841, taking circular pictures at snapshot speeds just two years after the official announcement of photography's invention. (*Courtesy Rollei Photo Technik*)

VOIGTLANDER, PETER WILHELM FRIEDRICH (1812–78)

The firm of Voigtlander in Austria had a long and proud association in the business of making instruments and later optics. Two years after the introduction of photography, Friedrich was responsible for the manufacture of the Petzval portrait lens which allowed much shorter exposure times with the new Daguerreotype process. The Voigtlander firm has always had an outstanding name in lens manufacture and introduced the first zoom lens in 1959.

VOLTAGE STABILIZER

For colour enlarging, changes in voltage can radically affect the colour of the enlarger lamp and cause unpredictable shifts in colour during printing. To prevent this, it is desirable to have a stabilizer introduced into the electricity supply for the darkroom or to have one built into the enlarger (see *Colour Enlarging*).

VORTOGRAPHS

These were some of the first B/W non-objective photographs ever made with a camera and appeared about 1917. They were made by Alvin Langdon Coburn, with a kaleidoscopic arrangement of mirrors which abstracted the whole image into planes and fragments, creating images reminiscent of Cubism which had only recently been invented. Such images began the active search for photographic abstraction, separate from, but aligned with, rising art influences of Cubism, Dadaism and Surrealism. At this time, many photographers began experimenting with non-objective images, including Man Ray, Christian Schad, Erwin Quedenfeldt, Edward Steichen, Paul Strand and Moholy-Nagy. (See *Abstract Photography, Surrealism*.)

Left Works by Christian Vogt. (*Courtesy Christian Vogt*)

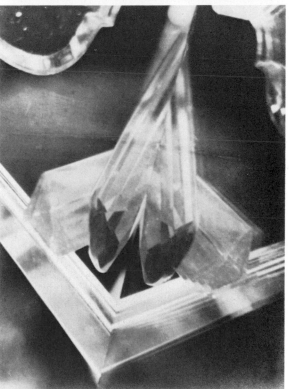

In his early work, A.L. Coburn reflected the trends of the day, producing misty images of landscapes which were prime examples of salon pictorialism (*top*). Later however, he was to alter his approach entirely, making some of the first abstract photographs which he called Vortographs (*above*) (*Courtesy Royal Photographic Society and Kodak Museum*)

WASHING

Removing excess or undesirable chemical residues completely from paper or film emulsions is essential to the long life of a photographic image and washing must be very thorough. (See *Enlarging, Developers, Archival Processing and Storage*.)

WATER BATH

To reduce contrast in negatives and prints a bath of clear, still water is often used during development. By sliding the print or film into it and allowing two minutes at the same temperature as the developer, without agitation, processing continues at a reduced level of activity. The material is then returned to the developer for a short period of time and once again placed in the water bath and so on. This will effectively soften highlight action and reduce contrast. (See *Enlarging, Black and White Photography*.)

WATT/SECOND

A watt/second is a unit of power which equals the Joule and it is considered to be one watt operating for one second. It is often used to indicate the relative power of electronic flash generators, particularly studio units, but to effectively compare output of different equipment, measurement must be made of the actual fall of light from the lamp head. This would then account for reflector design, filament design, temperature of the flash tube, resistance in cabling and so on. Beam candle power/second (BCPS) is now used for this measurement but photographers who wish to discover the comparative lighting power of various units can do this by a controlled test, using Polaroid B/W Type 55 film to record the fall of light on a large, grey scale in front of the camera, which has been placed at a measured distance from the light source. If a colour scale is also included in the test, a good indication may be seen of the colour temperature of the lamp as well but this, of course, would require a full colour transparency test. (See *Electronic Flash*.)

WAVELENGTH

Electro-magnetic energy moves in a pulsating wave motion and visible light rays have an extremely short wave form which is measured in units of 1,000,000,000th of a metre which is called a millimicron. This unit is given a special name: the nanometer, abbreviated to nm. Visible light waves have peak-to-peak measurements in the 400nm (bluish) to 700nm (reddish) range. (See *Light, Vision*.)

WEDDING PHOTOGRAPHY

On the actual day of the event, probably the person least popular is the wedding photographer, but later when the day has gone, what has been photographed assumes maximum importance. For this reason good wedding photographers will work fast, diplomatically and with absolute certainty. The photographer who tells the happy couple the sad story about failure to capture the momentous occasion, whatever the reason, will, if working professionally, put future work at risk, and an amateur working out of friendship will often put that friendship in jeopardy. Results must, therefore, be absolutely guaranteed.

As with any assignment with this stringent proviso, risks can be minimized: check all equipment, particularly flash synchronization and shutter performance. Have back-up items for all essential equipment. Know all the peculiarities of the environment under lighting conditions likely to be found on the day and be thoroughly familiar with the wedding protocol and the service itself. Research is important in every detail, so if it is possible to attend a rehearsal, do so.

Discuss in detail with the couple the style of picture which is wanted and the presentation – if it is to be as framed photographs, formal album, candid book, audio-visual material and so on. Be sure to agree beforehand on price and sizes for work done on the day and subsequent reprints. Guide the bride about suitable make-up, the best being lightly applied street make-up with a little extra colouring to enhance the modelling on cheek bones. Hair styles should be swept away from the face.

Make sure in advance that the church authorities have no objection to photography in the church itself and if they will permit the use of flash during the service and, if using flash on mains supply, find out about plug points and unobtrusive places to locate equipment and cables. If the building is of special interest it may be necessary to fit stained glass windows with neutral density screens so that they may be included in the shot in their full natural beauty.

Most couples will want a mixture of formal but very naturally posed pictures of: the bride by herself, full length and close-up; the bride and groom, full length and close-up; bride, groom, best man and bridesmaids; and one large group of the entire wedding party with close members of the family. It is certain that the cutting of the cake at the wedding reception should also be reasonably formal, but in most other activities the couple will usually appreciate informal or candid pictures. It is a romantic event and this should be reflected in the photography – by using warm key lights, softly diffused fill light, montage treatments to suggest a dreamy atmosphere and, possibly, out-of-focus backgrounds to minimize visual disturbance from them.

Many couples today are interested in a sequential series of the whole day: bride at home with her family getting ready; leaving the home; in the car; arriving at the church; bride and father entering the church; the service; a kiss between the

bride and groom; in the registry; leaving the church; at the reception; cutting the cake; leaving for the honeymoon. By using fast film, this could almost all be shot by available light, giving a sense of immediacy to the final result and the whole can be made into a bound book by mounting successive photographs back to back (see *Mounting*). Look for the unrehearsed incidents, the happy incidents and the great moments of joy and try to illustrate the whole character of the event and those who attend. Avoid stiff, unnatural poses in any of the wedding party.

Equipment for this kind of photography needs to be totally reliable and have a quick film change capability and it is usual that professionals will employ a 120 single lens reflex such as Hasselblad, Bronica or Rollei with interchangeable roll film magazines and it is probably wise also to have a 35mm SLR loaded with fast film to pick up quick, candid moments in the ceremony. Lighting can be by tungsten

floodlight or, more normally, by multiple flash with each unit developing power sufficient for a guide number of 120–150 with 64 ASA film and with a rapid recycling time of five seconds or less. Tripod clamps are useful accessories (see *Camera Supports*).

Long lenses are handy for reaching in on close-ups during crowded moments or to isolate the couple in romantic backgrounds, but remember that when a lens is three times normal focal length or more it will add considerable visual weight to the human figure. Ultra wide angle lenses of 50% of normal focal length are usually undesirable because of distortion, but one which is 75% of normal can be most helpful in tight group shots or during volatile situations at the reception. If these are used, adjust lighting to cover the increased field of view. (See also *Lighting, Multiple Flash, Synchro-Sunlight, Available Light, Portraiture, Image Synthesis, Lenses, Basic Photography*.)

WEIGHTS AND MEASURES

METRIC AND IMPERIAL CONVERSION TABLES

The bold figures in the centre columns can be read as either metric or imperial measure and the corresponding value read off the side columns.

LENGTH

Inches		Millimetres	Sq. inches		Sq. centimetres
0.03937	1	25.400	0.15500	1	6.452
0.07874	2	50.800	0.31000	2	12.903
0.11811	3	76.200	0.46500	3	19.355
0.15748	4	101.600	0.62000	4	25.806
0.19685	5	127.000	0.77500	5	32.258
0.23622	6	152.400	0.93000	6	38.710
0.27559	7	177.800	1.08500	7	45.161
0.31496	8	203.200	1.24000	8	51.613
0.35433	9	228.600	1.39500	9	58.064

Feet		Centimetres	Sq. feet		Sq. metres
0.032808	1	30.48	10.764	1	0.09290
0.065616	2	60.96	21.528	2	0.18581
0.098424	3	91.44	32.292	3	0.27871
0.131232	4	121.92	43.056	4	0.37161
0.164040	5	152.40	53.820	5	0.46452
0.196848	6	182.88	64.583	6	0.55742
0.229656	7	213.36	75.347	7	0.65032
0.262464	8	243.84	86.111	8	0.74322
0.295272	9	274.32	96.875	9	0.83613

Yards		Metres	Sq. yards		Sq. metres
1.0936	1	0.9144	1.1960	1	0.8361
2.1872	2	1.8288	2.3920	2	1.6723
3.2808	3	2.7432	3.5880	3	2.5084
4.3745	4	3.6576	4.7840	4	3.3445
5.4681	5	4.5720	5.9800	5	4.1806
6.5617	6	5.4864	7.1759	6	5.0168
7.6553	7	6.4008	9.3719	7	5.8529
8.6489	8	7.3152	9.5679	8	6.6890
9.8425	9	8.2296	10.7639	9	7.5251

AREA / VOLUME

Cu. feet		Cu. metres
35.315	1	0.02832
70.629	2	0.05663
105.944	3	0.08495
141.259	4	0.11327
176.573	5	0.14158
211.888	6	0.16990
247.203	7	0.19822
282.517	8	0.22653
317.832	9	0.25485

Cu. yards		Cu. metres
1.3080	1	0.7646
2.6159	2	1.5291
3.9239	3	2.2937
5.2318	4	3.0582
6.5398	5	3.8228
7.8477	6	4.5873
9.1557	7	5.3519
10.4636	8	6.1164
11.7716	9	6.8810

UK pints		Litres
1.75976	1	0.56826
3.51952	2	1.13652
5.27928	3	1.70478
7.03904	4	2.27305
8.79880	5	2.84131
10.55856	6	3.40957
12.31832	7	3.97783
14.07808	8	4.54609
15.83784	9	5.11435

continued overleaf

Length

Miles		Kilometres
0.6214	1	1.6093
1.2427	2	3.2187
1.8641	3	4.8280
2.4855	4	6.4374
3.1069	5	8.0467
3.7282	6	9.6561
4.3496	7	11.2654
4.9710	8	12.8748
5.5923	9	14.4841

Area

Sq. miles		Sq. kilometres
0.3861	1	2.5900
0.7722	2	5.1800
1.1583	3	7.7700
1.5444	4	10.3600
1.9305	5	12.9499
2.3166	6	15.5399
2.7027	7	18.1299
3.0888	8	20.7199
3.4749	9	23.3099

Volume

UK gallons		Litres
0.21997	1	4.54609
0.43994	2	9.09218
0.65991	3	13.6383
0.87988	4	18.1844
1.09985	5	22.7305
1.31982	6	27.2765
1.53978	7	31.8226
1.75975	8	36.3687
1.97972	9	40.9148

TEMPERATURE CONVERSION TABLE

Look up the degree figure, either F or C that you want to convert in the middle column and you'll find the converted figure on the right (in the case of Fahrenheit) or the left (in the case of Celsius).

C		F	C		F	C		F	C		F	C		F
−17.8	0	32.0	2.8	37	98.6	23.3	74	165.2	37.2	99	210.2			
−17.2	1	33.8	3.3	38	100.4	23.9	75	167.0	37.8	100	212.0			
−16.7	2	35.6	3.9	39	102.2	24.4	76	168.8	38.3	101	213.8			
−16.1	3	37.4	4.4	40	104.0	25.0	77	170.6	38.9	102	215.6			
−15.6	4	39.2	5.0	41	105.8	25.6	78	172.4	39.4	103	217.4			
−15.0	5	41.0	5.6	42	107.6	26.1	79	174.2	40.0	104	219.2			
−14.4	6	42.8	6.1	43	109.4	26.7	80	176.0	40.6	105	221.0			
−13.9	7	44.6	6.7	44	111.2	27.2	81	177.8	41.1	106	222.8			
−13.3	8	46.4	7.2	45	113.0	27.8	82	179.6	41.6	107	224.6			
−12.7	9	48.2	7.8	46	114.8	28.3	83	181.4	42.2	108	226.4			
−12.2	10	50.0	8.3	47	116.6	28.9	84	183.2	42.8	109	228.2			
−11.7	11	51.8	8.9	48	118.4	29.4	85	185.0	43.3	110	230.0			
−11.1	12	53.6	9.4	49	120.2	30.0	86	186.8	43.9	111	231.8			
−10.6	13	55.4	10.0	50	122.0	30.6	87	188.6	44.4	112	233.6			
−10.0	14	57.2	10.6	51	123.8	31.1	88	190.4	45.0	113	235.4			
−9.4	15	59.0	11.1	52	125.6	31.7	89	192.2	45.6	114	237.2			
−8.9	16	60.8	11.7	53	127.4	32.2	90	194.0	46.1	115	239.0			
−8.3	17	62.6	12.2	54	129.2	32.8	91	195.8	46.7	116	240.8			
−7.8	18	64.4	12.8	55	131.0	33.3	92	197.6	47.2	117	242.6			
−7.2	19	66.2	13.3	56	132.8	33.9	93	199.4	47.8	118	244.4			
−6.7	20	68.0	13.9	57	134.6	34.4	94	201.2	48.3	119	246.2			
−6.1	21	69.8	14.4	58	136.4	35.0	95	203.0	48.9	120	249.0			
−5.6	22	71.6	15.0	59	138.2	35.6	96	204.8	49.4	121	249.8			
−5.0	23	73.4	15.6	60	140.0	36.1	97	206.6	50.0	122	251.6			
−4.4	24	75.2	16.1	61	141.8	36.7	98	208.4						
−3.9	25	77.0	16.7	62	143.6									
−3.3	26	78.8	17.2	63	145.4									
−2.8	27	80.6	17.8	64	147.2									
−2.2	28	82.4	18.3	65	149.0									
−1.7	29	84.2	18.9	66	150.8									
−1.1	30	86.0	19.4	67	152.6									
−0.6	31	87.8	20.0	68	154.4									
0	32	89.6	20.6	69	156.2									
0.6	33	91.4	21.1	70	158.0									
1.1	34	93.2	21.7	71	159.8									
1.7	35	95.0	22.2	72	161.6									
2.2	36	96.8	22.8	73	163.4									

Temperature conversions

$$°F = \tfrac{9}{5}(°C) + 32$$
$$°C = \tfrac{5}{9}(°F - 32)$$

WEIGHT

Ounces		Grams	Pounds		Kilograms
0.035274	1	28.350	2.2046	1	0.45359
0.070548	2	56.699	4.4092	2	0.90718
0.105822	3	85.049	6.6139	3	1.36078
0.141096	4	113.398	8.8185	4	1.81437
0.176370	5	141.748	11.0231	5	2.26796
0.211644	6	170.097	13.2277	6	2.72155
0.246918	7	198.447	15.4324	7	3.17515
0.282192	8	226.796	17.6370	8	3.62874
0.317466	9	255.146	19.8416	9	4.08233

CONVERSION FACTORS
Imperial to metric conversions

To find	Multiply	By
centimetres	inches	2.54
metres	feet	0.3048
metres	yards	0.9144
kilometres	miles	1.609344
grams	ounces	28.3495231
kilograms	pounds	0.45359237
litres	US gallons	3.78541178
millilitres (cc)	US fl. ounces	29.5735296
square centimetres	square inches	6.4516
square metres	square feet	0.09290304
square metres	square yards	0.83612736
millilitres (cc)	cubic inches	16.387064
cubic metres	cubic feet	0.028316874
cubic metres	cubic yards	0.764554858

USEFUL APPROXIMATE EQUIVALENTS

1 millimetre	$= \frac{1}{25}$ inch
1 inch	= 2.54 centimetres
1 foot	= 30.5 centimetres
1 yard	$= \frac{9}{10}$ of a metre
1 metre	= 39.3 inches (3.3 feet)
1 kilometre	$= \frac{6}{10}$ mile
1 sq. inch	= 6.45 sq. centimetres
1 sq. foot	= 0.093 sq. metres
1 sq. metre	$= 10\frac{3}{4}$ sq. feet
1 litre	= 33.8 ounces (USA)
1 litre	= 35 ounces (UK)
1 gallon (USA)	= 3.8 litres
1 gallon (UK)	= 4.6 litres
1 litre water	= 1 kilogram
1 kilogram	= 2.2 pounds
1 ounce	= 31 grams

LENGTH

1000 nanometres	=	1 micrometre
1000 micrometres	=	1 millimetre
10 millimetres	=	1 centimetre
10 centimetres	=	1 decimetre
1000 millimetres	=	1 metre
100 centimetres	=	1 metre
10 decimetres	=	1 metre
10 metres	=	1 dekametre
10 dekametres	=	1 hectometre
10 hectometres	=	1 kilometre
1000 kilometres	=	1 megametre

Nautical

1852 metres	=	1 int. nautical mile

AREA

100 sq. millimetres	=	1 sq. centimetre
100 sq. centimetres	=	1 sq. decimetre
100 sq. decimetres	=	1 sq. metre
100 sq. metres	=	1 are
100 ares	=	1 hectare
100 hectares	=	1 sq. kilometre

WEIGHT (MASS)

1000 milligrams	=	1 gram
10 grams	=	1 dekagram
10 dekagrams	=	1 hectogram
10 hectograms	=	1 kilogram
100 kilograms	=	1 quintal
1000 kilograms	=	1 tonne

VOLUME

1000 cu. millimetres	=	1 cu. centimetre
1000 cu. centimetres	=	1 cu. decimetre
1000 cu. decimetres	=	1 cu. metre
1000 cu. metres	=	1 cu. dekametre

CAPACITY

10 millilitres	=	1 centilitre
10 centilitres	=	1 decilitre
10 decilitres	=	1 litre
1 litre	=	1 cu. decimetre
10 litres	=	1 dekalitre
10 dekalitres	=	1 hectolitre
10 hectolitres	=	1 kilolitre
1 kilolitre	=	1 cu. metre

WESTON, BRETT (1911–)

Son of his famous father, Edward, who was able to interest the young boy in serious photography even at the age of 12. Brett's work is in no way derivative of his father's work but is no doubt influenced considerably by it. Superlative technique, eloquent detail and richly structured organic textures are shining examples of large format photography. His acknowledged mastery of black and white printing depends to some extent on the use of Amidol developer to enhance the darker tones and to bring long-scale highlights to his prints. He is represented by Photography West Gallery, Carmel, California and is exhibited widely.

WESTON, EDWARD (1886–1958)

Endowed with a rich talent, both intellectual and intuitive, Weston was recognized as a gifted artist by the time he helped to found the F64 Group in the early 1930s. His photographs were frankly optical and deeply revealing of the hidden essence of his subjects. Even his studies of the nude appeared to turn into monumental organic form and, forsaking his earlier fascination with natural abstraction, he continued to polish an already glittering technique with large format cameras while he searched for deeper and deeper meaning in the rich tapestry of the Californian landscape. He taught photographers everywhere that conventional photography could be a perfect expressive means of the philosophic perceptions of our world, provided the execution of its technical aspects were mastered to the limit.

WET COLLODION PROCESS

The Englishman, Frederick Scott Archer, introduced this practical method of making glass negatives 12 years after the invention of the Daguerreotype and it was to be used by photographers for two or three decades until superseded by the silver halide/gelatin emulsion of R.L. Maddox in 1871. Collodion was flowed onto a prepared glass plate and this was exposed before it dried, usually allowing the photographer about 25 minutes between coating and final development. Portable darkroom tents or horse-drawn caravans were necessary and considerable agility and expertise were needed to obtain first class results. The achievements of Francis Frith who, in 1858, photographed archaeological subjects in Egypt using this process, often during temperatures of $55°C$ ($132°F$), must be assessed in the light of the difficulties with the technique, as must the creative imagery of all the master photographers of the 1850s and sixties. Particularly to be noted in this respect is the work of Nadar, Julia Margaret Cameron, Silvy, Bisson and Rejlander, all of whom produced strikingly alive pictures under most difficult technical conditions.

WET MOUNTING

Not usually to be recommended for modern prints but there is some merit in using a simple gluten-free wheat paste or pure cellulose paste to attach archival prints to museum mounts. (See *Mounting, Archival Processing, Storage and Presentation*.)

White subjects must never be over-exposed if their delicacy of tone is to be seen.

WETTING AGENT

This is a concentrated detergent of a special kind which reduces surface tension to assist the flow of water during the drying of negatives. Used as a final still bath after the washing, it usually prevents drying marks from water droplets, but must be used with discretion and according to manufacturers' instructions. Kodak Photoflo and May and Baker Cascade are two reliable brands (see *Appendix*).

WHITE, MINOR (1908–76)

Beginning photography in Portland, Oregon, when he was 22, White was a charismatic figure in US photography for the rest of his life. He tirelessly promoted the non-commercial aspects of modern photography, more concerned with introspective images than informational, was a noted teacher at Rochester Institute of Technology in the fifties and sixties, began publishing and editing *Aperture* magazine and published a number of books. He was instrumental with Ansel Adams in popularizing the Zone System of photographic processing and exposure control after Adams had established its basic techniques. To some extent he was a mystic, determined to introduce the intuitive and meditative aspects of oriental art into photography in the USA and his personal images have been of great value to the main body of US photography arising out the last four decades.

WHITE, PHOTOGRAPHING OF

White is usually very difficult to photograph in such a way that detail may be seen in the surface texture and still permit the white area to retain the impression of brilliant reflectance values. A highlight exposure reading should be taken and exposure adjusted so that it is slightly less than normal, for maximum brightness values. A shadow reading is then taken of those dark tones which must be reproduced and a compromise exposure decided upon which allows highlight

and shadows to fit the *brightness range* of the film and paper to be used. Do not increase exposure to allow the shadow detail to record but add light in the shadows or adjust processing to lower contrast. Due to the ability of the eye to maintain a sense of whiteness in any light tone, provided it is placed at the top of reflectance values in a hierarchy of grey or colour tonal steps, white as recorded in a photography may actually be grey or pastel coloured if isolated from the main image.

WHITE LIGHT

Visible light emanating from the sun at noon can be considered white light, a mixture of all colour bands of the electro-magnetic spectrum within the range of 400–700 nanometer (nm). White light is rapidly biased by neighbouring colour materials or by particle colours in the atmosphere so it is rare, in fact, that purity and total neutrality is achieved. (See *Vision*, *Lighting*, *Light*.)

WIDE ANGLE LENSES

Lenses of shorter focal length than normal generally take in a wider *angle of view* and these are considered wide angle lenses. Such lenses increase spatial depth between objects and can distort perspective from certain viewpoints. (See *Lenses*, *Perspective*, *Optics*.)

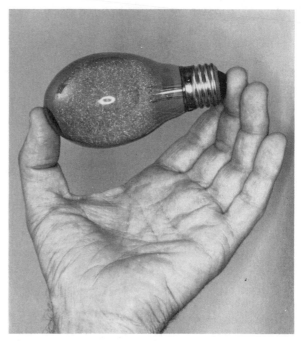

The wire-filled flash is extremely powerful but not reusable after each exposure.

WIDELUX CAMERA

A special camera with a slowly rotating lens which sweeps a landscape in a wide angled arc, giving a panoramic view on a long narrow negative, it is available for 35mm or 120 film.

WINDISCH FORMULA

(See *Compensating Developer*.)

WINDOW LIGHT

A large frame covered with muslin or translucent frosted plastic is often made for studio use through which a powerfully diffused light is delivered to the subject. This in some ways resembles the north window light of the painter or the studio window light of the nineteenth century photographers. (See *Lighting*.)

WIRE-FILLED FLASH LAMPS

Invented in the 1930s, these were portable powerful lighting accessories for the photographer, especially for the photojournalist. Still in use today in the form of flash cubes or small daylight blue lamps, they have been largely superseded by electronic flash, except for special purposes.

WOLCOTT, ALEXANDER S. (1804–44)

Credited with making the world's first photographic portrait (on 7 October 1839 in the USA), he also invented a special portrait camera based on the use of the folded light path and concave mirrors which considerably increased the speed of Daguerreotyping. He opened the world's first professional photographic portrait studio in early 1840, using a 20–30 second exposure instead of the more usual 3–5 minute exposure of normal Daguerreotypes.

WORKING STRENGTH

Concentrated solutions are usually supplied for breaking down into working solutions of great dilution. This dilution usually decreases shelf life considerably. (See *Mixing Solutions* for method of dilution.)

WRAP-AROUND LIGHT

This is a bland lighting plan, covering a wide area and it can be created in the studio to allow subjects to change position rapidly and yet still be reasonably well lit. (See *Lighting*.)

WRATTEN FILTERS

These are made and marketed by Kodak Limited, worldwide, and are considered to be the standard for many professional or scientific photographers. (See *Filters*.)

Whenever travelling by air, place film, electronic cameras and tape recorders into leadlined Film Shield bags to protect them from excessive x-ray.

XENON ARC

Daylight quality light is emitted by the Xenon Arc, either as continuous burning energy or as a flash or pulse of up to 7200 per minute, which is so rapid that it appears continuous. Colour temperature is about 5000K and this type of illumination is often used in large format copy systems or in the photo-mechanical industry using special integrated power supplies.

XEROGRAPHY

The dry copying process for reproducing text, documents and half-tone pictures has advanced considerably in recent years. It depends on the electrostatic sensitizing of a receiver plate which is exposed by short-wave light energy to make the surface conductive and receptive to a positive image. Development in the machine by a dry toner or a pigmented powder causes this to adhere proportionately to the charged image area, making reproduction visible. By an electrostatic induction process, a transfer is effected between image and a sheet of unprocessed paper. This copy, while still in the machine, is fixed by heating or fuming the transferred image to make a dry, permanent bond with the paper substrate which then passes from the machine.

The process is almost instantaneous and colour reproductions are also possible. Photographers and artists have found that xerography is an interesting area for experiment, using large format film originals, often to generate full colour images in the final copy. The transfer sheets suitable for use with Xerox and 3M colour copies are another interesting process whereby the final copy may be permanently transferred to various substrates by using heat and pressure (see *Appendix*).

X-RAYS

Roentgen discovered x-rays and their great powers to permeate solids in the closing years of the nineteenth century. These rays occupy part of the electro-magnetic *spectrum* well below the short waves of UV radiation and although they are invisible, they do substantially affect photographic emulsions. Where this is intentional, such as in medical or industrial diagnostic photography, special film is needed to readily absorb a maximum amount of exposure for a minimum dosage of energy transmitted.

Where there is an unintentional exposure to x-rays, such as in airport security systems, unprocessed film can be damaged, especially colour film. Hand searches are advisable but this request may be ignored in Europe. The final effect on photographic material can be cumulative, depending on the number of security checks the photographer must pass in his journey and it is wise to pack all film and automatic cameras in Filmshield bags to help reduce the hazard. On important assignments, the least number of stop-overs should be planned in air travel and film material should be hand carried at all times and hand searches requested. (See *Light*.)

X SYNCHRONIZATION

On leaf and focal plane shutters it is possible to expose electronic flash which is of short peak and duration, by firing it precisely when the whole film format is uncovered. This is done by synchronizing the flash unit with the opening of the shutter so that when it is wide open, the circuit is closed and the lamp fired. Leaf shutters can be synchronized at all speeds on the x setting, but x or electronic flash synchronizing on focal plane shutters generally does not exceed $\frac{1}{125}$ of a second. M synchronization, which is usually also found on leaf shutters, is only used for expendable flash. (See *Shutter, Electronic Flash*.)

YELLOW

One of the most visible of all colours, it is, in photographic colour print material, also one of the most fugitive. In any material whose colour is subject to destruction by light, it is often yellow which will lose density and suffer colour shifts before any other. Photographers designing images for ex-

x-rays penetrate below the surface of objects. Here is an x-ray of a watch, showing what is beneath the outer case. (*Courtesy D. Macleod*)

hibition or long time archival storage should, if possible, minimize the yellow areas of the image.

YOUNG–HELMHOLTZ THEORY

Thomas Young (1773–1829) suggested a theory which was later developed further by Hermann von Helmholtz (1821–94), that there are in the retina of the eye three receptors: one sensitive to each of the primaries of red, green and blue-violet. From these few basic elements which the sensors of the brain identify in light, all other colour constituents may be experienced. The sensation of yellow is produced by activating both the red and green receptors and the entire gamut of colour bands found in light, however subtle the mix, is identified individually shade by shade, by suitable proportional activity arising in one or more of the three receptors which have been energized by the relative intensities of red, green and blue-violet, seen in an object by the eye. This remains the prevailing theory in explaining colour vision in man. (See *Vision*, *Additive Colour*, *Colour Harmony*.)

ZEISS, CARL (1816–88)

The most famous lens maker in the world, Carl Zeiss who was born in Germany, contributed enormously over the years to the rapid use of photography by the world's millions. He gathered great research talent around him in the realm of optics, including Ernst Abbe and Paul Rudolph. From this group came many famous lenses including the Tessar and

Planar designs. There are now two Zeiss factories, one in East and one in West Germany, at the original Jena site. The West German Zeiss factory has, in modern times, become the producer of possibly the world's finest optics for small and medium format cameras.

ZONE SYSTEM

The brightness or luminance value of a scene will generally be of a greater range than the print can possibly reproduce and since the invention of the photo-electric exposure meter in 1932, systems have been devised to match photographic tones more nearly to the reality of the original scene. In 1935 and 1938 technical specialists of the Weston Electric Instrument Company were able to show a mathematical connection between the brightness range of a scene, subsequent negative processing and available densities of tone on enlarging papers. They emphasized contrast control by correct exposure rather than variable development of the negative. In 1940 John Davenport, an amateur, Ansel Adams and Fred Archer, who were on the faculty of Art Centre College of Design, Los Angeles, were researching the same field.

Adams and Archer improved Davenport's published technique and in 1945, in his book *Exposure Record*, Ansel Adams explained what became known as the Zone System of exposure estimation.

Adams taught that the three subject variables, scene brightness (luminance), exposure and development, were inter-related and could be visualized before the photograph was taken. The infinite gradation of tone in the original scene was to be grouped in ten zones, zone O being black and zone IX, white. Eight zones of grey tone lie between these two, zone V being the middle grey of about 18% reflectance. To make a good negative record from zone to zone requires a full f stop change in exposure. The photographer is asked to pre-visualize the tonal sequence of the subject, placing the critical area of interest in a zone of his/her choosing. The shadows are read, then the brightest highlight and the subject contrast is decided from this information. Contrast control to bring the tonality of the original scene to that of the printing paper is exercised by changing exposure and development times. The latitude of modern emulsions may take some of the precision away from the zone system of exposure, but when properly understood and properly exercised, the method produces prints of extraordinary quality and brilliance. The *New Zone System Manual*, by White, Zakia and Lorenz, is published by Morgan and Morgan, USA, and is an excellent guide to the system.

Appendix

PHOTOGRAPHIC PERSONALITIES LISTED IN THIS BOOK

ABBÉ, ERNST	1840–1905	German
ADAMS, ANSEL	1902–	American
ALHAZEN (Al Haytham)	965–1038	Arab
ARBUS, DIANNE	1923–71	American
ATGET, EUGÈNE	1857–1927	French
AVEDON, RICHARD	1923–	American
BAYARD, HIPPOLYTE	1801–87	French
BRANDT, BILL	1905–	British
BRASSAI	1899–	Hungarian
BRUGUIÈRE, FRANCIS	1880–1945	American
BURROWS, LARRY	1926–71	British
CALLAHAN, HARRY	1912–	American
CAMERON, JULIA MARGARET	1815–79	British
CARTIER-BRESSON, HENRI	1908–	French
CUNNINGHAM, IMOGEN	1883–1976	American
DAGUERRE, LOUIS J.M.	1787–1851	French
DUCOS DU HAURON, LOUIS	1837–1920	French
EASTMAN, GEORGE	1854–1932	American
EINZIG, RICHARD	1932–80	British
EVANS, WALKER	1903–75	American
FENTON, ROGER	1819–69	British
GODOWSKY, LEOPOLD	1902–	American
HERSCHEL, SIR JOHN F.W.	1792–1871	British
HINE, LEWIS	1874–1940	American
KERTÉSZ, ANDRÉ	1894–	Hungarian
KLEIN, WILLIAM	1928–	American
LAND, DR EDWIN HERBERT	1909–	American
MANNES, LEOPOLD D.	1899–1964	American
MAREY, ÉTIENNE JULES	1830–1904	French

MARTIN, PAUL	1864–1942	British
MEES, CHARLES E.K.	1882–1960	British
MICHALS, DUANE	1932–	American
MOHOLY-NAGY, LASZLO	1895–1946	Hungarian
MUYBRIDGE, EADWEARD	1830–1904	British
NADAR, FELIX	1820–1910	French
OSTWALD, WILLHELM	1853–1932	German
PENN, IRVING	1917–	American
PETZVAL, JOSEPH M.	1807–91	Hungarian
RAY, MAN	1890–1976	American
SANDER, AUGUST	1876–1964	German
SISKIND, AARON	1903–	American
SMITH, EUGENE W.	1918–78	American
STEICHEN, EDWARD	1879–1973	American
STEINERT, OTTO	1864–1946	American
STIEGLITZ, ALFRED	1915–78	German
STRAND, PAUL	1890–1976	American
TALBOT, WILLIAM HENRY FOX	1800–77	British
UELSMANN, JERRY	1934–	American
VOGEL, HERMANN WILHELM	1834–98	German
VOGT, CHRISTIAN	1946–	Swiss
VOIGTLANDER, PETER WILHELM FRIEDRICH	1812–78	Austrian
WESTON, BRETT	1911–	American
WESTON, EDWARD	1886–1958	American
WHITE, MINOR	1908–76	American
WOLCOTT, ALEXANDER S.	1804–44	American
ZEISS, CARL	1816–88	German

ASSOCIATIONS AND SOCIETIES

ADVISORY CENTRE FOR EDUCATION (ACE)
32 Trumpington Street
Cambridge CB2 1QY
Great Britain

AMERICAN SOCIETY OF MAGAZINE PHOTOGRAPHERS
205 Lexington Avenue
New York
NY 10016
USA

ARTS COUNCIL OF GREAT BRITAIN
105 Piccadilly
London W1V 0AU
Great Britain

ASSOCIATION OF FASHION, ADVERTISING AND EDITORIAL
PHOTOGRAPHERS LIMITED (AFAEP)
10a Dryden Street
London WC2E 9NA
Great Britain

ASSOCIAZONE FOTOGRAFI ITALIANI PROFESSIONISTI
Viale Monza 111
Milan
Italy

AUSTRALIAN CENTRE FOR PHOTOGRAPHY
76a Paddington Street
Paddington
North Sydney
New South Wales 2060
Australia

BIBLIOTHÈQUE NATIONALE
58 rue Richelieu
75002 Paris
France

BRITISH ASSOCIATION OF PICTURE LIBRARIES AND AGENCIES
(BAPLA)
PO Box 93
London NW6 5XW
Great Britain

BRITISH SOCIETY OF UNDERWATER PHOTOGRAPHERS (BSOUP)
26 Radcliffe Square
Putney Hill
London SW15
Great Britain

CITY AND GUILDS OF LONDON INSTITUTE
46 Britannia Street
London WC1X 9RG
Great Britain

DANSK FOTOGRAFISK FORENING
Valdemarsgade 19
1665 Kopenhagen V
Denmark

EUROPHOT
Postbus 366
2000 Antwerpen
Belgium

INSTITUTE OF INCORPORATED PHOTOGRAPHERS (IIP)
Amwell End
Ware
Hertfordshire SG12 9HN
Great Britain

MASTER PHOTOGRAPHER'S ASSOCIATION (MPA)
TMT House
1 West Ruislip Station
Ickenham Road
Ruislip
Middlesex HA4 7DW
Great Britain

PHOTOGRAPHIC SOCIETY OF AMERICA
2005 Walnut Street
Philadelphia
PA 19103
USA

PROFESSIONAL PHOTOGRAPHERS OF AMERICA INCORPORATED
(PP of A)
1090 Executive Way
Des Plaines
Illinois 60018
USA

ROYAL PHOTOGRAPHIC SOCIETY OF GREAT BRITAIN (RPS)
The Octagon
Milsom Street
Bath
Great Britain

SOCIETY OF INDUSTRIAL ARTISTS AND DESIGNERS (SIAD)
Nash House
12 Carlton House Terrace
London SW1 5AH
Great Britain

SOCIETY FOR PHOTOGRAPHIC EDUCATION (SPE–USA)
PO Box 1651
FDR Post Office
New York
NY 10022
USA

SOCIÉTÉ FRANÇAISE DE PHOTOGRAPHIE
9 Rue Montalembert
75007 Paris
France

GRANTS AND BURSARIES

ARTS COUNCIL PHOTOGRAPHY GRANTS
Photography Officer
Arts Council of Great Britain
105 Piccadilly
London W1V 0AU
Great Britain

CHURCHILL TRAVELLING FELLOWSHIPS
The Winston Churchill Memorial Trust
15 Queen's Gate Terrace
London SW7 5PR
Great Britain

EASTMAN KODAK COMPANY
343 State Street
Rochester
New York 14650
USA

JOHN SIMON GUGGENHEIM MEMORIAL FOUNDATION
90 Park Avenue
New York
NY 10016
USA

KODAK LIMITED
Kodak House
Station Road
Hemel Hempstead
Herts
Great Britain

MAGAZINES AND BOOK PUBLISHERS

AMATEUR PHOTOGRAPHER
Surrey House
1 Throwley Road
Sutton
Surrey SM1 4QQ
Great Britain
(Weekly magazine)

AMPHOTO
750 Zeckendorf Boulevard
Garden City
NY 11530
USA
(Book publishers)

APERTURE
Elm Street
Mullerton
NY 12546
USA
(Quarterly magazine)

APERTURE BOOK
The Book Organisation
Elm Street
Millerton
NY 12546
USA
(Book publishers)

ARTS COUNCIL SHOP
8 Long Acre
Covent Garden
London WC2E 9LG
Great Britain
(Book sales)

ASAHI CAMERA
Asahi Shimbun
Tokyo 100
Japan
(Monthly magazine (English))

AUSTRALIAN PHOTOGRAPHY
381 Pitt Street
Sydney
Australia
(Monthly magazine)

B.T. BATSFORD LIMITED
4 Fitzhardinge Street
London W1H 0AH
Great Britain
(Book publishers)

BRITISH JOURNAL OF PHOTOGRAPHY
28 Great James Street
London WC1
Great Britain
(Annual magazine)

CAMERA
Bretton Court Centre
Peterborough PE3 8DZ
Great Britain
(Monthly magazine)

CAMERA
Zurichstrasse 3
Lucerne
Switzerland
(Monthly magazine (English))

C.J. BUCHER
Zurichstrasse 3
6000 Lucerne
Switzerland
(Book publishers)

CREATIVE PHOTOGRAPHY
New Roman House
10 East Road
London N1 6AU
Great Britain
(Monthly magazine)

DESIGN CENTRE BOOKSHOP
28 Haymarket
London SW1Y 4SU
Great Britain
(Book sales)

DIAFRAMMA
Via degli Imbriani 15
20158 Milan
Italy
(Monthly magazine)

GORDON FRASER
Fitzroy Road
London NW1 8TP
Great Britain
(Book publishers)

HENRY GREENWOOD AND COMPANY
LIMITED
28 Great James Street
London WC1
Great Britain
(Book publishers)

HOLT RINEHART AND WINSTON
383 Madison Avenue
New York
NY 10017
USA
(Technical, art and colour book
publishers)

LIGHT IMPRESSIONS CORPORATION
Box 3012
Rochester
NY 14614
USA
(Book publishers and distributors)

LUSTRUM PRESS
331 West Broadway
New York
NY 10013
USA
(Book publishers)

MCGRAW HILL BOOK COMPANY
1221 Avenue of the Americas
New York
NY 10020
USA
(Book publishers)

MODERN PHOTOGRAPHY
130 East 59th Street
New York
NY 10022
USA
(Monthly magazine)

MORGAN AND MORGAN INCORPORATED
145 Palisade Street
Dobbs Ferry
NY 10522
USA
(Book publishers)

NIPPON CAMERA
1-5-15 Ningyo-cho
Nihonbashi
Chouh-Ku
Tokyo
Japan
(Monthly magazine (English))

PETERSEN'S PHOTOGRAPHIC MAGAZINE
6725 Sunset Boulevard
Los Angeles
California 90028
USA
(Monthly magazine)

POPULAR PHOTOGRAPHY
1 Park Avenue
New York
NY 10016
USA
(Monthly magazine)

THE PROFESSIONAL PHOTOGRAPHER
Executive Way
Des Plaines
Illinois 60018
USA
(Monthly magazine)

SLR CAMERA
38/42 Hampton Road
Teddington
Middlesex TW11 0JE
Great Britain
(Monthly magazine)

SOVIETSKOIE FOTO
M. Lubyanka 14
101878
Moscow (Central)
USSR
(Monthly magazine)

PATRICK STEPHENS LIMITED
Bar Hill
Cambridge CB3 8EL
Great Britain
(UK distributor for Amphoto
publications and *Kodak
Professional Hand Book*)

TRAVELLING LIGHT PHOTOGRAPHY
LIMITED
130 Benhill Road
London SE5
Great Britain
(Book publishers)

ZOOM
2 rue du Faubourg Poissoniere
75010 Paris
France
(Bi-monthly magazine)

GALLERIES, MUSEUMS AND EXHIBITIONS

GEORGE EASTMAN HOUSE
900 East Avenue
Rochester
New York 10019
USA

FOX TALBOT MUSEUM
Lacock
Wiltshire SN15 2LG
Great Britain

INTERNATIONAL CENTRE OF
PHOTOGRAPHY
1130 Fifth Avenue
New York
NY 10028
USA

KODAK MUSEUM
Headstone Drive
Harrow
Middlesex HA1 4TY
Great Britain

LIGHT IMPRESSIONS GALLERY
8 South Washington Street
Rochester
NY 14614
USA

MUNCHER STADTMUSEUM
Photo-und-Film Museum
8000 Munich 2
St-Jakobs-Platz 1,
Federal German Republic

MUSEUM OF HOLOGRAPHY
11 Mercer Street
New York
NY 10011
USA

MUSEUM OF MODERN ART
11 West 53 Street
New York
NY 10019
USA

NATIONAL PORTRAIT GALLERY
2 St Martin's Place
London WC2H 0HE
Great Britain

NIKON SALON
5-63 chome
Ginza
Chou-Ku
Tokyo 106
Japan

PENTAX MUSEUM
3-21-20 Mishiazabu
Mirato-Ku
Tokyo 106
Japan

PHOTO-GALERIE IM KUNSTHAUS ZURICH
Kunsthaus
Heimplatz 1,
8001 Zurich
Switzerland

THE PHOTOGRAPHER'S GALLERY
8 Great Newport Street
London WC2
Great Britain

SCIENCE MUSEUM
South Kensington
London SW7 2DD
Great Britain

SMITHSONIAN INSTITUTE, HALL OF
PHOTOGRAPHY
1000 Jefferson Drive SW
Washington DC 20560
USA

VICTORIA AND ALBERT MUSEUM
South Kensington
London SW7 2RL
Great Britain

WITKIN GALLERY
41 East 57 Street
New York
NY 10022
USA

PHOTOGRAPHIC SCHOOLS AND WORKSHOPS

AGFA–GEVAERT NV
Agfacolour School
Septestraat 27
2510 Mortsel (Antwerpen)
Belgium

ANSEL ADAMS JUNE WORKSHOPS
Box 455
Yosemite National Park
California 95389
USA

ARIZONA STATE UNIVERSITY
Tempe 85282
USA

ART CENTRE COLLEGE OF DESIGN
1700 Lida Street
Pasadena,
California 91103
USA

THE BANFF CENTRE SCHOOL OF FINE ARTS
Banff
Alberta
Canada TOL OCO

BROOKS INSTITUTE
2190 Alston Road
Santa Barbara 93103
USA

CORNELL UNIVERSITY
Photographic Department
Ithaca
New York 14853
USA

EASTMAN KODAK COMPANY
Marketing Education Centre
343 State Street
Rochester
New York 14650
USA

FRIENDS OF PHOTOGRAPHY
Box 239
Carmel
California 93921
USA

ILLINOIS INSTITUTE OF DESIGN
3360 S. State Street
Chicago 60616
USA

INTERNATIONAL CENTRE OF PHOTOGRAPHY
1130 Fifth Avenue
New York
NY 10028
USA

KODAK LIMITED
Marketing Education Centre
Gadebridge Lane
Hemel Hempstead
Herts HP1 3HQ
Great Britain

LES RENCONTRES INTERNATIONALES DE
LA PHOTOGRAPHIE (RIP)
rue des Arènes
13200 Arles
France

LONDON COLLEGE OF PRINTING
Elephant and Castle
London SE1
Great Britain

NATIONAL ART EDUCATION ASSOCIATION
1916 Association Drive
Reston
Virginia 22091
USA

NATIONAL SOCIETY FOR ART EDUCATION
(NSAE)
Champness Hall
Drake Street
Rochdale
Lancs OL16 1QZ
Great Britain

NEW YORK SCHOOL OF HOLOGRAPHY
120 W. 20th Street
New York
NY 10011
USA

NEW YORK UNIVERSITY
51 West 4th Street
New York 10003
USA

MASSACHUSETTS INSTITUTE OF
TECHNOLOGY
77 Massachusetts Avenue
Cambridge 02139
USA

PHOTOGRAPHIC ART AND SCIENCE
FOUNDATION
111 Stratford Road
Des Plaines
Illinois 60016
USA

PHOTOGRAPHERS' PLACE
Bradbourne
Ashbourne
Derbyshire DE6 1PB
Great Britain
(Art orientated)

PRINTING AND PUBLISHING INDUSTRY
TRAINING BOARD (PPITB)
Merit House
Edgware Road
London NW9 5AG
Great Britain

ROCHESTER INSTITUTE OF TECHNOLOGY
1 Lomb Memorial Drive
Rochester
New York 14623
USA

ROYAL COLLEGE OF ART
Photography Department
Kensington Gore
London SW7
Great Britain

SAN FRANCISCO CITY COLLEGE
50 Phelan Avenue,
San Francisco 94112
USA

SAN JOSE STATE COLLEGE
San Jose 96114
USA

SWISS PHOTO WORKSHOPS
PO Box 124
5600 Lenzburg
Switzerland

TECHNICAL EDUCATION COUNCIL (TEC)
76 Portland Place
London WIN 4AA
Great Britain

UNIVERSITY OF ARIZONA
Center of Creative Photography
Tucson
Arizona
USA

UNIVERSITY OF FLORIDA
Gainesville 32601
USA

UNIVERSITY OF NEW MEXICO
Department of Art
Albequerque
NM 87131
USA

SPECIAL EQUIPMENT

DURACELL PRODUCTS COMPANY
P.R. MALLORY AND COMPANY
INCORPORATED
S. Broadway
Tarrytown
New York 10591
USA
(Photographic batteries)

EDMUND SCIENTIFIC COMPANY
300 Edscorp Building
Barrington
New Jersey 08007
USA
(Kirlian and other special effects
products)

FABER-CASTELL CORPORATION
Newark
New Jersey
USA
(Graphic supplies)

GALLERY 614 INCORPORATED
614 W. Berry Street
Fort Wayne
IN 46222
USA
(Information and training in carbro
printing)

GOLDFINGER
329 The Broadway
Muswell Hill
London N10
Great Britain
(General supplies, US products,
archival supplies)

HANS NESCHEN (GMBH, KG)
Postfach 1340
Windmuhlenstrasse 6
D-3062 Buckeburg
W. Germany
(Adhesive for archival use)

HOLLINGER CORPORATION
3810 S. Four Mile Run Drive
Arlington
Virginia 22206
USA
(Archival products)

3M COMPANY
Printing Products Division
3M Center
St Paul
MN 55101
USA
(Anti-static equipment)

MEDION LIMITED
Box 1
Oxted
Surrey
Great Britain
(Air ionizers)

MULTIPLEX COMPANY
454 Shotwell Street
San Francisco
CA 94105
USA
(Holography)

G. RYDER AND SONS
Denby Road
Bletchley
Milton Keynes
Great Britain
(Archival storage materials)

SIMA PRODUCTS CORP.
Skokie
Illinois 60076
USA
(Film Shield x-ray protection bags)

SOLIGOR A/C PHOTO INCORPORATED
168 Glen Cove Road
Carle Place
NY 11544
USA
(Special optics, lenses, spot meters)

SPECIAL SERVICES

ARTLAW
358 Strand
London WC2
Great Britain
(Legal advice of all kinds to visual
artists, especially copyright
and commercial law)

BRECHT-EINZIG LIMITED
65 Vineyard Hill Road
London SW11 7JL
Great Britain
(Architectural photo-library)

BRITISH STANDARDS INSTITUTE (BSI)
2 Park Street
London W1A 2BS
Great Britain

FREE STYLE SALES CO. INC.
5124 Sunset Boulevard
Los Angeles
CA 90027
USA
(Mail order photographic suppliers)

FRIENDS OF PHOTOGRAPHY
Sunset Centre
San Carlos at 9th Carmel
California 93921
USA
(General information; workshops;
exhibitions; grant advice)

INTERNATIONAL CENTRE OF PHOTOGRAPHY
1130 Fifth Avenue
New York
NY 10028
USA
(General information; personal
critique of portfolios; exhibitions
and workshops; community
projects)

KEITH JOHNSON PHOTOGRAPHIC LTD
Ramillies House
1–2 Ramillies Street
London W1Y 1DF
Great Britain
(Professional photographic dealers)

LIBRARY OF CONGRESS
10 First Street SE
Washington
DC 20450
USA
(Registration of copyright – USA)

PHOTOGRAPHY FOR THE DISABLED
190 Secrett House
Ham Close
Ham
Richmond
Surrey
Great Britain

PHOTOTHERAPY JOURNAL
1968 W. Weston Avenue
ILL. 60640
USA

CAMERA MANUFACTURERS

	UK distributor	US distributor
ARCA–SWISS OSCHWALD BROS. 8047 Zurich Fellenbergstrasse 272 Switzerland (Large format)	KEITH JOHNSON PHOTOGRAPHIC LTD Ramillies House 1–2 Ramillies Street London W1 Great Britain	CALUMET PHOTO INCORPORATED 1590 Touhy Avenue Elk Grove Village Illinois USA (Large format)
CANON JAPAN CANON INC. 11–28, Mita 3 – Chome Minato-Ku Tokyo 108 Japan	CANON (UK) LTD Brent Trading Centre North Circular Road Neasden London NW10 0JF Great Britain	CANON USA 1 Canon Plaza Lake Success New York USA
EASTMAN KODAK COMPANY 343 State Street Rochester New York USA	KODAK LTD (UK) Hemel Hempstead Herts Great Britain	EASTMAN KODAK COMPANY 343 State Street Rochester New York USA
VICTOR HASSELBLAD AB Box 220 S-401 23 Goteborg 1 Sweden	HASSELBLAD (GB) LTD York House Empire Way Wembley Middlesex HA9 0QQ Great Britain	VICTOR HASSELBLAD INC. 10 Madison Road Fairfield New Jersey NJ 07006 USA
KONICA JAPAN KONISHIROKU PHOTO IND. CO. LTD No 26–2 Nishishinjuku 1-Chome Shinjuku-ku Tokyo 160 Japan	KONISHIROKU UK 51 High Street Feltham Middlesex Great Britain	KONICA 20–25 Brooklyn-Queens Expressway Woodside New York USA

LEICA ERNST LEITZ WETZLAR GMBH D-6330 Wetzlar West Germany	E. LEITZ (INSTRUMENTS) LTD 48 Park Street Luton Bedfordshire LU1 3HP Great Britain	E. LEITZ INC. Rockleigh New Jersey 07647 USA
MINOLTA JAPAN MINOLTA CAMERA CO. LTD. 30, 2-Chome Azuchi-Machi Higashi-Ku Osaka 541 Japan	MINOLTA UK 1–3 Tanners Drive Blakelands Milton Keynes Great Britain	MINOLTA CORPORATION 101 Williams Drive Ramsey New Jersey USA
NIKON JAPAN NIPPON KOGAKU KK Fuji Building 2–3 Marunouchi 3-Chome Chiyoda-Ku Tokyo 100 Japan	NIKON UK LTD 20 Fulham Broadway London SW6 1BA Great Britain	NIKON INC. 623 Stewart Avenue Garden City New York USA
OLYMPUS OPTICAL CO. LTD 43–2 Hatagaya 2-Chome Shibuya-Ku Tokyo Japan	OLYMPUS OPTICAL CO. (UK) LTD 2–8 Honduras Street London EC1Y 0TX Great Britain	OLYMPUS CAMERA CORP. Crossways Park Woodbury New York 11797 USA
POLAROID CORPORATION 549 Technology Square Cambridge Massachusetts USA	POLAROID (UK) LTD Ashley Road St Albans Herts. AL1 5PR Great Britain	POLAROID CORPORATION 549 Technology Square Cambridge Massachusetts USA
ROLLEI FOTOTECHNIK GMBH 33 Braunschweig Salzdahlumer Strasse 196 West Germany	A.V. DISTRIBUTORS LTD 26 Park Road Baker Street London NW1 Great Britain	BERKEY PHOTO INC. PO Box 1060 Woodside NY 11377 USA
SINAR AG Schaffhausen CH 8245 Feuerthalen Switzerland	LAPTECH PHOTOGRAPHIC DISTRIBUTORS LTD 3 Belsize Crescent London NW3 5QY Great Britain	SINAR-BRON AMERICA 166 Glen Cove Road Carle Place New York 11514 USA
CONTAX-YASHICA COMPANY LTD 20–3 Denenchofu-Minami Ohta-Ku Tokyo 145 Japan	PHOTAX (LONDON) LTD 59 York Road London SE1 7NJ Great Britain	CONTAX CAMERA YASHICA INC. 411 Sette Drive Paramus New Jersey 07652 USA

FILM AND CHEMICAL MANUFACTURERS

UK	US
	ACUFINE INCORPORATED 439–447 E. Illinois Street Chicago Illinois 60644 USA (Developers and chemicals)

AGFA–GEVAERT A.G. 5090 Leverkusen 1 Bayerwerk West Germany	**AGFA–GEVAERT LIMITED** 27 Great West Road Brentford Middlesex Great Britain	**AGFA–GEVAERT** 275 North Street Teterboro New Jersey USA
	KODAK LTD Hemel Hempstead Herts Great Britain	**EASTMAN KODAK COMPANY** 343 State Street Rochester New York 14650 USA
		EDWAL SCIENTIFIC PRODUCTS CORPORATION 12120 S. Peoria Street Rochester New York 14650 USA (Developers)
	DU PONT (UK) LTD PHOTO PRODUCTS Wedgwood Way Stevenage Herts. Great Britain	**E.I. DU PONT DE NEMOURS AND COMPANY** Photo Products Department 1007 Market Street Wilmington DE 19898 USA
		ETHOL CHEMICALS INCORPORATED 1808 North Damen Avenue Chicago Illinois 60647 USA (Developers)
FUJI PHOTO FILM COMPANY LTD 26–30 Nishiazabu 2-Chome Minato-Ku Tokyo 106 Japan	**FUJIMEX** Faraday Road Dorcan Swindon Wiltshire SN3 5HW Great Britain	**FUJI PHOTO FILM COMPANY LTD** 350 Fifth Avenue New York NY 10001 USA
		GAF CORPORATION Clinton Street Binghampton New York 13902 USA (Graphic communications equipment and supplies)

CIBA–GEIGY PHOTOCHEMIE AG
CH-1710 Fribourg
Switzerland

ILFORD LIMITED
Basildon
Essex
Great Britain

ILFORD INCORPORATED
West 70 Century Road
PO Box 288
Paramus
New Jersey 07652
USA

3M COMPANY LIMITED
Bracknell
Herts
Great Britain

3M COMPANY
3M Center
St Paul
Minnesota
USA

MAY AND BAKER LIMITED
Dagenham
Essex RM10 7XS
Great Britain

PATERSON PRODUCTS LIMITED
2–6 Boswell Court
London WC1N 3PS
Great Britain
(Chemicals; film clips; darkroom
equipment)

POLAROID (UK) LIMITED
Ashley Road
St Albans
Herts AL1 5PR
Great Britain

POLAROID CORPORATION
Cambridge
MASS 02139
USA
(Polaroid hot line: (617) 547 5176
during business hours, USA time)

UNICOLOUR DIVISION–PHOTO SYSTEMS
INCORPORATED
PO Box 306
Dexter
Michigan 48130
USA
(Colour materials and equipment)

GENERAL EQUIPMENT MANUFACTURERS

B + W FILTER FABRIK
6200 Wiesbaden
West Germany
(Filters, special effects)

TOM WALKER PHOTOGRAPHIC LTD
Station Road
Irthlingborough
Northants. NN9 5QE
Great Britain

KALT CORP.
20036 Broadway
Santa Monica
California 90404
USA

BELL AND HOWELL COMPANY
7100 McCormick Road
Chicago
Illinois
USA
(Projectors, cameras, movie
equipment)

	BERKEY TECHNICAL COMPANY Westwood Park Trading Estate 22 Concord Road London W3 0TQ Great Britain (Cameras, enlargers, tripods, lighting)	BERKEY TECHNICAL COMPANY 26–45 Brooklyn-Queens Expressway West Woodside New York 11377 USA
		BESSELER PHOTO MARKETING COMPANY INCORPORATED 8 Fernwood Road Florham Park New Jersey 07392 USA (Enlargers, darkroom supplies, colour supplies, processing)
	BOWENS SALES AND SERVICE LIMITED Royalty House 72 Dean Street London W1V 6DQ Great Britain (Professional flash equipment, cameras, enlargers, meters)	BOGEN PHOTO CORPORATION 100 S. Van Brunt Street Englewood 07631 New Jersey USA
BRAUN WEST GERMANY ROBERT BOSCH GMBH Geschaftsbereich Photokina Beun Inselkraftwerk 10 D-7000 Stuttgart 60 West Germany		BRAUN NORTH AMERICA PHOTO PRODUCTS DIVISION 55 Cambridge Parkway Cambridge Mass 02142 USA (Flash equipment)
BRONCOLOR BRON ELEKTRONIC AG CH-4123 Auschwil Switzerland (Flash equipment)	LAPTECH PHOTOGRAPHIC DISTRIBUTORS LTD 3 Belsize Crescent London NW3 5QY Great Britain	SINAR BRON AMERICA 166 Glen Cove Road Carle Place NY 11514 USA
		HONEYWELL INCORPORATED 5501 S. Broadway Littleton Colorado USA (Cameras, auto-focus systems, electronics, flash)
HOYA JAPAN 572 Miyazawa-CHO Akishima SHI Tokyo 196 (Filters)	INTROPHOTO Priors Way Maidenhead Berks Great Britain	HOYA UNIPHOT INC. B1–10 34th Avenue Woodside NY 11377 USA

KEITH JOHNSON PHOTOGRAPHIC LTD
Ramillies House
1–2 Ramillies Street
London W1
Great Britain

LARSON ENTERPRISES INCORPORATED
PO Box 8705
18170 Euclid Street
Fountain Valley
California 92708
USA
(Photographic light control systems, lighting equipment, location equipment)

MULTIBLITZ
DR. ING DA MANNESMANN GMBH
D 5000 Koln 90
Westhoven-BRD
West Germany
(Flash equipment)

KEITH JOHNSON PHOTOGRAPHIC LTD
Ramillies House
1–2 Ramillies Street
London W1
Great Britain

MACDONALD'S PHOTO PRODUCTS
11211 Gemini House
Dallas
Texas 75229
USA

KEITH JOHNSON PHOTOGRAPHIC LTD
Ramillies House
1–2 Ramillies Street,
London W1
Great Britain

NORMAN ENTERPRISES INC.
2601 Empire Avenue
Burbank
CA 91504
USA
(Studio and location flash equipment)

KAFITZ CAMERAS
234 Baker Street,
London W1
Great Britain

SOLIGOR, AIC PHOTO INC.
Carle Place
New York 11514 USA
(Spot meters, lenses, special accessories)

SPIRATONE INCORPORATED
135–06 Northern Boulevard
Flushing
New Jersey 11354 USA
(Lenses, general photo–equipment)

KEITH JOHNSON PHOTOGRAPHIC LTD
Ramillies House
1–2 Ramillies Street,
London W1
Great Britain

TIFFEN MFG CORPORATION
71 Jane Street
Roslyn Heights
New York 11477 USA
(Filters and special effects)

VIVITAR
PONDER AND BEST
1620 Stewart Street
Santa Monica
CA 90406 USA
(Lenses, flash, cameras)

CARL ZEISS
Postfach 1369/1380
D-7082
Oberkochen
West Germany
(Lenses)

CARL ZEISS (OBERKOCHEN) LTD
31–36 Foley Street
PO Box 4YZ
London W1A 4YZ
Great Britain

APPENDIX

OTHER PRODUCTS

ADVANCE PROCESS SUPPLY COMPANY
400 N. Noble Street
Chicago
Illinois 60622
USA
(Process photo silkscreen supplies)

AIR PHOTO SUPPLY CORPORATION
158 South Station
Yonkers
New York 10705
USA
(Luminos photo linen)

EASTMAN KODAK COMPANY
INDUSTRIAL PHOTOGRAPHIC SYSTEM SALES
343 State Street
Rochester
NY 14650
USA
(Photo-resists)

NAZ-DAR COMPANY
1087 N. North Branch Street
Chicago
Illinois 60622
USA
(Printing inks for use on glass surfaces)

3M COMPANY
PHOTOGRAPHIC PRODUCTS DIVISION
3M Center 220–3E
St Paul
Minnesota 55101
USA
(Adhesives, photo materials,
anti-static equipment)

JOHN G. MARSHALL MANUFACTURING INCORPORATED
167 N. 9th Street
Brooklyn
NY 11211
USA
(Photo oils, protective lacquer sprays,
toothing lacquers)

MC DONALDS PHOTO PRODUCTS
1121 Gemini Lane
Dallas
Texas 75229
USA
(Adhesives, pastes, print lacquers)

MC GRAW COLORGRAPH COMPANY
175 West Verdugo
Burbank
CA 91503
USA
(Photo silkscreen supplies)

NEGA-FILE INCORPORATED
PO Box 78
Furlong
PA 18925
USA
(Negative filing materials)

NORLAND PRODUCTS LIMITED
695 Joyce Kilmer Avenue
New Brunswick
NJ 08902
USA
(Specialized photo-resists)

PHOTO TECHNICAL PRODUCTS GROUP
623 Stewart Avenue
Garden City
NY 11430
USA
(Ademco heat seal films, dry mounting
laminating equipment and accessories)

PRINT FILE INCORPORATED
Department J
Box 100
Schenectady
NY 12304
USA
(Filing aids)

QUESTAR
Box MP 700
New Hope
PA 18938
USA
(Special telephoto lenses)

QUICK WAY COLOR COPIES
100 East Ohio
Chicago
Illinois 60611
USA
(Transfer paper for heat release,
photocopy process)

ROCKLAND COLLOID CORPORATION
500 River Road
Piermont
NY 10968
USA
(Ready-mixed photo emulsions)

ROSCO LABORATORIES INCORPORATED
36 Bush Avenue
Port Chester
NY 10573
USA
(Filters, lighting, special effects
materials)

ROSCOLAB LIMITED
69/71 Upper Ground
London SE1 9PQ
Great Britain
(Filters, lighting, special effects
materials)

SEAL INCORPORATED
550 Spring Street
Naugatuck
CONN 06770
USA
(Mounting materials and equipment)

WINSOR AND NEWTON
Wealdstone
Harrow
Middlesex
Great Britain
(Transparent oil hand colouring
materials)

XEROX CORPORATION
Xerox Square
Rochester
NY 14644
USA
(Transfer material for colour xerox
machine)

ZELLERBACH PAPER COMPANY
9111 N.E. Columbia Boulevard
Portland
OR 97220
USA
(Transeal heat transfer paper for
photo use and Xerox copying)